DADA

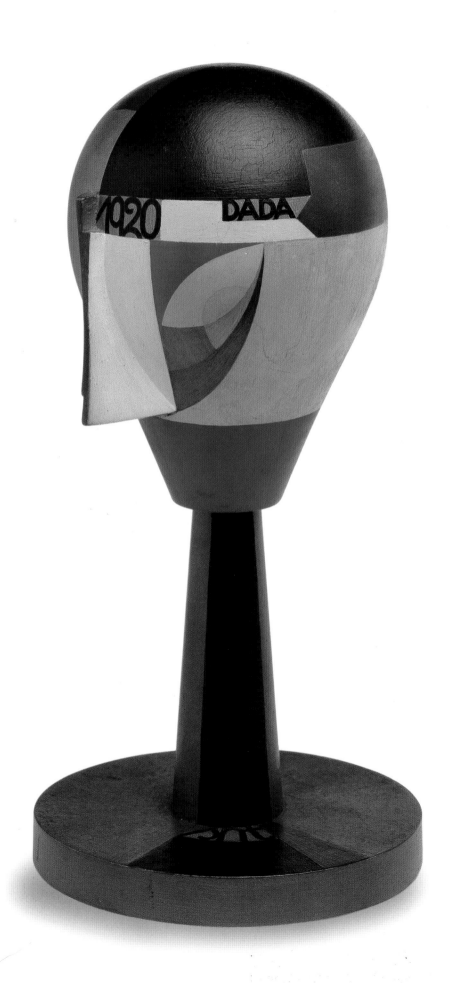

ZURICH
BERLIN
HANNOVER
COLOGNE
NEW YORK
PARIS

DADA

LEAH DICKERMAN

with essays by
BRIGID DOHERTY
DOROTHEA DIETRICH
SABINE T. KRIEBEL
MICHAEL R. TAYLOR
JANINE MILEAF
MATTHEW S. WITKOVSKY

National Gallery of Art, Washington
in association with
D.A.P./Distributed Art Publishers, Inc.

Centre Pompidou
Musée national d'art moderne, Paris
5 October 2005 – 9 January 2006

National Gallery of Art, Washington
19 February – 14 May 2006

The Museum of Modern Art, New York
18 June – 11 September 2006

title page
Sophie Taeuber, Untitled (Dada Head), 1920. Centre Pompidou, Musée national d'art moderne-Centre de création industrielle, Paris. Purchase, 2003 (plate 47)

opposite
The Schwitters visit the Van Doesburgs in The Netherlands, 1919. Theo van Doesburg Archive, Netherlands Institute for Art History, The Hague

page VIII
Detail, view of Mr. Jolibois at the Salon Dada, Paris, June 1921. Roger Viollet (see page 346)

endpapers
Detail, Francis Picabia, L'Oeil cacodylate (The Cacodylic Eye), 1921. Centre Pompidou, Musée national d'art moderne-Centre de création industrielle, Paris. Purchase, 1967 (plate 365)

page 520
Marcel Duchamp in (Walter and Louise Arensberg's?) bathroom, New York, c.1916–1917, gelatin silver print. Collection Timothy Baum, New York

The hardcover edition is published by the National Gallery of Art, Washington, and D.A.P./ Distributed Art Publishers, Inc., 155 Avenue of the Americas, Second Floor, New York, N.Y. 10013-1507. Tel. 212-627-1999, Fax 212-627-9484

Produced by the Publishing Office, National Gallery of Art, Washington www.nga.gov

Editor in Chief: Judy Metro
Senior Editor: Karen Sagstetter
Production Manager: Chris Vogel
Design Manager: Margaret Bauer
Editing and production assistance: Caroline Weaver, Mariah Shay, Evie Mantzavinos, Amanda Sparrow

Design by Daphne Geismar daphnegeismar.com

Typeset in Quadraat and Grotesque by Amy Storm

Printed by Grafisches Zentrum Drucktechnik (GZD), Ditzingen-Heimerdingen, Germany

Library of Congress Cataloging-in-Publication Data
Dickerman, Leah, 1964-
Dada: Zurich, Berlin, Hannover, Cologne, New York, Paris/Leah Dickerman; with essays by Brigid Doherty...[et al.].
p. cm.
Catalogue of an exhibition held at the Centre Pompidou, Musée national d'art moderne, Paris, Oct. 5, 2005–Jan. 9, 2006; at the National Gallery of Art, Washington, Feb. 19–May 14, 2006; and at The Museum of Modern Art, New York, June 18–Sept. 11, 2006.
Includes bibliographical references and index.
ISBN 0-89468-313-6
(softcover: alk. paper)—
ISBN 1-933045-20-5
(hardcover: alk. paper)
1. Dadaism—Exhibitions.
2. Arts, Modern—20th century.
I. Dickerman, Leah.
II. Centre Georges Pompidou.
III. National Gallery of Art (U.S.)
IV. Museum of Modern Art (New York, N.Y.)
V. Title.
NX456.5.D3D53 2005
709'.04'062074—dc22
2005017984

10 9 8 7 6 5 4 3 2 1

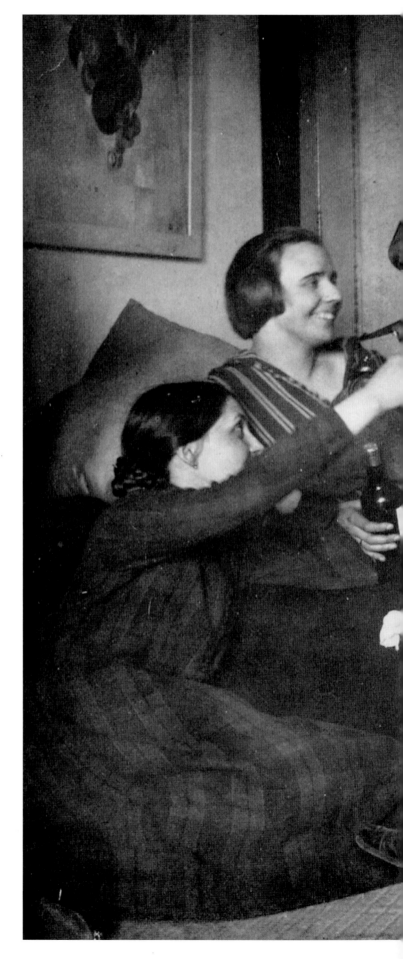

The exhibition in Washington is made possible through the generous support of the Anna-Maria and Stephen Kellen Foundation and the Catherine B. Reynolds Foundation

Additional support for the exhibition in Washington has been provided by the Annenberg Foundation and Thomas G. Klarner

The exhibition is organized by the National Gallery of Art, Washington, and the Centre Pompidou, Paris, in collaboration with The Museum of Modern Art, New York

The exhibition is supported by an indemnity from the Federal Council on the Arts and the Humanities

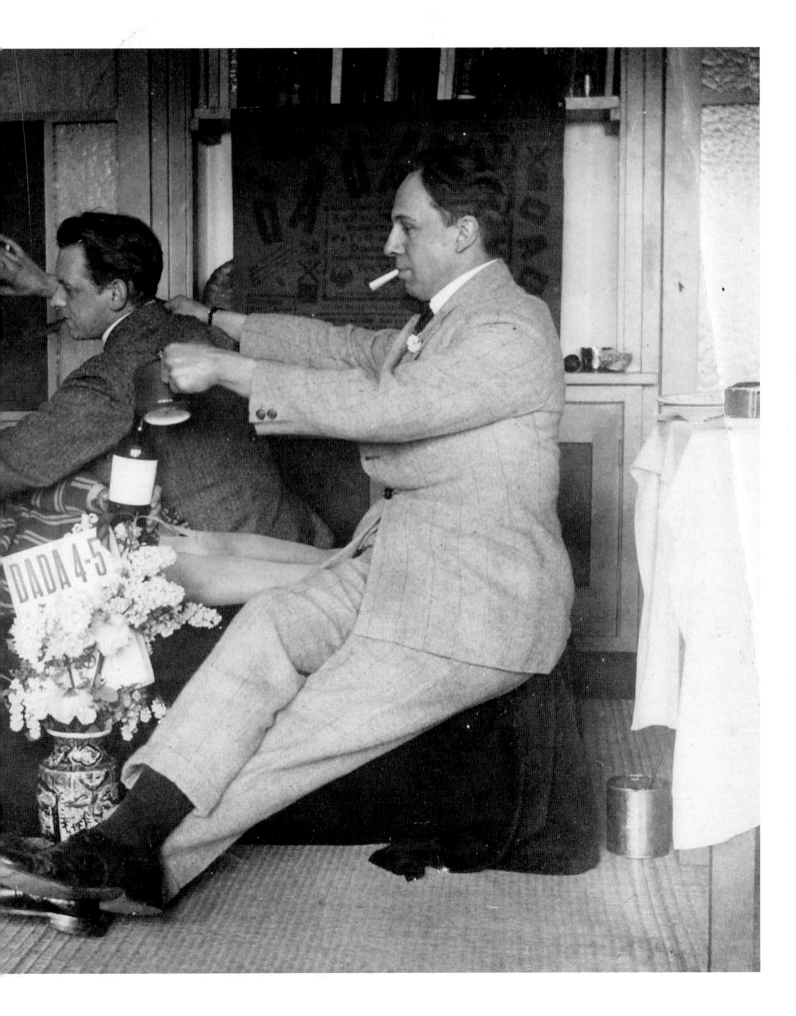

CONTENTS

ZURICH

BERLIN

HANNOVER

COLOGNE

NEW YORK

PARIS

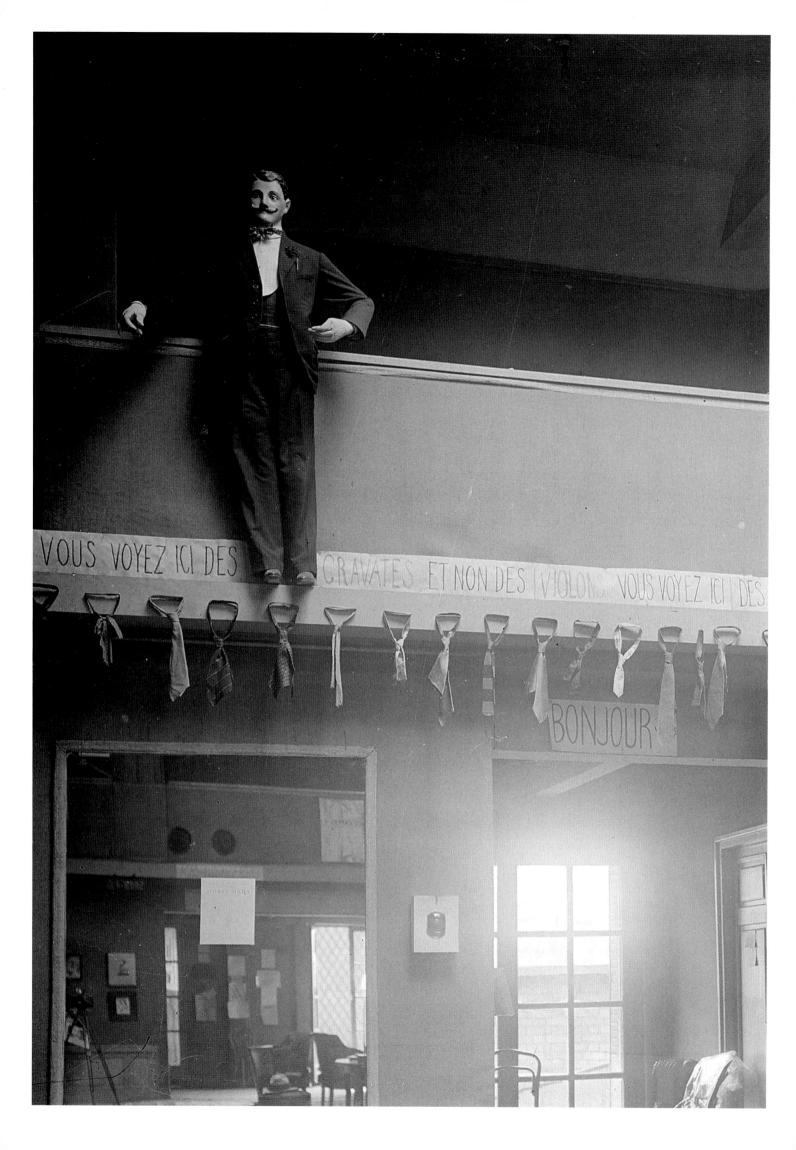

FOREWORD

Born in the heart of Europe in the midst of World War I, Dada displayed a raucous skepticism about accepted values. Its embrace of new materials and methods created an abiding legacy for the century to come, with strategies that included collage, montage, assemblage, readymades, chance, performance, and media pranks. Radical then, they are foundational today—so much so that Dada may have had the greatest influence on contemporary art of any avant-garde movement.

A reevaluation of international Dada is thus both long overdue and particularly relevant. *Dada* is the first major museum survey in the United States of the Dada movement, although Marcel Duchamp himself organized an overview at the Sidney Janis Gallery in 1953. It is the first in France since 1966. While Dada has been shown in conjunction with surrealism in several benchmark exhibitions, viewing it separately, as this exhibition allows, clarifies its formal innovations and thematic concerns.

Part of Dada's radical achievement lies in imagining a global network of artists of diverse nationalities. Dadaists made use of new media that allowed contacts between people across distances: letters, postcards, journals, and magazines not only were important means of sharing ideas and images but also were incorporated into new forms of artwork. This exhibition surveys the many types of dadaist art-making that emerged in the movement's primary centers: Zurich, Berlin, Hannover, Cologne, New York, and Paris. This structure is intended to be less geographical than intellectual, bringing together the creative work of artists in close dialogue with each other. *Dada* traces the connections between artists in different cities and across the ocean and the movement of ideas that transformed art as it had been known.

Dadaism emerged in a period of rapid technological development that included the birth of the photo-illustrated press, radio broadcasting, and the industrial assembly line, as well as the popularization of cinema. Its adherents boldly embraced and roundly criticized this media and machine culture. Filling their work with references to modern life, they also experimented with contemporary forms in their art-making, including film, photography, and other types of mechanical reproduction, becoming a first generation of new media artists.

Through the generosity of many lenders, *Dada* incorporates a diverse range of work, including painting, sculpture, photography, collage, photomontage, prints, sound recordings, and film in a dynamic multimedia display, and spans the period from approximately 1916, when the Cabaret Voltaire was founded in Zurich, to 1924, by which time most of the Dada groups had dispersed or transformed. It includes many key figures in the history of modernism, such as Hans Arp, Kurt Schwitters, Hannah Höch, Max Ernst, Francis Picabia, Man Ray, and Marcel Duchamp, but also introduces others less well known. The lenders deserve our profound gratitude for parting with so many important objects, making it possible

to show them—often for the first time—in relation to other dadaist works. We are enormously indebted to them.

We are delighted with the collaboration among our three institutions in mounting this landmark exhibition. This partnership allowed us to gather together many more significant works than if any one institution had acted alone. A core group of shared loans, along with certain thematic focal points, links the American and French versions of the exhibition.

We would like to thank Leah Dickerman, associate curator of modern and contemporary art at the National Gallery of Art, and Laurent Le Bon, curator, Centre Pompidou, Musée national d'art moderne, for their efforts from the beginning in mounting this complex exhibition. Anne Umland, curator of painting and sculpture at The Museum of Modern Art, joined them as an active coordinating curator responsible for the installation in New York. The curators have enjoyed a fruitful collaboration with a group of accomplished scholars on the American and French catalogues and on an anthology of essays separately published by the Center for Advanced Study in the Visual Arts at the National Gallery of Art. Together, these publications have resulted in an important reevaluation of this crucially influential movement.

We extend our appreciation to the Anna-Maria and Stephen Kellen Foundation, the Catherine B. Reynolds Foundation, the Annenberg Foundation, and Thomas G. Klarner for their generous sponsorship of *Dada* in Washington, and to Pro Helvetia, Arts Council of Switzerland, for its support in Washington and Paris. In Paris the exhibition has been made possible through the support of PPR and Yves Saint Laurent. We are very grateful to them.

We also appreciate the support of the Federal Council on the Arts and the Humanities, which provided an indemnity for this exhibition in the United States. This exhibition has benefited from a French government indemnity for its presentation in Paris.

Earl A. Powell III
Director
National Gallery of Art
Washington

Glenn Lowry
Director
The Museum of Modern Art
New York

Bruno Racine
President
Centre Pompidou
Paris

Alfred Pacquement
Director
Centre Pompidou
Musée national d'art moderne
Paris

ACKNOWLEDGMENTS

Mirroring Dada itself, the organization of an exhibition of this scale and complexity has forged a network of contacts facilitated by new media—an international community with a sympathy of interests for which we are profoundly grateful. Its presentation would not be possible without the support of these many dedicated individuals. We wish especially to thank the directors of the three collaborating institutions: Earl A. Powell III, National Gallery of Art, Washington; Glenn Lowry, The Museum of Modern Art, New York; and Alfred Pacquement, Centre Pompidou, Musée national d'art moderne, Paris.

My coorganizers and I are deeply grateful to the generosity of our lenders, who are listed on page XV. Many went to considerable trouble to make works in their collections available to us and to assist us in our research.

We owe a special debt of gratitude to the many colleagues who have contributed to the preparation of this exhibition and book. For their expertise, resourcefulness, and good will, we warmly thank:

Suzanne Folds McCullagh, Mark Pascale, and Stephanie D'Allessandro, The Art Institute of Chicago; David Juda, Annely Juda Fine Art; Michael Parke-Taylor, The Art Gallery of Ontario; Katy Rothkopf, The Baltimore Museum of Art; Jörg Tramm, Berliner Rathaus; Jörn Merkert, Freya Mülhaupt, Ursula Prinz, and Gunda Luyken, Berlinische Galerie; Yves Peyré, Bibliothèque Littéraire Jacques Doucet; Marc Blondeau, Blondeau & Associés S.A.; Antony Griffiths, The British Museum; Jeanie Deans, Carroll Janis Inc.; William Robinson, The Cleveland Museum of Art; Beverly Calté, Comité Picabia; Roland Celette, Embassy of France; Thomas Wriessnig, Embassy of Germany; Eric Amhof, Embassy of Switzerland; Rainer Hüben, Fondazione Marguerite Arp; Larry Gagosian, Gagosian Gallery; Marcel Fleiss, Galerie 1900–2000; Hendrik Berinson and Adam Boxer, Galerie Berinson / Ubu Gallery; Dieter Brusberg, Galerie Brusberg; Mathias Rastorfer, Galerie Gmurzynska; Johann-Karl Schmidt and Karin Schick, Galerie der Stadt Stuttgart; Weston Naef and Anne Lyden, The J. Paul Getty Museum; Andreas Stolzenburg and Ulrich Luckhardt, Hamburger Kunsthalle; Kerry Brougher, Hirshhorn Museum and Sculpture Garden; Ursula Zeller and Nina Bingel, Institut für Auslandsbeziehungen; James Snyder, The Israel Museum; Wolfgang Schepers, Kestner-Museum; Elizabeth Kujawski, Elizabeth Kujawski Art Advisors; Christian Klemm, Kunsthaus Zurich; Mendes Bürgi, Hartwig Fischer, and Christian Müller, Kunstmuseum Basel; Pia Müller-Tamm and Maria Müller, Kunstsammlung Nordrhein-Westfalen; Timothy Benson, Los Angeles County Museum of Art; Jürgen Pech, Max-Ernst-Kabinett; Matthew Drutt, The Menil Collection; Sabine Rewald, Malcolm Daniel, and Catherine Heroy, The Metropolitan Museum of Art; Heidi Schumacher, Ministerium für Wissenschaft, Weiterbildung Forschung und Kultur; Iris Müller-Westermann, Moderna Museet; Rainer Mason, Musée d'art et d'histoire, Genève; Fabrice Hergott and Emmanuel Guigon, Musée d'art moderne et contemporain, Strasbourg; Suzanne Pagé, Musée d'art moderne de la ville de Paris; Eva Afuhs and Roger Fayet (previously of), Museum Bellerive; Kasper König and Stephan Diederich, Museum Ludwig; Renee Price and Scott Gutterman, Neue Galerie New York; Roland März and Dieter Scholz, Neue Nationalgalerie; Robert Rainwater and Elizabeth Wyckoff (previously of), The New York Public Library; Anne D'Harnoncourt and Innis Shoemaker, Philadelphia Museum of Art; Jay Gates, The Phillips Collection; Patrick Elliott, Scottish National Gallery of Modern Art; Richard Dalheim, Senatsverwaltung für Wissenschaft, Forschung und Kultur; Karin Orchard, Schwitters Archive, Sprengel Museum Hannover; Peter-Klaus Schuster, Staatliche Museen zu Berlin, Nationalgalerie; Sabine Schulz, Städtische Galerie im Städelschen Kunst-institut; Anita Beloubek-Hammer, Staatliche Museen zu Berlin Kupferstichkabinett; Christian von Holst, Karin von Maur, and Ulrike Gauss, Staatsgalerie Stuttgart; Jan Debbaut, Frances Morris, and Jennifer Mundy, Tate; Irène Kuitenbrouwer-Lesparre, Van Rees Foundation; Uwe Fleckner, Universität Hamburg; Sabine Fehlemann, Von der Heydt-Museum; Helen Molesworth, Wexner Center for the Arts; Adam Weinberg, Whitney Museum of American Art; and Jock Reynolds and Jennifer Gross, Yale University Art Gallery. We also thank Timothy Baum, François Blancpain, André Buckles, Mark Kelman, Gerd Sander, Alain Tarica, and Walter Vitt.

Within these collegial ranks, we would like to extend special recognition to Walburga Krupp of Stiftung Hans Arp und Sophie Taeuber-Arp; Francis Naumann of Francis Naumann Fine Art, Inc.; Isabel Schulz of the Schwitters Archive, Sprengel Museum, Hannover; Werner Spies, Ernst scholar; and Michael Taylor of The Philadelphia Museum of Art, who responded to so many queries with good humor and seemingly bottomless expertise that they have become an integral part of our Dada team.

Collaboration with Laurent Le Bon, curator at the Centre Pompidou, Musée national d'art moderne; and Anne Umland, curator of painting and sculpture at The Museum of Modern Art, has been a rare privilege. Their

wisdom, insight, friendship, and humor have made our work together a pleasure. Each headed the presentation of the exhibition at their respective venues and contributed to our joint efforts.

The National Gallery of Art created the checklist of core loans traveling to all three venues, administered the exhibition, and produced the American version of this book. At this museum, director Earl A. Powell and deputy director Alan Shestack offered continued support of this project. Working with Dodge Thompson, head of the department of exhibitions, Jennifer Cipriano and Jennifer Overton managed the myriad organizational details relating to the budget, indemnity, and the processing of loans. Mark Leithauser led a talented creative team including Jame Anderson, Gordon Anson, Donna Kirk, and Barbara Keyes in designing the installation of the exhibition. With the guidance of Susan Arensberg, Lynn Matheny and Carroll Moore produced the didactic materials that accompanied the exhibition. We would like to thank Aaron and Barbara Levine for their generosity in making these materials possible. Michelle Fondas was the expert registrar who arranged for the comings and goings of this diverse group of objects, and Merv Richard headed the conservation team, providing counsel in arranging the safe transport and installation of many fragile items. With the help of a generous donor, Thomas G. Klarner, who also provided support for the exhibition in Washington, executive librarian Neal Turtell has built a fine collection of rare Dada books and journals in a short period. At the National Gallery of Art Library, Ted Dalziel and Tom McGill enabled us to assemble critical research materials.

In the publishing office, Judy Metro deserves warm thanks for her guiding hand. Karen Sagstetter was the brave editor who coordinated the details of this complex volume, tamed unruly prose, and crafted order within. She was ably assisted by Caroline Weaver, Mariah Shay, Evie Mantzavinos, and Amanda Sparrow. Margaret Bauer and Chris Vogel oversaw the design and production process with expertise and insight. Daphne Geismar of New Haven, Connecticut, produced an elegant and dynamic design that serves as a fitting tribute to its subject. Sara Sanders-Buell and Ira Bartfield obtained images and rights and permissions for reproduction.

In my own department of modern and contemporary art, I am truly grateful for the unflagging support and sage advice of department head Jeffrey Weiss and the comradeship and counsel of Molly Donovan. I have been lucky to work with a series of young scholars on the project. Isabel Kauenhoven, the first of these, was tireless in tracking down objects and assisting with the research required in forming our original checklist. Matthew S. Witkovsky, who began as a postdoctoral intern in this department, is now assistant curator in the department of photographs. At all times a ready interlocutor about ideas, he crafted the checklist for the book and journal section of the exhibition at its American venues, along with writing for this volume. Amanda Hockensmith provided all manner of research large and small, as well as serving as a sharp second eye for many of the essays. Mark Levitch offered his wide-ranging expertise on the social history of World War I and took on a broad range of editorial tasks. Their positions were supported by the department of academic programs, headed by Faya Causey. Jennifer Roberts, research associate, has shown unflagging attention, devoted resourcefulness, and a love of eccentric facts in every aspect of the preparation of this catalogue and exhibition. Anna Lakovitch was a tireless assistant for the first stage of the project. Her successor for the second half of the project, Marcie Hocking, has provided steadfast assistance of all kinds, including the massive task of organizing the photographs for this publication. Her managerial and organizational talents were particularly apparent to all during my maternity leave, when she kept the project moving with able grace, and for this I am deeply thankful.

At the Centre Pompidou in Paris, the director of the Musée national d'art moderne, Alfred Pacquement, provided astute and enthusiastic leadership for the exhibition. In this, he was aided by deputy director Isabelle Monod-Fontaine and chief administrator Sylvie Perras. Within the larger administration of the Centre Pompidou, the project received key support from Bruno Racine, president, and Bruno Maquart, director general. Catherine Sentis-Maillac, assisted by Delphine Reffait, headed the department of exhibition production. Working with the guidance of Martine Silie, head of the department of exhibitions, Armelle de Girval, Carole Benaiteau, and Victoire Disderot managed the project's logistical demands. Olga Makhroff administered outgoing loans from the Centre Pompidou's rich holdings. Jacques Hourrière headed the conservation team in charge of stabilizing and safeguarding fragile artworks. Anne-Catherine Prud'hom was the talented conservator of graphic works. In the department of the registrar, under the direction of Annie Boucher, Raphaële Bianchi was responsible for tracking the comings and goings of this

widely spread group of objects. Jasmin Oezcebi was the chief designer of the installation in Paris in the department of design and installation, led by Katia Lafitte. Jess Perez, head of workshops and fabrication, was in charge of the capable art handling team.

Working with Laurent Le Bon, Sophie Bernard, Nathalie Ernoult, and Isabelle Merly provided crucial research and curatorial assistance. Knowledgeable colleagues in lending departments who offered support for the exhibition and expertise about their own collections include: Agnes de la Beaumelle and Jonas Storvse in the department of works on paper; Phillippe-Alain Michaud in the department of film; Quentin Bajac in the department of photography; and Didier Schulmann in the Bibliothèque Kandinsky. The French version of the catalogue was produced by the Centre Pompidou's department of publications, headed by Annie Perez. Anne Lemonnier was the editor in charge of that edition, ably assisted by Jessica Kelly and Xavier Delamare.

At The Museum of Modern Art, Glenn Lowry, director, has provided warm support for this project. Jennifer Russell, Maria DeMarco Beardsley, and Carlos Yepes have expertly managed the administration of its complexities. In the department of painting and sculpture, Anne Umland has received able curatorial assistance first from María José Montalva, and then from Adrian Sudhalter, whose particular expertise in Berlin Dada has had an important impact on our presentation. Administrative assistant Aynsley Harwell has provided help with tasks of all kinds with characteristic cheer. Joachim Pissarro was a great ally in the task of securing key loans. John Elderfield has frequently provided wise counsel, and his scholarship on Kurt Schwitters and Hugo Ball has been a touchstone for the exhibition and its accompanying publications. Jerome Neuner has led a team in the department of exhibition design and production in creating once again an elegant and nuanced design for the New York presentation. The conservation team overseeing the safety and stabilization of fragile objects included Scott Gerson, Roger Griffith, Lynda Zycherman, and Lee Ann Daffner. Jennifer Wolfe and John Alexander were the expert registrars. The department of drawings was a particularly generous lender to the exhibition, and we are especially grateful for the enthusiasm and support of Gary Garrels, Jodi Hauptman, and Kathleen Curry. Colleagues in other departments lending work to this exhibition who provided both aid and knowledge include: Cora Rosevear and Avril Peck in painting and sculpture; Peter Galassi and Susan Kismaric in photography; Deborah Wye in prints and illustrated books; and Milan Hughston in the library.

This exhibition has been several years in the making, and all three curators are deeply grateful for the forbearance of friends and colleagues. At home, I am particularly thankful for the irreverent affection of my husband, Neil Shneider, and the infantile delight of my son, Daniel.

Leah Dickerman
NATIONAL GALLERY OF ART

NOTE TO THE READER

Titles

If the original title could be established, it is provided in the original language, followed by an English translation. Original titles in this context are titles for which there is documentation before 1925. Artists' inscriptions and writings as well as early exhibition catalogues and other Dada publications provide the best sources for these. When artists inscribed titles on their works, or when artists' inscriptions have been used as titles in the literature, spellings and accents have been retained, even if grammatically incorrect. When there is no record of an early title, the work is labeled "Untitled," followed by a later title in parentheses in English, if one has become prevalent in the literature. For untitled photographs, descriptive phrases are included in parentheses.

However, the origins of many titles are unknown. In other cases, it is not clear whether the artist titled the work at the time that it was made. We have labeled many of these works "Untitled." The complex titling practices of several artists merit further comment. Hans Arp's utilization of general descriptions to refer to his works in exhibition catalogues and other Dada publications raises the question of whether he regarded these descriptions as titles at the time. Needlework was often labeled simply *broderie* or *stickerei* (embroidery); a collage, *tableau en papier* or *Papierbild* (paper picture). An abstract wool wall hanging, needlepoint, or oil painting might be called *Gestaltung* (construction or form). The titles more frequently used today were often assigned either by Arp or his second wife Marguerite Arp-Hagenbach decades after the works were executed. We have provided these later titles in English translation only.

Kurt Schwitters inscribed titles on about half of his works, and these often included terms, letters, and numbers that were part of a system he developed. *Merzbild* (Merz picture) refers to assemblages and oil paintings with collage elements, and "Mz," an abbreviation for *Merzzeichnung* (Merz drawing), refers to collages of or on paper or board with some painted or drawn elements. Following these terms, Schwitters often added "A," "B," or other letters as subject classifications. Originally, "A" indicated either landscape or abstraction and "B," still life. Starting in 1919, however, the use of these letters seems to have shifted with "A" identifying a group of more three-dimensional works, and "B"

marking large format, two-dimensional collages. The category "i-drawing" indicates works in which Schwitters selected and cut fragments from printer's misprints, declaring them to be works of art.

French titles have been given for works by Marcel Duchamp because the artist continued to title his works primarily in French even after he moved to New York. Exceptions are made if Duchamp originally inscribed the title in English (as with *Fresh Widow*), or if a work was first exhibited and published in English-language publications (*Fountain*).

Dimensions

Height precedes width and depth; centimeters precede inches.

Mediums

Printed matter is ubiquitous in Dada artistic production. From Schwitters' use of bus tickets in collages to Duchamp's alterations of postcards to the many Dada journals and posters, the significance of photomechanical reproduction cannot be over-emphasized. Mediums are included for journals, posters, and other printed works when possible. When multiple examples of printed ephemera appear in fragmented form in collages and assemblages, however, the print medium has not been included.

Terms

assemblage—Assemblage is a three-dimensional work of art comprising found elements. See distinctions from collage and relief, below.

collage—Collage is a work made of cut or torn and pasted papers. When other flat, glued elements are applied, such as fabric or feathers, but the overall effect is still two-dimensional and mostly paper is used, elements are specified, as in "collage of papers, fabric, and feather." It is worth noting that Schwitters used diverse fragments, including scraps of date book pages, railroad and bus tickets, wallpaper, ration stamps, paper doilies, and cigar wrappers. The Berlin dadaists also used a similarly diverse mix of paper mediums.

photomontage—Photomontage is a collage work that includes cut or torn and pasted photographs or photographic reproductions. If a photomontage has been photographed and printed, the resulting print is referred to as a reproduction of photomontage.

relief—A relief is a three-dimensional work that is hung on the wall like a painting. Reliefs are generally made of wood. In contrast, collage is made of paper elements and exhibits less depth and surface variation, while assemblage consists of found elements and may or may not retain a painting-like orientation to the wall.

Rayographs and *Schadographs*—Both are "photograms," camera-less photographic prints that record the placement of objects and other elements on photosensitive paper that has been exposed to light. By 1922, May Ray was using the term "Rayographs" for his work in this genre, whereas Tristan Tzara dubbed Schad's photograms "Schadographs" in 1936.

readymade, rectified readymade, assisted readymade—A readymade is a manufactured, commonplace object elevated to the status of art by means of the artist's selection. A rectified readymade is a readymade the artist has altered by means of adding some relatively small detail or "correction," such as pencil marks to a postcard of the *Mona Lisa* in the case of Duchamp's *L.H.O.O.Q.* An assisted readymade is a readymade that the artist has more fully altered. Since "readymade" was coined by Duchamp, it has been used only in captions with works by him, although the term can also be used productively in relation to certain other artists' works.

Translations

Translations of quotations within the essays are by the individual authors of the essays, unless otherwise noted.

LENDERS TO THE EXHIBITION

The Art Institute of Chicago

The Baltimore Museum of Art

Timothy Baum

Berlinische Galerie

Merrill C. Berman

Claude Berri

Bibliothèque Littéraire Jacques Doucet, Paris

Bibliothèque Paul Destribats, Paris

The Bluff Collection, LLC

David Ilya Brandt and Daria Brandt

The British Museum, London

Carnegie Museum of Art, Pittsburgh

Centraal Museum, Utrecht

Centre Pompidou, Musée national d'art moderne

The Cleveland Museum of Art

Arnold Crane Collection, Chicago

Gale and Ira Drukier

Succession Marcel Duchamp, Villiers-sous-Grez, France

Carla Emil and Rich Silverstein

Aaron I. Fleischman

Fondazione Marguerite Arp, Locarno

Galerie Berinson, Berlin / UBU Gallery, New York

Galerie Remmert und Barth, Düsseldorf

Gemeentemuseum Den Haag, The Hague

The J. Paul Getty Museum, Los Angeles

The Getty Research Institute for the History of Art and the Humanities, Los Angeles

Hamburger Kunsthalle

The Manfred & Hanna Heiting Collection

Hirshhorn Museum and Sculpture Garden, Smithsonian Institution

Institut für Auslandsbeziehungen e.V., Stuttgart

The Israel Museum, Jerusalem

Carroll Janis

Jasper Johns

Mark Kelman

Kestner-Museum, Hannover

Kunsthaus Zürich

Kunstmuseum Basel

Kunstsammlung Nordrhein-Westfalen, Düsseldorf

Los Angeles County Museum of Art, the Robert Gore Rifkind Center for German Expressionist Studies

Marlborough International Fine Art Est.

The Menil Collection, Houston

The Metropolitan Museum of Art

Ministerium für Wissenschaft, Weiterbildung, Forschung und Kultur des Landes Rheinland-Pfalz

Moderna Museet, Stockholm

Estate of H. Marc Moyens

Mugrabi Collection, Courtesy Gagosian Gallery

Musée d'art et d'histoire, Cabinet des estampes, Genève

Musée d'Art Moderne de la Ville de Paris

Musée d'Art Moderne et Contemporain de Strasbourg

Musée d'art moderne, Saint-Etienne

Museo Thyssen-Bornemisza, Madrid

Museum Bellerive, Zurich

Museum Ludwig, Cologne

The Museum of Modern Art, New York

National Gallery of Art, Washington

National Gallery of Art, Library

Francis M. Naumann Fine Art, New York

Neue Galerie New York

The New York Public Library

Sylvio Perlstein

Philadelphia Museum of Art

The Phillips Collection

Private collections

Private Collection, Courtesy Aargauer Kunsthaus Aarau

Private Collection, Courtesy Annely Juda Fine Art, London

Private Collection, Courtesy Blondeau & Associés S.A., Paris

Private collection, Courtesy Galerie 1900-2000

Ernestine W. Ruben

Yves Saint Laurent and Pierre Bergé

San Francisco Museum of Modern Art

Estate of Kurt Schwitters / Kurt und Ernst Schwitters Stiftung, Hannover

Scottish National Gallery of Modern Art

Seattle Art Museum

Solomon R. Guggenheim Museum, New York

Sprengel Museum Hannover

Staatliche Museen zu Berlin, Kupferstichkabinett

Staatliche Museen zu Berlin, Nationalgalerie

Staatsgalerie Stuttgart

Städtische Galerie im Städelschen Kunstinstitut, Frankfurt am Main

Michael and Judy Steinhardt

Stiftung Hans Arp und Sophie Taeuber-Arp e.V., Rolandseck

Tate

Von der Heydt-Museum, Wuppertal

Clodagh and Leslie Waddington, London

Thomas Walther Collection

Westfälisches Landesmuseum für Kunst und Kulturgeschichte Münster, Germany

WestLB Düsseldorf

Whitney Museum of American Art, New York

Yale University Art Gallery

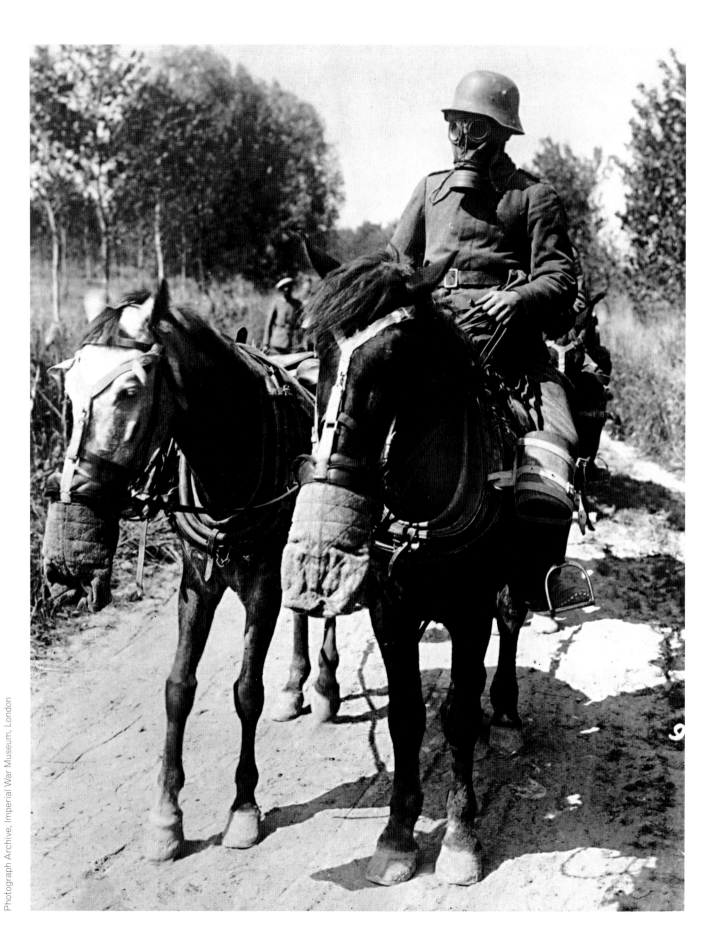

A German soldier and transport horses with gas masks.
Photograph Archive, Imperial War Museum, London

INTRODUCTION
LEAH DICKERMAN

Dada's many artifacts present an image of group camaraderie. Press clippings document antics masterminded by fraternal bands. Carefully posed snapshots attest to playful solidarity. Multisignature manifestos proclaim common, if at times obscure, purposes. Journals offer broad compilations of materials stitched together by iconoclastic commentary. Performance programs and exhibition catalogues inventory diverse contributions presented to the public within a common framework. The word *Dada* itself provides an overarching moniker for the raucous activities of its participants. Even suggestions of contention between individuals makes clear that something communal is at stake.

Yet as a larger constellation of ideas and identity, Dada is not well understood. Scholars and museums have tended to deal with its individual actors monographically, leaving the broader premises of Dada work alone.[1] Or the movement has been presented as a precursor to something else more defined—generally surrealism.[2] When it has been taken on, Dada has often been discussed in terms of absurdity, nonsense, and anti-art—concepts with some justification in its rhetoric and thought, but which paradoxically tend to deflect further exploration of meaning. The question explored in this book is: how might we understand the idea of Dada?

Of course, Dada itself works against easy generalization or definition. It cannot be understood as a movement in the traditional sense of a small alliance of artists, working and showing together, committed to a common aesthetic credo and style. The word Dada offers a bluff, providing

little guidance. Tristan Tzara asserted that it meant nothing— "*ne signifie rien*"[3]—but it is less nonsense than manifesto. The dadaists, who saw in its paternity title to the larger movement and idea, later contested the circumstances of its invention. It was most likely chosen from a French-German dictionary by Richard Huelsenbeck and Hugo Ball in Ball's Zurich flat in 1916.[4] An obscure and infantile word meaning "hobby horse" in French, it resonated in other languages. Dada's adherents clearly delighted in its connotative, rather than denotative, possibilities, and its openness to consistent redefinition. "The suggestivity of the word," garnered Huelsenbeck's praise in his 1920 historical sketch of Dada—"its ability to hypnotize, by guiding the vulgar mind to ideas and things which none of the originators had thought of...."[5]

Moreover, and in contrast to surrealism, which remained fundamentally centralized in terms of leadership and geography, Dada was notably diffuse, with activities in a handful of city centers created by a network of itinerant, often politically displaced artists of diverse nationalities. Diffuse in an unprecedented way, for previously there had not been an artistic movement so self-consciously international.[6] Indeed, its aims were often supranational: emerging amid the racially tinged nationalistic discourse of World War I, Dada made antinationalism a central tenet.[7] In one of its most important innovations, Dada fashioned itself as a network, a web of connections linking actors and local groupings, which served as a conduit of ideas and images. Dada's promotion of a proto-globalized identity is evident in stationery that Tristan Tzara produced for the "Mouvement Dada" in Paris, which mimicked corporate models by listing Dada branches underneath the letterhead [fig. 1]. The six cities represented in this book and exhibition were the most important centers, but there were activities conducted under the banner of Dada in places as far-flung as Romania and Japan.[8] Specific conditions framed distinct identities, which are explored in the essays that follow. We can contrast Zurich's carnivalesque cabaret culture within an expatriate community of politically dislocated individuals with Berlin Club Dada's radicalized dissection of a new media culture. In the Cologne Dada group's work, there is a sense of delving under the appearance of things into a submerged microcosmos, a fantastic and debased biotechnological world, and in Hannover, a form of irreverent nostalgia, as Kurt Schwitters simultaneously elegized and exploded late-nineteenth-century bourgeois culture. In New York, more distant from the cataclysm of the Great War, there was not

fig. 1 Tristan Tzara, Dada letterhead, "Mouvement Dada," 1920, letterpress. The Museum of Modern Art Library, The Museum of Modern Art, New York

surprisingly a greater focus on the machine and commodity and the impact of these modern totems on the human psyche. And in Paris, where so many of Dada's wandering emissaries returned after the war, a series of quasitheatrical spectacles seemed half celebration, half rebellious rebuff to the national "return to order" that dominated Parisian postwar culture.

Dada's character as a movement was forged through a complex network of circulated texts and personal contacts that encompassed publishing and trading journals replete with manifestos and reproductions; publicizing activities in the press and sharing collected press clippings with friends; sealing epistolary bonds with the exchange of postal artwork; and establishing personal ties as travel became easier in the wake of war. Moving between city centers, Tzara, Hans Arp, Schwitters, Francis Picabia, and Max Ernst in particular served as key apostles of dadaist ideas. Tracing the movement of ideas is complex and often surprising, challenging myths of origin that we have come to accept. To tell one tale: in Zurich in 1915, with the example of Pablo Picasso's cubist collages in mind, Arp created small abstract constructions from found papers and printed materials **[4, 5]**. Working in Arp's orbit, Christian Schad experimented with a form of automatic collage, laying collected scraps on light-sensitive paper, to create abstract photograms **[61–65]**. Tristan Tzara later carried a group of these tiny photographic compositions to Paris, whereupon Man Ray began to experiment with the technique **[337–339]**, though the latter credited a darkroom accident for the new development. In another case in point, Ernst, who is often perceived as a surrealist *avant la lettre* and oriented toward Paris, called his early assemblages *Merzbilder* in recognition of Kurt Schwitters' relief constructions built of found materials **[194]**.

Sociologists have suggested that the interaction and validation within a group can radicalize intellectual innovation, leading to positions more extreme than individual members would adopt in isolation.[9] Such group dynamics help us understand why so many of those artists who have had the greatest impact on twentieth-century art founded their careers, and defined the terms of their mature practice, within the crucible of Dada. And it helps us grapple with how certain precepts about the nature of art objects and modes of viewing previously held dear were quickly—and multiply—shattered. Thus something crucial is missing in suggesting—as most scholarship has done implicitly in its fragmented form—that there is nothing more macro, nothing more overarching about the idea of Dada. Dada's

radical rethinking of art making is fundamentally a collective achievement—a communal testing of the meaning of artistic identity in the modern age. And, it is a rethinking driven in large part by historical and ethical imperatives.

MODERN SHOCK

Dada was born of a moment of moral and intellectual crisis, poised between the disaster of war and the shock of an emerging modern media culture. The particular pathos of the Great War now seems distant. On 28 June 1914, the assassination of the Habsburg heir Franz Ferdinand by a Serbian nationalist triggered a chain of military presumptions and defensive alliances (some confirmed by secret treaty) in a semiautomatic, machinelike way, which seemed to exclude considerations of prudence, moral purpose, or even national interest. But if its rationale was obscure, World War I undeniably shifted the terms of battle, bringing it into the modern era as the first mass global war of the industrialized age. The conflict, lasting more than four years, changed the world, serving as an era of passage from the nineteenth to the twentieth century. It catalyzed vast numbers of technological innovations aimed at improving the efficiency of killing one's enemy and protecting one's own: the wristwatch, the steel helmet, poison gas, the semiautomatic rifle, and aerial surveillance photography were among the most notable. It was the first conflict in which submarines played a significant role,

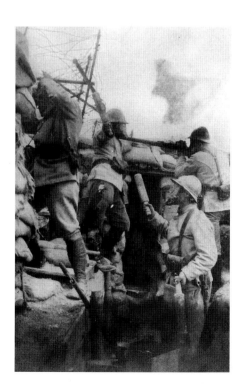

fig. 2 French troops engaged with hand grenades and rifles in a frontline trench. From Francis Joseph Reynolds, *The Story of the Great War* (New York, 1916)

and the first time Zeppelins and airplanes were used for military purposes. Trench warfare and barbed wire, if not exactly new inventions, were used in newly systematic and pervasive ways **[fig. 2]**. On a visit to the Western Front, Field Marshal Paul von Hindenburg and General Erich Ludendorff coined the expression "Materialschlacht" or "the battle of equipment."[10] The introduction of these instruments produced the characteristically modern sense of disjunctive time frames, in which fragments of the past continue to exert force on the present, a perception of time the early twentieth-century sociologist Ernst Bloch has called nonsynchronicity.[11] Examples of the collision of historical modes on the battlefield are rife: cavalry forces faced new machine guns and mustard gas. Documentary photographs show both horses and soldiers wearing gas masks **[see p. XVI]**. The first tanks were launched, but because of their tendency to upend in trenches and ditches **[fig. 3]**, they were soon accompanied by vulnerable bands of foot soldiers who rigged temporary bridges for the armored cars to pass over. The conflict manifested on the battlefield between technological development and human mindset brought home the shock of modernity: rather than arriving quietly, it crashed in uncomfortably (and often fatally).

Battles such as the five-month siege at the Somme River in 1916 marked the demise of the idea of the "field of glory," and with it an older aesthetic and ethical code of heroism and courage.[12] Intended to break through the deadlock that characterized so much of the war, the Battle of the Somme became a byword for futile slaughter. In the opening assault, French and British soldiers were sent against German forces, who were holding a network of deep trench fortifications protected by machine-gun posts and entanglements of barbed wire; huge numbers of Allied troops, marching slowly and upright in straight lines, were killed before reaching the other side.[13] In the following weeks, Anglo-French troops dug themselves in and the area became an arena for attrition **[fig. 4]**. In an effort to break the stalemate, Allied forces deployed the first tanks; but after an initial advantage, all thirty-six were soon disabled by enemy fire, mechanical breakdowns, and ditchings over rough ground. By the end of the year, each side had suffered about six hundred thousand casualties with no significant military gains.

The disparity in effectiveness between methods of killing and those of self-protection led to previously unimagined mutilations of the body, with injuries and deaths of a new kind and unprecedented scale. Nearly ten million died, resulting in the loss of much of a generation of men, for the most part, those who were youngest and most active. More than twenty million were wounded. Several hundred thousand of those marked by the greatest disabilities—who suffered disfiguring facial wounds or who had lost limbs and sight—were labeled *grands mutilés* in French and *Schwerkriegsbeschädigte* in German. The sight of the horrendously

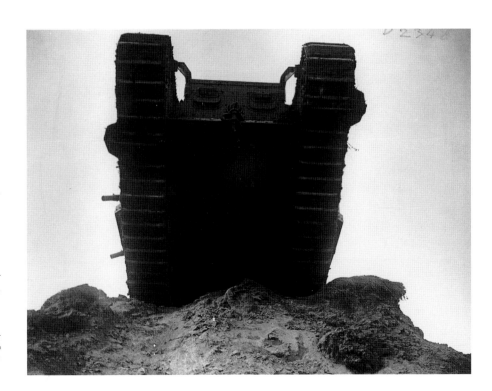

fig. 3 A British Mark IV tank photographed from German trenches during the Battle of Cambrai, 21 October 1917. Photograph Archive, Imperial War Museum, London

shattered bodies of veterans returned to the home front became commonplace [**fig. 5**].[14] The accompanying growth in the prosthetic industry struck contemporaries as creating a race of half-mechanical men [**fig. 6**] and became an important theme in dadaist work.[15] Not all scars were visible: the war left terrible psychic wounds in its stead (also a dadaist motif[16]) as soldiers were affected not only by having witnessed atrocities and having violence inflicted on them, but also by having inflicted it on others.[17] The military recognized for the first time psychological trauma on a par with physical injury; and a large number of those discharged for disability had been diagnosed with war neurosis or "shell-shock."[18] Grafton Elliott Smith, one of those who first described its pathology and symptoms, cautioned that for those suffering, reason was not lost, but rather was "functioning with painful efficiency."[19]

For many intellectuals, World War I produced a collapse of confidence in the rhetoric—if not the principles—of the culture of rationality that had prevailed in Europe since the Enlightenment. In many ways, the conflict set the stage for the great quandaries and imperatives of the twentieth century, unleashing the demonic triad of mechanized warfare, mass death, and totalitarian politics that shaped the century to come. A sense of the fragility of civilization itself permeates much contemporary commentary. In Sigmund Freud's wartime essay on the mental distress felt by non-combatants—what he described as the pervasive "consciousness of disorientation"— the psychoanalyst lamented: "We cannot but feel that no event has ever destroyed so much

that is precious in the common possessions of humanity, confused so many of the clearest intelligences, or so thoroughly debased what is highest."[20] The French poet Paul Valéry concluded simply, "The illusion of a European culture has been lost, and knowledge has been proved impotent to save anything."[21]

Such statements implicitly rejected official efforts— most visible in the tens of thousands of monuments and memorials built in the war's wake—to contain the trauma of the conflict under the principles of sacrifice, glory, and duty.[22] And for many, what was perceived as a broader unwillingness to examine the cultural conditions that produced the war was cause for the greatest cynicism and disenchantment. In his essay, "Der Geist von 1914" (The Spirit of 1914), Kurt Tucholsky, a critic and journalist who had served on the Eastern Front, satirized the postwar German worldview:

> We didn't lose the war—you merely won it. No one was conquered, least of all us. We have goodwill enough to want to do business with you again—if it has to be we will crawl after you a bit, but not much. You have to understand, of course, that 'tactical considerations' make it necessary and useful for us to rain extravagant abuse upon the whole world every time we dedicate a memorial—we believe ourselves in part....We are, incidentally, the center of the world.[23]

The dadaists were quick to see such unexamined aggression and nationalism in relation to a rising fascism. Their sensitivity to this threat was already visible in works like George

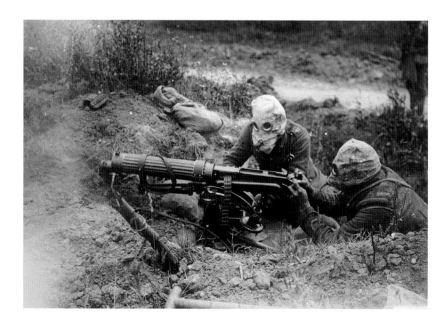

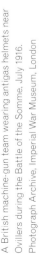

fig. 4 A British machine-gun team wearing antigas helmets near Ovillers during the Battle of the Somme, July 1916. Photograph Archive, Imperial War Museum, London

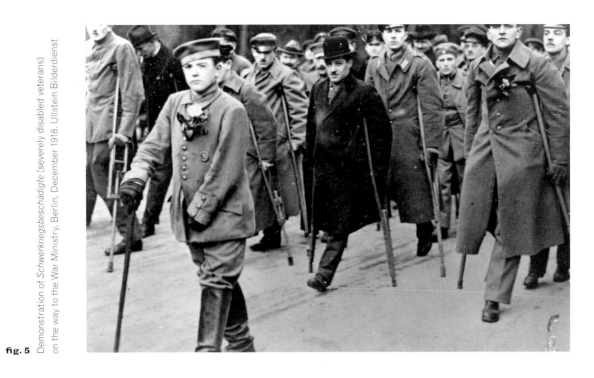

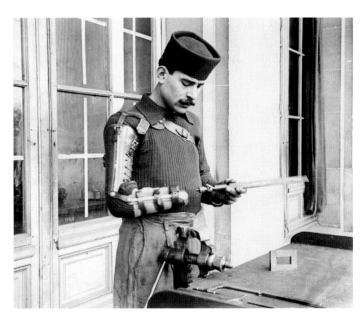

Grosz' *Die Stimme des Volkes, die Stimme Gottes* (Voice of the People, Voice of God), 1920, **[69]**: the early appearance of two swastikas—a symbol of the völkish right adopted that year by the emergent National Socialist party—signals the political alignment of a gathering of scabrous and bestial humanoids, who speak in collaged fragments from the conservative press.

Dadaism was born of this crisis of disillusionment. "How can one get rid of everything that smacks of journalism, worms, everything nice and right, blinkered, moralistic, europeanized, enervated?" demanded Hugo Ball in a first public manifesto. "By saying Dada." [24] Certainly its collaborators' own wartime experiences were formative. Many of those who were to claim allegiance to Dada sought to avoid the fighting from the outset. Arp, Ball, Huelsenbeck, Tzara, and Marcel Janco decamped for Zurich in neutral Switzerland, while Marcel Duchamp and Jean Crotti left for New York, which was still unaligned at the beginning of the war. As gathering points for these groups of iconoclastic refugees, these two cities became independent points of origin for the movement. Acquiring the paperwork necessary to travel or avoid conscription often required a certain amount of deception; a number feigned mental or physical disability (Arp, Schad, John Heartfield), while others may have actually suffered in greater or lesser degree from psychological ailments (Johannes Baader and perhaps Tzara and George Grosz as well). Walter Serner forged documents for others, abusing his title of Doctor of Law and placing himself in danger of arrest. Yet for other future dadaists, it was precisely the experience of war that heightened their sense of outrage. In battlefield sketches, Otto Dix and Georg Scholz produced eyewitness visual accounts of the degradations of trench warfare. Louis Aragon, Dix, and Hans Richter were all severely wounded; Max Ernst sustained somewhat more minor injuries **[fig. 7]**; Grosz and Paul Eluard may have suffered from shell shock. Philippe Soupault almost died from an experimental army-administered vaccine. André Breton and Aragon, trained as medical orderlies, encountered large numbers of traumatized soldiers. Of those who were conscripted, several went to great lengths to avoid the front: John Heartfield simulated mental illness. Wielande Herzfelde and Rudolf Schlichter conducted hunger strikes in protest. Picabia deserted during a stopover in New York, joining Duchamp and Crotti there. Dada's women members were also touched: the Baroness Elsa von Freytag-Loringhoven's husband was taken as a prisoner of war and ultimately committed suicide in the camps. Hannah Höch joined the Red Cross, and Suzanne Duchamp served as a nurse's aide. Taking different paths, all reached positions of committed opposition to the war and entrenched skepticism about the social and cultural institutions that had given rise to it.

Yet, as its adherents make clear, the sense of shock that permeated Dada's discourse was due to more than the war in isolation. The conflict galvanized developments in the culture at large, propelling a quantum leap into modernity. The period marked an exponential expansion of mechanized industrialization, fueled by newly abstract modes of finance that replaced the direct exchange of the traditional community and included the expansion of speculative stocks and bonds, the introduction of checks into common use, and the end of the gold standard. Hand in hand with these came the vertiginous growth of a modern commodity culture. Modern marketing developed as a professional discipline in the years 1910 to 1925—a result of the availability of a broader range and quantity of products, and the existence of larger firms and new forms of transportation that increased distance between producers and consumers.

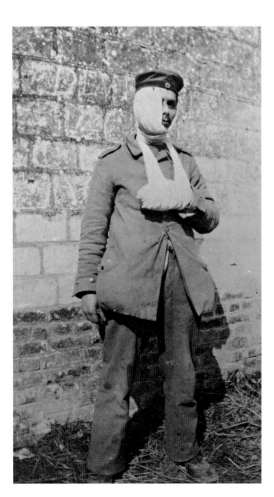

fig. 7 Max Ernst, a German artillery engineer during World War I, after being wounded by the recoil of his own cannon, 1915. Private collection

Practices commonplace today, such as international advertising, branding, product standardization, and a focus on the psychology of the consumer, were all introduced and developed in this period, often drawing on lessons learned from wartime experiences with propaganda and distribution.[25] These changes helped to forge a new public culture broader in geographical scope, but in which relations between people were increasingly abstract and attenuated.

Perhaps most important for the Dada movement was the emergence of a modern media culture, a development catalyzed by the experience of war. Propaganda poster campaigns with coordinated messages were deployed on a massive scale. The development of communication technologies—radio, cinema, and newsreels, and a new photo-illustrated press—fostered the flow of information from battlefront to home front. The science of wireless telegraphy was still embryonic during the war, plagued by breaches in security, but led to a surge in public broadcasting and the mass production of "radio music boxes" in its wake. Newsreels, which first appeared in 1911, captured battle action (albeit usually re-created), and nurtured the emergence of a commercial film industry. Innovations in printing technologies allowed for greater ease in combining photographic reproductions and text on a single page. Massive quantities of photographic images documenting the war were distributed through the new pictorial sections of newspapers and magazines. "The World War was the first great event experienced in this manner, and since then no significant event occurs that is not captured by the artificial eye,"[26] noted Ernst Jünger, a decorated front-line soldier, who in the postwar period wrote cynically rapturous accounts of the intoxicating effects of mechanized warfare. These wartime developments triggered a postwar mass-media explosion—the precipitous growth of the culture of mechanical reproduction. For the individual observer, there was a threshold jump in the number of images and amount of print material circulating in the public sphere.

This combination of watershed changes and shaken faith was the terrain of dadaism. For those who were to claim allegiance to the movement, art as it was known was irretrievably implicated in the cultural values that led to war, and their writing on this subject is poignant in its anger and grief. Grosz spoke of Dada as a response to "the cloud wandering-tendencies of so-called sacred art which found meaning in cubes and the gothic, while the field commanders painted in blood."[27] Others condemned art for functioning as a palliative that prevented moral questioning: Huelsenbeck

described it as a fraudulent "moral safety valve,"[28] and a "compensatory phenomenon"[29]; Arp called it "a way of deadening man's mind."[30] The artist too was "thoroughly obsolete," weak, ineffectual and without interest in the truly important issues of the day.[31] Given the impossibility of return to such a mode of art making, the implicit question the dadaists posed for themselves was how to reimagine artistic practice in this age of media and technological warfare.

A first premise clear to all was that art must not look away: "For us," wrote Ball in his diaries, "art is not an end in itself—more pure naïveté is necessary for that—but it is an opportunity for the true perception and criticism of the times we live in."[32] In its rejection of idealism, Dada offered a counterpoint to the kind of sentiments expressed by the composer Albert Roussel in a 1916 letter from the front to his wife, which describes the fragile mental refuge to be gained in forms of transcendence: "...when you reflect a bit and stay at a distance, in order to be free to have a personal vision, you feel a great breath of idealism rising up and welling up inside you: for many this will be the great benefit of this abominable war and, let us hope, a benefit that will survive it."[33] Dada in contrast can be understood as a refusal to "stay at a distance," a refusal of both transcendence and sublimation. Its adherents recognized themselves to be immersed, with no position above or outside that would allow a more reflective view. As a group, they demanded an art that put the shocks and scars sustained, the ironies, absurdities and hypocrisies witnessed on display—an art that, as Huelsenbeck put it, visibly "let itself be thrown by the explosions of last week."[34] Yet this insistence on stripping away illusion was understood to mean not only the rejection of social illusion for an unflinching examination of the historical moment, but also the rejection of art as *illusionistic*, conjuring imaginary worlds.

DADA TACTICS

How then should we characterize a dadaist approach to art? How should we understand its formal procedures? Clearly Dada is not defined by a consistent style, though the concept of style is still relevant, if waning, when we speak of Dada's predecessors (and its most important influences as well as its bailiwicks): cubism, futurism, and expressionism. Looking at Dada across the work of various artists from six cities of production, as this book allows us to do, makes clear the degree to which it coheres instead around a set of strategies—abstraction, collage, montage, the readymade, the incorporation of chance and forms of automatization—so

foundational for the rest of the century that today we have to struggle to recognize their historical novelty. Together they signal an assertive debunking of the ideas of technical skill, virtuoso technique, and the expression of individual subjectivity. At the same time, Dada's cohesion around these procedures points to one of its primary revolutions—the reconceptualization of artistic practice as a form of tactics. That last word with all of its military connotations is helpful. It suggests a form of historical mimicry, a movement from the battlefield to the cultural sphere, in which art is imagined in a quasimilitary way. Indeed Huelsenbeck suggested that the goal was to remake oneself in the mold of a soldier—"to make literature with a gun in hand."[35] And, the concept of tactics helps define a mode of intervention within a predetermined field, intended as assault.

One effect of Dada's tactical mode is the violation of traditional artistic categories—art and non-art, medium and its domain. A defining premise for the movement is deceptively simple and yet has shaped the century: that art might be assembled from the stuff of modern life itself. For if Dada's approach is militarized, its primary media are the transfigured forms of a new communication and commodity culture: advertising, propaganda, the press, and the mass-produced object. There are obvious precedents here in cubist collage, though it is worth remembering that Pablo Picasso's and Georges Braque's experiments with the form, and the introduction of mechanically reproduced

elements into the sphere of painting, predate Dada only by a few years. Yet, in Dada, collage's inherent transgression of the boundaries of fine art is taken to a new extreme—an unprecedented degree of permeability in the conceptualization of the work, an utterly new openness to the stuff of the external world. Picasso's *Guitar, Sheet Music, and Glass* of 1912 is assembled from pasted material rather than painted, bits of the world largely culled from modern print culture—wallpaper and imitation wood grain, sheet music, newspaper—affixed onto the surface **[fig. 8]**. Yet for all their visual and semantic flexibility,[36] here individual fragments still have a referential role to play, and these elements coalesce into a café still life in a memory trace of a perspectival view. With Dada, less than a decade later, it became possible to imagine a very different kind of work: Kurt Schwitters' *Merzbild 10 A: Konstruktion für edle Frauen* (Merzpicture 10 A: Construction for Noble Ladies) (1919) **[143]** is no longer organized as a picture, but exists as an unsublimated accumulation, a sampling of the found elements of modern life. Schwitters called his method and his art *Merz*, which he defined as "the principle of using any material."[37] Though famously at odds with the Hannover artist, Huelsenbeck likewise saw what he called "the new medium" as central to dadaism: "Perspective and color...are shareholders in the cowardly and smug philosophy that belongs to the bourgeoisie. The new medium, on the other hand, points to the absolutely self-evident that is within reach of our hands...."[38] In Dada works, language, politics, the machine and the commodity permeate the work of art by way of the detritus, processes, and idioms of a new media and commodity culture. Other forms of degradation within the work reiterate this aesthetic impurity: abstraction that functions as a refusal of transcendence; readymade components that offer (and combine) abject and commercial references; high cultural references that are deflated.

At the same time that the frame of the Dada piece no longer serves as a barrier to the outside world, Dada art spills out of traditional object boundaries into the terrain of modernity itself with performance, media pranks, and installation works. Examples of this type of artistic activity conceived more as event or experience than object per se are plentiful and can be found in all of the Dada city centers: in Zurich, false reports of a duel between Tzara and Arp leading to court proceedings were planted in a newspaper by Walter Serner. Baader disrupted a service in the Berlin Cathedral, an act that was widely reported in the press. In

fig. 8 Pablo Picasso, *Guitar, Sheet Music, and Glass*, after 18 November 1912, Paris, pasted paper, gouache, and charcoal on board. Collection of the McNay Art Museum, Bequest of Marion Koogler McNay

1919 Kurt Schwitters began making the first elements of what would become an ongoing reconstruction of his home, incorporating collections of found and purloined things. Calling it his *Merzbau*, Schwitters described the work as "an abstract...sculpture into which people can go."[39] At the *Dada-Vorfrühling* (Dada Early Spring) exhibition held in Cologne in 1920, visitors were asked to pass through the men's room, where they found an aquarium filled with red-colored water, a doll's head, an alarm clock, and an ax for destroying the piece. In New York, the Baroness Elsa promenaded in costumes made from found objects, propositioning men that she passed, while in Paris, dadaists organized a series of soirées, both shocking and chic. An ambitious program at the Parisian Salle Gaveau included a performance of Tzara's twenty-person *Vaseline Symphonique* and an episode in which both performers and audience stabbed balloons labeled with the names of contemporary cultural and political icons: Jean Cocteau, Georges Clemenceau, Marshal Pétain. This type of work, of course, is impossible to present fully within a museum exhibition or book. Yet this abandonment of not only picture making, but object making, reflects a sea change in the conceptualization of art without which certain common contemporary modes of practice are inconceivable.

A second effect of Dada's tactical approach is the transfiguration of audience relationships. The German cultural commentator Walter Benjamin described this in an extraordinary early analysis of dadaism in his 1936 essay, "Das Kunstwerk im Zeitalter seiner technischen Reproduzierbarkeit" (The Work of Art in the Age of Mechanical Reproduction). There, from the historical vantage point of a decade or so, he speaks of Dada as initiating a new form of spectatorship, explicitly aggressive, suggestively militarized. The Dada artwork was useless for contemplation—a mode of reception whose archetype, Benjamin reminds us in a footnote, was theological: the awareness of being alone with one's god. Instead, it "became an instrument of ballistics. It hit the spectator like a bullet, it happened to him, thus acquiring a tactile quality."[40] Divinity in the artwork was shot dead. Dada cultivated response, be it outrage or conspiratorial laughter. It seems likely that this small revolution in imagining the association between work and viewer grew out of Dada's cabaret origins at the Cabaret Voltaire in Zurich in 1916. In that context, performers assumed an interactive relationship with spectators, drawing them into the acts on stage, teasing and provoking. These performative assumptions lie at the core of Dada's approach.

DADA DIAGNOSTICS

In their deployment of these strategies, dadaists often functioned as diagnosticians, revealing the symptoms of modernity. Benjamin speaks of Dada's moral shock effects as anticipating the technical effects of film in the way that they "assail the spectator."[41] But it may be more accurate to say that its adherents were seismically sensitive to historical shifts, making certain phenomena visible in their artistic activities, often a decade or so before they became common topics within written cultural commentary. Making visible often took the form of a kind of exploded mimicry, the adoption of the structures of modernity in hyperbolic or transformed ways.[42] As one example, Baader's towering construction, *Das grosse Plasto-Dio-Dada-Drama: Deutschlands Grösse und Untergang oder Die phantastische Lebensgeschichte des Oberdada* (The Great Plasto-Dio-Dada-Drama: Germany's Greatness and Decline or The Fantastic Life of the Superdada) **[see p. 86]**, dominated the second room of the Erste International Dada-Messe (First International Dada Fair) held in Berlin in 1920. Baader, who had already defined a role for himself as a media prankster par excellence, built his ambitious work—perhaps the largest assemblage yet conceived and one of a diverse array of montage accumulations at the Dada Fair—with clippings culled from newspapers and periodicals, reproductions of artworks, and objects including a mannequin, gears, architectural fragments, and a mousetrap.[43] From the center of this agglomeration, two cylindrical paper forms extending from the middle of the work linked this media overload to the military form of artillery guns—weapons imbricated in the artifacts of print culture. The presence of a significant amount of dadaist ephemera suggested the group too was implicated in the ironic commemoration of this monument to the modern age.

Herein lies a fundamental distinction from surrealism, which in comparison, was much more closely tied to the culture of poetry and the book, a rarefied social world, and more focused on the individual unconscious detached from the larger social one. Nor do the issues of the public—of politics, mass communication, and audience relationships—come to center stage in surrealism as they do in Dada. Dada's engagement with the public sphere is defining. Its accumulations and overload relate not to a literary world but mark instead an assertive engagement with the terms, just recognizable at the moment of their emergence, of a new modern media culture.

Within the broader artistic avant-garde, the first decades of the twentieth century were rife with proposals for

new forms of born-again consciousness, for fostering "new men" who would serve as perfect analogues of the age: the list would include the armored psyche of proto-fascism, the collective class consciousness of the Russian avant-garde, the hygienic nationalism of the French *esprit nouveau*, or the addictive personality of Italian futurism, intoxicated by speed and war. Yet the dadaists' "new man" seems almost a perverse parody: with various inflections and modifications, the dadaists presented themselves as openly traumatized, alternately cynical and ecstatic, self-mocking, and incapable of naive belief.[44] They put on display ego without a protective shell, parried by shock and vulnerable to what might come. "The neurosis of a whole epoch cannot be concealed any longer…" wrote Ball. "Life vacillates between two extremes, between reticent unworldly expectations and a ruthless and terrifying instinctual urge that cannot be repressed. Each person hopes for support, clarity and reassurance from others, and yet each one has to learn that he himself is in urgent need of help and care."[45] Artists within the movement gave birth to a striking number of alter egos, which served as parodic, at times debased, inversions of a rational and authoritative masculinity. Dadamax reappeared in Ernst's work, often as a feeble construction of nonfunctional machine parts aligned in anthropomorphic form with the suggestion of pathetic genitals (a leaky faucet!) **[225]**. In creating Rrose Sélavy, Duchamp thoroughly transformed his identity, presenting himself as female, wholly commodified, and explicitly Jewish **[269, 321]**.[46] Anna Blume inhabited Schwitters' literary and artistic efforts—a bourgeois lady of clichéd sentiments and fashionable taste, who takes form through the force of the artist's noble and base desires.

Tzara's "Manifeste Dada 1918" (Dadaist Manifesto) **[fig. 9]**, perhaps the most widely distributed of all Dada texts, played a key role in articulating a dadaist ethos around which the movement could cohere. Picking up on ideas discussed within Zurich Dada circles, and first declaimed there in July 1918, the manifesto was later published in *Dada no. 3*. Tzara begins by pointing to the paradox of his use of the manifesto form:

> To put out a manifesto you must want: A B C
>
> To fulminate against 1, 2, 3
>
> To fly into a rage and sharpen your wings to conquer and disseminate little abcs and big abcs, to sign, shout, swear, to organize prose into a form of absolute and irrefutable evidence, to prove your non plus ultra and maintain that novelty resembles life just as the latest appearance of some whore proves the essence of God.[47]

Tzara immediately undermines the socially instrumental logic of the manifesto genre—"I write this manifesto and I want nothing, and in principle I am against manifestos, as I am against principles." (In fact much of Dada work begins with the transfiguration of forms of public speech—the newspaper page, the sermon, and the political broadsheet as well as the manifesto.) Then throughout the text, he denounces again and again the possibility of a collective social or moral foundation, attacking a range of sacred cows—God, philosophy, universal beauty, science, and commerce—and speaking instead of the failure of all systems of thought, of a "distrust of unity."[48] Something of the specifics of his assault emerge in a passage which reads:

> If I cry out:
> *Ideal, ideal, ideal,*
> *Knowledge, knowledge, knowledge,*
> *Boomboom, boomboom, boomboom,*
> I have given a pretty faithful version of progress, law, morality and all other fine qualities that various highly intelligent men have discussed in so many books, only to conclude that after all everyone dances to his own personal boomboom, and that the writer is entitled to his boomboom: the satisfaction of pathological curiosity; a private bell for inexplicable needs; a bath; pecuniary difficulties; a stomach with repercussions in life; the authority of the mystic wand formulated as the bouquet of a phantom orchestra made up of silent fiddle bows greased with philtres made of chicken manure. [49]

Tzara links "ideal" and "knowledge" to the militaristic and sexually evocative "boomboom," intimating the inherent corruption of the former. But perhaps more surprising is how quickly the passage turns from this form of social critique to what is ultimately most individual and resistant to social control: the subject's psychic formation ("pathological curiosity") and the sexual or scatological body ("a stomach with repercussions in life" and "inexplicable needs"). Tzara, that is, takes a turn into radical subjectivity. This move coincides with the collapse of language itself in the production of grammatically correct but semantically opaque phrases.

While clearly a theory of dadaism cannot be extrapolated from any one text, Tzara's manifesto hints at fundamental terms: the way that Dada practice took shape within the crucible of a modern crisis in the notion of the public. As a point of comparison, the Russian avant-garde, wholly contemporaneous with Dada, might be understood to mark

the apogee of faith in the possibility of the collective—the coordination of individual needs and desires, abetted by modern technologies, into a harmonious public and class-based entity. Dada exhibits in this moment of an emergent media culture a profound skepticism about all governing social systems—law, education, even language itself—and a collapse of faith in the possibility of a cohesive public. The performance of what is generally held to be private—the mind and the body's lawlessness, their perversities and pathologies—stands as a primary mode of resistance. The result is at times a misfiring of expectations, at others, a display of incommunicability aimed not at audience comprehension but its subversion. But Dada's tactics are more broadly those of intervention into governability, that is, subversions of cultural forms of social authority—breaking down language, working against various modern economies, willfully transgressing boundaries, mixing idioms, celebrating the grotesque body as that which resists discipline and control.

Consider in this regard a concept celebrated in early Parisian Dada circles—the idea of the *geste gratuit*, an act seemingly detached from moral considerations or instrumental purpose. In this, dadaists took their cue from the aimless murder carried out by Lafcadio in André Gide's *Les Caves du Vatican* (The Vatican Cellars), 1914. Proto-Dada performances of such gratuitous gestures followed, which took on a quasimythic status within the group. Arthur Cravan punctuated a lecture at the Salle des Sociétés Savantes with random pistol shots. Jacques Vaché attended the premiere of Guillaume Apollinaire's *Mamelles de Tirésias* (Breasts of Tiresias) dressed as an English officer and disrupted the intermission by threatening to "shoot up" the audience. What seems clear in the aggressive amorality of these acts, though strangely unacknowledged, is the war's proximity. Mimicking the psychic inurement of the soldier, such gestures dramatize the moral amnesia of the battlefield within a civilian arena. The conflation of civilian and military is disturbing—the just causes of patriotic speeches are undermined by the automatized sociopathologies of the soldier.

In another sphere of assault, one might look at Marcel Duchamp's *Obligation Monte Carlo* (Monte Carlo Bond) [320] created in Paris in 1924. Duchamp mimicked the new forms of a modern speculative economy, creating a document crowned with a photographic portrait taken by Man Ray of the artist sporting soapy horns and, in a continuous pattern on its green background, the repeated pun "moustiques domestiques demistock" (domestic mosquitoes

half-stock), which parodied more conventional certification of authenticity. Yet the bond was no fake: some were notarized so they actually had legal value, officially entitling the owner to collect shares in dividends of the company, and at least in the first year, Duchamp diligently paid dividends. Yet the company itself was dedicated to a system conceived by Duchamp for playing roulette, which tended toward equilibrium, neither profit nor ruin. And gambling famously serves as a counter logic to labor in modern capitalism: work and production are irrelevant, and chance the converse of rationality.

Skepticism about collective judgment itself became a central premise around which a dadaist ethos cohered. It emerged as point of controversy in the mock trial of Maurice Barrès, held in Paris in 1921 [see figs. 6.10, 6.11]. Often seen as an event that foretold the end of Dada, it was also one that laid positions bare. The trial was conceived by André Breton, a founding member of the Paris Dada circle who would become the central theorist of surrealism, to interrogate the abandonment of moral principles by the author, Maurice Barrès. Barrès jettisoned a radical libertarianism to adopt an ultranationalist position during the war, glorifying the fighting. But despite Breton's and Tzara's common disdain for patriotic display, the spectacle brought tensions between the two to a head, leading to a final break. The terms of Tzara's protest are telling, for he objects to the act of claiming moral authority over others. "I have no confidence in justice, even if this justice is made by Dada." The famed Dada spokesman proceeded to call both the writer, represented at the trial by a mannequin, and those prosecuting him, "a bunch of bastards," adding "greater or lesser bastards is of no importance."[50] This refusal to enforce a collective moral code lies as one of the dividing lines between Dada and surrealism. "Dada," said Breton in retrospect, "with its acknowledged commitment to indifference, [had] strictly nothing to do with it."[51]

Yet along with Dada's discomfort with modern collectivity, a certain nostalgia for older forms of community based in traditional religious structures often appears. Hugo Ball's melancholic writings, with their pervasive alchemical metaphors and metaphysical longing, suggest the kind of mourning for what has been lost in the transition described in Ferdinand Tönnies' classic account of the rise of modernity—in the movement from *Gemeinschaft* (community) to *Gesellschaft* (society), from forms of social existence based on traditional family and village structures to new forms rooted in urban existence, in the anonymous market and abstract social relations.[52] Along with its interventions

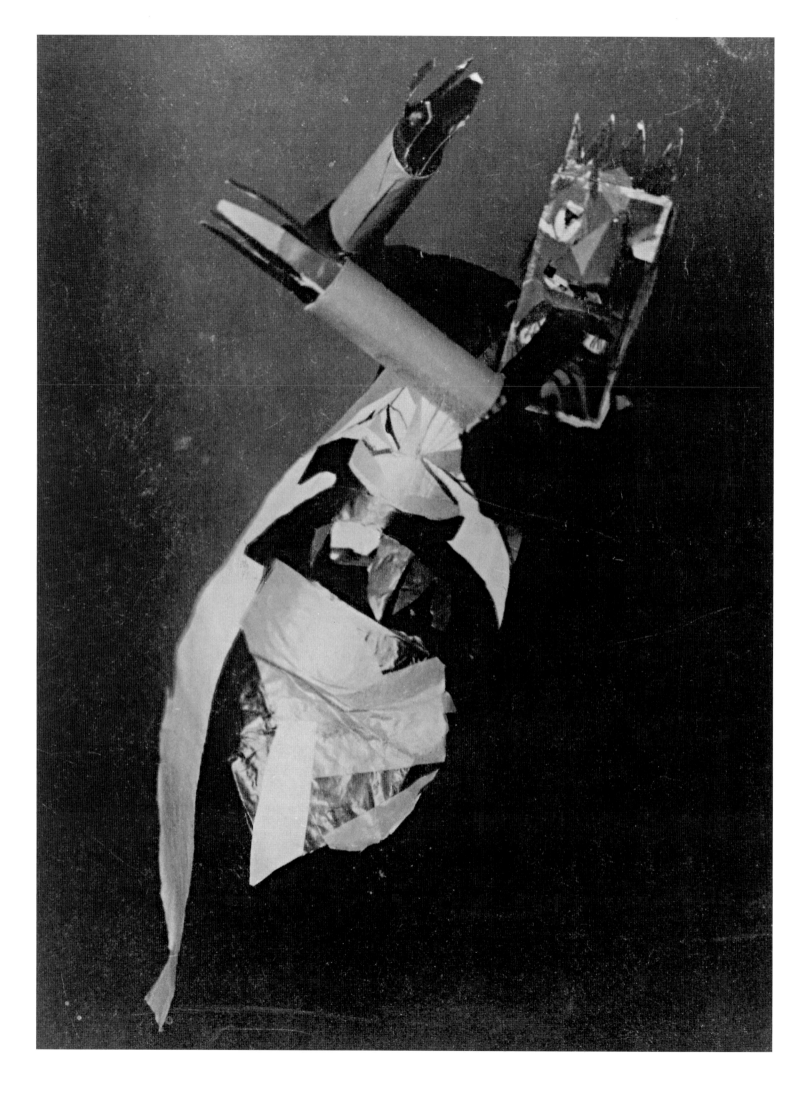

ZURICH

1

Hans Arp
Hugo Ball
Viking Eggeling
Emmy Hennings
Richard Huelsenbeck
Marcel Janco
Francis Picabia
Adya van Rees
Otto van Rees
Hans Richter
Christian Schad
Arthur Segal
Walter Serner
Sophie Taeuber
Tristan Tzara

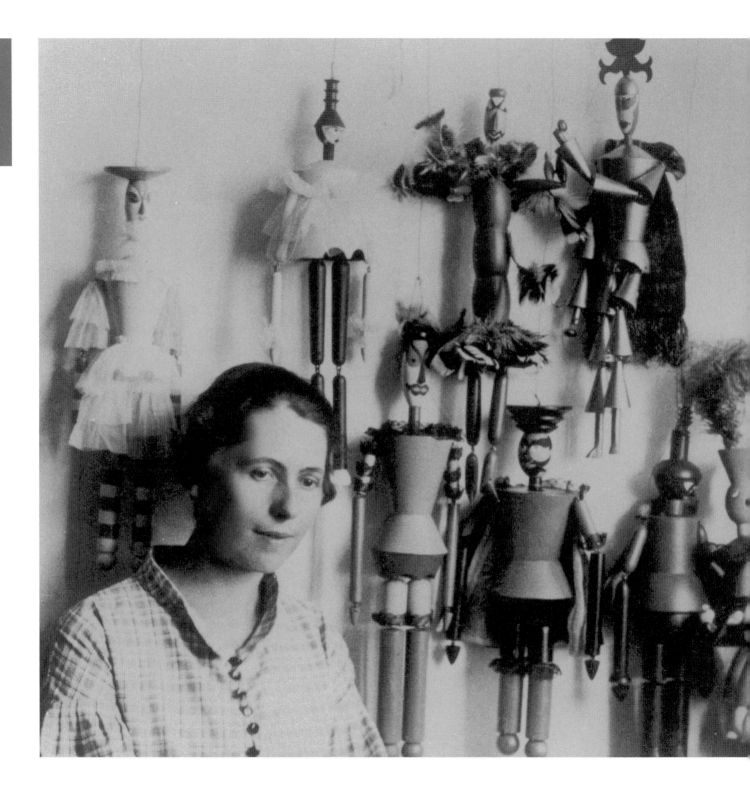

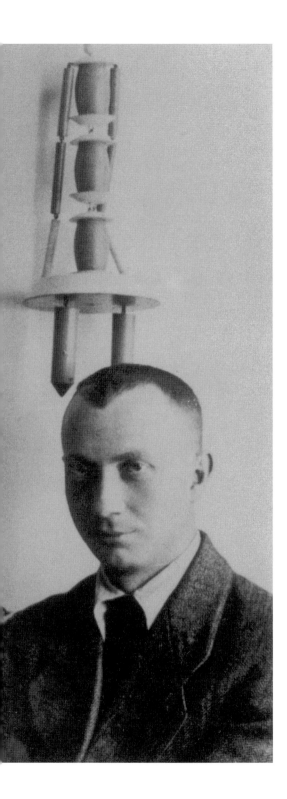

Dada was launched in Zurich. Its manifestation in that city was distinguished by its origins within the cabaret, the primacy given to defining a theory of abstraction expressed across media, and interest in various forms of primitivism. Yet, in the activities of a small group of artists living there during World War I, a certain idea of Dada developed with enough coherence to travel and be adopted elsewhere. Zurich was a crucible for Dada's revolution. Many of the fundamental ideas and strategies that later characterized Dada as a movement grew out of events and activities that took place within this city of refuge.

Because of Switzerland's famed policy of political neutrality, Zurich served as a safe haven for those escaping from the escalating conflagration of World War I. Iconoclasts of all kinds were attracted to the city: pacifists, draft dodgers, spies, and profiteers, as well as political and intellectual refugees of many stripes, including the Russian Bolshevik exiles Vladimir Lenin and Grigori Zinoviev and the anarchist Mikhail Bakunin. In relation to Berlin, Munich, Bucharest, and Paris, where the founding dadaists had spent their prewar years, Zurich was by all accounts a conservative city. Its very tranquillity, abundance, and disengagement from the conflict created at times a feeling of unreal isolation from the larger European world. At one point in his memoirs, Richard Huelsenbeck, a founding member of the Zurich Dada group, writing with cosmopolitan disdain, labeled the entire country "one big sanatorium."[1] But Huelsenbeck also clearly conveyed the overarching sense of freedom and relief that accompanied his arrival in Zurich: "In the liberal atmosphere of Zurich, where the newspapers could print what they pleased, where there were no ration stamps and no 'ersatz' food, we could scream out everything we were bursting with."[2] This sense of refuge was shadowed by a keen awareness of proximity to threat, felt both geographically and psychically. Hans Arp wrote defiantly: "Despite the remote booming of the artillery, we sang, painted, pasted and wrote poetry with all our might,"[3] while Hugo Ball drew a more precarious picture, describing Switzerland as a "birdcage, surrounded by roaring lions."[4]

The origins of the Dada movement are inextricably tied to the short life of the Cabaret Voltaire, an iconoclastic nightclub that served as the first public gathering place for Dada artists and writers. The learned Ball, the Cabaret's founder with his companion Emmy Hennings, served as Dada's earliest intellectual leader. Ball was a studious figure whose writings reveal an incredible breadth of cultural erudition. His diaries serve not only as the most important

record for our understanding of events in Zurich, but also as an intellectual genealogy, making links between his thinking and other contemporaries. In Munich before the war, Ball wrote for *Die Aktion*, *Der Sturm*, and other radical journals and began a serious involvement with the avant-garde theater, working as literary adviser to several progressive theatrical groups. Along with the playwright and poet Hans Leybold, Ball cofounded an experimental journal of his own called *Revolution*, which launched proto-dadaist assaults on bourgeois mores. The publication of one of Ball's poems, "Der Henker" (The Hangman), led to the confiscation of the journals; but at the ensuing trial, the judge declared the poem to be incomprehensible and therefore harmless. Ball's Munich activities brought him into expressionist circles around the Blaue Reiter (Blue Rider), and Vasily Kandinsky, the group's leading figure, was to remain a central and lasting influence on Ball. The two developed plans to reopen the Munich Artists' Theater in an effort to promote a "new form of theatrical expression," ambitions that were jettisoned with the outbreak of war. A meeting in a Munich café established a

second important relationship for the founding of Dada: Ball befriended Huelsenbeck and began a formative collaboration with the younger man.

Hennings, a figure of quite a different type, sat at the class margins in a way that distinguished her from her future (and male) Dada colleagues. She was an experienced professional entertainer, who had been associated with theatrical companies, vaudeville, cabarets and nightclubs, and avant-garde ventures from about 1905.[5] Contemporary criticism and memoirs present a consensus about her extraordinary stage presence. Capturing both her charisma and dissipation, the *Züricher Post* ran a piece on the Cabaret Voltaire declaring: "The star of the cabaret, however, is Mrs. Emmy Hennings. Star of many nights of cabarets and poems. Years ago she stood by the rustling yellow curtain of a Berlin cabaret, hands on hips, as exuberant as a flowering shrub; today too she presents the same bold front and performs the same songs with a body that has since then been only slightly ravaged by grief."[6] Like many other female entertainers of her day, Hennings slipped in an amphibian way

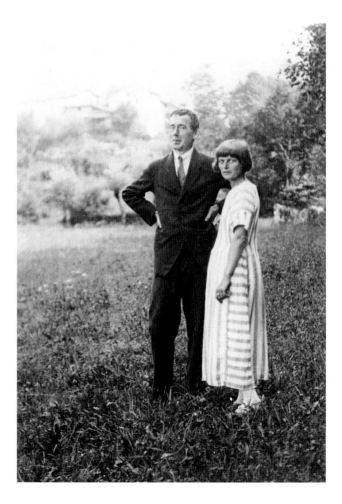

1.1 Hugo Ball and Emmy Hennings, 1918. Deutsches Literaturarchiv, Marbach am Neckar

between advanced intellectual circles and a seedy, underworld existence. She worked as a model, nightclub hostess, and lady of the night, was arrested several times for prostitution and theft, and suspected of homicide.[7]

Ball and Hennings had met in Munich in 1913 and soon became a couple **[fig. 1.1]**. When World War I broke out, Ball exhibited considerable patriotic fervor, volunteering for military service three times, only to be rejected each time on medical grounds. But his initial enthusiasm was transformed into keen opposition when he made an unauthorized visit to the Belgian front and was horrified, precipitating a personal crisis that nearly ended in suicide. Soon afterward, Ball moved to Berlin, where Hennings and Huelsenbeck joined him, establishing the beginnings of a Dada coterie. Along with Huelsenbeck, he organized a series of antiwar evenings featuring aggressive performances that later served as a precedent for events at the Cabaret Voltaire. At one in February 1915 called "Gedächtnisfeier für gefallene Dichter" (The Memorial for Fallen Poets), Ball read an ironic poetic obituary of his close friend Leybold—who had committed suicide after being injured at the front in the fall of 1914[8]— in a deliberately unsentimental, biting manner that in its lack of patriotic tribute shocked the audience. Huelsenbeck recited *chants nègres*—poems intended to capture the rhythm and tonality of African tribal songs—to the beat of a drum. The pair ended the evening by handing out a manifesto, which declared, "We want to provoke, perturb, bewilder, tease, tickle to death, confuse...."[9]

His political convictions strengthened, Ball was now unwilling to fight. By the end of May, he and Hennings had arrived in Zurich. Ball had used two passports and registered with the police under a false name in order to avoid military inspection at the border, and he was later picked up by the police for falsifying documents and briefly imprisoned. Without papers, opportunities for work were limited, and the couple became destitute. Ball began working in a button factory and was suspected of having pimped for Hennings.[10] The first shift in luck came when Ball was taken on as a pianist and playwright for a touring vaudeville group called the Maxim Ensemble, a turn of events that schooled Ball in popular forms of variety theater.

THE CABARET VOLTAIRE

Despite these inauspicious beginnings, Ball approached Jan Ephraim, the owner of the Holländische Meierei Café at Spiegelgasse 1, and proposed starting an avant-garde cabaret, arguing that it would be popular with intellectuals

1.2 Restaurant "Meierei," Zurich, c. 1935, location of Cabaret Voltaire in 1916. Baugeschichtliches Archiv der Stadt, Zurich

and draw a crowd. Ephraim agreed. The café was in a narrow, medieval building in the Niederdorf quarter, a "slightly disreputable" amusement district, densely packed with bars, inns, and variety shows, set within an otherwise orderly city **[fig. 1.2]**.[11] While many German localities, concerned with political opposition, limited free speech during wartime, the Swiss focused on maintaining morals. A nighttime curfew implemented in 1913 was renewed in 1916, and a vice squad was established. Tristan Tzara evokes the ambience in his "Chronique zurichoise," calling the Spiegelgasse "the most obscure of streets in the shadow of architectural ribs, where you will find discreet detectives amid red street lamps."[12]

Nonetheless, the unassuming café room already had a cultural pedigree; it was the site in 1914 of the Cabaret Pantagruel, named for the protagonist of François Rabelais' ribald masterpiece. A gathering place for a group of modern Swiss poets, it served as Zurich's "first literary café."[13] In naming his cabaret in similar style, Ball acknowledged his avant-garde predecessors on the premises, though the gesture may also have been partly motivated to ease the process of acquiring official permission.[14] Ball's chosen name paid homage to the great satirist of Enlightenment mores and politics and suggested the contemporary imperative for the cabaret. Huelsenbeck testifies in his memoirs that Voltaire already fascinated Ball during their time in Berlin, especially in his role as a fierce opponent of organized religion and his mocking hostility to sectarian virtue.[15] His close friend, he suggests, connected "his moral reaction [to the war] with free thinking—as the name Voltaire indicates."[16] But for

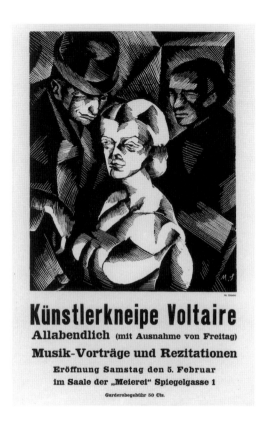

1.3 Marcel Slodki, poster for the opening of Artists' Pub Voltaire, later known as Cabaret Voltaire, 1916, lithograph. Kunsthaus Zürich

1.4 Karl Schlegel, invitation to the opening of Artists' Pub Voltaire, 1916, lithograph. Kunsthaus Zürich

Ball, the legacy of Voltaire was also embedded in the cabaret tradition of deflating contemporary pieties. "The ideals of culture and of art as a program for a variety show," Ball wrote in his diaries, "that is our kind of *Candide* against the times."[17]

As Ball imagined it, the founding of the cabaret had explicitly political overtones as a gathering point for all the artistic émigrés of modernist leanings who had gravitated to Zurich in the war years—a place where participants "would not only enjoy independence, but give proof of it."[18] It was also in many ways an effort to recreate community within this city of exile. Ball issued a poster, a printed card, and an advertisement of invitation in the press **[figs. 1.3, 1.4]**, which he summarized in his diary on 2 February 1916: "Cabaret Voltaire. Under this name a group of young artists and writers has been formed whose aim is to create a center for artistic entertainment. The idea of the cabaret will be that guest artists will come and give musical performances and readings at the daily meetings. The young artists of Zurich, whatever their orientation, are invited to [make] suggestions and contributions of all kinds."[19] The invitation seems to have been effective, for as Ball recorded in his diaries, on the opening night three days later: "At about six in the evening while we were still busy hammering and putting up futuristic posters, an Oriental-looking deputation of four little men arrived with portfolios and pictures under their arms; repeatedly they bowed politely. They introduced themselves: Marcel Janco the painter, Tristan Tzara, Georges Janco, and a fourth gentleman whose name I did not quite catch. Hans Arp also happened to be there and we were able to communicate without too many words."[20] Marcel Janco, Tzara, and Arp joined Ball and Hennings to become the core members of a group around the Cabaret.

Tzara (whose original name was Samuel Rosenstock) and Janco were both Romanian Jews, from highly assimilated families, who met in high school. Both had precocious, internationalist cultural ambitions, founding the Simbolul (Symbol) group and putting out a periodical of the same name, which Janco financed, before they finished school. Janco arrived in Zurich soon after his exams, and Tzara joined him a year later in fall 1915. At 29, Arp was older and more established, having successfully launched an artistic career in the most prestigious German modernist circles. At the outbreak of war in 1914, Arp and his brother, both Alsatians by birth, bearing German citizenship, fled to Paris to avoid conscription in the German army. Yet there, as German nationals of military age, they were suspected

of espionage, interrogated by French authorities, and re-leased with the recommendation that they depart France. It was a blow for the Francophilic Arp. Huelsenbeck wrote in 1920 of his Dada comrade's disillusionment: "Arp was Alsatian; he had lived through the beginning of the war and the whole nationalistic frenzy in Paris, and was pretty well disgusted with all the petty chicanery there, and in general with the sickening changes that had taken place in the city and the people on which we had all squandered our love before the war."[21] No longer welcome, the Arp brothers left Paris in spring 1915 to join their mother in Switzerland. In Zurich, again subject to the German draft, Arp effectively feigned insanity before the German consular official to avoid conscription.[22]

The success of the Cabaret's opening night, which brought together a sympathetic group of artists and writers from across Europe, must have suggested to Ball that something had begun, for he quickly sent Huelsenbeck a post-card requesting his presence in Zurich. Huelsenbeck writes in his memoirs of being eager to leave Germany—where he was likely to be drafted—at the time he received Ball's summons. Huelsenbeck arrived soon after in Zurich, having offered a doctor's certificate of mental exhaustion in order to obtain the necessary travel documents, and bringing with him an interest in primitivism established in Berlin. On 11 February, Ball wrote: "Huelsenbeck has arrived. He pleads for stronger rhythm (Negro rhythm). He would prefer to drum literature into the ground."[23]

Inside, the Meierei Café had a small stage, a piano, and space for forty or fifty people. The program was highly eclectic. Most of the songs, especially early on, reflected Hennings' talents and experience and fell within the frame-work of traditional cabaret and variety theater. Hennings sang famed standards such as Aristide Bruant's "A la Villette," Frank Wedekind's "Donnerwetterlied" (Thunder Song), and Erich Mühsam's "Revoluzzerlied" (Song of Revolution), as well as less known works—some written by Hennings herself and accompanied by Ball's melodies. Huelsenbeck wrote sentimentally of this repertoire:

> These songs, known only in Central Europe, poke fun at
> politics, literature, human behavior, or anything else
> that people will understand. The songs are impudent but
> never insulting.... The songs created the "intimate"
> atmosphere of the cabaret. The audience liked listening
> to them, the distance between us and the enemy grew
> smaller, and finally everyone joined in.[24]

Huelsenbeck's description prefigures those aspects of the cabaret tradition—its satiric impulse and its performative engagement with the audience—that would ultimately be assumed by Dada and extended to different fields of art making. The importance of this cabaret legacy helps us understand the origins of Dada's radical innovation—its definition of a mode of artistic practice in which art, eschew-ing contemplative detachment, serves as a form of diag-nosis and critique of modernity itself and elicits audience response, whether it be shock or conspiratorial amusement. But Huelsenbeck also suggests the way in which the Cabaret served to foster community, a social formation under double threat from the diaspora of war and the dispersed audiences of a new technological and media age. These same forces set the cabaret genre itself on the verge of obsoles-cence. But in Zurich during the war years, evenings at the Meierei Café offered a self-consciously low-tech corrective to the increasingly attenuated bonds of modern society.

Along with traditional cabaret entertainments, the Cabaret's repertoire also included an assortment of works of high seriousness, in a mixing of high and low that was con-sistent with cabaret tradition, though experimentation at the Cabaret Voltaire would soon push the genre to a new avant-garde extreme. In a subtle declaration of intentions, Ball read passages from Voltaire. Others offered selections from classic Russian literature, including Anton Chekhov, Nikolai Nekrasov, and Ivan Turgenev. But greater emphasis was given to modernist works. There were recitations of German expressionist poems by Kandinsky and Wedekind, and French ones by Max Jacob, André Salmon, and Jules Laforgue. Arp read from Alfred Jarry's *Ubu roi* (King Ubu) when Ball's volume of Lautréamont failed to arrive in time. Compositions by Franz Liszt, Claude Debussy, Alexander Scriabin, Sergei Rachmaninoff, and Camille Saint-Saëns were all played on the café's piano. On the walls hung artwork by Otto van Rees, Arthur Segal and Janco, Marcel Slodki, Elie Nadelman, Pablo Picasso, August Macke, and Amedeo Modigliani, many that Arp had secured for exhibition, and others by Arp himself.[25] Huelsenbeck put it bluntly: "We wanted to make the Cabaret Voltaire a focal point of the 'newest art'...."[26]

The display of artwork within the cabaret had pre-cedent.[27] But the combination of music, poetry, and visual art that resulted also reflects Ball's keen interest in the idea of the *Gesamtkunstwerk*—the total work of art that would integrate various media into a multisensory whole. The term itself is Wagnerian, used to describe the composer's vision of the spectacle of opera, but Kandinsky, who greatly

influenced Ball, was perhaps its most influential advocate at the beginning of the twentieth century. Kandinsky's conception privileged the possibility of synaesthetic effects—the crossing and reverberation of sensory responses in a way that would allow for a fully corporeal, rather than an intellectual response. The core idea that the perception of the visual arts would be integrated with auditory effects and bodily display emerges as a defining precept for dadaism without which Dada's mixing of the performative and visual arts could not be conceived, but it did so in a transformed way. Kandinsky's interest in the pursuit of purity—of the possibility of direct sensory resonance without the mediation of language and intellect—was corrupted at Dada's inception, in the Cabaret Voltaire's raucous embrace of popular entertainment and satirical humor.

Alongside such intellectual ambitions, Huelsenbeck's memoirs offer a reminder of the realities of the cabaret. It was nighttime entertainment in a seedy quarter, and the roughness should not be underestimated. Windows could not be opened after 10 pm, when music was played, and Huelsenbeck recalled that "Whenever someone opened the door, thick clouds of smoke would come pouring out like the smoke that hovers over fields during the burning of the harvest leavings. A caustic cindery smell wafted through the corridor. ...There were almost no women in the cabaret. It was too wild, too smoky, too way out."[28] Larger aims aside, Ball played "anything the drunken audience demanded,"[29] and brawls initiated by intoxicated students were not uncommon.[30]

But not all of the intoxication seems to have been due to alcohol. In late February Ball noted in his diaries a

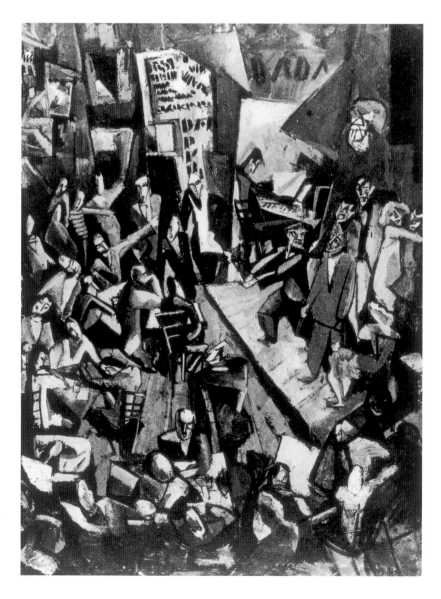

1.5 Marcel Janco, *Cabaret Voltaire*, 1916, oil on canvas. Photograph of lost painting. Kunsthaus Zürich

24

sense of "undefined ecstasy" and reported, "the little cabaret is about to come apart at the seams and is getting to be a playground for crazy emotions." He spoke of a sense of escalation as the evening's activities progressed—a "race with the expectations of the audience... [that] calls on all our forces of invention and debate."[31] Performances moved farther away from cabaret standards and the canon of high modernism toward more radical and chaotic experiments. Arp's description of a painting (now lost) **[fig. 1.5]** of the Cabaret Voltaire by Janco captures well the frenzied atmosphere:

> On the stage of a gaudy, motley, overcrowded tavern there are several weird and peculiar figures representing Tzara, Janco, Ball, Huelsenbeck, Madame Hennings and your humble servant. The people around us are shouting, laughing, gesticulating. Our replies are sighs of love, volleys of hiccups, moos and the miaowing of medieval Bruitists. Tzara is wiggling his behind like the belly of an Oriental dancer. Janco is playing an invisible violin and bowing and scraping. Madame Hennings with a Madonna face, is doing the splits. Huelsenbeck is banging away nonstop on the great drum, with Ball accompanying him on the piano, pale as a chalky ghost.[32]

Such raucous antics have often been dismissed as so much nonsense—as "spontaneous foolishness," to cite Ball's words in isolation.[33] However, key facets of the cabaret's particular atmosphere—the highly charged, aggressive relationship with the audience; the public posture of chaotic abandon; and the performance of an exuberant infantilism that undercut any pose of high seriousness—would each become central strategies within Dada practice.

Though the political character of the Zurich group has often been downplayed, it would be a mistake to ignore the consistency of its members in presenting their activities as an urgent moral imperative, a deeply felt ethical response to the cultural crisis provoked by World War I. Ball described a form of calculated irreverence: "Our cabaret is a gesture. Every word that is spoken and sung here says at least one thing: that this humiliating age has not succeeded in winning our respect."[34] Huelsenbeck retrospectively called events at the Cabaret Voltaire "a violently moral reaction"[35] and "spontaneous aggressive activity,"[36] continuing that when Emmy Hennings sang:

> "They kill one another with steam and with knives'" in Switzerland, which was encircled by fighting armies, she was voicing our collective hatred of the inhumanity of war. This beginning

> of dada was really a humanitarian reaction against mass murder in Europe, the political abuse of technology, and especially the Kaiser, on whom we, particularly the Germans, blamed the war.[37]

In his account, Tzara more cryptically, but nonetheless forcefully offered: "We took an oath of friendship on the new transmutation that signifies nothing, and was the most formidable protest, the most intense armed affirmation of salvation liberty blasphemy mass combat speed prayer tranquillity private guerilla negation and chocolate of the desperate."[38] "One day," Ball indignantly concluded, "they will have to admit that we reacted very politely, even movingly."[39]

Moreover, members of the group seemed agreed that their activities were aimed in part at producing a new type of consciousness, which sat outside of conventional morality and institutional frameworks—and which, reflecting dadaism's strong anarchic thrust, might best be described as a kind of assertive and self-conscious amorality, or individual revolt against systemic orders. Huelsenbeck defined a morality independent of social authority: "Dada was a collective struggle...for individual rights....It was not interested in providing moral justification for political activism, or, for that matter, for any particular system. The Dadaist knows that moral struggle is individual; man must arrive at his own decisions, his own values."[40] Ball wrote of creating a new man, an idea with great currency in the early twentieth century, but his formulation is atypical in its stress on the equilibrium between ideal and base, and on emotional extremes: "We demanded that we had to seek out and prepare the young man with all his virtues and defects, with all his good and evil, with all his cynical and ecstatic aspects; we had to be independent of any morality."[41] Ball's mention of cynicism and ecstasy is far from a passing comment; rather these modes of consciousness preoccupied the Zurich dadaists. Recurrent themes in song and verse, mimicked and elicited on stage, fascination with these states links a range of phenomena of keen interest to the group, including sexual rapture, religious transcendence, insanity, and intoxication. Though seemingly opposite, ecstasy and cynicism— one a form of investment so intense that it commands both body and psyche, and the other a form of alienation so deep that belief is impossible, leaving only mocking scorn— are at the same time intimately related: both transcend the governing orders of social authority, and both are incompatible with resignation.

At times, participants saw activities at the Cabaret as acting therapeutically on the psychological effects of war.

Shell shock was first defined and described as a psychological pathology during World War I.⁴² But the dadaists perceived signs of generalized psychic trauma among noncombatants, manifested in a form of psychic numbing or anesthesia. Arp, who was in general less given to political statements, wrote of Dada as a countermeasure to this inured state: "The people who did not participate directly in the terrible madness of World War I acted as if they were unable to comprehend what was going on around them. Like lost sheep they stared at the world with glazed eyes. Dada sought to jolt men out of their wretched consciousness. Dada detested resignation."⁴³ Dada was envisioned as a shock tactic, analogous to the electric shock therapy used to treat shell shock, breaking through a protective mental buffer to consciousness.

These statements hint at the way the Cabaret might be understood as a travesty of the official public order. Instead of the presentation of a militarized duty-bound masculinity, infantilism and childish disregard for the rules reigned. Instead of a carefully orchestrated structure, evening performances offered improvisation, the deliberate juxtaposition of uncoordinated actions, delight in the chaotic itself. Instead of appeals to rational ideals and moral absolutes, the cabaret celebrated bodily impulses, psychic desires, and pathologies. And instead of a tone of high seriousness, it offered mocking laughter.

ABSTRACTION

Among the works that we think hung on the Cabaret's walls—to be seen in juxtaposition with the evening performances—were a group of collages made by Arp **[4, 5]**. Arp's small and elegant works, deploying fragments of colored paper and packaging into graceful centripetal compositions, demonstrate his assimilation of the lessons of Picasso's papiers collés, which incorporated banal, nonartistic materials from modern print culture into a series of café still lifes **[see Introduction, fig. 8]**. Yet Arp reads something else in Picasso's work, taking it a step further in his own—the collages hung in the Cabaret Voltaire are fully abstract. Without representational content, attention is intensely focused on the use of found material itself.

Abstraction—the idea of creating nonrepresentational painting—was itself terribly new, at most a few years old. Arp's interest in it was shaped by his contact with Kandinsky, the leader of the expressionist Blaue Reiter group, who is often credited with making the first abstract painting in 1913. The Russian painter's writing is pervaded by a desire to create a visual idiom based on the sensory rather than the communicative. By excluding subject matter that could be named, it would evade intellectual processing and resonate instead with the "inner soul"—the unconscious, prelinguistic mind that lies beyond everyday modern consciousness. For Kandinsky, abstraction served as an ethical imperative, a critique of modernity, allowing artist and viewer to circumvent the narrow materialism and instrumentalized character of contemporary life through exploration of the ineffable.⁴⁴ Paradoxically, it was a modern form aimed against the modern itself. Arp, Ball, and Huelsenbeck were all admirers of Kandinsky, and his ideas grounded their thinking.

The Zurich dadaists embraced abstraction at this moment of its invention, and it became a primary force. Rather than stressing medium specificity as many later abstract artists have done, it was imagined in a multimedia context, in which abstraction in language, performance, and the visual arts were seen as integrally related enterprises, and each of great weight. The concomitant pursuit of these varied modes helps clarify the historical specificity of abstraction in Zurich. It was understood to be expressive less of individual subjectivity than of a communal and historical consciousness, and it carried an important ethical valence. Huelsenbeck wrote: "In that period, as we danced, sang and recited night after night, abstract art was tantamount to absolute honor."⁴⁵

Performances at the Cabaret Voltaire became increasingly radical, moving further away from vaudeville entertainment and toward the invention and exploration of new genres. On 30 March 1916, Huelsenbeck, Tzara, and Janco took the stage to recite a *poème simultané* titled "L'amiral cherche une maison à louer" (The Admiral Is Looking for a House to Rent) with discrepant texts spoken in French, German, and English, the languages of the principal nations at war.⁴⁶ The text of this work later appeared in the volume *Cabaret Voltaire* **[fig. 1.6]**. At one level, it was a parable of a military man failing to find a place for himself on the home front. Legible as a typeset script, when recited, the work provided a form of semantic overload, with words colliding cacophonously in a field of sound so that meaning was rendered only partially intelligible. Interrupting communication, it was a performance of static and conflict, offering an unspoken analog to the contemporary political situation. Ball understood the resulting noise of the work's performance to "represent the background—the inarticulate, the disastrous, the decisive" and to express "the conflict of the *vox humana* [human voice] with a world that threatens, ensnares, and destroys...."⁴⁷ Catastrophe was embedded

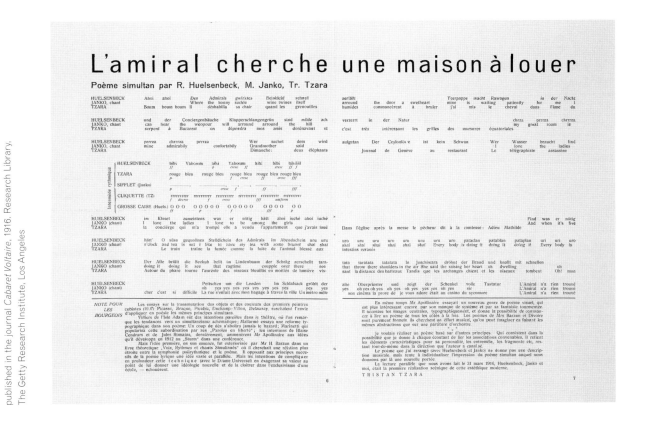

1.6

within speech. In his diaries, Ball describes the new poetic form in a manner that presages later dadaist interest in the structures of montage—"a contrapuntal recitative in which three or more voices speak, sing, whistle, etc., at the same time in such a way that the elegiac, humorous or bizarre content of the piece is brought out by these combinations."[48]

The simultaneous poem was followed in the same evening by the presentation of two *chants nègres*, which developed upon Huelsenbeck's earlier performances of primitivist poetry in Berlin. Dressed in black-cowled robes and accompanied by the beat of drums,[49] Huelsenbeck and members of the group recited seemingly abstract poetic lines intended to evoke the rhythms of African songs. It seems that the project was not entirely an imaginative flight of fancy. Huelsenbeck related that on hearing a practice session of the dadaists' verses in gibberish, which ended with the repeated refrain "umba, umba," Jan Ephraim, an old sailor, protested that they sounded nothing like the African and Oceanic songs he had heard on his travels. "He was one of those people," wrote Huelsenbeck with detectable disdain, "who take things literally and retain them verbatim." However, Ball suggested trying something more authentic, and Ephraim returned with a sheet filled with remembered verse. "I recited my new 'authentic' Negro

poems, and the audience thought they were wonderful.... Naturally, no force on earth could have gotten me to leave out the 'umba' at the end of every verse, although my Dutchman shook his head disapprovingly."[50] Tzara later seems to have pursued the idea of authenticity further. He incorporated fragments of African songs documented by ethnographers and culled from anthropology magazines in the Zurich library into poems of his own.[51] Like Arp's collages, the simultaneous poem and the *chants nègres* presented the Cabaret's European audience with a radical form of abstraction, in this case, of the spoken word. In the weeks that followed, the group's experimental initiatives in this direction became even more concerted.

In his diary entry of 23 June 1916, Ball announces the invention of a new poetic genre, *Verse ohne Worte* (poems without words) or *Lautgedichte* (sound poetry), built solely of abstract phonemes, so that the weight of the composition resided in phonic rhythm and performative intonation. That evening he had offered his final performance at the Cabaret, a reading of the first of these poems,[52] dressed in a cardboard costume—shiny blue cylinders that sheathed his legs and incapacitated his body to the degree that he needed to be carried on and off the stage, a collar fastened at the neck that flapped like wings as he moved his arms, and a blue

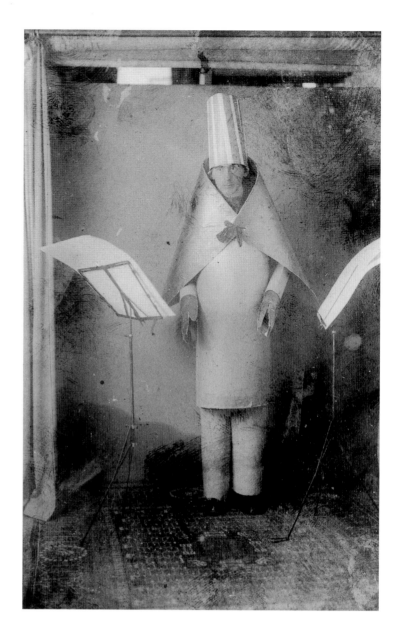

and white striped "witch doctor's hat." The ensemble was captured in a single photograph [**fig. 1.7**]. It was a revelatory, if traumatic, moment. Ball relates that as he began reading the third of these poems, "Elefantenkarawane" (Elephant Caravan), the syllables of which invoked the rolling rhythm of elephants, he startled himself as his voice reached back in time and took on the cadence of liturgical singing:

> I do not know what gave me the idea of this music, but I began to chant my vowel sequences in a church style like a recitative, and tried not only to look serious but to force myself to be serious. For a moment it seemed as if there were a pale, bewildered face in my Cubist mask, that half-frightened, half-curious face of a ten-year-old boy, trembling and hanging avidly on the priest's words in the requiems and high masses in his home parish. Then the lights went out, as I had ordered, and bathed in sweat, I was carried down off the stage like a magical bishop.[53]

Ball offers the most important theorization of these poetic efforts, describing in his diaries ideas that he most certainly conveyed to his Cabaret colleagues in conversation. The melancholic writer explicitly links the pursuit of abstract poetry with a critique of modern media culture—as an effort to get beyond the modern instrumentalization of language to a form perceived as authentic and primal. "In these phonetic poems," Ball read out in manifesto-like program notes before the magical bishop episode, "we renounce the language that journalism has abused and corrupted. We must return to the innermost alchemy of the word, we even give up the word, to keep for poetry its last and holiest refuge. We must give up writing secondhand: that is, accepting words (to say nothing of sentences) that are not newly invented for our own uses."[54] The idea of refuge so central here resonates with the group's own stay in Zurich. At least part of the impetus for this flight from communicative language was the desire to destroy the ideological potential for speech, its ability to serve as a vehicle for war or as a disciplinary medium in which social values are conveyed and enforced. "Adopt symmetries and rhythms instead of principles. Oppose world systems and acts of state by transforming them into a phrase or brush stroke,"[55] Ball commanded his future readers, once again linking abstraction in the visual

arts and language. The ineffable would work against structures of authority communicated through language. Moreover, assault on "language as a social order" would counter sociality itself, producing instead a productive form of solipsism:

> The destruction of the speech organs can be a means of self-discipline. When communications are broken, when all contact ceases, then estrangement and loneliness occur, and people sink back into themselves.... Spit out the words: the dreary, lame, empty language of men in society. Simulate gray modesty or madness. But inwardly be in a state of tension. Reach an incomprehensible, unconquerable sphere.[56]

In this internal sphere of refuge, "incomprehensibility" offers a buffer against external forces—providing a defensive rationale for abstraction. But Ball's description suggests that it is also a withdrawal into a fragile psychic space.

PRIMITIVISM

Ball also grants the "grammalogue"—the resonant sound image—with a strongly mnemonic character. It stands out in troubled times for its particular fixity in memory and acuity in recall, unhampered by the ordinary static of consciousness and forgetfulness. Successful word images, Ball writes, are "hypnotically engraved on the memory" and "emerge again from the memory with just as little resistance and friction."[57] Ball sets this frictionless recall in implicit contrast with a more generalized difficulty in remembering —a statement that hints at his anxiety about memory, a common site of disquiet among many intellectuals in the modern period, who perceived a fundamental cultural shift in relation to the past.[58]

Moreover, these abstract phonemes take on a transhistorical character, connected to earlier times and earlier states of mind, and to ideas of rediscovery and resurrection. In speaking of sound poetry, Ball's writing takes on a particular anachronistic tone, full of religious metaphors and alchemical images: "We have loaded the word with strengths and energies that helped us to rediscover the evangelical concept of the 'word' (logos) as a magical complex image."[59] Magic, Ball makes clear, serves as individualism's last stand against the external social order—a subversive counterforce to system.[60] Moreover, detached from social purpose, unfettered by the historical present, the rhythm of these phonic phrases allows access to what is beyond the conscious mind, stirring primal memories: "Touching lightly on a hundred ideas without naming them, this sentence made it possible

to hear the innately playful, but hidden, irrational character of the listener; it wakened and strengthened the lowest strata of memory."[61] In relating the magical bishop episode, Ball tells of how the cadence of his speech connects him with the past—both to a collective ritual thousands of years old, "the ancient cadence of priestly lamentation," and to his own childhood, the ten-year-old boy, "trembling and hanging avidly on the priest's words in the requiems and high masses in his home parish."

The very urgency of the dadaists' search for access to primal memories and earlier modes of consciousness speaks to a sense of break in historical continuity—a shared feeling that in this modern moment the past was no longer accessible, that its presence among the living was no longer sustained as it had been in traditional communities through ritual, oral history, and myth.[62] Though it has not been stressed in accounts of the Dada movement, a nostalgic impulse of mourning for older social forms was acutely present in Zurich. Ball himself seems to acknowledge this in his description of the activities of the Cabaret Voltaire as "both buffoonery and a requiem mass."[63] And certainly this longing for the past relates directly to the cataclysm of the present.

While a notion of the unconscious was central to the Cabaret participants, it was not, as is seen later in surrealism, necessarily a Freudian understanding of the concept. Rather Ball describes a specific kind of internal probing, what he calls a "primeval memory," which exists beyond the reach of intellect or socialization. "The childlike quality I mean," writes Ball, "borders on the infantile, on dementia, on paranoia.... The primeval strata, untouched and unreached by logic and by the social apparatus, emerge in the unconsciously infantile and in madness, when the barriers are down...."[64]

With his interest in insanity, Ball acknowledged the importance for his thinking of the writings of the Italian criminologist and physician Cesare Lombroso (1835–1909),[65] who played a key role in the modern shift away from understanding mental illness as a disease of the brain toward an understanding of it as a disorder of the psyche.[66] Lombroso championed atavism, the continued appearance of primitive features in segments of the population, as the central explanation for deviance from the norm—the underlying cause of criminality, insanity, and genius, an argument that suggests important analogies between these states of being. In his first major work, *Genio e follia* (Genius and Madness), 1864, in what might be the first scientific treatise to draw such a link, Lombroso examined the creative acts

of 107 patients. He saw in their artwork—in its stress on the obscene, absurd, and surreal—a parallel with "art of the primitive" and proof that pathology of the mind reflected a throwback to an earlier evolutionary state of human development. The connection between madness and genius, the creative potential of insanity, as well as the particular quality of "primitive" representation in Lombroso's text all resonate within Ball's thinking. And for Ball and the Zurich group, a cultivated madness became a goal.

Within the militarized context of World War I, insanity also had an immediate historical valence. Feigning madness was a common strategy for avoiding conscription, and several members of the Zurich group had themselves simulated various psychopathologies, preferring such a label to the front.[67] Having chosen to mimic mental illness for self-protective reasons, the group's allusions to madness within forms of artistic production carried distinct political connotations—reinscribing an alignment with the traumatized and those who declined to participate and offering an ongoing indictment of what passed for rationality. In an aggressive sonnet written by Ball and addressed to the reader, the schizophrenic (whose mutilations suggest he has served at the front) functions as destabilizing mirror: "A victim of dismemberment, completely possessed / I am—what do you call it—schizophrenic. / You want that I vanish from the scene, / In order that you forget your own appearance."[68]

Interest in a primeval stratum of the mind also bears a resemblance to certain Jungian notions, including the understanding of the libido as a primitive ur-drive, rather than repressed as in the Freudian understanding, and the incipient theory of a collective unconscious. In papers on schizophrenia, Jung posited a fundamentally historical theory of the mind, in which regression led back to an archaic level of consciousness, characterized by a form of symbolic thinking that reflected a communal rather than individual inheritance. Indeed, the links to Jung are surprisingly direct. Not only were Jung's studies of schizophrenia undertaken at the Burghölzli, an early center for the study of the disease, which was situated nearby in the forests outside of Zurich, but Sophie Taeuber's sister worked as his secretary.[69]

Attention to psychoanalytic developments takes its most explicit (and comic) turn at a slightly later date with the opening at the Swiss Marionette Theater in September 1918 of a puppet adaptation of *Il re cervo* (*König Hirsch* / *The King Stag*), a whimsical play in three acts by the eighteenth-century Venetian satirist Carlo Gozzi[70] (a return to enlightenment satire if one keeps the precedent of Voltaire in mind). Sophie Taeuber designed sets of abstract gridded patterns that resembled her current work with Arp, and marionettes [49] with symmetrical bodies of turned wood and abstract painted faces that showed the influence of painted Oceanic masks. The fairy tale itself was transformed

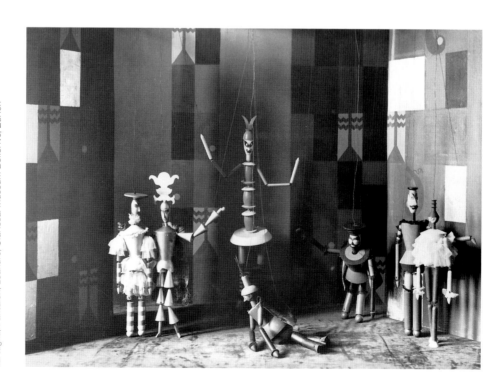

1.8 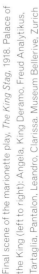 Final scene of the marionette play, *The King Stag*, 1918. Palace of the King (left to right): Angela, King Deramo, Freud Analytikus, Tartaglia, Pantalon, Leandro, Clarissa. Museum Bellerive, Zurich

into a modern allegory of disciplinary battles with a trio of characters renamed Freud Analytikus, Dr. Komplex (a Jungian figure), and the fairy Urlibido vying over the souls of the king and his beloved and the action relocated to the forest outside of the Burghölzli.[71] At the climax, Tartaglia, the king's evil minister, cries: "Kill me, kill me. I have not analyzed myself and can't stand it anymore!" The final speech ended with a pun that played on the names of the three leading figures of contemporary psychology (Freud, Jung, and the now largely forgotten Alfred Adler): "To speedily become a younger (*junger*), happier (*freudiger*) eagle (Adler), that is the goal of life" **[fig. 1.8]**. Tzara declared the performance a sensation,[72] and the marionettes were subsequently reproduced in the Dada journal *Der Zeltweg* (named after the street where Arp lived) and shown at several exhibitions.[73]

In Ball's writing, and within the Zurich group, ideas about a primeval stratum of the mind, ancient ritual, psychic regression, and infantile states were often conflated, their differences collapsed into a general notion of primitive, or ur-consciousness. These ideas in turn were often tied, in the productive but misguided ways of modernism, to an interest in non-Western tribal culture. Signs of this curiosity proliferated in the group's activities, including African allusions in Ball's sound poems[74] and the "witch doctor's hat" he wore in his first performance of "Elefantenkarawane," Huelsenbeck's drums and *chants nègres*, a poster Janco made on the occasion of the 31 March 1916 performance of "le chant nègre" with nude figures that resembled African carved sculpture **[14]**, the masked and costumed dances performed at the Cabaret Voltaire and Galerie Dada and elsewhere **[fig. 1.9]**, later tribal pieces collected by group members and exhibited alongside avant-garde work, and the patterns on Sophie Taeuber's Dada heads evoking oceanic or northwest Indian decoration **[43–47]**.

The idea of a special affinity between modern society and primitive or tribal cultures had significant currency at the time, due in large part to Wihelm Worringer's influential treatise *Abstraktion und Einfühlung* (Abstraction and Empathy).[75] Written as his dissertation in 1906 and published in a trade edition two years later, the text was the subject of intense discussion within Kandinsky's Blaue Reiter group. (Kandinsky briefly posits a link between the modern and the primitive in the introduction of his manifesto, "Über das Geistige in der Kunst" (Concerning the Spiritual in Art), writing of "our sympathy, our spiritual relationship, with the Primitives."[76] Debunking the idea that the abstraction

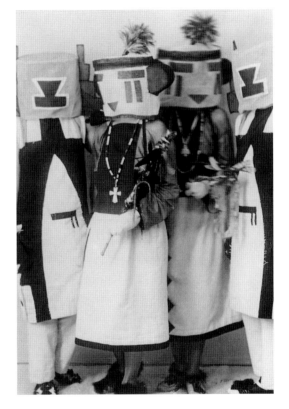

1.9 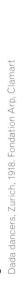 Dada dancers, Zurich, 1918. Fondation Arp, Clamart

seen in ancient and tribal art was a failure of skill or technical means, or reflected an inability to produce more naturalistic work, Worringer argued instead that it reflected a different psychic attitude — "a greater unrest inspired by man in relation to the phenomena of the outside world."[77] For Worringer this feeling of alienation, expressed in the will to abstraction, had great relevance to modern culture: "…man is now just as lost and helpless vis-à-vis the world picture as primitive man."[78] For the dadaists, Worringer's thoughts must have seemed particularly apt for the moment.

The perceived affinity between the modern and primitive took on a performative manifestation in masked dances staged at the Cabaret Voltaire; the first was held on 24 May 1916.[79] Janco, and later others, made masks out of the ephemeral materials of modernity, of newspaper and cardboard [9–11, fig. 1.10]. Drawing on both Picasso's cubist constructions and a variety of ancient and tribal masking traditions, they managed to signify to their audience as both primitive and modern.[80] Ball was enthusiastic, describing another moment of being transported to the primal core on the edge of insanity:

> They were designed to be effective from a distance; in the relatively small space of the cabaret they have a sensational effect. We were all there when Janco arrived with his masks, and everyone immediately put one on. Then something strange happened. Not only did the mask immediately call for a costume; it also demanded a quite definite, passionate gesture, bordering on madness. Although we could not have imagined it five minutes earlier, we were walking around with the most bizarre movements, festooned and draped with impossible objects, each one of us trying to outdo the other

in inventiveness. The motive power of these masks was irresistibly conveyed to us.…What fascinates us all about the masks is that they represent not human characters and passions, but…passions that are larger than life. The horror of our time, the paralyzing background of events, is made visible.[81]

For Ball, the effacement of modern individuality in donning the masks allowed expression of greater historical consciousness —the truth about the times generally repressed. A prolific and charged symbol in contemporary critical writing, the mask was most often discussed as a façade of propriety or convention that one was forced to adopt in modern society.[82] Ball offers a significant transformation of these terms: a physical mask with primitive antecedents could supercede that modern psychic mask of social convention, and allow access to that place, bordering on madness, in which "barriers are down."

DADA, THE MOVEMENT

The Cabaret Voltaire closed in early July 1916. Huelsenbeck reported that Ephraim "told us we must either offer better entertainment and draw a larger crowd or shut down the cabaret."[83] But it is also clear that Ball was becoming exhausted by his efforts and no longer wished to continue.[84]

In the few months of the Cabaret's existence, there was increasing discussion, with Tzara at the helm, of expanding the group's reach beyond Zurich. "There are plans for a Voltaire Society, and an international exhibition," Ball wrote in early April. "The proceeds of the soirées will go toward an anthology to be published soon."[85] Ball and Huelsenbeck resisted the idea of "organization," but it seems that Tzara soon prevailed, and the publication was soon in the works with Ball actively involved in its preparation.

Adorned with a luxurious red cover with an abstract woodcut by Arp, the only issue of *Cabaret Voltaire*, published on 31 May 1916 [7], was already distant from the seedy, nocturnal experience of the cabaret,[86] and, despite the group's iconoclasm, its purpose was a self-historicizing one: "[Cabaret Voltaire] was," Tzara insisted, "not a journal but a documentary publication on the cabaret we founded here."[87] The publication offered its readers a miscellany of the group's activities, "which at that time seemed to us to constitute 'Dada' "[88]: an introduction by Ball, a catalogue of one of the Cabaret Voltaire exhibitions, a chapter of Ball's "fantastic novel," the simultaneous poem and other contributions by the same range of modernists whose work had appeared at the Cabaret (Guillaume Apollinaire, Picasso, Kandinsky, Filippo Marinetti, Blaise Cendrars) and by the

1.10 Dada masks, Zurich, 1916–1918. Mark Kelman, New York

Probably Tristan Tzara, poster for the *Mouvement Dada: 8. Dada-Soirée* (Dada Movement: Eighth Dada Soirée), Kaufleuten Hall, April 1919, lithograph with collage additions. The New York Public Library, Elaine Lustig Cohen Dada Collection, Astor, Lenox, and Tilden Foundation

1.11

dadaists themselves. As Tzara intended, the printed anthology also granted a new portability to the contents and the ideas they represented, allowing them to reach a broader audience.

Yet the media potential for a new audience that so captivated Tzara seems to have rankled Ball and may well account for his opposition to the idea of a Dada movement. Writing in a later diary entry about the group's effort to organize an international Dada event, Ball wrote: "In the end we cannot simply keep on producing without knowing whom we are addressing. The artist's audience is not limited to his nation anymore.... Can we write, compose, and make music for an imaginary audience?"[89] Ball laments the loss of the intimacy—the shift from a direct relationship between a performer and an audience physically present before him, and its replacement by one that would have an international scale, but would be inherently more mediated and abstract. Perhaps for Ball there was some sense, as well, that making Dada public, presenting it as a movement, would transform him into a propagandist—bringing him uncomfortably close to the wartime media abuses he deplored.

Ironically, it was most likely Ball who provided that crucial emblem of movement identity: the word Dada itself.[90] Against the background of heated discussion about plans for a Voltaire Society, Ball noted in his entry for 18 April 1916 "Tzara keeps on worrying about the periodical. My proposal to call it Dada is accepted."[91] The word first appeared in print in Tzara's *La première Aventure céléste de Mr Antipyrine* (The First Celestial Adventure of Mr. Antipyrine) **[6 and p. 426]** and in the *Cabaret Voltaire* in an advertisement for the forthcoming journal. Huelsenbeck later recounted that it was chosen from a German-French dictionary while he was visiting Ball[92]

and that the two delighted in the primal quality of its infantile sound and its appropriateness as an emblem for "beginning at zero."[93] Though it resonated with the fragmentary and abstract phonemes of the sound poetry performed at the cabaret, the group clearly embraced its multiple meanings and evocative connotations across languages. Stressing both this semantic mobility and richness, Ball added to his first mention of the word: "Dada is 'yes, yes' in Rumanian, 'rocking horse' and 'hobbyhorse' in French. For Germans it is a sign of foolish naiveté, joy in procreation, and preoccupation with the baby carriage."[94] Suggesting basic drives and childlike behavior, the word was at the same time self-consciously absurd, even self-mocking, and a subversive anthem of resistance to more fully instrumentalized speech and disciplined rationality. Resistance to fixed meaning remained a key feature; and later dadaist productions generated countless new definitions.

Though it may not have been Ball's intention, the word Dada offered tremendous media potential. Tzara seems to have recognized its publicity value early on; Huelsenbeck recalled that Tzara "had been one of the first to grasp the suggestive power of the word Dada,"[95] and he developed it as a kind of brand identity—a newly visible phenomenon in both the sphere of culture and consumer economics.[96] (Indeed, Ball hinted that the word Dada already resonated as a brand name, offering in a manifesto the slogan: "Dada is the world's best lily milk soap."[97]) In Zurich Tzara placed "Mouvement Dada" as a banner headline across a series of posters announcing evening events **[15, fig. 1.11]**, transformed the Galerie Corray into the Galerie Dada, and published three poetry books under the series title "Collection Dada"[98]—as well as launching the

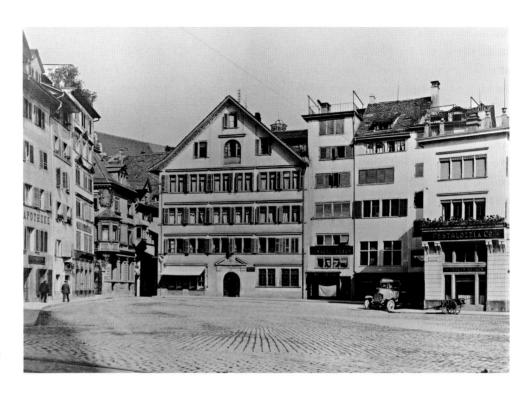

PROGRAMM

I Dada-Abend
Freitag 14 Juli 16
Zunfthaus Waag
Zürich

I.

Hans Heusser: „Prelude". „Wakauabiuthe", exotische Tanzrytmen. „Eine Wüstenskizze". (eigene Kompositionen)

Emmy Hennings: „Zwei Frauen" (Prosa) Verse („Makrele", „Aether", „Gefängnis", „Jütland".)

Hans Arp: Erläuterungen zu eigenen Bildern (Papierbilder I — V)

Hugo Ball: „Gadji Beri Bimba" (Verse ohne Worte, in eigenem Kostüm).

Tristan Tzara: „La fièvre puerpérale" (Poème simultan, interpreté par Ball, Huelsenbeck, Janco, Tzara.)

Chant nègre I (nach eigenen Motiven aufgeführt von Ball, Huelsenbeck, Janco, Tzara.)

Chant nègre II (nach Motiven aus dem Sudan, gesungen von Huelsenbeck und Janko.)

II.

Marcel Janco: Erläuterungen zu eigenen Bildern

Hans Heusser: „Bacchanale aus der Oper Chrysis". „Japanisches Theehaus". „Burlesque". (eigene Kompositionen)

Rich. Huelsenbeck und Tristan Tzara: Poème mouvementiste (Masques par M. Janco) Concert voyelle. Poème de voyelle. Poème bruitiste.

Drei Dada-Tänze (getanzt von Emmy Hennings. Masques par Marcel Janco. Musik von Hugo Ball.)

Richard Huelsenbeck: „Mpala Tano" (Verse)

Cubistischer Tanz (Kostüme und Arrangement von Hugo Ball, Musik aus „Leben des Menschen" von Andrejew. Aufgeführt von Ball, Hennings, Huelsenbeck, Tzara.)

journal for which the name had originally been chosen. And he gave Dada (and Arp's abode) the façade of a corporate structure, using envelopes printed with the return address: Administration / Mouvement Dada / Zurich / Zeltweg 83.[99]

As part of this effort to forge a broader identity, the group staged the "first *public* Dada evening,"[100] as Ball wrote, underscoring the word *public*, on 14 July 1916 at Zurich's Waag Hall, an old guildhouse on one of the city's main squares [**fig. 1.12**]. Hennings read poems, Arp offered a discussion of his paper collages; Ball, Huelsenbeck, Janco, and Tzara performed their simultaneous poem; and members of the group in various combinations recited *chants nègres* and performed costumed and masked dances [**fig. 1.13**]. The event also marked a movement away from the margins of culture, seen in the shift within the topography of the city from the seedy Niederdorf, where no respectable citizen would go, to a central area where the bourgeoisie was part of the potential audience. [101] Yet if it was a step toward a more mainstream identity, it also made the dadaist assault on bourgeois pieties all the more direct.

Along with the other offerings of the evening, the core members read manifestos, appropriating a traditional form of public and political communication aimed at establishing principles.[102] But Ball's text turned on the group itself, mocking its ambitions and suggesting a kind of "dada hubris."[103] "Just a word," declaimed Ball, "and the word a movement."

> Very easy to understand.... To make of it an artistic tendency must mean that one is anticipating complications. Dada psychology, dada Germany cum indigestion and fog paroxysm, dada literature, dada bourgeoisie, and yourselves, honored poets, who are always writing with words but never writing the word itself, who are always writing around the actual point. Dada world war without end, dada revolution without beginning, dada, you friends and also-poets, esteemed sirs, manufacturers, and evangelists. Dada Tzara, dada Huelsenbeck, dada m'dada, dada m'dada dada mhm, dada dera dada, dada Hue, dada Tza.[104]

A first public event, a first manifesto, but also an ending, for despite its obscurity, the manifesto was intended and received, Ball wrote, as a "thinly disguised break with friends."[105] Ball soon distanced himself from the group, leaving Zurich for the Ticino in the first of several leave-takings and bringing to a close the period of his greatest intellectual influence.[106]

With Ball's absence and the closing of the cabaret, Tzara emerged as a new leader, converting Ball's persona as cabaret master of ceremonies into a role as a savvy media spokesman with grand ambitions. Tzara was "the romantic internationalist," wrote Huelsenbeck in his 1920 history of Dada, "whose propagandistic zeal we have to thank for the enormous growth of Dada."[107] As a result, it was largely through the filter of Tzara's efforts and writing that ideas about Dada were communicated to an audience outside of Zurich. While Ball had not articulated a specific theory or program for Dada, Tzara's writings marked a certain shift, distilling concepts that had emerged at the Cabaret into discernible principles capable of being communicated. Departing from the more mystical aspects of Ball's thought with its religious and alchemical imagery, Tzara, as discussed in the introduction to this volume, offered a declaration of resistance to various forms of social government. In his widely distributed "Manifeste Dada 1918," he wrote, "To impose your ABC is a natural thing, hence deplorable."[108]

THE GALERIE DADA

In January 1917, in Ball's absence, the group organized the *Première Exposition Dada* (First Dada Exhibition) at the Galerie Corray [12]. Works by Arp, Janco, Hans Richter, and Adya and Otto van Rees were shown along with tribal pieces, and Tzara offered three lectures on modern art. Returning to Zurich for a few months,[109] Ball surely visited the show for he soon joined the other members of the group in founding the Galerie Dada. Hans Corray relinquished the rooms above the Sprüngli confectionery and chocolate emporium, which he used as his gallery space, and the first of three exhibitions, mixing avant-garde work by the members of the expressionist Sturm group and by the dadaists themselves with primitive and children's art, was opened in March.[110] The new location represented a significant step away from the sordid Niederdorf district,[111] and there were other signs as well of Dada's newly genteel aspect: programs were printed in advance, guest lists made, invitations distributed, and relatively high entry fees charged. A series of ambitious experimental soirées were planned, but on the weekends only, offering a respite from the relentless nightly performances of the Cabaret Voltaire; midweek, visitors were offered tours and, starting in May, afternoon tea. An evening café on the premises was called the Kandinsky Room. Reflecting on this period of Zurich activities from the stridently politicized atmosphere of Berlin of 1920, Huelsenbeck wrote: "As I think back on it now, an art for art's sake mood lay over the Galérie Dada—it was a manicure salon of the fine arts, characterized by tea-drinking old ladies trying to revive their vanishing sexual powers with the help of 'something mad.'"[112] At the time, however, Ball described the Galerie as a "continuation of

1 OTTO VAN REES Maquette for a poster for an exhibition of the work of Otto van Rees, Adya van Rees-Dutilh, Hans Arp, 1915, collage on board, 72.6 × 52.5 (28 9/16 × 20 11/16). Centraal Museum, Utrecht, The Netherlands

2 HANS ARP Untitled *(Diagonal Composition—Crucifixion),* 1915, wool tapestry on a stretcher, 122 × 122 (48 1/16 × 48 1/16). Private collection

3 OTTO VAN REES Untitled *(Still Life),* 1915, oil and sand on canvas, 38 × 46 (14 15/16 × 18 1/8). Centre Pompidou, Musée national d'art moderne-Centre de création industrielle, Paris. Purchase, 1957

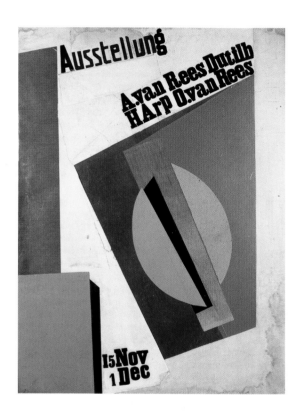

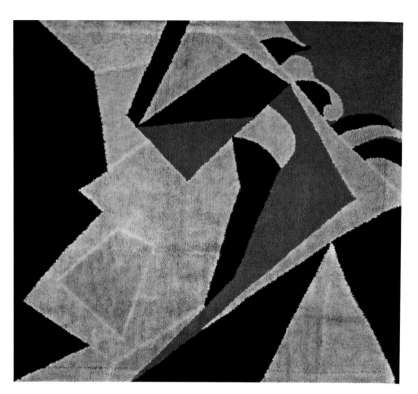

4 HANS ARP Untitled *(Abstract Composition)*, 1915, collage of papers, fabric, and board on paper, 24 × 20 (9 $\frac{7}{16}$ × 7 $\frac{7}{8}$). Kunstmuseum Basel, Kupferstichkabinett, Gift of Marguerite Arp-Hagenbach

5 HANS ARP Untitled *(Construction with Planes and Curves)*, 1915, collage of papers and board on board, 21 × 14 (8 $\frac{1}{4}$ × 5 $\frac{1}{2}$). Kunstmuseum Basel, Kupferstichkabinett, Gift of Marguerite Arp-Hagenbach

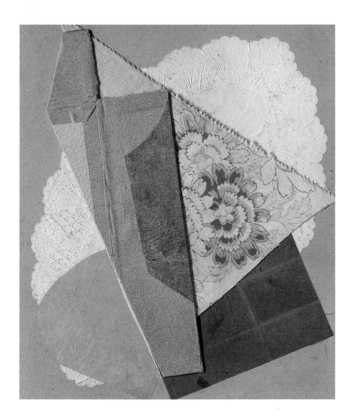

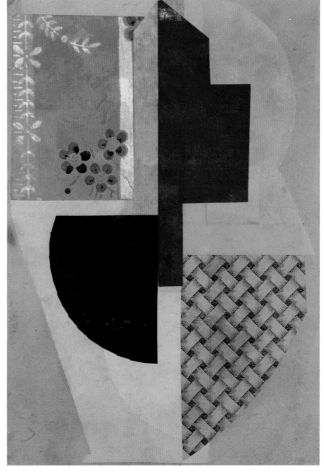

6 MARCEL JANCO Cover and interior pages of the illustrated book
La première Aventure céléste de Mr Antipyrine (The First Celestial Adventure
of Mr. Antipyrine) by Tristan Tzara, Collection Dada, 1916, linoleum cut,
22.5 × 14.8 (8 ⅞ × 5 ⅞). The Museum of Modern Art, New York. Purchase

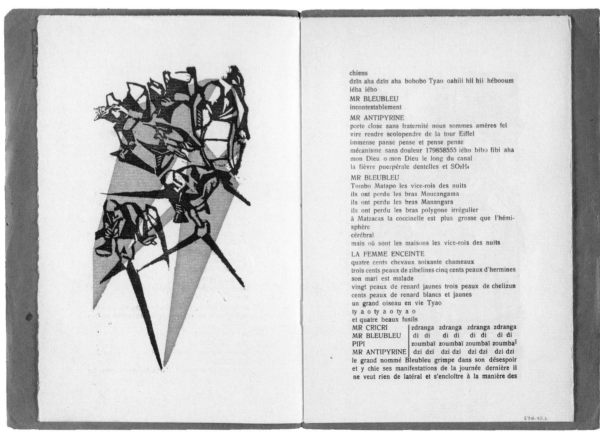

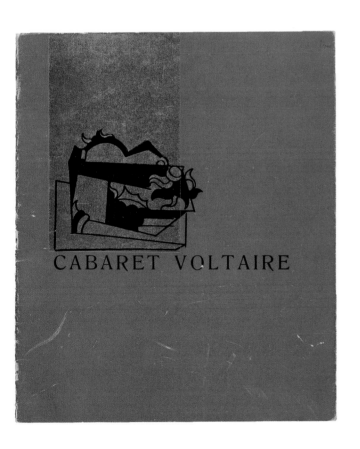

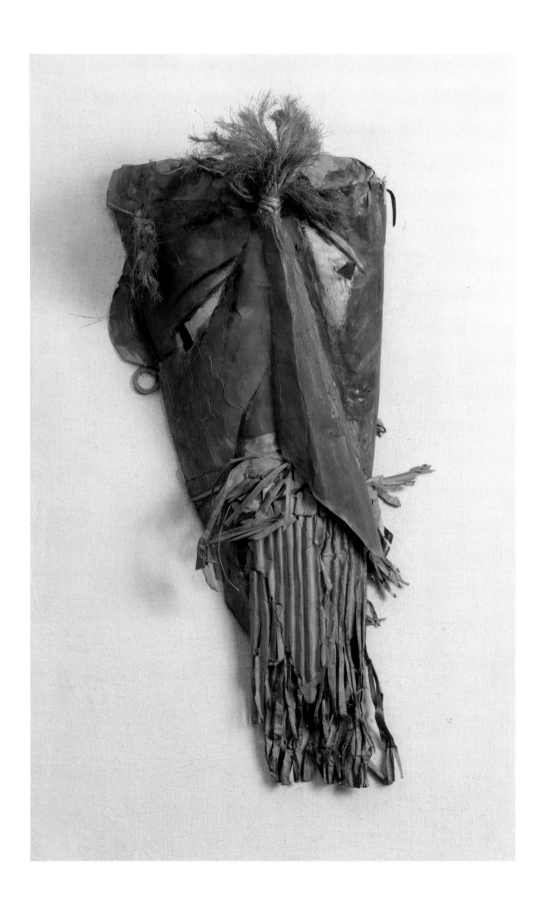

10 MARCEL JANCO Untitled (*Mask*), 1919, papers, board, twine, gouache, and pastel, 45 × 22 × 5 (17 ¹¹⁄₁₆ × 8 ¹¹⁄₁₆ × 1 ¹⁵⁄₁₆). Centre Pompidou, Musée national d'art moderne-Centre de création industrielle, Paris. Gift of the artist, 1967

11 MARCEL JANCO Untitled (*Mask, Portrait of Tzara*), 1919, paper, board, burlap, ink, and gouache, 55 × 25 × 7 (21 ⅝ × 9 ¹³⁄₁₆ × 2 ¾). Centre Pompidou, Musée national d'art moderne-Centre de création industrielle, Paris. Gift of the artist, 1967

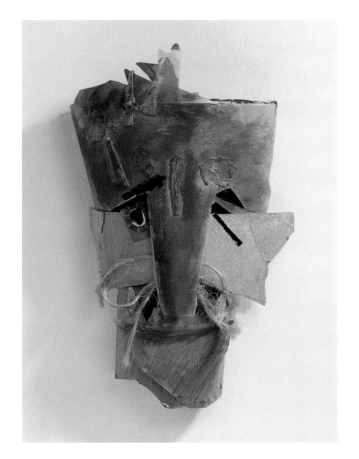

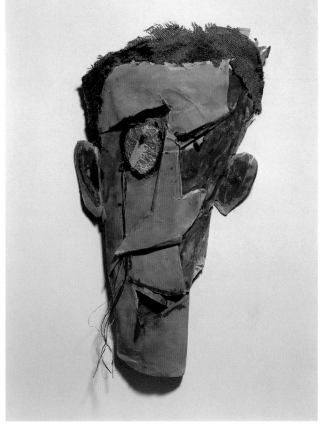

12 MARCEL JANCO Poster for *1re Exposition Dada* (First Dada Exhibition), 1917, linoleum cut, 42.5 × 26.4 (16 ¾ × 10 ⅜). Collection Merrill C. Berman

13 MARCEL JANCO Illustration on the cover of the journal *Dada*, no. 3, Tristan Tzara editor, Mouvement Dada, 1918, wood engraving, 33.7 × 24.6 (13 ¼ × 9 ¹¹⁄₁₆). National Gallery of Art, Library, Gift of Thomas G. Klarner

14 MARCEL JANCO Title page of the program for the *Sturm-Ausstellung, II. Serie* (Sturm-Exhibition, II. Series) and for the *Sturm-Soirée*, 1917, with Janco's illustration for a poster for "le Chant Nègre" (Negro Song), 1916, 23 × 14.5 (9 ¹⁄₁₆ × 5 ¹¹⁄₁₆). Collection Timothy Baum, New York

15 MARCEL JANCO Poster for *Mouvement Dada: Tristan Tzara lira de ses oeuvres…* (Dada Movement: Tristan Tzara Will Read from His Works…), 1918, linoleum cut with watercolor stencil, 46.1 × 31.4 (18 ⅛ × 12 ⅜). Elaine Lustig Cohen Dada Collection, The New York Public Library, Astor, Lenox and Tilden Foundations

16 MARCEL JANCO *Jazz 333*, 1918, oil on board, 70 × 50 (27 ⁹⁄₁₆ × 19 ¹¹⁄₁₆). Centre Pompidou, Musée national d'art moderne-Centre de création industrielle, Paris. State Purchase 1963, National Funds for Contemporary Art 1964

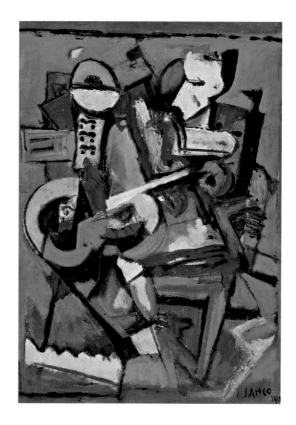

17 HANS ARP and **SOPHIE TAEUBER** Untitled *(Pathetic Symmetry)*, 1916–1917, cotton needlepoint, 76 × 65 (29 15⁄16 × 25 9⁄16). Centre Pompidou, Musée national d'art moderne-Centre de création industrielle, Paris. Gift of Marguerite Arp-Hagenbach, 1967

18 HANS ARP Untitled *(Terrestrial Forms – Forest),*1916/1917, wool needlepoint, 30.5 × 32.4 (12 × 12 ¾). Mark Kelman, New York

19 SOPHIE TAEUBER Untitled *(Composition with Squares, Circle, Rectangles, Triangles),* 1918, wool needlepoint, 61 × 62.5 (24 × 24 ⅝). Stiftung Hans Arp und Sophie Taeuber-Arp e.V., Rolandseck

20 SOPHIE TAEUBER Untitled *(Vertical-Horizontal Composition),* 1916, wool needlepoint, 50 × 38.5 (19 ¹¹⁄₁₆ × 15 ³⁄₁₆). Fondazione Marguerite Arp, Locarno

22 HANS ARP Untitled *(Rectangles According to the Laws of Chance),* 1916, collage on board, 25 × 12.5 (9 ¹³⁄₁₆ × 5). Kunstmuseum Basel, Kupferstichkabinett, Gift of Marguerite Arp-Hagenbach

23 HANS ARP Untitled *(Squares Arranged According to the Laws of Chance),* 1917, collage, ink, gouache, and bronze paint on colored paper, 33.2 × 25.9 (13 ⅛ × 10 ¼). The Museum of Modern Art, New York. Gift of Philip Johnson

26 **SOPHIE TAEUBER** Untitled *(Triptych)*, 1918, oil on canvas on board,
left panel: 112 × 53 (44 ⅛ × 20 ⅞); center panel: 112 × 52.2 (44 ⅛ × 20 ⁹⁄₁₆);
right panel: 112 × 52 (44 ⅛ × 20 ½). Kunsthaus Zürich, Gift of Hans Arp

27 SOPHIE TAEUBER and **HANS ARP** Untitled *(Chalice)*, 1916, turned, painted wood, height 28.8 (11 ⁵⁄₁₆), diameter 13.6 (5 ⅓). Private collection

28 SOPHIE TAEUBER and **HANS ARP** Untitled *(Amphora)*, 1917, turned, painted wood, height 30 (11 ¹³⁄₁₆), diameter 15.2 (5 ¹⁵⁄₁₆). Sammlung des Landes Rheinland-Pfalz für das Arp-Museum Rolandseck

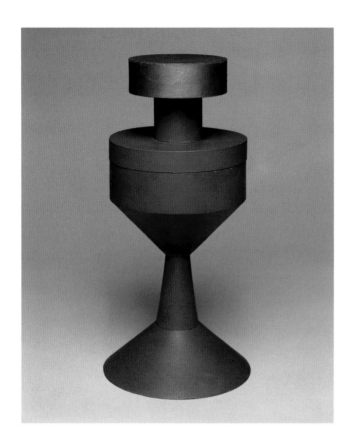

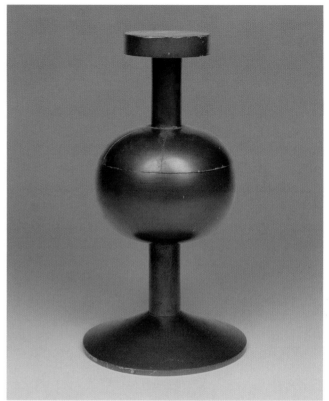

29 SOPHIE TAEUBER Untitled *(Poudrier)*, 1916 or later, turned, painted wood, height 30 (11 ¹³⁄₁₆), diameter 16.8 (6⅝). Aargauer Kunsthaus Aarau, Depositum aus Privatbesitz

30 SOPHIE TAEUBER Untitled *(Dada Bowl)*, 1916, turned, black lacquered wood, height 20.4 (8 ¹⁄₁₆). Musée d'Art Moderne et Contemporain de Strasbourg

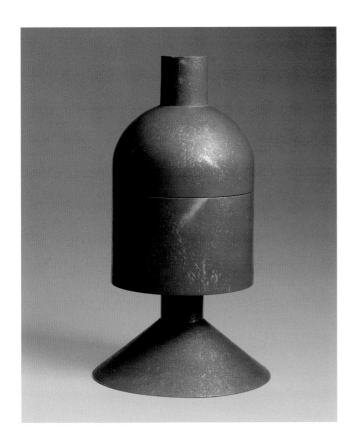

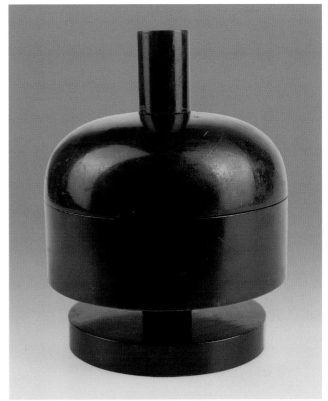

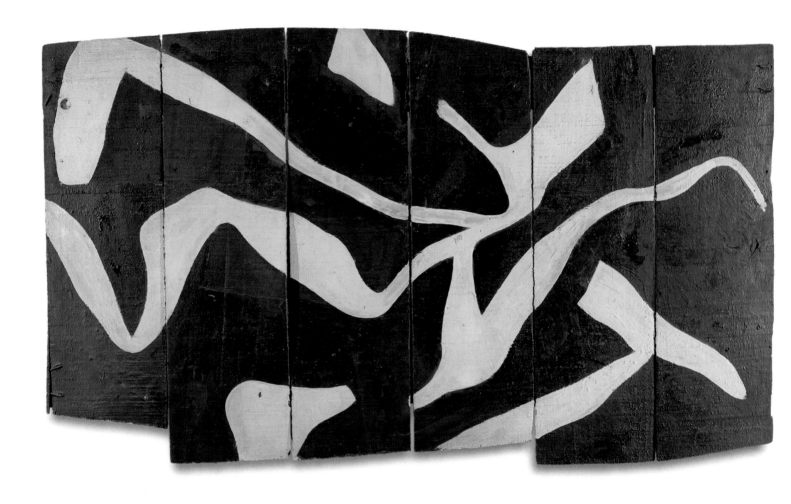

32 HANS ARP Untitled *(Large Drawing),* 1917, pencil and ink on paper,
44 × 58 (17 ⁵⁄₁₆ × 22 ¹³⁄₁₆). Centre Pompidou, Musée national d'art moderne-
Centre de création industrielle, Paris. Gift of Maître Guy Loudmer, 1989

33 HANS ARP Untitled *(Automatic Drawing),* 1917–1918 (inscribed 1916),
ink and pencil on paper, 42.6 × 54 (16 ¾ × 21 ¼). The Museum of Modern
Art, New York. Given anonymously

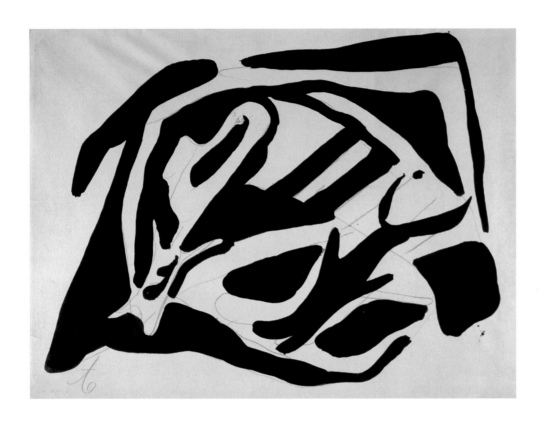

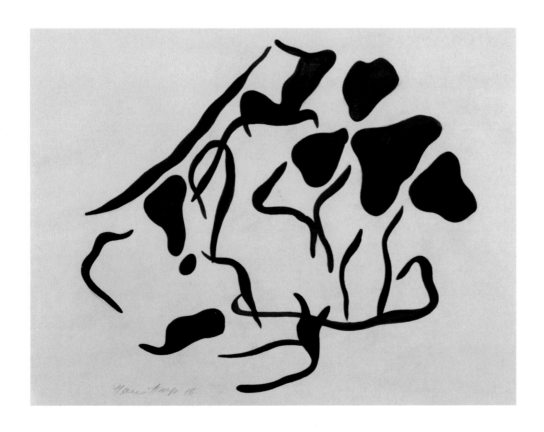

34 HANS ARP Untitled (*Enak's Tears*), 1917, painted wood relief, 86.2 × 58.5 × 6 (33 ¹⁵⁄₁₆ × 23 × 2 ⅜). The Museum of Modern Art, New York. Benjamin Scharps and David Scharps Fund and Purchase

35 HANS ARP Untitled (*Dada Relief*), c. 1917, painted wood relief, 24 × 18.5 (9 ⁷⁄₁₆ × 7 ⁵⁄₁₆). Kunstmuseum Basel, Gift of Marguerite Arp-Hagenbach, 1968

36 HANS ARP Untitled (*Burial of the Birds and Butterflies*), c. 1917, painted wood relief, 40 × 32.5 × 9.5 (15 ¾ × 12 ¹³⁄₁₆ × 3 ¾). Kunsthaus Zürich, Gift of G. & J. Bloch-Stiftung

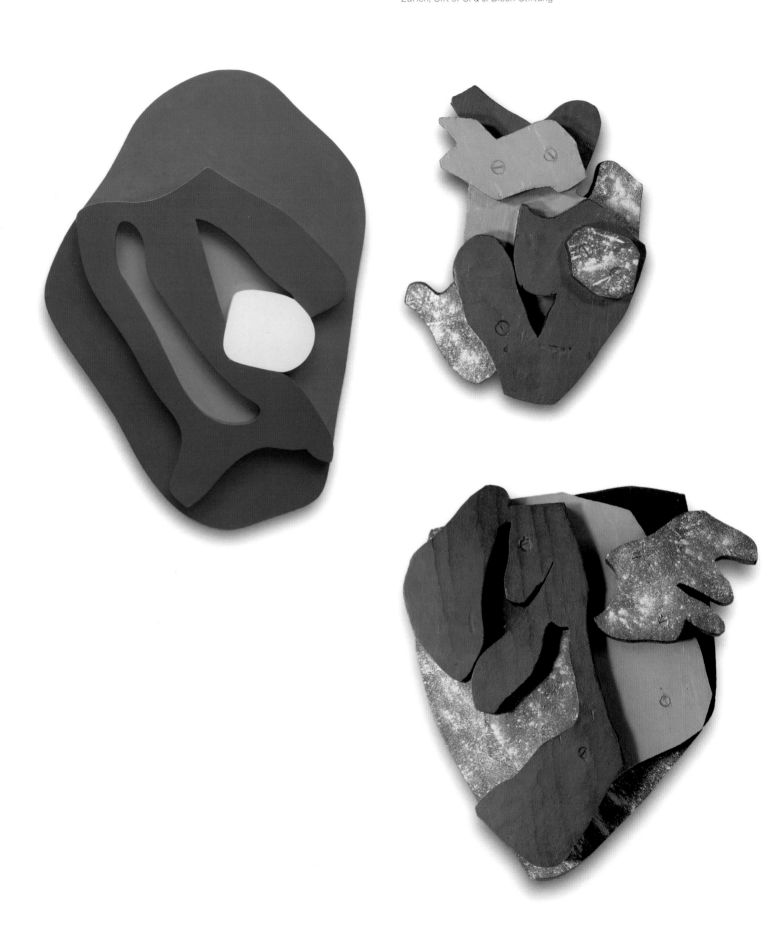

37 HANS ARP Untitled *(Forest),* c. 1917, painted wood relief, 32.7 × 19.7 × 7.6 (12 ⅞ × 7 ¾ × 3). National Gallery of Art, Washington, Andrew W. Mellon Fund

38 HANS ARP Untitled *(Forest),* 1917, painted wood relief, 41.3 × 53 × 8.3 (16 ¼ × 20 ⅞ × 3 ¼). The Cleveland Museum of Art, Contemporary Collection of The Cleveland Museum of Art, 1970.52

39 HANS ARP Untitled *(Plant Hammer),* c. 1917, painted wood relief, 62 × 50 × 8 (24 ⁷⁄₁₆ × 19 ¹¹⁄₁₆ × 3 ⅛). Lent by The Gemeentemuseum Den Haag, The Hague, The Netherlands

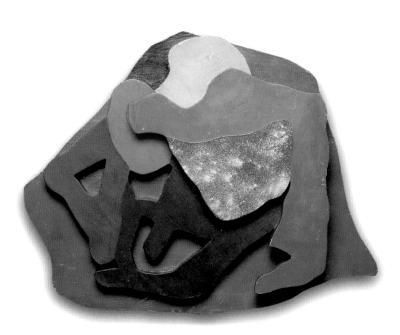

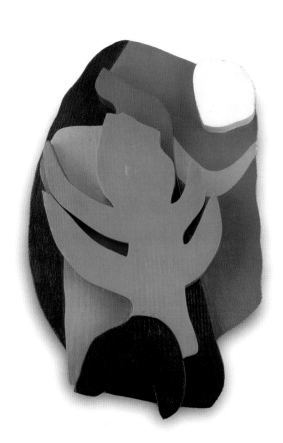

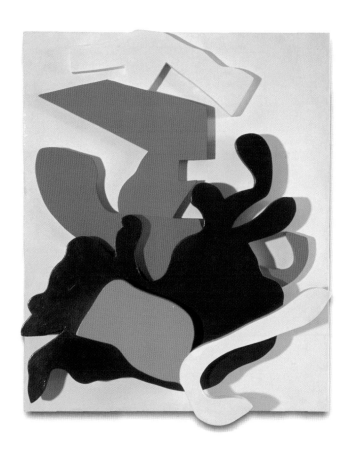

40 HANS RICHTER *Visionäres Selbstporträt* (Visionary Self-Portrait), 1917, oil on canvas, 53 × 38 (20 ¹³⁄₁₆ × 15). Centre Pompidou, Musée national d'art moderne-Centre de création industrielle, Paris. Gift of the artist, 1972

41 HANS RICHTER *Visionäres Porträt-Ekstase durch Verzweiflung gefährdet* (Visionary Portrait-Ecstasy Threatened by Doubt), 1917, oil on canvas, 54 × 39.5 (21 ¼ × 15 ⁹⁄₁₆). Galerie Berinson, Berlin/UBU Gallery, New York

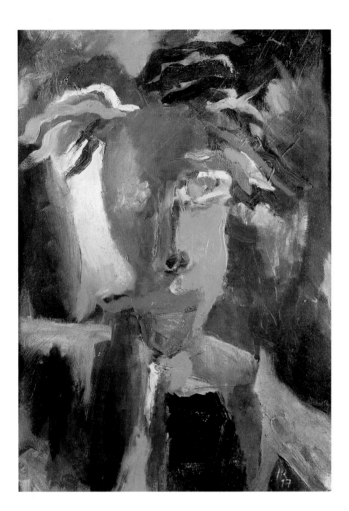

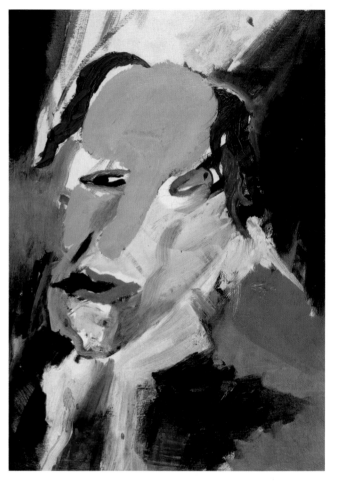

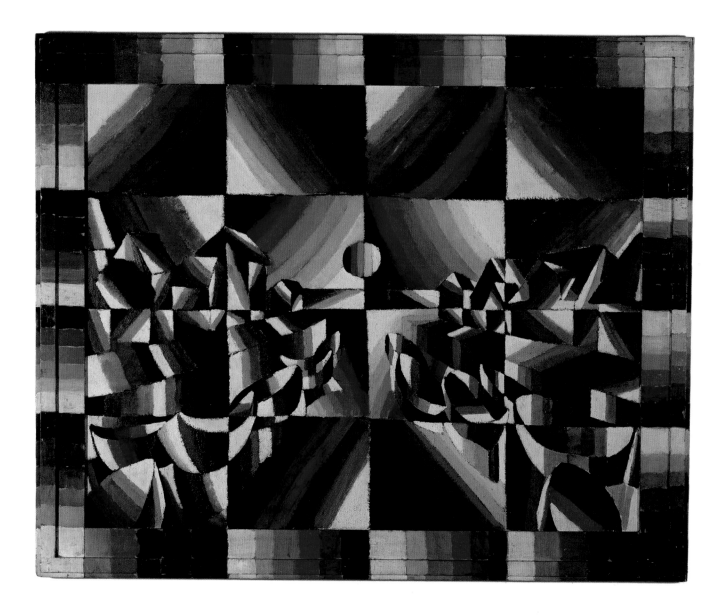

46 SOPHIE TAEUBER Self-Portrait with *Dada-Kopf* (Dada Head),
photograph by Nic Aluf, 1926, gelatin silver print, 11.4 × 8.9 (4 ½ × 3 ½).
San Francisco Museum of Modern Art, Fractional and Promised
Gift of Carla Emil and Rich Silverstein

47 SOPHIE TAEUBER Untitled *(Dada Head)*, 1920, oil on turned wood,
height 29.4 (11 ⁹⁄₁₆). Centre Pompidou, Musée national d'art moderne-Centre
de création industrielle, Paris. Purchase, 2003

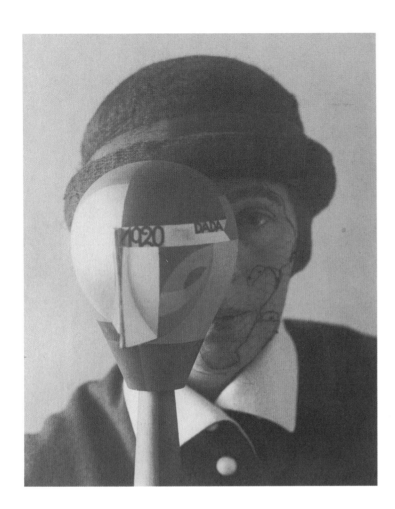

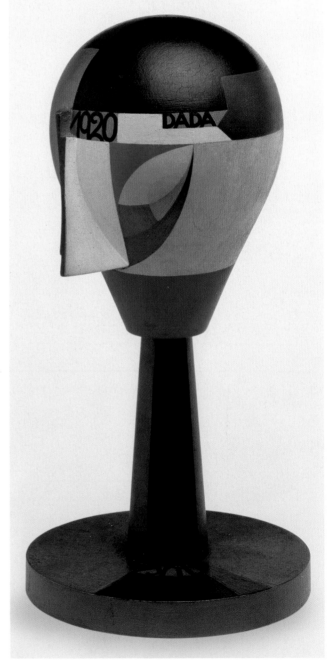

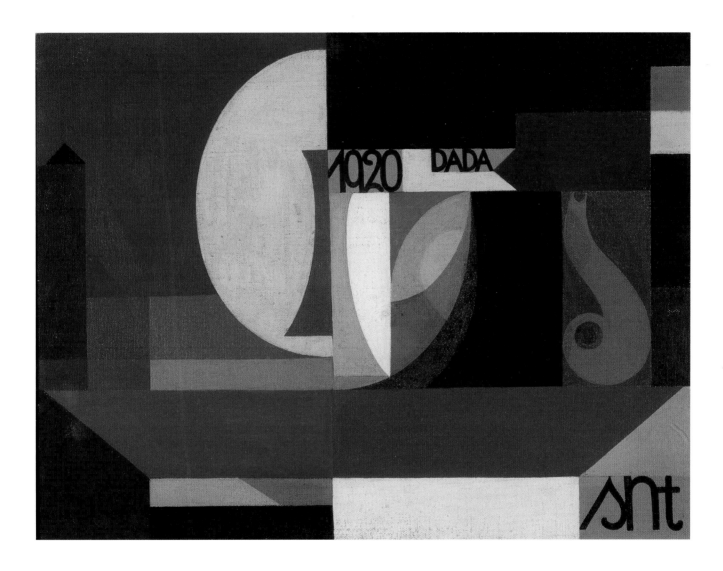

49 SOPHIE TAEUBER Marionettes, 1918, for the play *König Hirsch*
(The King Stag) by Carlo Gozzi, 1762. Adaptation by René Morax
and Werner Wolff for the Swiss Marionette Theater, 1918; Carl Fischer,
fabricator. Museum Bellerive, Kunstgewerbesammlung MfGZ, Zürich

König Deramo (King Deramo), turned, painted wood, bells, brass,
brocade, and metal joints, 57.5 × 13 (22 ⅝ × 5 ⅛)

Angela, turned, painted wood, tulle, and metal joints,
48.5 × 13 (19 1/16 × 5 ⅛)

Die Wachen (Military Guards), turned, painted wood and metal joints,
40.5 × 18.5 (15 15/16 × 7 ¼)

Freud Analytikus (Freudian Analyst), turned, painted wood, brass,
and metal joints, 60 × 17 (22 ⅝ × 6 11/16)

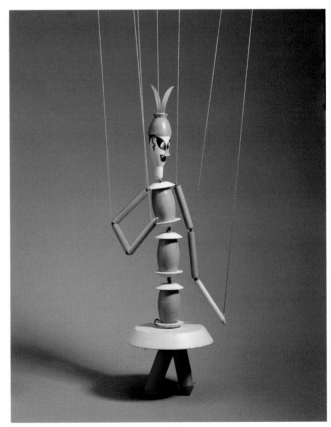

50 HANS ARP Untitled *(Bird Mask)*, 1918, wood relief, 19 × 23.5 × 3 (7 ½ × 9 ¼ × 1 ³⁄₁₆). Stiftung Hans Arp und Sophie Taeuber-Arp e.V., Rolandseck

51 HANS ARP Untitled *(Fish and Vegetal Configuration)*, c. 1917, painted wood relief, 37.5 × 46.5 × 9.2 (14 ¾ × 18 ⁵⁄₁₆ × 3 ⅝). Aaron I. Fleischman

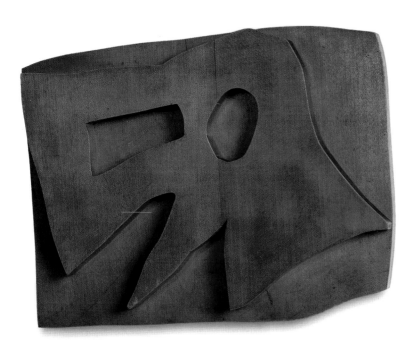

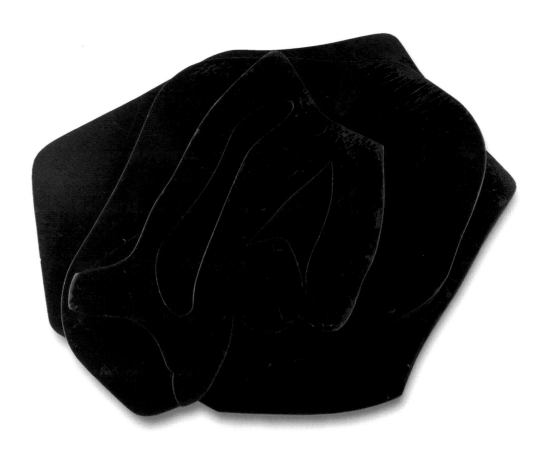

Tartaglia, turned, painted wood, embroidered fabric, brass, and metal joints, 49 × 17.5 (19 ⁵⁄₁₆ × 6 ⅞)

Hirsch (Stag), turned, painted wood, brass, and metal joints, 52 × 17 (20 ½ × 6 ¹¹⁄₁₆)

Dr. Komplex (Doctor Complex), turned, painted wood, brass, and metal joints, 38.5 × 18.5 (15 ⅛ × 7 ¼)

Truffaldino, turned, painted wood, feathers, and metal joints, 49 × 13 (19 ⁵⁄₁₆ × 5 ⅛)

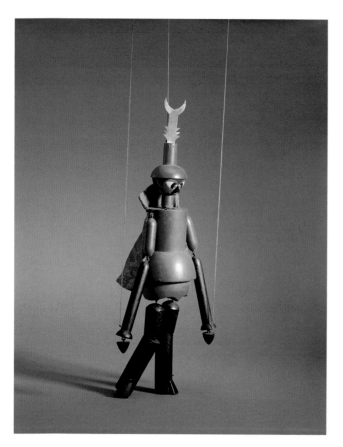

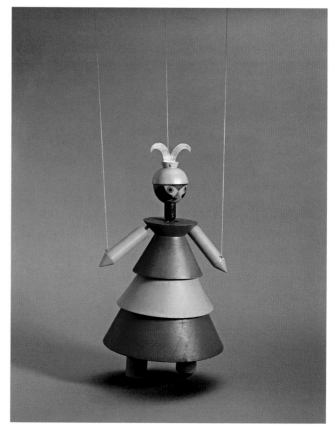

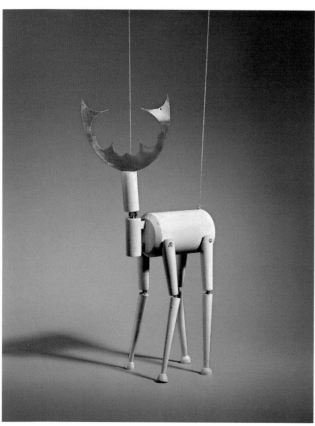

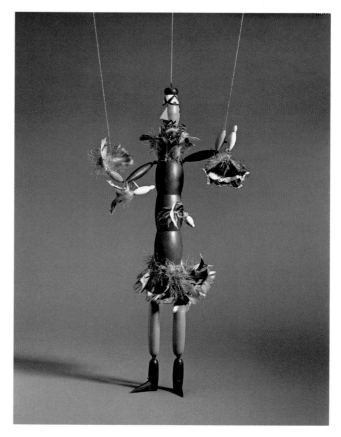

55 FRANCIS PICABIA *Réveil matin I* (Alarm Clock I), 1919, ink on paper (partly printed from inked alarm clock parts), 31.8 × 23 (12 ½ × 9 ⅟₁₆). Private collection, courtesy Blondeau et associés, Paris

56 FRANCIS PICABIA *Construction moléculaire* (Molecular Construction), illustration on the cover of the journal *391*, no. 8, Francis Picabia editor and publisher, February 1919, line block reproduction of ink drawing, 43.8 × 27.5 (17 ¼ × 10 ⅓₁₆). National Gallery of Art, Library, David K. E. Bruce Fund

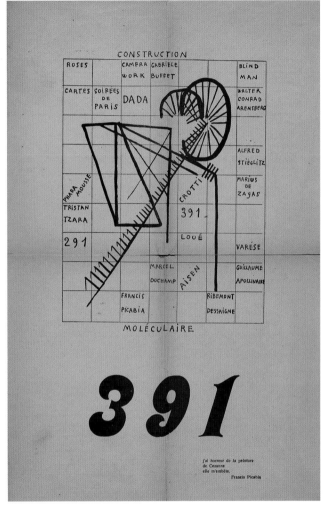

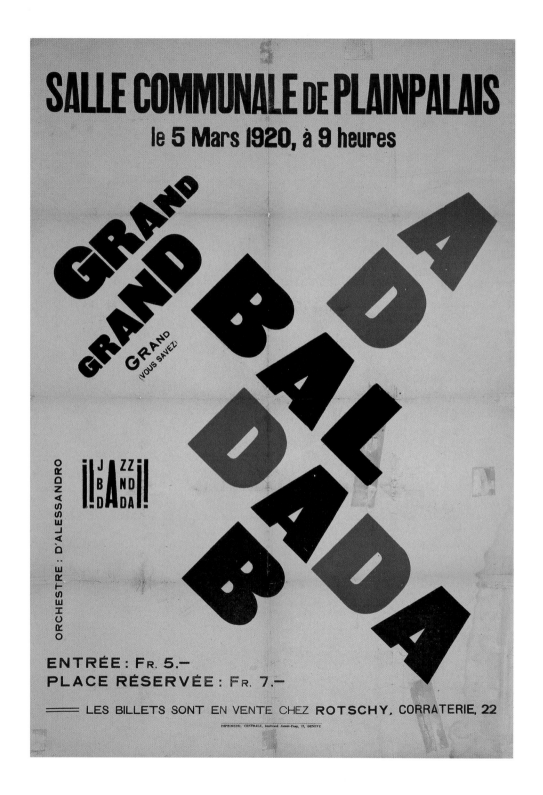

58 CHRISTIAN SCHAD *Trépanation indienne* (Indian Trepanning), 1920, assemblage of wood, decorative tacks, oil, and found objects, 47 × 38 × 6 (18 ½ × 14 ¹⁵⁄₁₆ × 2 ⅜). The Israel Museum, Jerusalem, The Vera and Arturo Schwarz Collection of Dada and Surrealist Art at The Israel Museum

59 CHRISTIAN SCHAD *Composition en M* (Composition in M), 1920, assemblage of wood, metal chain, upholstery brads, decorative tacks, and oil, 70 × 47.5 × 8 (27 ⁹⁄₁₆ × 18 ¹¹⁄₁₆ × 3 ⅛). Kunsthaus Zürich, Vereinigung Zürcher Kunstfreunde

60 CHRISTIAN SCHAD *Composition en N* (Composition in N), 1919, assemblage of painted wood, papers, brass, lace, fabric, oil, and found objects, 44 × 55 × 5.5 (17 ⁵⁄₁₆ × 21 ⅝ × 2 ¹³⁄₁₆). Museo Thyssen-Bornemisza, Madrid

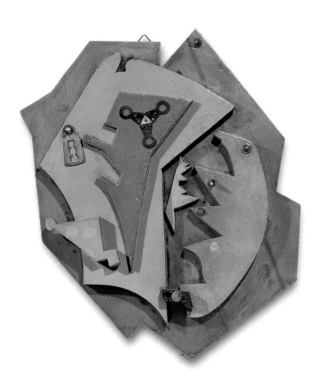

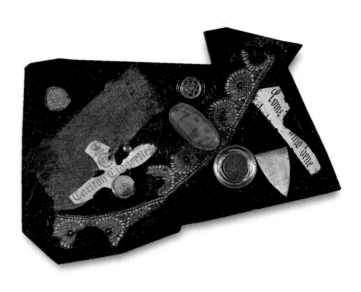

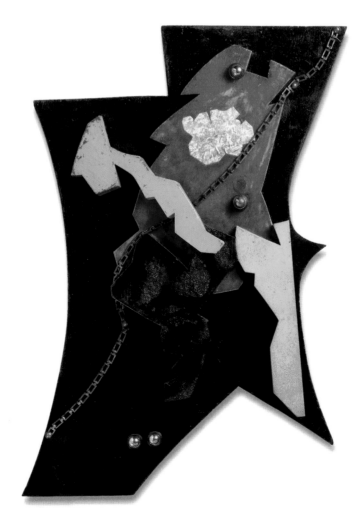

61 CHRISTIAN SCHAD Untitled *(Schadograph no. 14)*, 1919, photogram: gelatin silver printing-out paper print, 8.1 × 5.8 (3 3/16 × 2 5/16). Galerie Berinson, Berlin / UBU Gallery, New York

62 CHRISTIAN SCHAD Untitled *(Schadograph no. 2)*, 1918, photogram: gelatin silver printing-out paper print, 16.8 × 12.7 (6 5/8 × 5). The Museum of Modern Art, New York. Purchase

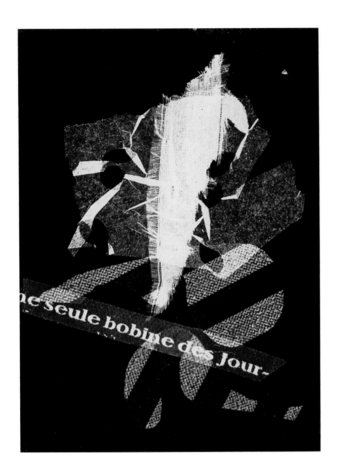

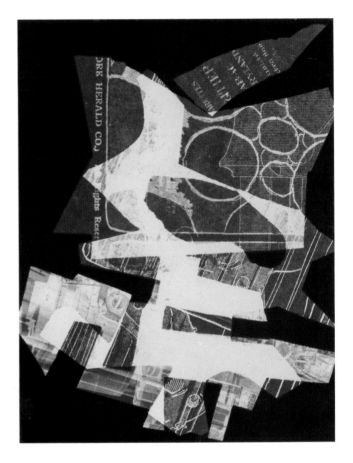

63 CHRISTIAN SCHAD Untitled *(Schadograph),* 1919, photogram: gelatin silver printing-out paper print, 8.2 × 5.9 (3 ¼ × 2 ⁵⁄₁₆). Thomas Walther Collection

64 CHRISTIAN SCHAD *Transmission ischiatique* (Ischiatic Transmission [Schadograph no. 5]), 1919, photogram: gelatin silver printing-out paper print, 6 × 8.3 (2 ⅜ × 3 ¼). Lent by The Metropolitan Museum of Art, Gilman Collection, Purchase, Ann Tenebaum and Thomas H. Lee Gift, 2005

65 CHRISTIAN SCHAD Untitled *(Schadograph no. 4),* 1918, photogram: gelatin silver printing-out paper print, 6.4 × 8.9 (2 ½ × 3 ½). The Museum of Modern Art, New York. Purchase

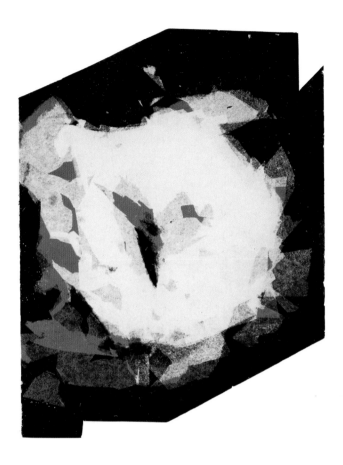

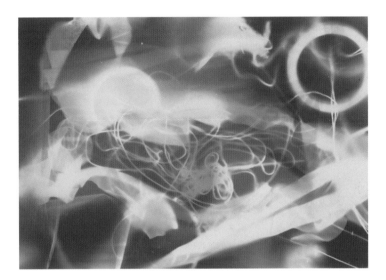

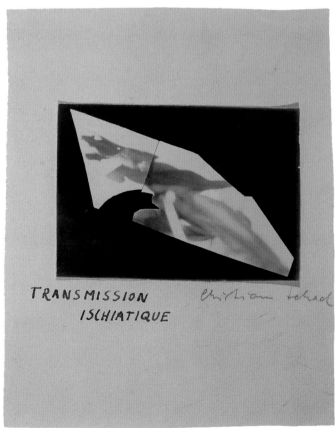

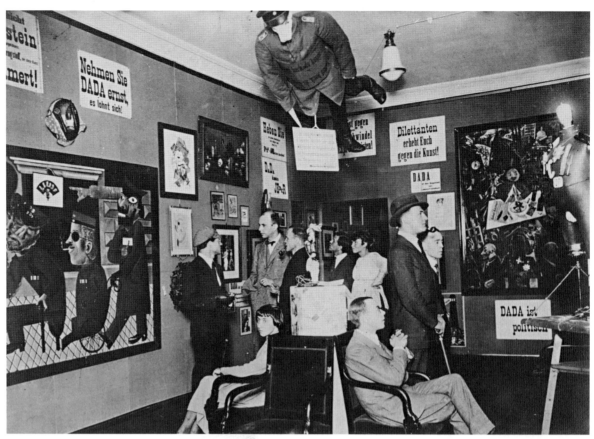

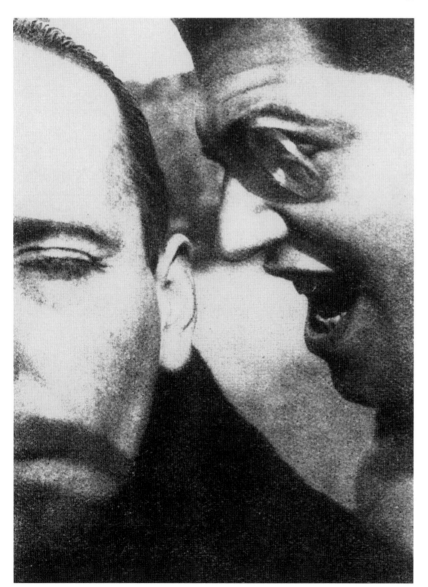

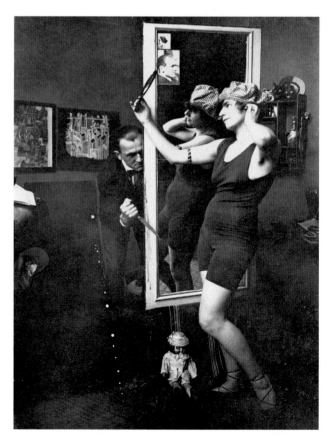

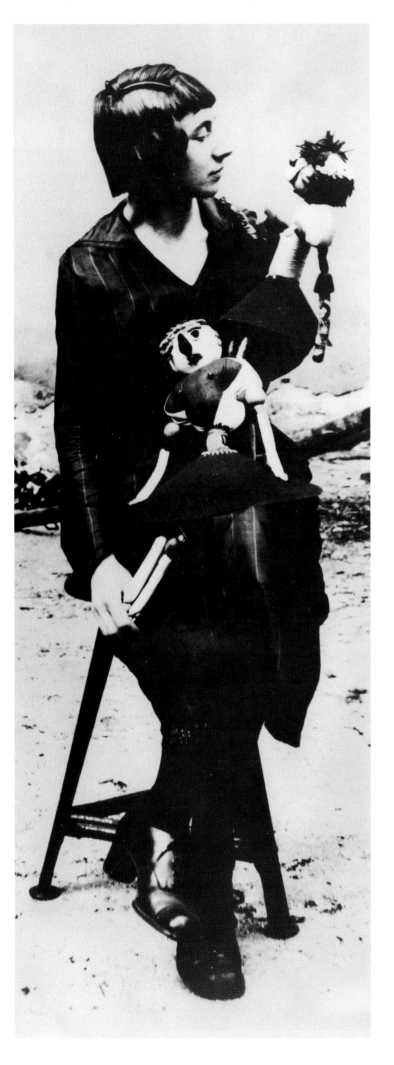

BERLIN

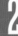

2

Johannes Baader
Otto Dix
George Grosz
Raoul Hausmann
John Heartfield
Wieland Herzfelde
Hannah Höch
Richard Huelsenbeck
Hans Richter
Rudolf Schlichter
Georg Scholz

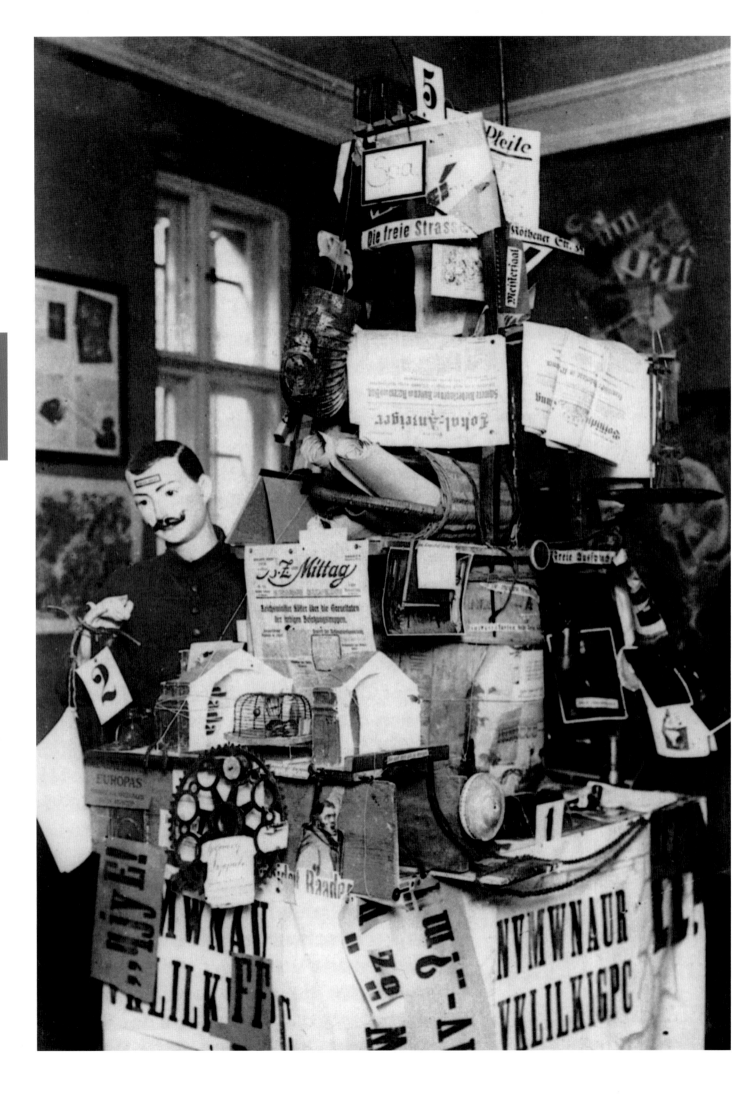

BRIGID DOHERTY

Early in 1917, Richard Huelsenbeck, a twenty-four-year-old German medical student and poet, returned to Berlin from Zurich, where he had spent the preceding year in the company of Hans Arp, Hugo Ball, Emmy Hennings, Marcel Janco, Hans Richter, Sophie Taeuber, Tristan Tzara, and others who took part in the beginnings of Dada at the Cabaret Voltaire. Back in the German capital in the midst of the acute material deprivation and increasing social and political tension brought on by World War I, Huelsenbeck soon began to collaborate with the artists and writers George Grosz, John Heartfield, Wieland Herzfelde, and Franz Jung in the publication of *Neue Jugend* (New Youth), a periodical that anticipated the posters, flyers, and magazines of Berlin Dada in form as well as content [84, p. 431]. On 22 January 1918, Huelsenbeck delivered his "Erste Dada-Rede in Deutschland" (First Dada Speech in Germany) and recited from his book of poems, *Phantastische Gebete* (Fantastic Prayers) [p. 426], as part of an "author's evening" at art dealer I. B. Neumann's gallery on the fashionable Kurfürstendamm. Over the course of the next few weeks Grosz, Heartfield, Herzfelde, and Jung joined him in founding the "Club Dada," which also counted Johannes Baader, Raoul Hausmann, Hannah Höch, Walter Mehring, and Otto Schmalhausen among its members. In the "First Dada Speech," Huelsenbeck recounted the origins, aims, and effects of Dada in Zurich. He asserted Dada's thoroughgoing "newness" and its aesthetic as well as ethical opposition to cubism, futurism, and, above all, expressionism. And he announced, using bitter, cynical, and deliberately contradictory rhetoric that would emerge as characteristic of Berlin Dada's proclamations: "We were against the pacifists, because it was the war that had given us the possibility to exist in all our glory. We were for the war, and today Dada is still for the war. Things have to collide: the situation so far is nowhere nearly gruesome enough."[1]

On 12 April 1918, the Berlin dadaists staged an evening of lectures, poetry readings, and performances at the Berlin Sezession, which at that time was also host to a retrospective exhibition honoring the sixtieth birthday of German painter Lovis Corinth (1858–1925), a founder of the Munich Sezession, which favored alternatives to academic art exhibitions, and twice president of its Berlin counterpart (1911, 1915–25). Among the 140 oil paintings in Corinth's 1918 Berlin Sezession exhibition was *Im Schutze der Waffen* (Beneath the Shield of Arms) [fig. 2.1], a bombastic, patriotic work that represented what the artist described as his effort during the war to cultivate in his painting "a terrifying earnestness" that would "regenerate" German art and set it apart from the

2.1 Lovis Corinth, *Im Schutze der Waffen* (Beneath the Shield of Arms), 1915, distemper on canvas. Ostpreussisches Landesmuseum, Lüneberg

art of other nations, especially France and Russia.[2] Corinth's nationalist politics, as well as his faith in the capacity of art, and of oil painting in particular, at once to remain meaningfully bound to tradition and to contribute significantly to the development of contemporary society, could not be more different from the internationalist and at least seemingly anti-art stance of the Berlin dadaists. World War I and its social and political upheaval shook the foundations of Corinth's faith in painting at the same time as those events helped generate unprecedented commercial interest in his art, especially his depictions of the landscape surrounding the Walchensee in Upper Bavaria. But if the great painter Corinth came to wonder whether art could continue to contain and convey meaning in contemporary German society, the artists of Berlin's Club Dada responded to the circumstances that aroused Corinth's doubt by producing works intended not only to break with, but virtually to destroy, artistic tradition as well as the commercial market in which works of art circulated as commodities, or what Corinth called "mere objects of value."[3]

DADAIST MANIFESTO

Speaking to an overflowing audience in the rooms where Corinth's paintings hung, Huelsenbeck offered what he called the "first theoretical account of the Dada principle." Titled, according to the evening's printed program and invitation, "Dadaismus im Leben und in der Kunst" (Dadaism in Life and Art), Huelsenbeck's presentation, which an unsympathetic critic described as having lasted an hour and a half, included a reading of his "Dadaistisches Manifest" (Dadaist Manifesto), a three-page flyer and the first Club Dada publication, signed copies of which were available for purchase that evening at a price of five marks.[4] Grosz recited from his own lyric poems and danced in a new kind of production he called "Sincopations," a semi-Americanized misspelling intended as an homage to jazz music. In the evening's final presentation, Hausmann added to all the "firsts" announced by the Berlin dadaists in 1918 the novelty of his "Das neue Material in der Malerei" (The New Material in Painting), a manifesto later published and exhibited under the title *Synthetisches Cino der Malerei* (Synthetic Cinema of Painting) **[93]** at the Erste Internationale Dada-Messe (First International Dada Fair) in June 1920.

Contemporary newspaper reviews and the reminiscences of participants describe the events of the April 1918 Dada evening as tumultuous, indeed nearly riotous, both onstage and off. "The threat of violence hung in the air," wrote a reviewer for the *Berliner Börsen-Courier*. "One envisioned Corinth's pictures torn to shreds with chair legs. But in the end it didn't come to that. As Raoul Hausmann shouted his programmatic plans for dadaist painting into the noise of the crowd, the manager of the Sezession gallery turned the lights out on him."[5] The threat of dismemberment that the reviewer believed Dada and its outraged audience posed to Corinth's paintings reiterated a central theme of the text Huelsenbeck presented that evening. The "Dadaist Manifesto" opens with the double assertion that works of art are not so much expressive of as shaped by the age in which they are produced, and that artists are the "creatures," rather than, say, the geniuses, of their epoch. "Art" in the "Dadaist Manifesto" takes on specifically human characteristics—it "lives" in particular historical periods, and possesses a "consciousness" with particular "contents." Moreover, the art Huelsenbeck praises has, as he puts it, visibly "let itself be thrown by the explosions of the last week." Questions of intentionality, contingency, corporeality, and historicity are thus crucial to what Huelsenbeck promulgates as the "highest art" of his day, an art "which is forever gathering up its limbs after yesterday's crash." "The best and most extraordinary artists," he explains, "will be those who every hour snatch the tatters of their bodies out of the frenzied cataract of life,

holding fast to the intellect of their time, bleeding from hands and hearts." "Dadaism," Huelsenbeck asserts, is the first art movement that "no longer confronts life aesthetically." Instead, the tatters of the contemporary artist's body and consciousness have their counterpart in the "slogans of ethics, culture, and interiority" that Dada "tears to pieces" in the new forms of poetry produced in Zurich and through the introduction of "new materials in painting" that both Huelsenbeck's manifesto and Hausmann's lecture advocated as part of the internationalist expansion of Dada in Berlin.[6]

The "Dadaist Manifesto" alludes to World War I as "the explosions of last week" and "yesterday's crash," asserting, simultaneously and almost paradoxically, both the war's presence and its historicity, its belonging at once to the moments of the manifesto's production and presentation, and to a more or less immediate past. The manifesto calls up the overwhelming physical and psychological effects of the war. In so doing it means to insist on the necessary subjection of contemporary artists to the collisions that produced those traumatic effects, as well as the necessary recognition, on the part of artists and their audiences, that those collisions had a history, that they belonged to the present as well as to a past that could be mapped, even if that past had taken place only yesterday, or last week. In insisting on the proximity as well as the historicity of the collisions it invokes, the "Dadaist Manifesto" presents the experience of the war as metonym of the experience of modernity, also understood as historical category, a period in which the dadaists recognized themselves to be immersed, and in relation to which they nonetheless sought, in their art and writing, to assume a position of critical distance. As Huelsenbeck bodied them forth in the Berlin Sezession's decorated rooms, "yesterday's crash" and "the explosions of last week" represented the present of the manifesto as did the war that was still raging, and the metropolitan modernity of Berlin in April 1918.[7]

Echoing the themes while simultaneously amplifying and dismantling the urgent rhetoric of Huelsenbeck's manifesto, the text Hausmann presented at the Dada evening in April 1918 takes up the call for the introduction of "new materials in painting" and aims specifically to distinguish Berlin Dada's use of so-called "new materials" from its cubist and futurist precedents. Describing Dada as "perfectly kindhearted malice, alongside exact photography the only legitimate pictorial form of communication and balance in shared experience," Hausmann offered these emphatic, ungrammatical conclusions to the crowd assembled at the Berlin Sezession:

In Dada you will recognize your real situation: miraculous constellations in real material, wire, glass, cardboard, fabric, corresponding organically to your own utterly brittle fragility, your bagginess. Only here, and for the first time, there are no repressions, no anxious obstinacies, we are far from the symbolic, from totemism; electric piano, gas-attacks, manufactured relations, men howling in military hospitals, whom we with our wonderful contradictory organisms for the first time help along to some kind of just compensation, spinning central axle, reason to stand or fall. Through the exquisite punch of our deployment of material as the newest art of a progressive self-presentation captured in motion with the relinquishment of the traditional protections of those standing around in the vicinity, as embodied atmosphere.[8]

Thus Dada art emerged, at least prospectively, as an aggressively paradoxical (kindheartedly malicious) counterpart to the exactness of photography, a new kind of art that would at once mimic cinema and instantiate the "real situation," that is to say the bodily disposition, of contemporary viewers, some of whom, Hausmann suggested, would discover in Dada not only a version of the circumstances and character of their own unhappy corporeality, but also a therapeutic intervention into their lives that would restore to art an authentic ethics that the dadaists believed modern art had elsewhere transformed into nothing but slogans. The last unwieldy, incomplete sentence of Hausmann's text attempts to establish the relations among the dadaists, as makers of art, the material out of which they make their art, the beholders of the art they make, and the site or situation of all those relations, taken together. The dadaists, Hausmann says, make art out of material not previously put to such use. In so doing they develop a "progressive" form of "self-presentation," or what he also calls "miraculous constellations" of "real material" that "correspond organically" to the beholder's own fragile, brittle, baggy body. Finally, the "exquisite punch" of Dada art, its "progressive self-presentation," is "captured," as if cinematographically, "in motion with" (which in Hausmann's terms would seem to mean, at once, "at the same time as," "in the company of," and "as a consequence of") its audience's letting go of conventional defenses (defenses, say, against getting punched in the first place). Moreover the apparently simultaneous making and viewing of the dadaists' "progressive self-presentation" is captured specifically as "embodied atmosphere," or as something like the (again paradoxical) quasi-cinematic presentation of the making and viewing of Dada's new art as the

work of art itself. Thus Hausmann proposed a renovation of the work of art with the aim of making art respond to the needs, in particular the physical needs, of contemporary viewers, who are represented in the text by the fragile, brittle, baggy "you" whom Hausmann addresses directly, and by the "men howling in military hospitals" he also mentions. Despite the urgency of Hausmann's call for the use of new materials in the production of works of art and in contradiction to his suggestion that the Berlin dadaists were already using such new materials, the earliest documented appearance of such materials in Hausmann's own production dates to spring 1920, and Hannah Höch's *Dada-Plastik*, a small sculptural assemblage of metal, wire, feathers, and patterned paper, was not made until 1919.[9] Instead, by the time Hausmann re-titled his manifesto "Synthetic Cinema of Painting" [see 93] sometime after March 1919, the predominant form of Dada montage involved primarily the use of materials, including photographic illustrations, appropriated from the print media.

THE INVENTION OF PHOTOMONTAGE

Not long after he spoke of "The New Material in Painting" to the outraged audience at the Berlin Sezession, Hausmann joined Hannah Höch for a summer holiday on the Baltic Sea. That vacation provided the occasion for what Hausmann and Höch, who were involved in a turbulent romantic relationship between 1915 and 1922, later described as the invention of photomontage, the medium in which Berlin Dada's most significant contributions to modern art were made. Given the importance of photomontage to Berlin Dada, it is worth considering what the dadaists had to say about how they came to deploy that technique, which encompasses the production of pictures consisting in whole or in part of photographs cut-and-pasted or otherwise combined or manipulated in the process of their making or presentation. According to Hausmann, he "began in summer 1918 to make pictures out of colored papers, newspaper clippings, and posters," which is to say that he started, shortly after advocating the introduction of "new material in painting," to work in a medium whose materials were, by the sound of it, all but identical to those that had been used, beginning in 1912, in cubist collage. They were subsequently used in diverse ways in the collage practices of the Italian futurists and the Zurich dadaists —all precedents Hausmann acknowledges in recounting how he came to make photomontages.[10] Sometime later that summer of 1918, he and Höch rented a room in a fisherman's cottage in the village of Heidebrink on the island of

Usedom. It was there, Hausmann would explain in a memoir originally published in French in 1958, that he "conceived the idea of photomontage."

> In nearly every house there was to be found hanging on the wall a color lithograph depicting an infantryman in front of military barracks. In order to render this memento of the military service of a male member of the family more personal, a portrait photograph of the owner of the martial image had been glued in place of the head in the lithograph. It was like a thunderbolt: one could—I saw it instantaneously—make *pictures*, assembled entirely from cut-up photographs. Back in Berlin that September, I began to realize this new vision, and I made use of photographs from the press and the cinema.[11]

Höch sketched a similar story in notes she made for a 1966 lecture on Dada, in which she describes the dadaists' practice of photomontage as a way of "working systematically with photographic material." In Höch's recollections, Dada photomontage:

> began with our seeing an amusing oleograph on the wall of our guest room in a fisherman's cottage on the Baltic Sea. It depicted—fitted in among the pompous emblems of the Empire—five standing soldiers in five different uniforms—yet photographed only once—upon whom the head of the fisherman's son had five times been glued. This naively kitschy oleograph hung in many German rooms as a memento of the son's service as a soldier. It provided the occasion for Hausmann to expand upon the idea of working with photographs. Immediately after our return we began to do pictorial photomontage.[12]

Prints that had been turned into photomontages like those Höch and Hausmann describe were commonly found in German homes before and during World War I. Höch herself kept one such picture and labeled it "The Beginning of Photomontage" [fig. 2.2]. Neither Höch nor Hausmann ever specified what the photomontages they say they made in September 1918 looked like. In particular, they never made clear whether or not the visual form of the first photomontages bore any resemblance to the popular images that inspired them. A montage painting exhibited at the First International Dada Fair in Berlin in 1920 perhaps alludes to the role that souvenir soldier portraits played in the Berlin dadaists' purported invention of photomontage. *Bauernbild* (Farmer Picture), also known as *Industriebauern* (Industrial Farmers) [126] by Georg Scholz, an artist later acclaimed

anything but calculated cynicism. Human beings, after all, were hungry in large numbers.

The inclusion of the dog-food advertisement in the care-package montage establishes an ethical dimension of Berlin Dada, in this case by means of the juxtaposition of the callous promotion of commodities in a time of war and deprivation with the care understood to inhere in the assembling of packages that in German are called *Liebesgaben* (gifts of love). As a supplement to the organized production of care-packages, groups of women in wartime Germany gathered in so-called *Klebestuben* (glue-rooms) to assemble albums composed of newspaper and magazine clippings, postcards, and reproductions of works of art **[fig. 2.4]**.[24] The care-packages and the montages that Grosz is said to have sent to his friends at the front therefore demand to be situated in relation to a widespread popular practice of making montages on the pages of what were known as *Klebebücher* (glue-books), a term that anticipates the dadaists' description of their own first pictorial montages as *Klebebilder* (glue-pictures).

Apart from the dog food, the other items whose advertisement Herzfelde mentions—hernia belts and fraternal song books—could often be seen among the commodities promoted in wartime advertising. Song books were marketed as gifts to lift morale and to encourage sing-along camaraderie among soldiers at the front, and hernia belts are not hard to find in the back pages of the wartime illustrated press. Grosz' mention of ersatz honey as a sign of the times

in Germany during World War I, and as a touchstone for the invention of photomontage, may on first reading have seemed fanciful. But the marketing of artificial honey in wartime Germany can tell us more about Dada photomontage and the culture in which it emerged than we might think. Even if the Iron Cross as trademark was a dadaist flourish in Grosz' anecdote, photomontage as purportedly invented by Grosz and Heartfield was at least partly a response to the marketplace in which a "Hurrah!" and a *Heil und Sieg* were used to promote a honey substitute. In Herzfelde's story, cardboard montage enclosures quickly led to montage postcards independently mailed to the front. Then the soldiers who received those postcards produced their own in response, sending them back along the same postal route. But Herzfelde cautions that even if soldiers came to fashion montage postcards in the trenches, photomontage cannot exactly be seen as an invention of the anonymous masses. Nonetheless, as Herzfelde tells it, the soldiers' response did encourage Heartfield to develop out of a "politically inflammatory pastime" a "conscious technique," which is to say a pictorial medium characterized by certain consistent practices and ambitions. Although Heartfield's typographic designs for *Neue Jugend* **[84]** and other Malik Verlag publications in 1917 and 1918 demonstrate a range of approaches to the selection and arrangement of materials that were crucial to Berlin Dada montage, no photomontage by Heartfield or Grosz can be dated securely before 1919.

2.4 Maria Anita Kolb, *Klebebuch* (Glue-Book), 2 February 1916. Courtesy of Ida Dehmel Archive, Staatsbibliothek Hamburg

In 1930 Johannes Baader staked his own claim to have made the first Dada montages in the form of "letters" he sent to Raoul Hausmann's wife, Elfriede Hausmann-Schaeffer. Those letters, he explains, were "communications" that meant to exploit the exceptional quantity and variety of "possibilities and stimuli for association" provided by "montage technique" in order to convey, more perspicuously than a newspaper, "extremely rich content" in a "condensed, visually striking form."[25] Although Hausmann confirmed Baader's story about the letters and dated them to March 1918, the first example of such work by Baader that has survived is a photomontage postcard given to Hannah Höch as a birthday greeting on 1 November 1919 **[fig. 2.5]**.[26] Addressed, in fragments of cut-and-pasted typography, to "H—ann—a dada," the postcard includes miniature portrait photographs of Baader and Hausmann, each labeled with the name of the other. The portrait of Hausmann, who

may have collaborated with Baader in producing the montage, takes the place of a postage stamp, while the portrait of Baader appears on the other side of the postcard, which ordinarily would display the missive's picture of a landscape, monument, work of art, or some other typical postcard subject. Along the bottom of the Baader-portrait side of the card, a strip of pasted paper shows the incomplete phrase "Legen Sie Ihr Geld in da" with the "a" cut in half as the paper wraps around the right-hand edge of the card, splitting the word "dada" in two, and compelling the postcard's beholder to turn the card around in her hand in order to read the rest of the word and the injunction of which it is part: "Legen Sie Ihr Geld in dada an!" (Invest your money in dada!). Another narrow band of paper wraps around the center of the postcard to cover the "h" in "Ihr," as if to suggest that the work of montage should be seen as penetrating the "you" to whom it is addressed, just as that

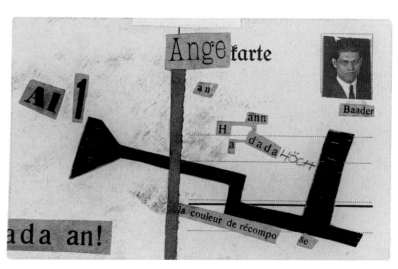

Johannes Baader and Raoul Hausmann, *Angekarte*, 1 November 1919, postcard with collage of papers and ink, front and back. Berlinische Galerie, Landesmuseum für Moderne Kunst, Photographie und Architektur

2.5

technique rearranges the assignment of the names Baader and Hausmann so that they correspond respectively to photographic portraits of Hausmann and Baader. "The individual situation of the receiver, the addressee, the reader, the viewer, which assumes various forms according to mood, atmosphere, and time, was from the outset taken into account, and that expanded all the more the richness of what was being communicated," Baader said about his earliest montages.[27] Thus Baader emphasizes the transactional or relational character of his montage's presentation of words and pictures, over and against other semiological dimensions. That emphasis is typical of Berlin Dada, and it must be taken into consideration in any attempt to understand the significance of Berlin Dada montage in particular.[28]

During his involvement with Dada, Baader typically presented what he did and what he made as fundamentally or originally a form of textual composition and distribution, from his habitual submission of letters for publication in newspapers and his scandalous distribution of manifestos in public places to his production of photomontages and assemblages that took printed texts as their primary materials. A pictorial work like *Der Verfasser des Buches "Vierzehn Briefe Christi" in seinem Heim* (The Author of the Book "Fourteen Letters of Christ" in His Home) [103], which refers to a volume published by Baader in 1914, makes plain Baader's identification with Christ by means of the assumption of the latter's "authorial" persona in the presentation of the letters of the messiah as his own, and *Ehrenporträt von Charlie Chaplin* (Honorary Portrait of Charlie Chaplin) with the alternative title, *Gutenberggedenkblatt* (Commemorative Sheet for Gutenberg) [105], pays tribute to Johannes Gutenberg (c. 1397–1468), producer of the so-called Gutenberg Bible, the first book printed using movable type. Both present the medium of the printed book or flyer as the locus of the authorial identity and historical memory. In each case, Baader points to the potential transformation of print media in the context of an encounter with photography, and more specifically, in the case of *Honorary Portrait of Charlie Chaplin*, an encounter with cinema. In *The Author in His Home*, Baader as author (*Verfasser*, literally, one who composes, forms, or "puts together" a text) of the *Fourteen Letters of Christ* appears in the shape of, or rather attaches his name to, a mannequin that had been photographed when it was displayed as part of his monumental montage structure *Das grosse Plasto-Dio-Dada-Drama: Deutschlands Grösse und Untergang oder Die phantastische Lebensgeschichte des Oberdada* (The Great Plasto-Dio-Dada-Drama: Germany's Greatness and Decline or The Fantastic

Life of the Superdada) at the First International Dada Fair in Berlin in June 1920 [see p. 86]. In that work, Baader, who had trained and practiced as an architect, assembled a kind of megalomaniacal self-portrait that recalled his 1906 design for a *Welt-Tempel-Pyramide* (World-Temple-Pyramid) inspired in large part by Baader's reading of the philosophy of Friedrich Nietzsche (1844–1900). *The Great Plasto-Dio-Dada-Drama*, as Hanne Bergius has described it, demonstrates how "the revaluation of architecture from *Gesamtkunstwerk* (total work of art) to *Gesamt-Zerstörwerk* (total work of destruction) takes place in the process of assemblage,"[29] namely the assemblage of printed matter, from current daily newspapers to Dada poster-poems, machine parts, and objects extracted from the context of daily life in contemporary domestic spaces, a work of destruction that is presented in this instance as a vivid and indeed specifically "plastic," which is to say sculptural, "drama" of national collapse, a drama that exists at the same time as the construction of the "fantastic life story" of its author.

Perhaps transformation or transfiguration would be a better word than invention for what the dadaists did with and to photomontage, since Hausmann, Höch, Grosz, Heartfield, and Herzfelde all agree that Dada montage emerged in response to material that they encountered in popular culture and the mass media, and since Baader's rather different account also stresses the role of the press, and his wish, as an "author," to alter the meanings communicated in public discourse of newspapers and illustrated magazines. On 15 February 1919, the first photomontage published by those associated with Berlin Dada appeared on the cover of the four-page satirical broadsheet *Jedermann sein eigner Fussball* (Everyone His Own Soccerball) [86], which represented an effort by Grosz, Heartfield, Herzfelde, and Mehring to align their work more closely with the aims of the recently founded German Communist Party. Seventy-six hundred copies of *Everyone His Own Soccerball* were sold on the streets of Berlin before the broadsheet was banned that same day.[30] Designed by Heartfield, the cover includes two examples of photomontage. To the left of the title, a dashing young man doffing his hat and swinging his walking stick seems not to have noticed that his torso has been replaced by a soccer ball with the tube through which it was inflated still attached; nor does he seem to realize, more generally, that the rest of him is far too large for his head. That head is a photographic portrait of Wieland Herzfelde, who would soon spend time in jail as a consequence of the Malik Verlag's publication of *Everyone His Own Soccerball* and its

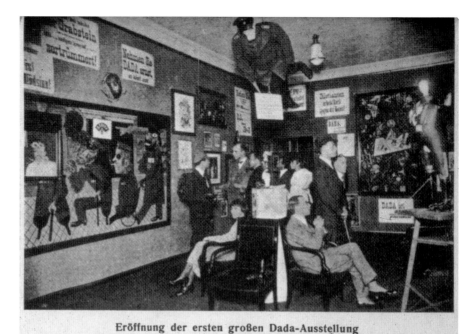

Eröffnung der ersten großen Dada-Ausstellung
in den Räumen der Kunsthandlung Dr. Burchard, Berlin, am 5. Juni 1920.
Von links nach rechts: Hausmann, Hanna Höch, Dr. Burchard, Baader, W. Herzfelde, dessen Frau, Dr. Oz, George Grosz, John Heartfield.

successor, *Die Pleite* (Bankruptcy). At the center of the page a fan displays portrait photographs of members of the administration of the recently elected Social Democratic president of the Reich, Friedrich Ebert (fourth from the left on the upper part of the fan), as well as one of the uniformed General Ludendorff, whose military support, along with that of the counterrevolutionary Freikorps, had been crucial to the Social Democrats' consolidation of political power following the abdication of Kaiser Wilhelm II on 9 November 1918, and especially to their suppression of the so-called Spartacist Uprising that had been launched by the communists in Berlin in mid-January 1919. Attributed to Grosz and presented as evidence in a contest to select the most beautiful man among those represented on the fan, the photomontage was exhibited with the title *Galerie deutscher Mannesschönheit, Preisfrage "Wer ist der schönste?"* (Gallery of German Male Beauty, Prize Question: "Who Is the Most Beautiful?") at the First International Dada Fair in 1920, where it hung on top of a large montage painting, *Kriegskrüppel (45% Erwerbsfähig)* (War Cripples [45% Fit for Service]) **[see 124, fig. 2.6]** by Otto Dix, Dresden-based artist and close associate of the Berlin dadaists. Now lost, Dix's work showed a parade of patriotic so-called "war-cripples" marching along a city street. Also affixed to the top of Dix's picture (seen at far left) at the Dada Fair was one of Grosz' own montage

paintings, *Ein Opfer der Gesellschaft* (A Victim of Society) (later titled *Remember Uncle August, the Unhappy Inventor*) **[72]**.[31] Surrounded by a wooden frame and hung from the top of the frame around 45% *Fit for Service*, Grosz' *Victim of Society* replaced the head of one of Dix's mutilated veterans with a portrait that disfigures what seems to be an unfinished oil painting of President Ebert with montage fragments of machine parts, a straight razor, and Goodyear brand inner tubes. Both the inner tubes and Ebert's largely occluded but still recognizable face recall elements of the composition of the cover of *Everyone His Own Soccerball*, in which the inflatable man bearing Herzfelde's head in Heartfield's photomontage appears as a mocking counterpart to the gathering of male beauties in Grosz' photomontage below, with Herzfelde's portrait affixed to a makeshift inflatable doll, and those of Ebert & Co. to an accoutrement of middle-class women, both objects with a built-in readiness to change shape or collapse. When shown framed within the composition of 45% *Fit for Service* at the Dada Fair, Grosz' *Gallery of German Male Beauty* found a more trenchant counterpart in the mutilated faces and reconfigured bodies of the veterans in Dix's picture, which were themselves based on photographs of wounded World War I soldiers **[fig. 2.7]**, and which, unlike many images published in the illustrated press, presented evidence of the destruction of human bodies

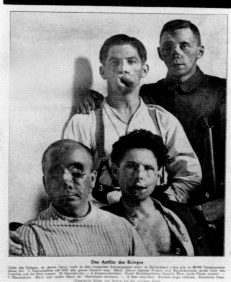

2.7 "The Face of the War," photograph published on front cover of *Die Freie Welt* (The Free World), 1920. Bibliothek für Publizistik, Freie Universität, Berlin

by the technologies of modern warfare without showing the successful repair of that destruction by medical science and engineering, specifically the development of highly sophisticated prosthetic limbs quite unlike the makeshift apparatuses Dix depicts. A pointing hand of the sort often seen in contemporary advertising (itself a kind of minimally metaphorical emblem of the literalist pointing of Dada montage) calls attention to the presence of Grosz' photomontage as a supplement to Dix's montage painting. It asserts, in its own deictic literalism, that this assemblage of montage pictures should be recognized as a polemical presentation of montage as a technique with which the dadaists intended to intervene in contemporary life as it had been transformed first by the war, and then by the politics and the media culture of the early Weimar Republic.

THE FIRST INTERNATIONAL DADA FAIR

Printed with red and black typography over a photolithographic reproduction of John Heartfield's and George Grosz' collaborative montage, *Leben und Treiben in Universal-City, 12 Uhr 5 mittags* (Life and Activity in Universal City at 12:05 in the Afternoon), which is now lost, the newspaper-sized cover page of the catalogue **[78]** to the First International Dada Fair asserts that "the Dada movement leads to the sublation of the art trade."[32] Billed as an "Exhibition and Sale" of

roughly two hundred "Dadaist Products," it was held from 30 June to 25 August 1920 in Otto Burchard's Berlin art gallery. "*Aufhebung*" is the dadaists' word for what their movement does to the traffic in art, and the cover page reaffirms the trebled meaning attached to that term: the Dada Fair "preserved" the art trade to the extent that it put dadaist products on the market; at the same time, the exhibition aimed to generate within the walls of a well-situated Berlin art gallery an affront to taste that would "eradicate" the market into which its products were launched, as if to "elevate" the enterprise of dealing in works of art in the first place. Organized by George Grosz, who is given the military rank "Marshal" on the cover page; Raoul Hausmann, "Dadasopher"; and Heartfield, "Monteurdada," the Dada Fair failed as a commercial venture. Despite charging a considerable admission fee of three marks thirty (a sum even higher than the catalogue announces), while asking an additional one mark seventy for the catalogue, which was published three weeks into the run of the show, the dadaists could not bring in enough from sales to turn a profit. (Ticket number 310 was sold on 16 July, number 389 on 4 August.)[33] Portfolios of reproductive graphic works, including a set of lithographs by Grosz called *Gott mit uns* (God with Us) **[73, 74]**, were available for viewing and for purchase at a table in the gallery, but there is no evidence that any of the other exhibited objects were sold in conjunction with their display at the Dada Fair. (A single work is marked "sold" in the catalogue; originally titled, in English, *High School Course in Dada*, it was made by Grosz' brother-in-law Otto Schmalhausen, and is now lost.)

Not only did the Dada Fair draw a smaller ticket-buying audience than its organizers had hoped, it ended up costing Grosz and Herzfelde 900 marks in fines as a result of their conviction at trial in April 1921 on charges of having slandered the German military by putting *God with Us* on public view.[34] When Heartfield included the boldfaced typeset question "Have you already been shown George Grosz' new portfolio *God with Us*?" in the space surrounding Herzfelde's introductory text in the exhibition catalogue, he may have intended the question provocatively, in ironic imitation of the tone and typography of commercial advertisements. And if he did not envision a response that eventually would include the Berlin police department's confiscation from the Malik-Verlag's offices of copies of *God with Us* as well as seven original drawings by Grosz, Heartfield was certainly accustomed to seeing Berlin Dada publications banned, as they had been regularly since 1917. Nonetheless, when inviting readers of the catalogue to "take note of the

many Dada publications of the Malik-Verlag on the book table," Heartfield and the other dadaists could hardly have anticipated the successful legal prosecution of the artist and publisher of *God with Us* and the subsequent confiscation and destruction of the portfolio's original plates.

More successful than the Berlin dadaists' attempts to turn a profit (or at least recoup investments in the exhibition) were their efforts to generate publicity for the Dada Fair in the German and international print media. They hired a professional photographer from one of Berlin's most prominent agencies to document the show's opening **[see fig. 2.6, p. 443]**, and photographs of the Dada Fair were reproduced in illustrated weeklies as far away as Amsterdam, Milan, Rome, and Boston. The Dada Fair also received dozens of published reviews, both in Germany and abroad. Most of those reviews were hostile, a good number venomously so; some journalists seemed merely bemused; and the few critics who argued for the significance of the exhibition, including Kurt Tucholsky, Lu Märten, and Adolf Behne, did so ambivalently. Whatever their assessment of its merits, newspapers all over the world devoted coverage of one kind or another to the Dada Fair, with articles appearing, for example, in Prague, Paris, Milan, London, New York, Buenos Aires, and El Paso, Texas.

A note appended to the catalogue's list of works by Hans Arp, Baader, Johannes Theodor Baargeld, Dix, Max Ernst, Grosz, Hausmann, Heartfield, Höch, Francis Picabia, Rudolf Schlichter, Schmalhausen, Scholz, and others, indicates that roughly fifty of those works were scheduled subsequently to be included in the "First Exhibition of Modern Art" of the "Société Anonyme, 19 East 47th Street, New York" as "the first German Dada works to be shown in America." The first exhibition of the Société Anonyme, Inc., had in fact already taken place in April 1920, under the direction of Katherine Dreier, Marcel Duchamp, and Man Ray. Dreier, however, did undertake plans for a Dada exhibition to include works from Berlin after visiting the Dada Fair on the recommendation of Cologne dadaist Ernst, with whom she had been in contact since October 1919.[35] The possibility that works from the Dada Fair might be exhibited in the United States aroused the interest of the German government's Ministry of the Exterior, which undertook to assess the effects such an exhibition might have on American perceptions of the young German republic; a copy of the catalogue to the Dada Fair with handwritten marks highlighting the notice of the planned exhibition in New York can still be found in the ministry's files in the German National Archives.[36]

Throughout Herzfelde's introduction to the exhibition, his language often functions as if mechanically, taking its place as one among a number of apparatuses for the destruction of what he calls "the cult of art." The dadaist, he says, aims neither to compete with photography nor to "breathe a soul" into the photographic apparatus, but instead seeks to incorporate that medium's technologies and effects, above all those of the cinema, into the production of works that set aside an "aspiration to art" in the service of an obligation to make "what is happening here and now" their content. Photographs in particular emerge in the introduction as objects to be made, or otherwise appropriated, both by the dadaists and by "the mass of human beings." "Any product," Herzfelde explains, "that is manufactured uninfluenced and unencumbered by public authorities and concepts of value is in and of itself dadaist, as long as the means of presentation are anti-illusionistic, and proceed from the requirement to further the disfiguration of the contemporary world."

There is a sense in which Herzfelde's introduction makes the case not only for the dadaists' destruction of the cult of art, but also for their invention of a new kind of artistic production that refuses to "emancipate itself from reality" or to "disavow the actual," a new art, or at least a new way of making pictures, that seeks to intensify "the pleasure of the broad masses in constructive, creative activity (*gestaltende Beschäftigung*)," for example, by taking "the illustrated newspaper and the editorials of the press as [its] source." Montage is the technique the Berlin dadaists deployed. As a "capitulation to cinema" and a way of making objects that engage "reality" and "the actual" through "means of presentation [that] are anti-illusionistic," montage connects Berlin Dada agonistically to traditions of painting, and at the same time shapes its destruction of the cult of art. Herzfelde's affirmative attitude toward the production of a new kind of art represents a position the Berlin dadaists did not hold for long. In September 1920, Grosz, Heartfield, Hausmann, and Schlichter would renounce in their manifesto "Die Gesetze der Malerei" (The Rules of Painting) the principles of montage on which Herzfelde's conception of dadaist pictures rested.[37]

THE POLITICS OF DADA MONTAGE

Displayed prominently at the Dada Fair, Grosz' and Heartfield's 1920 sculptural montage, *Der wildgewordene Spiesser Heartfield (Elektro-mechan. Tatlin-Plastik)* (The Middle-Class Philistine Heartfield Gone Wild [Electro-Mechanical Tatlin Sculpture]) **[81]**, presents the body named for Heartfield as

a collection of objects mounted on a boy-sized tailor's dummy. The figure of the mannequin recalls the work of the Italian artists Giorgio de Chirico and Carlo Carrà, whose experiments in "metaphysical painting" frequently involved such imagery and were of great interest to the dadaists at the time.[38] Posed with the aid of a metal support (in this case a component of a gas lamp that also resembles the makeshift prosthetic leg of one of the so-called "war cripples" in the painting by Dix that hung on the opposite wall of the gallery at the Dada Fair) in a manner that recalls the display of antique statues, *Middle-Class Philistine Heartfield Gone Wild* relates to a series of works called "corrected masterpieces" by Rudolph Schlichter, a Karlsruhe-based artist and Heartfield's collaborator in the production of the *Preussischer Erzengel* (Prussian Archangel) **[80]** that hung from the ceiling of Burchard's gallery during the Dada Fair, at which a number of the "corrected masterpieces" also were exhibited. According to Herzfelde, Schlichter's "corrected masterpieces" provided a new and positive alternative to bourgeois habits of viewing works of art and outmoded scholarly approaches to antiquity, an alternative that, by conjoining fragments of ancient statues to objects of contemporary modernity, could reinvigorate the viewer's capacity to respond tactilely to the plasticity of ancient art. Although not now known as a "corrected masterpiece," Schlichter's *Phänomen-Werke* (Phenomenon Works) **[129]**, a montage that was almost certainly shown at the Dada Fair, gives the name of a contemporaneous bicycle, car, and truck manufacturer to a picture that includes a reproduction of Polykleitos' *Doryphoros* (c. 450 BC), as if to suggest that the human possibilities (of proportion, harmony, beauty, goodness, perfection) embodied in that literally canonical sculpture had, by the time of the Dada Fair, been replaced by the mere symmetries of vehicles with spinning wheels incapable of taking up the standing figure's hopeful, chiastic pose. Like Schlichter, Heartfield and Grosz simultaneously "modernize" the form of an ancient statue by attaching to it a range of objects that clearly have their origins in contemporary German life, from the gas-lamp-prosthesis to the lightbulb-head, revolver, knife and fork, doorbell, and military decorations. In *Middle-Class Philistine Heartfield Gone Wild*, among the things mounted on the *Spiesser's* body, the cast of plaster teeth on its crotch stands out. As if at once signaling the emasculation of an injured veteran and disfiguring the form of an ancient Apollo, the misplaced dental prosthesis destabilizes the gender and the sexuality of the *Spiesser*, exploiting a potential effect of montage that played a part in many Berlin Dada photomontages, prominent among them those of Hannah Höch.

As the translation of the title indicates, the dadaists used the word *Spiesser* to name a middle-class philistine, a person of petit-bourgeois sensibility. But the word *Spiesser* has other, older meanings invoked by the dadaists. In Germany in the seventeenth century, a *Spiesser* or *Spiessbürger* was an upstanding member of a civilian militia, armed with a pike and ready to march.[39] The *Spiesser*, then, is a paramilitary man, a figure of habitually upright posture, something like a knight. That is a connection subsequently stressed in the writings of Adolf Behne, a prominent German critic and theorist of art and architecture who reviewed the Dada Fair and knew the Berlin dadaists and their work well. Pointing to a tendency among Germans of all classes to arrange the décor of their domestic spaces along diagonals, Behne argued that the "deeper cause" of that inclination lay in the "unconscious retention of a posture of struggle and defense. …Just as the knight, suspecting an attack, positions himself crosswise to guard both left and right, so the peace-loving burgher, several centuries later, orders his art objects in such a way that each one, if only by standing apart from all the rest, has a wall and moat surrounding it. He is thus truly a militant, middle-class philistine [*Spiessbürger*]."[40]

If, as Behne claims, nineteenth- and early twentieth-century Germans ordered their dwellings and displayed works of art according to unconsciously held pseudo-feudal postures, prominent artists working in Germany in that period consciously took up the pose and put on the costume of the knight. For Lovis Corinth, the armored, pike-bearing knight provided a figure of positive identification in his self-portraiture and in paintings like *Beneath the Shield of Arms* **[see fig. 2.1]**. For the expressionist painter Oskar Kokoschka, in whose work the knight also often appears and who painted himself as an errant one in his eponymous self-portrait of 1915, the type of *Der irrende Ritter* (The Knight Errant) underwrote an allegory of the artist's undoing, depicted here in the knight's collapse across a craggy outcropping with his back to a temperamental sea **[fig. 2.8]**. "It is not my trade to unmask society," Kokoschka explained in his autobiography, "but to seek in the portrait of an individual his inner life."[41] Hence this self-portrait has been seen to display the painter's own "inner life" in a grouping of allegorical figurations of his relationships and experiences around the time of its production.[42] (Both the reclining knight and the winged figure hovering in the dark sky above him resemble the painter as he portrayed himself in other works of the period.) When Kokoschka mentioned the painting in a letter of 27 December 1915 to Herwarth Walden, impresario of the

Berlin art gallery Der Sturm, he called it "Knight in a Magical Landscape."[43] No matter which, if any, the picture's particular points of reference may be, the place where Kokoschka's self-representation appears is meant to seem enchanted. For Kokoschka, plying the painter's "trade" is like taking up the quest of a knight errant whose charge is "to seek in the portrait of an individual his inner life."

Middle-Class Philistine Heartfield Gone Wild was almost certainly made in the wake of Grosz' and Heartfield's critique of Kokoschka in the so-called "*Kunstlump-Debatte*" (Art Rogue Debate), in which the dadaists excoriated the expressionist painter and playwright for having beseeched the German public to take measures to ensure the preservation of the nation's cultural heritage during civic unrest. In a statement that ran in more than forty German newspapers in March 1920, Kokoschka implored those involved in violent political conflict to avoid damaging works of art. He was responding to the events of 15 March 1920, in Dresden, where in the wake of the counterrevolutionary Kapp-Lüttwitz Putsch that had overthrown the constitutional government in Berlin on 12 March, fighting had erupted between Reichswehr troops loyal to the "national dictatorship" of the putschists and the workers demonstrating in connection with the general strike

that would bring about the demise of the Kapp government on 17 March. Fifty-nine persons were killed and 150 wounded during that day's clash on Dresden's Postplatz; the battle also sent a stray bullet into Peter Paul Rubens' *Bathsheba* in the nearby Zwinger picture gallery.

"Der Kunstlump" dismisses Kokoschka's plea and urges "vigorous resistance" to the expressionist's position on the part of all those "who, knowing that bullets tear human beings to pieces, feel it a trivial matter when bullets damage paintings."[44] Indeed "Der Kunstlump" takes its disagreement with Kokoschka a step further, as Grosz and Heartfield announce: *"We greet with pleasure the fact that bullets whiz into the galleries and palaces, into the masterpieces of Rubens, instead of into the homes of the poor in the workers' districts."*[45] A 1920 montage painting, *Der Streichholzhändler I* (The Matchbox Seller I) **[122]**, by Dix shows an actual copy of Kokoschka's published plea lying in a gutter not far from a blind and limbless World War I veteran. As he attempts to sell matches on a Dresden sidewalk, the legs of indifferent middle-class citizens wearing seamed stockings and spotless button-up spats hurry past. With its paper torn and its text truncated, Kokoschka's appeal as pasted into Dix's montage painting echoes the damaged condition of the match-selling veteran's

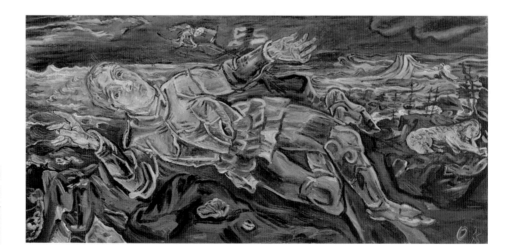

2.8 Oskar Kokoschka, *Der irrende Ritter* (The Knight Errant), 1915, oil on canvas. Solomon R. Guggenheim Museum, New York

body, and vice versa: a dachshund raises his leg before the mutilated match seller, sprinkling him with piss as the gutter's filthy puddles soak the paper of Kokoschka's statement. Dix's display of contempt for Kokoschka's appeal responds to the expressionist's plea for the protection of works of art as if that plea implied a corollary disregard for the situation of human beings. The dadaists, by contrast, demand the transformation of the social and political conditions against which the workers were originally demonstrating and of which they take Kokoschka's text itself to be symptomatic, not because Kokoschka lends his support to the radical, antidemocratic right (he does nothing of the kind), but because instead of standing on the side of demonstrating workers, he speaks up on behalf of masterpieces.

In place of the work of art as a means of seeking the inner lives of individuals, the dadaists' collaborative "product" insists on the exteriority of the object and its subject: the artwork is a thing mounted with devices and artifacts of everyday life, not a magical landscape into which we gaze, not a sacred sculpture that promises to transport us to a better world. The *Spiesser* himself is oriented outward, knight-like in the disposition of his defensiveness, but bereft of a quest. Postured and outfitted for present-day life, *Middle-*

Class Philistine Heartfield Gone Wild stands for the disenchantment of the work of art.[46] It also signals the dadaists' self-mocking identification with the anarchist radicalism and petit-bourgeois revolutionism condemned at the time by the Russian Soviet leader V. I. Lenin and by the German Communist Party, of which Grosz, Heartfield, and Herzfelde were founding members, as a form of "going wild" that Lenin in particular presented in terms of psychic regression and sexual impotence, both of which resonate with the damaged, boy-sized form of *Middle-Class Philistine Heartfield Gone Wild*.[47]

"Der Sträfling" Monteur John Heartfield nach Franz Jungs Versuch ihn auf die Beine zu stellen ("The Convict" Monteur John Heartfield after Franz Jung's Attempt to Get Him Up on His Feet) (also known as *The Engineer Heartfield*) **[75]** offers a related depiction of the contemporary failed revolutionary, again named for Heartfield but now clearly bearing a face modeled on Grosz' own. Once more, the revolutionary, now incarcerated, appears as a damaged, perhaps emasculated, and regressed World War I veteran, in this case a war-neurotic, shown as though simultaneously jailed for his participation in a postwar revolt and hospitalized for treatment of hysterical symptoms.[48] It is tempting to see *"Convict" Monteur*

John Heartfield as a kind of riposte to Kokoschka's well-known depiction of himself as at once criminal and Christ-like in a poster designed for Walden's *Sturm* journal in 1910 **[fig. 2.9]**, not least because of the montage's repetition of motifs from Grosz' cover drawing for Herzfelde's chronicle of his own incarceration as a political prisoner in March 1919, which shows the young poet and publisher standing in his cell with blood pouring from a wound on his head **[fig. 2.10]**. In contrast to Kokoschka's self-portrait and his own portrayal of Herzfelde, Grosz' depiction of Heartfield (again, a depiction of a figure that looks not like its nominal portrait subject, but like its maker) insists on the situatedness of the monteur-as-convicted-criminal, who is shown, according to Herzfelde's entry in the catalogue to the Dada Fair, as a "deformed body" within the "indifferent walls" of his cell, where a "new home dangling above him... incorporates a wine- and delicatessen shop." The criminal-monteur, Herzfelde asserts, has as his "sole material reflections" an "intimacy with the machine" and an "obsession with good food."[49] Both his own body and the space in which he dwells make that intimacy and that obsession plain. In the montage, Heartfield wears on the outside of his blue cover-alls, or so-called Monteur-Anzug (the standard outfit of a machinist), a heart that is literally mechanical and in that graphically distinct from the enflamed, empathetic heart of the expressionist artist as emblematized by Max Pechstein on the cover of the brochure "An alle Künstler!" (To All Artists!) **[fig. 2.11]**, which had aimed to enlist the support of artists across the political spectrum for the Social Democratic government, a project to which the dadaists were opposed, as far as both art and politics were concerned.

The space of the room in *"Convict" Monteur John Heartfield* also had its origins in so-called metaphysical painting, especially the work of Giorgio de Chirico. Grosz' skewed perspectival construction of the chamber resembles the rooms in a number of other montages at the Dada Fair, including several works by Hausmann, for example, *Ein bürgerliches Präcisionsgehirn ruft eine Weltbewegung hervor* (A Bourgeois Precision Brain Incites a World Movement) (later known as *Dada siegt* [Dada Triumphs]) **[87]**, as well as Grosz' own *"Daum" marries her pedantic automaton "George" in May 1920, John Heartfield is very glad of it. (Meta-Mech. constr. nach [according to] Prof. R. Hausmann)* **[77]**.[50] The title was given originally in English. Those works variously explore something like a theme of "home" as a place of estrangement, a theme also taken up by Baader in his *The Author of the Book "Fourteen Letters of Christ" in His Home* **[103]**, and one

that we might recognize as having been expanded, or actualized, in the assemblage *Great Plasto-Dio-Dada-Drama* which, as it were, made a home for Baader's mannequin-surrogate within the space of the Dada Fair. In Hausmann's montages, the figuration of the estrangement of the contemporary individual (paradigmatically the artist) in his so-called home, involves juxtapositions of heavily clothed bodies — a photograph of Hausmann in his overcoat, hat, and gloves in *Dada Triumphs*, and a purloined photograph of Minister of Defense Gustav Noske's seated, suited body in *Selbstporträt des Dadasophen* (Self-Portrait of the Dadasoph) **[89]** — with anatomical models that expose the internal organs of the human body. It is as if, for Hausmann, human interiority demanded to be seen in relation to the interiors, specifically the bourgeois interiors, which the dadaists depicted as the dwelling places, as well as the studios and prison cells, of themselves and their contemporaries.[51] As noted, Baader's *Great Plasto-Dio-Dada-Drama* stages the history of Germany and the life story of the Oberdada as coterminous. "World War," the fourth level of the assemblage, declares that "the

press created the World War. The Oberdada will end it," while presenting a placard bearing the handwritten word "Spa," the site of the western headquarters of the German army during World War I and of the Kaiser's abdication in November 1918. In thus marking the intersection of the Kaiser's life story and his own, and in making that intersection contiguous with the "World Revolution" that is the title of the work's scaled-down fifth level, Baader displays not only his own megalomania, but also an aspect of the politics of Berlin Dada visible in other works on display at the Dada Fair.

In Hannah Höch's *Dada-Rundschau* (Dada Panorama) **[109]**, the president of the Weimar Republic, Friedrich Ebert, and his minister of defense, Gustav Noske, appear as photographic fragments clipped from a notorious picture that had been published in Germany's most widely circulated illustrated paper, the *Berliner Illustrirte Zeitung* [BIZ], in August 1919 **[fig. 2.12]**.[52] (In Hausmann's *Self-portrait of the Dadasoph*, a portrait photograph of Noske that also had been published in the BIZ stands in for the Dadasoph's body while his head is shown as an assemblage of machine parts, including a

2.12 Photograph of Friedrich Ebert and Gustav Noske, *Berliner Illustrirte Zeitung (BIZ)*, 24 August 1919. Bibliothek für Publizistik, Freie Universität, Berlin

pressure gauge and a film projector.) *Dada Panorama*, which was almost certainly exhibited at the Dada Fair,[53] presents photographic fragments of right-wing, antirepublican demonstrations and Spartacist street fighting alongside political and military exercises both graceful and grotesque (Woodrow Wilson's head on a gymnast's balancing body, prancing women on their way to parliament, generals with hats and heads aloft).[54] No longer wading as he was in the original photograph, Ebert wears tiny but shiny military boots. Confronted with a foot powder advertising slogan that appears as a caption to Ebert's appearance in the montage, we are asked to see the president as wearing those boots pro-phylactically, and specifically "against damp feet." Thus the logic of Höch's comic montage would associate the boots at once with a banal effort of self-protection by means of per-sonal hygiene, and with the brutal military suppression of left-wing opponents of Ebert's regime. In place of the Baltic Sea in which Ebert and Noske stand in the newspaper's so-called bathing picture, a "Dada" cloud puffs up around Noske's legs. Is it poison gas? Or dust settling after the blast of an artillery shell?

Dada derided the politics and the culture of the early Weimar Republic's social democracy, but it also exploited the incorporation of the Weimar Republic in the president of the Reich.[55] Hausmann put the matter succinctly in 1919: "Wilhelm II was the embodiment of the peaceful German. Ebert [is] the true face of the German revolutionary. A sleepy rear-end trimmed with a beard."[56] Dada discovered in Ebert's incarnation of the republic a "perfect deformity"[57] to be caricatured in montage. In Dada, Ebert as the embodi-ment of the republic is always imagined in relation to the Kaiser's prior display of his royal body of power, his endless posing for photographs as a uniformed commander in chief or as a Great Elector in lace cuffs.

Dada montage provided no "image of the people" as a counter-image to its montage satires of individual Social Democrats. In *Dada Panorama*, Ebert and Noske loom large, while "the people" is merely a glimpse offered up in minia-ture pictures of counterrevolutionary demonstrations and in a photograph of far-away Spartacists spread like ink blots or scattered like specters or living shadows beneath unlit street lamps and fired on by government snipers held in tight focus by a photojournalist's nearby camera. However, Höch does hint at a different kind of political representation—not the Kaiser, not the heads of the new republican state, not "the people" per se, but several women members of Germany's recently elected National Assembly. The Weimar constitution granted women the vote, and, following the first elections in January 1919, thirty-six of the nearly four hundred seats in the assembly were occupied by women. Pictured here among the caption fragments "Deutsche—Frauen—in die Nationalversammlung" (German Women to the National Assembly) are three of the women elected that year.[58] The politicians' heads are mounted with deliberate clumsiness on the bodies of two barefoot dancers. Although the politics of someone like Anna von Giercke were far from Höch's own—a member of the reactionary right-wing Deutsch-nationale Volkspartei Von Giercke is the one whose head is attached not to a neck but to the caption—the montage might be seen to present these female delegates as a conceiv-able alternative incarnation of the new state, as representa-tives of a potentially dynamic democracy.[59] The juxtaposition of those lithe bodies bearing the heads of women politicians with the corpulent bodies of Ebert and Noske compares an altogether ordinary masculinity (dressed preposterously in bathing costumes) with a certain athletic and modern femininity (clothed in a way that recalls the robes of classical democracy). Höch's grouping of women representatives wearing antique robes and setting out together for parlia-ment invokes a certain utopianism of its moment. The sur-face of the picture speaks (in a tiny line of type to the right of the dancing feet) of "political enlightenment," and else-where instructs the viewer to "read and pass it on to men and women!" though it never specifies what is to be read. The montage also calls for the liberation of the dadaist herself, demanding, in the lower right hand corner, "limitless free-dom for H. H." But in German the letters read "ha ha"— not "aich aich"—and the pun is intended. The image of Weimar's first female elected officials also laughs, as Von Giercke's head bounces unbodied on a dancer's knee, and a horse's stepping fetlocks accompany the women en route to the National Assembly. This, then, is another image of the republic mocked, however mildly.

In selecting for dismemberment the bathing picture in particular, Höch pointed to what the dadaists took to be the ludicrous ambiguity of the republic's self-representation in the technological medium of the photographically illus-trated press. The blossoms placed by means of montage in the politicians' costumes mock the homely, summer-vaca-tion masculinity of Weimar's elected leaders as itself a travesty of charismatic legitimacy. And if the flowers have been added to the bathing trunks in Höch's montage, some-thing has also been taken away: a slice is missing from Noske's crotch. His swimsuit looks like a bandage, and

between the lines that mark the place of the wound, blood-like spots of red are soaked into the paper that is the montage's material support.

In *Dada Panorama*, Ebert and Noske turn from "bathers" into corpses. The figurative injuries that Dada montage inflicts on them are miniaturized as the castration made visible in Noske's wound and memorialized with flowers. The men float in the shallow space of Höch's montage, where shards of newsprint and areas covered in dense black paper are interspersed with bright patches of red and orange water-color. They resemble glimpses of fire and are complemented by areas of blue overlaid with strokes of black, evoking a sky filling with smoke. Bits and pieces of sky and flames appear throughout the montage, with Ebert and Noske hovering, as though tossed in the air by an explosion. "Rays of light" in the form of a word of clipped newsprint fall upon or emanate from Ebert's head; he seems transfigured, for an instant beatific. A star can be seen behind Noske's head, as if he too had been blessed in advance of ascension. But their beatitude quickly fades. Floating, the men are like bloated corpses, their bellies perhaps not merely standing, emblematically, for the "Weimar beer-belly culture" the dadaists derided and aimed to destroy, but recalling, with unkind if almost poignant irony, the soft swollen torsos of victims of assassination, first killed by a bullet, then tossed into a canal. Such had been the fate of Rosa Luxemburg, a leader of the Spartacist revolt, when the revolt was put down by the Freikorps working in the service of the Social Democrats in January 1919.

The title of Höch's *Schnitt mit dem Küchenmesser Dada durch die letzte Weimarer Bierbauchkulturepoche Deutschlands* (Cut with the Kitchen Knife Dada Through the Last Weimar Beer-Belly Cultural Epoch in Germany) **[108]** describes the presentation—by means of a technique of montage that approximates crude surgery—of a cross-section of German culture circa 1920, a sample of a collective body to be sliced from the nation's beer belly.[60] As in other Berlin Dada works, in *Cut with the Kitchen Knife* the figuration of the Weimar Republic is connected to that of the Kaiser, who appears here simultaneously assembled out of fragments of early Weimar and dissected as though he were a corpse standing tall for his autopsy. The figure begins in the upper right of the picture with a little black top hat resting on the head of a black-and-white reproduction of a painted bust showing the Kaiser pompously posed with all his golden braids and chains, his satin sash and regal sleeves. Next to the Kaiser's exposed ear is a large "K" meant to let us know whose ear it

is. (On the other side of the "K," an image of Wolfgang Kapp escaping Berlin in an airplane after his failed putsch does, however, provide another possible referent, making the "K" a sign of overlap or a bridge between two fallen regimes.) Hindenburg, outfitted with the body of the dancer Sent M'ahesa and engaging in a limb-stretching gesture of exotic self-display, forms a human epaulet on the monarch's shoulder. A large cogwheel fitted to a metal shaft is attached to the Kaiser's upper back, and makes him look like a wind-up toy. But even if (or perhaps exactly because) the Kaiser appears as a mechanical puppet, in Höch's rendering of Weimar's beer-belly culture he still presides, with stern, aristocratic arrogance and the flourish of a chest thrust out at the world. (The effect of this thrust is intensified by the thickness of the material on which the painting is reproduced; the Kaiser's cardboard support literally makes him stand out from the rest of the montage.) Another general stands at ease on the royal arm, his feet landing on the heads of Gustav Noske and an admiral with whom Noske seems to be conferring. Like an oversized decorative cuff, the heads of Lenin, the dadaist Johannes Baader, and the Soviet emissary Karl Radek finish off the Kaiser's arm—with Lenin and Radek mounted on the limber bodies of acrobats in checkered suits, and Baader's head attached to the figure of two female gymnasts in matching team leotards who dangle like an elongated hand coyly placed on an imaginary or invisible hip. That gesture is repeated at upper right by a tiny hand-on-hip belonging to the film star Asta Nielsen, shown here in a sailor's costume with her belly covered, or perhaps implanted, with seed pods cut from a botany book and the head of a counterrevolutionary Bavarian soldier clipped from a newspaper. Nielsen's gesture is partly hidden under Wilhelm's top hat, and it is not hard to see the repetition as indicating what's on the Kaiser's mind, as showing us the mental arrangements and preoccupations of his posing. We are also asked to contrast the Kaiser's gesture with two made by Ebert, who gesticulates to rouse an absent crowd toward the center at upper left, and who acquires the pose of a woman performing a topless balancing act just below. Ebert's arms—the arms of the equilibriste—are held rigidly perpendicular to the vertical axis of the torso and head in a gesture that suggests that he, like the wind-up Kaiser, could easily be made to spin (the rearrangement of his eyes in the montage has the effect of making him look already dizzy).

The Kaiser's torso features an automobile wheel with an inflated tire tilted and protruding like a tremendous mechanical nipple. (In a typical dadaist displacement, the

pneumatic nipple emerges from Sent M'ahesa's crotch.) The giant nipple as synecdoche for a breast resembles the smaller ones sewn on to the *Dada Puppen* (Dada Dolls) [117] that Höch also exhibited at the Dada Fair—a resemblance accentuated by the nipple's seeming ready to be set in motion by the winding device at the Kaiser's back, as though to remind us of all the ways the monarch was marketed: here he's a nostalgic toy or a backward-looking mascot.[61] The wheel-nipple abuts the head of the poet Else Lasker-Schüler, who is made to wear a gigantic man's hat that extends from the monarch's chest like another improbable breast. An engine with exposed exhaust valves stands in for waist and groin. If the cylinders look like a tidy arrangement of mechanical intestines, the engine's casing resembles a sexy metal pelvis turned seductively and thrust slightly forward. At one end of the engine block is Karl Marx's head; at the other are the much larger head, collar, necktie, and lapels of the theater director Max Reinhardt, who now wears on his nose a gesturing hand—or, he wears that hand *as* his nose, if we think the original feature is gone and not just augmented. The small dramatic hand appears as a miniature where the Kaiser's own paralyzed extremity is missing; indeed the hand's little index finger points up into the Kaiser's left sleeve. Dripping from or screwed into the bottom of the engine's oil pan is Hausmann's face, captured mid-syllable in the recitation of a dadaist sound poem. Open wide, Hausmann's mouth further sexualizes the Kaiser's body, providing the monarch with a *vagina-dentata* that recalls the false teeth on the sculptural montage, *Middle-Class Philistine Heartfield Gone Wild*, which was exhibited on the other side of the room at the Dada Fair. The Kaiser's composite body comes to an end beneath Hausmann's face, with the little trunk, arms, and legs of a deep-sea diver standing or perhaps dangling (here the figure again resembles the loose-limbed *Dada Dolls*) in the faded paper space of the picture surface. The Kaiser, pushing forward his mounted breasts and pelvis, shouting from his glued-on genitals, now poses as though proud of his obscene disfiguration.

It is worth recalling that *Cut with the Kitchen Knife* as displayed at the Dada Fair differed significantly from the montage as we know it today. Höch reworked the picture after the exhibition. She added certain montage elements—for example, the upside-down wrestlers who replace Wilhelm's mustache and give the surface of his face its annoying erotics: the wrestlers might excite him, or they might make him sneeze; in any case they add a new dimension to his "stony majestic countenance." Other parts of the original

picture were removed—most notably the word "WELTREVO-LUTION" (world revolution), which in the first version issues from Marx's end of the engine at the Kaiser's hip, jutting downward stiffly like a walking stick, crutch, or peg leg, or maybe hanging in place of a sword or a ceremonial baton. In the revised version, the bland, fractured phrase "*Die grosse/dada/WELT*" (the great Dada world) replaces "world revolution," and the new words are descriptive rather than incendiary—they repeat the structure of and provide the antithesis to the line "*die anti-dadaistische Bewegung*" (the anti-dada movement) that is attached to the Kaiser's brow.

Cut with the Kitchen Knife makes of the Kaiser an upright cadaver and suggests thereby that the monarch lived on monumentally as the hidden figure of the Weimar beer-belly republic. Höch's photomontage does this partly paradoxical work with a notable self-consciousness about its own representational techniques and their relation to other kinds of visual and political expression. It matters, for example, that the portrait of the Kaiser that Höch uses is a reproduction of a painting. The paintedness of the portrait is more visible in the reproduction than one might expect: we see the weave of the canvas on a shadowed cheek, the touch of the brush on a sculpted chin, dabbed strokes making the eye glow fiercely, and so forth. The Kaiser's costume is also an essentially painted thing—painted as opposed to photographic, like most of the montage elements, or engraved, like the hat on the monarch's head or the one that seems to stand in for a breast. The roosterishness of the portrait pose—captured best, which is to say with grandiose and cheap expedience, in the way the fabric sleeve and sash are handled—permits the posture of what appears as the composite figure's lower body, where the monarch's castration is finally displayed frontally in or as Hausmann's mouth. For its part, the area around Reinhardt's head and next to an aerial photograph of an airplane cabin with passengers might once have been seen to represent, from left to right and up, a bit of light-colored sleeve, the cup over the hilt of a sword, and pieces of plumage left behind by a helmet that has been removed. But the visual impression those passages make within the montage does not sustain that representation. The play of shadow and light is now dramatic, not to say gothic; what in paint might have resembled the ends of feathers begin in montage to look like small severed body parts—missing fingers, or worse. That is the effect montage has on the prior image of the Kaiser: montage makes painting incomprehensible, ridiculous; it does to the bombast of the portrait as painted (and photographically

reproduced) representation what the material cutting apart and reassembling of the represented body does to the figure of the monarch.

The (actual) mechanical reproduction of the Kaiser's painted portrait and the (notional) mechanical-toy motion of the monarch and of his scaled-down double, the president with balancing hands, are each figurations of the debasement of history in the epoch of Weimar Germany's beer-belly culture. Walther Rathenau—whose photographic portrait appears in *Cut with the Kitchen Knife* scalped and blinded beneath the pointed toe of Nidda Impekoven, the young dancer above whose decapitated body floats Käthe Kollwitz' solemn head in the center of the picture—proposed the same connection between the repetitions of technological reproduction and those of history, when in 1919 he drew this conclusion concerning the representation of the Kaiser in the media of print and photography: "World history unwinds from a barrel-organ." In *Cut with the Kitchen Knife*, figures of Germany's contemporary history get beheaded, blinded, castrated, impregnated with the seeds of counterrevolution, but they keep dancing like music-box ballerinas. Höch's montage couples a travesty of the traditions of Western painting with a travesty of political representation, and it does so by aligning its mockery of those two kinds of representation on the picture surface in such a way as to insist that what now makes painting visible (what makes possible painting's being seen) and what now sets history in motion, is in each case a machine, an apparatus turning cogwheels to produce one lifeless figure after another. The fantasmatic machines of Dada montage had a counterpart in Weimar modernity: the film projector, or the cinematic apparatus more broadly conceived, to which the dadaists so often paid tribute, and in relation to which their work demands to be understood.

DADA AND CINEMA

As announced in the titles of Hausmann's manifesto "Synthetic Cinema of Painting," Grosz' pen and ink *Selbstporträt (für Charlie Chaplin)* (Self-Portrait [for Charlie Chaplin]) **[fig. 2.13]**, and Baader's montage *Honorary Portrait of Charlie Chaplin* **[105]**, cinema was a touchstone for Berlin Dada and its ambitions to renovate the production and reception of art. In those works and elsewhere, Berlin Dada represents the bodies of the dadaists and their contemporaries as reproducing the technologies and effects of the cinema—from the spinning of movie cameras and projectors to the demonstrative self-assertion of the film star performing first before

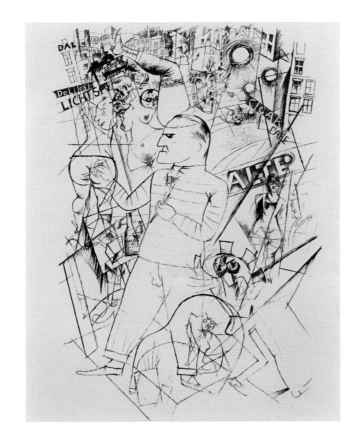

2.13

a camera and finally, when projected on the screen, before a mass audience. Hausmann's *Self-portrait of the Dadasoph* **[89]** offers its montage fragment of a movie projector perhaps less as a metaphor for consciousness than as an actual fantasy of having a prosthetic head, while Grosz' *Self-portrait for Charlie Chaplin* depicts the artist at work in a manner that announces how his drawing strives to imitate the simultaneities of cinematic montage at the same time as it shows how paying tribute to Chaplin arouses him, or allows him to materialize his virility, in a penile erection that stands as an answer to the emasculation otherwise made visible in Grosz' Dada portraits. In *Dada im gewöhnlichen Leben* (Dada in Ordinary Life), or *Dada Cino*, **[91]**, Hausmann suggests that a life in which Dada penetrated everyday experience would be a kind of living cinema, an experience, as he pictures it in this static image, of being a composite body that incorporates, through montage, a grown man's flânerie, an infant's intrauterine dreaming, a male artist's fantasy of getting into, or falling out of, a female figure skater's skirts (the head in this case is Grosz'), and the travels of a civilian collective rumbling along atop an armored tank.

In Berlin Dada montage, cinematic technologies and effects simultaneously interrupt and construct the human body, a body understood as the site, indeed the manifestation, of contemporary modernity, with its pleasures, terrors, contradictions, and possibilities. Some fifteen years after the dissolution of the Dada movement in Berlin, the philosopher and literary critic Walter Benjamin described Dada as having amused itself with "barbarisms," and as having produced the sort of "excesses and crudities of art [that], especially in periods of so-called decadence, actually emerge from the core of its richest historical energies." "Only now," Benjamin asserts, "is its impulse recognizable: Dadaism attempted to produce with the means of painting (or literature) the effects which the public today seeks in film." Thus Benjamin sees Dada as having taken on "one of the primary tasks of art," that is, "to create a demand whose hour of full satisfaction has not yet come."[62] Now, however, things look different, and if Benjamin's remarks on Dada still seem perspicuous, indeed perhaps singularly insightful, his prospective confidence in the demands to be met by means of cinema's reinvention, after Dada, of "distraction" as a "variant of social behavior," is bound to be more difficult to reconstruct.[63] Ours is an age in which the situations that made themselves felt in Berlin Dada's barbarisms are at once almost unthinkably remote and uncannily familiar.

Parts of this essay have been published previously in *October* 84 (Spring 1998) and *October* 105 (Summer 2003).

1 Richard Huelsenbeck, "Erste Dadarede in Deutschland" (1918), reprinted in Karl Riha and Hanne Bergius, eds., *Dada Berlin: Texte, Manifeste, Aktionen* (Stuttgart, 1977), 17.

2 Lovis Corinth, cited in Andrea Bärnreuther, "Biography," in *Lovis Corinth*, ed. Peter-Klaus Schuster et al [exh. cat, Haus der Kunst] (Munich, 1996), 19.

3 Corinth, cited in Bärnreuther, "Biography," in *Lovis Corinth*, 21. See also Maria Makela, "Lovis Corinth's 'Themes': A Socio-Political Interpretation," in *Lovis Corinth*, 59–68.

4 Also for sale that evening was a 16-page prospectus called *Club Dada* that had recently been published, with Baader and Hausmann as editors, by the *Freie Strasse*, a journal and publishing concern founded by Franz Jung in 1916. On the events of April 12, 1918, see "Programm und Einladung zum Vortragsabend, Freitag, 12. April 1918, abends 8 ¹/₂ Uhr in der Berliner Sezession" (1918), in *Dada Berlin*, 6; *The Dada Almanach* (New York, 1966; originally published as *Dada Almanach*. Berlin, 1920), 36; Hanne Bergius, *Montage und Metamechanik: Dada Berlin —Artistik von Polaritäten* (Berlin, 2000), 421; and Hans Richter, *Dada: Art and Anti-Art*, trans. David Britt (London, 1965; originally published as *Dada: Kunst und Antikunst*, Cologne, 1964), 104–107. On the allegedly unpleasant length of Huelsenbeck's presentation, see K., "Dadaismus," *Berliner Zeitung am Mittag*, April 13, 1918, reprinted in Cornelia Thater-Schulz, ed., *Hannah Höch. Eine Lebenscollage* (Berlin, 1989), vol. 1, part 1, 365.

5 P. H., "Literatur Narrheiten in der Sezession," *Berliner Börsen-Courier*, April 13, 1918, reprinted in Thater-Schulz, *Hannah Höch: Eine Lebenscollage*, vol. 1, part 1, 367.

6 Richard Huelsenbeck, "Dadaist Manifesto," quoted in Richard Huelsenbeck, *En Avant Dada: A History of Dadaism* (originally published as *En avant Dada. Die Geschichte des Dadaismus*. Hanover, 1920), in *The Dada Painters and Poets: An Anthology*, Robert Motherwell, ed., Ralph Manheim, trans. (Cambridge, Mass., 1989), 40; trans. mod. based on the original German in Huelsenbeck, "Dadaistisches Manifest," in *Dada Berlin*, 22, 24. For a reading of the "Dadaist Manifesto" that situates its rhetoric of dismemberment in relation to the physical and psychic traumas experienced by soldiers during and after World War I, see Brigid Doherty, "See: We Are All Neurasthenics, or the Trauma of Dada Montage," *Critical Inquiry* 24 (Autumn

1997), 82–132.

7 On Huelsenbeck as "prototype" of a twentieth-century figure who "is a moralist and a rationalist, but he presents himself as a sociopath; he leaves behind documents not of edification but of paradox," see Greil Marcus, *Lipstick Traces: A Secret History of the Twentieth-Century* (Cambridge, Mass., 1989), 218–244.

8 Raoul Hausmann, "Synthetisches Cino der Malerei," reprinted in *Bilanz der Feierlichkeit: Texte bis 1933*, ed. Michael Erlhoff (Munich, 1982), vol. 1, 16.

9 Bergius, *Montage und Metamechanik*, 37, 32.

10 See Raoul Hausmann, *Courrier Dada* (Paris, 1958), 44, and Hausmann, *Am Anfang war Dada*, eds. Karl Riha and Günter Kämpf (Giessen, 1972), 49.

11 Ibid.

12 Hannah Höch, "Erinnerungen an Dada" in *Hannah Höch 1889–1978: Ihr Werk, Ihr Leben, Ihre Freunde*, Elisabeth Moortgat et al., eds. [exh. cat., Berlinische Galerie] (Berlin, 1989), 207–208. The manuscript in the Höch archive is titled Höch "Vortrag Düsseldorf 1966," Hannah Höch Archive, Berlinische Galerie, Berlin. In a 1959 interview published in English in *Arts Magazine*, Höch told a somewhat different version of this story, omitting any reference to the fishermen's cottages, and mentioning specifically the "official photographers of the Prussian army regiments" as makers of "very primitive photomontages" whose "aesthetic purpose, if any, was to idealize reality." See Edouard Roditi, "Interview with Hannah Höch," *Arts Magazine* (December 1959), 24–29.

13 The Grosz-Heartfield postcard to Scholz is reproduced in Helen Adkins, "Erste Internationale Dada-Messe," in *Stationen der Moderne*, Eberhard Roters, ed. [exh. cat., Berlinische Galerie] (Berlin, 1989), 166. Scholz' modern farmers are not visible in any of the photographs of the Dada Fair, but the *Bauernbild* is listed in the exhibition catalogue; see Wieland Herzfelde, "Zur Einführung," *Erste Internationale Dada-Messe* (Berlin, 1920), catalogue no. 93, n.p.

14 Bergius identifies the device as a "butter machine" (*Montage und Metamechanik*, 198).

15 The inadvertent pointing of the boy's little finger as it draws the viewer's eye to the printed page underscores this debasement insofar as that deictic gesture itself is paired ironically with the action of the boy's index finger tucked behind his middle and ring finger as it pins the toad's foot to the table. For a critique of the deictic

character of montage, see Theodor Adorno, *Aesthetic Theory*, trans., ed., and intro. Robert Hullot-Kentor (Minneapolis, 1997), 155.

16 George Grosz, *Ein kleines Ja und ein grosses Nein: Sein Leben von ihm selbst erzählt* (1955; Hamburg, 1986), 103; originally published, in English, as *A Little Yes and a Big No: The Autobiography of George Grosz*, trans. Lola Sachs Dorin (New York, 1946). See 147–148 of the American edition for the Ford reference.

17 George Grosz, quoted in *Foto-Auge*, eds. Franz Roh and Jan Tschichold (1929; New York, 1973), 7; Hannah Höch, quoted in "Interview with Hannah Höch," 26.

18 Richard Huelsenbeck, *Dada siegt: Eine Bilanz des Dadaismus* (1920; Hamburg, 1988), 34. Describing the revolutionary moving assembly line installed at the Ford plant in Highland Park, Michigan, in 1913, Henry Ford noted in his autobiography that "the idea came in a general way from the overhead trolley that the Chicago packers used in dressing beef." See Henry Ford, *My Life and Work* (1922; Garden City, 1926), 81. On Fordism in the German context, see Mary Nolan, *Visions of Modernity: American Business and the Modernization of Germany* (Oxford, 1994). Among the books in Hannah Höch's library was a copy of the German translation of Ford's 1922 autobiography, *My Life and Work*, which was a bestseller when published as *Mein Leben und Werk* in Germany in November 1923, and which Höch received as a gift from the prominent critic, Adolf Behne, author of one of the most insightful reviews of the 1920 Dada Fair. See BG HHC H346/79, Hannah Höch Archive, Berlinische Galerie. In a 1922 exhibition catalogue, George Grosz assigned the following title to one of his montages: *Das Gehirn meines Schwagers M. E. Fimmen, New York oder Marschall Grosz fordert Taylors System in der Malerei* (The Brain of My Brother-in-Law M. E. Fimmen, New York or Marshal George Grosz Calls for the Introduction of the Taylor System in Painting) (see Bergius, *Montage und Metamechanik*, 49).

19 George Grosz, "Randzeichnungen zum Thema," in *Blätter der Piscator-Bühne*, January 1928. Reprinted in Peter Claus Schuster, ed. *George Grosz. Berlin-New York* [exh. cat., Neue Nationalgalerie] (Berlin, 1994), 218. Erwin Piscator (1893–1966) was the founder of Berlin's Proletarian Theater (1920–1921), whose productions featured designs by John Heartfield, and later of his own "Piscatorbühne" (1927–1928; reopened briefly in 1929), whose renowned 1928 production of Jaroslav

Hasek's *The Adventures of the Good Soldier Schweik* was designed by Grosz and featured innovative scenography, including animated cartoons projected behind the actors, as well as cut-out figures and objects transported across the stage on treadmills.

20 On the food shortages that plagued Germany during World War I, and on the social and political consequences of those shortages in Berlin in particular, see Belinda J. Davis, *Home Fires Burning: Food, Politics, and Everyday Life in World War I Berlin* (Chapel Hill and London, 2000).

21 John Heartfield, quoted in "Rundfunkgespräch (DDR) mit Renate Stoelpe und John Heartfield. 2. Erfindung der Fotomontage" (part two of a two-part radio interview, broadcast on September 12, 1966), typed transcript with handwritten corrections, John Heartfield Archive, Akademie der Künste zu Berlin, 6–7. Sergei Tretiakov (1892–1939) was the author of the first book on Heartfield, *John Heartfield: A Monograph* (Moscow, 1936). Heartfield spent ten months in the Soviet Union in the early thirties (April 1931–January 1932), and his discussions with Tretiakov on the subject of the invention of photomontage likely would have taken place at that time, although he might also have discussed the medium with Tretiakov during the latter's visit to Berlin in early 1931. For an English translation of the relevant passage in Tretiakov's monograph, see Tretiakov, "Remarks About Heartfield's Photomontages," in *John Heartfield: Photomontages of the Nazi Period* (New York, 1977), 26. For a German translation of numerous passages from the monograph, see Tretiakov, "Elemente der Montage," in Klaus Honnef and Peter Pachnicke, eds., *John Heartfield* [exh. cat., Akademie der Künste zu Berlin and Rheinisches Landesmuseum] (Cologne, 1991), 339–346.

22 See Richter, *Dada: Art and Anti-Art*, 114–118.

23 Herzfelde, *John Heartfield: Leben und Werk. Dargestellt von seinem Bruder* (Dresden, 1962), 17–18. The texts of the second (1971) and third (1976) editions of Herzfelde's book contain notable revisions to this passage. Grosz sent a similar package to his friend and future brother-in-law, the artist Otto Schmalhausen, shortly after the Dada evening at the Berlin Sezession in April 1918. See Grosz, letter of April 26, 1918, to Schmalhausen, who was in a military hospital at the time, in *Briefe, 1913–1959*, ed. Herbert Knust (Reinbek, 1979), 63.

24 See *Liebesgaben für den Schützengraben, 1914–18*, ed. Birte Gaethke [exh. cat.,

Altonaer Museum] (Hamburg, 1994).

25 Bergius, *Montage und Metamechanik*, 22.

26 Bergius, *Montage und Metamechanik*, 22.

27 Bergius, *Montage und Metamechanik*, 22.

28 In this regard, Berlin Dada montage calls for approaches that differ from those that have lately shaped the study of cubist collage, in particular the work of Pablo Picasso and Georges Braque, as analyzed powerfully by Yve-Alain Bois and Rosalind Krauss. See Yve-Alain Bois, "Kahnweiler's Lesson," in Bois, *Painting as Model* (Cambridge, Mass., 1990), 65–97; Bois, "The Semiology of Cubism," in William Rubin et al. *Picasso and Braque: A Symposium* (New York, 1992), 169–208; Rosalind Krauss, "The Cubist Epoch" (review essay), *Artforum* 9, no. 6 (February 1971): 32–38; Krauss, "In the Name of Picasso," in Krauss, *The Originality of the Avant-Garde and Other Modernist Myths* (Cambridge, Mass., 1985), 23–40; and Krauss, "The Motivation of the Sign," in Rubin et al. *Picasso and Braque: A Symposium*, 261–286.

29 Bergius, *Montage und Metamechanik*, 276. On *The Great Plasto-Dio-Dada-Drama* see also Michael White, "Johannes Baader's *Plasto-Dio-Dada-Drama*: The Mysticism of the Mass Media," *Modernism/Modernity* 8, no. 4 (November 2001): 583–602.

30 See Barbara McCloskey, *George Grosz and the Communist Party: Art and Radicalism in Crisis* (Princeton, NJ, 1997), 55. McCloskey cites the figure of 7600 copies as part of Walter Mehring's account of the distribution of *Jedermann sein eigner Fussball*, for which she provides a reference to *Dada: Art and Anti-Art*, 110–111. Although no mention of the number of copies sold appears in Richter's citation of Mehring in *Dada: Art and Anti-Art*, 110–112, I present here the figure as stated by McCloskey.

31 See Brigid Doherty, "Figures of the Pseudorevolution," *October* 84 (Spring 1998): 75–80.

32 On the Dada Fair, see Helen Adkins, "Erste Internationale Dada-Messe," in *Stationen der Moderne*, 157–83, and Bergius, *Montage und Metamechanik*, 233–304, 349–414.

33 See Bergius, *Montage und Metamechanik*, 289.

34 See Bergius, *Montage und Metamechanik*, 293–296, and Rosamunde Neugebauer, *George Grosz: Macht und Ohnmacht satirischer Kunst* (Berlin, 1993), 73–78.

35 See Bergius, *Montage und Metamechanik*, 285–287.

36 Bundesarchiv, Potsdam: Auswärtiges Amt, Zentralstelle für Auslandsdienst, 919/1 "Ausstellungspropaganda."

37 See Hausmann, Schlichter, Grosz, and

Heartfield, "Die Gesetze der Malerei," a manifesto published posthumously in Thater-Schulz, ed., *Hannah Höch: Eine Lebenscollage*, vol. 1, part 2 (1919–1920) (Berlin, 1989), 696–698.

38 For a concise account of the significance of Giorgio de Chirico and *pittura metafisica* for Berlin Dada, see Roland März, "Republikanische Automaten: George Grosz und die Pittura metafisica," in Schuster, ed., *George Grosz: Berlin—New York*, 147–156.

39 For more on the figure of the *Spiesser*, see Brigid Doherty, "The Work of Art and the Problem of Politics in Berlin Dada," *October* 105 (Summer 2003): 73–92.

40 Adolf Behne, *Neues Wohnen, Neues Bauen* (1927), cited in Walter Benjamin, *The Arcades Project*, trans. Howard Eiland and Kevin McLaughlin (Cambridge, Mass., 1999), 215. Translation slightly modified.

41 Kokoschka, cited in Claude Cernuschi, *Re/Casting Kokoschka: Ethics and Aesthetics, Epistemology and Politics in Fin-de-Siècle Vienna* (London, 2002), 55.

42 See, for example, Jaroslaw Leshko, "Kokoschka's Knight Errant," *Arts Magazine* (January 1982), 126–133; Thomas M. Messer, "Der irrende Ritter," in *Oskar Kokoschka* (Vienna, 1986), 183–186; and Werner Hofmann, "Der irrende Ritter," in *Oskar Kokoschka*, 265–278.

43 See Tobias G. Natter, ed., *Oskar Kokoschka: Early Portraits from Vienna and Berlin, 1909–1914* [exh. cat., Neue Galerie] (New York, 2002), 180.

44 George Grosz and John Heartfield, "Der Kunstlump," in *Der Gegner* 10–12 (n.d. [April 1920]; reprint, Berlin, 1979), 53.

45 Grosz and Heartfield, "Der Kustlump," 55. Italics in original.

46 On modernism and disenchantment, see T. J. Clark, *Farewell to an Idea: Episodes from a History of Modernism* (New Haven and London, 1999), 7; on modernist disenchantment and reenchantment in the art of Adolf Menzel, see Michael Fried, *Menzel's Realism: Art and Embodiment in Nineteenth-Century Berlin* (New Haven and London, 2002), 231–246.

47 See Doherty, "The Work of Art and the Problem of Politics in Berlin Dada," 80–88.

48 See Doherty, "Trauma of Dada Montage," 102–118.

49 Wieland Herzfelde, "Introduction to the First International Dada Fair" (1920), trans. Brigid Doherty, *October* 105 (Summer 2003), 103.

50 The peculiar perspectival construction of pictorial space in these Berlin Dada works has its origins in the so-called metaphysical paintings of Giorgio de Chirico, which were also

important to the development of the art of Max Ernst (1891–1976) and Paul Klee (1879–1940), among others, around 1918–20. See Hal Foster, "Convulsive Identity," *October* 57 (Summer 1991), 18–54; Rosalind Krauss, "The Master's Bedroom," *Representations* 28 (Fall 1989), 55–76; Krauss, *The Optical Unconscious* (Cambridge, Mass., 1993), 33–98; and Ann Temkin, "Klee and the Avant-Garde, 1912–1940," in ed., Carolyn Lanchner, *Paul Klee* [exh. cat., Museum of Modern Art] (New York, 1987), 13–37.

51 Middle-class interiors figure as a subject of significant interest in German literature and philosophy circa 1914–1940; some instances of particular salience with regard to Dada montage are: Georg Kaiser, *From morn to midnight*, trans. Ashley Dukes (1916; New York, 1922); Bertolt Brecht, *Drums in the Night* (1919–22), trans. John Willett in Brecht, *Collected Plays*, 8 vols., ed. John Willett (1970; London, 1994), vol. 1, 63–115; Theodor Adorno, *Kierkegaard: Construction of the Aesthetic*, trans., ed., foreword by Robert Hullot-Kentor (1933; Minneapolis, 1989); and Walter Benjamin, *The Arcades Project.*

52 For more on the publication of this photograph and its significance for the culture and politics of the early Weimar Republic see, Doherty, "Figures of the Pseudorevolution," 69–77.

53 Although it is neither visible in installation photographs nor listed in the exhibition catalogue, *Dada-Panorama* was consistently named by Höch as one of the works she showed at the Dada Fair. See Suzanne Pagé, "Interview avec/mit Hannah Höch," in Pagé et al., *Hannah Höch* [exh. cat., Musée d'art moderne de la Ville de Paris] (Paris, 1976), 28; Adkins, "Erste Internationale Dada-Messe," in *Stationen der Moderne*, 180; and Bergius, "Dada Rundschau: Eine Photomontage," in *Hannah Höch 1889–1978*, 101–106.

54 Maria Makela has identified the face at the far left as General Ludendorff's and the one at far right as General von Seeckt's. See Makela, "By Design: The Early Work of Hannah Höch in Context," in Peter Boswell et al., *The Photomontages of Hannah Höch* [exh. cat., Walker Art Center] (Minneapolis, 1996), 61. The Kaiser appears here once again, third from left, while the detached heads recall the popular practice of gluing individual portrait photographs of soldiers onto mass-produced images of military figures that was one of the sources for Berlin Dada's self-described "invention" of photomontage during World War I. That practice and the origin myth of Dada montage that drew on it are here ironically inverted as heads are made to fly off.

55 On the political engagement of the Berlin dadaists, see Samantha Kate Winskell, "Dada, Russia, and Modernity, 1915–1922" (Ph.D. diss., Courtauld Institute, London, 1995); Richard Sheppard, "Dada and Politics," in *Dada: Studies of a Movement*, ed. Richard Sheppard (Chalfont St. Giles, 1980), 51–60; and McCloskey, *George Grosz and the Communist Party*, 48–103.

56 Hausmann, "Alitterel—Delitterel—Sublitterel" (1919), *Bilanz der Feierlichkeit: Texte bis 1933*, Michael Erlhoff, ed., vol. 1(Munich, 1982), 56. On the depiction of Kaiser Wilhelm II in Berlin Dada montage, see Doherty, "Figures of the Pseudorevolution."

57 See Ernst Kris and E. H. Gombrich, "The Principles of Caricature," in Kris, *Psychoanalytic Explorations in Art* (New York, 1952), 190.

58 See Bergius, "Dada Rundschau," 106; and Boswell et al., *The Photomontages of Hannah Höch*, 27. On women in the politics of the Weimar Republic, 1918–1920, see Julia Sneeringer, *Winning Women's Votes: Propaganda and Politics in Weimar Germany* (Chapel Hill and London, 2002), 19–68.

59 See Maud Lavin, *Cut with the Kitchen Knife: The Weimar Photomontages of Hannah Höch* (New Haven, 1993), 37; and Boswell et al., *The Photomontages of Hannah Höch*, 27. In "Dada Rundschau" (105), Bergius describes the montage as appearing ambivalent on this point.

60 On *Cut with the Kitchen Knife*, see Dawn Ades, *Photomontage* (London, 1976), 30–32; Gertrud Jula Dech, *Schnitt mit dem Küchenmesser Dada durch die letzte Weimarer Bierbauchkulturepoche Deutschlands: Untersuchungen zur Fotomontage bei Hannah Höch* (Münster, 1981); Dech, *Hannah Höch: Schnitt mit dem Küchenmesser Dada durch die letzte Weimarer Bierbauchkulturepoche Deutschlands* (Frankfurt am Main, 1989); Lavin, *Cut with the Kitchen Knife*, 19–35; Courtney Federle, "Kuchenmesser DADA: Hannah Höch's Cut through the Field of Vision," *Qui Parle* 5, no. 2 (Spring/Summer 1992), 120–134; Makela, "By Design," 61–64; and Bergius, *Montage und Metamechanik*, 130–159.

61 One could of course speak here of the Kaiser's *uncanniness* in the terms put forth by Freud in "The Uncanny" (1919), where he mentions in particular "the impression made by wax work figures, ingeniously constructed dolls and automata." See Freud, "The Uncanny," *The Standard Edition of the Complete Psychological Works of Sigmund Freud*, vol. 17 (London, 1955), 217–256. For a discussion of Freud's text with specific reference to the automaton in surrealism but with implica-tions for the study of Dada as well, see Hal Foster, *Compulsive Beauty* (Cambridge, Mass., 1993), 128–140.

62 Walter Benjamin, "The Work of Art in the Age of Its Technological Reproducibility (Second Version)," in *Selected Writings*, ed. Michael W. Jennings et al. (Cambridge, Mass. 1996–2003), vol. 3, 118.

63 Benjamin, "The Work of Art in the Age of Its Technological Reproducibility (Second Version)," 119. See Miriam Bratu Hansen, "Benjamin and Cinema: Not a One-Way Street," *Critical Inquiry* 25, no. 2 (Winter 1999): 306–43; Hansen, "Room for Play: Benjamin's Gamble with Cinema," *October* 109 (Summer 2004): 3–45; and Howard Eiland, "Reception in Distraction," *Boundary 2* 30, no. 1 (Spring 2003): 51–66.

BERLIN

PLATES

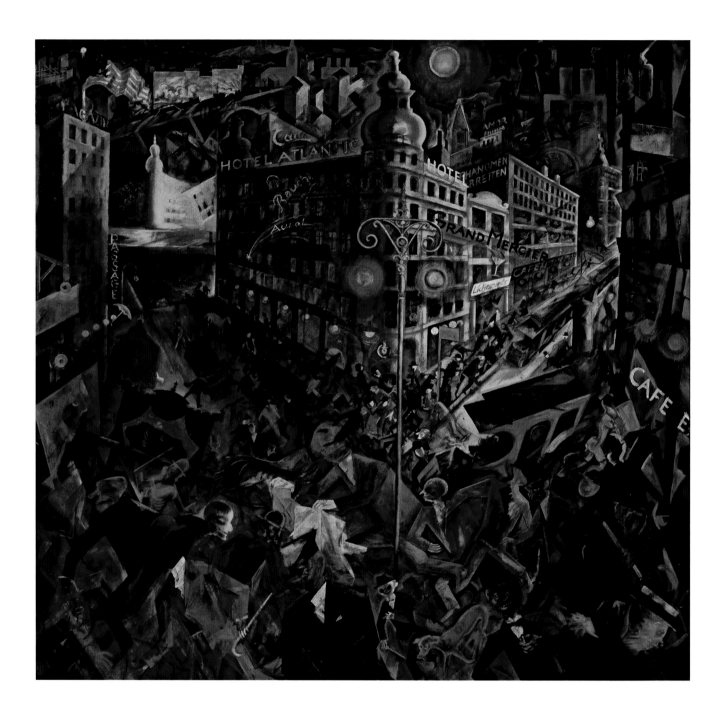

67 GEORGE GROSZ *Menschen im Café* (People in a Café), 1917,
ink on paper, 44 × 58.9 (17 5⁄16 × 23 3⁄16). The British Museum, London

68 GEORGE GROSZ *Panorama (Nieder mit Liebknecht)*
(Panorama [Down with Liebknecht]), 1919, ink and watercolor on paper,
48.9 × 34.6 (19 1⁄4 × 13 5⁄8). Private collection

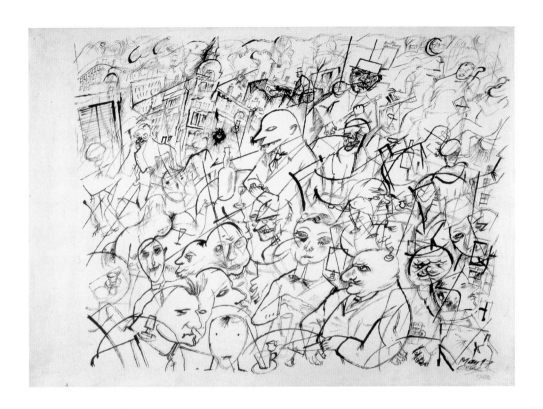

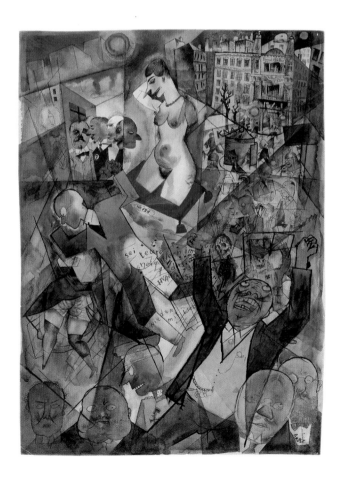

69 GEORGE GROSZ *Die Stimme des Volkes, die Stimme Gottes* (Voice of the People, Voice of God), 1920, ink and collage on paper, 35.3 × 50 (13 ⅛ × 19 ¹¹⁄₁₆). Centre Pompidou, Musée national d'art moderne-Centre de création industrielle, Paris. Purchase, 1978

70 GEORGE GROSZ Front and back covers for the journal *Der blutige Ernst*, no. 3: *Der Schuldigen* (Bloody Serious, no. 3: The Guilty Ones), Carl Einstein and George Grosz editors, November 1919, letterpress, open: 38 × 55.6 (14 ¹⁵⁄₁₆ × 21 ⅞). The Museum of Modern Art, New York. The Museum of Modern Art Library

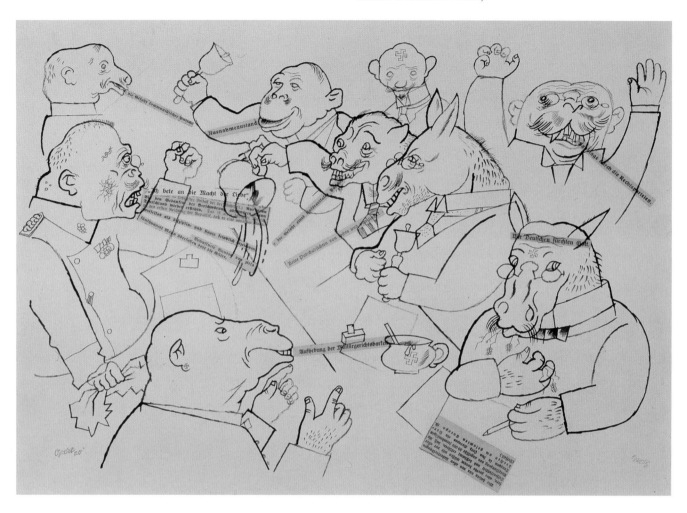

71 GEORGE GROSZ *Der Schuldige bleibt unerkannt* (The Guilty
One Remains Unknown), 1919, collage with ink on paper, 53.8 × 35.9
(21 ³⁄₁₆ × 14 ⅛). The Art Institute of Chicago, Gift of Mr. and Mrs.
Stanley M. Freehling, 1964.236

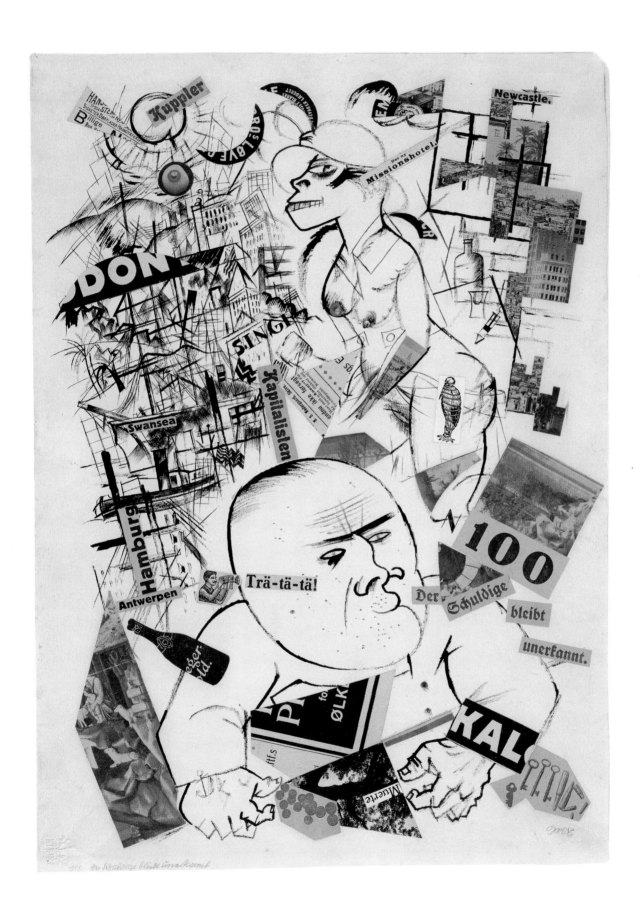

72 GEORGE GROSZ *Ein Opfer der Gesellschaft* (A Victim of Society)
(later titled *Remember Uncle August, the Unhappy Inventor*), 1919, oil and
graphite on canvas with photomontage and collage of papers and
buttons, 49 × 39.5 (19 ⁵⁄₁₆ × 15 ⁹⁄₁₆). Centre Pompidou, Musée national d'art
moderne-Centre de création industrielle, Paris. Purchase, 1977

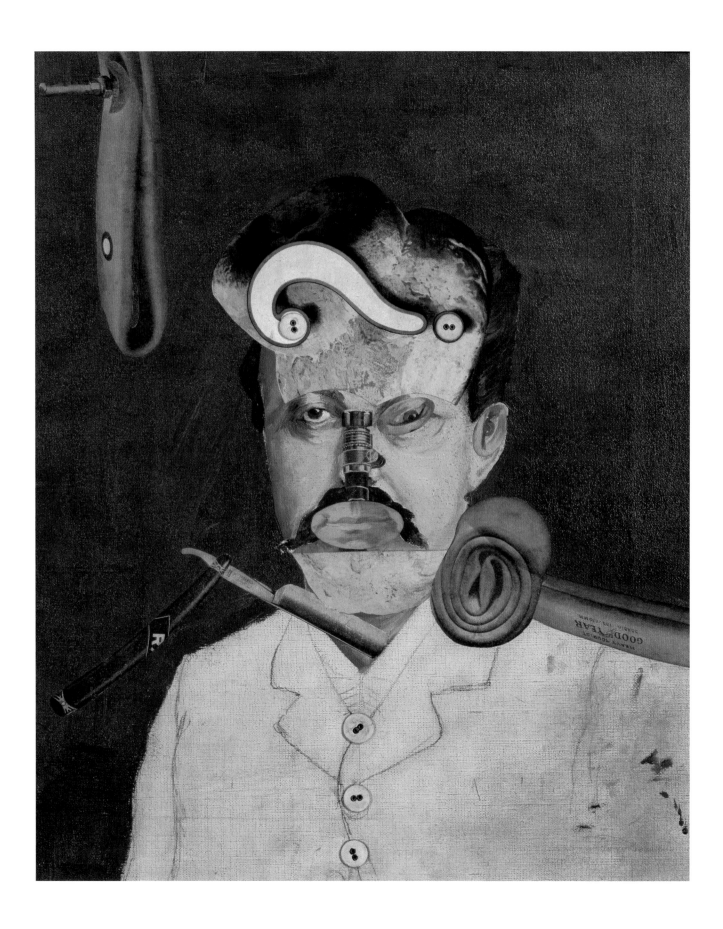

GEORGE GROSZ Prints from the portfolio *Gott mit uns* (God with Us), Malik-Verlag, 1920, two of ten photolithographs (nine prints plus illustrated cover), each sheet: 49 × 35.5 (19 5⁄16 × 13 15⁄16). Los Angeles County Museum of Art, the Robert Gore Rifkind Center for German Expressionist Studies

73 Plate 4: *Licht und Luft dem Proletariat* (Light and Air for the Proletariat)/*Liberté, égalité, fraternité* (Liberty, Equality, Fraternity)/ *The Workman's Holiday*, 1919, composition: 34.9 × 29.7 (13 3⁄4 × 11 11⁄16)

74 Plate 5: *Die Gesundbeter* (The Faith Healers)/*Le Triomphe des sciences exactes* (Triumph of the Exact Sciences)/*German Doctors Fighting the Blockade*, 1918, composition: 31.6 × 29.6 (12 7⁄16 × 15 5⁄8)

LIBERTÉ, ÉGALITÉ, FRATERNITÉ LICHT UND LUFT DEM PROLETARIAT THE WORKMANS HOLIDAY

LE TRIOMPHE DES SCIENCES EXACTES DIE GESUNDBETER GERMAN DOCTORS FIGHTING THE BLOCKADE

75 GEORGE GROSZ *"Der Sträfling" Monteur John Heartfield nach Franz Jungs Versuch ihn auf die Beine zu stellen* ("The Convict" Monteur John Heartfield after Franz Jung's Attempt to Get Him Up on His Feet) (also known as *The Engineer Heartfield*), 1920, watercolor and pencil on paper with photomontage, 41.9 × 30.5 (16 ½ × 12). The Museum of Modern Art, New York. Gift of A. Conger Goodyear

76 GEORGE GROSZ *Tatlinistischer Planriss* (Tatlinesque Diagram), 1920, watercolor, pencil, and ink on paper with photomontage and collage, 41 × 29.2 (16 ⅛ × 11 ½). Museo Thyssen-Bornemisza, Madrid

77 GEORGE GROSZ *"Daum" marries her pedantic automaton "George" in May 1920, John Heartfield is very glad of it. (Meta-Mech. constr. nach* [according to] *Prof. R. Hausmann)*, 1920, watercolor, pencil, and ink on paper with photomontage and collage, 42 × 30.2 (16 ⁹⁄₁₆ × 11 ⅞). Berlinische Galerie, Landesmuseum für Moderne Kunst, Photographie und Architektur

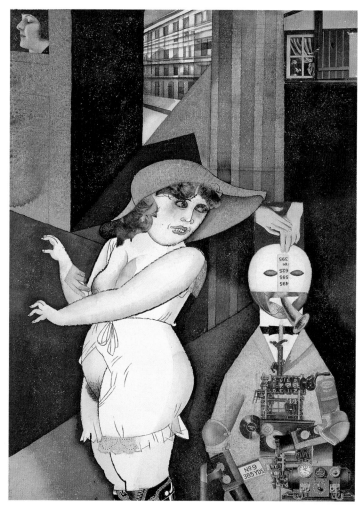

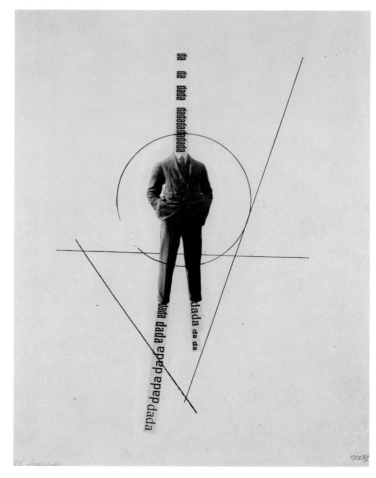

80 JOHN HEARTFIELD and **RUDOLF SCHLICHTER** *Preussischer Erzengel* (Prussian Archangel), 2004 (reconstruction of lost 1920 original), papier mâché (pig's head); wire mesh (body); palm grass, hemp, and horse hair (filling); uniform cut from field gray material, following original pattern; World War I field cap, boots, and shoulder lapels; woodcut signs; height c. 180 (72). Neue Galerie New York

81 GEORGE GROSZ and **JOHN HEARTFIELD** *Der wildgewordene Spiesser Heartfield (Elektro-mechan. Tatlin-Plastik)* (The Middle-Class Philistine Heartfield Gone Wild [Electro-Mechanical Tatlin Sculpture]), 1988 (reconstruction of 1920 original), tailor's dummy, revolver, doorbell, knife, fork, letter "C" and number "27" signs, plaster dentures, embroidered insignia for the Black Eagle Order on horse blanket, Osram light bulb, Iron Cross, stand, and other objects, overall, including base: 220 × 45 × 45 (85 ¹³⁄₁₆ × 17 ¹¹⁄₁₆ × 17 ¹¹⁄₁₆). Acquired from Projektmitteln des Senators für kulturelle Angelegenheiten, Berlin 1988. Berlinische Galerie, Landesmuseum für Moderne Kunst, Photographie und Architekur

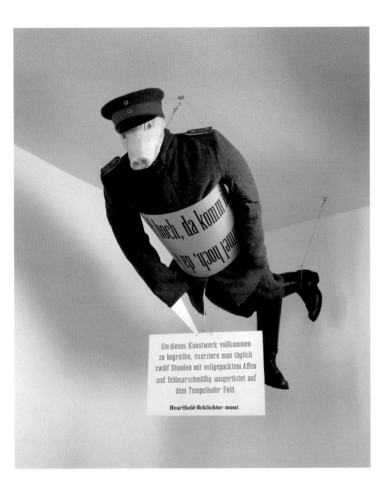

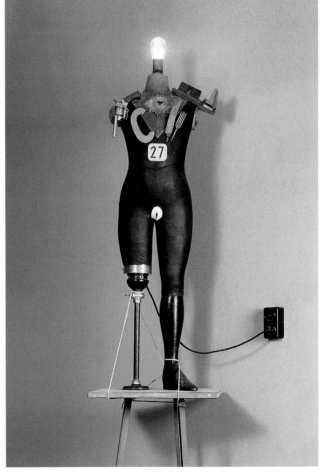

82 JOHN HEARTFIELD Cover of the journal *Der dada*, no. 3, Raoul Hausmann, John Heartfield, and George Grosz editors, Malik-Verlag, April 1920, photolithograph, 23 × 15.6 (9 1/16 × 6 1/8). National Gallery of Art, Library, Gift of Thomas G. Klarner

83 GEORGE GROSZ and **JOHN HEARTFIELD** Cover of the book *Dada siegt! Eine Bilanz des Dadaismus* (Dada Triumphs! A Report on Dadaism) by Richard Huelsenbeck, Malik-Verlag, 1920, 22.3 × 14 (8 3/4 × 5 1/2). Elaine Lustig Cohen Dada Collection, The New York Public Library, Astor, Lenox and Tilden Foundations

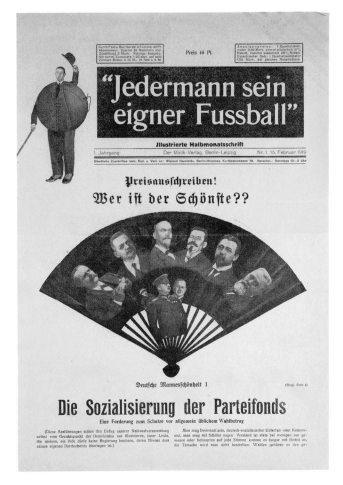

88 RAOUL HAUSMANN *Elasticum*, 1920, photomontage and collage
with gouache on the cover of the exhibition catalogue *Erste Internationale
Dada-Messe* (First International Dada Fair), 31 × 37 (12 ³⁄₁₆ × 14 ⁹⁄₁₆).
Galerie Berinson, Berlin / UBU Gallery, New York

89 RAOUL HAUSMANN *Selbstporträt des Dadasophen* (Self-Portrait
of the Dadasoph), 1920, photomontage and collage on Japanese
paper, 36.2 × 28 (14 ¼ × 11). Private collection, Courtesy Annely Juda
Fine Art, London

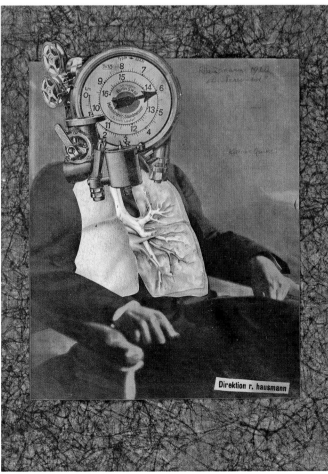

90 RAOUL HAUSMANN *P*, 1921, collage with ink, 31.2 × 22 (12 ⁵⁄₁₆ × 8 ¹¹⁄₁₆).
Hamburger Kunsthalle

91 RAOUL HAUSMANN *Dada im gewöhnlichen Leben* (Dada in
Ordinary Life) (also known as *Dada Cino* [Dada Cinema]), 1920, collage and
photomontage on paper with ink inscription, 31.7 × 22.5 (12 ½ × 8 ⅞).
Private collection

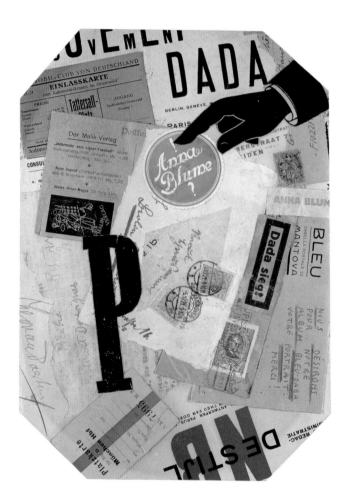

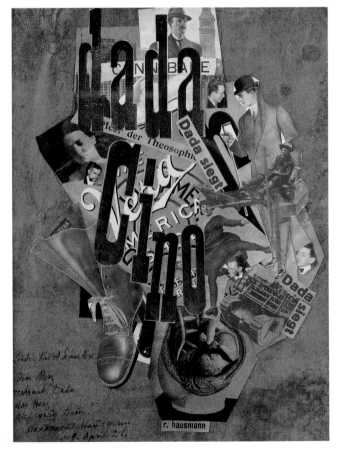

92 RAOUL HAUSMANN *Porträt einer alten Frau (Dr. S. Friedlaender-Mynoud)* (Portrait of an Old Woman…) (also known as *Mynona*), 1919, collage on silver Japanese paper, 25.5 × 21.2 (10 1/16 × 8 3/8). Collection Merrill C. Berman

93 RAOUL HAUSMANN *Synthetisches Cino der Malerei* (Synthetic Cinema of Painting), 1918, collage of cigar wrappers and fabric on printed Japanese paper, 37.8 × 28.2 (14 7/8 × 11 1/8). With text of Raoul Hausmann's first Dada manifesto, 1918. Collection Merrill C. Berman

94 RAOUL HAUSMANN *Der Kunstreporter* (The Art Critic), 1919–1920, photomontage and collage with ink stamp and crayon on printed poster poem, 31.8 × 25.4 (12 1/2 × 10). Tate. Purchased 1974

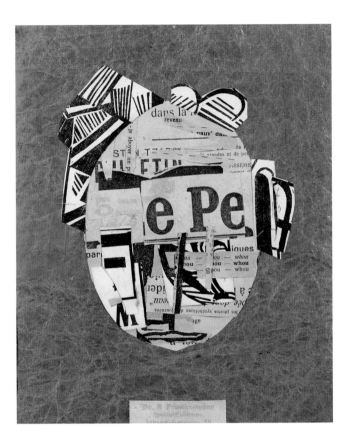

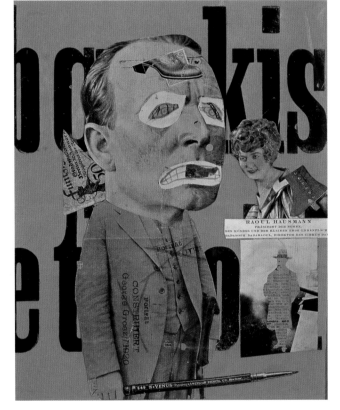

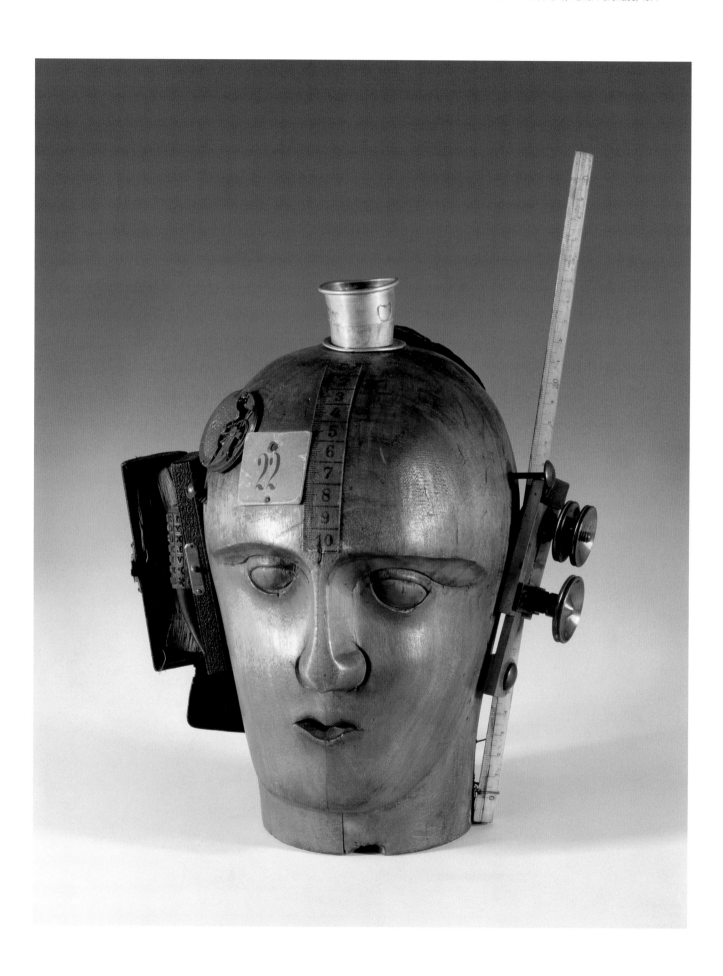

96 RAOUL HAUSMANN *Kutschenbauch dichtet* (Mr. Jones Makes Poetry), 1920, watercolor and gouache on paper, 42.5 × 32 (16 ¾ × 12 ⅝). Musée d'art moderne, Saint-Etienne

97 RAOUL HAUSMANN *Porträt Conrad Felixmüller als mechanischer Kopf* (Portrait of Conrad Felixmüller as a Mechanical Head), 1920, pencil on paper, 36.5 × 34.5 (14 ⅜ × 13 ⁹⁄₁₆). Staatliche Museen zu Berlin, Kupferstichkabinett

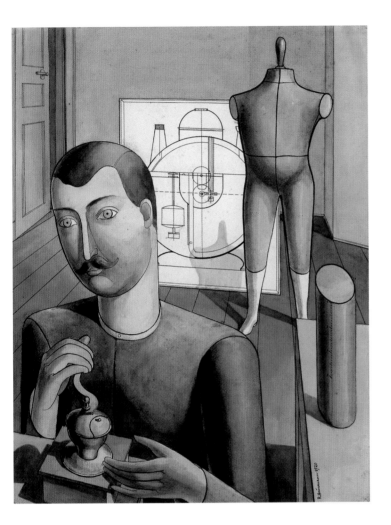

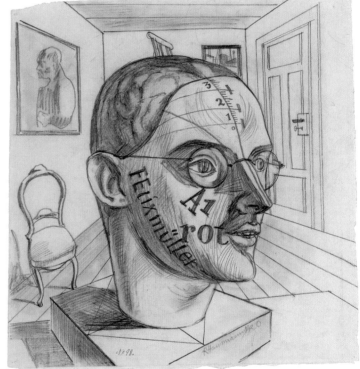

98 RAOUL HAUSMANN *ABCD* or *Portrait de l'artiste*, 1923–1924, collage
and photomontage on paper, 40.4 × 28.2 (15 ⅞ × 11 ⅛). Centre Pompidou,
Musée national d'art moderne-Centre de création industrielle, Paris.
Purchase, 1974

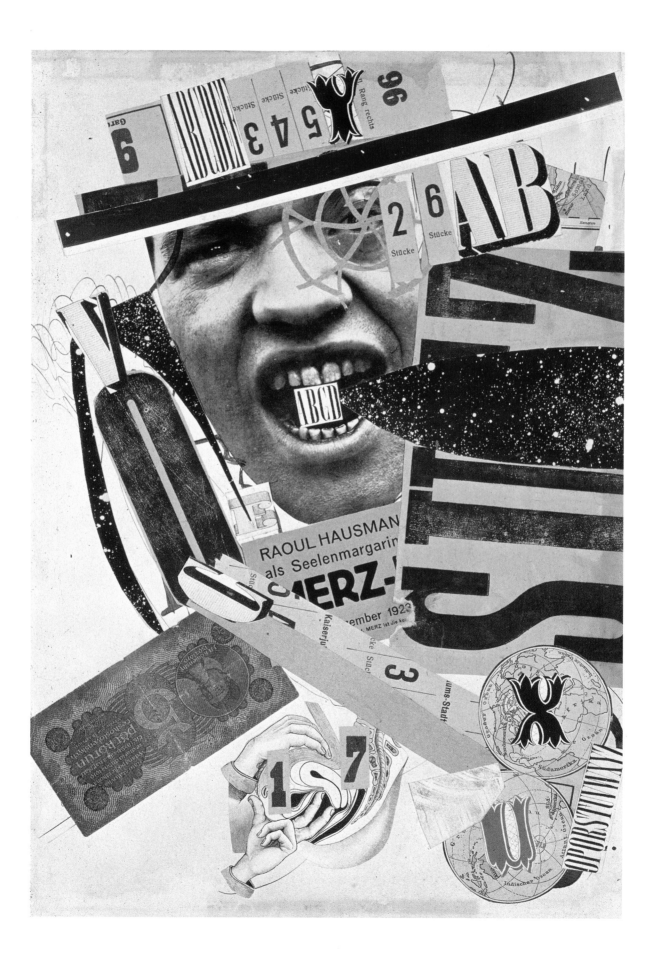

99 RAOUL HAUSMANN *OFFEAHBDC*, poster poem, 1918, line block, 32.5 × 47.5 (12 ¹³⁄₁₆ × 18 ¹¹⁄₁₆). Centre Pompidou, Musée national d'art moderne-Centre de création industrielle, Paris. Purchase, 1974

100 RAOUL HAUSMANN *fmsbwtözäu*, poster poem, 1918, line block, 33 × 48 (13 × 18 ⅞). Centre Pompidou, Musée national d'art moderne-Centre de création industrielle, Paris. Purchase, 1974

101 RAOUL HAUSMANN *391 Berlin-Dresden*, 1921, ink on paper with photomontage and collage, 43.3 × 35 (17 ⅛ × 13 ¾). Courtesy Galerie Natalie Seroussi

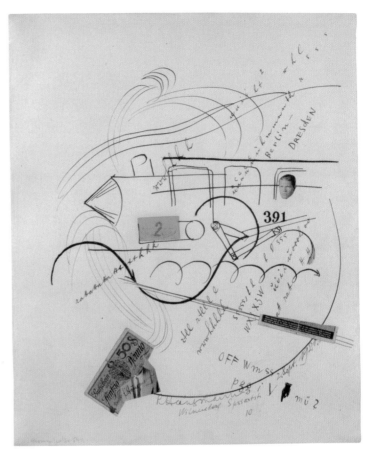

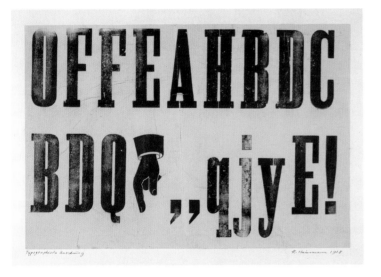

102 RAOUL HAUSMANN and **JOHANNES BAADER** Untitled, 1919/1920, printed reproduction of photomontage, on newsprint, 25.4 × 15.8 (10 × 6 ¼). Kunsthaus Zürich, Graphische Sammlung

103 JOHANNES BAADER *Der Verfasser des Buches "Vierzehn Briefe Christi" in seinem Heim* (The Author of the Book "Fourteen Letters of Christ" in His Home), c. 1920, photomontage and collage on book page with ink inscription, 21.6 × 14.6 (8 ½ × 5 ¾). The Museum of Modern Art, New York. Purchase

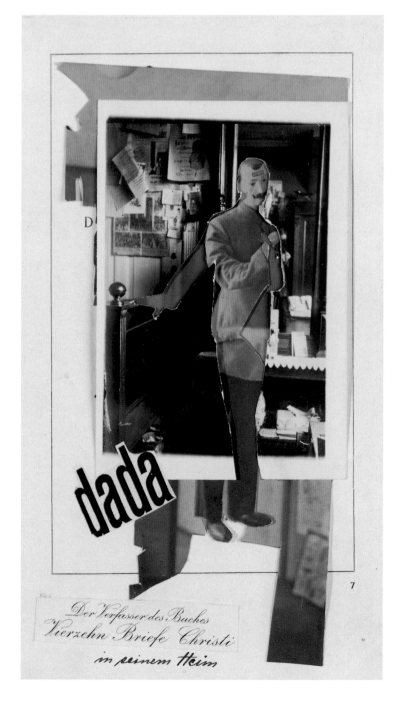

104 JOHANNES BAADER *Reklame für mich: Dada Milchstrasse*
(Advertisement for Myself: Dada Milky Way), 1919–1920, collage and
photomontage on poster by Raoul Hausmann for *Dada Milchstrasse*
(Dada Milky Way), 50 × 32.5 (19 11/16 × 12 13/16). Collection Merrill C. Berman

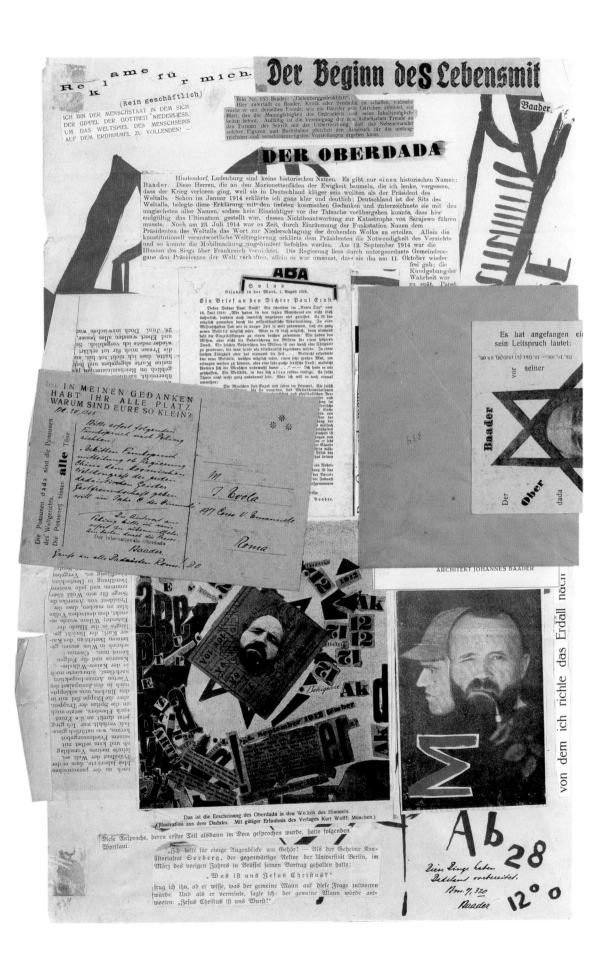

135

105 JOHANNES BAADER *Ehrenporträt von Charlie Chaplin* (Honorary Portrait of Charlie Chaplin) or *Gutenberggedenkblatt* (Commemorative Sheet for Gutenberg), 1919, collage with photomontage (photograph of Baader) on paper, 35 × 46.5 (13 ¾ × 18 ⁵⁄₁₆). Centre Pompidou, Musée national d'art moderne-Centre de création industrielle, Paris. Purchase, 1967

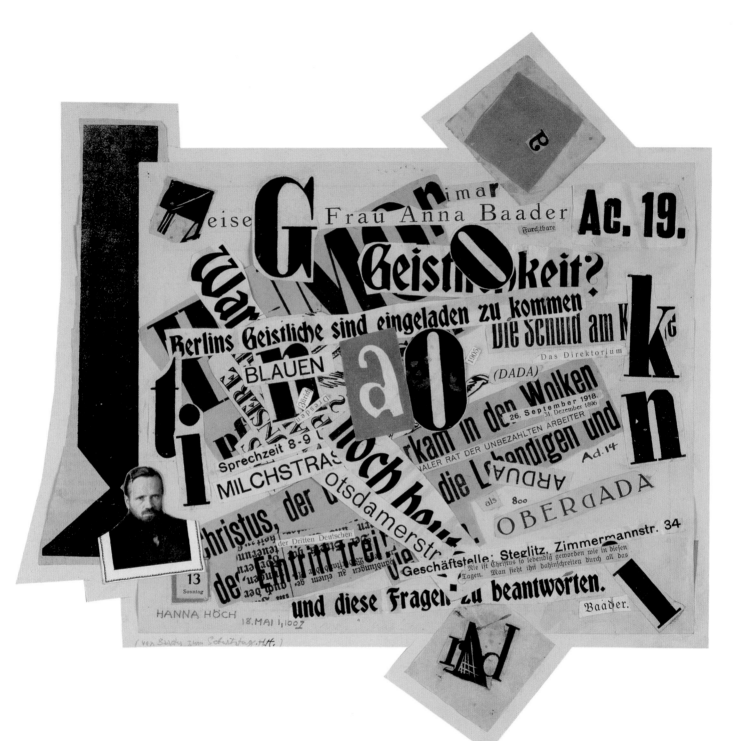

106 JOHANNES BAADER Front and back of leaflet *Dadaisten gegen Weimar* (Dadaists versus Weimar), Central Council of World Revolution, 1919, letterpress, 23.5 × 20.7 (9 ¼ × 8 ⅛). The Museum of Modern Art, New York. The Museum of Modern Art Library

107 JOHANNES BAADER Spread from *Gedankenbuch* (Commemorative Booklet), c. 1922, collage within booklet, 22 × 14.7 (8 ¹¹⁄₁₆ × 5 ¹³⁄₁₆). Private collection, Courtesy Annely Juda Fine Art, London

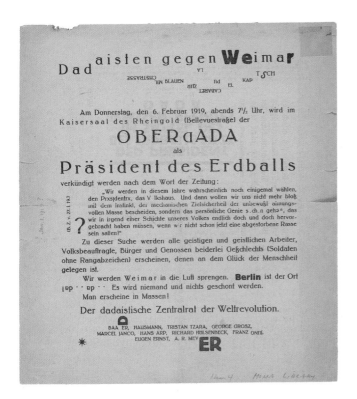

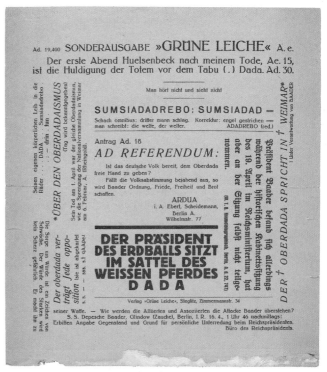

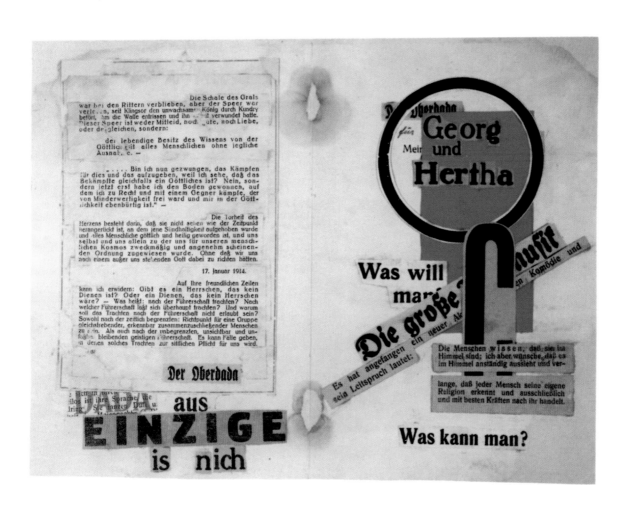

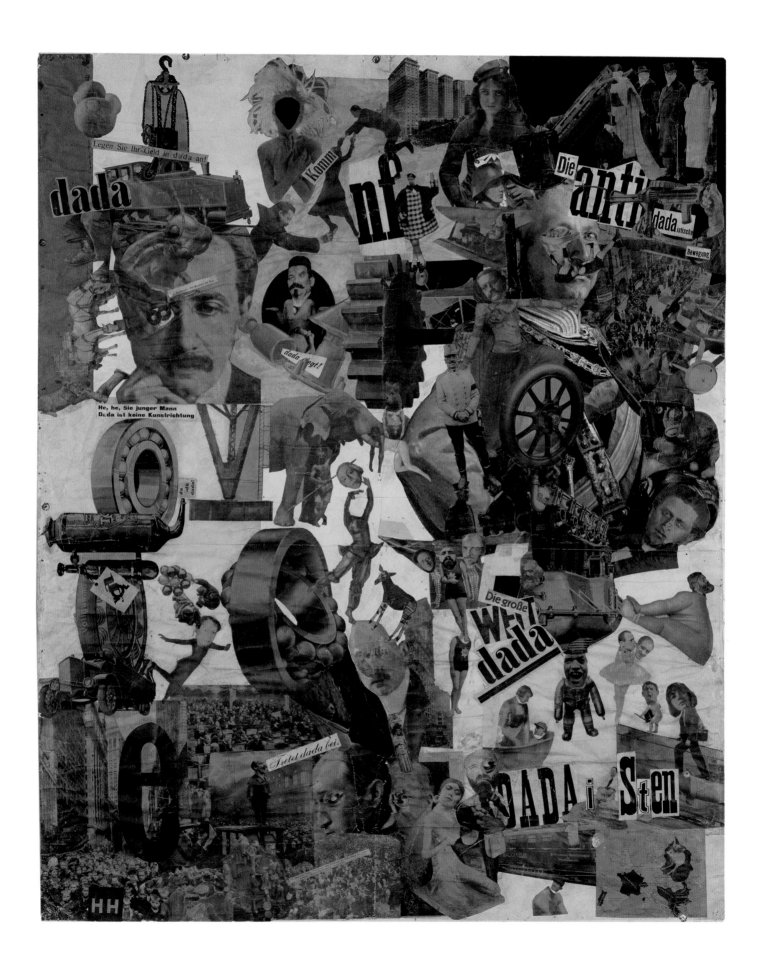

109 HANNAH HÖCH *Dada-Rundschau* (Dada Panorama), 1919, photomontage and collage with gouache and watercolor on board, 43.7 × 34.5 (17 ³⁄₁₆ × 13 ⁹⁄₁₆). Berlinische Galerie, Landesmuseum für Moderne Kunst, Photographie und Architektur

110 HANNAH HÖCH *Und wenn du Denkst, der Mond geht unter* (And When You Think the Moon Is Setting), 1921, photomontage and collage, 21 × 13.4 (8 ¼ × 5 ¼). Private collection

111 HANNAH HÖCH *Hochfinanz* (High Finance), 1923, photomontage and collage on paper, 36 × 31 (14 ³⁄₁₆ × 12 ³⁄₁₆). Galerie Berinson, Berlin/UBU Gallery, New York

112 HANNAH HÖCH *Staatshäupter* (Heads of State), 1918–1919, photomontage on iron-on embroidery pattern, 16.2 × 23.3 (6 ³⁄₈ × 9 ³⁄₁₆). Institut für Auslandsbeziehungen e.V., Stuttgart

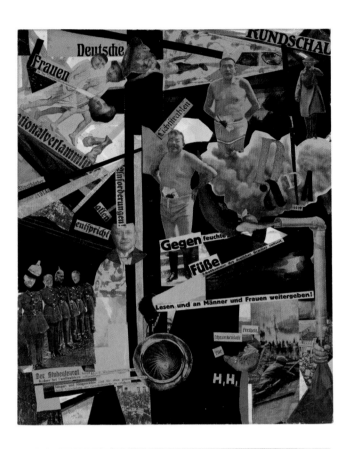

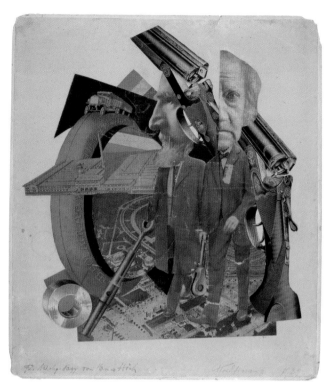

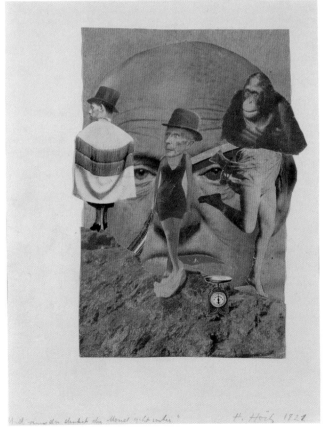

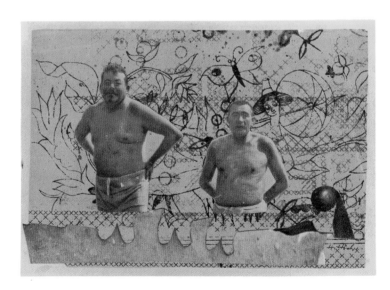

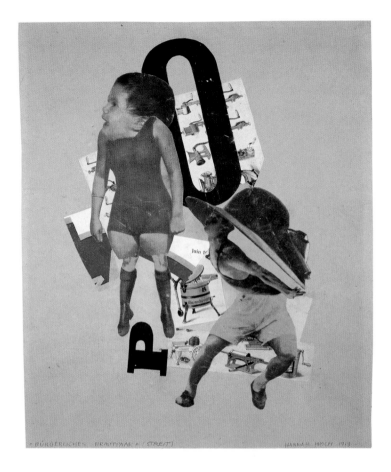

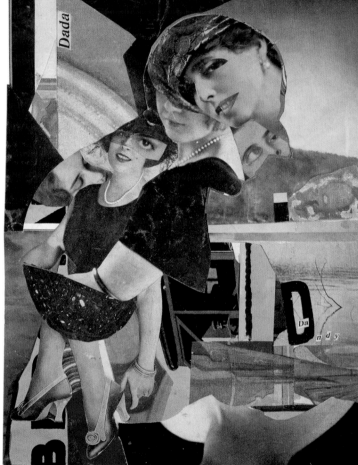

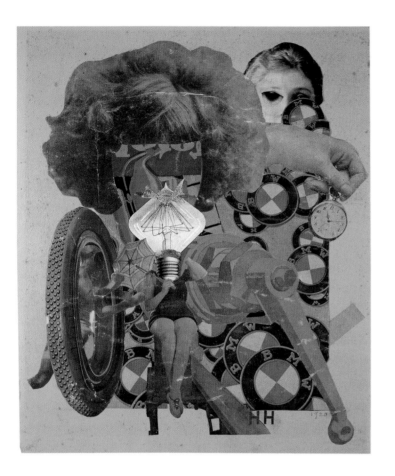

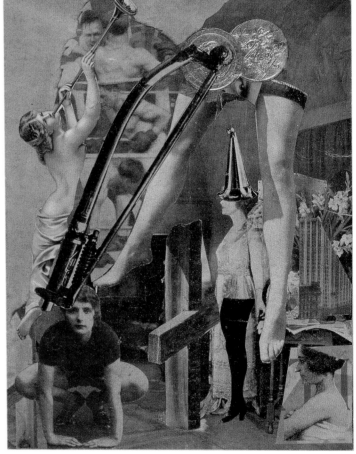

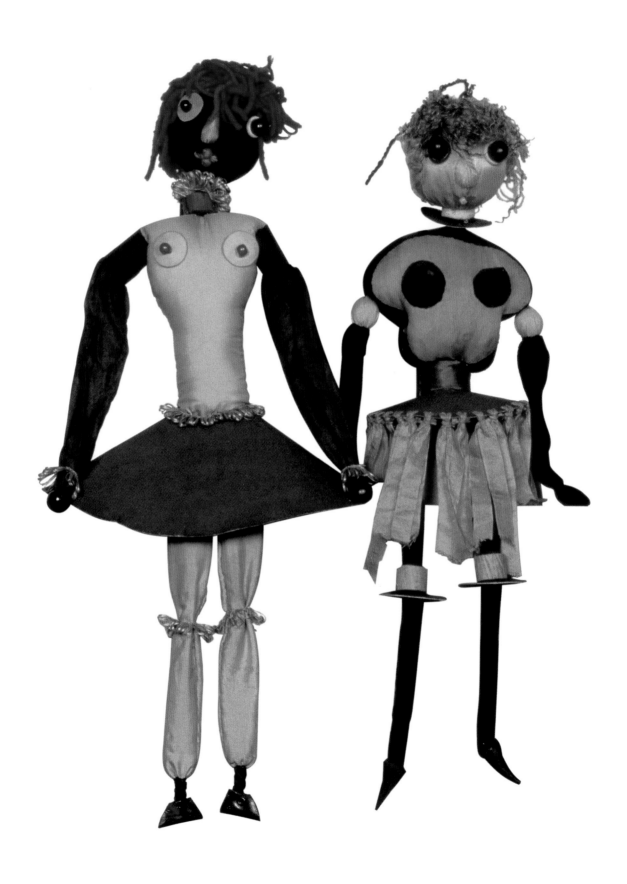

120 HANNAH HÖCH *Goldener Mond* (Golden Moon), 1923, collage and gouache on black construction paper, 19.2 × 26.5 (7 9/16 × 10 7/16). Collection Timothy Baum, New York

121 HANNAH HÖCH *Schneider Blume* (Tailor's Flower), 1920, collage (of cut sewing or handiwork patterns) with photomontage, in artist's frame with glued zippers, fasteners, and snaps: 51.6 × 43.8 × 3.4 (20 5/16 × 17 1/4 × 1 5/16). Hirshhorn Museum and Sculpture Garden, Smithsonian Institution, Gift of Louise Rosenfield Noun in Honor of James T. Demetrion, 1996

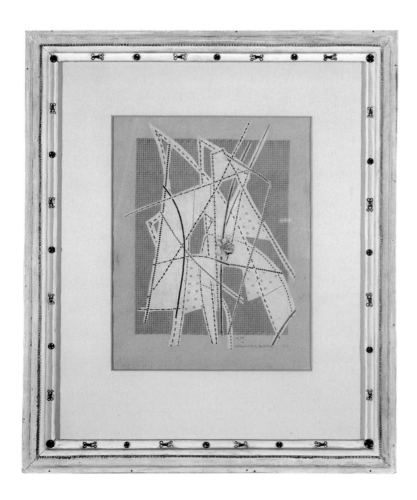

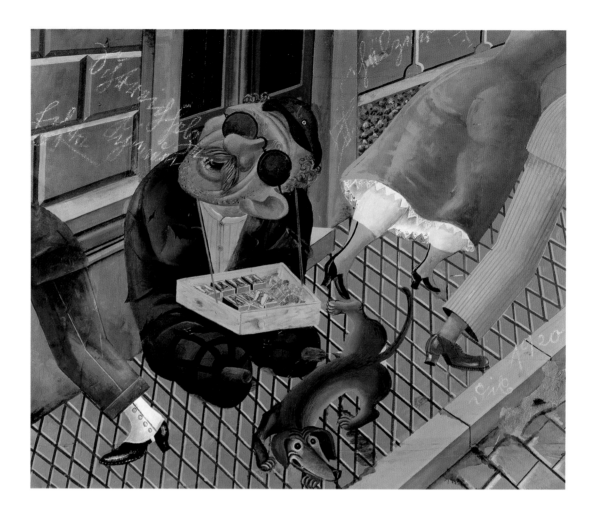

123 OTTO DIX *Die Skatspieler* (Skat Players) (later titled *Kartenspielende Kriegskrüppel* [Card-Playing War Cripples]), 1920, oil on canvas with photomontage and collage, 110 × 87 (43 ⁵⁄₁₆ × 34 ¼). Staatliche Museen zu Berlin, Nationalgalerie

124 OTTO DIX *Kriegskrüppel* (War Cripples), 1920, drypoint, plate 25.9 × 39.4 (10 ⅜ × 15 ½). The Museum of Modern Art, New York. Purchase

125 OTTO DIX *Prager Strasse* (Prague Street), 1920, oil on canvas with collage, 101 × 81 (39 ¾ × 31 ⅞). Galerie der Stadt Stuttgart

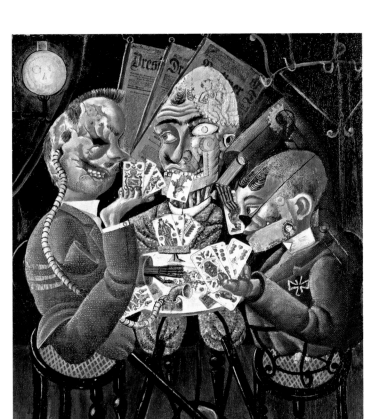

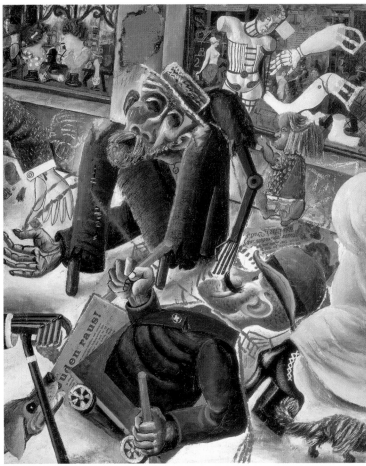

126 GEORG SCHOLZ *Bauernbild* (Farmer Picture), also known as
Industriebauern (Industrial Farmers), 1920, oil on wood with collage and
photomontage, 98 × 70 (38 ⁹/₁₆ × 27 ⁹/₁₆). Von der Heydt-Museum Wuppertal

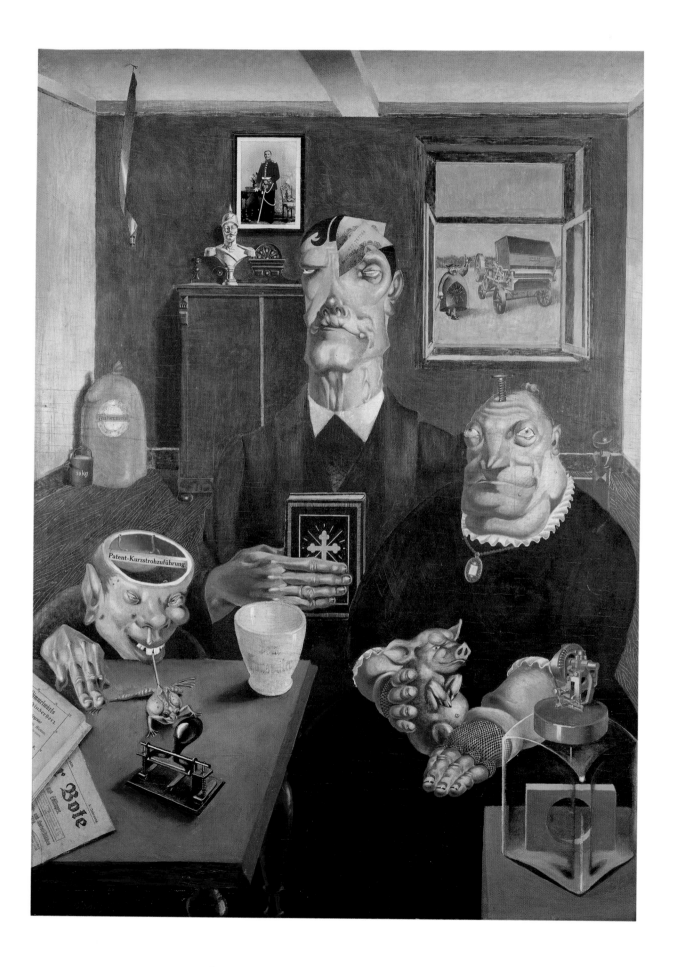

127 GEORG SCHOLZ *Von kommenden Dingen* (Of Things to Come),
1922, oil on board, 74.9 × 96.9 (29 ½ × 38 ⅛). Neue Galerie New York

128 OTTO DIX *Erinnerung an die Spiegelsäle von Brüssel*
(Memory of the Mirrored Halls in Brussels), 1920, oil on canvas,
124 × 80.4 (48 ¹³⁄₁₆ × 31 ⅝). Centre Pompidou, Musée national d'art
moderne-Centre de création industrielle, Paris. Purchase in
memory of Siegfried Poppe, 1999

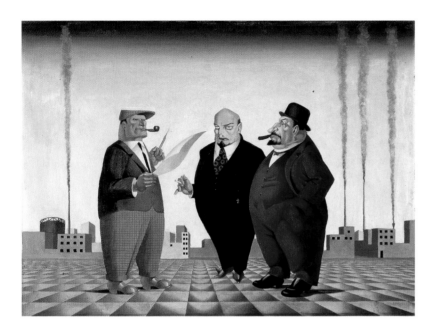

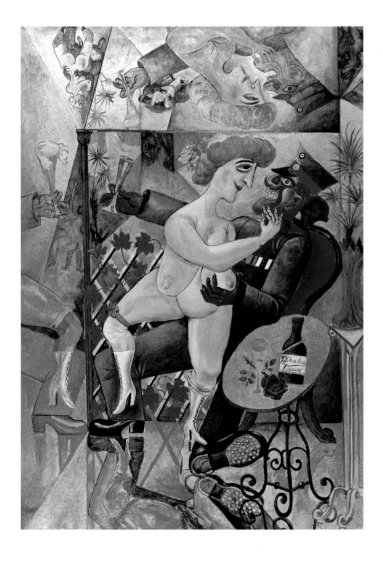

129 RUDOLF SCHLICHTER *Phänomen-Werke* (Phenomenon Works),
1920, photomontage and collage of papers and fabric with watercolor and
opaque watercolor on paper, 61.7 × 46.6 (24 ⁵⁄₁₆ × 18 ³⁄₈). Private collection,
Frankfurt am Main

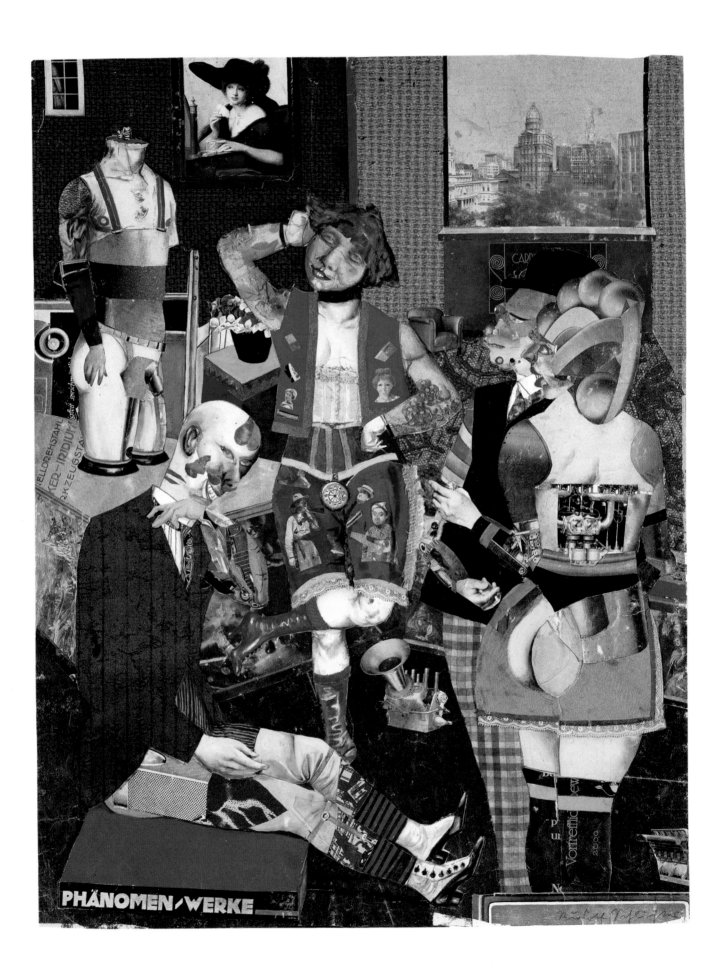

PHÄNOMEN/WERKE

130 RUDOLF SCHLICHTER *Dada Dachatelier* (Dada Rooftop Studio),
c. 1920, watercolor and ink on paper, 45.8 × 63.8 (18 $\frac{1}{16}$ × 25 $\frac{1}{8}$). Berlinische
Galerie, Landesmuseum für Moderne Kunst, Photographie und Architektur

131 RUDOLF SCHLICHTER *Tote Welt* (Dead World), c. 1920,
watercolor on paper, 49.5 × 64.7 (19 $\frac{1}{2}$ × 25 $\frac{1}{2}$). Staatsgalerie Stuttgart/
Graphische Sammlung

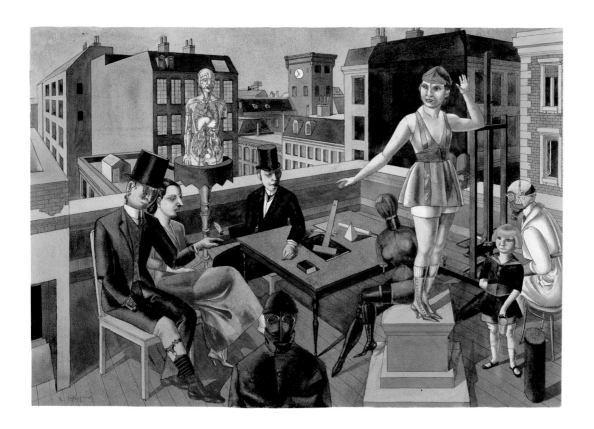

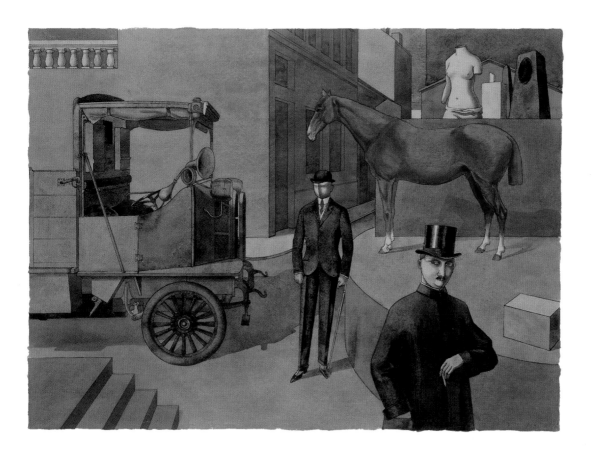

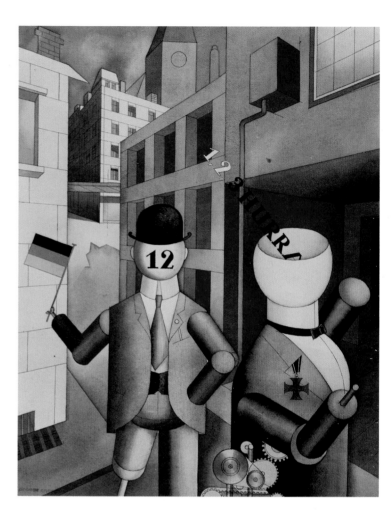

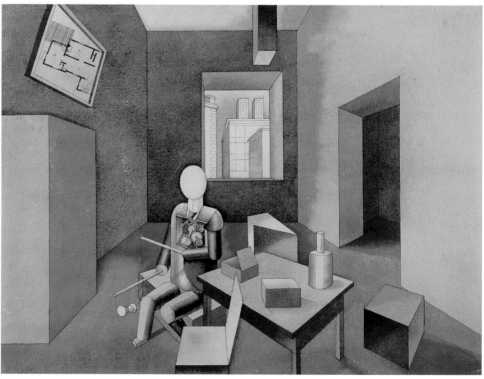

134 GEORGE GROSZ Untitled, 1920, oil on canvas, 81 × 61 (31 ⅛ × 24). Kunstsammlung Nordrhein-Westfalen, Düsseldorf

135 GEORGE GROSZ *Grauer Tag* (Gray Day), 1921, oil on canvas, 115 × 80 (45 ¼ × 31 ½). Staatliche Museen zu Berlin, Nationalgalerie

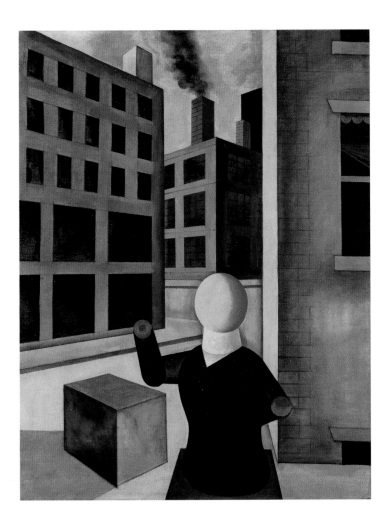

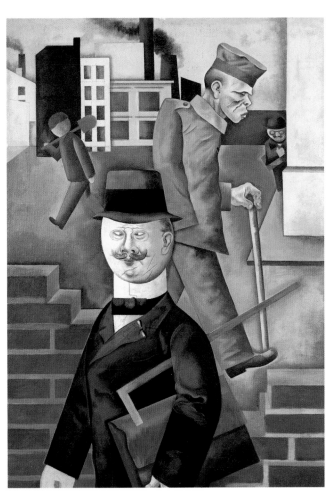

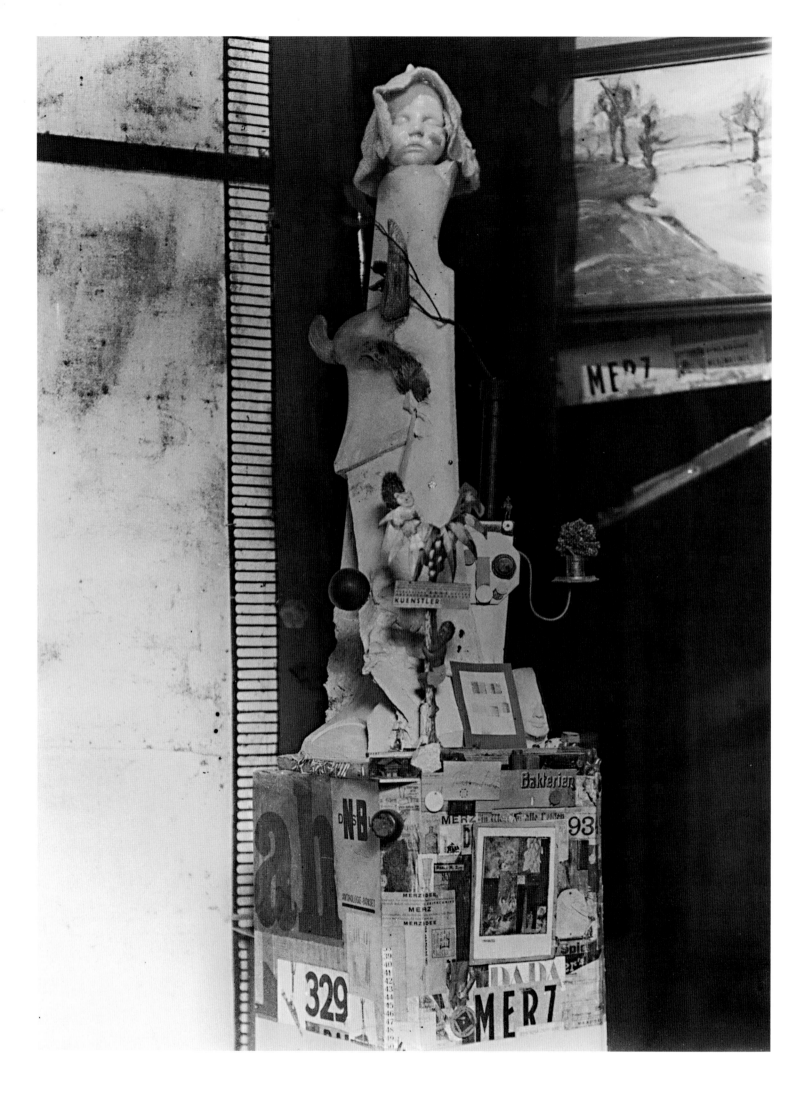

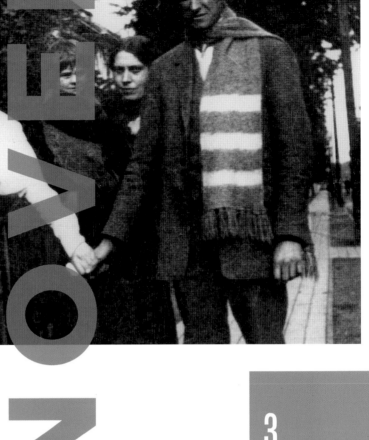

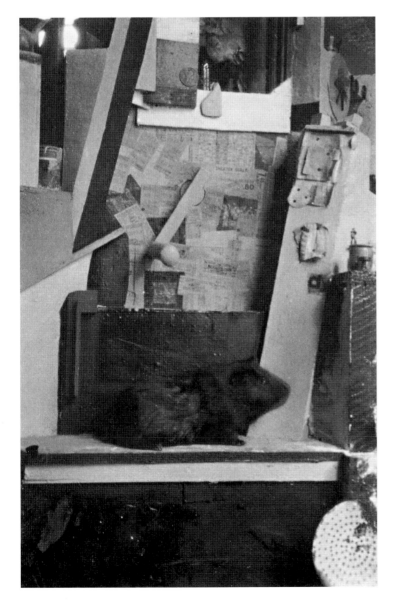

OVER

HANNOVER

3

Hans Arp
Theo van Doesburg
El Lissitzky
Kurt Schwitters

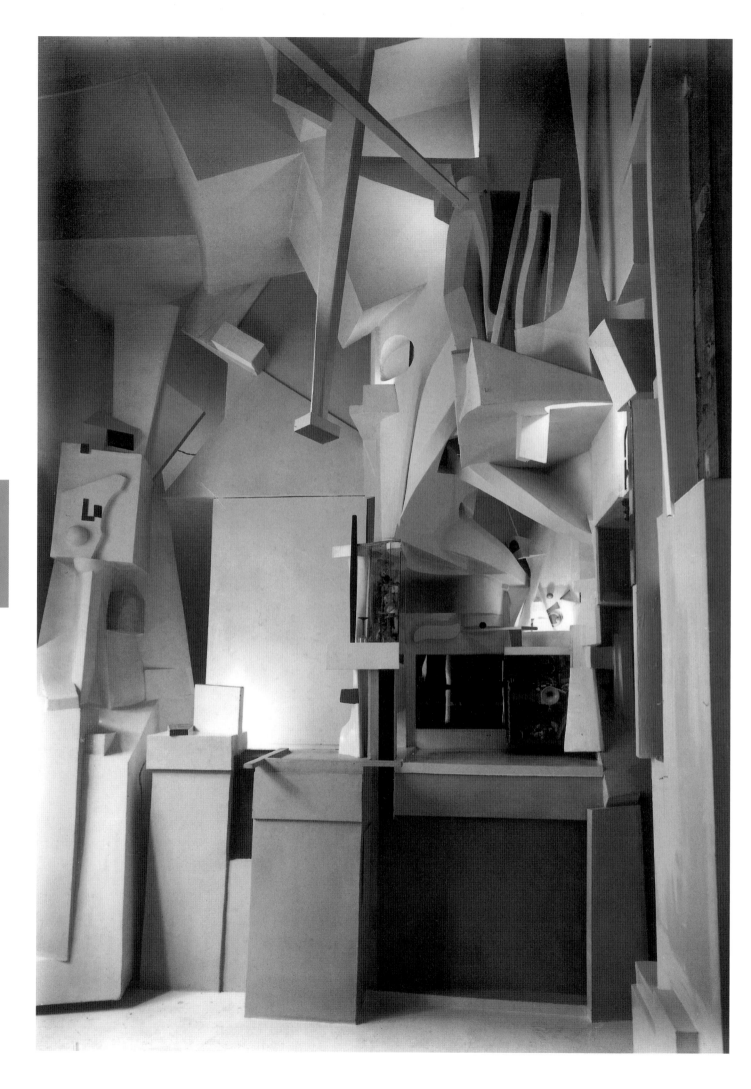

OVERLEAF
Left: Kurt Schwitters, *Merzsäule*
(Merz Column), Hannover,
c. 1923. Room installation with
paper, cardboard, metal, plas-
ter, wood, crocheted cloth, cow
horn, laurel branch, wall sconce
on wood, destroyed 1943. Kurt
Schwitters Archiv im Sprengel
Museum Hannover

Top right: (Left to right)
El Lissitzky, Theo van Doesburg,
Hans Arp, Nelly van Doesburg,
Helma Schwitters with son
Ernst, and Kurt Schwitters in
front of the Schwitters' house
at 5 Waldhausenstrasse,
Hannover, 1922. Foundation
Arp, Clamart

Bottom right: Kurt Schwitters,
Merzbau: KdeE (Cathedral of
Erotic Misery), detail with
guinea pig, Hannover, c. 1929.
Room installation with paper,
photographs, pasteboard,
wood, metal, plaster, stone, glass,
urine, cleaning rag, coal, and
barrel organ, destroyed 1943.
Kurt Schwitters Archiv im
Sprengel Museum Hannover

LEFT
Kurt Schwitters, *Merzbau:
Grosse Gruppe* (Grand Group),
detail, Hannover, c. 1932.
Room installation with paper,
cardboard, pasteboard, plas-
ter, glass, mirror, metal, wood,
stone, and electric lighting,
destroyed 1943. Kurt Schwitters
Archiv im Sprengel Museum
Hannover

In a significant departure from Dada formations in other cities, Hannover Dada was a one-man enterprise launched by the artist Kurt Schwitters (1887–1948). Although trained as a painter, Schwitters adopted collage as his preferred medium and process, ultimately extending its principles to a great many other activities, including sculpture, architecture, graphic design, music, poetry, and criticism. Together with a supporting cast, Schwitters forged links between Hannover and the broader Dada movement that were instrumental in helping put Hannover Dada on the map.

Foremost among affiliates were Paul Erich Küppers, who as the director of the Kestnergesellschaft (Kestner Society), an art society founded in 1916, was influential in bringing modern art and culture to Hannover with a renowned exhibition, education, and publishing program and so provided the matrix on which Hannover Dada could develop;[1] Christof Spengemann, a critic and publisher of the short-lived journal *Der Zweemann*, and a friend of Schwitters; and Paul Steegemann, a publisher and editor of the new series, *Die Silbergäule* (Silver Horses), which he founded in 1919 and made into an important imprint for Dada and other experimental texts. The group of cultural transformers and innovators also included Alexander Dorner, who took on the directorship of the Provinzial-Museum Hannover in 1922 and the following years helped make Hannover a center of constructivist art; and in the private sphere, the collector and businessman Herbert von Garvens, who in 1920 made his important collection of modern and tribal art available to the public and sponsored many cultural events on his premises.[2]

Schwitters came to the German Dada movement belatedly when Dada was already identified with certain stylistic and thematic properties, especially nonsense and playfulness. He was able to define himself with respect to Dada while also keeping his independence from the movement. Here, I will discuss how Schwitters embraced collage and developed Merz art in connection to new approaches to image/text relationships; his "Ursonate," an abstract sound poem written in sonata form; and the *Merzbau*, his interior room sculpture that combines collage with constructivist and expressionist form. Schwitters was involved in important collaborative projects, such as his Dada/Merz performance tours with Raoul Hausmann to Prague and with Theo van Doesburg to the Netherlands, and the publication of his *Merz* magazine as an important platform for Dada and constructivist ideas; he collaborated with Hans Arp and Russian artist El Lissitzky in particular **[170–173]**.

Schwitters gave his art in general the moniker "Merz." Merz was a principle of openness toward everything. Merz designated above all a collage process that Schwitters defined so broadly that it could be applied to any and all matter of things, so much that he also considered his own works of art as collage material for later projects, thus creating a rich web of connections that extended into space and time. Schwitters' Merz art traces its roots to Dada, though much of it came to fruition only after the movement proper had come to an end. Schwitters also remained deeply attached to expressionist art theory and later discovered related concerns in constructivism and Russian futurism, often through his journal *Merz*. Hannover was not a Dada center in the way that Zurich and Berlin—as gathering points for a community of closely allied artists—were. If Hannover Dada was Merz, it was tied to Schwitters and traveled with him, thus making him an important conduit for avant-garde ideas, including Dada.

Schwitters was to become one of the most important Dada-related collage artists and writers of the twentieth century. But during 1917–18, he was still primarily a local artist who emulated the lessons of modernism only when the Kestner Society began to introduce expressionist art to Hannover. Schwitters had trained at the Kunstakademie (Art Academy) in Dresden from 1909 to 1914, apparently without noticing the emerging Dresden expressionist

group Die Brücke (The Bridge), and without associating with George Grosz and Otto Dix, fellow students who later became key members of the Berlin and Dresden Dada groups.[3] Having returned to Hannover after his studies, he married his cousin Helma Fischer; in 1917 he joined the Hannover Sezession, an organization of more progressive artists that had split from the conservative Kunstverein (Art Society) with which Schwitters had exhibited since 1911, and garnered a few laurels for rather traditional naturalistic still-life paintings, portraits, and landscapes. During the war years, however, Schwitters began to seek more progressive forums and to associate with a group of artists and writers who met regularly at the Café Köpke in Hannover, a group that included Steegemann and Spengemann. During that time, he also seems to have frequented the public lectures and recitals at the Kestner Society, wrote expressionist poetry in the style of August Stramm, and slowly changed the style and subject matter of his painting, moving it ever closer to futurist or expressionist-inspired abstraction. Because he suffered from epileptic seizures, he was not drafted for service in World War I until 1917 in the last round of enlistments, as the German government desperately tried to replenish the ranks. He was declared unfit after three months of basic training and assigned to do his auxiliary service as a machine draftsman in the ironworks in Wülfen, near Hannover.

He would later explain that "In the war [in the machine factory], I discovered my love for the wheel and recognized that machines are abstractions of the human spirit."[4] Indeed, the wheel became an important motif in Schwitters' work around 1919. As a symbol of technology and movement, it marks his engagement with modernity, but the symbol of technology was soon replaced with actual machine-made elements when he adopted collage as his main medium and began to form his work with newsprint, ticket stubs, stamps, candy wrappers, and other materials. The early works include *Konstruktion* (Construction), 1919 [**fig. 3.1**], a highly simplified drawing of wheels and axles spread over the page as so many parts of a disassembled machine. Schwitters' newly abstract mode belongs distinctly to the immediate postwar period. During the war, he was still painting such deeply melancholy, expressionist-inspired works as *Trauernde* (Mourning Woman), which was included in a 1917 exhibition at the Kestner Society and in a 1918 group show at Sturm Gallery in Berlin. His turn to modernism reflects deepening engagement with abstraction, prompted

3.1 Kurt Schwitters, *Konstruktion* (Construction), 1919, ink on paper. Private collection

by his exposure to expressionist and futurist art at the Kestner Society, where he could consult journals and art books and attend public programs. He was also working in the machine factory as a technical draftsman. But his departures from past modes of representation were surely also catalyzed by the war itself.

Like everybody else, he was deeply affected by the loss of life the war inflicted, his awareness made more poignant because his firstborn son had died in 1917, barely a week after his birth. For Schwitters, the war period was a time of intense searching when he recognized that tradition could no longer offer security. His encounter with Dada in 1918/19 propelled him to embrace abstraction and the new medium of collage. Working with the fragments of the immediate past, Schwitters understood collage as a mode that could simultaneously acknowledge the loss of tradition while also offering hope for its redemption. Dada gave Schwitters the language with which to express his liberation from tradition. As he would later explain:

> In the war, things were in terrible turmoil. What I had learned at the academy was of no use to me and the useful new ideas were still unready. . . . Then suddenly the glorious revolution was upon us. I don't think highly of revolutions; mankind has to be ripe for such things. . . . I felt myself freed and had to shout my jubilation out to the world. Out of parsimony I took whatever I found to do this because we were now an impoverished country. One can even shout with refuse, and this is what I did, nailing and gluing it together. I called it "Merz": it was a prayer about the victorious end of the war, victorious as once again peace had won in the end; everything had broken down in any case and new things had to be made out of the fragments: and this is Merz. It was like an image of the revolution within me, not as it was, but as it should have been.[5]

After the war Schwitters quickly began to join the ranks of Germany's most experimental artists. Working simultaneously in many different fields, including poetry, music, performance, graphic design, and architecture, he created a new identity as a collage artist of unprecedented breadth. Once exposed to Dada, he recognized it as the most vital form of modern art and defined his art in relation, but also in opposition, to it. In July 1919, on the occasion of his first important one-man show at Herwarth Walden's Sturm Gallery in Berlin, which gave him national and even international visibility, he adopted the term "Merz" for his art. Walden was Germany's foremost dealer of modern art and

publisher of the important journal *Der Sturm*. He had made his reputation with expressionist and futurist art, so that the emergence of Dada threatened his status as a cutting-edge dealer unless he also promoted Dada. However, the Berlin dadaists rejected Walden precisely because of his public identification with expressionism. For that reason, Schwitters' choice of the term "Merz" may have resonated with Walden, because it defined his work as something independent of Dada and yet related to it. There is kinship between the two terms as both are found words that do not designate anything specific in most languages. His association with Walden is the first indication of Schwitters' different, yet parallel and often dynamically intertwined, experience with Dada. It was also one of the reasons Richard Huelsenbeck had rejected his request to become a member of Berlin's Club Dada, the other being Huelsenbeck's unforgiving assessment of Schwitters as a latter-day romantic. Schwitters, in contrast to dadaists in Huelsenbeck's circle, ascribed to art a spiritual function. He proclaimed, "Art is a primordial concept, exalted as the godhead, inexplicable as life, indefinable and without purpose."[6]

The term "Merz" is derived from a fragment of the word "Kommerz-und Privatbank" (Commerce Bank) included on a scrap of paper in one of his assemblage paintings, the *Merzbild* 1, 1919 (now lost). For Schwitters, Merz functioned as something of a brand name, providing an identifiable, overarching label for his activities in various fields. But it also designated a process and a mind set. He defined it in the most encompassing manner possible: "The word 'Merz' had no meaning when I formed it. Now it has the meaning which I gave it. The meaning of the concept 'Merz' changes with the change in the insight of those who continue to work with it. Merz stands for freedom from all fetters, for the sake of artistic creation."[7]

"AN ANNA BLUME"

In a curious twist in the history of art, it was a poem—the most personal form of speech—and not a public manifestation or even a work of art that put Schwitters and Hannover on the Dada map, a poem that was published not in Hannover but in Berlin, in Walden's expressionist magazine, *Der Sturm*.[8] "An Anna Blume" (1919), Schwitters' parody of a love poem, became a cause célèbre; it revealed a different Schwitters from the melancholic personality for which he was known. The poem's publication and events surrounding it also revealed a great deal about the dynamics

of Hannover Dada. If it is unusual that a poem should garner so much attention, it is also rare for a poem to be launched with so orchestrated a campaign. "An Anna Blume" was a watershed in Schwitters' career because it propelled him almost overnight to international fame. But "An Anna Blume" also marks a particular moment in the history of German modernism when in a highly visible manner the market claimed an experimental work for its own purposes.

"An Anna Blume" mixes the declarations of romantic love and desire we associate with love poetry with banal, clichéd phrases. It seems expressionist in tenor, but is actually lighter in spirit as it plays with nonsense and reflects the influence of Dada poets like Tristan Tzara and Hans Arp. It incorporates found sentences and sentence fragments, a telling indication of Schwitters' emerging fascination with collage processes, and constantly shifts perspective, disrupting syntax and creating an ironic distance from the emotions expressed. This mixture of traditional and experimental form defines the poem as innovative. Catchy, familiar phrases anchor the poem in the everyday while the unexpected turns and juxtapositions offer small, subversive surprises.

The several English translations differ in important details from the original German, quoted here in note 8. The earliest English version, a 1922 translation by Myrtle Klein authorized by Schwitters, gives the heroine's name as "Anna Blossom"; in his own translation, published in Stefan Themerson's *Kurt Schwitters in England* (London, 1958) and reproduced here,[9] Schwitters used "Eve Blossom." The poem opens with an exalted evocation of the beloved: "O thou, beloved of my twenty-seven senses, I love thine!," but soon the flow of exclamations expressive of the intense confusion generated by love and desire is interrupted by everyday speech, with a simple "PRIZE QUESTION." The poet offers three numbered statements from which to choose the correct answer in a form reminiscent of the mathematical problems presented in algebra textbooks: "1. eve Blossom is red. 2. eve Blossom has wheels 3. what color are the wheels?" (In the German version, the suggested answers differ and read: "1. Anna Blume has a bird [is crazy] 2. Anna Blume is red 3. Which color is the bird?") This passage of seemingly rational thought is in turn followed by yet another declaration of the poet's love—a series of gushing assertions about Anna's astounding and memorable qualities—only to conclude with a more allusive and debased evocation of Anna Blume as a "drippy animal."

To Eve Blossom

O thou, beloved of my twenty-seven senses,
I love thine!
Thou thee thee thine, I thine, thou mine, we?
That (by the way) is beside the point!
Who art thou, uncounted woman,
Thou art, art thou?
People say, thou werst,
Let them say, they don't know what they are talking about.
Thou wearest thine hat on thy feet, and wanderest on thine hands,
On thine hands thou wanderest
Hallo, thy red dress, sawn into white folds,
Red I love eve Blossom, red I love thine,
Thou thee thee thine, I thine, thou mine, we?
That (by the way) belongs to the cold glow!
eve Blossom, red eve Blossom what do people say?
PRIZE QUESTION: 1. eve Blossom is red,
 2. eve Blossom has wheels,
 3. what color are the wheels?
Blue is the color of your yellow hair,
Red is the whirl of your green wheels,
Thou simple maiden in everyday dress,
Thou small green animal,
I love thine!
Thou thee thee thine, I thine, thou mine, we?
That (by the way) belongs to the glowing brazier!
eve Blossom,
eve,
E-V-E,
E easy, V victory, E easy,
I trickle your name.
Your name drops like soft tallow.
Do you know it, eve,
Do you already know it?
One can also read you from the back
And you, you most glorious of all,
You are from the back as from the front,
E-V-E.
Easy victory.
Tallow trickles to strike over my back!
eve Blossom,
Thou drippy animal,
I
Love
Thine!
I love you!!!!

Hannover publishers Steegemann and Spengemann, Herwarth Walden, and Schwitters himself all must have recognized the potential impact of the poem right from the beginning. The publication and subsequent marketing of "An Anna Blume" was an unusually coordinated event designed to launch Schwitters' new Merz art, which was about to be shown at Sturm Gallery. Walden, by promoting Schwitters' art and poetry, aimed to prove that he was very much at the forefront of emerging trends.

The publicity campaign surrounding "An Anna Blume" reveals contrasting approaches to advertising and the media within the established art market with which Schwitters became allied, and within the avant-garde circle of Berlin dadaists. Both vied for visibility and enthusiastically embraced the media to promote their goods. But there is also an important difference. Schwitters and his supporters used the media to advertise a product that was understood as a novelty and widely associated with the new—Dada. The ultimate goal was to integrate a new product into the workings of an established institution, Sturm Gallery. The Berlin dadaists, however, explored media techniques to promote a critique of art itself, particularly to lambaste its perceived autonomy.[10]

A month before the publication of "An Anna Blume" in the August issue of Der Sturm, Spengemann enticed Der Sturm readers with the question: "Who really is Anna Blume?" and answered himself: "Twisted brain! He painted the image of the time and didn't know it. Now he kneels before the daisies and prays."[11] Thus advertising a good that had not yet been made public, Spengemann effectively launched the poem and its author and forged a new alliance between himself, Walden, and Schwitters. Walden had already shown Schwitters' more orthodox work in a group show in 1918; now in July 1919, he exhibited for the first time Schwitters' new Merz art—his innovative assemblages and collages. The July issue of Der Sturm was thus given the task of launching Schwitters as both experimental poet and artist. Spengemann entitled his article "Der Künstler" (The Artist), and not "the engineer," the designation the Berlin dadaists preferred. He promoted a traditional view of the artist as an inspired being and Schwitters' experimental work as being part of a tradition going back to romanticism. Schwitters' manifesto-like short statement, "Die Merzmalerei" (Merz painting), which Walden printed right next to Spengemann's text, reinforced the reception of his work within the context of the established category of abstract art:

> Merzbilder (Merz pictures) are abstract works of art. The word Merz denotes essentially the combination of all conceivable materials for artistic purposes, and technically the principle of equal evaluation of the individual materials. Merzmalerei [Merz painting] makes use not only of paint and canvas, brush and palette, but of all materials perceptible to the eye and of all required implements. Moreover, it is unimportant whether the material used was already formed for some purpose or

> other. A perambulator wheel, wire-netting, string and cotton wool are factors having equal rights with paint. The artist creates through choice, distribution and dematerialization of the materials.[12]

The first announcements about Schwitters and Anna Blume had been followed by an extended publicity and publication campaign that built on the overwhelming enthusiastic reception—and equally vociferous rejection—of the poem. Steegemann brought out a volume of Schwitters' poetry later in the same year, putting the name Anna Blume in the title, Anna Blume. Dichtungen (Anna Blume. Poems) **[141]**. In this volume, the original poem is given the subtitle "Merzgedicht 1" (Merz Poem 1), indicating that both Schwitters and Steegemann understood the significance of the poem in the launching of Schwitters' career and now saw it as a manifesto-like embodiment of Merz art.[13] The many other publications that followed and similarly evoked Anna Blume kept her name in the public mind, assuring Schwitters' continued notoriety as the author of the most famous Dada poem.[14]

The Berlin dadaists, however, saw in Anna Blume the most potent justification for Schwitters' exclusion from Club Dada and frequently referred to Anna Blume to publicly affirm the differences between themselves and Schwitters. For Huelsenbeck, in particular, the poem reeked of bourgeois sentimentality and outdated, misguided romanticism. He announced in his Dada Almanach (1920): "Dada rejects emphatically and as a matter of principle works like the famous 'Anna Blume' of Kurt Schwitters."[15] His comrade-in-arms Rudolf Schlichter took the occasion of the Erste Internationale Dada-Messe (First International Dada Fair) in 1920 (from which they had barred Schwitters' participation) to stage a kind of burning in effigy when he exhibited a sculpture entitled Der Tod der Anna Blume (Anna Blume's Death). Schwitters, in turn, countered by singling out and attacking Huelsenbeck and his politically defined art, most famously in his 1920 essay, "Merz":

> In his introduction to the recently published Dada Almanach, Huelsenbeck writes: "Dada is making a kind of propaganda against culture." Thus Huelsendadaismus [a word game: Huelse = husk] is politically oriented, against art and against culture. I am tolerant and allow everyone his own view of the world, but am compelled to state that such an outlook is alien to Merz. Merz aims, as a matter of principle, only at art, because no man can serve two masters.[16]

3.2 Kurt Schwitters, "Gesetztes Bildgedicht" (Typeset Picture-Poem), 1922. From John Elderfield, *Kurt Schwitters* (New York, 1985)

"An Anna Blume" taught Schwitters a number of valuable lessons about audience reception, the importance of publicity, how to establish a network of professional connections between artist, dealer, and publisher, and no less vital, about the demarcation line between himself and the Berlin dadaists, all of which proved to have lasting influence on his further development. The most fundamental lesson, however, lay in the poem itself. "An Anna Blume" taught Schwitters the value of experimentation with form, syntax, and metaphor, and remarkably, provided him with a set of new motifs—Anna Blume's attributes—that he began to explore intensively in the next year or two. Moreover, with its combination of experimental speech and vivid imagery, the poem became a productive starting point for thinking about visual representation.

Schwitters' methods for incorporating Dada's visual vocabulary into his exploration of image / text relations become apparent in his *Aq.* (Aquarelle [watercolor]) **[see 139]** drawings and associated designs, made in 1919 and 1920, and in his large Merz paintings from the same period. Anna Blume often appears as a motif in these works. This tendency becomes visible as well in his slightly later experimentation with concrete poetry, such as "Gesetztes Bildgedicht" (Typeset Picture-Poem), 1922 **[fig. 3.2]**, in which the letters A and B figure prominently,[17] and finally in his expansive sound poem, the "Ursonate" (1921–32).

Schwitters designed the cover of his *Anna Blume. Poems* in homage to Anna Blume. It is rendered in a childlike yet highly sophisticated drawing style, in which Schwitters seeks to transmit the intensity and multiple meanings of his poem with iconic evocations of its heroine and her attributes. There is a man on the left walking upside-down on what might be a high-wire—one end is attached to a heart and the other to a wheel; a locomotive on the right, moving forward and backward on the tracks as the arrows tell us; another heart inscribed with a coffee mill; a windmill with turning blades in the upper right; and a sun or moon, all arranged around the central figure of a wheel and a profile head with a prominent wide-open eye. The design is framed above by the name "A-N-N-A" (the palindromic qualities of her name underscored by two arrows pointing in opposite directions), which delineates the outer contours of the profile head, and below, the carefully written word "und" (and) in gothic script. The entire drawing is squeezed between two larger blocks of text comprising the name of the series (*Die Silbergäule*) at the upper margin, and the author's name, book title, and publisher's name at the bottom, equally traced in old-fashioned gothic script and held in check by the word "dada" stenciled in red diagonally across the design in a clear, pared-down modern typeface.

It all seems innocent enough. The drawing is a simple illustration of the poem and nothing more. Yet, there is a complexity in the design that belies its childlike fragmentary form, perhaps most readily apparent in the word "und," which seems almost to fall out of the composition into a space beyond its frame. Conceptually "und" is the link that

binds Anna and Kurt Schwitters, and additionally, it suggests myriad other connections between the different emblematic parts that make up the composition. "Und" functions as an invitation to participate, to insert ourselves into the scene, an invitation that the big observing eye reiterates visually with its gaze and the arrow that links the eye with the windmill to the right. The conjunction "und" as a metaphor for the collage process itself preoccupied Schwitters at this time, and he explored its conceptual implications in a more formal and complex manner in the large assemblage painting *Das Undbild* (The And Picture) **[fig. 3.3]**, where the conjunction, now in large modern non-serif type, prominently crowns the composition in which many diverse parts are joined together to make up the whole.[18] What lies in between the visual and the textual in Schwitters' interpretation is either "dada"—the acknowledgement of fracture as a given—or "und"—the suggestion that connections can be forged.

MERZBILDER (MERZ PICTURES) AND MERZZEICHNUNGEN (MERZ DRAWINGS)

"Merz," Schwitters announced, "means to create connections, preferably between everything in this world."[19] His *Merzbilder* (Merz pictures) became the more ambitious venue for his investigation of possible links between disparate things—objects and concepts alike. Collage offered him the means to do so in a complex and more difficult to read manner than in the *Aq.* drawings: in these larger, layered works, reading and seeing are entangled. Relations are suggested;

images shift against text fragments; they are overlaid with color or show beneath a transparent strip of paper, so that we as interpreters encounter multiple sites and constellations but rarely find a story line that coheres. Or, when the suggestion of an overall theme does emerge, we cannot relate all the incidents within the composition to it because of the overabundance of competing information.

Merzbild 32 A. Das Kirschbild (The Cherry Picture) **[142]** brings back Anna Blume, but in a veiled and multilayered fashion that depends on the shifting relationship between the visual and the textual. The work is built up in layers of collage elements, including bits of newspaper, address and product labels (some with readable text), textured materials like burlap, even found wood and the head of a pipe, all affixed to the supporting ground. In spite of the diverse materials and multiple areas of visual interest, the composition has a central focus, provided by a white flashcard of the kind given to children to learn words. It pictures a small bunch of cherries and is placed right above a prominent red triangle formed from a bit of coarse, slightly bunched cloth that in turn is glued to a larger pale gray-blue rectangle. The text on the card beneath the cherries translates the name of the fruit into German and French ("Kirschen" and "cerises"), thus transforming image into text. There is more text, as both the card and the rectangle underneath are inscribed in an awkward, graffiti-like manner with thin lettering, the card with "Ich liebe Dir!" (I love you [in the grammatically incorrect form that Schwitters also used in his poem]) and right next to the red triangle, "Anna Blume hat" (Anna Blume has). Has what?

The bunch of cherries and the red triangle, linked to the graffiti-like evocation of love, are long associated in the history of art with the sexual, and "Anna Blume hat [has]" provides sexual innuendo; Schwitters enhances the insinuation with the image of the two pussycats in the lower right. In this context, the French "cerises" on the flash card and the assertion provided by the text on the label in the upper center *"Qualität sehr fein"* (extra fine quality) suddenly take on a suggestive dimension. Yet something unexpected happens when we try to link these visual incidents and bits of information: the eye constantly shifts between deciphering a text and taking in an image, much the way the eye moves from the image of the cherry on the flash card to the identifying words underneath, and there shifts between the two languages only to move back again to the image. Our eye becomes like the locomotive on the Anna Blume cover, moving backward and forward on a track between different

3.3 Kurt Schwitters, *Das Undbild* (The And Picture), 1919, assemblage of gouache, papers, board, wood, metal, leather, cork, and wire grating on paper. Staatsgalerie Stuttgart

reading options; an instantaneous understanding of the image as sign is no longer possible; multivalent, its reading now unfolds in time and so takes on the quality of text.

So far we have traced a network of connections seemingly stretched over the surface of the composition, but as in other Merz paintings, Schwitters here also suggests the possibilities of a reading of the temporal kind we commonly associate with archaeology. It cuts through the accumulated layers of fragments to the supporting ground, the base layer, which functions as a kind of prior whole that predates the fragmentation on top. Indeed, in some Merz paintings, as in *Das Kreisen* (Revolving), 1919, the collage elements are treated as stacked-on additions to an existing surface; in others, as in *Merzbild 5B. Rot-Herz-Kirche* (Red-Heart-Church), 1919, the work is built up on the surface of one of Schwitters' own earlier paintings. In other works still, like *Merzbild 1A. Der Irrenarzt* (The Alienist) **[fig. 3.4]**, the found materials are affixed to a figurative painting (here the portrait of his sister) and so set up a dialogue between the base layer and the layers of fragments of material on top. That Schwitters treats the relationship between the layers as a kind of "before and after" comparison finds an analogy in his *Merzbild 10A: Konstruktion für edle Frauen* (Construction for Noble Ladies) **[143]**, into which he inserted in its entirety one of his earlier figurative paintings depicting the profile of a woman

(most likely a portrait of his wife Helma). Schwitters nailed an assortment of found objects around and on top of the painting. Several evoke Anna Blume's attributes, such as the wheel forms, the two halves of a toy locomotive, as well as an arrow sign and a funnel, all implying movement. These Merz paintings and others reveal how Schwitters, in contrast to the Berlin dadaists, was less interested in investigating the relationship between painting and mass media reproduction than in exploring the limits of abstraction. Schwitters considered his Merz paintings abstract works of art. But what makes these works abstract if there are so many recognizable components? Does Schwitters believe that the shattering of a prior whole (the implied or real base layer of the assemblage painting) and the dispersal of its parts over the picture plane makes a painting abstract? If so, Schwitters reveals his continued and belated assimilation of expressionist ideas, echoing Vasily Kandinsky's prewar definition of abstraction when Kandinsky postulated that the artist must provide remnants of representation or other guides, like a sweeping line, to serve as triggers for an engagement with the otherwise abstract image.

Merzbild 12b Plan der Liebe (Plan of Love) **[138]**, 1919–23, reveals more clearly how Schwitters works with and against the picture plane to create shifting surfaces and collisions of structures. The work is ostensibly an abstract,

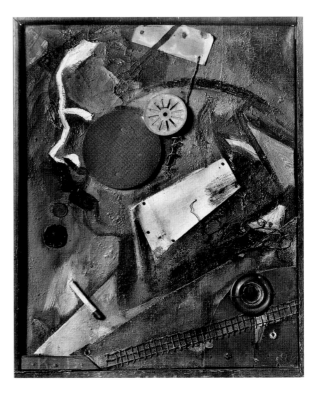

3.4 Kurt Schwitters, *Merzbild 1A. Der Irrenarzt* (Merzpicture 1A. The Alienist), 1919, assemblage of oil, papers, canvas, board, wood, wire, metal, coin, and cigarette on canvas. Museo Thyssen-Bornemisza, Madrid

geometric assemblage from 1923, organized along a clear grid. It includes a few paper fragments imprinted with text, such as the title words "Plan der Liebe" and the name "Paul," a banknote and other textual references to money, as well as several diagrammatic drawings and plans. However, the geometric assemblage is actually affixed to one of his earlier Merz paintings from 1919 in a futurist design mixed with collage material. The later additions allude to Schwitters' Holland Dada tour, which he undertook with Theo van Doesburg and Vilmos Huszar in 1923, providing a diaristic component as well as acknowledging the De Stijl influence in the emphasis on the grid. But the new additions also cover up and thus destroy the work underneath, subjecting the crystalline, fragmented form of the earlier picture to the ordering system of the grid, a transformation from painting into diagram or map. There is enough of the former image visible to contradict both the emphasis on abstraction and the power of the grid; instead, the relationship between the old and the new becomes dialogic. Schwitters' break with tradition is rarely complete.

Schwitters termed his small collages *Merzzeichnungen* (Merz drawings). The designation "drawing" is significant since it reveals how Schwitters thought of his collage work fundamentally differently than most other German dadaists. To Schwitters, collage was a graphic art, and like drawing, associated with writing. As such he defined collage in terms of a northern European tradition in which painting and drawing both convey information, either quasi-diagrammatically or with the help of actual text. The art historian Svetlana Alpers contrasted the work of Dutch painters in the age of Johannes Vermeer with that of Italian painters who continued to conceive of painting as a window into the world that would be approached by the viewer face to face. She termed the Italian Renaissance model the "art of depicting" and referred to the northern model as the "art of describing."[20] A painting by Vermeer, for example, much like Schwitters' Merz paintings and drawings, is filled with a great variety of written and printed information, from depicted maps to letters and signs. Maps, Alpers reminds us, were traditionally understood as allowing us to see something that was otherwise invisible. Drawing is thus a form of mapmaking, which prompted the Dutch artist Samuel van Hoogstraaten to exclaim: "How wonderful a good map is in which one views the world as from another world thanks to drawing,"[21] and according to Alpers, offers an encompassing view of the world without asserting order based on human measure that is offered by perspective pictures. For Schwitters, who centuries

later was searching for a new language with which to express the very loss of human measure, collage, and his Merz drawings in particular, became an "art of describing" with which to chart the loss of tradition.

Schwitters had made his first small collages in 1918 under the influence of Hans Arp who apparently introduced him to the process. Among these early works, *Zeichnung A 2. Haus. (Hansi)* (House [Hansi]) **[fig. 3.5]** is the best known. It has been interpreted as homage to Arp,[22] and its clear geometry and colors suggest that, recalling Arp's geometric collages from 1915 **[4,5]**. Schwitters, however, did not expand on these early experiments and resumed making small collages, as opposed to collage paintings, only in 1919/20. These small collages were predominantly composed of papers imprinted with text, as in *Merzz. 22.* **[fig. 3.6]**, including food stamps, ticket stubs, address labels, candy wrappers, and the like, rather than plain colored papers as in the 1918 works. Because of their emphasis on mass cultural material, the Merz drawings can be compared to collages produced within the circle of the Berlin dadaists, above all with work by Hausmann and Hannah Höch. But even so, Schwitters' collages tend to be more indeterminate, mapping a wealth of information, and so enunciate his differences from the more politicized Berlin dadaists. Despite these divergences, the works also indicate why Schwitters was able to forge a close friendship with both Hausmann and Höch who, like Schwitters, believed that art should transcend the politics of the day.

Schwitters engages the theme of modernism in a more equivocal manner that suggests anxiety. Untitled (*Pottery*) **[158]**, is composed of a variety of fairly large fragments most of which tend toward rectangular shapes with the exception of a dark quarter-circle in the lower left. Many of the fragments are imprinted with text and one, on the lower right, with a map of a transportation system. The one above it, which takes up most of the right upper half of the composition and is inscribed with an address (visible only as a fragment), is written in ink in a large, fluid hand. The other text fragments also help situate us in several, particular places: the tram ticket stems from the city of Halle (an der Saale), and so does the handwritten address where we see the last three letters of Halle and the "S" as an abbreviation of "Saale." The fragment above the address, however, locates us in another part of the country, in Stuttgart, while the "Leipziger Strasse" on the small piece of paper to the left of the map takes us back to Halle with its greater proximity to Leipzig. Geographically then, Schwitters seems to locate

us securely in a particular place, Stuttgart, which is the most noticeable printed name in the composition, but actually dislocates us repeatedly by taking us to a number of other places.

On the left side of Schwitters' little collage, we encounter a line drawing of a young woman torn from a newspaper advertisement; she sports an up-to-date hair style and a lacy camisole while her shoulders are bare; her arms, in which she seems to be holding another piece of folded lingerie, are folded in front of her. Yet, when we look more closely, we see that it is not at all the same woman who holds the garment; rather, Schwitters, in a manner reminiscent of Höch, remade her lower body by superimposing another cut-out from an ad, this one showing the legs and buttocks of a woman wearing embroidered tap pants. This bit of almost seamless surgery, the amputation of the abdomen and the prosthetic lower body, is so cleverly done that the woman now appears to be holding another even more enticing model of herself—Anna Blume laid bare—whose garter belt invitingly tangles in front of the (male) viewer's eyes. But even more violence has been done to her. Besides having reconstituted her womb, Schwitters also pierced her lower right arm and the upper left strap of her camisole, leaving two prominent holes, so that she now appears to be a marionette that has become unhinged. And her face framed by the abundance of wavy hair has been forcefully exposed: it seems that Schwitters first glued a white piece of paper over her face, but then tore it off, leaving behind crude marks of violation.

There is little color in this collage, but it is significant. The half circle on the lower left is one of the black film-pack wrappers frequently employed as collage material. It is imprinted with a large red triangle whose apex points to the woman's prosthetic, but coyly hidden, vagina. To the right of her, in the center of the collage, is a small, torn paper of a colored photographic reproduction in faded red of a bouquet of flowers. The collage, then, echoes the *Cherry Picture* **[142]** as it maps Anna Blume's violent deflowering. It is clearly not accidental that one of the three legible words in the flamboyantly written address on the right reads "Wilden" (wild); paired with the word "Töpferei" (pottery), suggesting the making of form and creativity, the collage insinuates the performance of a violent act—rape. And so we can read the other small torn and cut paper in the lower right with its typewritten script as a price tag of this performance of violence: "*mit st / enen / Wert*" (with value). But what kind of value? "*Keinen Wert*"? That reading does not work with the letters provided. "*Einen Wert?*" Neither does this; in fact there is no meaningful way to connect "*mit…Wert*" with the other words. The little fragment, then, encapsulates the message of the work as a whole. The value of mapping woman, of being creative through the body of woman, is uncertain. Schwitters employs the realism of collage (modernism's actual fragments) to instantiate the realities of modern life—the assault on individuality, destruction of subjectivity, and the loss of tradition. As in so many other works of this period, the anxiety about a rapidly transforming mass culture is the hidden subtext of this collage.[23]

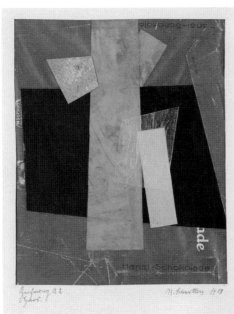

3.5 Kurt Schwitters, *Zeichnung A 2 Haus. (Hansi)* (Drawing A 2 House. [Hansi]), 1918, collage of papers and wrapper on paper with cardstock border. The Museum of Modern Art, New York. Purchase

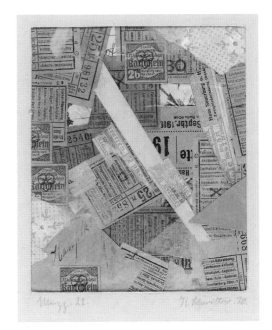

3.6 Kurt Schwitters, *Merzz. 22.* 1920, collage. The Museum of Modern Art, New York. Katherine S. Dreier Bequest

Schwitters' collage evokes a subject favored by several of the Berlin dadaists: violence against women, most poignantly expressed in the theme of *Lustmord* (sexual murder), which plays a pivotal role in the work of Grosz, Schlichter, Dix, and other artists, writers, filmmakers, and playwrights.[24] Sexual violence stands at the heart of the volatile reception of modernity in which woman is associated with modernity's destructive forces and in turn becomes the subject of male violence. Schwitters' design lacks the aggressiveness of the other artists' work; in comparison to the graphic depiction of murder and dismemberment by Grosz, for example, Schwitters' focus on the topic becomes an almost sweet rendering of a highly charged problem; his interest in the other pictorial elements within the collage is too great to allow violence to overwhelm the composition. Schwitters insistently evokes that theme, but within the forms of his work, as when he contrasts the whole and destroyed surfaces within the Merz paintings. It is the focus on the destruction that situates him squarely within the larger nexus of modernist, and particularly German dadaist, art.

THE HOLLAND DADA TOUR

When Schwitters launched his own Merz movement in dialogue with, and opposition to, Berlin Dada, he almost immediately began to seek contacts with Dada artists in other places. In 1919, he established written contact with Tzara and sent him poems and reproductions of his work while asking him for copies of Zurich Dada publications. Tzara in turn reproduced Schwitters' work in *Der Zeltweg*, the Zurich Dada publication, in October 1919; the two artists were to remain in close contact for years to come, still planning joint ventures late in 1922.

Arp served as another link between Schwitters and the Zurich dadaists. He, like Schwitters, was not interested in an overtly politicized version of Dada and did not actively participate in Berlin Dada. The two collaborated on several projects, including a collage novel, *Franz Müller's Drahtfrühling* (Franz Müller's Wire Springtime), which was never completed.[25] Arp and Schwitters were bound by a common interest in the poetic: both enjoyed nonsense and explored composition, without predetermined meaning, in written and visual form. They also shared a profound fascination with the organic. It is visible in Arp's work in his early collage, *Vor meiner Geburt* (Before My Birth), and in the biomorphic forms he developed at that time and expanded on later. Besides the ongoing work on the collage novel, they also collaborated in *Memoiren Anna Blumes in Bleie* (Anna Blume's Lead Memoirs), published

by Verlag Walter Heinrich in Freiburg im Breisgau in 1922. Their close friendship and respect for each other becomes particularly apparent in their collaboration on several issues of Schwitters' magazine, *Merz*, especially in *Merz 4* (1923), the *Banalitäten* (Banalities) issue, and above all *Merz 5*, which Schwitters issued as a portfolio of Arp's lithographs, the so-called *Arpaden* issue (1923) **[176–182]**.

But Schwitters' friendships also led to more public events in the tradition of Dada manifestations, linking Dada and Merz in numerous ways and leading to new configurations within the Dada movement. Such new alignments were possible in part because of the internal split within Berlin Dada, which divided the political group including Huelsenbeck, John Heartfield, and Grosz and the "Freie Strasse" group, which included Hausmann and Höch. In 1920 Hausmann, Huelsenbeck, and Johannes Baader had undertaken a highly successful Dada tour to Prague with extraordinary public success, measured in terms of scandal, protestations, and a rowdy audience response, all duly noted in the local press. Hausmann later reported:

> It took some courage to appear in front of an audience of 2,000 that before the soirée opened, was already roaring....Several dozen men climbed on the stage and started to beat us up. I was pushed to the edge of the podium, where I fell down. A number of people trampled me, my pants were torn, my glasses broken. ...Then I shouted into the audience: "The beating was for us but a pleasant massage, but for you a disgrace!"—We began a discussion open to everyone in the audience.[26]

The next year (1921), when the Berlin Dada group was beginning to fall apart, Hausmann, Höch, and Schwitters, and his wife Helma, undertook a second Dada tour to Prague. They advertised this event as an "Anti-Dada-Merz" tour, giving a first indication that new constellations were beginning to emerge in opposition to Huelsenbeck's and Grosz' highly politicized definition of Dada. This group favored an understanding of Dada that was antibourgeois and antitradition but still embraced art, closer in definition to Dada as it had evolved in Zurich.

The 1921 Prague event was anything but raucous, apparently to the dismay of the audience that had hoped for a repeat of the earlier Dada performance. Schwitters and Hausmann focused in particular on the latest developments in their own art, sound poetry, and experimental texts, which presented a challenge to their audience. They performed together Schwitters' short piece, "Mama, da steht ein Mann"

(Mother, there is a man standing), taking turns reading the individual sentences, and similarly alternated reciting the phonemes and syllables of Schwitters' poem "Cigarren" (Cigars), accelerating their delivery as they went along. Hausmann opened the evening with his manifesto, "PRÉsentismus," a critique of bourgeois art and a rejection of Dada destructiveness in favor of a new concept of art aimed at a revolution of sensory abilities. Hausmann also performed his poster poem "fmsbw" [100] and Schwitters read "An Anna Blume," some of his grotesque poems, "Alphabet von hinten" (Alphabet Backwards), as well as a text spoofing his conservative art critics, "To my Dresden Critics." What was significant about this Prague event was that it not only cemented the friendship and collaboration between the three artists, but also marked an important shift in the Dada artist-audience relationship. As dadaists turned to more theoretical, abstract concerns, they lost their provocative, public edge. The audience had come hoping to be provoked, but as the press reported, felt let down. "The audience whistled and shouted at the beginning, but even so became so bored after a while that most did not return after the first intermission."27

One of the few Dada Hannover events that actually took place in the city of Hannover itself was Dada-Revon (Revon is the last two syllables of Hannover read backwards, a name invented and frequently used by Schwitters) after the Dada Constructivist Congress in Weimar in September 1922. Schwitters, who participated in the Weimar meeting and helped lend it a Dada tenor, invited several of the participants to Hannover. With Van Doesburg, with whom he had been friendly since 1921, Schwitters quickly organized a "Dada Evening" in the Hotel Fürstenhof in Weimar on 25 September 1922 and then in Jena at the Kunstverein (Art Society) on 27 September. The Dada-Revon event took place at the Galerie von Garvens on 30 September 1922. With Theo and Nelly van Doesburg, Arp, Tzara, and Hausmann participating, it was planned as a kind of dress rehearsal for a Dada tour through the Netherlands in the following year.

The "Holland Dada tour" was to be the last Dada event that brought together the non- or anti-dadaists: Schwitters, the De Stijl artists Huszar and Van Doesburg, who unbeknownst to his friends also worked under a Dada pseudonym, I. K. Bonset. Arp, Tzara, and Georges Ribemont-Dessaignes were supposed to participate but had to cancel because of visa problems and financial constraints. Beginning 5 January 1923 and lasting until 13 April, the tour took the artists to The Hague, Haarlem, Amsterdam, Delft, Hertogenbosch, and

Utrecht in January; Rotterdam and Leiden in February; and a soirée in Drachten in April, organized by Thijs and Evert Rinsema. In the Netherlands, art and architecture had been shaped in recent years by Piet Mondrian's and De Stijl's rigorous formal constraints, and the country seemed anything but receptive to art that advocated chaos as means of social and cultural change. Nonetheless, the artists on the Holland Dada tour provoked their audiences with unexpected actions, and the audiences in turn responded raucously, turning these events into audience/performer happenings.

At the same time, the participants in the Holland Dada tour considered themselves and their work as a corrective to Berlin (Huelsenbeck) Dada. It was only now that Schwitters had begun to adopt the term Dada in a more consistent manner for his own work, rather than defining Merz solely as anti-Dada. It was now that Van Doesburg revealed his Dada alter ego. Now that Berlin Dada had run its course, those dadaists who continued to believe in the spiritual function of art came to the fore and joined forces with artists in other movements who pursued similar objectives. The anti-Dada stance of the Prague tour had manifested itself in a focus on formal issues, the participants reciting concrete poetry and performing highly controlled dance or body movements to highlight their underlying belief that the individual and therefore society could be transformed by means of controlled and directed alterations of motor and sensory abilities. The Holland Dada tour returned to an earlier model seen in the events at the Cabaret Voltaire that aimed to liberate the individual from the constraints of bourgeois norms, paving the way for individual and social change. Holland Dada tour participants felt, like most of the Zurich dadaists, that change was essentially aimed at returning art to its true function: to bring a spiritual dimension to life that had been lost with the advance of the technological age. In 1923, when Schwitters cosigned the "Manifest Proletkunst" (Manifesto of Proletarian Art) with Theo van Doesburg, Arp, Tzara, and Spengemann, he proclaimed with his colleagues a belief in a higher goal, the creation of a *Gesamtkunstwerk* (total work of art).28 The striving for a total work of art aimed at deepening life's experiences was equally shared by expressionist, Dada, De Stijl, and constructivist artists; its theoretical underpinnings and external form, however, manifested themselves differently within the different movements. Nevertheless, there were increasingly close formal relationships, all evolving toward a more geometric style, which overcame the destruction of form that initially had been set into motion to reform form itself.

MERZ MAGAZINE

Schwitters launched his magazine *Merz* in 1923 and continued to publish occasional issues until 1932. He devoted the first issue to "Holland Dada," asking, "May I introduce ourselves...We are Kurt Schwitters, not dada, but MERZ; Theo van Doesburg, not dada, but Stijl; Petro van Doesburg, you will not believe it, but she refers to herself as Dada; and Huszar, not dada, but Stijl."[29] Schwitters conceived of his *Merz* magazine in the spirit of other Dada publications and modeled it on precursors like the Berlin *Der Dada*; here, in the spirit of Dada, he willfully confuses the reader about the meaning of Dada and Merz. *Merz* 1 highlighted contributions from Schwitters himself, Van Doesburg, Huszar, Antony Kok, as well as Höch and Francis Picabia, and recounted in anecdotal detail the successes of the Holland Dada tour, and as he did on the tour, Schwitters liberally uses the term Dada throughout the publication, often in conjunction with the terms "Merz" and "De Stijl." *Merz* 1, then, becomes the public document of a particular kind of Dada, the one practiced by the contributing artists and performed on the Holland Dada tour and now advertised under the heading of Merz. In Holland, so Schwitters explains, Dada experienced its true victory. ("Our appearance in Holland resembled an enormous, unheard of victorious campaign.")[30] In its collaboration with De Stijl artists and its appropriation of Dada performance techniques, Schwitters suggested that Merz constituted the real Dada and so functioned as a corrective to Dada as practiced elsewhere, presumably Club Dada Berlin under the leadership of Huelsenbeck. In a *Merz* 1 article entitled, "Die Bedeutung des Merzgedankens in der Welt" (The Importance of the Merz Idea in the World), Schwitters asserted that Merz' reformist spirit was informed by a De Stijl rhetoric of social transformation through art; at the same time, he trumpets Merz' superiority over De Stijl: "Merz, and only Merz is able to transform...the entire world into a work of art....For the time being, Merz creates preliminary studies for a collective shaping of the world, for a universal style. These preliminary studies are the *Merzbilder*."[31]

Already here, Schwitters considered his own concept of Merz in relation to other avant-garde movements. He had previously proclaimed that one of the tasks of Merz was the forging of connections among different things. This focus on connections gave Schwitters above all a way of explaining the odd accumulation of vastly diverse materials that made up his *Merzbilder*, but also suggested the possibility of interpretation for these abstract or chaotic, i.e., meaningless,

compositions. In *Merz* 1, he defined connections in a more encompassing way in a social, philosophical, or aesthetic manner. Making connections meant to explore the common thread that bound different artistic expressions to each other and was also a way of explaining the affinities he felt with artists who seemed to pursue a radically different path than he did. Schwitters had always emphasized the flexibility of the Merz concept, its openness to new needs and insights.

Now, in his *Merz* magazine, he began to explore Merz in relation to the considerably more formalist styles of De Stijl and constructivism, uncovering commonalties between them and his own work. There had always been a formalist streak in Schwitters even at his most Dada—we might think of a number of his early *Merzzeichnungen*—but in 1922–23, he began to subtly shift the meaning of Merz by moving closer to constructivist aesthetics. In 1919, in his article "Die Merzmalerei" (Merz painting), Schwitters declared that "The word Merz means essentially the bringing together of all conceivable materials for artistic purposes."[32] Now, in *Merz* 1, under the influence of Van Doesburg, Schwitters gives this idea at once a more global and purposeful dimension. He writes, "The task of Merz in the world is: to balance opposites and to set emphases."[33] Although *Merz* 1 advertises Merz, the issue is also an homage to Van Doesburg, noticeable above all in Schwitters' subtle redefinition of Merz in light of De Stijl aesthetics.

Merz 2 was devoted to Dada poetry and *Merz* 4 to French dadaism. *Merz* 3 and 5 were issued as portfolio collections of lithographs by Schwitters and Arp respectively and sold outside the subscription to the magazine **[176–182]**. With issue number 6 **[174]**, the journal had become almost entirely a platform for the discussion of constructivist, De Stijl, and elementarist ideas.

Merz, then, functions as a public forum for the evaluation and popularization of various avant-garde concepts. In it, one can trace Schwitters' move away from dadaist rhetoric to one strongly inspired by constructivism and De Stijl. Aside from *Merz* 1, several of the 1923 issues of *Merz* stand out as important markers of Schwitters' development and as an overall indication of the complex, multilayered relationship between Dada and other avant-garde art. In *Merz* 2, Schwitters published the "Manifest Proletkunst," signed in The Hague on 6 March 1923 by Van Doesburg, Schwitters, Arp, Tzara, and Spengemann—a direct though implicit attack on Huelsenbeck. The common denominator between the signatories, the manifesto suggests, was a deep belief in the spiritual or uplifting potential of art.

The Russian constructivist artist El Lissitzky would become an even more powerful influence in the following years. Lissitzky and Schwitters both pursued a vision of a new total work of art by bringing together a variety of activities under one umbrella term; Merz, in the case of Schwitters, and "Proun" for Lissitzky. Before coming to Berlin in 1921 as ambassador at large for the new Soviet regime and its cultural program, Lissitzky had been busy in revolutionary cultural politics in the aftermath of the Bolshevik revolution. He had created a series of utopian architectural designs, become a key innovator in the graphic arts, and generally promoted cultural change through art. In Berlin, he quickly became active in avant-garde circles, particularly Hans Richter's G, and cast a critical eye on German art. He also founded a magazine, *Veshch*, in 1922, which became a forum for his exhibition reviews and thus a platform for his critique of German postwar art. In one review he had lauded Schwitters for his good eye for color and his facility in organizing materials, but also critiqued him for not having advanced enough from his early work. Schwitters, contrary to his usual behavior when critiqued, invited the Russian artist to Hannover to look at more of his work, asked Lissitzky to attend the Dada-Revon evening after the Constructivist Congress in Weimar, and arranged for his work to be exhibited at the Gallery Garvens in the following month. Schwitters also introduced him to the Kestner Society and facilitated the purchase of one of his watercolors as well as an exhibition which took place in January–February 1923. For that exhibition, the Kestner Society also commissioned a portfolio of his prints, to be followed by another commission a few months later. Lissitzky thus became a key figure in the cultural life of Hannover, and his collaboration with Schwitters on *Merz 8/9* **[172]** must have been seen by both as a unique opportunity to explore and promote their converging ideas about art.[34]

This issue of *Merz* makes immediately apparent how strongly Lissitzky had influenced Schwitters. The format of the magazine presents a strikingly new, clearly readable typography arranged in a dynamic off-center horizontal-vertical grid reminiscent of De Stijl compositions. The content focuses on the topic of contemporary production seen from a particular perspective, the analogy between organic and machine forms. The cover bore in large capital letters a dictionary definition: "Nature, from the Latin Nasci, i.e., to become or come into being. Everything that through its own force develops, forms or moves." This definition of nature as a state of becoming puts *Merz 8/9* right at the heart of an

ongoing fundamental debate about the place of technology in German society. Particularly in the period of stabilization and the subsequent few years of relative prosperity, but already since Ferdinand Tönnies' book *Gemeinschaft und Gesellschaft* (Community and Civil Society), 1887, and Oswald Spengler's *Der Untergang des Abendlandes* (The Decline of the West), 1918–1922, discussion about technology had centered on the loss of tradition that invariably accompanies industrial development. For conservative intellectuals and politicians, rapidly expanding technology was perceived as an especially pernicious problem—necessary for the economic and social survival of the country, but destroying the traditional fabric of society. Some on the ideological right and the center circumvented that problem by interpreting technology as an organic part of nature to make it more palatable.[35] There is a certain unexpected overlap between the thoughts of these conservative intellectuals and the ideas presented in *Merz 8/9* by two artists associated with highly progressive cultural politics. When Schwitters and Lissitzky illustrate a crystal and enumerate at the same time the basic shapes (crystal, sphere, plane, rod, strip, spiral, and cone) as the underlying geometry out of which everything is made, they suggest that all manmade technological forms find their origin in primordial, eternal manifestations and thus have their roots in nature. In so doing, nature and technology are shown as being organically intertwined. But within the artistic avant-garde, Lissitzky and Schwitters were not alone in this understanding. Within constructivist circles, artists such as Kazimir Malevich and László Moholy-Nagy voiced similar ideas, and even progressive critics saw modern technological forms as prefigured in Karl Blossfeldt's micro-photographs of plants. This strand of avant-garde thought can be understood as a response to the deep-rooted anxiety that affects all societies that undergo rapid change. Schwitters and Lissitzky suggest that the link to the organic and the original must be maintained to ensure a vital, nondestructive modernity.

THE "URSONATE"

Two of Schwitters' lifelong projects—those which perhaps best express the central concerns of his career—originated in the Dada period. The first was his "Ursonate," and the second was the *Merzbau*. The inspiration for Schwitters' "Die Ursonate" (The Primal Sonata) was Raoul Hausmann's poster poem "fmsbw," 1918 **[100]**, which Hausmann had performed on their "Anti-Dada-Merz" tour to Prague in September 1921. For Hausmann, the poster poem represented poetry at its most reductive, elemental, and also most

modern. Hausmann had chosen the sequence of letters from a tray of letterpress type, thus introducing chance into its production. Reduced to a few phonemes, the most basic unit of speech, and spoken aloud, the poem communicates sound at its purest, stripped of its link to a concept. (The letter "f" signifies a sound in the primary sign system of language.) At the same time it is printed poster-size, communicating visually like an advertisement that can be taken in at a glance. Schwitters, however, treated the poem like everything else he encountered, as a found object. The string of phonemes of the first line of Hausmann's poem became the material of an extended experiment that ultimately grew into a forty-minute sound poem, the "Ursonate." "Ur" may refer here either to Hausmann's poem as the germ from which Schwitters' sound poem grew as if from an original fertile matrix, or to the archaic, the primitive, or prelinguistic, as the state that predates the split of the sign into language and image. Schwitters took Hausmann's phonemes and arranged them in new groupings, repetitions, and variations. In Schwitters' hands, Hausmann's "fmsbw" proliferates into "Fümms bö wö tää zää Uu/pögiff/kwii Ee," decompressing the poem and expanding it into time and space. Yet Schwitters holds the apparent overabundance and rampant growth at bay by training it into the form of a classical sonata organized in four movements, with a prelude and a cadenza in the fourth movement, to be performed with the human voice.

The "Ursonate" apparently took form slowly in the manner of a collage joined together from several individual texts, including "Porträt Hausmann," which is a variation of Hausmann's original poems, "Lanke trr gll" (1923), "grimm glimm gnimm bimbimm" (1923), and "Priimiitittiii" (1927); each works with repetition, emphatic sound, and vocal climax; in the "Ursonate," they are transformed into individual movements or substantial thematic sequences within movements; in performance, the quasi-organic flow of the sound patterns strains against—and at the same time is contained by—the strict sonata form. In so binding the primitive to the classical, Schwitters opens a psychic space in which the Dionysian and Apollonian intertwine to deepen experience to all possible registers, or, to speak like Kandinsky, to make the spiritual apparent through resonance and vibration.

Throughout the 1920s, Schwitters expanded and refined his composition. Stymied by the paradox that musical notes cannot denote verbal sounds, he developed an annotation system to give it permanent, legible form.[36] He hoped that Katherine Dreier would be able to publish it in

the United States and sent her a draft with extensive guidelines on how to read the score, advising his correspondent to:

> please place the pages on the floor so that there will always be four pages in a vertical row, then the whole thing will begin to look like a composition. . . . When you follow the numbers in the margin, you can easily see the composition in either compressed or wide open, simple or complex form. It was a happy surprise for myself when I saw that the sonata is very structured since until now I could only hear it, because I had composed everything by heart.[37]

We learn several important things from this letter: that Schwitters originally worked on his sound poem intuitively, much the way he pushed the collage elements around on the supporting ground until they cohered and took on a desired form; that in reading, one would discover groupings and networks of possible connections (the compressed and the expanded version, simple and complex); and that the text was to be read on the horizontal plane of the page. A typographic version of the score was eventually designed by Jan Tschichold and issued as a number of the journal *Merz* **[fig. 3.7]**. But Schwitters also believed that the true character of his sound poem would only reveal itself in recital: in reading the score one could experience it only incompletely. For this reason Schwitters was keen to make a complete recording of his work. Schwitters himself was endowed with an extraordinary malleable voice and performed it on numerous occasions. Today it is considered one of the most extensive explorations of sound poetry. As Eugene Thacker describes it, "Short, machine-gun syllables are dotted out in incessant repetition with subtle changes, then in a flurry the voice drops, then rises in an arch over a single letter, slowly morphing into the outer shape of a syllable."[38]

These preoccupations were not wholly new. In *Cherry Picture* and other Merz paintings, Schwitters placed the broken image—the collage elements—on top of the unbroken supporting ground and so gave it a temporal dimension; within the broken image he then created networks of possible connections between different signs, indicating that meaning is relational—that it is actively created in the process of tracing the many strands of the web. Additionally, Schwitters imbued some of the written text with a decidedly performative, enunciatory dimension, like the exclamation "Ich liebe Dir" (I love you) in *Cherry Picture*, reminding us that sound and thought are as inseparable as the two sides of a coin.

What is so fascinating about Schwitters' piece, Thacker observes, "is that it is always a performing voice, in the act of embodying itself (as sound, as phoneme, as syllable, as pitch.)"[39] The "Ursonate," like "An Anna Blume," became standard fare for his Merz matinées in Hannover and elsewhere. *Kleine Dada Soirée* **[169]**, the poster designed by Van Doesburg and likely Schwitters for their Holland Dada tour in 1923, announces "Gedichte von Abstracter Lyrik bis zum Urlaut" (Poetry from abstract poem to the Ur-sound). A handwritten program for a Merz evening in Braunschweig on 23 November 1923 announces under the heading #5: "Poems. A. An Anna Blume; b. The Station; c. Softly; d. Denatured Poetry; e. 4 (Number-poem); f. BLRP (Ur-sound Poem); g. Encore (if desired). 6. Finale! (Takes 10 minutes). If desired, recital of the 'Sonata in FMS.' This performance will take at most 15 minutes and is not an official part of the program. For invited guests only. The performer invites only the well-meaning and musical guests. Interruptions will prompt the performer to stop the recital."[40]

We get a glimpse here of the "Ursonate" in the making, in its earliest form when it demanded only fifteen minutes of performance time. But it is the cautious invitation to listen that is so revealing. Schwitters knew that his abstract poem and emphatic delivery caused great consternation. Thinking of his poems in musical terms, Schwitters gambled that a listener with a trained ear would be more

3.7 Kurt Schwitters, spread from *Merz* no. 24: "Ursonate," a phonetic poem with typography by Jan Tschichold, Merzverlag, 1932. National Gallery of Art, Library, Gift of Thomas G. Klarner

likely to understand the experimental form. We know from other accounts that by at least the mid-1920s Schwitters had learned to take his audience's discomfort in stride. More often than not, his performance led to outbursts of laughter, and he would no longer stop but simply increased the volume of his voice until people calmed down again, ready to listen. Richter relates one such event and describes how a change came over the listeners once the laughter had ceased:

> Their faces, above their upright collars, turned first red, then slightly bluish. And then they lost control. They burst out laughing, and the whole audience, freed from the pressure that had been building up inside them, exploded in an orgy of laughter. The dignified old ladies, the stiff generals, shrieked with laughter, gasped for breath, slapped their thighs, choked themselves. Kurtchen [Schwitters] was not the least put out by this. He turned up the volume of his enormous voice to Force Ten and simply swamped the storm of laughter in the audience, so that the latter almost seemed to be an accompaniment to the "Ursonate".... Schwitters spoke the rest of his "Ursonate" without further interruption. The result was fantastic. The same generals, the same rich ladies, who had previously laughed until they cried, now came to Schwitters, again with tears in their eyes, almost stuttering with admiration and gratitude. Something had been opened up within them, something they had never expected to feel: a great joy.[41]

Schwitters, in reciting the sound poem, conveyed what the Merz paintings and Merz drawings could only suggest—that the pictures were designed as invitations to read a text and in reading, to trace different paths, creating new links and a multiplicity of meaning. Moreover, for Schwitters, this process of tracing new and different constellations would transform the viewer, reader, or listener. In his performance, Schwitters intoned these new connections, giving them expression so they resonated and opened within his listeners a new realm of experience.

THE *MERZBAU*

As Schwitters considered the "Ursonate" his life's work, the *Merzbau*—another expansive collage project in untraditional form—was its twin. Schwitters worked on it continuously from the early 1920s until his exile to Norway in January 1937. There he began work on a new *Merzbau* in his place in Lysaker, near Oslo, and when he was forced to flee Norway after the Nazi invasion, he started work on yet another *Merzbau*, his

Merzbarn in Ambleside in the Lake District of England. None of the earlier versions have survived; the first was destroyed in a bombing raid during World War II, the second in Norway by fire several years after his death. The *Merzbarn* survives in the initial unfinished state in which Schwitters left it at the time of his death in 1948. In its several incarnations, the *Merzbau* thus represents Schwitters' most sustained investigation of collage.

Schwitters started work on the *Merzbau* in earnest in the mid-1920s, but the earliest beginnings go back to 1919, to the Dada/early Merz period and his first experimentation with collage. Briefly put, the *Merzbau* is an organic work, forever in flux. Built like all Merz works with found objects, Schwitters eventually covered his accumulations with a shell of plywood and plaster shaped in clear geometric forms and then painted white. With its emphasis on collage techniques, the core is related to dadaism, while the shell manifests constructivist and expressionist ideas; yet both are so utterly intertwined and interdependent that the *Merzbau* realizes the ultimate goal of Merz, the fusion of all and everything in this world.[42]

The *Merzbau*, also known as the *Kathedrale des erotischen Elends* (Cathedral of Erotic Misery) [fig 3.8] after one of its most important parts, finds its origin in several independent early works fashioned from found objects, some of which were later incorporated. These earliest works—the *Merzbau*'s conceptual and actual underpinnings—are closely related to certain Berlin Dada works, in particular to sculptures shown at the 1920 Dada Fair. The mutilated mannequins dressed up in military uniform lambasting government authority echo Schwitters' early sculptures, where themes of technology and the mass media also are explored. Yet, these works slowly disappeared into the structure and made room for niches and grottoes. Some of the niches and grottoes that appeared were constructed by his friends, while others held items by which to remember them. Most of the grottoes, however, were soon no longer accessible either, although some could be reached through sliding doors or were even put on display like glass vitrines in a store or natural history museum. Schwitters' method of working expressed the major topic of his career—the destruction and construction of form expressed through process, or collage in its broadest understanding.

A columnar sculpture that eventually became Schwitters *Merzsäule* (Merz Column) marks the *Merzbau*'s earliest beginnings.[43] Like the *Merzbau*, it is no longer extant, but clearly documented in a photograph [see p. 154]. If we judge by its

placement in a corner of Schwitters' studio, it seems to have been conceived as part of a larger environment, for the surrounding walls are covered with the same kind of materials from which it was built.[44] Formally it relates to Johannes Baader's *Das grosse Plasto-Dio-Dada-Drama: Deutschlands Grösse und Untergang oder Die phantastische Lebensgeschichte des Oberdada* (The Great Plasto-Dio-Dada-Drama: Germany's Greatness and Decline or The Fantastic Life of the Superdada) **[see p. 86]**, 1920, which was included in the Dada Fair. The Merz Column combined pure geometries in its base, with natural forms in its upper half, and was clearly autobiographical. The top documented Schwitters' family life with the poignant death mask of his infant son; it is surrounded by toys and a selection of organic materials, including a twig and dried flowers; and a small picture frame that leans against the sculpture, as well as objects with either smooth or irregular edges that are more three-dimensional and organic looking than the materials below on the base. There Schwitters pasted down and affixed flyers, announcements, and papers printed with large numbers or letters—all memorabilia produced by the printing press that document his life as a member of the international avant-garde, such as magazine covers (including the "Anthologie Bonset" issue of *De Stijl* [1921] and *Merz 1* Holland Dada).[45] In the base part, Schwitters put a picture frame as well, but as opposed to the frame on top, this one hangs flat against the wall and thus

blends with the surrounding printed materials; it holds one of Schwitters' own collages, *Der erste Tag* (The First Day), c. 1918, announcing himself and his products as part of a modern print culture and the international avant-garde.

No other early Schwitters sculpture, however, shows more affiliation to Berlin dadaist work than a large sculpture constructed with a tailor's dummy and richly invested with symbolism. Schwitters' *Die heilige Bekümmernis* (The Holy Affliction) **[fig. 3.9]**, c. 1920, was, like the Merz Column, directly incorporated into the growing structure of the *Merzbau* and provides the other thematic underpinning for the larger emerging architectural work. The Merz Column pointed to the origins of collage in mass cultural reproduction and, with its reference to the organic, underscored its break with tradition. *Holy Affliction* imports from Berlin Dada the theme of trauma and the alienated subject. We only know the work from a photograph that shows Schwitters standing in front of his sculpture seemingly engaged in a dialogue with it. A female tailor's dummy is placed on a wooden stool that provides it with prosthetic legs; Schwitters fitted the dummy with a lightbulb for a head and a Christmas tree ornament for an arm and hung two cords around its neck, one supporting a tablet printed with the admonishment "Gebt und spendet reichlich für Oberschlesien!" (Give and donate generously for Upper Silesia), the other a box reminiscent of a street vendor's tray or a hand organ, as it had a

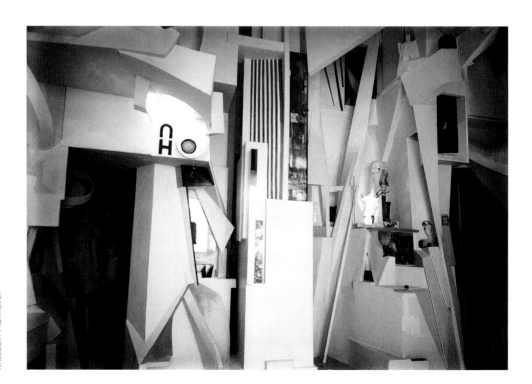

3.8 Kurt Schwitters, *Der Merzbau*, general view with 1923 column, photographed c. 1930. Kurt Schwitters Archiv im Sprengel Museum Hannover

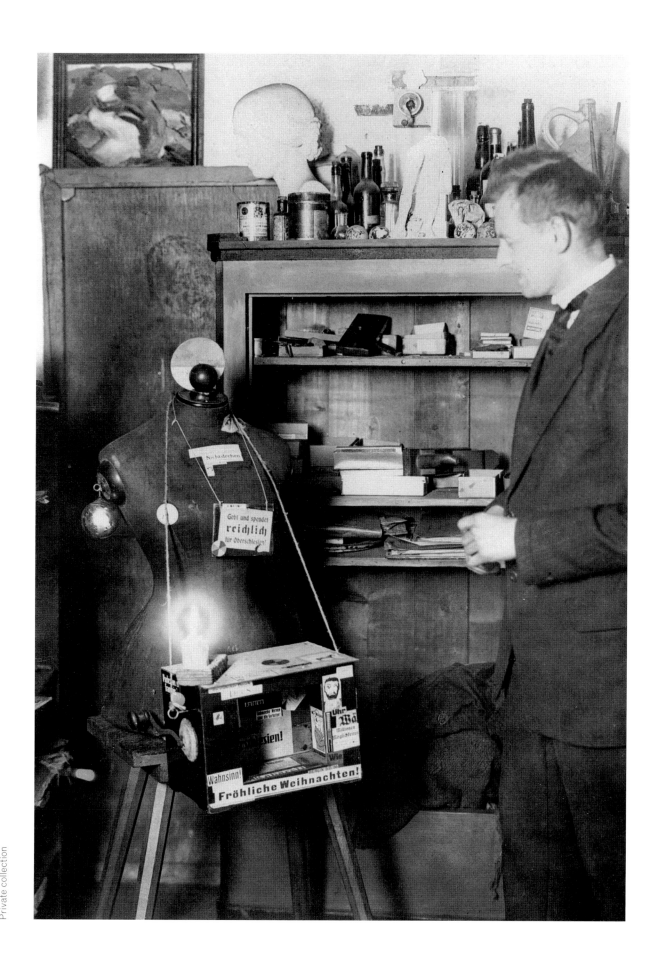

3.9 Kurt Schwitters with his Merz sculpture *Die heilige Bekümmernis*
(The Holy Affliction), c. 1920. Vintage gelatin silver print.
Private collection

handle attached to its side. The word "Oberschlesien" is repeated here in the cavity of the box, which also displays the words "Fröhliche Weihnachten!" (Merry Christmas) and "Wahnsinn" (insanity) and in this photograph, a lit candle is placed on its top.[46] The sculpture takes its name from a fifteenth-century saint, Heilige Kümmernis (St. Uncumber), the Christian daughter of a heathen king who, legend has it, asked Christ that she be disfigured to avoid marriage to a heathen suitor. Her prayers were answered; she sprouted a beard, and thus disfigured, could thwart her suitor's desire.

Both the form and its political theme make *Holy Affliction* a telling indicator of Schwitters' relationship to Berlin Dada and a marker of their differences. The work itself echoes Grosz' and Heartfield's sculpture **[81]** of a mutilated military figure also fashioned from a tailor's dummy, and other closely related works shown at the 1920 Dada Fair in Berlin, and similarly refers to the war and its aftermath,[47] but with a significant difference: Schwitters' sculpture is female. Schwitters transposes the Berlin dadaists' attack on militarism and the war as the source of mutilation and trauma into an interpretation of trauma as the psychic pain of the alienated subject—we can see Schwitters himself here—whose erotic desire for wholeness (the complete national body) is frustrated. The focus on the mutilated female body brings to mind Grosz' several representations of *Lustmord*, but the lit candle acknowledges the saint (and Schwitters) as the worshiper or supplicant, not as the attacker.

Lustmord, however, is a theme in one of the grottoes in the later *Merzbau*; as Schwitters describes in his explanatory text, "KdeE" [Kathedrale des erotischen Elends / Cathedral of Erotic Misery]:

> Each grotto takes its character from some principal components. There is the Nibelungen Hoard with the glittering treasure; the...Goethe Grotto with one of Goethe's legs as a relic and a lot of pencils worn down to stubs;...the Sex-Crime Cavern with an abominably mutilated corpse of an unfortunate young girl, painted tomato-red, and splendid votive-offerings;...an art exhibition with paintings and sculptures by Michelangelo and myself being viewed by a dog on a leash;...the organ which you can turn anti-clockwise to play "Silent Night, Holy Night" and "Come Ye Little Children"; the 10% disabled war veteran with his daughter who has no head but is still well preserved; the Mona Hausmann, consisting of a reproduction of the Mona Lisa with the pasted-on face of Raoul Hausmann covering over the stereotyped smile; the brothel with the 3-legged lady made by Hannah Höch; and the great Grotto of Love.[48]

Lustmord here becomes one incident among many others addressing the misery and spectacle of modern life; it is incorporated, as was *Holy Affliction* with her hurdy-gurdy, into the *Merzbau*, or more specifically, that part which he called the Cathedral of Erotic Misery, and adds a charged tone to the accumulated fragments of modernity. However, as the *Merzbau* grew, the "Sex-Crime Cavern," too, became but a memory trace registered in the verbal description but no longer visible, much as the many grottoes dedicated to his friends or built by them became hidden under the pure geometry of the encasing shell.

If we consider the *Merzbau* a giant, three-dimensional Merz painting, then we have to note an important inversion: in the Merz painting, the collage fragments sat on top of a former (or implied) unified image; in the *Merzbau*, the unified base has become the white, purified shell. Schwitters had toyed already with such an inversion on a small scale when he worked with a local carpenter to design and execute his inlaid boxes, like *Untitled* (Inlaid Box Anna) **[168]**, in which he created a collage effect with pieces of veneer, but actually presented a unified surface plane. The box itself was empty, ready to take in whatever objects it was to hold. Anna Blume, becoming the receptacle of fragments and presenting the varied, yet unified surface, initiates a possible path to the fragments' redemption. In the *Merzbau*, fragments initially served as growth cells that pushed upward and outward, defining the contours of the shell while also being defined by it. The *Merzbau* makes visible not only an architectural form, but also defines the membrane between chaos and order, or fragmentation and wholeness.

Schwitters conceived of the *Merzbau* as a sculpture that could be entered, and entering, one undertook a peculiar route through a fairly narrow passageway in which one no longer saw the fragments of which it was constructed except in the occasional glass-enclosed niche, but instead stepped guided by the architecture into an open space in the very center of the structure itself. Schwitters designed the passage as a purifying trajectory into a contemplative space where the visitor was invited to sit down, take in the surroundings, and then note observations in a notebook he had placed there. Visitors remarked on the silence and the astonishing vistas the *Merzbau* offered and described the experience as spiritual. So said Schwitters' friend and artist colleague, Rudolf Jahns:

> Schwitters asked me to go through the grotto alone. So I went into the construction which, with all its bends, resembled a snail-shell and a grotto at the same time....If you walked all the

way around, you finally reached the middle, where I found a place to sit, and sat down. I then experienced a strange, enrapturing feeling. This room had a very special life of its own. The sound of my footsteps faded away and there was absolute silence.[49]

And in a letter to Alfred Barr in 1936, Schwitters explained:

[I by no means] construct an interior for people to live in.... I am building an abstract (cubist) sculpture into which people can go. From the direction and movements of the constructed surfaces, there emanate imaginary planes which act as directions and movements in space and which intersect each other in empty space. The suggestive impact of the sculpture is based on the fact that people themselves cross these imaginary planes as they go into the sculpture. It is the dynamic of the impact that is especially important to me. I am building a composition without boundaries, each individual part is at the same time a frame for the neighboring parts, all parts are mutually interdependent.[50]

The *Merzbau* evolved fully only long after Schwitters' Dada period, but finds its physical and conceptual origin there, extending into space and time the issues Schwitters had first addressed in his earlier work. Here the fragments of his two- and three-dimensional collages are arrested and shaped into pure, unified form and here erotic desire is channeled into spiritual enlightenment. Even vocalization is silenced and turned again into writing of full sentences on the page, now infused with interiority, as we see in Jahns' concluding observation: "There was only the form of the grotto whirling around me, and when I was able to find words to describe it they alluded to the absolute in art."[51] In Rudolf Jahns' words, which were echoed by other visitors, we recognize that Schwitters achieved his goal first expressed in his 1920 essay "Merz" of transcending the trivial and everyday, of indeed infusing art with deeper psychological and spiritual meaning: "Art is a primordial concept," he said then, "exalted as the godhead, inexplicable as life, indefinable and without purpose. I only know how I make it, I know only my medium, of which I partake, to what end I do not know."[52] In the same article, Schwitters quotes his friend Spengemann's review of his small sculpture, *Haus Merz* (Merz House) **[fig. 3.10]**. "I see in *Haus Merz* the cathedral: the cathedral. Not as a church, no, this is art as a truly spiritual expression of the force that raises us up to the unthinkable: absolute art."[53] Schwitters constructed his Merz art with the fragments of the everyday. "Erotic

3.10 Kurt Schwitters, *Haus Merz* (Merz House), 1920. Architectural model: oil(?) on wood and metal. Destroyed. Kurt Schwitters Archiv im Sprengel Museum Hannover

misery," for Schwitters, describes the Kantian sublime, the experience of one's separation from the natural world and the simultaneous recognition of one's autonomy. "The sublime," for Immanuel Kant, explains Stephen Melville,

presents an object that exceeds cognition, and the subject experiences a mixture of pleasure and pain: pain at the incapacity of the faculties to come to terms with this object and pleasure at the capacity of the faculties to recognize their own incapacity. One might imagine it as linked to the human ability to recognize something as 'too big': the capacity to make excess itself count and not simply exceed.[54]

Schwitters' Merz does not break with tradition but rather formulates paths to its redemption.

1 Küppers mounted important exhibitions of the work of Emil Nolde, Paula Modersohn-Becker, Ludwig Meidner, and August Macke, among others, all artists who had made their mark before World War I. After censorship was lifted, Küppers curated a special exhibition, *French Painting to 1914* (an exhibition of French art from Courbet to Picasso). For a history of the Kestnergesellschaft and a complete listing of the exhibitions and other cultural events there, see Henning Rischbieter, *Die zwanziger Jahre in Hannover* (Hannover, 1962), 22–29.

2 For a complete listing of Steegemann, Spengemann, and Garvens' programs, see Rischbieter, *Die zwanziger Jahre*, 61–96.

3 Schwitters tried his hand with an essay on abstract art in 1910, "Das Problem der abstrakten Kunst" (The Problem of Abstract Art), on which he worked through the summer and fall of that year and in which he focuses in particular on color/sound relationships. The essay exists in different longer and shorter versions, and as a further indication that he was preoccupied with the problem of abstraction, he also tackled some of the ideas in letters to his fiancé, Helma Fischer. See Kurt Schwitters, *Das literarische Werk*, vol. 5, ed. Friedhelm Lach, trans. Ralph Manheim (Cologne, 1973–1981), 26–37.

4 Schwitters, in *Sturm-Bilderbuch IV* (Berlin, 1921), 2.

5 "Kurt Schwitters" (1930), in Schwitters, *Das literarische Werk*, vol. 5, 335. Trans. in Werner Schmalenbach, *Kurt Schwitters* (New York, 1967), 32.

6 "Merz" (1920) in Schwitters, *Das literarische Werk*, vol. 5, 76 and 406.

7 "Merz" (1920) in Schwitters, *Das literarische Werk*, vol. 5, 77, and 406.

8 *Der Sturm* 10, no. 5 (August 1919): 72. Schwitters, *Das literarische Werk*, vol. 1, 58–59.

An Anna Blume

O, du Geliebte meiner 27 Sinne, ich
 liebe Dir!—
Du deiner dich dir, ich dir, du
 mir.—Wir?
Das gehört (beiläufig) nicht hierher.
Wer bist du, ungezähltes Frauenzim-
 mer? Du bist—bist du?—
Die Leute sagen, du wärest.
Lass sie sagen, sie wissen nicht wie
 der Kirchturm steht.
Du trägst den Hut auf deinen Füssen
 und wanderst auf die Hände, auf
 den Händen wanderst du.
Halloh, Deine roten Kleider, in weisse
 Falten zersägt.
Rot liebe ich Anna Blume, rot liebe
 ich dir!—
Du deiner dich dir, ich dir, du
 mir.—Wir?

Das gehört (beiläufig) in die kalte Glut.
Rote Blume, rote Anna Blume, wie
 sagen die Leute.
Preisfrage: 1. Anna Blume hat
 ein Vogel.
 2. Anna Blume ist rot.
 3. Welche Farbe hat der Vogel?
Blau ist die Farbe deines gelben
 Haares.
Rot ist das Girren deines grünen
 Vogels.
Du schlichtes Mädchen im
 Alltagskleid, du liebes grünes
 Tier, ich liebe dir!—
Du deiner dich dir, ich dir, du
 mir.—Wir?
Das gehört (beiläufig) in die
 Glutenkiste.
Anna Blume! Anna, A—N—N—A!
Ich träufle deinen Namen. Dein Name
 tropft wie weiches Rindertalg.
Weisst du es Anna, weisst du es schon?
Man kann dich auch von hinten lesen,
 und du, du Herrlichste von allen,
 du bist von hinten wie von vorne:
 A—N—N—A.
Rindertalg träufelt streicheln über
 meinen Rücken.
Anna Blume, du tropfes Tier,
Ich—liebe—Dir!
(Reprinted by permission.)

9 Schwitters, *Das literarische Werk*, vol. 1, 58–59. Stefan Themerson, *Kurt Schwitters in England* (London, 1958), 25.

10 Peter Bürger, *Theory of the Avant-Garde*, trans. Michael Shaw (Minneapolis, 1984). Bürger's theory of the avant-garde is helpful here as he postulated that it is the critique of the institution of art that defines the avant-garde and differentiates it from other modernist manifestations; it permits us to place Schwitters, at least at this moment in his career, within the nexus of modernism rather than the avant-garde, always keeping in mind that the boundaries between the two tend to be in flux and are dependent on local topographies.

11 Christof Spengemann, "Der Künstler," *Der Sturm* 10, no. 4 (July 1919): 61. Translation in John Elderfield, *Kurt Schwitters*, New York, 1985, 50–51.

12 Schwitters, "Die Merzmalerei," *Der Sturm* 10, no. 4 (July 1919): 61. Reprinted in *Der Zweemann* 1, no. 1 (November 1919): 18; *Der Cicerone* 11, no. 18 (1919): 580 and 582. Schwitters, *Das literarische Werk*, vol. 5, 37 and 400, n. 37.

13 The volume was reprinted two times in a total edition of 13,000 copies.

14 In 1922, Walden capitalized on his own earlier success with Schwitters' poem with his new publication, *Elementar. Die Blume Anna. Die neue Blume Anna* (Elemental. The Blume [Flower] Anna. The New Blume [New Flower] Anna) (Berlin, 1922), in which he identifies the author as "Kurt Merz Schwitters."

Christof Spengemann similarly seized on Anna Blume's popularity and in his turn published *Die Wahrheit über Anna Blume. Kritik der Kunst. Kritik der Kritik. Kritik der Zeit* (The Truth about Anna Blume. Critique of Art. Critique of Criticism. Critique of the Times) (Hannover, 1920). See also Steegemann, "Das enthüllte Geheimnis der Anna Blume," *Der Marstall* 102 (1920), 11–31, a collection of correspondence, criticism, and parodies about Anna Blume. Schwitters himself seized on Anna Blume's notoriety and published a small volume, *Memoiren Anna Blumes in Bleie. Eine leicht fassliche Methode zur Erlernung des Wahnsinns für jedermann* (Anna Blume's Lead Memoirs in Bleie. An Easy-to-Understand Method for Everyone of How to Learn Madness) (Freiburg, 1922). There are numerous other events associated with Anna Blume including a campaign orchestrated by Steegemann in Hannover for which he printed the poem in poster form and placed it on advertising columns throughout the city in the same place where a week before a poster printed in the identical typeface and colors had been posted advertising the Ten Commandments.

15 Richard Huelsenbeck, *The Dada Almanach* (New York, 1966), 9. Originally published as *Dada Almanach*, (Berlin, 1920).

16 "Merz (Für den Ararat geschrieben)," *Der Ararat. Glossen, Skizzen und Notizen zur neuen Kunst* 2, no. 1 (Munich), 3–9; Schwitters, *Das literarische Werk*, vol. 5, 78. Trans. in Elderfield, 41.

17 *Gesetztes Bildgedicht* also contains the letter "O" and thus insinuates a reading as "From Alpha to Omega." The embedded "B," however, inevitably conjures the figure of Anna Blume, even if the poem is meant to be abstract, and suggests associated interpretations.

18 Bert M-P. Leefmans, "Das Undbild: A Metaphysics of Collage," in Jeanine Parisier Plottel, ed., "Collage," *New York Literary Forum* 10, no. 11 (1983).

19 "Merz" (1924), Schwitters, *Das literarishe Werk*, vol. 5, 187.

20 Svetlana Alpers, *The Art of Describing. Dutch Art in the Seventeenth Century* (Chicago, 1983), esp. ch. 4 "The Mapping Impulse," 119–168. I am indebted to Celeste Brusati who first drew my attention to the graphic aspects of Schwitters' collages and their relation to the northern tradition at the time when I was writing my dissertation on Schwitters.

21 Alpers, *The Art of Describing*, 141.

22 Most prominently by Annegreth Nill, "Rethinking Kurt Schwitters, Part One: An Interpretation of *Hansi*," *Arts Magazine* 5, no. 15 (January 1981):

112–118. The tribute to Arp is surely visible, but the title should be read as "Haus" (House), not Hansi as a careful study of Schwitters' handwriting indicates. See Dorothea Dietrich, "The Fragment Reformed. The Early Collages of Kurt Schwitters," (Ph.D. dissertation, Yale University, 1986), 7. See also *Elderfield*, 392, n. 4,7 who concurs with this view and points out that the Museum of Modern Art which owns the work retains "Hansi" because it has become the accepted title. The oeuvre catalogue also lists the collage with the incorrect title and suggests that "Haus" may be the correct one. See Karin Orchard and Isabel Schulz, eds. *Kurt Schwitters : catalogue raisonné*, vol. 1. 3 vols. (Ostfildern-Ruit, 2000-2005.) #285, 136.

23 Andreas Huyssen, *After the Great Divide. Modernism, Mass Culture, Postmodernism* (Bloomington, 1986), 44–62.

24 Maria Tartar, *Lustmord. Sexual Murder in the Weimar Republic* (Princeton, 1995).

25 Arp later mused, "What ever happened to Kurt Schwitters' novel, 'Franz Müllers Drahtfrühling,' on several chapters of which we collaborated? Is it buried under the ruins of his house at Waldhausenstrasse in Hannover destroyed by bombs? For hours Schwitters and I would sit together and dialogue rhapsodically. He channeled this kind of poetry into his novel. Every time when we met, be it in Hannover, Wyck auf Föhr, in Berlin, we would write poetry together." Hans Arp as quoted by Friedhelm Lach, *Der Merzkünstler Kurt Schwitters* (Cologne, 1971), 31.

26 Raoul Hausmann, as cited by Hanne Bergius, *Das Lachen Dadas: die Berliner Dadaisten und ihre Aktionen* (Giessen, 1989), 357.

27 *Bohemia*, September 8, 1921 as cited in Bergius, *Das Lachen Dadas*, 377.

28 The entire text is reprinted in Schwitters, *Das literarische Werk*, vol. 5, 143–144.

29 "Holland Dada" (1923). Reprinted in Schwitters, *Das literarische Werk*, vol. 5, 129.

30 "Holland Dada," Schwitters, *Das literarische Werk*, vol. 5, 131.

31 "Die Bedeutung des Merzgedankens in der Welt" (1923), *Merz* 1 in Schwitters, *Das literarische Werk*, vol. 5, 133.

32 "Die Merzmalerei" (Merz-Painting) (1919) in Schwitters, *Das literarische Werk*, vol. 5, 37.

33 "Die Aufgabe von Merz in der Welt ist: Gegensätze ausgleichen und Schwerpunkte verteilen." *Merz* 1 in Schwitters, *Das literarische Werk*, vol. 5, 134.

34 See Elderfield, 131–132 and the following pages for an in-depth discussion of *Merz* 8/9 Nasci to which this summary is indebted.

35 See Jeffrey Herf, *Reactionary Modernism*.

HANNOVER

Technology, Culture, and Politics in Weimar Germany and the Third Reich (Cambridge, 1984).

36 He had hoped that Lissitzky would design the score, but they couldn't come to an agreement; ultimately the score was designed by the eminent Swiss typographer Jan Tschichold and published as the last issue of *Merz*, accompanied by a gramophone recording of selections of different segments of the sonata, with Schwitters performing.

37 Schwitters to Katherine Dreier, letter September, 16 1926, in Ernst Nündel, ed., *Wir spielen, bis uns der Tod abholt. Briefe aus fünf Jahrzehnten* (Frankfurt and Berlin, 1974), 103.

38 Eugene Thacker, "The Voice's Body: Review of UbuWeb," *www.ubu.com/papers/thacker.html*. The website also offers a recording of Schwitters reciting the "Ursonate" and other sound poems.

39 Thacker, "The Voice's Body," *www.ubu.com/papers/thacker.html*.

40 "5. Gedichte. A. An Anna Blume; b. Der Bahnhof; c. Leise; d. Denaturierte Poesie; e. 4 (Zahlengedicht); f. BLRP (Urlautgedicht); g. Zugabe, nur auf Wunsch. 6. Schluss! (Dauert 10 Minuten). [7.] Nach Schluss auf Wunsch Vortrag der 'Sonate in FMS.' Dieser Vortrag dauert 15 Minuten und ist ausser Programm. Nur für geladene Gäste. Der Vortragende ladet hierzu alle Gutwilligen und nur die musikalischen Besucher des Abends ein. Unterbrechungen würden vom Vortragenden mit Schluss beantwortet." Reproduced on the webpage of the Schwitters Archive, Sprengel Museum, Hannover, *www.kurt-schwitters.org/f,1,1.html*.

41 Hans Richter, *Dada: Art and Anti-Art*, trans. David Britt (London, 1965), 142–143. Originally published as *Dada: Kunst und Antikunst* (Cologne, 1964).

42 There are a number of extensive studies of Schwitters' Merzbau. See Elizabeth Burns Gamard, *Merzbau: The Cathedral of Erotic Misery* (New York, 2000); Dietmar Elger, *Der Merzbau: Eine Werkmonographie* (Cologne, 1999); Elderfield, ch. 7, 144–171; Dietrich, ch. 8, 164–205; for an extensive discussion of the Merz-Column, see Dietrich, "The Fragment Reframed: Kurt Schwitters' Merz-column," *Assemblage* 14 (April 1991), 82–92.

43 For a discussion of the *Merzsäule*, see Dietrich, "The Fragment Reframed."

44 See Elderfield, *Schwitters*, 145–146. It is possible that the column existed in an earlier stage already in December 1919 when Huelsenbeck visited Schwitters' studio on the occasion of his trip to Hannover to oversee the production of his *Dada Almanach*

(published in 1920 by Steegemann).

45 Dietrich, "The Fragment Reframed," 89.

46 Heartfield and Schlichter's sculpture **[80]** dressed up in an army uniform and hanging from the ceiling at the First International Dada Fair also carried a little sign around its neck with the inscription of the words of a Christmas song "Vom Himmel hoch da komm ich her"(High from the Heavens I come).

47 Upper Silesia, rich in coal and imperial Germany's second-largest industrial area next to the Ruhr, was in the wake of the Treaty of Versailles subject to a plebiscite that was to decide whether the area was to be ceded to Poland or, because of its predominantly German population, stay within Weimar Germany's boundaries.

48 "Ich und meine Ziele" (1930), Schwitters, *Das literarische Werk*, vol. 5, 345 Trans. in. Elderfield, *Schwitters*, 161.

49 Rudolf Jahns, as quoted by Dietmar Elger, "Zur Entstehung des Merzbaus," *Schwitters Almanach* (1982), 34–35. Trans. in Elderfield, *Schwitters*, 153–154.

50 Letter to Alfred Barr, November 23, 1936. Archives of the Museum of Modern Art, New York. Cited by Elderfield, *Schwitters*, 156.

51 Rudolf Jahns, as quoted by Dietmar Elger, "Zur Entsehung des Merzbaus," *Schwitters Almanach* (1982), 34–35. Trans. in Elderfield, *Schwitters*, 153–154.

52 "Merz" (1920), Schwitters, *Das literarische Werk*, vol. 5, 76 and 406.

53 Christof Spengemann as quoted by Schwitters in "Merz" (1920), *Das literarische Werk*, vol. 5, 79 and 407.

54 Stephen Melville, "General Introduction," in *Vision and Textuality*, Melville and Bill Readings, eds. (Durham, 1995), 13. I am indebted to this for some of my thoughts about Schwitters' use of image and text.

PLATES

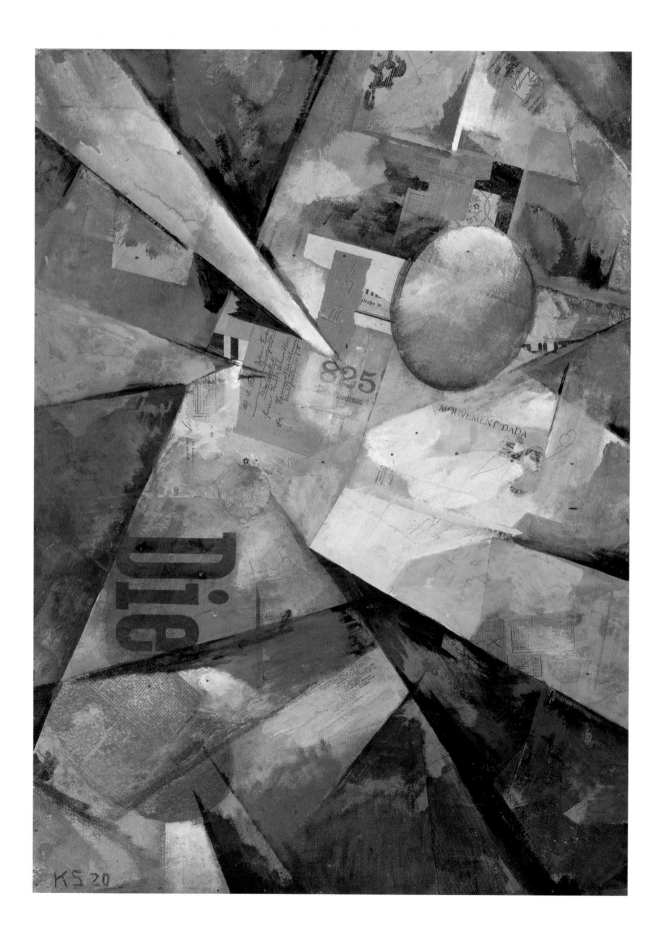

137 KURT SCHWITTERS *Bild mit heller Mitte* (Picture with Light Center),
1919, collage, watercolor, oil, and pencil on board, 84.5 × 65.7 (33 ¼ × 25 ⅞).
The Museum of Modern Art, New York. Purchase

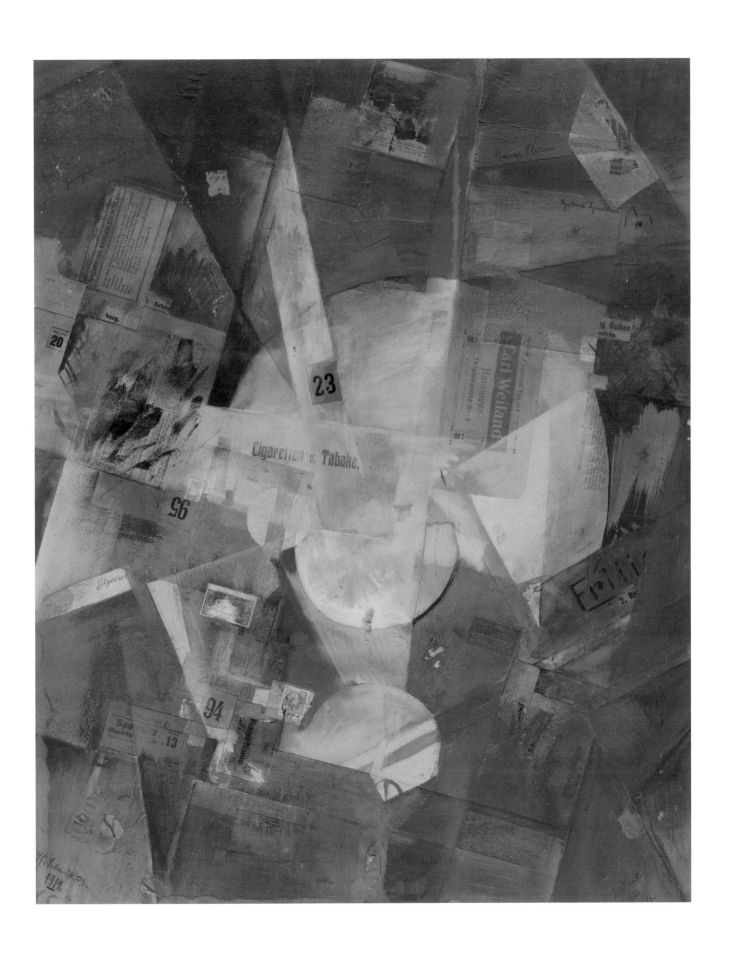

138 KURT SCHWITTERS *Merzbild 12 b Plan der Liebe* (Merzpicture
12 b Plan of Love), 1919–1923, collage of papers and board, tempera, water-
color, ink, and pencil on board, with artist's frame: 43.2 × 32.7 (17 × 12 ⅞).
Private collection

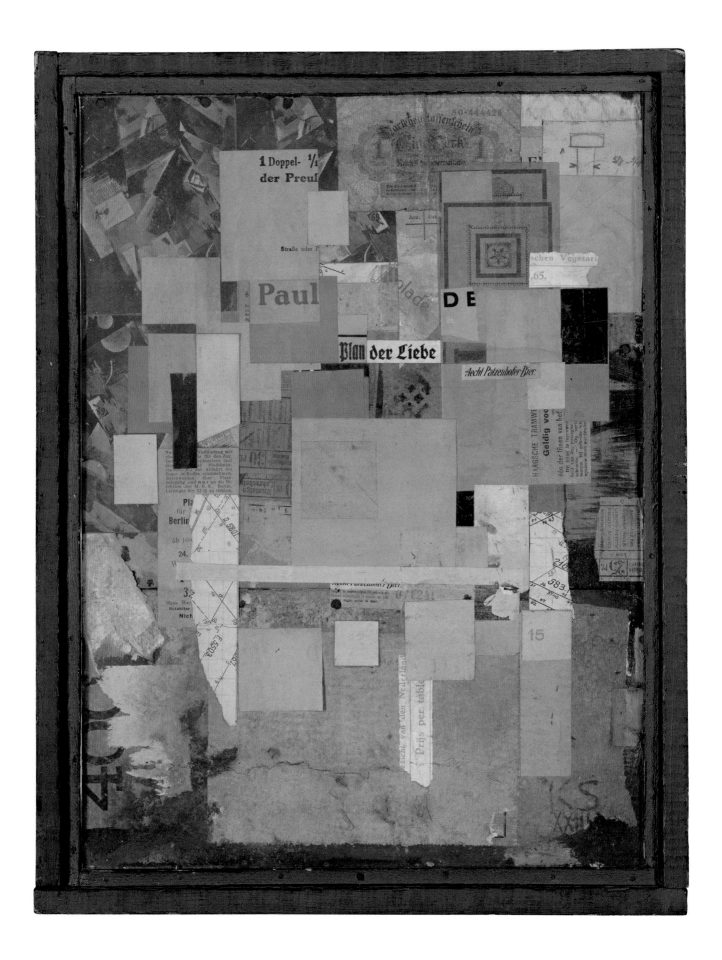

139 KURT SCHWITTERS *Aq. 21. Anna Blume und ich* (Aq. 21. Anna Blume and I), 1919, watercolor and colored pencil on paper, 21.1 × 17.2 (8 ⅜ × 6 ¾). Kurt und Ernst Schwitters Stiftung, Hannover

140 KURT SCHWITTERS Cover (bottom) and title page (bottom right) of *Die Kathedrale* (Cathedral) by Kurt Schwitters, Paul Steegemann Verlag, 1920, two lithographs, one with collage, 22.2 × 14.4 (8 ¾ × 5 ¹¹⁄₁₆). Research Library, The Getty Research Institute, Los Angeles

141 KURT SCHWITTERS Cover of the illustrated book *Anna Blume. Dichtungen* (Anna Blume. Poems) by Kurt Schwitters, Paul Steegemann Verlag, 1919, ink and watercolor on paper mounted on book cloth, 22 × 14.5 (8 ¹¹⁄₁₆ × 5 ¹¹⁄₁₆). Spencer Collection, The New York Public Library, Astor, Lenox and Tilden Foundations

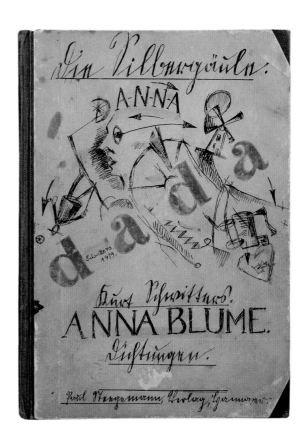

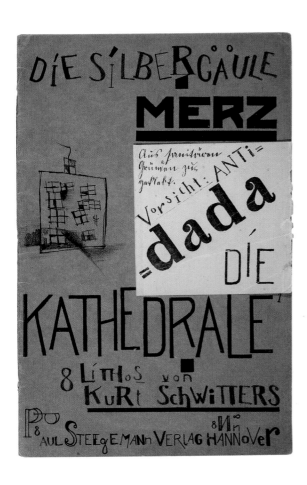

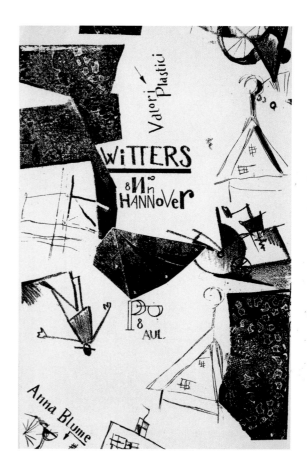

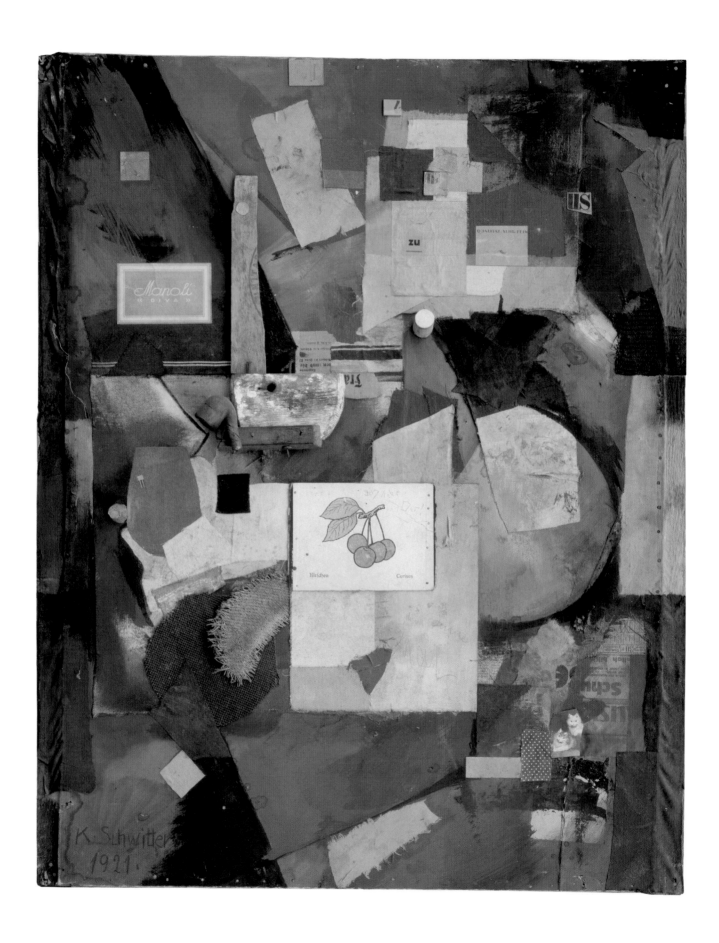

143 KURT SCHWITTERS *Merzbild 10 A: Konstruktion für edle Frauen* (Merzpicture 10 A: Construction for Noble Ladies), 1919, assemblage of wood, metal, tin funnel, leather, cork, paper, oil, and gouache on paper on wood, 108 × 83.4 (39 ¾ × 32 ⅛). Los Angeles County Museum of Art, Purchased with funds provided by Mr. and Mrs. Norton Simon, the Junior Arts Council, Mr. and Mrs. Frederick Weisman, Mr. and Mrs. Taft Schreiber, Hans de Schulthess, Mr. and Mrs. Edwin Janss, and Mr. and Mrs. Gifford Phillips

144 KURT SCHWITTERS *Merzbild 46 A. Das Kegelbild* (Merzpicture 46 A. The Skittle Picture), 1921, assemblage of wood, oil, metal, and board on board, with artist's frame: 55 × 43.8 (21 ⅝ × 17 ¼). Sprengel Museum Hannover

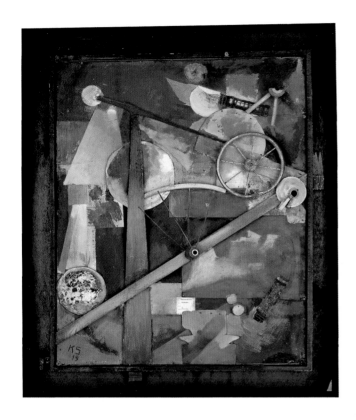

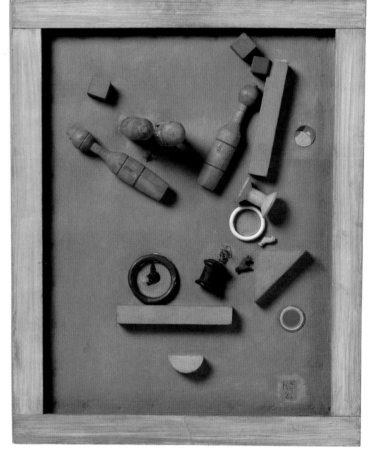

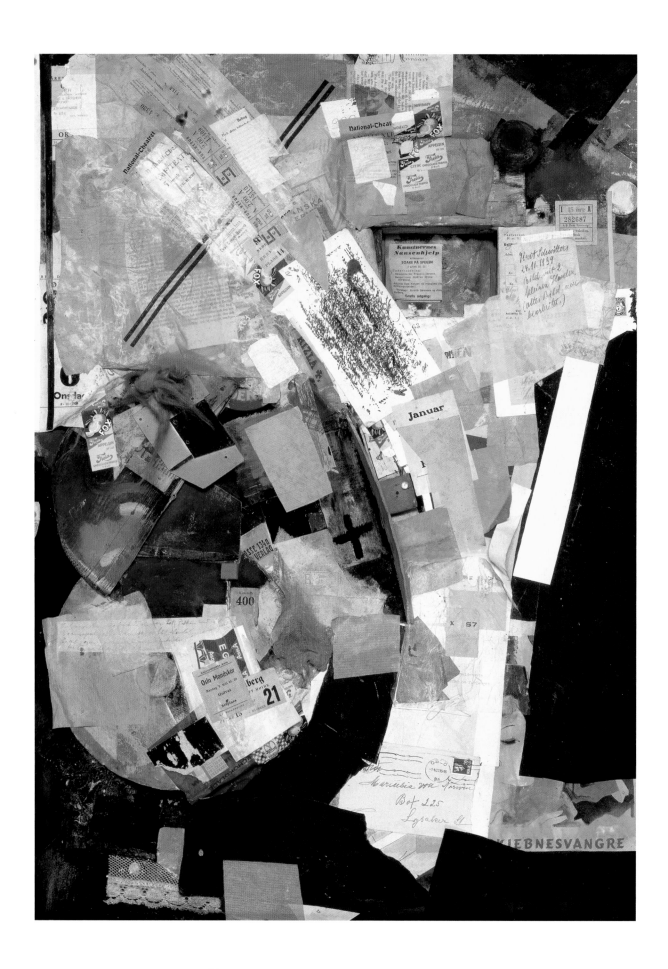

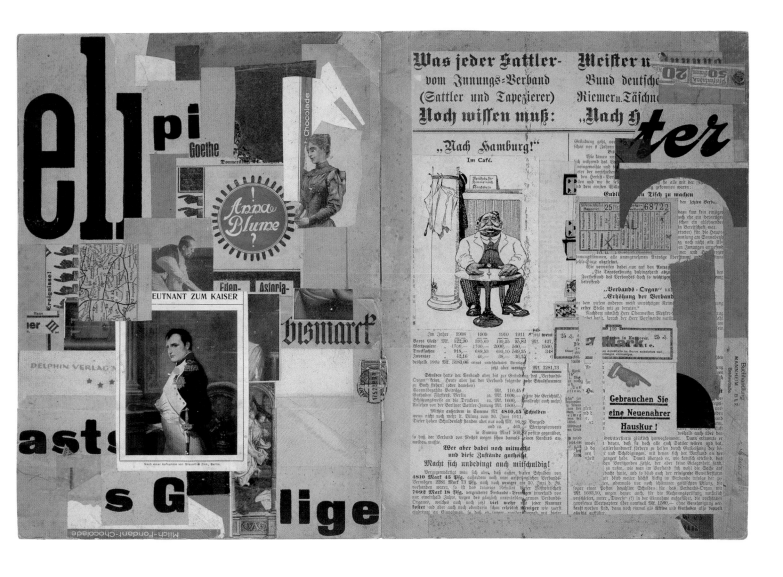

187

147 KURT SCHWITTERS *Mz 460 Twee Onderbroeken* (Mz 460 Two Underdrawers), 1921, collage of papers, fabric, and board on card stock, 20.3 × 17.1 (8 × 6 ¾). The Museum of Modern Art, New York. Katherine S. Dreier Bequest

148 KURT SCHWITTERS Untitled (*fec.*), 1920, collage with pencil inscriptions on paper on board, 25.1 × 18.2 (9 ⅞ × 7 ¼). The Museum of Modern Art, New York. Gift of the Marlborough-Gerson Gallery, Inc.

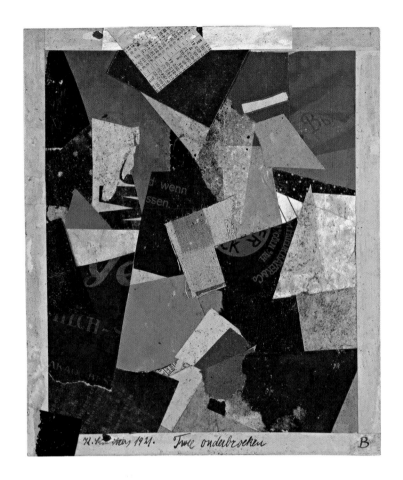

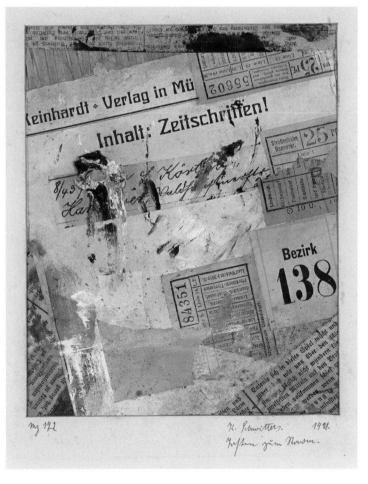

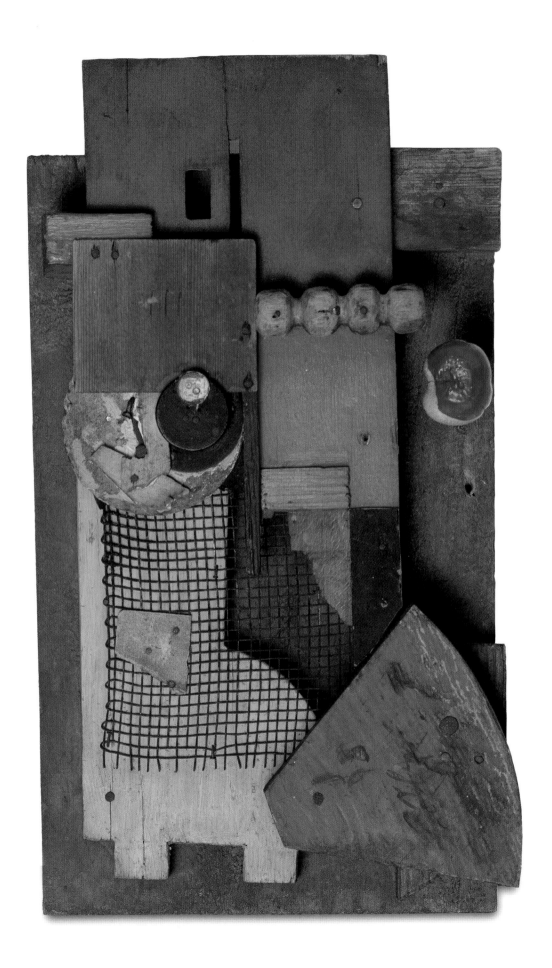

152 HANS ARP Untitled (*Bundle of a Da*), 1920–1921, driftwood relief with oil, 39 × 27.5 × 4.5 (15 ⅜ × 10 ¹³⁄₁₆ × 1 ¹³⁄₁₆). Centre Pompidou, Musée national d'art moderne-Centre de création industrielle, Paris. Gift of M. et Mme Christophe Tzara, 1989

153 KURT SCHWITTERS Untitled (*Wood Construction*), 1923 / 1926, driftwood(?) and painted wood relief, 16 × 23 (6 ⁵⁄₁₆ × 9 ¹⁄₁₆). Private collection

154 KURT SCHWITTERS *Breite Schmurchel* (Broad Schmurchel), 1924, painted wood and metal relief, 36 × 56 × 12 (14 ¾₁₆ × 22 ¹⁄₁₆ × 4 ¾). Staatliche Museen zu Berlin, Nationalgalerie

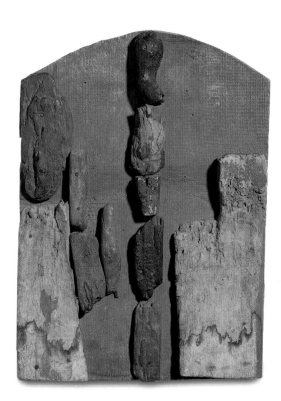

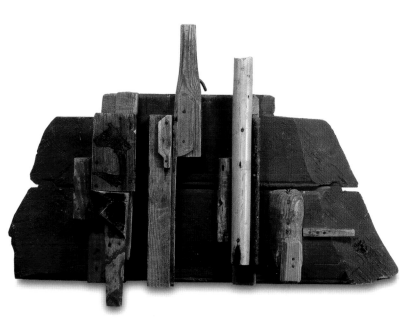

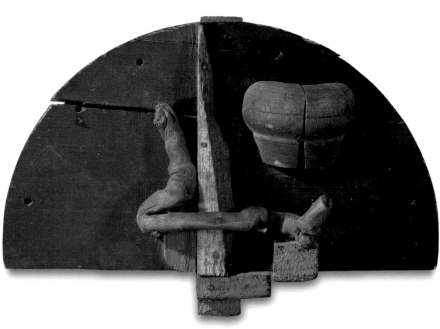

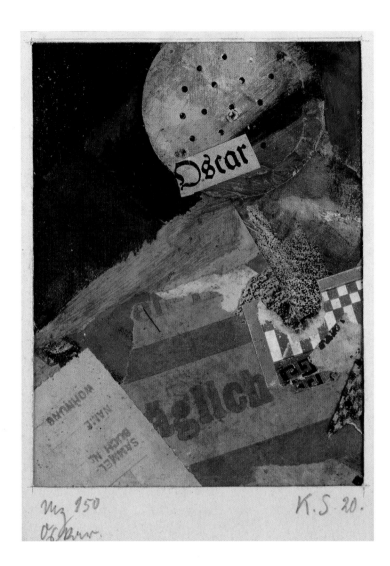

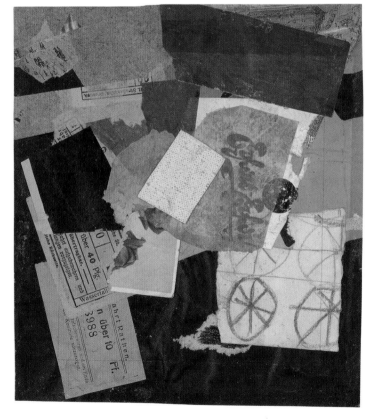

157 KURT SCHWITTERS *Mz 233. Eier* (Mz 233. Eggs), 1921, collage on paper, 27.8 × 24.7 (10 ¹⁵⁄₁₆ × 9 ¾). Private collection

158 KURT SCHWITTERS Untitled *(Pottery),* c. 1921/1922, collage on paper, 13.6 × 11.2 (5 ³⁄₈ × 4 ¹⁵⁄₁₆). Private collection, Courtesy of the Galerie Gmurzynska

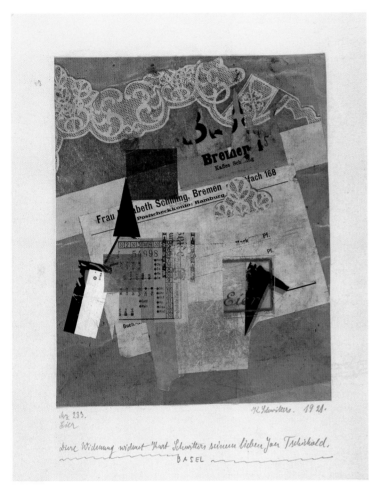

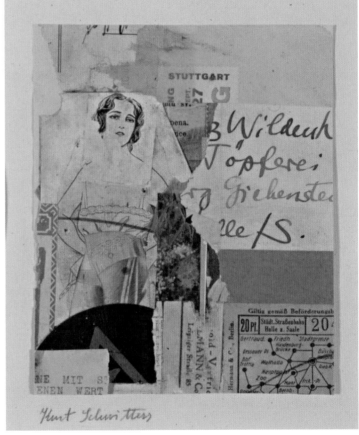

159 KURT SCHWITTERS *Mz 317. Lenox*, 1921, collage on paper, composition: 18 × 14.5 (7 ¹⁄₁₆ × 5 ¹¹⁄₁₆). Kurt und Ernst Schwitters Stiftung, Hannover

160 KURT SCHWITTERS Untitled (*With Large Cross Spider*), 1921, collage on paper, composition: 15.1 × 11.6 (5 ¹⁵⁄₁₆ × 4 ⁹⁄₁₆). Kurt und Ernst Schwitters Stiftung, Hannover

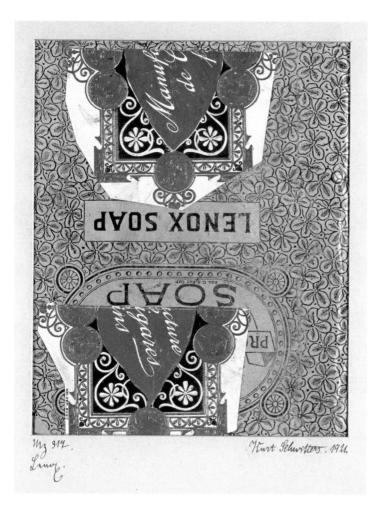

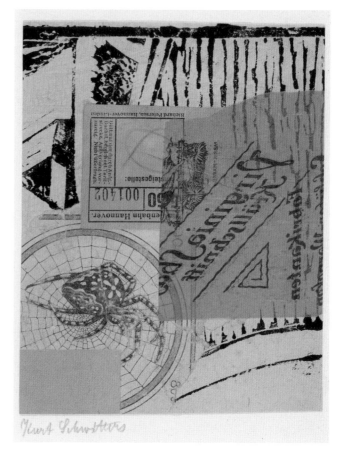

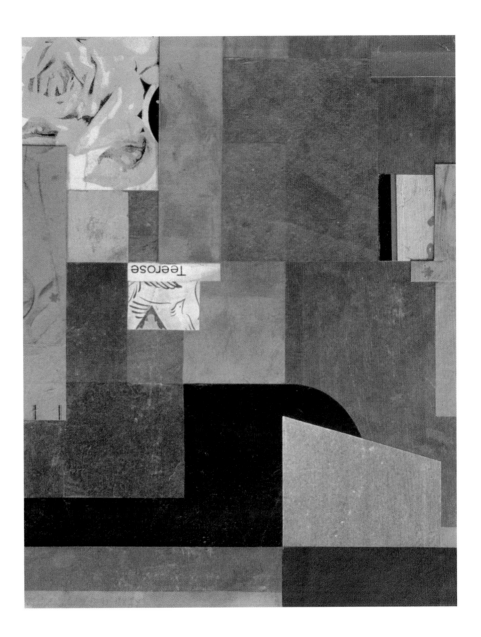

162 KURT SCHWITTERS *Merzmosaik aus Geviertornamenten*
(Merz Mosaic of Quartered Ornaments), 1924, i-drawing: misprinted,
discarded, trimmed printer's proof with pencil, with artist's mat,
composition: 12.9 × 10.2 (5 ⅛ × 4 1/16). Kurt und Ernst Schwitters
Stiftung, Hannover

163 KURT SCHWITTERS Untitled (*Lithograph with Rivet Holes*),
1919, lithograph, sheet: 29 × 23.2 (11 7/16 × 9 3/16). Cabinet des estampes
du Musée d'art et d'histoire, Genève

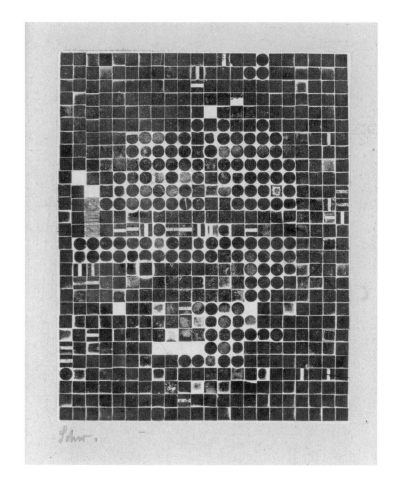

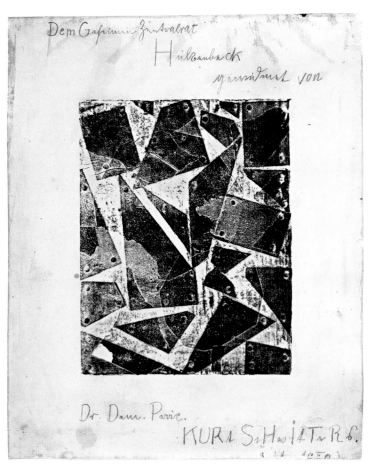

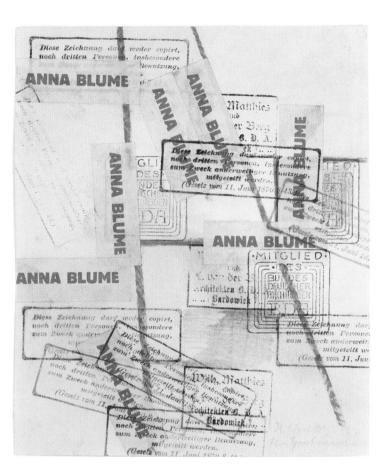

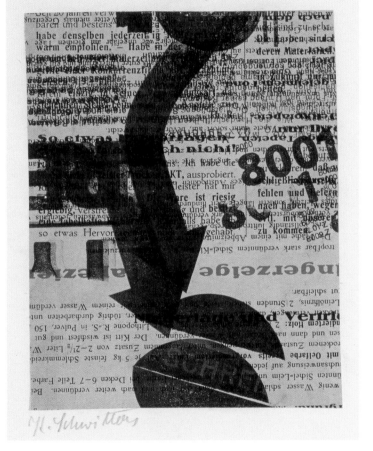

166 KURT SCHWITTERS Untitled *(Assemblage on Hand Mirror)*,
1920/1922, assemblage of oil, papers, board, wood, metal leaf, porcelain,
plaster, metal, and glass on mirror, 28.5 × 11 (11 ¼ × 4 ⁵⁄₁₆). Musée d'Art
Moderne de la Ville de Paris

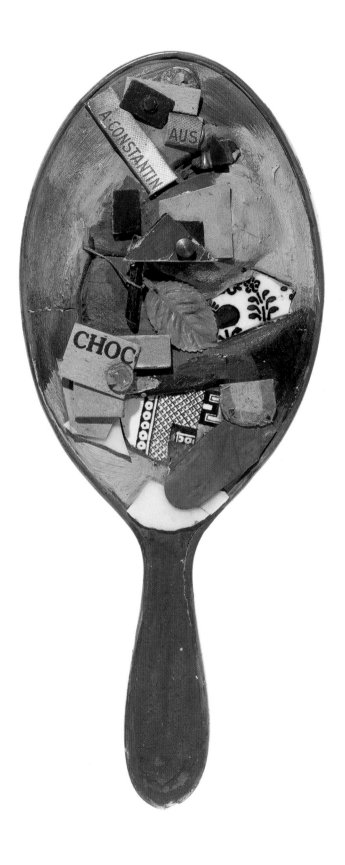

167 KURT SCHWITTERS Untitled *(Inlaid Box SK* or *P for Sophie and Paul Erich Küppers),* 1921, Albert Schulze fabricator, inlaid wooden box with ivory and mother-of-pearl, 23 × 23 × 16.7 (9 1/16 × 9 1/16 × 6 9/16). Kestner-Museum, Fritz Behrens-Stiftung, Hannover

168 KURT SCHWITTERS Untitled *(Inlaid Box Anna),* c. 1921, Albert Schulze fabricator, inlaid wooden box, 24 × 27.5 × 22.5 (9 7/16 × 10 13/16 × 8 7/8). Kestner-Museum, Hannover

169 **THEO VAN DOESBURG** (and **KURT SCHWITTERS**?) Poster and
program for *Kleine Dada Soirée* (Small Dada Evening), 1922/1923,
lithograph, 30.2 × 30.2 (11 ⅞ × 11 ⅞). The Museum of Modern Art, New York.
Gift of Philip Johnson

201

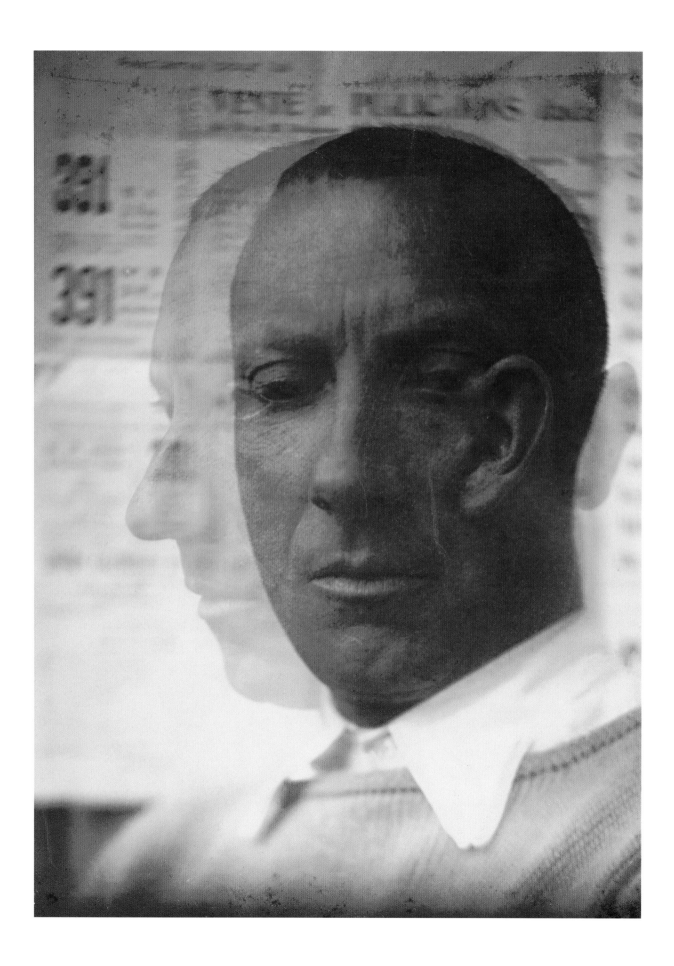

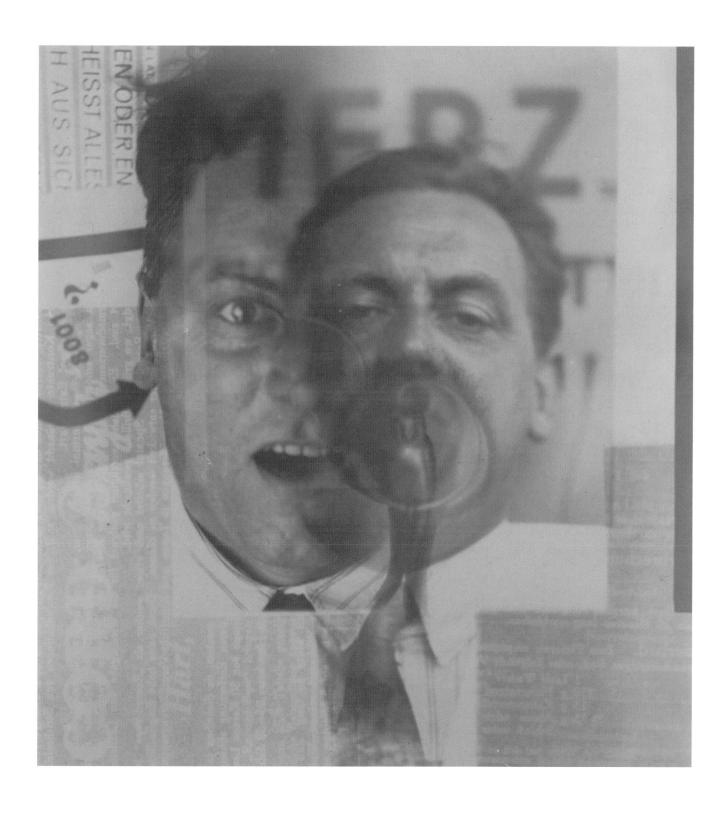

172 EL LISSITZKY and **KURT SCHWITTERS** Cover of the journal *Merz*, no. 8–9: *Nasci*, Kurt Schwitters and El Lissitzky editors, Merzverlag, April / July 1924, letterpress, 30.8 × 23.5 (12 ⅛ × 9 ¼). Elaine Lustig Cohen Dada Collection, The New York Public Library, Astor, Lenox and Tilden Foundations

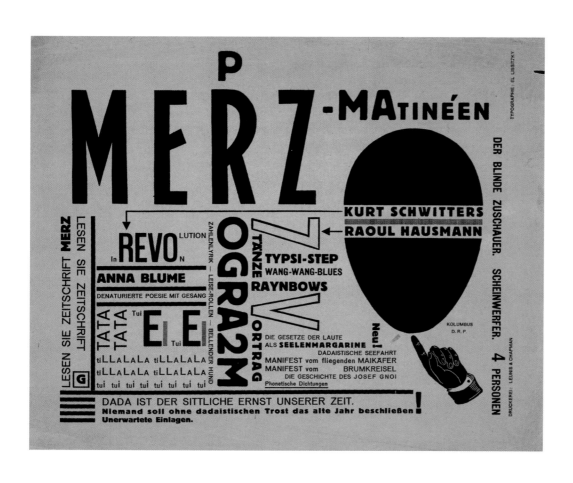

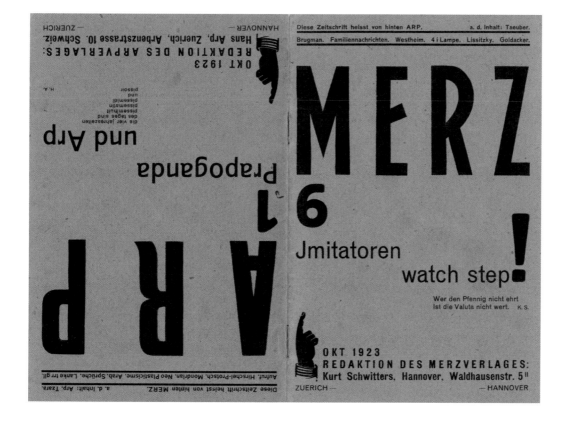

175 **KURT SCHWITTERS** *Merzbild 21 b, das Haar-Nabelbild*
(Merzpicture 21 b, the Hair-Navel Picture), 1920, assemblage of gouache,
charcoal, papers, board, wood, cork, fabric, cotton, hair, sealing
wax, button, and metal on paper, 91 × 72 (35 $\frac{13}{16}$ × 28 $\frac{3}{8}$). Staatliche
Kunsthalle Karlsruhe

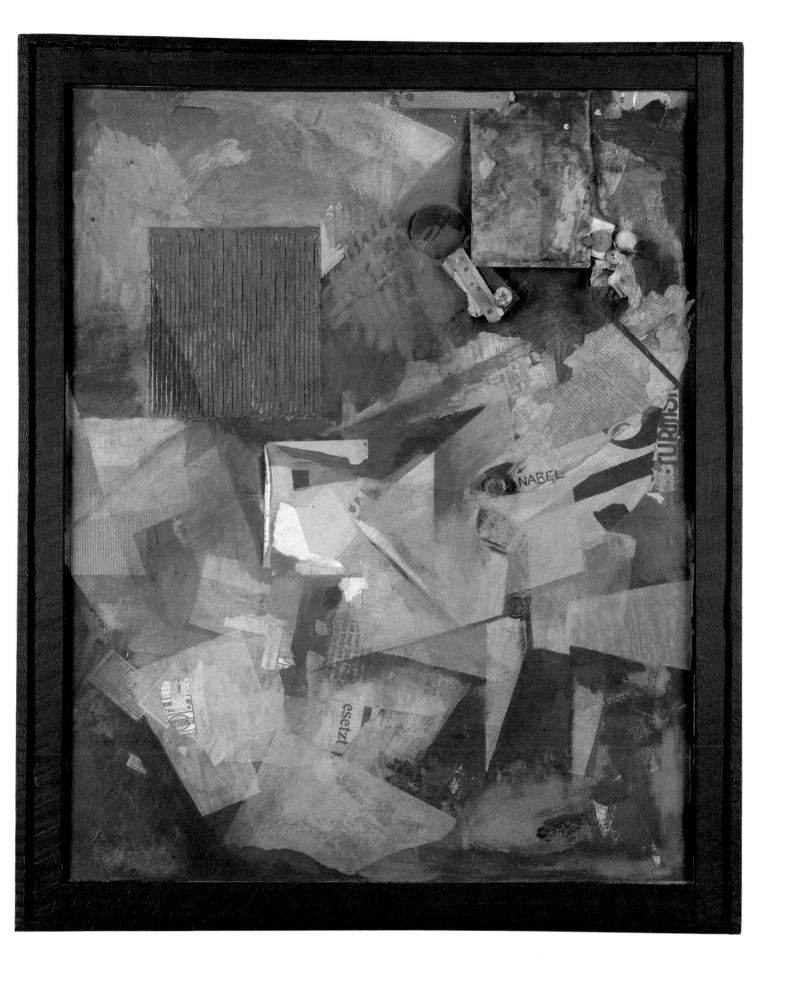

HANS ARP *Merz 5, Arp Mappe: 7 Arpaden* (Arp Portfolio: 7 Arpades), Kurt Schwitters editor, Merzverlag, 1923, seven lithographs, sheet (each): 45.1 × 34.9 (17 ¾ × 13 ¾). The Museum of Modern Art, New York. Gift of J. B. Neumann

176 *Schnurrhut* (Mustache Hat), composition (irreg.): 27.3 × 33 (10 ¾ × 13)

177 *Das Meer* (The Sea), composition (irreg.): 27 × 30.7 (10 ⅝ × 12 ⅛)

178 *Ein Nabel* (A Navel), composition (irreg.): 1.9 × 2 (¾ × ¹³⁄₁₆)

179 *Die Nabelflasche* (The Navel Bottle), composition (irreg.):
41.6 × 24.8 (16 ⅜ × 9 ¾)

180 *Schnurruhr* (Mustache Watch), composition (irreg.):
15.8 × 12.3 (6 ¼ × 4 ¹³⁄₁₆)

181 *Eierschläger* (Eggbeater), composition (irreg.):
42.9 × 28.7 (16 ⅞ × 11 ⁵⁄₁₆)

182 *Arabische Acht* (Arabic Eight), composition (irreg.):
15.5 × 9.8 (6 ⅛ × 3 ⅞)

183 KURT SCHWITTERS Folio 1 from *Merz 3, Merz Mappe: 6 Lithos*
(Merz Portfolio: 6 Lithos), Merzverlag, 1923, photolithograph, with collage
addition, 55.6 × 44.5 (21 ⅞ × 17 ½). The Museum of Modern Art, New York.
Gift of J. B. Neumann

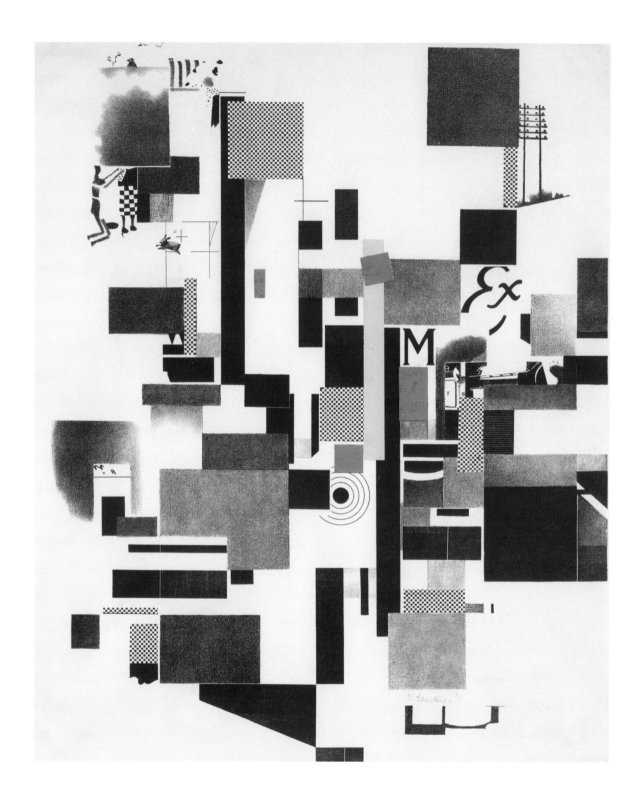

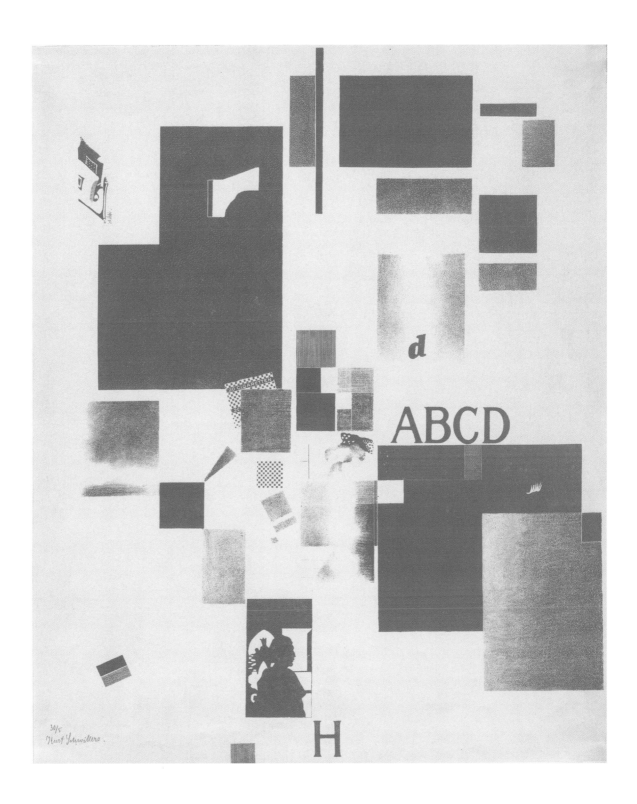

185 KURT SCHWITTERS *1. weisses Relief* (1st White Relief), 1924/1927, painted wood and glass relief, 66.5 × 48.7 × 28.7 (26 ³⁄₁₆ × 19 ³⁄₁₆ × 11 ⁵⁄₁₆). Sprengel Museum Hannover

186 KURT SCHWITTERS *Merz 1924,1. Relief mit Kreuz und Kugel* (Merz 1924, 1. Relief with Cross and Sphere), 1924, relief: ink?, oil, metal (ladle), board, and plastic panel on wood on board, 69.1 × 34.4 × 9.3 (27 ³⁄₁₆ × 13 ⁹⁄₁₆ × 3 ¹¹⁄₁₆). Kurt und Ernst Schwitters Stiftung, Hannover

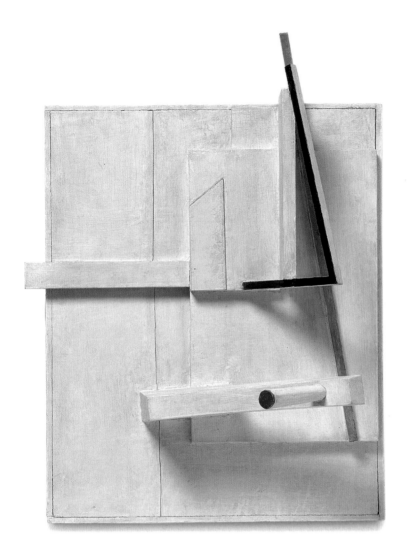

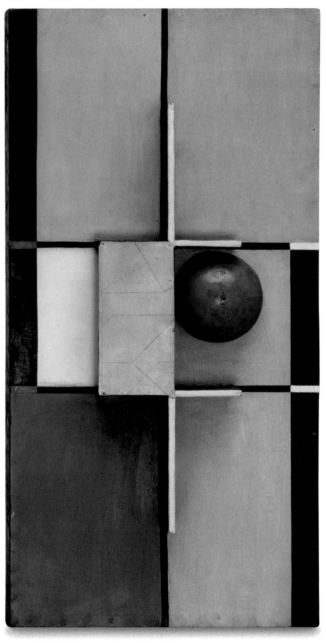

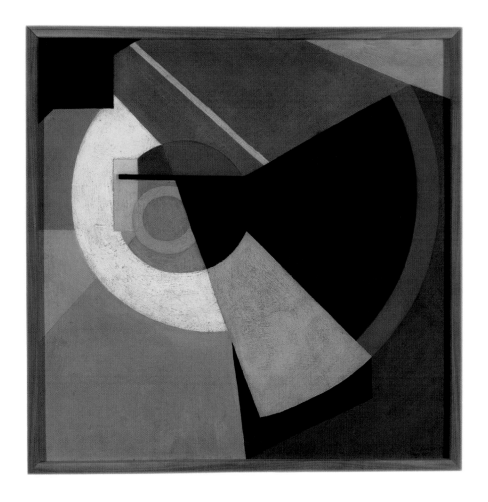

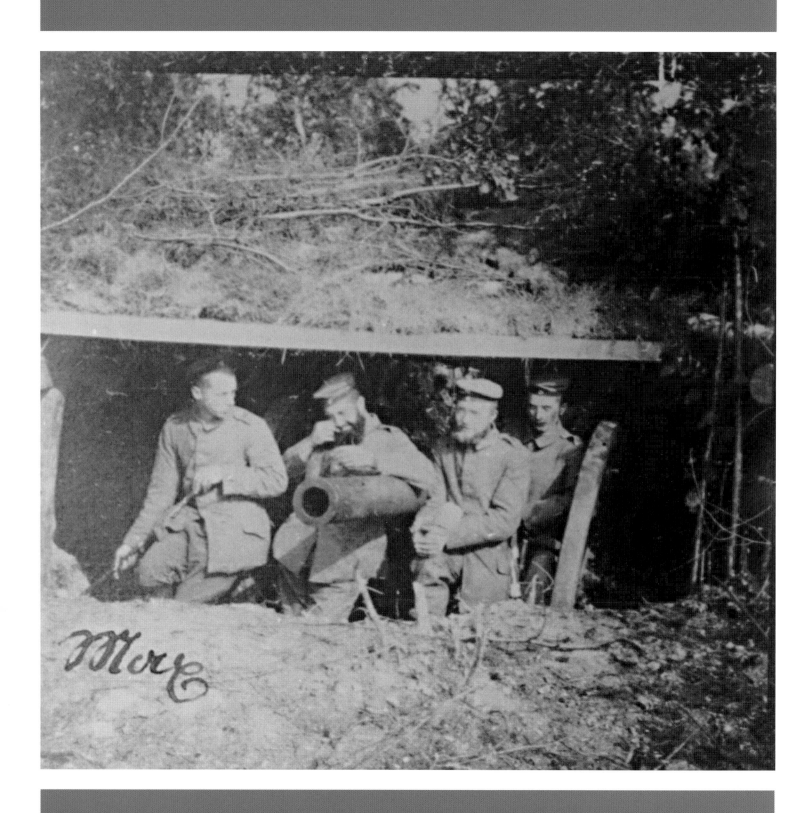

Humor-Ecke des Hotel Kaletsch, Bes. Wilh. Bunte, Düsseldorf

COLOGNE

4

Hans Arp
Johannes Baargeld
Max Ernst
Angelika Hoerle
Heinrich Hoerle

OVERLEAF
Left: Max Ernst (far left), a German field artillery volunteer, in a dugout during World War I, c. 1914–1918. Private collection

Top right: Max Ernst, *Humor-Ecke des Hotel Kaltesch, Düsseldorf* (Humor Corner of the Hotel Kaltesch, Düsseldorf), 1922, pencil on postcard. Sent to Tristan Tzara, 21 March 1922. Bibliothèque Littéraire Jacques Doucet, Paris

Bottom right: Gala (left) and Paul Eluard (second from right) visit Max Ernst (holding his son, Jimmy) and Luise Straus-Ernst (middle) with Johannes Theodor Baargeld (right), Cologne, November 1921. Musée d'art et d'histoire, Saint-Denis

BELOW
Luise Straus-Ernst, Max Ernst with son, Jimmy, and Gala and Paul Eluard gather in Max Ernst's studio during the Eluards' visit from Paris, November 1921. Musée d'art et d'histoire, Saint-Denis

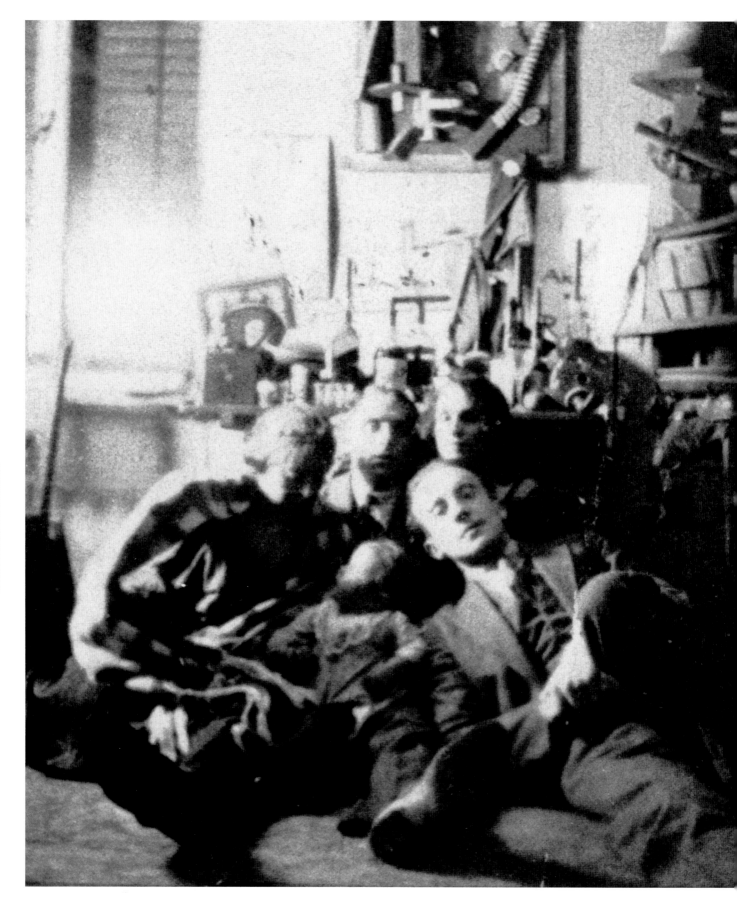

SABINE T. KRIEBEL

When the Second British Cavalry Brigade advanced into Cologne around one o'clock in the afternoon on 6 December 1918, the occupation troops were met with exhausted indifference by Cologne inhabitants [**fig. 4.1**]. In the words of an incoming British officer, the local residents "carr[ied] on much as they had been wont to do any and every day at this abnormal period."[1] The Armistice of 11 November 1918 declared a cessation of armed hostilities between Germany and the Allies and decreed that the principal river crossings of the Rhine's left bank would be occupied by Allied troops—the British in Cologne, the French in Coblenz, and the Americans in Mainz—while the right bank became a neutral zone, thus securing the Rhineland as a temporary Allied frontier. Although combat had ceased, the British naval blockade of raw materials and foodstuffs to Germany remained in effect until 11 July 1919—eight months after the Armistice was signed—and succeeded in pushing the civilian population to the brink of starvation.[2] Many in Cologne died of tuberculosis and the Spanish influenza epidemic in the summer and fall of 1918, their malnourished bodies unable to ward off disease. The British troops were robust in comparison, as a German bystander noted with satisfaction after witnessing their procession into Cologne: "The impression of the troops is first-rate, man and animal are in the best condition, clean clothing and armaments, outstanding discipline."[3] The unmistakable admiration for British order in this firsthand account typified the attitude of many Germans, who hoped that British military occupation would offer protection from the recent onslaught of looting and plundering in Cologne as well as the waves of revolutionary uprisings that convulsed Germany from Kiel to Cologne in October and November 1918. Many local businessmen and industrialists considered the Allied occupation to be the antitoxin to the Bolshevist "red plague."[4]

From December 1918 until the Treaty of Versailles came into force in January 1920, the British ruled Cologne according to martial law. Thereafter, they governed the city under the auspices of the Inter-Allied Rhineland High Commission, retreating in 1926. The military occupation took on a distinctly foreign quality, with English-language signs and a daily newspaper, tartan kilts and bagpipe processions punctuating Cologne's urban landscape [**fig. 4.2**]. The British "Peace Patrol" requisitioned Cologne schools, hotels, homes, furniture, and necessities to house 30,000 British troops (increasing to 55,000 in 1919),[5] and its laws molded civilian life.[6] British mandates were designed to ensure peace and order, though they also indulged in the power of

victor over the vanquished, magnifying the humiliation of defeat. The Germans, it must be said, nursed a virulent anglophobia during the war, which developed into something akin to a nationalistic mania. Where once the Germans hailed each other with "Gott strafe England" (God punish England!) in the city's streets, they now had to respectfully doff their hats to both British officers and the Union Jack when passing, though this order was rescinded in early January 1919.[7] Cologne residents were also required to set their clocks back one hour, in observance of Greenwich Mean Time. Other rules aimed to control subversive activities. Restaurants, railway compartments, and public swimming pools were often marked "For Allied Troops Only" to keep contact between British and Germans at a minimum.[8] The British imposed restrictions on free movement within the zone, disconnected private telephones,

set a curfew from 9 pm to 5 am (although the hours were incrementally cut back), and censored the press and the post.

This environment of foreign military control and censorship produced the conditions in which Cologne Dada would prosper. Dada's artistic pronouncements against order, tradition, and patriarchy, made public in the form of confrontational exhibitions and oppositional publications, were fueled by postwar disillusionment and heightened by foreign occupation. While the circumstances of military authority and censorship in Cologne provoked an artistic resistance to them, their relatively relaxed enforcement also paved the way for the appearance of Dada in Cologne. Such defiant activity would have been impossible in the French-occupied zone, where control over German press and cultural activities was nearly absolute. In British-occupied Cologne, censorship was strategically lenient. As British

4.1 British troops marching into Cologne, 1918. Köln, Rheinisches Bildarchiv

4.2 British soldiers with kilts and bagpipes marching into Cologne, c. 1919. Köln, Rheinisches Bildarchiv

journalist Ferdinand Tuohy wrote: "Provided publications and so on did not hold us up to ridicule or contempt, we were inclined to give the German his head; to let him have what his mental system required."[9] The very combination of restriction and tolerance in British-occupied Cologne provided a fertile ground for an aesthetics of protest in which an anxious, disillusioned postwar psyche was made manifest.

DER VENTILATOR

Thus, in February 1919, a publication provocatively called *Der Ventilator* (The Fan) circulated in Cologne, its heading assuring readers that it appeared with the permission of the British authority [**fig. 4.3**]. Declaring itself to be an entertainment supplement to the daily press, *Der Ventilator*'s purpose, as its title suggests, was to breathe fresh air into the fatigued acquiescence of postwar Cologne. The front page of the inaugural edition issued the following urgent call:



Warning!



Trust no one! Do not trust the most obvious of appearances. There are secret societies among you—do not even trust yourselves. Suspicious thought- and feeling-epidemics are afoot. No one is secure! Least of all from yourselves.



Citizens!



Hold onto your possessions! Do not allow any trade with your heart. Barricade your feelings. Hold onto your belongings—your most dangerous enemy is the spirit. This obtrusive, incomprehensible, unpropertied being will attack your peace and your owner's luck. Protect yourselves, defend yourselves, lock yourselves in....[10]

This absurdist, paranoid prose, which delights in fanning fear and suspicion, at once speaks to the distress of the postwar world and mocks it. In a society traumatized by the horrors of trench warfare and riddled by mass epidemics, from Spanish influenza to the "red plague," the cover page warns of the impending invasion of an invisible "Geist," which is simultaneously a haunting specter, the spirit, and the mind in the German language. That "dangerous enemy" is couched in terms often associated with the proletariat—that which owns nothing, threatens infiltration, undermines traditional stability, and in the popular imagination, was associated with a mass deluge or a pestilence—thus conflating an immaterial spiritual force with the recent manifestations of revolutionary politics in Germany.[11] A character named "Macchab" haunts



4.3 Alfred F. Gruenwald et al., front cover, *Der Ventilator*, February 1919, Cologne. Courtesy of Walter Vitt



the journal's pages. He is defined as a transformative spirit: "He will take on the most absurd forms.... He won't give you peace.... Macchab is elegant.... He is a harlequin who carries half of a death's head as a mask and grins.... Macchab is the crippled world: the shot Revolution." This exquisite, mutable jester is a phantom embodiment of an unconscious that refuses to be repressed, operating as an insistent, taunting reminder of a recently traumatic past. Macchab's tenacious yet mocking presence wants to transform tragic memory into skeptical consciousness, refusing therapeutic mourning by being seditious. As a whole, the leitmotiv of Der Ventilator is productive anxiety, indulging in the play between apparitions and realities, mockery and gravity, and feeding a culture of instability that forecasts Dada's tactics of provocation in Cologne.

Der Ventilator was financed by Alfred F. Gruenwald, who would soon adopt the ironic pseudonym Johannes Theodor Baargeld—"Bargeld" being the German word for cash or ready money. The son of a well-to-do Jewish insurance director, Alfred Gruenwald, a.k.a. Baargeld, turned his back on his wealthy bourgeois upbringing and became actively involved in the leadership of the Rhineland Marxists. Gruenwald's journal served as a satirically inflected political and artistic forum for members of what would become Cologne Dada, including Max Ernst, Heinrich Hoerle, Otto Freundlich, and Franz Seiwert. Between February 1919 and March 1919, five issues of Der Ventilator appeared, the authorship of its provocative essays artfully disguised by capricious pseudonyms, illustrated symbols, or abbreviations. Not only did these textual and pictorial aliases serve to protect the contributors, they also signaled a proclivity for the protean artistic identities that would typify Dada. "Jean Kammacher" was the pseudonym of the artist Heinrich Hoerle[12]; "antischmiz," a term meaning antibourgeois, was shared by Seiwert and Freundlich[13]; Ernst is said to have been the mind behind "Macchab."[14] The only undisguised name to appear in every issue of the journal was Josef Smeets, the editor answerable to the British censors. Smeets also served as the organizational secretary of Cologne's Independent Socialist Party (USPD), and his affiliation aligned Der Ventilator directly with radical politics.[15]

Stridently leftist and tinged with Christian undertones, Der Ventilator sought to appeal to the leftist audience of the Catholic Rhineland, mocking the new socialist German government and the staid bourgeoisie fearful of revolution. Since texts with references to extreme revolutionary movements were forbidden by the British authority, it is

remarkable that Der Ventilator eluded British censors for as long as it did, given its overtly political, disruptive look and tone.[16] The journal's continued publication was all the more weighted in view of the fraught political climate in which it emerged: in January 1919, Karl Liebknecht and Rosa Luxemburg, the key leaders of the revolutionary Spartacist movement—an offshoot of the USPD—were brutally murdered in Berlin by thugs in league with the socialist government. Der Ventilator was thus in line with the highly charged politics of the moment.

Yet the journal's collaborators were bent on provocation and willing to take risks. Indeed, Der Ventilator's politicized response to a theater scandal, in which Max Ernst and his wife Luise Straus took an active part, prompted the attention of British authorities. On 4 March 1919, the Ernsts and at least a dozen other protestors disrupted Raoul Konen's play Der Junge König (The Young King), filling the theater with shouts, aggressive whistling, and ironic singing in objection to Konen's pro-monarchist piece. Police forcefully threw protestors out of the theater. Although Der Ventilator's witty article in support of the disturbance, "Der Theaterputsch," was buried on page six, it managed to come to the attention of the British censors and the publication was promptly banned, terminating the subversive efforts of Gruenwald and his colleagues after six issues.

This short-lived satirical journal, steeped in radical politics and eccentric aesthetics, is a signal moment in the formation of a brief but important avant-garde movement in Cologne. The journal offers us a gauge of change, in which the spiritualist expressionist impulses of the prewar era begin to give way to something more cynical, absurd, and antagonistic. Its concerns are aesthetic and political, visual and textual, parodic and deadly earnest; it engages in cheeky humor, word play, and double entendres that often turn on the artists themselves. All of these postures and tactics would reappear in Cologne Dada's artistic artillery. Indeed, the neologism "Stupidien" which first appeared in issue one of Der Ventilator as a reference to its editors ("Gestütdirektoren Oststupidiens"), wove its way into Cologne dadaist nomenclature as satisfied self-mockery.[17]

The contributors to Der Ventilator were part of a wider phenomenon of Cologne artists and intellectuals who were disillusioned with German postwar society and sought to create social change through their art. Ernst was a key figure in Karl Nierendorf's Gesellschaft der Künste (Society of Arts), founded in November 1918, and his wife Luise Straus-Ernst was its first business manager.[18] Heinrich Hoerle,

Seiwert, and Otto Freundlich all were part of its orbit, as they would, to varying degrees, be attracted to Dada. The Society of Arts was a branch of Berlin's Arbeitsrat für Kunst (Workers' Council for Art), a socialist art council that sought to instigate a radical art program for a broad audience, thus integrating avant-garde art with leftist politics. Society of Arts meetings were monitored by the British, who remained suspicious of socialist activities.[19] The optimistic dynamism of the group as a force for change is suggested by its journal, Der Strom; its name drew on a language of potential energy, "Strom" meaning "current" and suggesting everything from river tides to electrical power. Hoerle designed the publication's emblem, and preliminary notices of Hoerle's Die Krüppel-mappe (The Cripple Portfolio) [202] and a suite of eight lithographs by Ernst (Fiat Modes) [189] were advertised on the back pages of the January 1919 issue.[20]

In the late summer of 1919, however, Ernst and Baargeld encountered Dada firsthand, discovering a mode of aesthetic dissent that would prove to be more artistically productive than their prior engagements. On their return from a mountain climbing holiday in the Bavarian Alps, the Ernsts and Baargeld stopped off in Munich in order to retrieve some Paul Klee drawings for an upcoming Society of Arts exhibit. Ernst visited Goltz Bookstore, where he is presumed to have seen the publication Dada 4–5 [53, 54], edited by Tristan Tzara in Zurich. Abstract or near-abstract works by Klee, Vasily Kandinsky, Raoul Hausmann, and Marcel Janco were reproduced side by side with nonsensical poetry in assorted typefaces by Francis Picabia and Richard Huelsenbeck, among others. Red and blue typography and backgrounds vibrantly offset artwork and verse; texts, in both French and German, were printed sideways, upside-down, and in the shape of an inverted triangle. Ernst also, according to Luise Straus-Ernst, spent many hours in a coffee house with Hugo Ball and Emmy Hennings, who had been actively involved in Zurich Dada.[21] Through them he heard of the Dada soirées at Cabaret Voltaire and other venues where dadaists performed an eclectic mix of cacophonous poems, farcical skits, experimental dances, and music. Ernst may also have heard accounts of several provocative exhibitions mounted in Zurich, which combined work by admired artists and underappreciated amateurs, juxtaposing graphics and tapestries with the drawings of children. Although accounts of Dada had made their way to Cologne that spring and summer—indeed, the important Berlin dadaist manifesto "Was ist der Dadaismus und was will er in Deutschland?" (What Is Dadaism and What Does It Want in

Germany?) by Jefim Golyscheff and Hausmann was published in a Cologne newspaper in 1919[22]—Ball and Hennings' tales of Cabaret Voltaire animated Dada for Ernst in a way that newspaper stories did not. Ernst also learned that his pre-wartime friend Hans Arp was part of the Zurich Dada group and many of his woodcuts of abstract, organic forms were reproduced in Dada 4–5. Leaving Munich, the Ernsts and Baargeld would have come away with a sense of Dada as a multilingual, anticonformist art that cultivated spontaneity, chance, and experiment.

Armed with a radically new set of artistic proposals for the Society of Arts exhibit, to be held in the Cologne Kunstverein (Cologne Art Association) in November, Ernst and Baargeld succeeded in rousing Heinrich and Angelika Hoerle, Franz Seiwert, Anton Räderscheidt, and Otto Freundlich to the Dada cause. As William Camfield observed, "The six weeks they had to prepare for that exhibition must have been a period of feverish activity. Baargeld was literally beginning his career as a self-taught artist, while Ernst was in the process of transforming his art...."[23] Like Ernst, the work of Angelika and Heinrich Hoerle would mutate from expressionist-inspired woodcuts and drawings into spare, absurdist social commentaries. For these artists in Cologne, the stimulus of Dada offered a highly fruitful set of aesthetic strategies for artistic and social dissent.

The enthusiasm for Dada's possibilities was not shared by all, however, meeting with resistance primarily from Nierendorf himself. Dada conflicted with the socialist, populist aims of the Society of Arts. A serious rift ensued, threatening to cancel the show, until Walter Krug, the director of the Cologne Art Association, intervened. Klug suggested a compromise solution: two exhibitions with two separate rooms, clearly marked by a sign at the entrance. Though installed at the request of the Society of Arts, the sign was a supremely indignant Dada proclamation:

> Dada has nothing in common with the Society of Arts
> Dada is not interested in this group's hobbies
> Signed: Johannes Theodor Baargeld, Max Ernst.[24]

Two arrows, pointing in opposite directions, directed visitors to the antipodal rooms. The Dada space was called Section D, and its catalogue Bulletin D, while the artists exhibiting with the Society of Arts used the fourth issue of Der Strom as their catalogue.

That Ernst and Baargeld's sign differentiated Dada from Society of Art "hobbies" in the context of the exhibition

space is both ironic and significant, for it asserts that the viewing public should earnestly consider the artwork (as opposed to amateur dabblings) displayed in Section D. Incoming visitors would have been greeted by a large fraternity pipe mounted over the entrance to the exhibition, beholding an object that hailed from patriarchal traditions while its irreverent placement in an art exhibit implicitly undermined those traditions. Commercially manufactured objects such as a piano hammer and models for polarization curves from a teaching-aids company were offered up next to artworks by Ernst, Baargeld, the Hoerles, Arp, Klee, and Ernst's deceased friend Hans Bolz. Dwarfing the names of the other artists on the list was the "unknown master of the twentieth century," twice repeated and printed conspicuously large in the center of the page, like a marquee, thereby giving the works of two unknowns primacy over known artists.[25] The exhibitors also revered unschooled self-expression, as suggested by the inclusion of children's drawings and of African tribal art, which was then misguidedly understood to be an expression of man's "primitive" impulses. If, as Ernst later claimed, the art of the mentally ill was also included in the show, then it would have augmented the display of art supposedly untrammeled by civilization and reason—a fascination typical of early twentieth-century avant-gardes.[26] Flowerpots are said to have been included in the motley display of objects and artworks.[27] Photography, whose status as high art was tenuous in the early 1920s, was incorporated into the exhibition as well, represented by several "expressionist photographs" by established artists. While the exhibition was certainly intended to shock, it was also conceived as a challenge to orthodox expectations of art, insisting on an aesthetic equality between the mass-produced and the handmade, the professional and the amateur, attempting to expand conventional notions of art by virtue of inclusion.

BULLETIN D

The journal *Bulletin D* (for Dada), which would amount to the first published summary of Cologne Dada's concerns, was anything but a rapidly assimilable broadcast, as the word "bulletin" might suggest. Instead, the journal mobilized the strategy of juxtaposition, suggesting relations between disparate, seemingly unrelated words and images, forcing the viewer to participate actively in assembling meaning—a meaning that insisted on being uncertain and unstable. The cover page **[190]**, coproduced by Ernst and Arp, inaugurates us into a whimsical, enigmatic world. A man on a flying

machine peaceably careens through the left-hand space while to his right two inverted bubble-bodies engage in a sexual act, copulating above a machine of sorts, all wheels, pistons, and pipes. This provocatively arranged combination of mechanical drawings, distracted doodlings, and mass-reproduced illustration offers the beholder exquisite machines and agile bodies in a harmonious, slightly fantastic universe—a blithe counterproposal to the killing machines and mutilated bodies of the recent war.

The interior pages proceed to undercut tradition through impertinent prose and incongruous pictures whose disjunctive content aimed to elicit multiple, often contradictory, associations in the reader. The journal opens to a languidly macabre verse by expressionist poet Jakob von Hoddis (1887–1942), whose fractured poetic syntax was admired for conjuring richly heterogeneous meanings.[28] "Lazy corpse, why do you grin so 'monoise'..." the first line of Hoddis' prose inquires, operating as a morbid lead-in to Baargeld's alphabetic mockery of art historical precedents, both dead and alive:

> Ahehe: Cézanne is chewing gum. The green forest
> ["Grunewald"—a play on Baargeld's birth name]
> digests van Gogh's yellow teeth...
> Behehe: The phallustrade of the Expressionists exhausts
> the lecithin reserves of the total developments like
> acquaintanced stomach rinds...
> Cehehe: incasso cassa picasso. Citizen pablo picasso
> distributes his completed oeuvre to Madrid's widows....

On the following page, Heinrich Hoerle and Ernst take pot shots at art historical contemporaries, not precedents, aiming their verbal scatterguns at Berlin Dada, which they have dubbed "Kurfürstendammdadaismus," conflating the name of Berlin's high-end shopping boulevard with their colleagues in Berlin. They deride George Grosz and "2 Herzfelde," (a dadaistic shorthand for the Herzfeld brothers, Wieland and Helmut, alias "John Heartfield"), allying them with bourgeois trappings ("Put him in a top hat!")— an absurd accusation because all three Berlin dadaists were card-carrying communists. These inventive Dada texts seek to dismantle artists, past and present, by taking apart the structures of language, employing nonsensical syntax and wordplay to construct the alternative linguistic schemes characteristic of Dada prose.

In a similar maneuver, Ernst and Baargeld subverted traditional systems of structure and logic by simultaneously imitating and undermining them in their artwork. For

instance, the framed geometrical blocks in Ernst's *Architektur* (Architecture) **[191]** stack up as precarious columns rather than stable constructions, implying a collapsing order— of expectations of art and civilization as we know it. Similarly, Baargeld's $1\pi d-10 = 0.01\ dada$ **[193]** is executed with mathematical precision but adds up to nonsense. We see a man's head, in the lower right, illustrated as a pseudo-medical cross section. He either peers through, or is a prosthetic extension of, a bullet-shaped telescope that leads to an illogical architectural space, the visual rhetoric of clarity, science, and logic effectively thwarted in an irrational dreamscape.

The Hoerles likewise made the familiar strange in their pictures, inserting the fantastic and the chimerical into the mundane. In Heinrich Hoerle's *Porträt einer Lilliputanerin* (Portrait of a Lilliputian), the table legs behind the diminutive figure have transformed into writhing snakelike forms. Angelika Hoerle's three-breasted equestrienne, reproduced on the last page of *Bulletin D* **[192]**, has a cubistic body that supplies simultaneous views of front and back, indicated by pubic tufts and tightly-drawn buttocks. Her multidimensional nudity is more strained than sensual, emphasized by rigid posture, a dour mouth, and a severe hat. Yet her acerbity is mischievously offset by the fanciful replication of breasts and the whimsy of the horse's weedlike tail, thus blending patrician restraint with irreverent caprice. The understatement of Angelika Hoerle's drawing is a wry finale to this erratic collection of Dada pictures and proclamations in *Bulletin D*, a quirky combination of ludic pleasures, blending fantasy with irony, social criticism with play.

Both show and catalogue were received disapprovingly by fellow artists and critics alike. Seiwert alternately called Dada a "bourgeois art enterprise"[29] and an "anti-bourgeois harlequinade,"[30] apparently not quite sure about Dada's class status. His confusion reflected the doubt of many viewers who were uncertain whether Dada was inaccessible, elitist indulgence or puerile nonsense. One newspaper critic wrote: "One doesn't quite know whether to grow indignant or just laugh at these products of methodical madness."[31] Seiwert, for his part, transformed indignance into action. Stating that Dada lacked in serious political intentions, he withdrew his works from Section D shortly before it opened and displayed them in the Society of Arts room instead.[32] Räderscheidt also withdrew his art. The work of both men was nevertheless reproduced in *Bulletin D*, which went to the printer before Seiwert and Räderscheidt's protest.

While critics recognized that Dada was a symptom of the age, they too questioned its usefulness in a period of psychic vulnerability. As an anonymous reviewer for the *Kölner Stadt-Anzeiger* wrote: "It has been said that this art reflects despair over the state of the modern world; admittedly, the human situation on this planet is hopeless; but hope, yearning, faith are and will remain the roots of all art," thus maintaining the conservative position that art should be uplifting and transcendent rather than confrontational.[33] The British occupation forces confiscated the remaining copies of *Bulletin D*. Some scholars speculate that censors were particularly offended by Otto Freundlich's essay "Die Lach-Rakete" (Laughing Rocket), which assaulted pillars of bourgeois morality, including motherhood, and had an incendiary line that was an explicit call to violence. One viewer responded enthusiastically to the show, however. Katherine S. Dreier, an American collector, was so taken with the work that she offered to show the exhibition in the United States. Ernst was to send copies of *Bulletin D* to New York, but his attempts were blocked by British occupation forces. However, an important conduit for introducing Dada to the United States had been established.[34]

COLOGNE DADA

What was Dada? What did it want in Cologne in the autumn of 1919? Dada's strategic assaults on tradition and authority in Cologne flourished among a group of artists already inclined to aesthetic dissent, but whose convictions and imaginations drew sustenance from an international affiliation of the like-minded. Thus, Baargeld's "Ahehe Behehe" verse assimilated the disrupted syntax and associative word juxtapositions of the poetry in *Dada 4–5*; Ernst's *Architecture* suggests that he might have been familiar with Kurt Schwitters' "*Merz*" assemblages, published in the July issue of *Der Sturm*, which Ernst probably saw at Goltz Bookstore.[35] "Merz," according to Schwitters in *Der Sturm*, "bring[s] together all conceivable materials for artistic ends, and in technical terms, a principal of equality for each kind of material"—a concept which the Cologne dadaists may have appropriated for their Section D exhibition tactics. *Bulletin D*, unlike *Der Ventilator*, toyed with typography, using various typefaces and sizes, though language always remained conventionally right-side up and, contrary to *Dada 4–5*, text and images appeared on separate pages, such that the two art forms were not in immediate dialogue.

Although Cologne Dada availed itself of previous Dada methods, it offered contributions of its own. For example,

Cologne Dada investigated the contradictoriness of systems, using conceptual incongruity as a tactic of social critique. Cologne Dada's attacks on art historical precedents were explicit, rather than implicit. Dadaists in Cologne were enthralled by the absurd and the unconscious, which translated into representations of hallucinatory dream states that confused the boundary between conscious and unconscious perception. In contrast to most artists in other Dada city centers, almost all of those who were actively involved in Cologne were not formally trained as artists—artistic "dilettantes" is the term that would appear in their dadaistic nomenclature. This behavior asserted that serious artistic practice was not reserved for those academically trained, but occurred outside of established systems of education, expanding the definition of an artist.

Dada in Cologne in 1919 encompassed an array of investigations that drew from the material world and psychological terrain of the postwar Rhineland. Developing a new idiom that would adequately articulate their radically altered sense of self and society, the Cologne dadaists wove their innovative pictorial and linguistic vernacular through artworks, publications, and exhibitions produced in collaboration, using the apartments of the Ernsts and the Hoerles as home base. While group efforts were a significant component of Cologne Dada, effecting a unique productive synergy, the exploration of Dada's possibilities by individual artists developed many of these dadaist tactics. Such individual investigations simultaneously honed, elaborated on, and diversified Dada's artistic artillery, fueled by the conditions of postwar Cologne.

MAX ERNST

Given that *Der Ventilator* and *Bulletin D* were both confiscated by the British authorities, perhaps it is not surprising that one strategy of dadaist subversion in the Rhineland should be embedded in that hostile print culture. Ernst frequented the Druckerei Hertz in Cologne, the very shop that printed several issues of *Der Ventilator* and *Bulletin D*, in order to scavenge. Using impressions or rubbings from the discarded printer's blocks, Ernst fabricated cryptic pictures that linked the handmade imprints with a combination of markings using pencil, ink, watercolor, and rubber stamps, making art from the detritus of the publishing trade. *adieu mon beau pays de Marie Laurencin* (Farewell My Beautiful Land of Marie Laurencin) **[199]** of 1919 is one such example of this technique. The work is a collage of impressions taken from several printer's blocks and links them with pen and ink. The

result is a visual puzzle that requires the viewer to create an ambiguous narrative around interconnected pictorial and linguistic signs, couching social critique in metaphorical terms. While the title alludes to the French artist Marie Laurencin, who assisted Ernst in his (failed) attempts to go to France to exhibit his work, the image itself resembles a tottering, damaged war machine in retreat (adieu, mon beau pays...), propelled by a chain resembling the continuous metal track of a tank. A star shoots from a canonlike form, attached to the machine with a mere fragile line. Devoid of a tank's armored, impermeable exterior, the machine reveals a vulnerable interior, the cavities and fissures suggestive of a geological cross section. Handwritten appeals for help in both German and French indicate a military machine in distress, its bilingual supplications addressing those on either side of the enemy line. These precariously balanced forms recall those of Ernst's *Architecture*, though this work assails not the pillars of construction but the trappings of the military-industrial machine, here rendered fragile and decrepit. As Hal Foster has convincingly argued, Ernst's diagrammatic collages mimic the distressed postwar male ego, using parody to critique the formation of the military-industrial subject. That is to say, Ernst concerns himself with the historical construction of consciousness: traumatized male subjectivity is evoked through the dysfunctional machine,[36] projecting a pathetic decrepitude onto an armored weapon, playing infirmity off of patriarchally aggrandized might. But it is precisely the tense relationship between hyperbolic masculinity and the failure to emulate it that produces and reinforces the psychic distress imaged in Ernst's collages. Although *adieu mon beau pays* looks to be conceptually derived from Picabia's *Réveille matin I* (Alarm Clock I) **[see 54]**, a direct imprint of disassembled alarm clock parts united with pen lines and reproduced in *Dada 4–5*, Ernst transformed Picabia's eroticized abstraction into parodic antimilitarism.

Ernst's portfolio, *Fiat Modes, pereat ars* (Let There Be Fashion, Down with Art) **[189]**, demonstrates a preoccupation with sexuality, commodity culture, and the partial, substituted, machinelike postwar body—themes reinforced by the use of discrete, readymade printer's blocks appropriated from an industry of mass-market mechanical reproduction. In one such lithograph, we are offered an armless male automaton, with spigotlike penis and similarly shaped nose, confronting a cone in which a female is inscribed, indicated by a Venus symbol. Two roughly delineated shapes on the top half of the cone suggest male and female sexual organs, though the phallic symbol seems disturbingly truncated, as

if castrated. On the right, Ernst has written backward "Zur Neuen Kunst? D D" (To the New Art? D D), asking us to read the text as if we were inside a display window. Ernst locates this scenario of sexual longing and the "new art" in a shop or public interior, elaborating on the radical proposals put forth in the Section D exhibition by linking commodity culture and art to desire. Several other lithographs in the series depict automaton-like tailors and their ambiguous relationship with dressmaker's dummies in enclosed, seemingly commercial, spaces. The "new art" is countered by the command in the lower left of the frame, its authority slightly undermined by careful lowercase lettering: "finger weg von der h. cunst," (Fingers off of the H[oly] Art). The "K" in "Kunst," or art, has been replaced with a "C," a reference perhaps to the debate recently put to rest on the appropriate spelling of Cologne. The authorities chose Köln over Cöln, preferring to emphasize its Lower Middle German etymology over its Latin one.[37] Thus, Ernst contrasts the (holy) latinization of the word "art" with the new blasphemous, libidinous, transformative Da Da.

Adopting multiple, shifting personae in a strategy reminiscent of Macchab, Ernst variously signed the lithographs "Ernst," "Dada Ernst," "max ernst," or "Dadamax ERNST," punning on the meaning of his last name as "serious" and suggesting that these absurd, provocative lithographs have an earnest point. *Fiat Modes, pereat ars* was published in January 1920 by Schloemilch Press at the address of Angelika and Heinrich Hoerle and granted financial support by the city of Cologne through the Arbeitsgemeinschaft bildender Künstler (ABK — Visual Artists Collective).[38] Ernst took no small pleasure in the fact that his affronts to bourgeois culture, religion, and art were supported by the city of Cologne.

Implementing the proposals suggested by *Fiat Modes*, Ernst literally grounded his art in the commercial market in another series of works, using the pages of a catalogue of teaching aids as the base for his images. Ernst amended these prefabricated pages, which provided the consumer with an illustrated inventory of objects for sale, by working over them with gouache, pencil, and ink in a process he called "overpainting." As William Camfield observed, the process of overpainting is the inverse of collage, because rather than transferring images from one context to another, as is the case with collage, overpainting transforms an already-established context into a new one. For example, *1 kupferblech 1 zinkblech 1 gummituch . . .* (1 Copper Sheet 1 Zinc Sheet 1 Rubber Cloth) (or *Deux figures ambigues* [Two Ambiguous Figures]) **[224]** has its basis in a page of a teaching aids catalogue representing various utensils and apparatuses for work in chemistry and biology **[fig. 4.4]**. Ernst worked over the page with gouache, transforming the neutral display of scientific instruments into two eccentric machine beings. With a few deliberate strokes of the brush, the unremarkable flatness of the page metamorphoses into a three-dimensional space in which a towering, open-armed figure strides toward an armless, legless man — his gender indicated by an erect phallic cone that Ernst took pains to hand draw onto the overpainting. A gender dynamic is implied here, in which the looming female menaces the truncated male, whose erect member is no match for her reaching, striding extremities and the long billy club that she wields on the right. The only hint of vulnerablity that Ernst lends this advancing female is the insertion of a small cleft or hole on the bulbous form that cantilevers out over her hind leg, intimating an orifice to be penetrated. That this sexualized form is on the same axis as, but insistently turned away from, the male's erect penis suggests that his desire has been thwarted. In recontextualizing scientific instruments as dysfunctional couple, Ernst's work operates as a commentary on damaged interhuman relations, focusing on the distressed postwar male ego in the wake of a highly technologized war.

Ernst's technique of overpainting produces a seamlessly constructed, dreamlike space, heightening the sense of fanciful illusionism in his works. In *das schlafzimmer des meisters es lohnt sich darin eine nacht zu verbringen/la chambre à coucher de max ernst . . .* (The Master's Bedroom, It's Worth Spending a Night There/Max Ernst's Bedroom . . .) **[239]**, for instance, we find ourselves looking into a smoothly manufactured interior that one might encounter in a dream. Concealing some objects while luring out others with his filmy gouache paint, Ernst projected an oneiric vision onto a page of animals and objects designed for writing, speech, and observation lessons **[fig. 4.5]**. A whale, a bear, a lamb, and a snake take their places next to a bed, a table, and a wardrobe, bringing wild nature into a confined domestic space. According to Ernst, the optical sensation of diverse, unrelated illustrations available on a single page of the teaching catalogue was so stimulating and shocking that they suggested absurd, hallucinatory and ever-changing associations.[39] The viewer is also drawn into that circuitry of associations, since the gouache is transparent enough in some areas to allow the suggestion of images underneath to bleed through to the visual surface and provoke unconscious mental connections in the beholder. Rosalind Krauss

has noted how the relationship between suppressed ground and at times transparent surface, masked images, and fleeting visual impressions in Ernst's work is related to Sigmund Freud's understanding of the workings of memory and the unconscious.[40] For Freud, a model of the unconscious was suggested in the Wunderblock, in which marks etched on a top sheet would leave traces on a waxen surface beneath it. He found a parallel in the impressions left on the mind by perceptual stimuli, which though impermanent, leave traces on the unconscious and suggest themselves later through flickers of remembrance.

Even without the notion of the Wunderblock, the overpainting technique is still suggestive in relation to Freud's writings, *Jokes and Their Relation to the Unconscious* and *The Interpretation of Dreams*, which Ernst read in 1913 while a student at the university. Ernst used Freud's theories as a basis for many of his collages, because they suggested a model for "the play between the conscious and the unconscious mind," as Charlotte Stokes has phrased it, loosely appropriating Freud's medical theories for artistic ends. Stokes

writes: "He made a new world by painting over and cutting up his father's world...subverted by dissections and malicious reassembly."[41] Importantly, that disrupted pictorial world never coalesces into a satisfying interpretation. Instead, Ernst's pictures refuse a stable meaning by suggesting infinite associations, an instability that is often experienced as a psychological disturbance by the viewer. Ernst's works often produce anxiety at the same time that they characterize it, elaborating upon the parodic strategies he first experimented with in *Der Ventilator*.

Before Ernst used gouache and reproduced images to summon strange and alienating worlds, he manufactured them in paint, influenced by the dreamlike scenarios and estranged perspectives of the Italian artist Giorgio de Chirico that he saw on his Munich trip. *Aquis submersus* (Submerged by the Waters) **[188]**, which was among the works Ernst showed in the Section D exhibit, depicts mundane events occuring in an eerie environment. A stilted mannequin figure stands before a swimming pool while another stiffly dives in, illuminated by a moon clock. The title refers to a

4.4 Utensils and apparatuses for work in chemistry and biology from *Bibliotheca Paedagogica*, 1914, p. 964. From William Camfield, *Max Ernst: Dada and the Dawn of Surrealism* (New York, 1993).

the Bulletin D exhibit in Düsseldorf in February 1920, published in *Düsseldorfer Nachrichten*, February 12, 1920; trans. in Spies, *Max Ernst Collages*, 277–278.

32 Stokes, "Rage and Liberation," 29–30. One of Seiwert's sculptures was reproduced in *Bulletin D*, because he withdrew his works after the catalogue had gone to the printer.

33 Camfield, *Max Ernst*, 63, Unsigned review, "Ausstellung im Kunstverein," *Kölner Stadt-Anzeiger*, November 12, 1919, trans. in Spies, *Max Ernst Collages*, 277–278.

34 Stokes, "Rage and Liberation," 29.

35 Camfield, *Max Ernst*, 57.

36 Hal Foster, "A Bashed Ego: Max Ernst in Cologne," in Leah Dickerman with Matthew Witkovsky, eds., *The Dada Seminars*, (National Gallery of Art, 2005) and "Armor Fou," *October*, 56 127–49. (Spring 1991): 64–97.

37 In February 1919, authorities officially changed the spelling of Cöln (etymologically related to the Roman colonia) to Köln (related to the lower middle German 'Kuhlen', which means cavities or hollows). *Köln Chronik*, 341.

38 Stokes, "Rage and Liberation," 27.

39 Camfield, *Max Ernst*, 82.

40 Rosalind Krauss, *The Optical Unconscious* (Cambridge, Mass., 1993), 54–58.

41 Stokes, "Rage and Liberation," 38.

42 Camfield, *Max Ernst*, 60.

43 *Die Chronik Kölns*, 344.

44 Sigmund Freud's writings on postwar trauma, "The Uncanny" of 1919 and *Beyond the Pleasure Principle*, attempt to come to terms with the operations of memory, forgetting, and repetition of traumatic events manifest in battlefield survivors. For social histories of shell shock, memory and crisis of masculinity, consult Eric Leed, *No Man's Land: Combat and Identity in World War I* (Cambridge, 1979); George Mosse, *Fallen Soldiers: Reshaping the Memory of the World Wars* (New York, 1990); and Jay Winter, *Sites of Memory, Sites of Mourning* (Cambridge, 1995). Ruth Leys' *Trauma: A Genealogy* (Chicago, 2000) is essential to understanding trauma from the perspective of medical history and demonstrates the fundamental instability of the concept of trauma. For accounts of war trauma, art, and literature, see Brigid Doherty, "Berlin Dada: Montage and the Embodiment of Modernity, 1916–1920"(Ph.d. diss., University of California, Berkeley, 1996); Brigid Doherty, "See? We are all Neurasthenics! Or, the Trauma of Dada Montage," *Critical Inquiry* 24, no. 1 (Autumn 1997): 82–132. Cathy Caruth, *Unclaimed Experience: Trauma, Narrative, and History* (Baltimore, 1996); "Male Hysteria: W. H. R. Rivers and the Lessons of

Shell Shock," in Elaine Showalter, *The Female Malady: Women, Madness, and English Culture, 1830–1980* (New York, 1985), 167–194.

45 Moreover, the cubistic transvestite has been given the face of Albert Gleizes, a cubist artist in Paris who refused to include the work of Baargeld and Ernst in an exhibition. In keeping with his "Ahehe Behehe," Baargeld's work not only mocks tradition but also contemporary artists.

46 Littlefield, *Dada Period in Cologne*, 14.

47 Stokes, "Rage and Liberation," 41.

48 Stokes, "Rage and Liberation," 42; Camfield, *Max Ernst*, 67.

49 Littlefield, *Dada Period in Cologne*, 16.

50 According to Fick, he was awarded the title of "dilettante" because as a full-time employee for the city of Cologne, he could not devote himself to art, and modified with "vulgar" because of the obscene sound to his name. Littlefield, *Dada Period in Cologne*, 16.

51 Littlefield, *Dada Period in Cologne*, 16.

52 Littlefield, *Dada Period in Cologne*, 16.

53 Maria Tatar has argued that the prevalent male fantasy of murdering women ("Lustmord") in painting and film during the Weimar Republic was a tactic for managing sexual, social, and political anxiety in the aftermath of World War I and women's emancipation. Maria Tatar, *Lustmord: Sexual Murder in Weimar Germany* (Princeton, 1995).

54 Stokes, "Rage and Liberation," 54.

55 *Dada Siegt! Eine Bilanz und Geschichte des Dadaismus. Abteilung Dada* was the name of a book by Berlin dadaist Richard Huelsenbeck, published by Wieland Herzfelde's Berlin-based Malik Verlag in 1920. It is not clear whether Ernst knew of Huelsenbeck's book at the time he printed his poster.

56 Camfield, *Max Ernst*, 73.

57 Littlefield, *Dada Period in Cologne*, 13.

58 Littlefield, *Dada Period in Cologne*, 14.

59 Spies, *Max Ernst Collages*, 34.

60 Maud Lavin's *Cut with the Kitchen Knife: The Weimar Photomontages of Hannah Höch* (Yale, 1993) treats these conflicts and Hannah Höch's artistic approach to them at length. There are very few accounts of Angelika Hoerle and her work. In addition to Littlefield, see Wolf Herzogenrath, "Angelika Hoerle, 1899–1923," in *Heinrich Hoerle Leben und Werk 1895–1936* [exh. cat. Kölnnischer Kuntsverein] (Cologne, 1981), 291–314. Kai Artinger, "Angelika Hoerle," *Etwas Wasser in der Seife: Porträts dadaistischer Künstlerinnen und Schrifstellerinnen*, ed. Britta Jürgs (Berlin, 1999), 49–66.

61 Littlefield, *Dada Period in Cologne*, 32–34.

62 Stokes, "Rage and Liberation," 36.

63 My thanks to Angelika Littlefield for pointing this out to me.

64 Littlefield, *Dada Period in Cologne*, 6.

65 Stokes, "Rage and Liberation," 21.

PLATES

and the unconscious mind. Yet the body represented is as often female as male, broadening dadaist explorations of unstable gender identity.

"Contrary to general belief," Ernst later asserted, "Dada did not want to shock the bourgeoisie. The bourgeoisie were already shocked. No, Dada was a rebellious upsurge of vital energy and rage; it resulted from the absurdity, the whole immense stupidity of that imbecilic war. We young people came back from the war in a state of stupefaction, and our rage had to find expression somehow or another. This it did quite naturally through attacks on the civilization responsible for the war. Attacks on speech, syntax, logic, literature, painting and so on."[65] Those "attacks," in the form of individual explorations and group collaborations, were well-aimed shots that drew their fuel in equal part from the matter of the everyday world and the subjective mind. Their assaults met their intended targets, not only rattling the arbiters of convention but encountering resistance from their military occupiers—interferences that only refueled their artmaking. Importantly, Cologne Dada seized on something latent and powerful in the postwar period, finding an analytic form for naming the absurd contradictoriness of the early twentieth-century experience. The way to articulate the unexplainable and the irrational was not to resort to rational systems but to parody, resist or subvert them, resulting in dialectical oppositions that revealed the tensions of the postwar age. Dada not only found a way of enunciating the conflicts between tradition and modernity, rationality and irrationality, human and machine, the unconscious and the material world, but also made those conflicts culturally generative and rich.

I would like to thank the following people for their generous assistance with this essay: Frank Daniel at the Stadtbibliothek Cologne, Angelika Littlefield, Michael Parke-Taylor, Anne Umland, Kathy Curry, Leah Dickerman, Amanda Hockensmith, Katherine Little, and Freyda Spira.

1 Ferdinand Tuohy, *Occupied 1918–1930* (London, 1931), 33. For other helpful sources on British-occupied Cologne, see Henry T. Allen, *The Rhineland Occupation* (Indianapolis, 1927); David G. Williamson, *The British in Germany 1918–1930, The Reluctant Occupiers* (New York, 1991); J. Garston, "The Armies of Occupation II: The British in Germany 1918–1929," *History Today*, XI, no. 7 (July 1961): 479–489; D.G. Williamson, "Cologne and the British, 1918–1926," *History Today*, XXVII, no. 11 (November 1977): 693–699.

2 C. Paul Vincent, *The Politics of Hunger: The Allied Blockade of Germany, 1915–1919* (Athens, Ohio, 1985).

3 "Der Eindruck der Truppen ist vorzüglich, Mensch und Tier im Besten zustand, saubere Kleider und Rüstung, hervorragende Disziplin." *Die Chronik Kölns* (Cologne, 1991), 338.

4 Williamson, *The British in Germany,* 1991, 701.

5 *Die Chronik Kölns,* 339.

6 Arnold Stelzmann, and Robert Frohn, *Illustrierte Geschichte der Stadt Köln* (Cologne, 1984), 312.

7 Garston, "Armies of Occupation II," 481.

8 Alex de Jonge, ed., *The Weimar Chronicle: Germany Between the Wars* (New York, 1977), 80.

9 Tuohy, *Occupied,* 93.

10 Warnung! Traut niemandem! Traut nicht dem offenbarsten Augenschein. Es sind Geheimbünde unter euch—traut euch selber nicht. Es gehen verdächtige Gedanken und Gefühlsepidemien um. Kein Mensch ist sicher! Am wenigsten von euch selber. Bürger! Haltet euch an dem, was ihr besitzt. Lasst euch auf keinen Handel mit dem Herzen ein. Verbarrikadiert eure Gefühle. Haltet euch am Besitz—euer gefährlichster Feind ist der Geist. Dieses zudringliche, unfassliche, besitzlose Wesen fällt eure Ruhe und euer Besitzerglück an. Schützt euch, verteidigt euch, schliesst euch ein....

11 Klaus Theweleit discusses the associations of proletarian revolution with floods and plagues and how it fueled the right-wing imagination in *Male Fantasies,* 2 vols., trans. Stephen Conway, (Minneapolis, 1987–1989).

12 Kammacher was also the street in Cologne known for its brothels. Charlotte Stokes, "Rage and Liberation: Cologne Dada," in Charlotte Stokes and Stephen C. Foster, eds., *Dada,*

Cologne, Hanover (New York, 1997), 27.

13 Walter Vitt, *Auf der Suche nach der Biografie des Kölner Dadaisten Johannes Theodor Baargeld* (Starnberg, 1977), 31.

14 Werner Spies, *Max Ernst Collages: The Invention of the Surrealist Universe* (New York, 1991), 34. Ernst later claimed that "Machab" was a medium he and some friends had conferred with early in the war.

15 Smeets was later arrested, tried, and ultimately excommunicated from the party because of his extreme politics in advocating a separatist Rhineland. Walter Vitt, *Bagage de Baargeld: neues über den Zentrodada aus Köln* (Starnberg, 1985), 17. See also Allen, *The Rhineland Occupation,* 325–32.

16 Vitt, *Auf der Suche,* 30, fn. 82.

17 The term "Stupidien" has been variously called a pun on the province Westphalia (Westphalien) in which Cologne is located, a typographical error on "Stupends" (stupendous), and an irreverent reference to Germany, land of the Stupids. Given the writers' tactics, it seems plausible that the word's meanings are multiple.

18 William Camfield, *Max Ernst: Dada and the Dawn of Surrealism* (Houston, 1993), 49.

19 Angelika Littlefield, *The Dada Period in Cologne: Selections from the Fick-Eggert Collection* (Toronto, 1988), 12.

20 Stokes, "Rage and Liberation," 23. For another helpful overview of Cologne Dada, see Wulf Herzogenrath, ed., *Von Dadamax zum Grüngürtel: Köln in den 20er Jahren* (Cologne, 1975).

21 Stokes, "Rage and Liberation," 27. Quoted from Luise Straus-Ernst's unpublished memoirs in Wulf Herzogenrath, ed., *Max Ernst in Köln: die rheinische Kunstszene bis 1922* [exh. cat., Kölnischer Kuntsverein] (Cologne, 1980), 298.

22 Camfield, *Max Ernst,* 55.

23 Camfield, *Max Ernst,* 58.

24 Camfield, *Max Ernst,* 58.

25 One of these two "masters" is thought to be Angelika Hoerle's brother Willy Fick. Wulf Herzogenrath and Dirk Teuber, *Willy Fick: ein Kölner Maler der zwanziger Jahre wiederentdeckt* (Cologne, 1986), 34.

26 Camfield, *Max Ernst,* 333, fn. 15.

27 Camfield, *Max Ernst,* 333, fn. 15.

28 Jörgen Schäfer's chapter "Das Bulletin D" in *Dada Köln: Max Ernst, Hans Arp, Johannes Theodor Baargeld und ihre literarischen Zeitschriften* (Wiesbaden, 1993), discusses the relationship between expressionist prose, Jakob von Hoddis' poetry, and dadaist collage texts. See in particular, 87–90.

29 Stokes, "Rage and Liberation," 29.

30 Littlefield, *Dada Period in Cologne,* 13.

31 Camfield, *Max Ernst,* 63. Otto Albert Schneider wrote this for a review of

COLOGNE

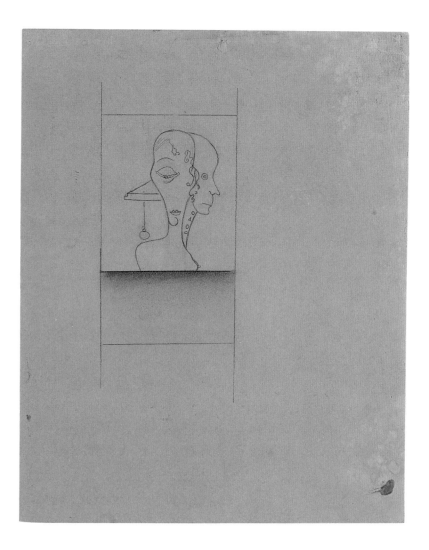

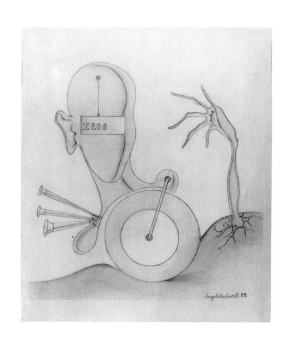

235

mutilations they witnessed on the front, Angelika Hoerle's last works were rooted in the experience of physical disintegration, wrought not only by technological warfare but also by an invisible bacterium.

The few remaining works of 1922 demonstrate an interest in metamorphosis and ambiguity. The cycloptic face is given a female countenance and blends with the profile of a man, staging a psychological tension of uncertain cause [**fig. 4.9**]. Although the title later assigned to this work is *Doppelkopf* (Faces), there is a third face etched in the boundary that delineates female and male. Here are doublings and triplings of bodies in a single form, recalling the strategies mobilized in Baargeld's self-portrait and Heinrich Hoerle's dreaming amputees. In Angelika Hoerle's work, however, the female body figures as an absurd site of analysis and conflict, a stark contrast to woman-as-sexual object that repeatedly resurfaced in the work of her male colleagues. Rather than rooting itself in prefabricated images, however, Angelika Hoerle's work is insistently a product of the hand, perhaps because it allowed for a realm of possibility and imagining outside the limits of mass-cultural representations.

Hoerle develops the theme of a dismembered, ambivalently gendered mannequin-body in another illustration, fusing the disparate, unrelated forms with a single strong line [**fig. 4.10**]. A mannequin head has a number plaque in place of its features—appointed the identity Z206— assigning this faceless, bodiless creature a rank and file in an unknown sign system. A bagpipe, doubling as a phallic form, constitutes its torso, while a wheel or drum propels the figure, thus incorporating emblems of the British occupation into the condemnation of war. This mannequin turns to look at a waving hand, rooted in the earth, the surprise gesture and hand motif appropriated from Heinrich Hoerle's *Cripple Portfolio*. Katherine Dreier was so impressed by this image—indeed, the collector called Angelika Hoerle a comet on the Cologne scene [64]—that she purchased this and two other illustrations not long before Hoerle's premature death in 1923. Angelika Hoerle's late work availed itself of dadaist thematics and absurdity, addressing postwar anxiety about the body and its substitutions (such as prosthetics), as well as the muddled boundaries between the conscious

4.7 Angelika Hoerle, *Frauenportrait* (Portrait of a Woman), 1921, pencil on paper. Art Gallery of Ontario, Toronto

4.8 Angelika Hoerle, *Mann mit Auge entfernte* (Man with Eye Removed), 1921, pencil on paper. Art Gallery of Ontario, Toronto

at a crossroads.[60] On the one hand, a radically new social role for women was emerging, characterized not only by the cropped hair, shortened hemlines, and greater sexual freedoms often associated with the image of the 1920s woman, but institutionalized by legal and economic changes, such as an increase in working women (albeit in low-level jobs), women winning the right to vote in 1918, and the right to run for public office in 1919. On the other hand, these changes were imposed onto long-held patriarchal beliefs and customs, slow to adapt to change. Many women of the period found themselves caught between progress and tradition, inspired by omnipresent mass-media representations of the so-called New Woman yet hampered by entrenched social structures. Thus, when one reporter for the *Rheinische Zeitung* wrote of his "good fortune to meet the German mistress of the Dadaists, Angelika, and to receive from her finely formed artist's hand a cup of mocha," he admired her beauty and hostessing skills but omitted mention of her art.[61]

Sometime in 1921, Angelika Hoerle contracted tuberculosis. Terrified of the disease that took his father and plagued him in childhood, Heinrich Hoerle abandoned Angelika and their mutual apartment. Alone and ill, Angelika spent her final months grappling with her illness, her identity, and, seemingly, with the legacy of Dada, because she pursued enigmatic, introspective line drawings that experiment with curious juxtapositions, the absurd, and manifestations of unconscious and conscious states. A series of disturbing, haunting illustrations that confront bodily infirmity and deformity includes studies of women,

pictorial alter egos that interrogate the trappings of femininity and the signs of independence in a period of women's conflicted liberation. A sketch of a woman, thin and hollow-eyed, on the edge of a mutilated paper scrap, is presumably a self-portrait **[fig. 4.7]**. Seemingly unrelated objects accumulate vertically, connected by a series of lines that utilizes Ernst's working methods with printer's impressions onto drawing. In significant contrast to Ernst, the marks on the page are not mediated by prefabricated forms, but are an immediate register of her hand, a direct externalization of her thoughts. The associative juxtaposition of forms was a key tactic of Dada, ranging from collages of objects and words to drawing. As Ernst once noted, "there need not be *colle* (paste) in a collage."[62]

At the bottom is a cycloptic, inward-looking face that would reappear in her works, a mythical sign for alienation. Askew on top of that head is an upturned hat, also a recurring symbol, that references Hoerle's apprenticeship in millinery, but also operates as a sign for cultivated independence, defining and separating the body from others. On top of the large head teeters a half-full wineglass. A wilted plantlike form, head down, rests in her womb. Her limp breast has been subjected to an imaginary severing, indicated by dotted lines, enacting a distancing from the sick body in a manner similar to *Mann mit Auge entfernte* (Man with Eye Removed) of 1921[63] **[fig. 4.8]**. In the drawing, a man soberly considers his removed prosthetic eye, while the gaping hole confronts the viewer mercilessly, almost aggressively. While many of the male dadaists grappled with the bodily

4.6 Angelika Hoerle, *Totenwagen und Pferd* (Hearse and Horse), 1919, pencil on paper. Art Gallery of Ontario, Toronto

overload of *die schammade*. The Stupid press also published a number of print series, such as Seiwert's *Geschöpfe* (Beings), Heinrich Hoerle's *Frauen* (Women) and Angelika Hoerle's *ABC Bilderbuch* (ABC picture book), which embodied their philosophy that simple forms in art would make it accessible. The members of Stupid would also disobey the occupation curfew and post their works of art on walls, fences, and even on the Cologne cathedral, thus making art accessible for the general populace in places where they would encounter them, namely, the city's streets.[58]

While Stupid is often understood as a radical break from Dada—a sign of dismay with Dada's ineffectiveness as a political movement in Cologne—it also might be said that it represents an evolution of the tactics of protest. And, as much as Stupid distanced itself from Dada, there are also some important continuities. Consider the cover page of the first (and last) issue of *Stupid*, with its inverted number 1, an irreverent typography not inimical to Dada practice. The name "Stupid" is self-mocking, and its referent is unstable (who is stupid—its audience or its makers?), suggesting an interest in ambivalence rather than certainty, as the manifesto asserts. Although Fick claimed that the name resulted from the printer's typographical error on the word "Stupend," or stupendous, the error seems to be a gross one (not one, but two misplaced letters) and it was without a doubt a resonant wordplay on Weststupidien. Moreover, the journal opened with a cryptic, not transparent, statement: "Art is the perseverance of those who are left behind." Whether this is a mournful reference to those lost to death in the trenches, tuberculosis, and the Spanish influenza or to those who no longer could (or chose not to) keep up with Dada's antics, is unclear. And while the images reproduced in the journal do employ a legible formal language, their content is psychologically tense, wrestling with themes of fear, surveillance, power relations, and death.

Narratives of Cologne Dada generally conclude like this: the Hoerles found their artistic and political convictions were better suited to Stupid's aims and by mid-1920 had distanced themselves from Dada. Baargeld understood Dada as a short-lived revolutionary art movement, and when the revolutionary moment effectively gave way to a period of stability, Baargeld gave up both Dada and politics in 1920 and dedicated himself to mountain climbing and his studies. He completed his doctorate in July 1923 on the development of privatized life insurance during the war which, it must be added, was nearly incomprehensible to his university advisors, for its sentence structures liberally drew on the

dadaist syntaxes he cultivated in his manifestos and texts—a remnant of resistance, perhaps, to the bourgeois existence to which he was now consigning himself. Ernst, who had long been frustrated with the provincialism of the German art world and sought contacts outside of the country, developed an artistic relationship with Parisian poet Paul Eluard and his wife Gala. Through visits and correspondence between Paris and Cologne, Eluard and Ernst collaborated on two books of Eluard's poetry, which Ernst illustrated with collages worked from old engravings to produce seamless but bizarre image worlds **[244–246]**. That professional liaison turned private in the summer of 1922, when the Eluards and Ernst began a ménage à trois. In September 1922, Ernst left his wife, child, and Cologne behind and moved to Paris, where he pursued both Gala and an artistic career. As Kurt Schwitters, the one-man Dada movement in Hannover, later wrote, "Since Max Ernst moved to Paris, Cologne has been as quiet as a graveyard."[59] By the late spring of 1920, Dada in Cologne ran its course. The productive synergy that once kept the artists unified then dissolved over the question of the relationship between aesthetics and social engagement.

ANGELIKA HOERLE

But Dada did persevere in Cologne after group efforts dissipated in 1920, its tactics not only persisting independently in the idiosyncratic works of Ernst, but also in the drawings of Angelika Hoerle. The presence of traces of Dada in Angelika Hoerle's work is unexpected, not only because her contributions to Cologne Dada, judging from a few extant works, seemed limited to group publications and the occasional illustration, but also because she left Dada for the Stupid group. One might speculate that Dada's preoccupations with the postwar psyche did not translate well into women's experiences on the home front. But Angelika Hoerle did offer up tongue-in-cheek postwar commentaries, mobilizing dadaist doublings and depicting not dysfunctional machines but a disrupted death ritual **[fig. 4.6]**. In languidly stubborn refusal, a horse, rather than pull the wagon and coffin, sleepily confronts it. The horse's fourth hoof is substituted by a wheel, though it is not clear if the device would expedite or impair the proceedings. Importantly, death is ambiguously gendered here—the coffin could hold either veteran or Spanish influenza victim—alluding to death's tragic frequency in the postwar period.

Angelika Hoerle's position as the only woman in a group of male artists was significant in the framework of early 1920s Germany, a period in which women's roles were

in others, the ruse of a young girl rehearsing obscene poetry in communion dress shocked still more, Ernst's devoutly Catholic father among them. The *Dada Early Spring* exhibition caused a deep rift between Ernst and his father, who dismissed his own son with the words "My curse be upon you!"

The incorporation of various found objects (and humans) into an unconventional exhibition space not only challenged protocols of display and decorum, but the gesture also confronted traditional notions of sculpture, developing the tactics that first emerged in Section D. Instead of presenting sculpture as a three-dimensional form, either carved or molded, made of culturally esteemed, durable materials (such as granite, marble, or bronze), that reinforces heroic or aesthetic values and asks the viewer to circumambulate in quiet contemplation or patriotic respect, the dadaists declared that sculpture could be temporary, banal, and interactive. Ernst's hatchet piece, for instance, solicited aggressive bodily participation rather than introspection, using everyday materials instead of enduring ones. Its premise was ephemerality and destruction rather than duration. Baargeld manufactured a short-lived and disturbingly misogynist ensemble, filling an ordinary fish tank with red water, immersing a mannequin's hand and an alarm clock and floating a wig. The work was presumably a modern Vanitas image, a meditation on the fleeting nature of life, but it amounted to a violent fantasy, an expression of male anxiety characteristic of the world war's aftermath that, as Maria Tatar has demonstrated, frequently took its aesthetic form in pictures or stories about *Lustmord*, or sexual murder, in 1920s Germany.[53]

The Cologne police closed the show on grounds of obscenity, an intervention that Fick later stated was in fear of potential British reprisals. The charge was dropped, however, when the "obscene" frontal nudity in question turned out to be a print of Albrecht Dürer's *Adam and Eve* that Ernst had incorporated into one of his sculptures. The second charge, that the exhibition was an advertisement for a homosexual brothel, based on the incorporation of a public urinal, was also dropped.[54]

Dada siegt! (Dada Triumphs!) **[222]** proclaimed Ernst's poster announcing the show's reopening, again printed by Druckerei Hertz.[55] DADA IST FÜR RUHE UND ORDEN!—Dada is for peace and medals!—turns the word "ordnung" (order) into "orden," referring to a military order or decoration, and thus referencing the intervention of police authority in a subversive gesture. Underneath, in small print, the poster warns: DADA ruht nie—DADA vermehrt sich (Dada doesn't rest—Dada reproduces itself).

While the text engages in puns, doubling back on itself, the images on the right-hand side seem to be independently referential: a cow, a decoration, an exclamation point, a cornucopia, a fish, a barmaid asking "Why am I not this brave bird"—images of festivity, feast, and plentitude, representing the motley assortment of remaindered printer's blocks that Ernst scavenged at the Druckerei Hertz. Although the dadaists triumphed over the authoritarian suppression of their exhibition, exuberantly declaring the victory of Dada, the *Dada Early Spring* exhibition was also the last group manifestation of Dada in Cologne, demarcating the limits of Cologne Dada's tactics as a sustainable protest. On the one hand, the performative, interactive aspects of the exhibit offered a model for political engagement in that they explicitly involved the viewer, demanding active rather than passive participation. In assaulting myriad art conventions, from technique to materials to display, these artists radically restructured them. On the other hand, their tone and intentions were often interpreted as aggressive, puerile nonsense by many of those very viewers. While taking Cologne Dada's previous proposals about art practice and display to their extreme in the *Dada Early Spring* exhibition, the event apparently failed to suggest further productive avenues of protest and the group project subsequently ran aground in Cologne.

The example of the Hoerles is instructive. Although they were closely involved in the production of *die schammade*, Angelika and Heinrich Hoerle distanced themselves from Dada activities around the time that Ernst and Baargeld geared up for the *Early Spring* exhibition, gravitating instead to what they perceived to be more politically engaged and accessible art. Their transition appears to have been gradual because the W5 Manifesto for *die schammade* included the Hoerles.[56] The Hoerles and Fick began to show their works at the atelier of Anton and Marta Räderscheidt at the Hildeboldplatz, instead. The group called itself "Stupid," and its publication of November 1920 asserted its aims in the following terms:

> Beyond all the intellectual palaver of the day, we wish to do simple work.... We don't want to say more than we know but at the same time we want to say what we can so clearly, so simply that everyone can understand it.... We wish to be the voices of the people.[57]

The mandate of simplicity, legibility, and accessibility translated into the following strategies: the pages of *Stupid* **[200]** carefully cultivated the empty whiteness of the page; its purpose is calming in contrast to the aggressive visual

at the heart of Marxist theory and Baargeld's politics. Man-made imitates machine, but at the same time, machine imitates man, producing an endless critical circuitry that both emulates and parodies industrialized labor.

DIE SCHAMMADE AND THE DADA EARLY SPRING EXHIBITION

While immersed in individual projects in 1920, the Cologne dadaists collaborated during that winter to produce a second Dada publication, which was to connect Cologne Dada with other manifestations of Dada in Europe. The journal *die schammade* was published in April 1920 [195–197]. The Hoerle apartment provided a base for work on contents, promotion, and layout,[46] and Druckerei Hertz printed it.[47] The title is a dadaist pun with multiple, unverifiable, connotations. Scholars' various suggestions include: a composite of the words "Scham" (which can mean shame and also genitals) and "made" (maggot or worm), thus implying an erotic burrowing; "Scharade" (charades); "Schamane" (witch doctor); or a literary reference to the German writer Friedrich von Schiller's "Schamade schlagen," which is a drum or trumpet call for retreat.[48] The front cover, imprinted with a biomorphic woodblock design by Hans Arp, announces its international Dada solidarity, listing its contributors along a "dadameter, antimeter, antinommetric dadascope." Ernst and Baargeld allowed themselves the distinction of appearing twice on the dadameter, both as themselves and as "dadamax" and Zentrodada, alongside Angelika Hoerle, "Heinz" Hoerle, and an impressive list of international dadaists including Tzara, Picabia, André Breton, Georges Ribemont-Dessaignes, Philippe Soupault, Paul Eluard, Richard Huelsenbeck, a mysterious "qualitätsdada" (quality dada), and 303 dadaisten.

Dilettanten erhebt euch (Dilettantes Arise) [196] asserts the title page, accompanied by one of Ernst's precarious vertical machines composed of printer's blocks. The publication is playful and visually overwhelming, its pages packed full with diagrammatic illustrations, prose, poetry, all rendered with enthusiastic typographical experimentation. Certain copies, if not all, were printed on lightly sparkling newsprint, providing a scintillating backdrop to this high-spirited visual overload. In contrast to *Bulletin D*, its pages are in dialogue with one another. For example, Angelika Hoerle's drawing of a house of pipes [197] is a pictorial response to Baargeld's nonsensical essay "Röhrensiedelung oder Gotik" (Pipe Colony or Gothic) on the facing page. Baargeld's text repeatedly riffs on pipes—pipe architecture, pipe colonies, pipe systems, pipe "aphrotektur," pipe

synthesis, and so on—and refers to the "Januarhochwasser," or the flooding of Cologne that January. As a public statement of Dada International, Heinrich Hoerle's assertion toward the end of the journal summarizes its aims, inflected by the terms integral to Cologne Dada: "Dilettantes Arise...: the old art is dead; when the artist drowns, art can begin to swim." This statement, with its strong Nietzschean undertones, urges the amateur, the new Dada artist, to supplant the traditional with the new, breathing life into dead art.

The final public manifestation of Dada in Cologne was conceived as sheer provocation, again assaulting the values of high art and bourgeois morality, but with heightened aggressiveness, even explicit violence. In early 1920, a jury-free exhibition of the visual artists was to open at the Kunstgewerbe Museum (Applied Arts Museum). Baargeld and Ernst submitted some of their work and were refused because, the museum director stated, paradoxically they were unacceptable to the (supposedly nonexistent) jury. Outraged at their exclusion from the museum exhibition, in April Baargeld and Ernst defiantly mounted their own show, in a space of popular enjoyment rather than high culture, renting the courtyard of a pub, the Brauhaus Winter. They named their exhibit the *Dada-Vorfrühling* (Dada Early Spring) exhibition. Attempts to recruit other artists from the Kunstgewerbe exhibition failed; the only other person Baargeld and Ernst persuaded to join them was Willy Fick, Angelika Hoerle's brother.[49]

Those who wanted to view the exhibit had to walk past the men's toilet in the pub, beyond the urinals, where a young girl in a communion dress recited lewd poetry, thus assaulting both the sanctity of high art and of religion. Viewers would have seen on display three works by Arp, nine by Baargeld, seventeen by Ernst, a joint work by Ernst and Baargeld and two by a "vulgar dilettante," Willy Fick.[50] The exhibition and artworks were often interactive, such that viewers were verbally addressed or physically involved. Meandering past urinals became an integral part of the show, for instance. Viewers were encouraged to destroy an Ernst sculpture, to which he had attached a hatchet. The sculpture was replaced several times during the period of the exhibition. For the opening night festivities, Fick, who had contributed a series of wooden reliefs, explained his collage technique while wearing an oversized checkered coat.[51] Apparently the far-fetched artistic theory that he delivered to the press prompted Freundlich to say to him, "Willy, you managed to embarrass even us."[52] While Fick managed to embarrass some, and Ernst's sculpture elicited aggression

JOHANNES BAARGELD

The works that Johannes T. Baargeld manufactured during his involvement with Dada in Cologne similarly destabilized high art and masculine subjectivity, mapping these issues onto his own body in his 1920 self-portrait, *Typische Vertikalklitterung als Darstellung des Dada Baargeld* (Typical Vertical Mess as Depiction of the Dada Baargeld) **[204]**. This collage of photographs and reproduced images represents a contradictory portrait of its maker, while its title explicitly allies that ambiguous identity with Dada. Baargeld has situated a reproduction of the bust of Venus de Milo on a table and topped it with a photograph of his face, framed by the visor of what looks to be a soldier's cap. This juxtaposition of male head on a female body stages an identity that is unstably masculine, for the erotic charge issued by Venus' breasts is pointedly feminine. Baargeld has this recontextualized torso do double duty in his portrait: not only does the irreverent use of classical sculpture travesty high art, it also conjures the bodies of mutilated veterans, transforming the oft-romanticized aesthetics of classical ruins, which themselves are dismembered, into a condemnation of war. Baargeld simultaneously imagines himself as a woman and as an amputee, eroticized female, and emasculated male. The conceptualization of montage as "klitterung" is significant in this context, for it means to patch up or piece together something from smaller parts, a messy process, not unlike the provisionally mended bodies of veterans.

Like Baargeld's self-portrait, Ernst's 1920 self-portrait, *the punching ball ou l'immortalité de buonarroti* (The Punching Ball or the Immortality of Buonarroti) **[220]**, links mutable gender identities and art historical precedents under the name of Dada. A formal photographic portrait of Ernst, inscribed "dadamax," awkwardly embraces a lady in a strapless gown with a flayed head. The mutilated transvestite is identified as "caesar buonarroti"—dictator (caesar) buonarroti—a mocking reference to Michelangelo Buonarroti and what Ernst suggests is the oppressive tyranny of his legacy. Ernst makes clear that the Renaissance "master" does not measure up to "dadamax," for the unit of measure reaches only as high as his mouth, while "dadamax," intact and impeccably dressed, outmeasures the ruler's five thousand maximum, leaving the artist's potency undiminished.

Revisiting the theme of unstable male subjectivity and classical mythology in two further photomontages, Baargeld deepens his critique of Western society's patriarchal structures and founding myths. In *Ordinäre Klitterung: Kubischer Transvestit vor einem vermeintlichen Scheidewege* (Vulgar Mess: Cubistic Transvestite at an Alleged Crossroads) **[203]**, Baargeld conflates the Greek myth of heroic Hercules at a moral crossroads with the odd drama of a cubistic transvestite.[45] The reference to its construction (a vulgar mess) is something base, not refined as art was expected to be. While the montage *Vulgar Mess* explores confused desire, *Venus beim Spiel der Könige* (Venus at the Kings' Game) **[205]** of 1920 thematizes thwarted longing, linking Venus, goddess of love to the King's Game, or chess, which is a game of war. Venus' classic pose, which simultaneously covers and emphasizes her sex, arouses the attention of her admirers in uniform. Yet their orifices, which are plant illustrations, double as horrifying absences, calling to mind soldiers whose faces have been partially blown off by artillery. The satisfaction of the veterans' biological drives, underscored by a plant metaphor, is hindered by gross mutilations, replaying the theme of sexual alienation that Heinrich Hoerle and Max Ernst explored as well.

While Baargeld's works often elicit primordial, biological, and violent associations—terms that suggest a concern with origins and drives, sex and death—they also invoke the impersonal processes of mechanical replication. For example, Baargeld's *Das menschliche Auge und ein Fisch, letzterer versteinert* (The Human Eye and a Fish, the Latter Petrified) **[208]** offers an enigmatic juxtaposition of human and fish eye, sadistically linked by a precisely drawn diagrammatic line. The work blurs the boundary between mechanical reproduction and the handmade, however, since the illustrations of the human tear duct and the fish eye are so precise as to be mechanically reproduced. The montage also delights in its handcrafted materiality, visible in the "messy" rupture of overlapping pieces, which Baargeld has emphasized by an interrupted doubling of the text "letzterer versteinert" (latter petrified) on the bottom border. Yet, the distinction between hand and machine is again upended, as the hand-drawn script mimics the typewritten word. Baargeld again enacts a reversal of these terms in his two drawings of 1920, *Hommes/sei vorsichtig lieber Heinz* (Men/Be Careful Dear Heinz) **[209]** and *Unendlicher Regenschirm* (Endless Umbrella) **[210]** which combine architectural and machine fragments with bodily elements, turning the routines of industrial manufacture into anthropomorphic processes, dumping, digesting, excreting. In purposefully blurring the distinctions between the man-made and the industrial, Baargeld issues an ambiguous critique of alienated labor,

HEINRICH HOERLE

Like Ernst's *Fiat Modes*, Heinrich Hoerle's *Die Krüppelmappe* (The Cripple Portfolio) [202] explored male subjectivity in the postwar period and can be understood as a contemporaneous counterproposal to Ernst's treatment of the subject. Hoerle and Ernst worked on their lithograph portfolios during roughly the same period—recall that *Cripple Portfolio* was advertised in the first issue of *Der Strom* in January 1919, as were the eight lithographs by Ernst that evolved into *Fiat Modes*. Like Ernst's *Fiat Modes*, Hoerle's project received funding from the city of Cologne and was published in 1920. In contrast to Ernst's cooly cerebral and ascetic picture puzzles, however, Hoerle's *Cripple Portfolio* is a haunting, obsessive imagining of the psychological horrors facing the mutilated veteran. Although Heinrich Hoerle was not himself injured during the war, what he witnessed as a telephone operator at the front amply fueled his imagination, as did the omnipresence of disfigured bodies in daily life in postwar Germany. The portfolio's title page "Helft dem Krüppel" (Help the Cripple) is a meditation on anguish, in which a maelstrom of repetitive lines eddy and flow around a mournful body and contorted clawlike feet, their undulations at once constituting his cloak and the surrounding landscape. The figure's downcast head, wings, and intricate cloak would remind the German viewer of Albrecht Dürer's famous winged *Melancolia I* of 1514, an emblem of psychological suffering and alienation from the surrounding material world.

Originally advertised as seven lithographs, the *Cripple Portfolio* increased to twelve as Hoerle developed the three basic themes that he explored obsessively in his drawings: amputees haunted by limblike growths in nightmarish scenarios; the social estrangement of mutilated soldiers; the veteran's traumatic wet dream. In one lithograph, for example, a man with stumps for arms and pegs for feet sits horror-stricken on a chair as an assortment of sprouting hands and feet in flower pots beckon him. In another, a legless man proceeds laboriously along a twisted road, menaced by a serpentine tree whose roots have escaped from the confines of the soil and transformed into gnarled footlike tendrils. In Hoerle's scenarios of social estrangement, men with cold, hard protuberances or stumps seek tender closeness. Intimacy takes on a fantasy dimension in the third narrative, in which amputated legs of bedridden veterans double as erect phalluses. Their ejaculations transform into fecund plants, one bearing fruit, the other, a foot. In Hoerle's lithographic imaginings, the inanimate becomes animate, forms metamorphose from one object into another.

One of the most distinctive characteristics of Hoerle's lithographs is the repetition of sinuous lines, which he meticulously impressed onto the polished stone surface with a grease pen, one after another, in order to give bodies and spaces their form. These insistently repeated undulations intensify the nightmarish psychological states he has depicted, conjuring the disquieting resonances of a disturbed dream state. Hoerle's unrelenting reiteration of marks on a surface also evokes the repetitive gestures of psychic trauma, in which the compulsion to repeat an action signals an attempt to expunge a traumatic memory from the mind.[44] Equating line with tremors of the psyche, Hoerle's haunting images seek to evoke pathos in the viewer. But there is an acrid irony operative in these works, generated by the combination of emotive line and grotesque subject matter, that pits sentiment against terror and hallucinatory imagination against bitter lucidity, transforming emotive psychological portraits into an astringent postwar commentary.

Hoerle's *Cripple Portfolio* lays out many of the defining preoccupations of Cologne Dada, even though the portfolio was in the works before Dada officially took root, by that particular name, in Cologne. The work anticipates the dadaists' preoccupation with the unconscious, in all of its phantasmal, disjunctive, enigmatic, and oddly associative forms. Indeed, more than any other manifestation of Dada elsewhere, the Cologne dadaists were captivated by the dreamlike and the chimerical. Although it is often claimed that an artistic concern with the unconscious first appeared with surrealism in 1924, the work produced in Cologne in the immediate postwar period demonstrates that a preoccupation with the unconscious preceded surrealism. Rather, the representation of unconscious processes was an attempt at analyzing and coming to terms with the psychological terrain of postwar society. Many veterans not only suffered from physical mutilations but psychological traumas in the form of shell shock, a variety of neurasthenic symptoms including nightmares, psychological disorientation, bodily paralysis, uncontrollable shaking, blindness, deafness, mutism, and the loss of taste and smell. The physically and psychologically traumatized World War I veteran fell short of social expectations of the heroic, masculine soldier, provoking a widespread crisis of masculinity in the postwar period. Heinrich Hoerle's *Dadahund* (Dada Dog) of 1920, a scrawny, neurasthenic, sexually aroused canine, names the effects of postwar male anxiety and explicitly links them to Dada. Like Ernst's excited automaton in *Fiat Modes*, Hoerle's dog and aroused war veterans illustrate compromised, neurotic male potency.

nineteenth-century novella by Theodor Storm that had recently been republished.[42] In the story, briefly summarized, the illegitimate son of a couple drowns in a pool during their chance re-encounter. The tale's references to painting (the boy's father is a painter), chance, and tragedy inspired Ernst's hallucinatory image. This uneasy scenario was a product of the artist's imagination and his hand, and a smooth continuity envelops the picture, making its aberrance seem oddly uncontrived.

Ernst also used photography to produce seamless oneiric worlds. In a series of 1920 collaborations with Arp, which they called FaTaGaGa, or FAbrikation de TAbleaux GAsométriques GArantis (Fabrication of Guaranteed Gasometric Paintings), Ernst often photographed the finished collages in order to suppress all traces of the handmade. *hier ist noch alles in der schwebe*…(Here Everything Is Still Floating…) **[218]**, for example, provides a smooth juxtaposition of a fish x-ray and an inverted beetle, which doubles as a boat, thanks to the smokestack affixed to its upturned belly. This particular work was photographed and enlarged,

concealing the ruptures between separate parts that had been pasted together. Contrast *physiomythologisches diluvialbild* (Physiomythological Flood Picture) **[219]**, signed by both Ernst and Arp, in which the traces of cut and paste are clearly evident. Rather than carefully trimming the reproductions along their borders, the artists roughly cut around the entire picture and pasted the image as it was. The result is a fantasy image that looks artificially manufactured, rather than sustaining the illusion that it is an extension of the physical world. Both FaTaGaGas, however, fuse psychological apparitions with material realities, blending enigma with recognizable objects and textures from the everyday world. They also seem to have drawn inspiration from the physical environment in which they were manufactured, their fascination with water provoked by the floods that had inundated Cologne in January 1920 and caused extensive damage to property.[43] Although we are given a hold in familiar material objects and experiences in the particularities of the collage, the meaning of the whole remains elusive, emulating a generalized experience of instablity in the postwar world.

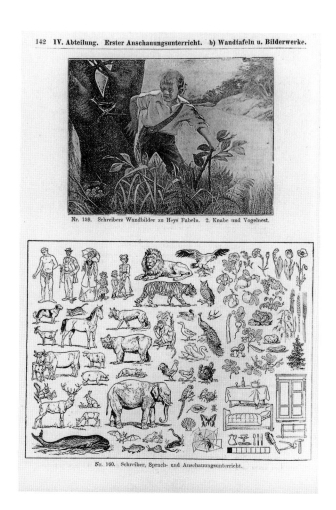

4.5 Page with Schreiber, Sprach- und Auschauungsunterricht (Language, speech, and pictorial instruction chart), from *Bibliotheca Paedagogica*, 1914, p. 142. Kunstmuseum Bonn

189 MAX ERNST Untitled prints from the portfolio *Fiat Modes,
pereat ars* (Let There Be Fashion, Down with Art), Schloemilch-Verlag,
1919–1920, four lithographs from portfolio of eight; each sheet:
43 × 31.9 (17 3/16 × 12 9/16), The Museum of Modern Art, New York. Abby
Aldrich Rockefeller Fund

239

Cover and pages of the journal *Bulletin D*, unique issue, catalogue for the
exhibition in Section D at Cologne Kunstverein, Johannes Baargeld
and Max Ernst editors, November 1919, each page: 31.5 × 24 (12 ⅜ × 9 ⁷⁄₁₆).
Research Library, The Getty Research Institute, Los Angeles

190 MAX ERNST Cover (with one drawing by **HANS ARP**)

191 MAX ERNST *Architektur* (Architecture), reproduction
of assemblage

192 ANGELIKA HOERLE *Reiterin* (Rider), reproduction of ink drawing

193 JOHANNES BAARGELD *1πd−10=0.01 dada*, reproduction of ink
and watercolor drawing

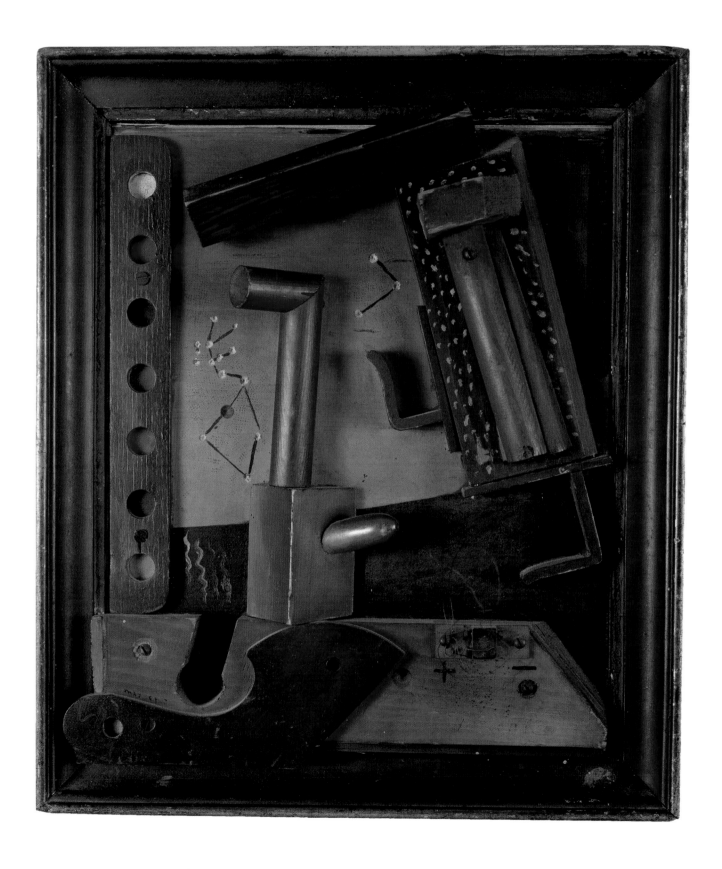

194 MAX ERNST *fruit d'une longue expérience* (Fruit of a Long Experience), 1919, assemblage of painted wood and metal wire, in artist's frame: 45.7 × 38.1 (18 × 15). Private collection

Cover, title page, and page from the journal *die schammade (dilettanten erhebt euch)* (The Schammade [Dilettantes Arise]), unique issue, Johannes Baargeld and Max Ernst (and Heinrich Hoerle?) editors, Schloemilch-Verlag, April 1920, each page: 32.4 × 25 (12 ¾ × 9 ¹³⁄₁₆), Research Library, The Getty Research Institute, Los Angeles

195 HANS ARP Cover, woodcut with collage of **MAX ERNST**'s "Dadameter"

196 MAX ERNST Untitled illustration on title page, reproduction of proof of printer's blocks with ink

197 ANGELIKA HOERLE Untitled illustration, reproduction of ink drawing

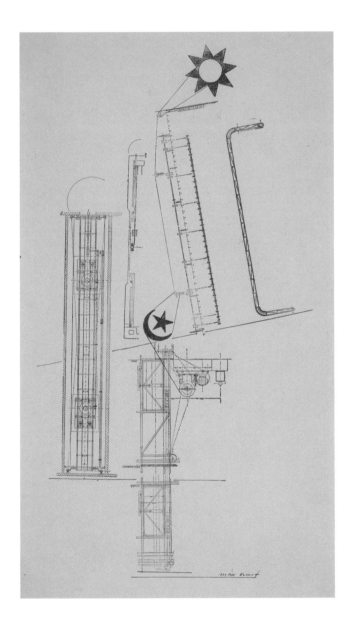

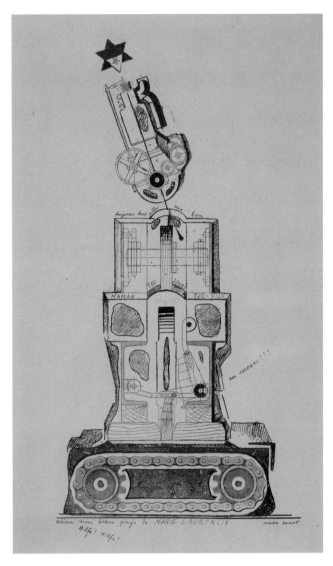

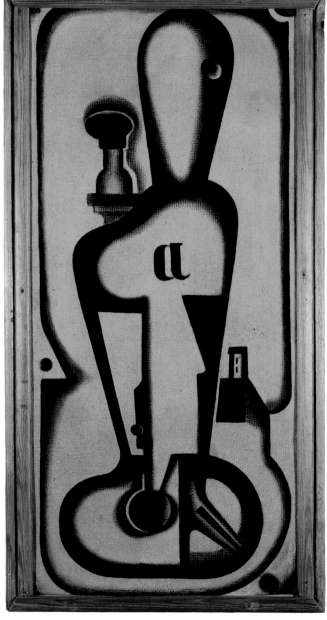

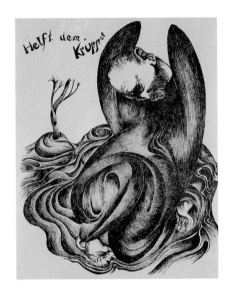
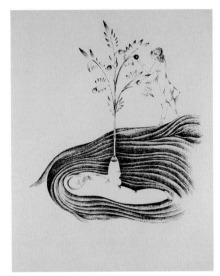
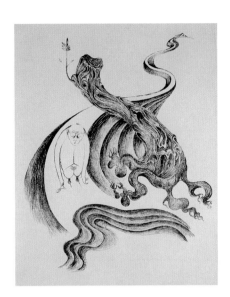
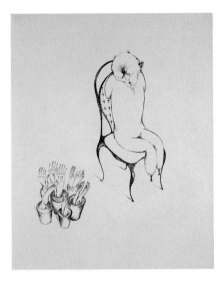
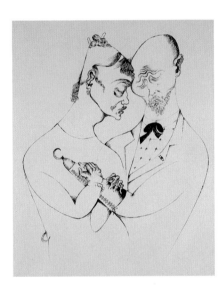
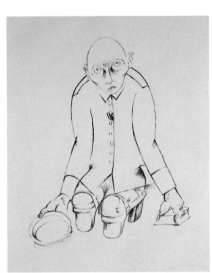

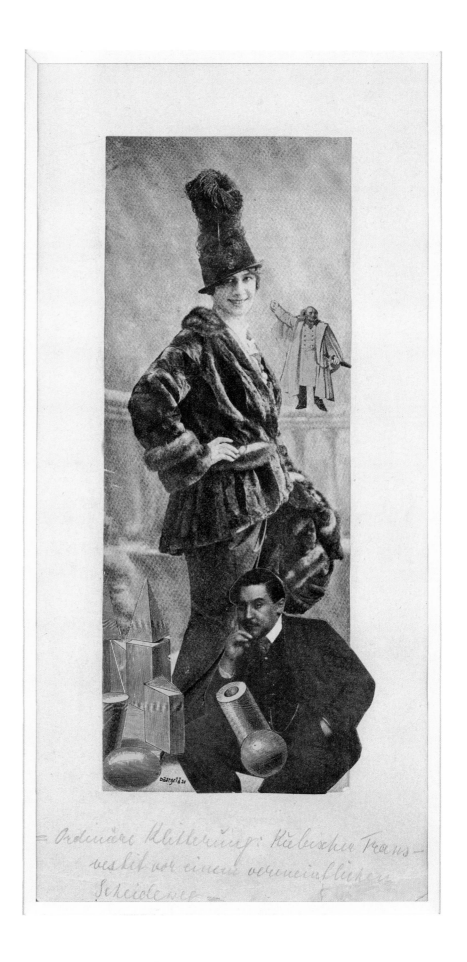

204 JOHANNES BAARGELD *Typische Vertikalklitterung als Darstellung des Dada Baargeld* (Typical Vertical Mess as Depiction of the Dada Baargeld), 1920, photomontage, 37.1 × 31 (14 ⅝ × 12 ³⁄₁₆). Kunsthaus Zürich, Graphische Sammlung

205 JOHANNES BAARGELD *Venus beim Spiel der Könige* (Venus at the Kings' Game), 1920, photomontage, collage, ink, and pencil on paper, 37 × 27.5 (14 ⁹⁄₁₆ × 10 ¹³⁄₁₆). Kunsthaus Zürich, Graphische Sammlung

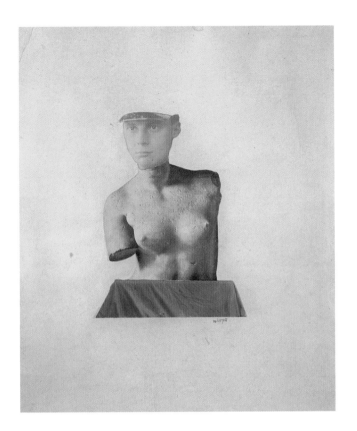

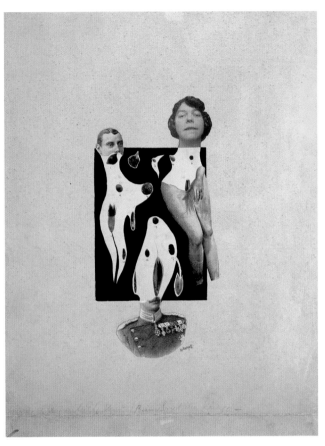

206 **JOHANNES BAARGELD** and **MAX ERNST** *Le Roi rouge*
(The Red King), 1920, ink on printed wallpaper, 49.2 × 38.7 (19 ⅜ × 15 ¼).
The Museum of Modern Art, New York. Purchase

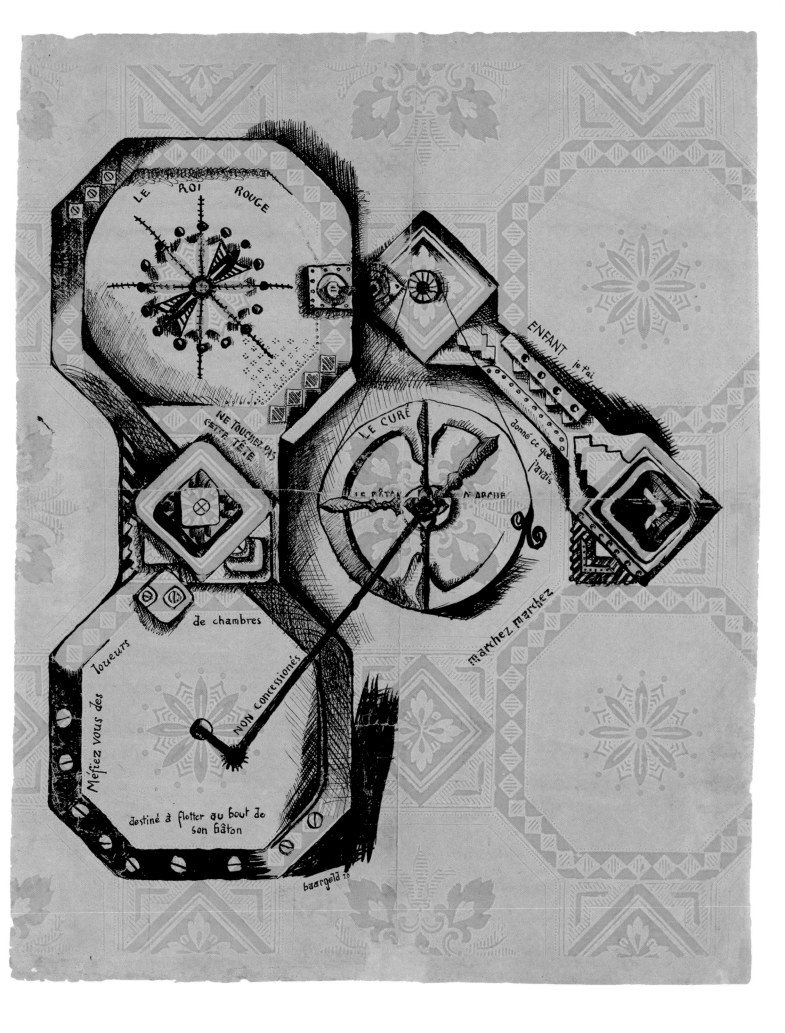

207 JOHANNES BAARGELD *Käfer* (Beetles), 1920, ink and pencil on tissue paper, 29.2 × 23.2 (11 ½ × 9 ⅛). The Museum of Modern Art, New York. Purchase

208 JOHANNES BAARGELD *Das menschliche Auge und ein Fisch, letzterer versteinert* (The Human Eye and a Fish, the Latter Petrified), 1920, collage, ink, and pencil on paper, 31.1 × 23.8 (12 ¼ × 9 ⅜). The Museum of Modern Art, New York. Purchase

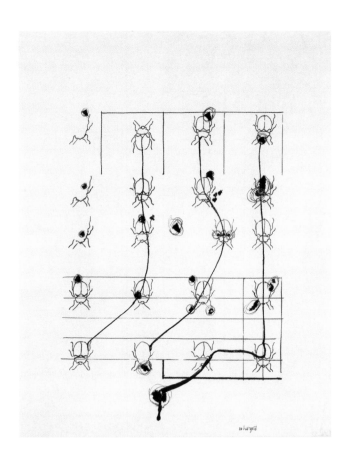

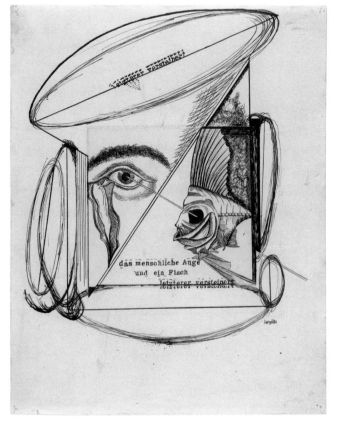

209 JOHANNES BAARGELD *Hommes / sei vorsichtig lieber Heinz*
(Men / Be Careful Dear Heinz), 1920, ink on paper, 31.4 × 23.2 (12 ⅜ × 9 ⅛).
Mark Kelman, New York

210 JOHANNES BAARGELD *Unendlicher Regenschirm*
(Endless Umbrella), 1919 / 1920, ink on paper, 32.5 × 24.5 (12 ¹³⁄₁₆ × 9 ⅝).
Galerie Remmert und Barth, Düsseldorf, Germany

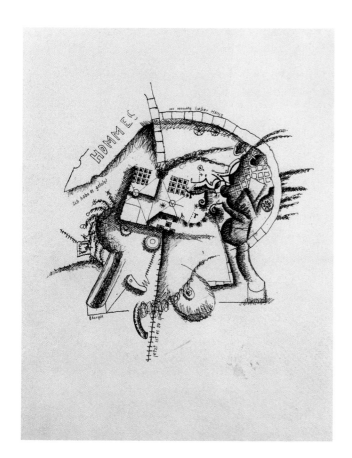

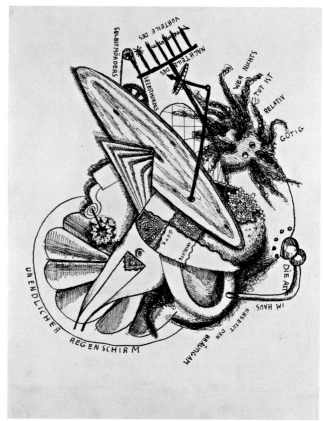

211 MAX ERNST Untitled, 1920, photomontage, collage, and pencil on photographic reproduction mounted on board, 6 × 14.6 (2 ⅜ × 5 ¾). The Menil Collection, Houston

212 MAX ERNST *c'est déja la 22ème fois que Lohengrin…* (It's the 22nd Time Already that Lohengrin…), 1920, gouache on photographic enlargement of photomontage, mounted on board with ink inscription, composition without mount: 21 × 29 (8 ¼ × 11 ⅟₁₆). WestLB Düsseldorf

213 MAX ERNST *die anatomie als braut* (The Anatomy as Bride), 1921, gouache and ink on photomontage, 10.7 × 7.8 (4 ³⁄₁₆ × 3 ⅟₁₆). Centre Pompidou, Musée national d'art moderne-Centre de création industrielle, Paris. Gift of Carlo Perrone, 1999

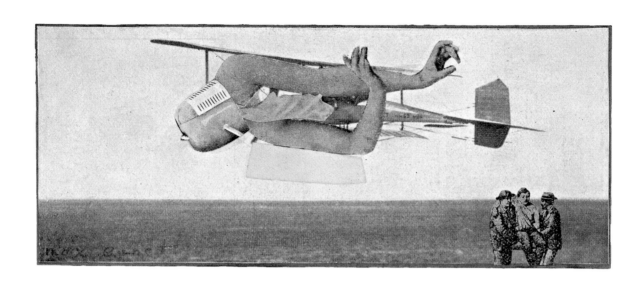

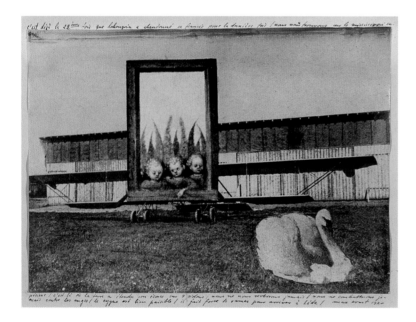

214 MAX ERNST *santa conversazione* (Sacred Conversation), 1921, photograph of photomontage and collage, 22.5 × 13.5 (8 ⅞ × 5 ⁵⁄₁₆). Private collection

215 MAX ERNST *die flamingi...* (The Flamingos...), 1920, photographic enlargement of photomontage, mounted on board with ink inscription, with mount: 29.3 × 23 (11 ⁹⁄₁₆ × 9 ¹⁄₁₆). Private collection

216 MAX ERNST *die chinesische Nachtigall* (The Chinese Nightingale), 1920, photographic enlargement of photomontage, 56 × 40 (22 ¹⁄₁₆ × 15 ¾). Private collection

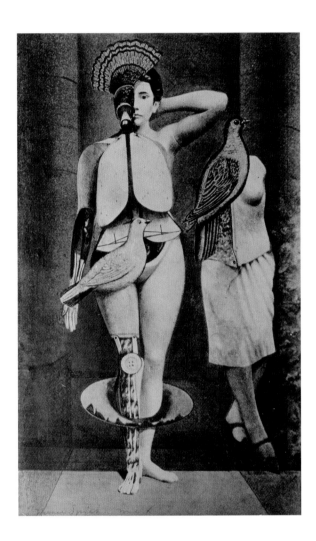

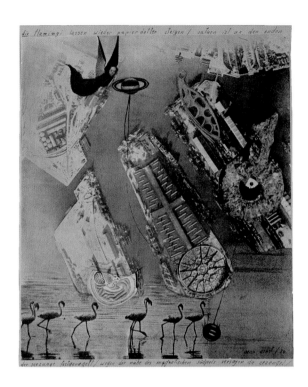

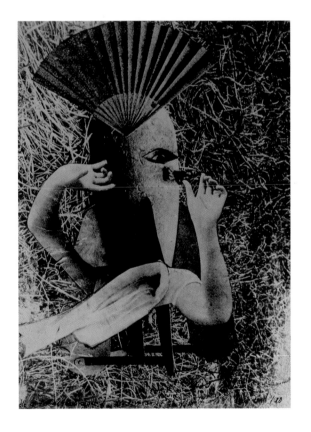

217 MAX ERNST *le chien qui chie…la chanson de la chair* (The Dog Who Shits…The Song of the Flesh), c. 1920, photomontage, gouache, and pencil on photographic reproduction mounted on board with ink inscription, 15 × 21 (5 ⅞ × 8 ¼). Centre Pompidou, Musée national d'art moderne-Centre de création industrielle, Paris. Purchase, 1981

218 MAX ERNST and **HANS ARP** *hier ist noch alles in der schwebe…* (Here Everything Is Still Floating…), 1920, gouache and ink on photographic enlargement of photomontage, mounted on board with ink inscription, with mount: 32 × 38.8 (12 ⅝ × 15 ¼); composition: 29.7 × 35.7 (11 ¹¹⁄₁₆ × 14 ¹⁄₁₆). Stiftung Hans Arp und Sophie Taeuber-Arp e.V., Rolandseck

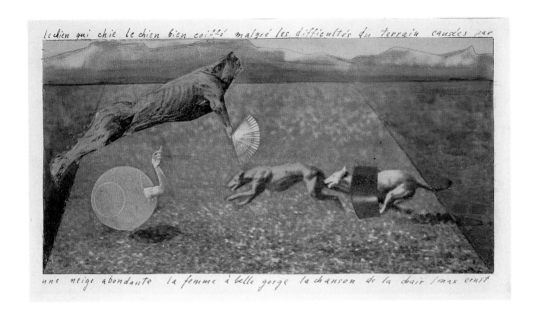

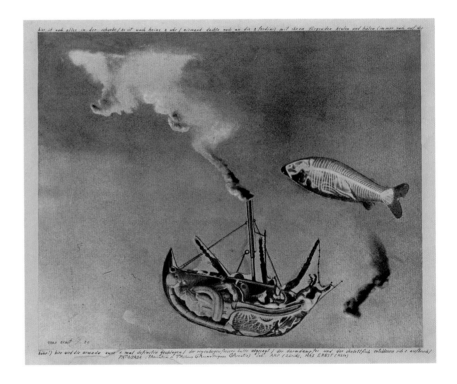

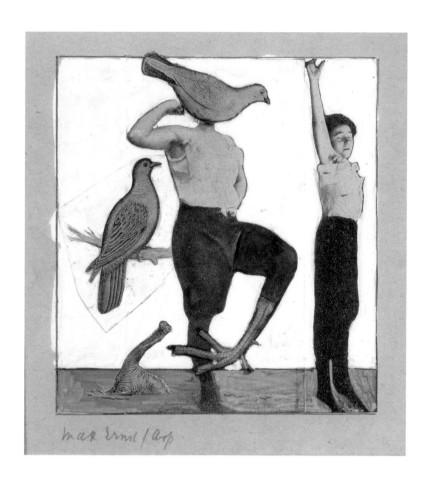

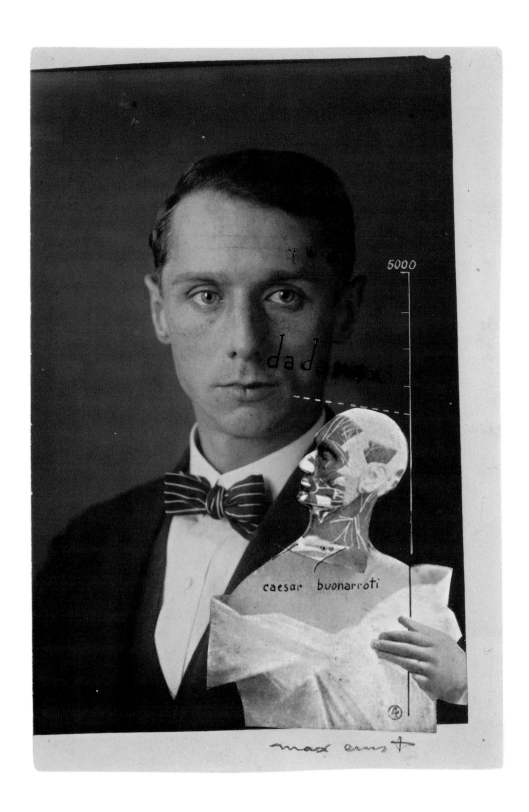

221 MAX ERNST *Rechtzeitig erkannte angriffspläne der assimilanzfäden auf die feste DADA 1:300 000* (The Attack of the Assimilative Threads on the Dada Stronghold Discovered in Time. Scale 1:300,000), c. 1920, collage and ink on paper, 20 × 19 (7 15⁄16 × 7 ½). Staatliche Museen zu Berlin, Kupferstichkabinett

222 MAX ERNST *Dada siegt!* (Dada Triumphs!), poster for the exhibition *Dada-Vorfrühling* (Dada Early Spring), Brauhaus Winter (Winter Brewery), 1920, letterpress, 43.2 × 63.5 (17 × 25). Elaine Lustig Cohen Dada Collection, The New York Public Library, Astor, Lenox and Tilden Foundations

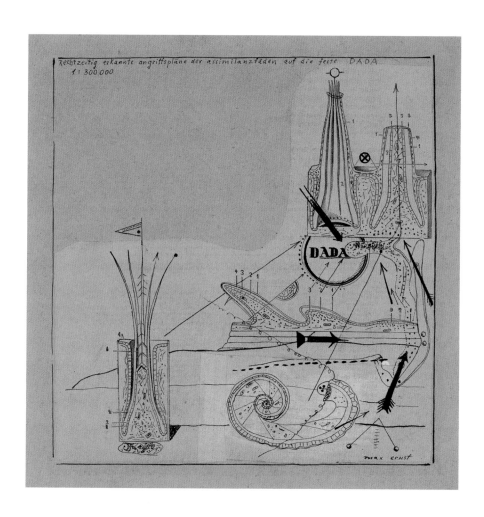

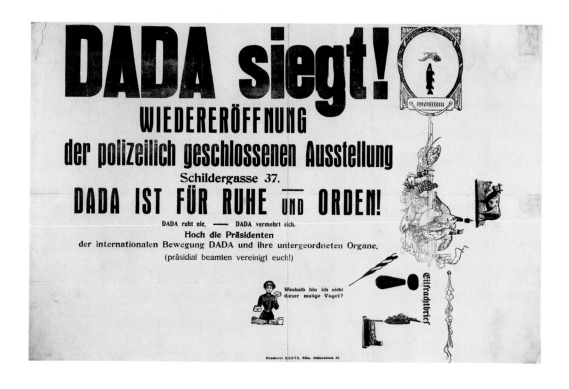

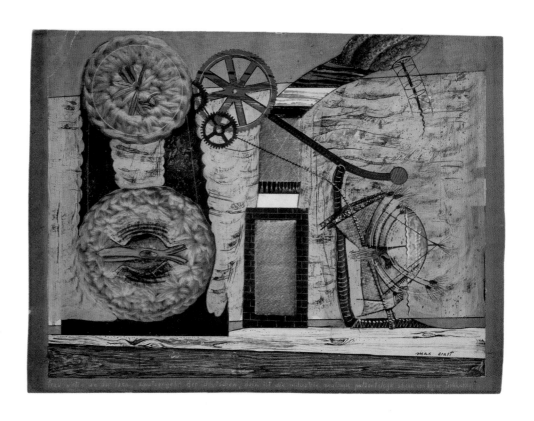

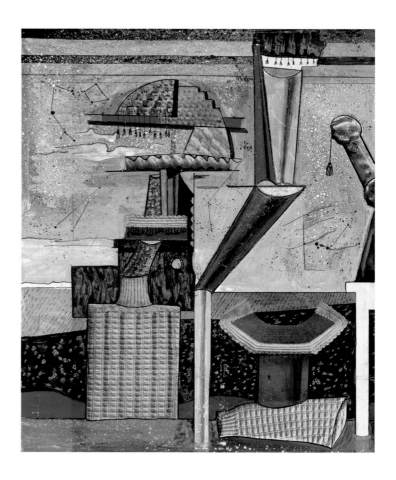

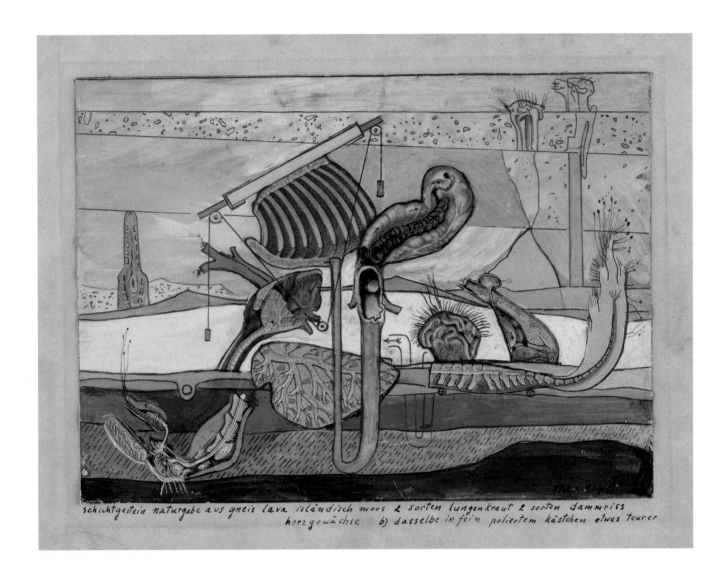

230 **MAX ERNST** *la bicyclette graminée…* (The Gramineous Bicycle …),
c. 1921, gouache and ink on botanical chart with ink inscription, 74.3 × 99.7
(29 ¼ × 39 ¼). The Museum of Modern Art, New York. Purchase

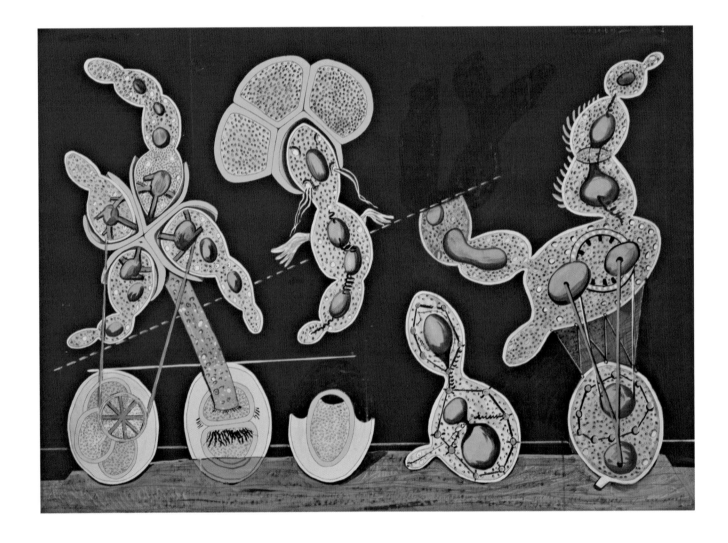

231 MAX ERNST *la petite fistule lacrimale qui dit tic tac* (The Little Tear Gland that Says Tick Tock), 1920, gouache, pencil, and ink on stenciled wallpaper mounted on board, 36.2 × 25.4 (14 ¼ × 10). The Museum of Modern Art, New York. Purchase

232 MAX ERNST Exhibition poster maquette for *Mutter Ey* (Mother Egg), Düsseldorfer Galerie, 1921, collage, photomontage, gouache, and ink on board, 64 × 49 (25 ³⁄₁₆ × 19 ⁵⁄₁₆); framed: 94.5 × 76.5 × 2 (37 ¹³⁄₁₆ × 30 ⅛ × ¹³⁄₁₆). Foundazione Torino Musei–Gallerie d'Arte Moderna e Contemporanea, Torino

233 MAX ERNST *Dada Augrandair, Der Sängerkrieg Intirol* (Dada Outdoors, the Singers' War in the Tirol), back cover of the journal *Dada*, no. 8, Max Ernst and Tristan Tzara editors, Paris: Au Sans Pareil, September 1921 (possibly published in Tarrenz, Austria), letterpress, 33.7 × 21 (13 ¼ × 8 ¼). With the illustration *Die Leimbereitung aus Knochen/La preparation de la colle d'os* (The Preparation of Glue) by Max Ernst and text by Tristan Tzara. National Gallery of Art, Library, Gift of Thomas G. Klarner

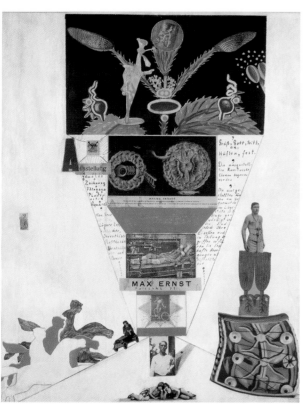

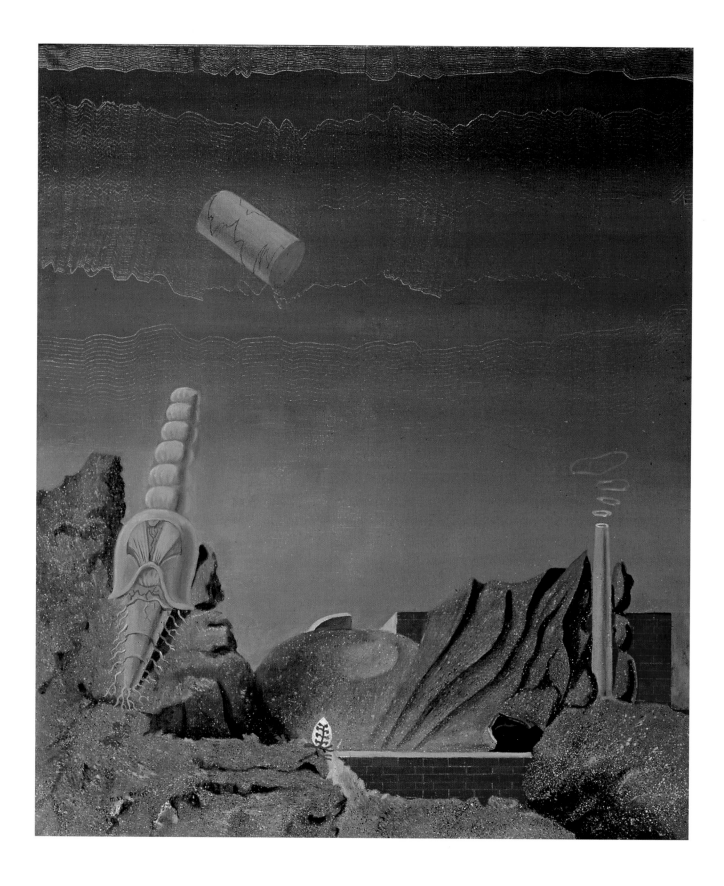

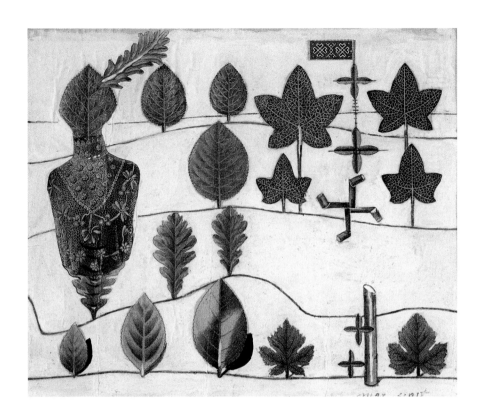

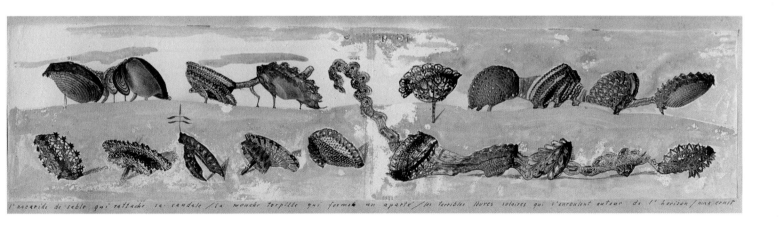

237 **MAX ERNST** *la puberté proche…*(Approaching Puberty…)
or *les pléiades (*Pleiads), 1921, photomontage, gouache, oil, and ink on
paper mounted on board with ink inscription, 24.5 × 16.5 (9 ⅝ × 6 ½).
Private collection

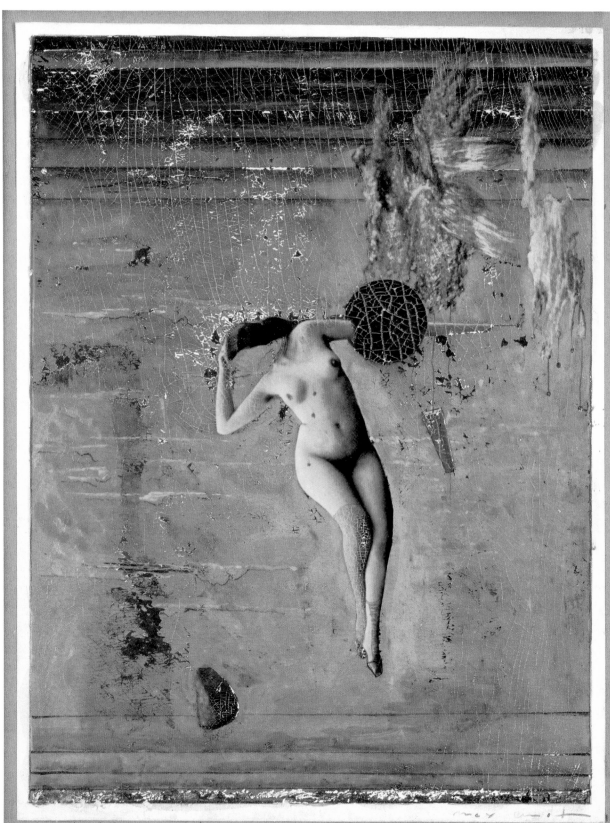

La puberté proche n'a pas encore enlevé la grâce tenue de nos
pléiades/ Le regard de nos yeux pleins d'ombre est dirigé vers le
pavé qui va tomber/ La gravitation des ondulations n'existe pas encore

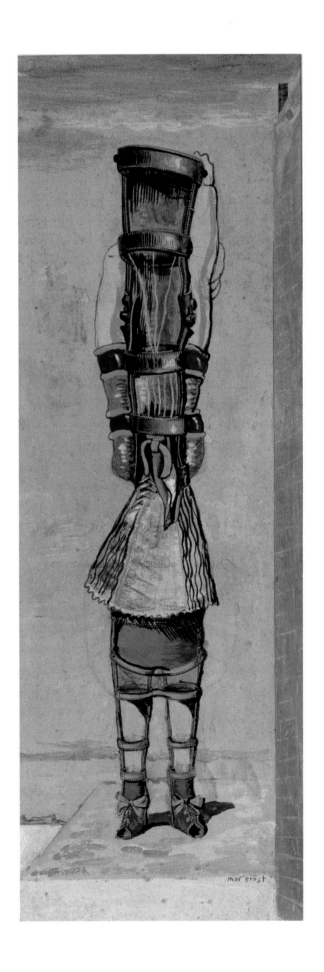

239 MAX ERNST *das schlafzimmer des meisters es lohnt sich darin eine nacht zu verbringen / la chambre à coucher de max ernst…*
(The Master's Bedroom, It's Worth Spending a Night There / Max Ernst's Bedroom…), c. 1920, gouache, pencil, and ink on printed reproduction mounted on board with ink inscription, 16.3 × 22 (6 7/16 × 8 11/16).
Private collection

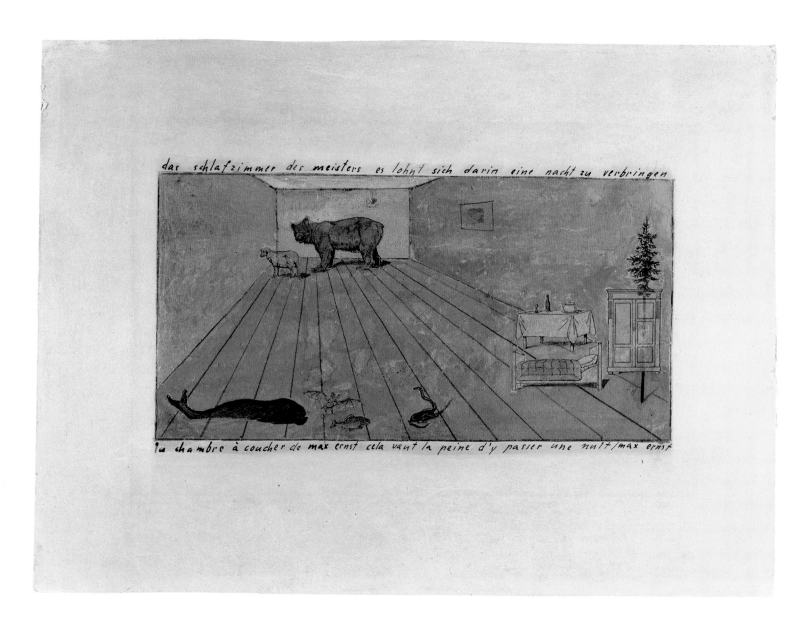

240 **MAX ERNST** *Célèbes* (Celebes) or *Der Elefant von Celebes*
[The Elephant of Celebes], 1921, oil on canvas, 125.4 × 107.9 (49 ⅜ × 42 ½).
Tate. Purchased 1975

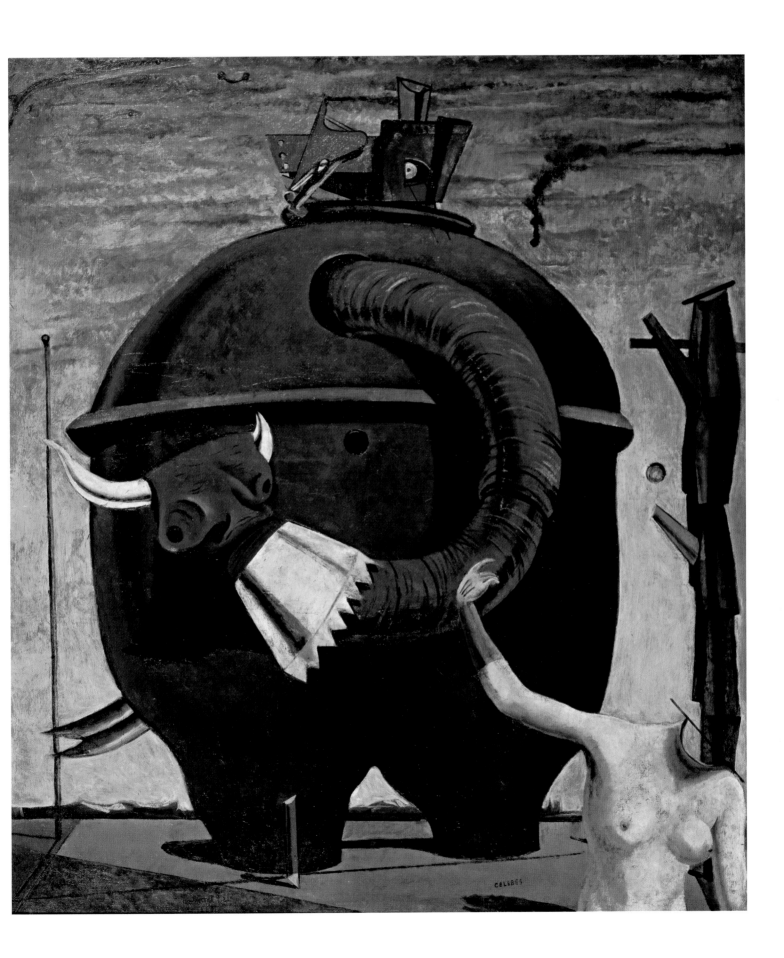

242 **MAX ERNST** *des éventails brisés* (Broken Fans), 1922, illustration for the book *Les Malheurs des immortels* (The Misfortunes of the Immortals) by Paul Eluard, Paris: Librairie Six, 1922, gouache on collage (colored after use in *Les Malheurs des Immortels*), sheet: 25 × 18 (9 ¹³⁄₁₆ × 7 ¹⁄₁₆), composition: 10.2 × 16.5 (4 × 6 ½). Private collection

243 **MAX ERNST** Page from *Les Malheurs des immortels* (The Misfortunes of the Immortals) by Paul Eluard, Paris: Librarie Six, 1922, reproduction of collage, 25 × 19 (9 ¹³⁄₁₆ × 7 ½). National Gallery of Art, Library, David K.E. Bruce Fund

244 Cover of the illustrated book *Répétitions* (Repetitions) by Paul Eluard, Paris: Au Sans Pareil, 1922, page: 21.6 × 13.8 (8 ½ × 5 ⁷⁄₁₆). The Museum of Modern Art Library, The Museum of Modern Art, New York

MAX ERNST Untitled illustration mounted on cover, line block (reproduction of collage of engravings)

MAX ERNST Illustration maquettes for the book *Répétitions* (Repetitions), gouache and ink on collage of printed reproductions, on paper (colored after use in *Répétitions*)

245 *les moutons* (The Sheep), 1921, 11.3 x 16.2 (4 ⁷⁄₁₆ × 6 ⅜), Centre Pompidou, Musée national d'art moderne-Centre de création industrielle, Paris, Gift of Marguerite Arp-Hagenbach, 1973

246 *la parole* (The Word) or *femme-oiseau* (Bird-Woman), 1921, 18.5 x 10.6 (7 ⁵⁄₁₆ × 4 ³⁄₁₆), Private collection

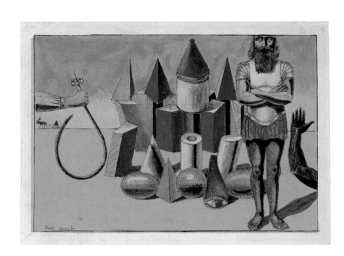

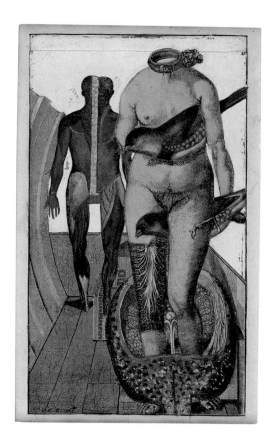

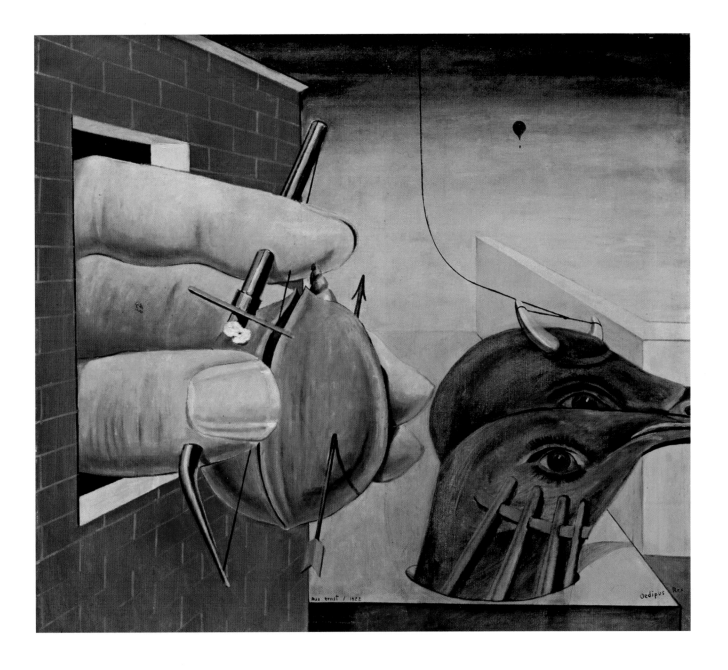

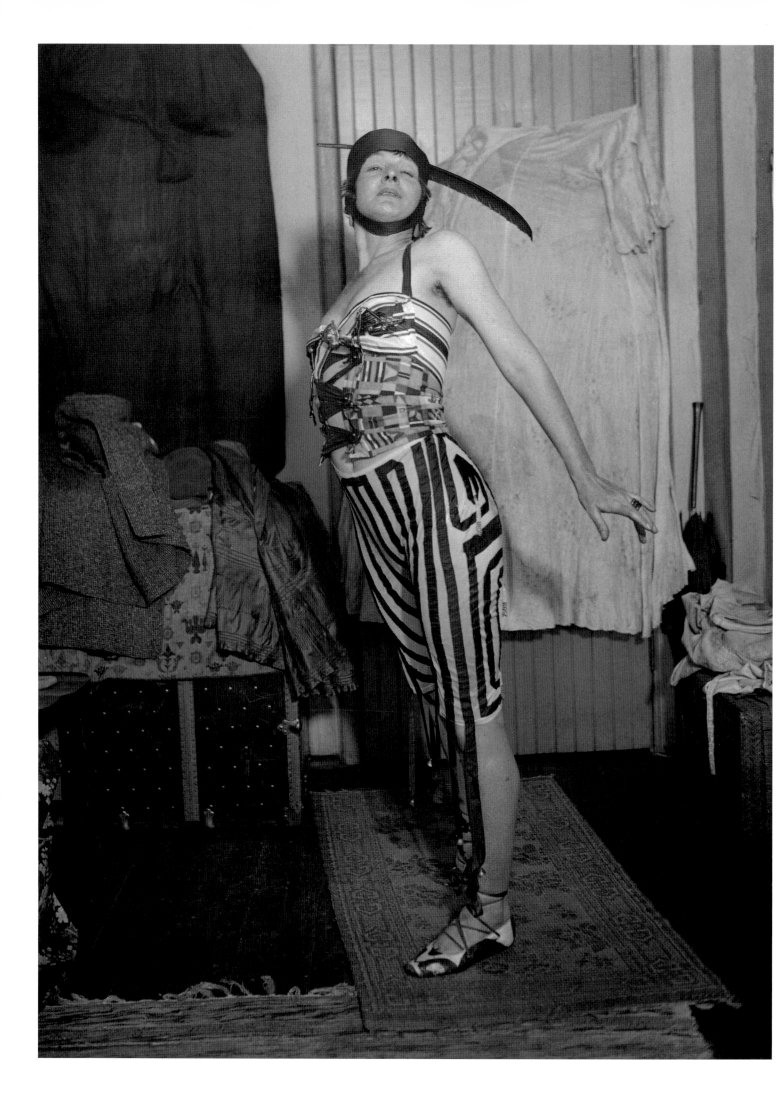

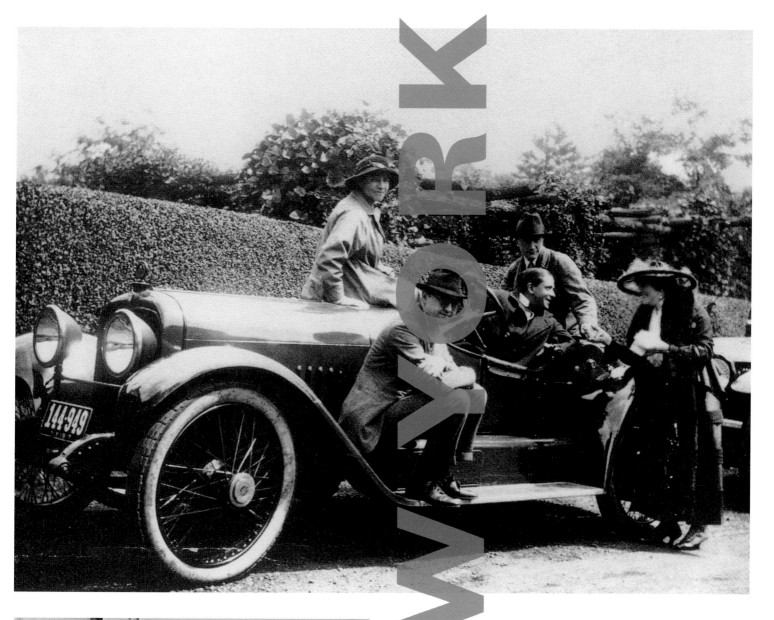

NEW YORK

5

John Covert
Jean Crotti
Marcel Duchamp
Elsa von Freytag-Loringhoven
Man Ray
Francis Picabia
Morton Livingston Schamberg
Joseph Stella
Beatrice Wood

When Marcel Duchamp submitted a white porcelain urinal, unaltered, under a pseudonym, to the first exhibition of the Society of Independent Artists, which opened in New York on 10 April 1917, he knowingly created a scandal that introduced the notion of Dada into American art.[1] *Fountain* **[261]** was thus a deliberately provocative Dada gesture — a premeditated joke, designed to flush out the hypocrisy of the society's professed liberal idealism. The rejection of the porcelain object by the hanging committee of the supposedly jury-free Independents exhibition helped to galvanize the disparate personalities of New York Dada into a cohesive group.[2] The timing of the *Fountain* scandal coincided not only with U.S. President Woodrow Wilson's war message on 2 April 1917, which led the United States Congress to declare war on Germany four days later, but also with the arrival of Dada publications in New York. Both events may have played a role in Duchamp's decision to enter his scandalous submission.

The Independents' refusal to exhibit *Fountain* led the New York Dada group to initially take as its rallying point the issue of creative freedom, which as I will argue had political as well as artistic ramifications in the prevailing climate of intense American nationalism that produced countless war posters and military parades in 1917–18. These artists developed a distinct set of strategies to express their deep-seated antipathy toward the barbaric war in Europe and their opposition to the sacrosanct terms and traditions of oil painting, which they viewed as abhorrent and absurd. It was this curious conflation of politics and painting that led artists such as Duchamp, Francis Picabia, Jean Crotti, John Covert, Morton Schamberg, Man Ray, and the Baroness Elsa von Freytag-Loringhoven to challenge accepted notions about art through their paintings, mixed-media assemblages, sculpture, found objects, readymades, photography, and performances. New York Dada's dismantling of painting's inherited rituals would eventually lead to the adoption of mechanical instruments, such as the commercial spray gun, film, photomontage, and photography, which often eliminated the presence of the artist as author of his or her own work.

GERMAN IDENTITY AND THE IMPACT OF THE WAR

Traditionally viewed as an extension of the artistic practices and concerns of French modernism, due in part to Duchamp and Picabia's earlier ties to the Puteaux cubist group and the Parisian avant-garde, New York Dada in fact had much stronger links to German art. The vast majority of its practitioners and patrons were of German extraction, including

Covert, Schamberg, the Baroness, the Stettheimer sisters, Walter Arensberg, and Katherine Dreier, many of whom had lived and worked in Germany before World War I, and retained strong family connections to their country of origin. This shared cultural heritage, which has been largely overlooked in the literature on New York Dada, is of crucial importance for understanding these artists' opposition to World War I and their condemnation of modern painting as disengaged surface decoration. At a time when countless American towns, streets, and families of German origin were anglicizing their names, due to the social stigma associated with being German during World War I, the efforts of the New York dadaists to liberate themselves from conformism and challenge all forms of cultural prejudices can also be seen as a conscious attempt to protect their collective identity.

This German context provides a new way of understanding the work of the New York dadaists, who steadfastly refused to follow the rubric of triumphant modernism promoted by the French avant-garde, especially as it was narrowly defined in the theories promoted by Albert Gleizes and Jean Metzinger in their 1912 treatise *Du cubisme*. The notion of painting as a pure language of color and form was anathema to these dadaists, whose shared interest in cryptography and other forms of arcane symbolism is much closer to the German secessionist model, exemplified by the hermetic paintings of Franz von Stuck and the Swiss artist Arnold Böcklin. While traveling in Germany and Switzerland in 1912, Duchamp had become enamored of Böcklin's haunting mythological paintings, which he saw as an antidote to the superficial "retinal" art being produced in Paris at the time, art that downplayed intellectual ideas in favor of the slickness of wet paint.[3] Duchamp's admiration for the cerebral nature of the work of Böcklin and other Swiss and German artists was shared by other New York Dada members such as John Covert, who trained at the Akademie der bildenden Künste (Academy of Fine Arts) in Munich before World War I, where he came into contact with the work of von Stuck and other secessionist painters.[4]

The political edge of New York Dada can be seen in the group's efforts to resist the dominant culture's fervent patriotism and its attendant vilification of German people and culture. This act of defiance can thus be compared (in an inverted form) to the political and artistic tactics adopted by the German dadaists, where an artist like Helmut Herzfeld, disgusted by the German government's anti-British propaganda (especially the often repeated slogan *Gott strafe England!* —May God punish England!) had anglicized his name to

John Heartfield. The actions of the New York Dada group take on new meaning when seen within the pervasive climate of extreme nationalism, fueled by a virulent anti-German propaganda campaign, in which performances of Mozart and Beethoven were banned, sauerkraut and hamburgers became liberty cabbage and liberty sandwiches, and dachshunds were openly kicked in the street. It is therefore no coincidence that the birth of New York Dada coincided with America's entry into World War I, which led numerous German-Americans to be falsely arrested for espionage and pro-German agitation, or worse still to become the victims of lynch mobs as mindless bigotry and hatred mounted in an anti-German atmosphere that bordered on hysteria.

The impact of the war was keenly felt by the artists who gathered together at the informal parties hosted by the art patrons, Louise and Walter Arensberg, in their apartment on 33 West 67th Street from 1915 to 1921, and thereafter at the lectures and exhibitions organized by the Société Anonyme at 19 East 47th Street. The social character of the Arensberg salon has been described by Gabrielle Buffet-Picabia, Picabia's first wife and an active participant in New York Dada, as a place "where at any hour of the night one was sure of finding sandwiches, first-class chess players, and an atmosphere free from conventional prejudice."[5] The spontaneous aura of the Arensberg salon meant that American artists, poets, actors, musicians, dancers, critics, businessmen, lawyers, and at least one clinical psychiatrist could mix freely with the displaced European avant-garde, thus creating what Buffet-Picabia later called "a motley international band which turned night into day, conscientious objectors of all nationalities and walks of life living in an inconceivable orgy of sexuality, jazz and alcohol."[6]

The Arensbergs' apartment housed one of the most advanced collections of modern art ever assembled in the United States and the work produced by the New York dadaists was stimulated by their constant exposure to the paintings and works on paper by artists such as Duchamp, Picabia, Henri Matisse, Georges Braque, and Henri Rousseau, as well as African and pre-Columbian art, and sculpture by Constantin Brancusi [fig. 5.1]. It was while surrounded by this stunning array of paintings and sculpture that the group members hotly debated such topics as art, literature, sex, politics, and psychoanalysis, while others preferred to play chess, drink champagne, or dance the night away in their bare feet.[7]

These often boisterous soirées helped to encourage the reputation for hedonistic excess for which New York Dada would become notorious, as the following remarks made by

Joseph Stella, a frequent visitor to the Arensberg salon, attest: "Dada means having a good time—the theatre, the dance, the dinner. But it is a movement that does away with everything that has always been taken seriously. To poke fun at, to break down, to laugh at, that is Dadaism."[8] The often amusing anecdotes that surround these high-spirited evenings, whose antics included boxer-poet Arthur Cravan's striptease act at the Independents,[9] and Duchamp's attempt in January 1917 to declare Greenwich Village a "free republic, independent of uptown," by climbing to the top of the Washington Square arch and bedecking it with red, white and blue balloons,[10] have led to the misleading conception that New York Dada lacked the political engagement and public confrontation of its counterparts in Europe.

The New York dadaists did not engage in the kind of militant cultural protest seen at the Cabaret Voltaire in Zurich and in later Dada activities in Berlin, Cologne, and Paris. However, the playful irreverence and self-gratifying escapism found in the work and activities of the artists who attended the Arensberg salon must also be understood within the context of the horrific carnage that took place during World War I. Despite their physical distance from the European

trenches, the traumatic presence of the war permeated almost every aspect of the work and play of the New York Dada group, although the response was sublimated and displaced through excessive drinking and drug abuse on the one hand, and the distancing devices of satire and irony on the other. Compare, for example, the costume that Covert wore to the Blindman's Ball in New York on 25 May 1917, in which he appeared as a hard-boiled egg, with the skeleton mask worn by George Grosz in Berlin. While Grosz' "Dada Death" costume conveys Berlin Dada's violent moral reaction to the savagery of World War I and the chaotic political and artistic upheaval that ensued after the hostilities ended, Covert's eggshell outfit displays an infantile desire for protection and nurture. The fragile nature of Covert's attire speaks to the crisis of masculinity that the war induced in the male artists associated with New York Dada, whose open vulnerability was in stark contrast to the aggressive tactics of the Berlin dadaists, which in turn served to conceal their own deep-rooted psychic trauma.[11] Like their European counterparts, the New York dadaists, many of whom were conscientious objectors or men deemed unfit for military service, viewed the conflict in Europe as an abomination, but their opposition

to the senseless carnage on the Western Front was subtle and humorous, rather than violent and histrionic.[12] As Duchamp later explained: "We saw the stupidity of the war. We were in a position to judge the results, which were no results at all. Our movement [meaning Dada] was another form of pacifist demonstration."[13]

PAINTING AT THE SERVICE OF THE MIND

The reckless abandonment and freedom from societal constraints enjoyed by the participants of the Arensberg salon would also come to characterize the artistic practices employed during the New York Dada manifestation, when artists such as Man Ray, Covert, and the Baroness used chance procedures, surface accretions, and unexpected juxtapositions to disrupt the surfaces of their paintings. Duchamp's defiance of the traditions and conventions of oil painting, following the humiliating rejection of *Nu descendant un escalier* (Nude Descending a Staircase no. 2) by the hanging committee of the Salon des indépendants exhibition in Paris in March 1912, undoubtedly encouraged other New York dadaists to question almost every aspect of the art-making process, especially in terms of materials and technique.[14] This event also helped to liberate Duchamp from a career as

a professional cubist painter, which he now saw as being doomed to repetition and bound by reactionary rules imposed by artists like Albert Gleizes and Jean Metzinger, whom he scornfully viewed as "monkeys following the motions of the leader without comprehension of their significance."[15] Duchamp's newfound independence also coincided with his increasingly close friendship with Picabia, who shared his impious irreverence and interest in questioning and breaking the cultural norms of art.

Duchamp later described his approach to art making after 1912 as coming out of his desire to push "the idea of doubt of Descartes…to a much further point than they ever did in the School of Cartesianism: doubt in myself, doubt in everything. In the first place never believing in truth."[16] This extreme form of doubt led him to entertain reservations about the practice of oil painting. Duchamp believed that in the modern era, professional painters had become so engrossed with the sensual appeal of their oil-based medium and its application that they had ignored the intellectual side of art making. As the artist later explained, Dada was an extreme protest against this physical side of painting: "Dada was very serviceable as a purgative. And I think I was thoroughly conscious of this at the time and of a desire to effect a

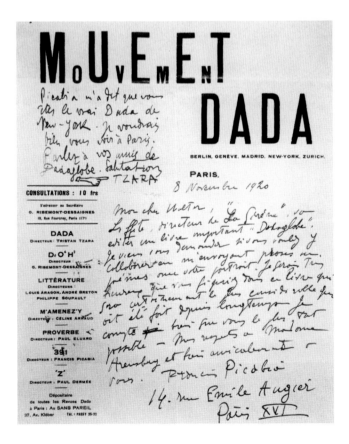

5.2 Francis Picabia, letter to Walter Arensberg, 8 November 1920. Contains handwritten note and drawing by Tristan Tzara. Philadelphia Museum of Art, Arensberg Archives

purgation in myself. I recall certain conversations with Picabia along these lines. He had more intelligence than most of our contemporaries. The rest were either for or against Cézanne. There was no thought of anything beyond the physical side of painting."[17]

One can discern Duchamp's concerted effort to overhaul the concept of art as a handcrafted enterprise in the two versions of the *Broyeuse de chocolat* (Chocolate Grinder), in which the artist looked for a way out of what he considered to be the straitjacket of avant-garde painting, with its emphasis on compressed space, asymmetry, and fragmentation. Duchamp painted *Chocolate Grinder no. 1* [250] of 1913, in a dry and impersonal painting style, akin to the mechanical drawing used in architectural plans. This quasi-scientific approach came out of his studies of perspective and optics while working as a librarian at the Bibliothèque Sainte-Geneviève in Paris, which encouraged him to introduce into his paintings "the precise and exact aspect of science, which hadn't often been done, or at least hadn't been talked about very much. It wasn't for love of science that I did this; on the contrary, it was in order to discredit it, mildly, lightly, unimportantly. But irony was present."[18]

In the emblematic *Chocolate Grinder no. 2* [251], of 1914, we can chart Duchamp's complete rejection of the artist's individual touch, or *patte* (literally "paw mark"), as the index of creative expression. The machine rollers appear to be lit from within, since all shading and modeling have been removed, thus emancipating painting from centuries of three-dimensional illusionism. This break with the past is continued in the saturated, monochrome background, which was achieved by spraying the canvas with an airbrush, while the lines of the chocolate grinding rollers are made of threads sewn into the canvas support like a tapestry and then varnished down. Duchamp even asked a commercial bookbinder to print the title in embossed gold letters on a leather label, much like a foil stamped title on a leatherbound book. This quest to rid painting of the master's hand as imprimatur of genius and uniqueness was parodied to ludicrous effect four years later, when Duchamp invited a professional sign painter to add a realistically rendered hand, with its index finger pointing in the manner of old-fashioned directional signs, to his mural-sized painting *Tu m'* [265] (which as a homophone consigns the dead-end occupation of painting to the grave). As the artist later recalled with great amusement, the sign painter, "A. Klang," dashed off the illusionistic pointing hand in five minutes.[19] By 1920 the ubiquitous pointing hand, a familiar trope from the world of advertising and signage, would become an instantly recognizable symbol of the Dada movement, whose magazines used its association with the international postal service to denote their collective efforts to redirect art and culture. Tristan Tzara even sent Walter Arensberg, whom Picabia had informed him was "the true Dada of New York," his own hand-drawn rendition of the Dada symbol [fig. 5.2], which serves to highlight the reciprocal exchange of ideas that took place between the European Dada groups and this small enclave across the Atlantic Ocean.

Duchamp's intellectual, rather than physical, approach to painting would have profound ramifications for the New York Dada group, for whom the *Chocolate Grinder no. 2* became a work of talismanic importance. The two *Chocolate Grinder* paintings had been shown together in the *Third Exhibition of Contemporary French Art* at the Carroll Galleries, New York, in March-April 1915, just a few months prior to Duchamp's arrival in the United States. This deliberate pairing of related early studies for *La Mariée mise à nu par ses célibataires, même* (The Bride Stripped Bare by Her Bachelors, Even) [or *The Large Glass*] [248], was repeated in April 1916, when both canvases were displayed in the *Exhibition of Modern Art* at the Bourgeois Galleries on Fifth Avenue. Showing the two paintings together revealed a clear evolution in Duchamp's ideas and working practice, which moved away from manual dexterity, in which the artist's touch was paramount, toward a more cerebral approach in line with the artist's stated aim of putting "painting once again at the service of the mind."[20] These works made an immediate impact on the artists associated with the New York Dada group, who had numerous opportunities to view them in the apartment of Louise and Walter Arensberg, where they were hung on separate walls of the main sitting room. Indeed, when Duchamp chose to reproduce *Chocolate Grinder no. 2* on the cover of the second issue of *The Blind Man* [263] he was perhaps acknowledging the importance of the work for the artists associated with the Arensberg salon, who had been inspired to radically change their practice after seeing the painting's unconventional materials and innovative techniques.

It would appear that Duchamp made a concerted effort to publicize his *Chocolate Grinder no. 2* painting after he moved to New York, perhaps in the vain hope of having it replace the *Nude Descending a Staircase* as the key work in his oeuvre in the estimation of the general public, artists, and art critics. How else can one explain his decision in 1916 to have a photograph taken of himself with the painting on his lap, as if he was in the process of completing it [fig. 5.3]?

This bizarre image was one of six photographs of avant-garde artists, which included fellow dadaist Jean Crotti, that were taken by Paul Thompson to accompany the article "Sometimes We Dread the Future."[21] The artists were each shown with their recent paintings, with Duchamp posed as if he were actually still working on his canvas, although upon closer inspection the "brush" that Duchamp holds in his hand looks decidedly like a pipe.[22]

Duchamp's doubt about painting's ability to engage with intellectual ideas would eventually lead to a profound and systematic questioning of received ideas about art, science, language, music, and identity, perhaps best exemplified in his use of chance procedures in the *3 Stoppages Étalon* (3 Standard Stoppages) of 1913–14, to challenge the legal and scientific authority of the standard meter in the Pavillon de Breteuil in Sèvres.[23] This general mistrust of accepted laws and traditions, echoed in Tzara's 1918 declamation on the front cover of *Dada 3* that "Dada places doubt above everything," would become one of the founding principles of New York Dada. The realization that painting was doomed to banal repetition and meaningless surface embellishment led Duchamp, together with other artists in the

New York Dada camp, to formulate a new approach to the inherited traditions of western art. The experimental nature of their work required the use of unexpected materials, such as glass, wire, dust, and soap, which went hand-in-hand with the development of new techniques, seen for example in Duchamp and Man Ray's adoption of the airbrush as an impersonal method of applying pigment. As Man Ray later recalled, "it was thrilling to paint a picture, hardly touching the surface—a purely cerebral act, as it were."[24] The realm of painting was also opened up to new subject-matter by these artists, who were drawn to the products and advertising of the burgeoning consumer society that surrounded them, as seen in the frequent use of diagrammatic machine engines and automobile parts, the formal beauty of which was often laced with an undercurrent of irony and eroticism.

THROUGH THE LARGE GLASS

These issues came to the fore in Duchamp's endlessly enigmatic *Large Glass* of 1915–23, which can be understood through the artist's meticulous notes as a complex allegory of frustrated desire in which the nine uniformed bachelors in the lower panel are perpetually thwarted from copulating

5.3 "Sometimes We Dread the Future," *Every Week*, 2 April 1917, p. 14. Article featuring Marcel Duchamp and Jean Crotti, with photographs by Paul Thompson. Duchamp is shown at top right. Philadelphia Museum of Art Archives

with the wasplike, biomechanical bride above. Duchamp inflated the division of the sexes to absurd proportions in this work, where the blossoming bride exists in a higher spatial fourth dimension, while the bachelors live in our own three-dimensional world. The cloud of love-gasoline that the bride emits sets in motion a chain of mechanical operations in the bachelor section below, including a glider on runners, a turning watermill, and an oscillating chocolate grinding machine, which culminate in the nine "shots" of chocolate-semen that penetrate the upper section. In a brilliant move, Duchamp fired matches dipped in paint from a toy cannon to designate the chance location of the bachelors' shots, the configuration of which he fixed by drilling holes in the glass panel. However, since everything in the fourth dimension is the mirror opposite of that seen in the third dimension, the erotic proceedings depicted in the work are doomed to end in frustration and disappointment: the bachelors fail to penetrate their bride, their machine-gun-like bullet holes merely outline her three-dimensional reflection as they perceive it from below.

The artist began the painstaking process of constructing this towering painting on two separate panes of glass shortly after he arrived in New York, using the detailed notes and studies that he had brought with him from Paris. What artists such as Man Ray and Jean Crotti gleaned by following the snail-like progress of Duchamp's "hilarious picture" was invaluable in terms of their future development. Man Ray, for example, recorded for posterity Duchamp's experiment with "dust breeding" in 1920 **[249]**, when the French artist allowed dust, cotton wool, and bits of tissue to accumulate on the lower section of the *Large Glass* for a period of six months. Man Ray's photograph of the dust-covered surface of the glass pane takes on the appearance of an aerial view of a lunar landscape, thus underscoring the strange and disorienting nature of the work, which was far removed from any concept of advanced painting as it was understood at the time. After enough dust had accumulated, it was carefully gathered into the area of the seven cone-shaped sieves in the bachelor section and affixed with a topcoat of varnish, thus creating a new blond-tinted color without having to resort to using oil paint from a tube. This use of chance to "find" the right hue for the sieves prevented the artist from conforming to his own personal taste in the selection of colors for the work.

The impact of Duchamp's use of quirky materials such as dust, glass, lead foil, and lead wire in the *Large Glass*, as well as his adoption of nontraditional techniques, is felt in the work of the Swiss artist Jean Crotti, who shared

a studio with Duchamp in the Lincoln Arcade building on Broadway and 67th Street in the fall and winter of 1915. It was while living and working alongside his fellow expatriate that Crotti's work underwent a dramatic transformation, moving away from his earlier interest in orphism and cubism, toward a new expression inspired by Duchamp's ironic mechanical analogies for the human sexual act. Crotti's paintings on glass, such as *Le Clown* (The Clown) **[302]**, and *Les Forces mécaniques de l'amour en mouvement* (The Mechanical Forces of Love in Motion) **[see 303]**, both made in 1916, reveal how quickly he assimilated his friend's ideas and working practices to develop his own elaborate iconography of automatic lovemaking machinery. Crotti's use of jarring elements such as artificial eyeballs in these works would earn him the nickname of the "malicious dentist," because according to Picabia "his paintings set your teeth on edge."[25] These joke-shop items help to differentiate Crotti's work from that of Duchamp, as can be seen again in the artist's explanation of *The Mechanical Forces of Love in Motion* in a contemporaneous newspaper interview, which highlights the distinct differences in their approaches and outlook. As Crotti told the critic Nixola Greeley-Smith, his painting represented "love in the most primitive sense," with the colors of the disks in the painting corresponding to concepts such as love (red), hope (green), and the ideal (blue).[26] This use of color symbolism is typical of Crotti's approach to art, which is mysterious and often quasi-religious in feeling. Although his stay in New York was short-lived, Crotti would continue to be affiliated with the expanding international Dada movement after he returned to France in the fall of 1916, where he would eventually develop, along with Duchamp's sister Suzanne, his second wife, an offshoot of Dada called TABU.

Duchamp's mechanomorphic imagery was also picked up by his close friend Picabia, who upon returning to New York in 1915 declared his intention to bring the machine into his studio: "Almost immediately upon coming to America it flashed on me that the genius of the modern world is in machinery and that through machinery art ought to find a most vivid expression."[27] The publication that year of the artist's machine drawings in 291 magazine **[278–282]** reveals that the artist stuck to his word. These symbolic object portraits used isolated items from the machine environment, such as an automobile spark plug, a portable electric lamp, and a broken Kodak camera, to represent specific friends and collaborators, including Agnes Ernst Meyer, Paul Haviland, Alfred Stieglitz, and Picabia himself, whose passion for fast cars led him to select the Klaxon horn as a

John Covert, *Study for Water Babies*, c. 1916, gelatin silver print. Private collection, Harrisburg, Pennsylvania

5.4

self-portrait. Although undoubtedly related to Duchamp's earlier interest in the metaphorical possibilities of biomechanical apparatuses, Picabia's appropriated object portraits, culled from illustrations in popular magazines and scientific journals, can also be seen as a continuation of Marius de Zayas' slightly earlier abstract caricatures and "psychotypes," in which scientific elements, such as mathematical equations, described the psychological character of the subject.

Picabia's linear object portraits were of great interest to the Stieglitz circle, which held caricature in high regard as an authentic art form. However, Picabia's caricatures were tinged with a satirical vein that was alien to the artists associated with Stieglitz' 291 Gallery. Their approach remained rooted in modernist ideas of abstraction, purity, and transcendence in the visual arts, as seen in de Zayas' characterization of these gendered machine portraits as a "striving toward objective truth."[28] Picabia, who constitutionally mistrusted notions such as truth and objectivity, saw these works instead as "pantomimes," whose antirational and antipatriotic message would become clearer as he developed his ideas.[29] Picabia's initial enthusiasm for machinery quickly evaporated as his subsequent paintings of rickety, magnetizing machines attest. This difference in approach is crucial to understanding New York Dada's skeptical attitude toward the machine and modern technology. The deployment to devastating effect of newly invented submarines, airplanes, and machine guns during World War I led these

artists to question the role of science and technology in modern society. This viewpoint differed radically from that of the Stieglitz circle, where artists such as de Zayas and Arthur Dove believed that the American industrial environment provided an appropriately indigenous subject matter that could inspire a legitimate American art, in line with Robert Coady's plea in his magazine *The Soil* for American artists to discover an authentic national expression in the products of American engineering, sports, and entertainment.[30]

In his subsequent paintings Picabia developed his signature mechanomorphic style, in which individual machines, often seen in cross section, can be read as metaphors for his alienated situation during the war years, when he suffered from drug-induced neurasthenia. In works such as *Révérence* (Reverence) **[277]**, and *Machine sans nom* (Machine with No Name) **[275]**, both painted in 1915, Picabia presented his precisely rendered, rigidly frontal and symmetrical machine forms against a monochrome background of contrasting color. These machines would become increasingly preposterous and destabilized in the paintings that followed, in which the artist devised amorous scenarios akin to the erotic proceedings of Duchamp's *Large Glass*.

When Picabia's machine paintings were first shown at the Modern Gallery, New York, in January 1916, they proved to be a revelation for American artists such as Morton Schamberg, who shared the European artist's distrust of the nationalist agenda being proselytized by Coady and de Zayas.

NEW YORK

Although his work changed significantly in response to Duchamp and Picabia's machine imagery, it should be pointed out that Schamberg had considered making paintings of modern mechanical appliances since 1912 and had completed a painting of a telephone by 1915.[31] Schamberg's subsequent work utilized the iconic, symmetrical format of Picabia's *Machine with No Name* and *Reverence* and Duchamp's *Chocolate Grinder* compositions, to respond to the new forms of machinery that were transforming the American industrial landscape. The artist's *Mechanical Abstraction* [310] and *Untitled (Mechanical Abstraction)* [311]—two of a series of nine exquisitely crafted images of single machines that he painted in 1916—outwardly reveal Schamberg's appreciation of the formal beauty of machinery and industrial manufacturing, while also underscoring his knowledge of the work of the displaced European avant-garde.[32] Walter Pach, in his review of the painter's memorial exhibition, held in 1919 at the Knoedler Gallery, New York, claimed that Schamberg had appreciated the work done by "some of the Frenchmen, notably Duchamp," who used subjects related to mechanical engineering and machinery. But Schamberg, he noted, "did not follow them, however, until by a chance, he was led by circumstances outside of his painting to consider the beauty which the makers of machines lent to their work. His incentive in painting themes drawn from the field of mechanics was therefore firsthand observation quite as much as the lead given by other men."[33] As William C. Agee has observed, Pach's narrative supplies further evidence to the Schamberg family tradition that the artist's paintings of telephones, a threading machine, a bookbinding wire stitcher, and other mechanical devices used in the textile and printing industries, were derived from machinery catalogues borrowed from his brother-in-law, who was a manufacturer of ladies' cotton stockings.[34]

Schamberg's work has traditionally been viewed as a purely formal distillation of machine elements that is proto-precisionist in its meticulous craftsmanship. Seemingly devoid of the sexual connotations and cryptic humor of Duchamp and Picabia's diagrammatic imagery, the artist's precisely rendered machine paintings are often seen as reflecting, without any trace of irony or criticism, the myth promoted by American industrial capitalism of technological progress as a new form of manifest destiny. This argument runs counter to Schamberg's left-wing political views, and I find it hard to reconcile his isolated, immobile, and defunctionalized machines (which caused one family member to blurt out, "the goddam thing wouldn't work")[35] with

the "spirit of rationalism and optimism" that has been assigned them.[36] It should be remembered that these paintings were made during World War I, which took a heavy emotional toll on the artist who was vehemently opposed to the conflict, at a time when he was exposed to the work and ideas of other New York Dada practitioners at the Arensberg salon. Unfortunately, Schamberg died tragically at the age of 37, a victim of the 1918 Spanish influenza pandemic, so we will never know his true intentions in creating these austere machinist paintings.

Like many artists in the New York Dada group, American John Covert remained committed to the medium of oil painting, despite Duchamp's increasingly acerbic attacks on its legitimacy. Nonetheless, Duchamp greatly admired Covert's work, later declaring him to have been "an outstanding figure from the beginning" who had found his personal expression in the form of "a combination of painting and sculpture, reliefs made of superimposed planes."[37] As Walter Arensberg's first cousin, Covert had direct access to Duchamp's paintings on the walls of the West 67th Street apartment and had long admired the French artist's innate ability to give visual form to mental concepts through the use of arcane imagery, makeshift materials, and disrupted surfaces. Unfortunately, Covert was prevented from developing these innovations in his own work until after the end of World War I, due to his service in the Division of Films of the Committee on Public Information (CPI), a censorship and propaganda organization initiated by President Wilson on 13 April 1917. In the artist's postwar works, such as *Vocalization* [307] and *Ex Act* [308], both made in 1919, Covert experimented with a coded visual language, informed by his interest in cryptography and the music and art analogies he had encountered during his student years in Munich, where Vasily Kandinsky was widely disseminating his ideas on synesthesia. That Covert affixed three-dimensional elements such as wooden dowels, string, nails, and upholstery tacks to enliven the surfaces of his paintings of the late 1910s can be seen as an extension of Duchamp's use of thread in *Chocolate Grinder no. 2* and lead wire to delineate the forms of the *Large Glass*. However, his use of photography and doll imagery in works such as *Water Babies* represents a unique contribution to New York Dada [309, fig. 5.4].

The distorted view of reality seen in *Water Babies* can be related to the artist's traumatic experiences during the first months of the war, when he was living in France. Covert presents us with a disturbing depiction of pathetic bodies

with useless, artificial limbs, whose fragmented forms are particularly exacerbated, through the optical laws of refraction, in the doll submerged in the half-full glass of water. Based on a photographic study, this disconcerting image brings to mind the paintings of mutilated and disfigured war veterans by the German artists Otto Dix and George Grosz, made shortly after the end of the war. It is this post-1918 German context that is so revealing, given Covert's German heritage and formal artistic training in Munich. The defeat of Germany, the colossal loss of life, and the return of shell-shocked and mutilated veterans inspired a generation of artists to explore images of dolls, mannequins, puppets, and automatons as metaphors for human dismemberment, psychological trauma, the crisis of faith and morality, and as a protest against society's acceptance of such suffering in the name of patriotism and glory.

Covert's experience of the war was recorded for posterity in an article he penned shortly after the conflict began, "The Real Smell of War," which appeared in the New York based magazine Trend in November 1914.[38] An undercurrent of fear and violence pervades his eyewitness report of mob rule in Paris, with French citizens wreaking vengeance on all things German and persons suspected of being German. For his part, the fair-haired Covert looked to be of German extraction. Moreover, having spent the preceding four years living in Munich, he spoke French with a heavy German inflection, making him all the more vulnerable to attack.[39] Unlike many of the other artists in the New York Dada circle, who experienced the conflict from the safety of American soil, Covert's profound understanding of the grim reality of modern warfare through his own experience of living in Paris and through the vivid accounts of soldiers who had seen the slaughter with their own eyes would leave its mark on his paintings and photographs of dismembered dolls and phantasmagoric toys.

Man Ray, who shared Duchamp's disdain for conventional oil painting, was probably the first American artist to respond to the iconography and implications of the Large Glass, as can be seen in his elaborate 1916 painting, The Rope Dancer Accompanies Herself with Her Shadows [286]. The artist assembled the composition from discarded scraps of cut papers that brought to mind the shadows cast by a precariously balanced tightrope dancer, whom he had seen in a vaudeville act the night before.[40] Although executed entirely in oil paint, the use of variously colored sheets of paper to determine the arrangement of the shadows cast by the crystalline tightrope walker under the bright footlights ultimately relates to Duchamp's use of aleatory methods in the 3 Standard Stoppages and the Large Glass.

Man Ray's 1917 assemblage Boardwalk [296] reflects the efforts of the New York Dada group to place the emphasis on the cerebral possibilities of painting. The title is a playful pun on the wooden promenades that run along the beachfronts of American tourist resorts, which Man Ray has conflated with the idea of traversing an irregularly shaped chessboard. This humorous title is typical of New York Dada's ability to introduce multiple meanings into works of art through wordplay, especially puns and nonsensical or cryptographic phrases, without privileging any single interpretation over another. The use of found objects and unconventional materials to enliven the flat surface of the painting was another important strategy employed by these artists, whose work often blurred the boundary between reality and illusionism. The thick plywood support, whose weather-beaten surface does indeed resemble that of a boardwalk plank, combines elements from the real world, in this case the circular furniture knobs and lengths of cord that seem to map out an imaginary chess position, with the painted geometric patterning of the checkerboard.

As if to test the viewer's ability to discern between reality and representation, Man Ray deliberately juxtaposed the painted sample of tweed fabric in the upper right-hand corner, rendered in a convincing trompe l'oeil illusionism, with the rectangular piece of paper he pasted on underneath, whose veneer makes reference to Pablo Picasso and Georges Braque's earlier use of simulated wood-grained wallpaper (and its painted equivalent). The use of an elongated perspective system to delineate the chessboard references the cubist grid, although this pictorial device is closer in spirit to the tradition of anamorphic painting, in which seemingly scrambled objects coalesce into recognizable images when they are viewed from an oblique angle. It is only when the work is seen from below, at eye level to the horizontal board, that the rectangles turn into the squares of a regular chessboard. This crucial shift in viewpoint can be understood as a metaphor for New York Dada's engagement with painting, whose established conventions would be extended, overturned, and finally replaced for the most part by film and photography, all in the matter of a few years. The end result is a complex, witty, and provocative work of art, whose meaning is conveyed on a number of levels while retaining some vestiges of the visual syntax of cubism. As the group forged its own artistic identity, these cubist effects would eventually be discarded.

THE READYMADE EFFECT

The work produced by the New York dadaists was informed by the ideas and activities of the European Dada groups, which they learned about through magazines and personal correspondence in a reciprocal and collaborative trans-Atlantic exchange. The first Dada publication to be circulated among the New York Dada group was almost certainly Tristan Tzara's *La première Aventure céléste de Mr Antipyrine (The First Celestial Adventure of Mr. Antipyrine)* **[6]**, which the Romanian poet and impresario of Dada sent to Duchamp in late 1916 or early 1917.[41] Illustrated with colored woodcuts by Marcel Janco, this booklet, published in Zurich in July 1916, included the first Dada manifesto, entitled "Le manifeste de M. Antipyrine." Tzara's short proclamation declared Dada to be decidedly against the war, as well as irrevocably opposed to all accepted ideas promoted by the "zoo" of art and literature, whose hallowed walls of tradition he wanted to adorn with multicolored shit:

> Dada is our intensity: it erects inconsequential bayonets and the Sumatral head of German babies; Dada is life with neither bedroom slippers nor parallels....DADA doesn't exist for anyone, and we want everyone to understand this. This is Dada's balcony, I assure you. From there you can hear all the military marches, and come down cleaving the air like a seraph landing in a public bath to piss and understand the parable.[42]

How this inflammatory tract, with its heady mixture of political, literary, and scatological references, was understood by the individual members of the Arensberg circle is hard to ascertain, although I would think it was the cumulative effect of reading one Dada magazine after another that must have imparted a gradual understanding of Dada's resolutely antiwar and antitraditionalist message.

The arrival of these Dada publications in New York may have informed Duchamp's decision to submit *Fountain* **[261]** to the Independents. As a Dada object designed to offend and discredit the organizers of the exhibition, the urinal needs to be distinguished from the other items Duchamp designated as readymades during this period, which included a snow shovel, a hat rack, and a metal dog comb **[253–259]** . Whereas these objects constituted an experiment with taste, conducted within the confines of the artist's studio, the urinal was explicitly chosen for its shock value and was intended for public rather than private consumption.[43] In later years, Duchamp was keen to emphasize that the choice of the urinal as a readymade came from the same experiment with taste, as the following excerpt from an interview with Otto Hahn attests: "Choose the object which has the least chance of being liked. A urinal—very few people think there is anything wonderful about a urinal. The danger to be avoided lies in aesthetic delectation."[44] Such a statement is ingeniously disingenuous, since the very idea of displaying a porcelain urinal in a public exhibition would have been considered the height of bad taste in 1917, the year the artist submitted *Fountain* to the Independents. Duchamp knew full well that a urinal has the least chance of being liked precisely because the artist has alluded to a hidden act in public, thus breaking one of society's strictest taboos.

There can be no doubt that Duchamp's subversive intent was to offend the moral standards of the society by entering a work that no public venue in 1917 could show, thus revealing its claims for aesthetic democracy to be a sham. As the artist later explained, his entry "had to be scandalous—the idea of scandal was presided to the choice...we sent it [the urinal] to the Independents and the poor fellows couldn't sleep for three days."[45] The artist's submission of *Fountain* to the American Independents and his invisible role in the subsequent scandal was thus a deliberately provocative Dada gesture, hatched in the spirit of the elaborate hoaxes and satirical humor that Duchamp so loved about the Parisian Indépendants.[46]

Despite many claims to the contrary, the readymades —and the intellectual ideas behind them—seem to have been too advanced, too cerebral, and perhaps even too shocking for American modernists to respond to. As the readymades proliferated around 1916–17, their presence in Duchamp's atelier created a disorienting environment of their own that must have unnerved visitors to 33 West 67th Street, where the artist occupied a small studio that was linked to the Arensbergs' apartment by a short hallway (where he worked rent-free in return for giving his patrons eventual ownership of the *Large Glass*). Snapshots of the artist's cluttered studio on the third floor of the Arensberg apartment building taken during this period **[fig. 5.5]** reveal that the readymades disrupted the space through their unconventional configuration. The *Porte-chapeaux (Hat Rack)* **[257]** and a snow shovel (*In Advance of the Broken Arm,* **[255]**) were hung from the ceiling; *Trébuchet (Trap)* **[256]**— a coat rack—was nailed to the floor by Duchamp in a fit of exasperation, after he had continually tripped over it; while the porcelain urinal, christened *Fountain* by Duchamp, was suspended from the lintel of an interior doorway. Friends of the artist who visited the studio were treated to

a discombobulating installation, where the boundaries between the readymades and the surrounding furniture and studio detritus were nonexistent, thus simultaneously challenging their physical surroundings as well as their preconceived notions about art.

Man Ray's mixed-media assemblages and found objects are often discussed in relation to the readymades, although the American artist's treatment of three-dimensional objects, which often reveals a compulsion for mimesis, is completely at odds with Duchamp's experiment with aesthetic indifference. The artist's 1917 sculpture *New York* is an example of Man Ray's poetic response to found objects and materials. The artist's homage to the architecture of his adopted city took the form of ten strips of wood of varying length, which were held together by a carpenter's C-clamp, in a configuration that resembles the sleek verticality and angular profile of the Woolworth Building and other vertiginous skyscrapers that had begun to dominate the Manhattan skyline. The artist's celebrated 1918 photographs of a phallic egg beater that he called *L'Homme* (Man) **[298]** and an assemblage of six clothespins and a metal light reflector entitled *La Femme* (Woman) **[299]** also need to be differentiated from Duchamp's concept of the readymade. While the fusion of sexual and mechanical elements is typical of New York Dada's approach to inanimate, mass-produced objects, Man Ray's cast shadows and dramatic lighting effects clearly take their

cue from Stieglitz' astonishing photograph of *Fountain* that was published in the second issue of *The Blind Man*, in which he transformed the gleaming men's room fixture into an anthropomorphic figure **[262]**.

The impact of the readymades is felt, however, on the dadaist assemblage *God* **[313]** of 1917, an enigmatic sculpture made by Morton Schamberg and the Baroness Elsa von Freytag-Loringhoven (née Else Hildegard Plötz). *God* consists of an upside-down, brass plumbing trap with brass and lead pipes, of the kind used in sinks to prevent the upward escape of noxious gases from a pipe in which water stands, which was removed from its functional setting and mounted on a wooden miter box. The delightfully sacrilegious title, which had already been used by Jean Crotti for a painting exhibited in New York in 1916, has obvious affiliations with the mocking irony of Dada, while the use of found materials outwardly suggests that the artists had understood the far-reaching ramifications of Duchamp's readymade gesture. Indeed, *God* was undoubtedly made in response to the editorial and photograph published in the May 1917 issue of *The Blind Man*, which attacked the puritanical decision by the Society of Independent Artists to censor *Fountain* on the grounds that it was a plain piece of plumbing, rather than a work of art: "As for plumbing, that is absurd. The only works of art America has given are her plumbing and her bridges."[47]

5.5 Marcel Duchamp's studio on 33 West 67th Street, New York, 1917–1918, gelatin silver print. Philadelphia Museum of Art, Marcel Duchamp Archive, Gift of Jacqueline, Peter and Paul Matisse in memory of their mother, Alexina Duchamp

There has been a great deal of speculation in recent years that the plumbing fixture assemblage may have been made exclusively by the Baroness, given its close visual relationship to other found-object assemblages that she made during this period.[48] However, recent technical analysis has revealed that the entire metal portion of the sculpture was painted silver, with a transparent resinous coating that has now aged to a brownish-rust color.[49] This silver metallic paint corresponds with the palette of Schamberg's machinist paintings of the time, thus confirming his active participation in the making of *God*. Indeed, Walter Arensberg,[50] Duchamp,[51] and the artist's surviving relatives all remembered Schamberg's role in the making of the piece, in which he was assisted by the Baroness who at that time was living in Philadelphia.[52]

The precise nature of this artistic collaboration is hard to discern. According to Schamberg's biographer, Ben Wolf, the assemblage came about through the artist's "inability to cope with a recalcitrant washbasin" in his Chestnut Street studio, which had been leaking water.[53] This account is supported by the Schamberg family legend that it was the Baroness who "took out" the plumbing trap, perhaps resolving the problem of the leaky sink once and for all by sawing through the pipes.[54] Given that the Baroness had made assemblages of found objects around this time, it has been assumed that it was her decision to select the piece as a readymade and attach it to the miter box, perhaps based on the false impression that her own works were mounted on similar wooden bases. However, it should be pointed out that objects such as *Limbswish* **[315]** were not displayed in this manner until the 1920s, when the Russian painter and set designer, Pavel Tchelitchew, and his partner, the pianist Allen Tanner, carefully mounted them on plain wooden blocks. My own hunch is that the original decision to saw through the pipes and remove this piece of household plumbing was made by the Baroness, while Schamberg's interest in the pictorial possibilities of industrial machinery may have led him to subsequently admire the graceful curves of the plumbing trap's convoluted pipes and thus consider the work as a sculptural equivalent of one of his paintings. The wooden miter box, which is of the kind used by carpenters to guide their saw blades, also accords with Schamberg's fascination for precision tools and may have been mounted by him when he photographed the piece in front of at least two of his machine paintings in 1917.

Schamberg's well-groomed, dandy-like appearance, as seen in photographs taken in the 1910s, belied his deep commitment to New York Dada and his leftist and pacifist views, which deeply upset his staunchly Republican family. As his niece, Jean Whitehill, later recalled, Schamberg particularly offended his conservative audience at a family meal during World War I by repeatedly asserting that the Germans were not villains.[55] This outburst needs to be seen within the context of the growing vilification of the Germans as barbaric "Huns" in Allied wartime propaganda, which began with the exaggerated reports of atrocities inflicted on the civilian population during the 1914 invasion of Belgium. This intensifying anti-German propaganda, which was bolstered by the German U-boat torpedoing of the British passenger liner *Lusitania* off the coast of Ireland on 7 May 1915, with the staggering loss of 1198 lives, including 128 Americans, was adopted by poster designers in the United States after America entered the conflict in April 1917. H. R. Hopps' *Destroy This Mad Brute* **[fig. 5.6]**, an old-fashioned, circus-style poster, is symptomatic of the way that artists depicted the German race as inherently violent and inhuman, which is taken to the extreme in this case, where the giant German gorilla strides across the Atlantic Ocean to threaten America with its "Kultur" (which takes the form of a bloody cudgel).

Schamberg, who was of German-Jewish extraction, would have been incensed at such mindless propaganda, which was designed to motivate young men to enlist in a war that he viewed as morally reprehensible. Schamberg's commitment to revolutionary causes, which has never been addressed in the literature on the artist, would eventually culminate in his deathbed decision to bequeath the proceeds from the sale of his machinist paintings to the Irish Republican Army, which was in rebellion against British rule.[56] Given Schamberg's openly expressed political views and his vehement opposition to World War I, it may well have been his decision to supply the assemblage with the sacrilegious title *God*, which has long been understood as a bitter antiwar and antireligious statement.

Schamberg's decision to photograph *God* **[312]** in front of one of his paintings from the series Mechanical Abstractions **[see 310, 311]** of 1916, thus emphasizing the sweeping curves of both works, clearly mimics Stieglitz' photograph **[262]** of *Fountain* in front of Marsden Hartley's *The Warriors* that was published in *The Blind Man*. The blurred nature of this reproduction would have made it unlikely that anyone viewing the photograph without prior knowledge of its carefully constructed composition would have been able to identify the Hartley painting in the background. This suggests that Schamberg was aware of Stieglitz'

deliberate juxtaposition of the urinal and Hartley's German officer painting. The visual rhymes apparent in his photograph of *God*, which is signed and dated 1917, similarly transcend the documentary purpose of such an image, perhaps suggesting that Schamberg and the Baroness were planning their own scandal in Philadelphia or New York, along the lines of *Fountain*. The fact that Schamberg obsessively photographed the sculpture, both in front of his own paintings and a sheet of silvered cardboard, also indicates that the artists were considering a public unveiling of the work, perhaps in the pages of a future issue of *The Blind Man*, whose first number had called for submissions on the front cover.[57]

The scandal provoked by the rejection of *Fountain* at the 1917 Independents exhibition helped to define the parameters of New York Dada's engagement with art and ideas, which can be generally described as open to all forms of artistic practice and opposed to World War I. Many members of the group held openly pacifist views and publicly criticized the misery and absurdity of modern trench warfare and its unbearable human costs. The mass-extermination seen on the battlefields of Europe had made it abundantly clear that the long conflict was being ruthlessly fought by depersonalized, mechanized armies, whose success depended on the sacrifice of the individual to the greater cause. This clash between outmoded tradition and machine-age modernity was understood to extend to the arena of

artistic practice, as Duchamp explained in one of his earliest interviews conducted in the United States:

> The war will produce a severe direct art. One readily understands this when one realizes the growing hardness of feeling in Europe, one might almost say the utter callousness with which people are learning to receive the news of the death of those nearest and dearest to them. Before the war the death of a son in a family was received with utter, abject woe, but today it is merely part of a huge universe of grief, which hardly seems to concern any one individual.[58]

This statement helps to explain why New York Dada maintained a group dynamic that remained resolutely open to all forms of styles and subject matter, as a way of preserving the notion of individuality, which was under constant threat from the type of society responsible for the thousands of deaths at Verdun.

The issue of creative freedom that was brought to the fore by the Independents' refusal to exhibit Duchamp's urinal accounts for the eclectic range of work produced by the artists associated with New York Dada. Thrust into the intensely creative atmosphere of the Arensberg salon were a diverse band of artists, whose number included such mavericks as the American visionary painter Louis-Michel Eilshemius and the irrepressible Baroness Elsa von Freytag-Loringhoven. The inclusion of legendary figures like Eilshemius and the Baroness also needs to be understood within the wider context of the crisis of modernism induced by Duchamp's challenge to avant-garde practice after 1912, through his dismantling of the artistic conventions associated with oil painting, which naturally led him to champion artists whose work was considered outside the mainstream of modern art as it was narrowly defined at the time. The active participation of these artists in New York Dada would have been unthinkable in the less-permissive European Dada centers, where Eilshemius' crudely painted romantic dreamscapes would have probably seemed retrogressive. But the artist's nudes [**fig. 5.7**], with their pronounced lack of studied anatomy and implicit eroticism, were genuinely admired by the practitioners of New York Dada, as witnessed by Duchamp's public declaration in 1919 that Eilshemius was his favorite living painter.[59]

The Baroness, a German émigré war widow, model, painter, sculptor, and poet, has been hailed recently as a pioneer of assemblage and performance art, whose found-object constructions and uninhibited behavior led Jane Heap

5.6 H. R. Hopps, *Destroy This Mad Brute*, c. 1917, poster. Hoover Institution Archives

290

title *New York 1920*, thus equating the burned safety matches, Hotel Brevoort matchbook, and other scorched detritus with the cultural wasteland of Manhattan. This radical image is deliberately juxtaposed with a second photograph featuring a section of a street map of Paris, where Man Ray hoped to find the creative freedom and artistic innovation that he felt was so lacking in New York. Between these images of New York and Paris he placed the printed words "trans atlantique," no doubt referring to the exchange of dadaist ideas and tactics between Europe and the United States around 1920 to 21. These maps are framed by a checkerboard pattern that the artist probably incorporated as a playful referent to his games of chess with Duchamp, as well as a metaphor for the comings and goings of the artistic and literary avant-garde between New York and Paris. Following the end of the First World War, these Atlantic crossings were made in record time by powerful ocean liners, for which "Transatlantique" was the popular term in the early 1920s. Indeed, one of these vessels, the S.S. *Savoie*, would take Man Ray to Paris in July 1921, where he would remain for the next nineteen years.

Another key work that illustrates New York Dada's increasing preoccupation with the use of mechanical apparatuses such as photography and film in their work was Duchamp's full-scale facsimile of the *Nude Descending a Staircase no. 2* **[fig. 5.9]**. The artist made the *Nude Descending a Staircase no. 3* **[252]** in 1916 for his patrons, Louise and Walter Arensberg, who had coveted the notorious painting since seeing it at the Armory Show three years earlier. Given that the original was now in the possession of Frederick C. Torrey, a San Francisco art and furniture dealer who did not want to part with it, Duchamp had a commercial photography

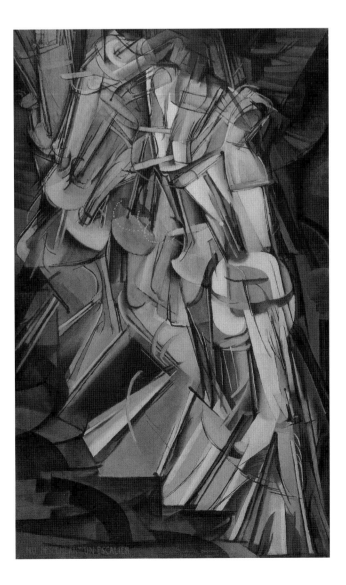

5.9 Marcel Duchamp, *Nu descendant un escalier* (Nude Descending a Staircase no. 2), 1912, oil on canvas. Philadelphia Museum of Art, The Louise and Walter Arensberg Collection, 1950

awaited works from the Dada Fair had still not arrived and were replaced by a selection by Sturm Gallery artists, leaving Schwitters as the only designated dadaist in the exhibition.

The lectures and symposia held at the Société Anonyme provided an active public forum for Dada in the early 1920s, while its well-stocked reference library disseminated Dada ideas by providing access to European magazines and periodicals. On the evening of 1 April 1921 a symposium on Dada was held in the galleries of the Société Anonyme, which was publicized in provocative advertisement cards that asked: "Do You Want to Know What a Dada Is?" The symposium began with Marsden Hartley's talk on "The Importance of Being Dada," in which the American painter presented a sophisticated analysis of Dada's ideology and aims. Although acknowledging the exhilarating nihilism of Dada, which he attributed to the writings of Friedrich Nietzsche, Hartley unequivocally embraced Dada's humor, freedom of individual choice, and its ability to "take away from art its pricelessness and make of it a new and engaging diversion, pastime, even dissipation."[69] Hartley's understanding of Dada's "joyous dogma" was opposed by Claire Dana Mumford, a painter, writer, and psychologist, who berated the "dreadful pictures" of the dadaists, which she claimed presented nothing new and, to prove her point, read long passages from the poetry of Algernon Charles Swinburne, whom she claimed was the original dadaist. Finally, Phyllis Ackerman, a professor of psychology at the University of California, summed up this Dada soirée with a discussion of the works of art on display in the galleries, which included paintings and works on paper by Schwitters, Paul Klee, and Heinrich Campendonk.[70]

ENTER RROSE SÉLAVY

Duchamp and Man Ray's *New York Dada* magazine also appeared in April 1921, perhaps suggesting that their publication was designed to coincide with the Dada symposium and the never realized exhibition of selected works from the Dada Fair. This German Dada context is important, since it reflects their efforts to reinvigorate New York Dada through their newfound understanding of the expanding European art movement. A crucial change that occurred during this second phase of New York Dada was the shift from painting to photography, photomontage, optics, and film. This can be partially explained by the artists' exposure to the work of Heartfield and other Berlin dadaists, either through magazines, or the descriptions of Dreier, who had experienced their work at first hand in the previous year. Duchamp had,

of course, played his part in the manifestation of Dada in Paris in 1919, and his understanding of Dada had greatly changed since the *Fountain* scandal.

The depersonalized, mechanical nature of these new media had great appeal to artists such as Duchamp and Man Ray, whose collaborative efforts reveal their common interest in questioning the postwar commodity culture in the United States. Informed by the seditious tactics of the European Dada groups, these artists managed to skillfully subvert the tropes of American advertising and technology for their own ends, creating the single-issue *New York Dada* magazine, and constructing a wickedly subversive alter ego, the lascivious Rrose Sélavy, to parody and expose the rampant commercialism that confronted them on a daily basis. American consumers were bombarded by advertising and marketing techniques that had reached new levels of sophistication by the early 1920s, but by manipulating the same technological advances used in the American mass media these artists were able to destabilize the optimistic message of mass-consumerism. The "Keep Smiling" logo of countless toothpaste ads had never seemed so sinister as when placed within the confines of their Dada magazine, where it reads more like an order, or a threat, than an invitation to happiness.

Whereas earlier magazines associated with the American dadaists had included reproductions of painting and sculpture, the eradication of such images from Man Ray and Duchamp's publication speaks to their insistence that in the postwar social and political context avant-garde painting and sculpture had lost their ability to engage with the dominant society and were thus deemed irrelevant and obsolete. Although other artists would continue to make paintings, by 1921 the use of surface accretions and foreign objects to disrupt the flatness of the two-dimensional canvas had become something of a cliché. Richard Boix's caricature [305] of the New York Dada coterie speaks to this fact, since it includes a cartoon version of a Dada painting, loosely based on a Braque still life that had appeared on the cover of the November 1915 issue of *291* magazine. The still life has been enlivened through the addition of extraneous elements, such as a three-dimensional detached foot, the word "GO," and the pointing hand from *Tu m'* [265]. Boix's illustration reveals the limitations of Dada's critique of painting, which was fast becoming a convention in itself.

Man Ray's *Trans atlantique* of 1921 [fig. 5.8] shows how photography reinvigorated the New York Dada group at this time. Man Ray's collage features an earlier Dada photograph of an upturned ashtray, for which he gave the sardonic

other major cities, including Berlin, Munich, and Cologne, which brought her into contact with German dadaists such as Max Ernst and Johannes Baargeld. Dreier is known to have visited the Gesellschaft der Künste (Society of Arts) exhibition in Cologne in October 1919, where Ernst and Baargeld were forced to show their controversial works in a separate gallery, which they labeled with the sign "DADA."[67] Dreier was thus among the first Americans to witness at first hand the work of the German dadaists, and shortly after her return to the United States in December she made arrangements with Ernst for an exhibition in New York based upon selections from the Cologne show. With this in mind, in the spring of 1920 she established the Société Anonyme, Inc., which she explicitly modeled on Herwarth Walden's Sturm Gallery in Berlin, with Duchamp serving as president, Man Ray as secretary, and herself as treasurer. It was Man Ray who came up with the name "Société Anonyme," a French term meaning incorporated, which superbly underscored New York Dada's efforts at self-erasure.

Although the overly zealous British army of occupation in Cologne eventually thwarted Dreier's efforts to bring over Dada works from the 1919 exhibition—by denying them an export license due to the scandalous nature of the works—her enthusiasm for German Dada continued after her return

to the United States. On a subsequent trip to Germany she made arrangements with George Grosz and John Heartfield to have selected works from the Erste Internationale Dada-Messe (First International Dada Fair) shipped over to New York in time for an exhibition at the Société Anonyme in February 1921. Once again, Dreier's efforts to exhibit works by European dadaists failed to materialize, since as she explained in a public lecture, the Société "never received them and...New York must again wait" for the opportunity to encounter German Dada.[68] The proposed Dada show was replaced by an exhibition of Alexander Archipenko's abstract sculpture and sculpto-paintings, thus denying American artists the chance to experience at first hand the work of Grosz, Heartfield, Raoul Hausmann, Johannes Baader, and other Berlin dadaists. In the end the only German dadaist that Dreier exhibited during the early years of the Société Anonyme was Kurt Schwitters, whose work she had seen in Berlin in 1920. The artist's *Merz* collages and paintings were shown in the fifth exhibition at the Société Anonyme in November–December 1920. Schwitters was also included in another group exhibition at the Société in March–April 1921, which coincided with the "What Is Dadaism?" symposium held on April Fool's Day. Although a flyer for this group show promised that "The Dadas have come to town!" the long-

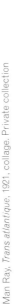

Man Ray, *Trans atlantique*, 1921, collage. Private collection

5.8

to designate her as the living embodiment of Dada in the early 1920s: "She is the only one living anywhere who dresses dada, loves dada, lives dada."[60] As Amelia Jones has argued, the Baroness' voracious sexual appetite, boundary-breaking street performances, outlandish costumes, and irrational behavior kept her on the margins of the Arensberg circle, whose bohemian atmosphere was not quite bohemian enough to handle her aggressive provocations.[61] Aside from her participation in the selection of *God* as an assisted readymade, the artist made several other assemblages during the New York Dada period, whose innovative use of found materials, often pinched from department stores, or picked up in the streets of lower Manhattan, more than justifies the recent resuscitation of the Baroness as an artist of central, rather than peripheral, importance to the New York Dada movement.

The Baroness' *Portrait of Marcel Duchamp* is an excellent case in point. This fantastic concoction, which survives today only in a photograph taken by Charles Sheeler around 1920 **[314]**, is made up of peacock feathers, a ring, a gear, a wound-up clock spring, wires, a fishing lure, and a host of other miscellaneous objects, all of which burst out of a wine glass. This arrangement, which both honors and ridicules its subject, reflects the Baroness' unrequited passion for Duchamp ("Marcel is the man I want"),[62] whose work she greatly admired, as opposed to his followers, whom she regarded as "*clever fakers — shitarses — prestidigitators.*"[63] The

portrait can be read as an attempt to capture the elusive nature of the artist, who at this time was constantly shifting his identity and appearance, perhaps best exemplified by his fabrication of the Rose (later Rrose) Sélavy alter ego in 1920. Indeed, the feathers are perhaps an allusion to the "Rose" who appears in Man Ray's photographs wearing a plumed hat, while the wine glass is almost certainly a reference to the artist's *Large Glass.*[64] The assemblage portrait reveals Duchamp's identity behind his fleeting mirage to be that of a magnificent bird of paradise. Having captured her prey by effectively transforming the artist into one of his own works, the Baroness presents the chimerical Duchamp like a trophy, which she in fact had intended to give to him as "Most Inventive Artist of the Year," but this presentation of Marcel in a glass might also be an antidote to the French artist's indifference to her sexual overtures.

As an extension of her practice of making elaborate assemblages incorporating found objects, the Baroness treated her body as an ever-changing work of art, which she covered in ornaments fashioned from urban detritus and commodities shoplifted from department stores **[see p. 274]**. *Limbswish* **[315]** is an example of how the Baroness' assemblages intersected with the adornment of her own body. The piece, which consists of a dangling, gold curtain tassel encased in a rusted metal spring, is thought to have swung from her hip. As the title suggests, it must have created a startling appendage to her body, swishing back and forth as she moved. The Baroness is known to have wandered the streets of Greenwich Village and Philadelphia wearing a French Poilu's blue trench helmet, affixed postage stamps to her face as a form of makeup, used two empty tin tomato cans fastened with green string as a bra, wore celluloid curtain rings as bracelets, and sported around her neck a birdcage with a live canary in it.[65] The helmet is an unmistakable reference to the hostilities in Europe, where her husband languished in a prisoner-of-war camp, having been captured by the French while attempting to return to Germany to fight in the war.[66] The French military headdress functions as an ironic reminder of the sudden twist of fate that had taken the Baron (and her life savings) away from her and plunged her into a destitute existence from which the helmet offered scant protection.

NEW YORK DADA AFTER THE WAR

The end of the war signaled a new phase of New York Dada, initiated by Katherine Dreier's crucial visit to Germany in 1919. While renewing contacts with her relatives in Bremen after the war, she actively sought out contemporary art in

5.7 Louis-Michel Eilshemius, *Rose-Marie Calling (Supplication)*, 1916, oil on board. Courtesy of Michael Werner Gallery, New York and Cologne

studio enlarge an existing image of the *Nude Descending a Staircase*, which had been widely reproduced in newspapers, magazines, and postcards since the opening of the Armory Show, to match the proportions of the original canvas. Although there has been a great deal of speculation in recent years that it might have been Man Ray or Charles Sheeler who made this enlargement, a label on the verso of the work reveals that the blown up, gelatin silver photograph was made at "Ye Little Photo Shoppe," located in the Hotel Chelsea Building on 228 West 23d Street, which specialized in "Developing, Printing and Enlarging" **[fig. 5.10]**.

The colossal photograph was then meticulously retouched by Duchamp, who used a wide variety of media, including pencil, ink, watercolor, crayon, and pastel, to crisply delineate the forms of the original composition, which had perhaps become faded or blurred during the enlargement

process. The painstaking operation of hand-coloring the entire photograph, after reinforcing the linear design through the use of rulers, compasses, and other technical instruments, offered Duchamp a unique opportunity to update the color scheme of the *Nude Descending a Staircase*, which had been painted in the muted, wood colors that were deemed appropriate for cubist compositions in 1912. The thin washes of cobalt blue, green, gray, and white used in the 1916 version give the work a metallic appearance that was more in keeping with New York Dada's embrace of the machine and the attempt to reconceptualize painting through impersonal and automatic forms of expression.

In compiling their *New York Dada* magazine, Duchamp and Man Ray modified the political and artistic strategies of their European Dada counterparts in order to address their own cultural needs. The inclusion of Man Ray's *Dadaphoto* **[301]**

5.10 Label on reverse of Marcel Duchamp's *Nude Descending a Staircase no. 3*, 1916, advertising "Ye Little Photo Shoppe." Philadelphia Museum of Art

is a good example of this realignment of European Dada practice. This work references photomontage in its superimposition of a photograph of a naked model standing behind a coat stand with a cartoonlike representation of a mannequin, complete with doll eyes and open mouth. This caricature of the female body as a sexually available automaton eroticizes Duchamp's readymade gesture, and Covert's earlier interest in dolls and children's toys, to reveal the sex underneath selling in American advertising. As such, it can be compared with Grosz and Heartfield's sculptural montage *Der wildgewordene Spiesser Heartfield* (The Middle-Class Philistine Heartfield Gone Wild) **[81]**, which was made in 1920, the same year that Man Ray created his dadaphoto. Both works present a mutilated victim as an object of display, whose truncated torso has to be propped up with the aid of an armature. Man Ray's compliant show-window mannequin is not a victim of warfare or political insurrection, but can be understood instead as a casualty of the sales techniques of fashion and magazine advertising campaigns, which demanded perfection and total acquiescence from its models, in order to sell the image of the female body as the embodiment of desire. The decision to include this photograph may have been the result of Man Ray and Duchamp's growing awareness of the technical innovations of the German dadaists, including photomontage, which permeate their own Dada publication. But there is a slippage here, perhaps resulting from the physical distance between Berlin and New York, for whereas Man Ray's use of multiple exposure is a true example of photomontage, technically speaking the Berlin dadaists used photocollage, in which separate photographs are cut and pieced together. However, the fetishistic nature of Man Ray's image perfectly complemented their efforts to expose the sales techniques of American advertising and the rapacious capitalism of the art market.

As the cover girl of *New York Dada* magazine, Rrose Sélavy also subverted the message of the new commodity culture through her gender ambiguity, lewd puns, and scurrilous behavior. Like a pair of advertising executives, Man Ray and Duchamp expertly marketed her international line of luggage tags, perfume bottles, and other leisure accessories, using carefully posed publicity photographs to construct an image of Rrose as a glamorous dame with obvious star quality. But Rrose was a transgendered travesty, and the increasingly elaborate readymades signed in her name came with "a complete line of whiskers and kicks" that undermined the increasing commercialization and false ideals of the art world. The cross-dressing Duchamp cleverly manipulated

the visual language and codes of the mass media to sell an image of a highly feminized female, who upon closer inspection is revealed to be a sham, the masquerade of an outrageous female impersonator, thus shedding doubt on the art market's claims for authenticity and objective truth. Rrose was a fly in the ointment, a "femme savante," who knowingly reflected back on a consumer culture its own desires, before rudely confronting them with the ambiguous message of the prostitute, whose promise of pleasure comes at a price.

New York Dada effectively came to an end in the summer of 1921, when Man Ray and Duchamp departed for Paris, where they would later be joined by the Baroness. The exodus of these artists to Europe coincided with Louise and Walter Arensberg's move to California, leaving no means of support for artists such as Covert, who was forced to take a position as a traveling salesman in his family's crucible company, thus severely limiting the time he could devote to making art. It was shortly after his arrival in Paris that Man Ray discovered the Rayograph, which allowed him to work directly with light itself, thus finally freeing him "from the sticky medium of paint."[71] This disavowal of oil painting's conventions, which had suppressed intellectual content in favor of sloppy virtuosity, had been the central concern of New York Dada from the start and can be seen as a metaphor for the personal liberation that these artists sought and seldom obtained. Dada offered a remedy for their shattered nerves, a universal panacea that "would protect against certain maladies, against life's multiple troubles," as Duchamp explained in a letter to Tzara, in which he proposed a financial venture in which the word "Dada" be marketed internationally as an insignia cast in silver, gold, and platinum, to "be worn as a bracelet, badge, cuff links, or tie pin."[72] Although this humorous spoof on Dada as a brand-name product was never realized, the implication was that these items would have allowed kindred spirits to recognize each other without recrimination, thus highlighting the underground nature of the New York Dada group, whose political edge I have located in their shared German identity, which was threatened by the flag-waving jingoism of the time. Their opposition to wartime propaganda and peacetime consumerism placed these artists at the margins of a society that distrusted their insistence on absolute freedom and individuality, while at the same time providing them with the necessary conditions in which to create their endlessly compelling works of art, whose antipatriotic and antirationalist Dada message is only just beginning to be heard.

1 This study of New York Dada is indebted to Francis Naumann's extensive research on the lives and artworks of the participants involved, which has laid the groundwork for all future scholarship on the group. See Naumann, *New York Dada 1915–23* (New York, 1994).

2 For a detailed analysis of the history and reception of Duchamp's *Fountain*, see William A. Camfield, *Marcel Duchamp: Fountain* [exh. cat., The Menil Collection] (Houston, 1989).

3 Thierry de Duve has persuasively argued for the importance of German secessionism for Duchamp's self-invention in Munich in 1912, where he began to formulate his critique of painting. See de Duve, *Pictorial Nominalism: On Marcel Duchamp's Passage from Painting to the Readymade*, trans. Dana Polan (Minneapolis, 1991).

4 For more on Covert's experiences in Germany and their impact on his subsequent Dada work see Michael R. Taylor, "From Munich to Modernism: John Covert, New York Dada, and the Real Smell of War," in Leo G. Mazow, ed., *John Covert Rediscovered* [exh. cat., Palmer Museum of Art] (State College, Pa., 2003), 22–33.

5 Gabrielle Buffet-Picabia, "Some Memories of Pre-Dada: Picabia and Duchamp," in Robert Motherwell, ed., *The Dada Painters and Poets: An Anthology* (New York, 1951), 260.

6 Buffet-Picabia, "Some Memories of Pre-Dada," 259.

7 For a spirited attempt to re-create the atmosphere and goings-on of the Arensberg salon, see Naomi Sawelson-Gorse, "sex, alcohol, soufflés, with chess, accompanied by music" in Martin Ignatius Gaughan, ed., *Dada New York: New World for Old* (Farmington Hills, 2003), 78–111.

8 Margery Rex, "'Dada' Will Get You if You Don't Watch Out; It Is on the Way Here," *New York Evening Journal* (January 29, 1921), n.p.

9 There are numerous, often conflicting accounts of Cravan's lecture on "The Independent Artists in France and America," which took place at the Grand Central Palace on May 24, 1917. For a lively memoir of Cravan's drunken antics see Gabrielle Buffet-Picabia, "Arthur Cravan and American Dada," in Motherwell, *The Dada Painters and Poets*, 16.

10 Calvin Tomkins, *Duchamp: A Biography* (New York, 1996), 193. On the night of January 23, 1917, Duchamp and six other friends illegally entered the side door of the Washington Square Arch and gained access to the roof, where they held a picnic and produced a quasi-legal document that proclaimed "the secession of Greenwich Village from the America of big business and small minds." Although usually dismissed as harmless pranks, the Dada activities of Duchamp and his cohorts during this period often have a political dimension, related to their opposition to World War I, as seen in this parody of military invasion and revolutionary insurrection.

11 The crisis of masculinity was the subject of Nancy Ring's doctoral dissertation, *New York Dada and the Crisis of Masculinity: Man Ray, Francis Picabia, and Marcel Duchamp in the United States, 1913–1921*, PhD diss. Northwestern University, 1991. The effect of World War I on the New York Dada circle has also been the subject of a recent book by Amelia Jones, which offers fascinating insights into the radical destabilization of Euro-American masculinity during the war years. See Amelia Jones, *Irrational Modernism: A Neurasthenic History of New York Dada* (Cambridge, Mass., 2004).

12 Duchamp expressed his pacifist views in one of his earliest newspaper interviews in New York: "The instinct which sends men marching out to cut down other men is an instinct worthy of careful scrutiny. What an absurd thing such a conception of patriotism is! Fundamentally all people are alike. Personally I must say I admire the attitude of combating invasion with folded arms." See Anonymous, "French Artists Spur on an American Art," *New York Tribune* (October 24, 1915), section 4, 3.

13 Herbert (sic) Crehan, "Dada," *Evidence* (Toronto), no. 3 (fall, 1961), 36. This interview between Duchamp and the art critic, Hubert Crehan, took place in New York in 1960 and was broadcast on WBAI-FM radio.

14 Albert Gleizes and Jean Metzinger, both members of the hanging committee of the Salon's cubist room, rejected the work on the grounds that it had "too much of a literary title, in the bad sense—in a caricatural way. A nude never descends the stairs—a nude reclines." See Jacques Caumont and Jennifer Gough-Cooper, "Ephemerides on and about Marcel Duchamp and Rrose Sélavy, 1887–1968," in *Marcel Duchamp* [exh. cat., Palazzo Grassi, Venice] (Milan, 1993), n.p. (entry for March 18, 1912).

15 Anonymous, "A Complete Reversal of Art Opinions by Marcel Duchamp, Iconoclast," *Arts and Decoration* 5 (September 1915), 427.

16 William Seitz, "What's Happened to Art? An Interview with Marcel Duchamp on Present Consequences of New York's 1913 Armory Show," *Vogue*, New York, 141, no. 4 (February 15, 1963), 113.

17 James Johnson Sweeney, interview with Marcel Duchamp, February 23, 1945, in Sweeney, "Eleven Europeans in America," *Museum of Modern Art Bulletin* 13, nos. 4–5 (1946), 20–21.

18 Pierre Cabanne, *Dialogues with Marcel Duchamp*, trans. Ron Padgett (New York, 1971), 39.

19 Duchamp explained to James Johnson Sweeney that he asked the sign painter to do the hand as an extension of his ideas on the readymades, since there is "something to a professional sign painter which you cannot imitate yourself. You can see it from the painting —even from the photograph. He did it in five minutes. It was wonderful." Unpublished interview with Marcel Duchamp, July 12, 1945, Philadelphia Museum of Art, Alexina and Marcel Duchamp Papers, reprinted with the permission of the Estate of James Johnson Sweeney, © Estate of James Johnson Sweeney.

20 Duchamp in Sweeney, "Eleven Europeans in America," 20.

21 Anonymous, "Sometimes We Dread the Future," *Every Week* (April 2, 1917), 14.

22 This photograph was almost certainly taken around April 1916, since the artist is posed in front of Jacques Villon's *Portrait of Mr. J.B., painter*, a work that was shown in the *Exhibition of Modern Art* held at the Bourgeois Gallery in that month. Given that Duchamp completed *Chocolate Grinder no. 2* in Paris in 1914, this masquerade was a curious self-projection for the artist, perhaps reflecting his growing realization of the importance of this painting in the development of his ideas.

23 Duchamp dropped three sewing threads from a height of one meter and then fixed them to strips of canvas with varnish, thus preserving the curvilinear pattern in which they fell. The artist called the set of measuring devices that resulted from this experiment the "meter diminished," whose trio of arbitrary lengths destabilized the very premise of a single unit of measurement.

24 Man Ray, *Self Portrait* (Boston, 1963), 73.

25 Francis Picabia claimed that it was Juliette Roche, the wife of Albert Gleizes, who came up with this nickname. See Pharamousse (Picabia), "Odeus de Partent," *391*, no.1 (Barcelona) (January 25, 1917), 4.

26 Nixola Greeley-Smith, "Cubist Depicts Love in Brass and Glass; More Art in Rubbers Than in Pretty Girl!" *The Evening World* (April 4, 1916), 3.

27 Anonymous, "French Artists Spur on an American Art," 2.

28 Marius de Zayas, untitled essay, *291*, nos. 5–6 (July–August 1915), n. p.

29 Francis Picabia, Statement, *291*, no. 12 (February 1916), n.p.

30 For an excellent discussion of Coady's ideas for a specifically American contribution to modern art, see Judith Zilczer, "Robert J. Coady: Man of *The Soil*," in Rudolf E. Kuenzli, ed., *New York Dada* (New York, 1986), 31–43.

31 Constance Rourke reported that around 1912 Schamberg had "talked constantly about pictures he was going to paint in which mechanical objects were to be a major subject, describing them in detail down to the last line and nuance of color." See Rourke, *Charles Sheeler: Artist in the American Tradition* (New York, 1938), 37. The artist had exhibited his painting entitled *Telephone* at the Montross Gallery, New York, in March–April 1915, shortly before Picabia and Duchamp arrived in the United States.

32 When Schamberg exhibited five of his machine paintings in a group show at the Bourgeois Gallery, New York, in April 1916, a critic noted: "Picabia has a doughty follower in the mechanical drawing allegories of Morton L. Schamberg." See Anonymous, "Exhibition Now On," with review of "More Moderns at Bourgeois," *American Art News* 14, no. 27 (April 8, 1916), 3. I am intrigued by this reference to Schamberg's work as allegorical, which suggests that his paintings may have had intended meanings that went beyond his appreciation of the formal beauty of modern industrial machinery.

33 Walter Pach, "The Schamberg Exhibition," *The Dial* 66 (May 17, 1919), 595.

34 For a detailed analysis of Schamberg's source material for the 1916 machine paintings and pastels, see William C. Agee, "Morton Livingston Schamberg: Notes on the Sources of the Machine Images," in Rudolf E. Kuenzli, ed., *New York Dada*, 66–80.

35 Ben Wolf, *Morton Livingston Schamberg* (Philadelphia, 1963), 30.

36 William C. Agee, *Morton Livingston Schamberg* [exh. cat., Salander-O'Reilly Galleries] (New York, 1982), 16. Agee's remark that "Schamberg's love of the formal beauty of the machine related his paintings more to Léger and purist tendencies than to Dada mockery and irony" is typical of the apolitical readings of the artist's work, which seek to retroactively subsume his paintings in later art movements such as precisionism and purism, of which he could have had no knowledge (see Wolf, *Morton Livingston, Schamberg*, 15). While I greatly admire Agee's unparalleled research on Schamberg's life and work, which builds upon the pioneering accounts of Henry McBride, Walter Pach, and

Charles Sheeler, I would like to entertain the possibility of alternative readings of the artist's Dada productions.

37 Marcel Duchamp, "John Covert," in *Collection of the Société Anonyme: Museum of Modern Art* (New Haven, 1950), 192.

38 John Covert, "The Real Smell of War: A Personal Narrative," *Trend*, no. 8 (November 1914): 204–210.

39 The article mentions one such assault that took place on the Boulevard St. Michel, when Covert was surrounded by an angry crowd that had seen him argue with a French cab driver over the price of a fare. A woman passing by heard his accent and screamed "Allemand!" before spitting at him, which forced the artist to run for his life. See Covert, "The Real Smell of War," 205.

40 Man Ray relates this anecdote in *Self Portrait*, 66–67.

41 When Pierre Cabanne asked Duchamp "When did you hear about Dada for the first time?" he replied, "In Tzara's book, *The First Celestial Adventure of Mr. Fire Extinguisher*. I think he sent it to us, to me or to Picabia, rather early, in 1917, I think, or at the end of 1916." See Cabanne, *Dialogues with Marcel Duchamp*, 55. In an earlier interview, Duchamp expressed his admiration for Tzara's booklet: "1917—I got Monsieur Antipyrine of Tzara to [*sic*] Arensberg. I was very much taken by it. It interested me very much." Unpublished interview with Marcel Duchamp, August 5, 1945, Philadelphia Museum of Art, Alexina and Marcel Duchamp Papers, reprinted with the permission of the Estate of James Johnson Sweeney, © Estate of James Johnson Sweeney. "M. Antipyrine" has traditionally been translated as "Mr. Fire Extinguisher"; it also refers to the trade name of a powerful headache remedy, widely available in France and Switzerland, which Tzara may have taken to cure the severe headaches that plagued him at this time.

42 Tristan Tzara, "Manifeste de M. Antipyrine," 1916, reprinted in Tzara, *Seven Dada Manifestos and Lampisteries*, trans. Barbara Wright (London, 1977), 1.

43 In the spring of 1916 Walter Arensberg recorded some of Duchamp's remarks on the question of taste, which offer fascinating insights into the artist's conception of the readymade: "Marcel dislikes the element of *taste*—gout [*sic*]—in the writings of [Guillaume Apollinaire, Gertrude Stein, and Max Jacob]—also in work of Picasso... Gertrude Stein + the Steins are *people of taste*. Even when their taste is bad. Marcel spoke of the bibelots on their mantel pieces—objects d'art which they have picked up in Italy etc etc etc and handle and love." See Molly Nesbit and Naomi Sawelson-Gorse,

"Concept of Nothing: New Notes by Marcel Duchamp and Walter Arensberg," in Mignon Nixon and Martha Buskirk, eds., *The Duchamp Effect* (Cambridge, 1996), 156–157.

44 Otto Hahn, "G255300 (United States of America)," trans. Andrew Rabeneck, *Art and Artists* 1, no. 4 (July 1966), 10.

45 Harriet, Carroll, and Sidney Janis, unpublished interview with Marcel Duchamp, New York, winter–spring 1952–53, transcript, 6–7, reprinted with the kind permission of Carroll Janis.

46 As Jeffrey Weiss has persuasively argued, Duchamp's antidote to the naive self-delusion of the sober-minded Independents was inextricably rooted in the history and reception of the Parisian society. See Weiss, *The Popular Culture of Modern Art: Picasso, Duchamp, and Avant-Gardism* (New Haven, 1994), 160–163.

47 "The Richard Mutt Case," editorial in *The Blind Man*, no. 2 (May 1917), 5.

48 Robert Reiss was the first scholar to publicly state that *God* may have been "the noncollaborative, unitary creation of the Baroness." See Reiss, "'My Baroness': Elsa von Freytag-Loringhoven," *Dada/Surrealism*, no. 14 (1985), 88. This statement was made at the suggestion of Francis Naumann, who later wrote that the Baroness "probably came up with the idea of combining the extraneous elements in this sculpture, as well as of assigning the unusual title." See Naumann, *New York Dada 1915–23*, 128.

49 I would like to thank Melissa S. Meighan, conservator of decorative arts and sculpture at the Philadelphia Museum of Art, for her technical examination of *God*, which revealed the presence of the silver-colored flake paint and the resin coating, which was almost certainly applied by Schamberg and not as part of the original use.

50 Walter Arensberg amended a checklist of works from his collection, prepared for California Use Tax purposes, by adding the following sentence: "God. This construction was made by both Schamberg and Von Loringshofen [*sic*]," Philadelphia Museum of Art, Arensberg Archives, series II, subseries C, box 30, folder 25, p. 8.

51 In a BBC radio interview with George Heard Hamilton, Duchamp made reference to "an American boy whose name was Schamberg, who died very young. You know, he disappeared. He even made some readymades. One of them [*God*] is in my room in the Arensberg Collection in Philadelphia." This interview, which took place in New York on January 19, 1959, was later published as "Mr. Duchamp, if you'd only known Jeff Koons was

coming," *The Art Newspaper*, no. 15 (February 1992), 13.

52 The presence of the Baroness in Philadelphia in the spring of 1917 was confirmed by George Biddle, who hired her as a model shortly before he enlisted in Officers' Training Camp. See Biddle, *An American Artist's Story* (Boston, 1939), 137.

53 Wolf, *Morton Livingston Schamberg*, 33.

54 In a letter to the editor, published in the April 18, 1990, issue of the *Philadelphia Inquirer*, Mrs. R. Schamberg mentioned that "the Morton Livingston Schamberg sculpture *God*, which is in (the) Arensberg Collection, is nothing more than an upside [*sic*] plumbing trap that the Baroness Elsa von Freytag-Loringhoven took out of a vacant house on Chestnut Street in the early 1900s. (Schamberg is one of my distantly related-in-laws)."

55 Jean Loeb Whitehill, interview with Toni Mergentime, March 27, 1963, in Mergentime, *Morton Livingston Schamberg: First Comprehensive Study*, unpublished manuscript, 5. Ben Wolf has also confirmed the artist's frustrations about World War I: "He was appalled by mass killing. He saw no justification for it, no matter which side did the killing. He could not subscribe to a black and white world, peopled solely by villains and heroes. He made pro-German statements publicly." See Wolf, *Morton Livingston Schamberg*, 26.

56 The artist's close friend, Charles Sheeler, informed the Schamberg family shortly after his sudden death on October 13, 1918, that Schamberg wanted his paintings sold and the proceeds given to the Irish Republican Army. However, the family refused to comply with his wishes and they and Sheeler consequently became estranged. This information is supplied in an unpublished interview given by Jean Loeb Whitehill to Virginia Zabriskie in the early 1960s, which is recorded in Toni Mergentime's study of Schamberg (p. 10, see note 55). The I.R.A., a militant nationalist organization devoted to a united Ireland, was organized by Michael Collins from remnants of rebel units dispersed after the Easter Rebellion of 1916. Schamberg was probably drawn to the I.R.A. cause through the Irish poet and playwright, Padraic Colum, who regularly attended the Arensberg salon. As a former member of the I.R.A., Colum would have informed his American friends of the organization's pro-German agitation during World War I, as part of their violent campaign against British rule.

57 The front cover of *The Blind Man* contained the following statement: "The

second number of *The Blind Man* will appear as soon as YOU have sent sufficient material for it," followed by the mailing address, which was the 33 West 67th Street apartment of the Arensbergs. The second issue did not call for submissions.

58 Anonymous, "The Nude-Descending-a-Staircase Man Surveys Us," *New York Tribune*, Special Feature Section (September 12, 1915), 2.

59 Duchamp wrote the name "Louis Eilshemius" in response to a questionnaire, entitled "Confidences," which asked: "Quels sont vos peintres préférés?" This questionnaire, which was circulated among modern artists living in Paris in 1919, including Picabia, Gleizes, and Metzinger, was published in Curnonsky, *Huit peintres, deux sculpteurs, et un musicien très modernes* (Paris, 1919), 6.

60 J[ane] H[eap], "Dada," *The Little Review* VIII, no. 2 (Spring 1922), 46.

61 Amelia Jones, "'Women' in Dada: Elsa, Rrose, and Charlie," in Naomi Sawelson-Gorse, ed., *Women in Dada: Essays on Sex, Gender, and Identity* (Cambridge, Mass., 1998), 156.

62 Elsa von Freytag-Loringhoven, quoted in Naumann, *New York Dada 1915–23*, 172.

63 Elsa von Freytag-Loringhoven, letter to Jane Heap (173). The Baroness may have had Joseph Stella in mind when she made this statement, since his 1916 painting *Prestidigitator* **[306]**, made in oil and lead wire on glass, was clearly indebted to Duchamp's then unfinished *Large Glass*.

64 In her poem "Love-Chemical Relationship," which she dedicated to Duchamp, the Baroness again conjured up the artist's *Large Glass* in the line: "Everything now is glass—motionless!" The idea of pinning down the ever-moving Duchamp is expressed again later in the poem when she writes: "Thou now livest motionless in a mirror!/Everything is a mirage in thee—thine world is glass—glassy!" This poem was published in *The Little Review* VI, no. 2 (June 1918), 58–59.

65 This list of the Baroness' accoutrements is based on George Biddle's memory of her appearance in 1917, when she first visited his studio in Philadelphia. See Biddle, *An American Artist's Story*, 137, as well as the description provided by Allen Churchill in *The Improper Bohemians: A Re-creation of Greenwich Village in Its Heyday* (New York, 1959), 169. The Baroness was wearing the French trench helmet when she met the painter Louis Bouché at a subway station. See Bouché, "Autobiography," unpublished manuscript, Louis Bouché Papers, Archives of American Art, microfilm roll no.

688, frames 700–703.

66 The Baron would spend four years as a prisoner of war in Brest, before being interned in Switzerland at the war's end, where he would commit suicide on April 25, 1919, in St. Gallen. See Irene Gammel, *Baroness Elsa: Gender, Dada, and Everyday Modernity—A Cultural Biography* (Cambridge, Mass., 2002), 164.

67 Dreier's visit to the Cologne Dada exhibition is recounted in Max Ernst, "Notes pour une biographie," in Ernst, *Ecritures* (Paris, 1970), 38–39.

68 Katherine Dreier, "What Has Modern Art Contributed?" Yale Collection of American Literature, The Beinecke Rare Book and Manuscript Library, Yale University, Katherine S. Dreier Papers. This lecture was delivered at the Heterodoxy Club, New York, March 5, 1921, to coincide with an exhibition held there which included works by Schwitters and Georges Ribemont-Dessaignes.

69 Marsden Hartley, "The Importance of Being Dada," in Hartley, *Adventures in the Arts: Informal Chapters on Painters, Vaudeville, and Poets* (New York, 1921), 251.

70 An undated press clipping entitled "Notes and Activities in the Art World" described Dr. Ackerman's "profound and eloquent" discussion of the works on exhibit as "bringing the evening to a safe and sane conclusion." This article is preserved in the scrapbook of Katherine Dreier, Société Anonyme Archive, The Beinecke Rare Book and Manuscript Library, Yale University, New Haven.

71 Man Ray, letter to Ferdinand Howald, April 5, 1922, University Libraries, Ohio State University, Columbus, Ohio.

72 Duchamp, undated letter to Tristan Tzara, Bibliothèque Littéraire Jacques Doucet, Paris.

NEW YORK

PLATES

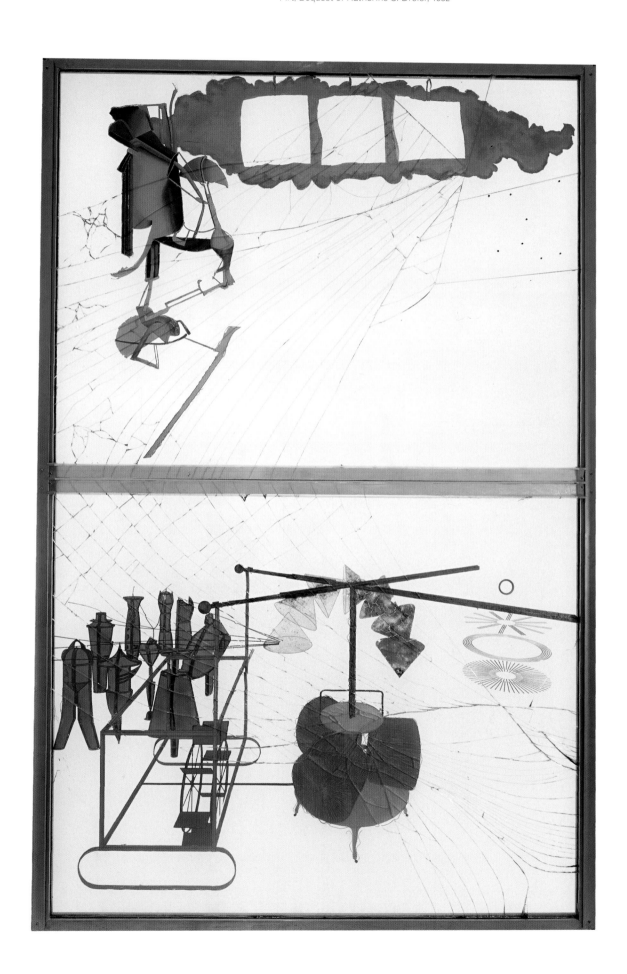

249 **MARCEL DUCHAMP** and **MAN RAY** *Elevage de poussière*
(Dust Breeding), 1920, gelatin silver print, 7.2 × 11 (2 ¹³⁄₁₆ × 4 ⁵⁄₁₆).
The Bluff Collection

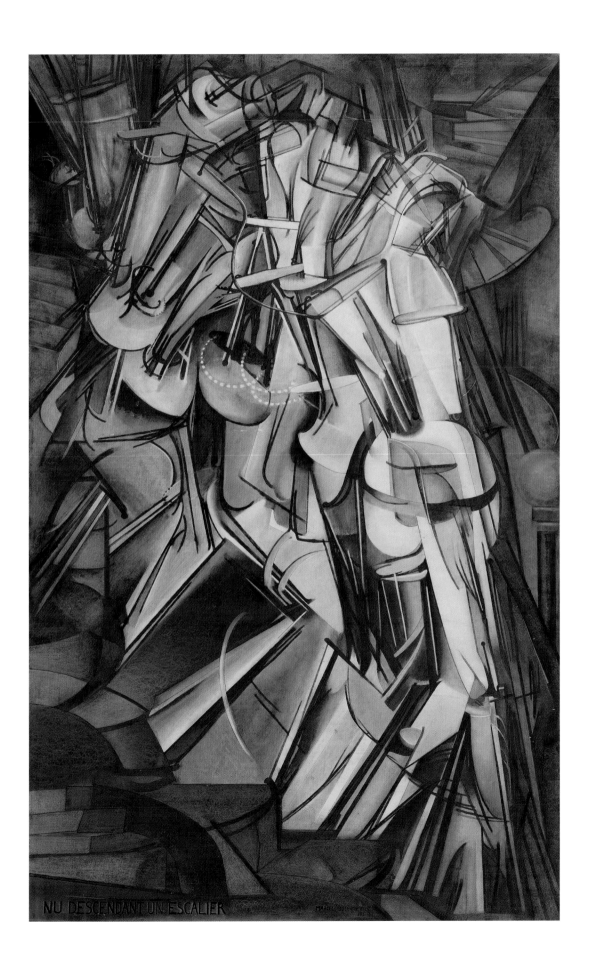

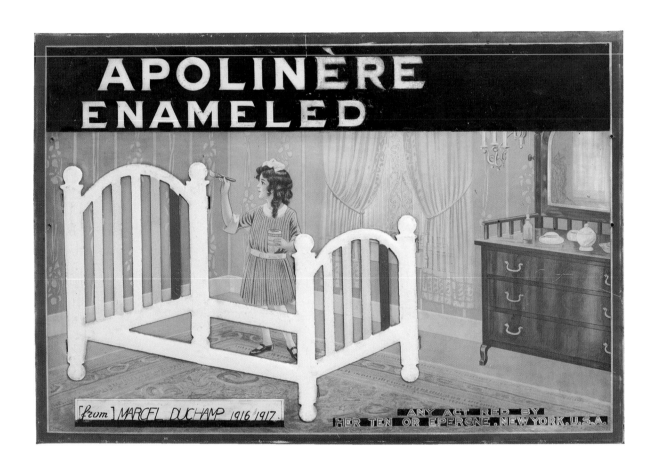

261 MARCEL DUCHAMP *Fountain*, 1964 (fifth version, after lost original of 1917), assisted readymade: porcelain urinal turned on its back. 36 × 48 × 61 (14 3/16 × 18 7/8 × 24). Mugrabi Collection, Courtesy Gagosian Gallery

262 ALFRED STIEGLITZ *Fountain*, photograph of sculpture by Marcel Duchamp, 1917, gelatin silver print, 23.5 × 17.8 (9 1/4 × 7). Succession Marcel Duchamp, Villiers-sous-Grez, France

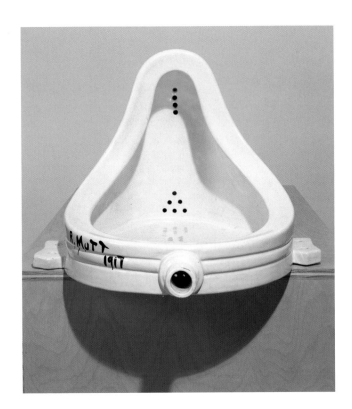

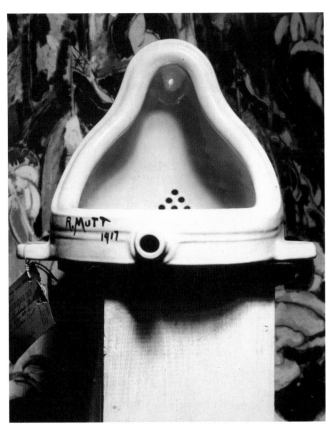

263 MARCEL DUCHAMP Cover and spread from the magazine
The Blind Man, no. 2, Beatrice Wood editor and publisher in association
with Marcel Duchamp and Henri-Pierre Roché, May 1917, cover: 27.9 × 20.3
(11 × 8). Centre Pompidou, Musée national d'art moderne-Centre de
création industrielle/Bibliothèque Kandinsky, Centre de documentation
et de recherche, Paris

264 MARCEL DUCHAMP Cover of the magazine *Rongwrong*, unique
issue, Marcel Duchamp, Henri-Pierre Roché, and Beatrice Wood editors
and publishers, July 1917, 28.1 × 30.3 (11 ⅟₁₆ × 8). Centre Pompidou, Musée
national d'art moderne-Centre de création industrielle/Bibliothèque
Kandinsky, Centre de documentation et de recherche, Paris

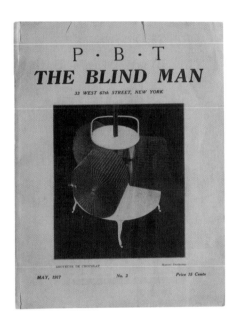

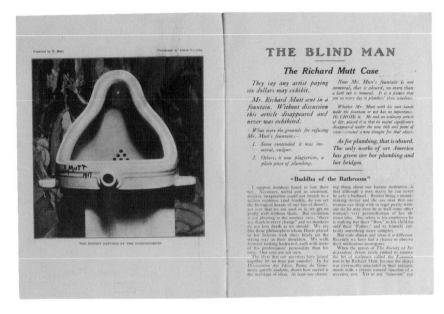

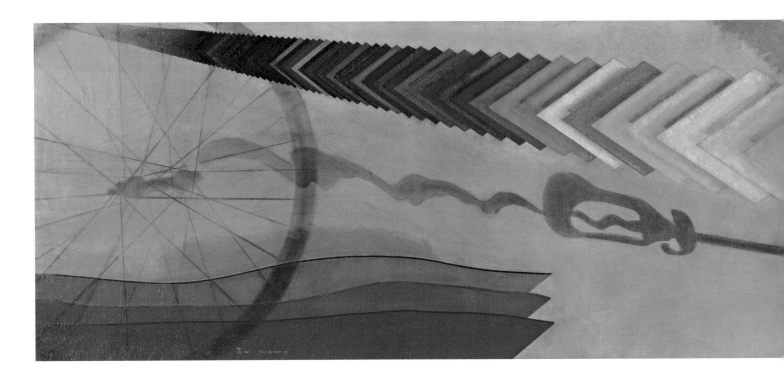

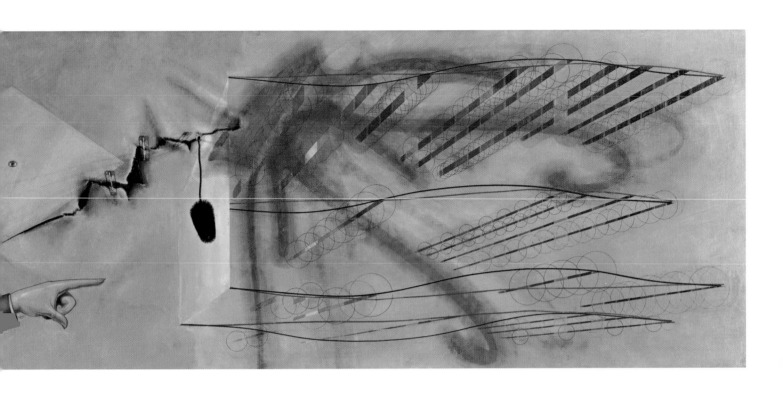

266 **MARCEL DUCHAMP** *Rotative Plaques verre (Optique de précision)*
(Rotary Glass Plates [Precision Optics]), 1979 (second replica, based
on the 1920 original), motorized optical device: painted plexiglass plates
on metal axle, motor, and metal and wood stand, 170 × 125 × 100
(66 ¹⁵⁄₁₆ × 49 ³⁄₁₆ × 39 ³⁄₈). Centre Pompidou, Musée national d'art moderne-
Centre de création industrielle, Paris. Acquisition 1979

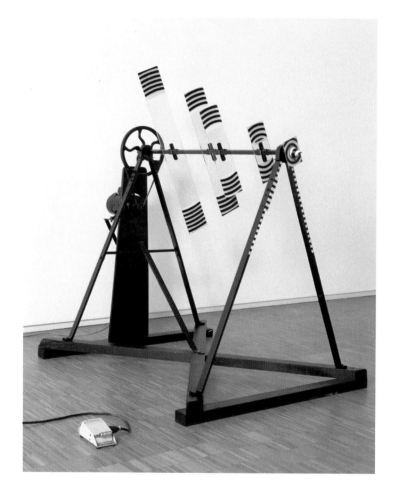

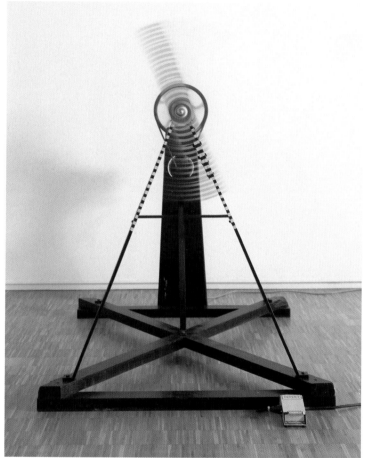

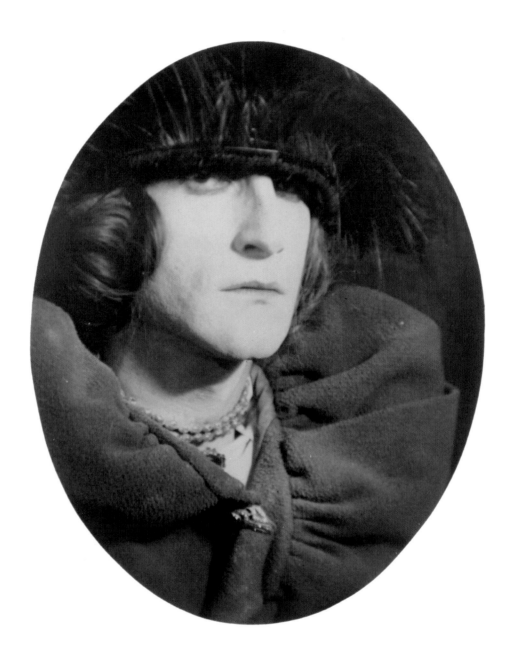

270 MARCEL DUCHAMP Cover of the magazine *New York Dada*, unique issue, Marcel Duchamp, editor with Man Ray, April 1921, letterpress and relief halftone, 37.5 × 25.5 (14 ¾ × 10 ⅟₁₆). National Gallery of Art Library, David K. E. Bruce Fund

271 MARCEL DUCHAMP and **MAN RAY** *Belle Haleine, eau de voilette* (Beautiful Breath, Veil Water), 1921, assisted readymade: Rigaud perfume bottle with artists' label in cardboard box, bottle height: 15.2 (6); box: 16.3 × 11.2 (6 ⅟₁₆ × 4 ⅟₁₆). Collection Yves Saint Laurent - Pierre Bergé

272 MARCEL DUCHAMP *The Non-Dada*, 1922, readymade: religious pamphlet enclosed in envelope, 14.3 × 11.1 (5 ⅝ × 4 ⅜). Scottish National Gallery of Modern Art, Edinburgh

273 ROSE SÉLAVY (MARCEL DUCHAMP) *Fresh Widow*, 1920,
miniature French window: painted wood frame and eight panes of glass
covered with black leather: 77.5 × 44.8 (30 ½ × 17 ¹¹⁄₁₆), on wood sill:
1.9 × 53.4 × 10.2 (¾ × 21 × 4). The Museum of Modern Art, New York,
Katherine S. Dreier Bequest

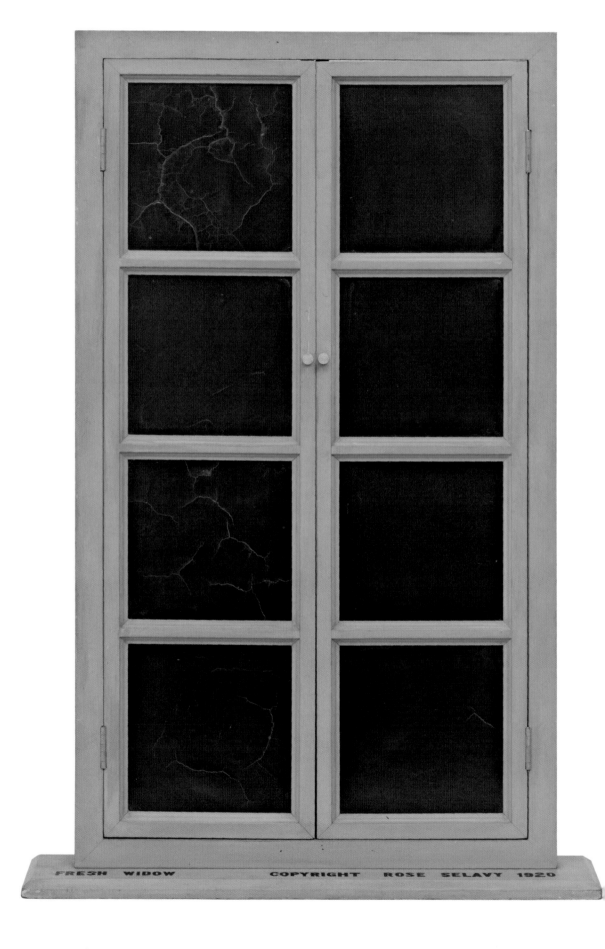

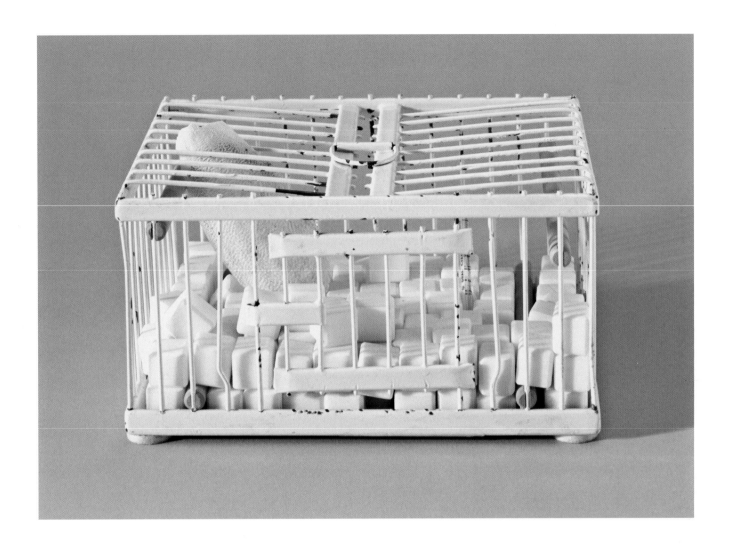

275 FRANCIS PICABIA *Machine sans nom* (Machine with No Name), 1915, gouache and metallic paint on board, 120.6 × 66 (47 ½ × 26). Carnegie Museum of Art, Pittsburgh, Gift of G. David Thompson, 1955

276 FRANCIS PICABIA *L'Enfant Carburateur* (The Child Carburetor), c. 1919, oil, enamel, metallic paint, gold leaf, pencil, and crayon on stained plywood, 126.4 × 101.3 (49 ¾ × 39 ⅞). Solomon R. Guggenheim Museum, New York

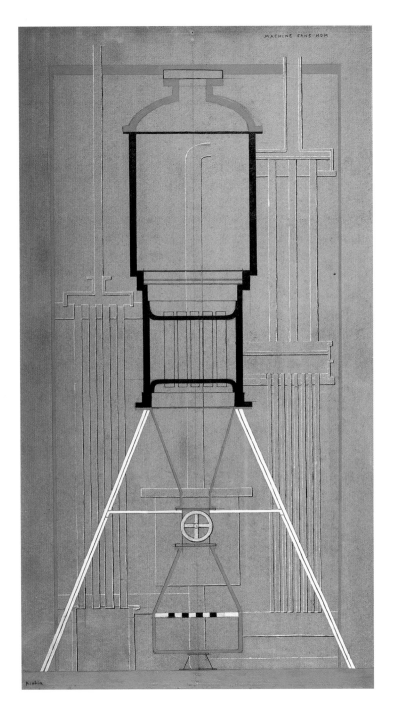

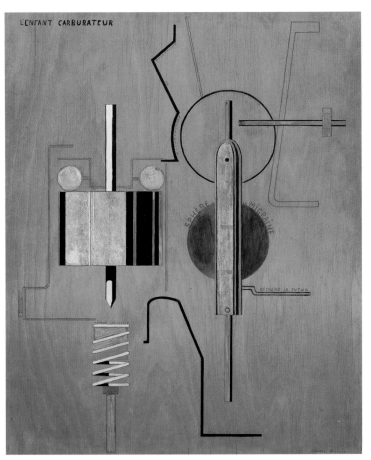

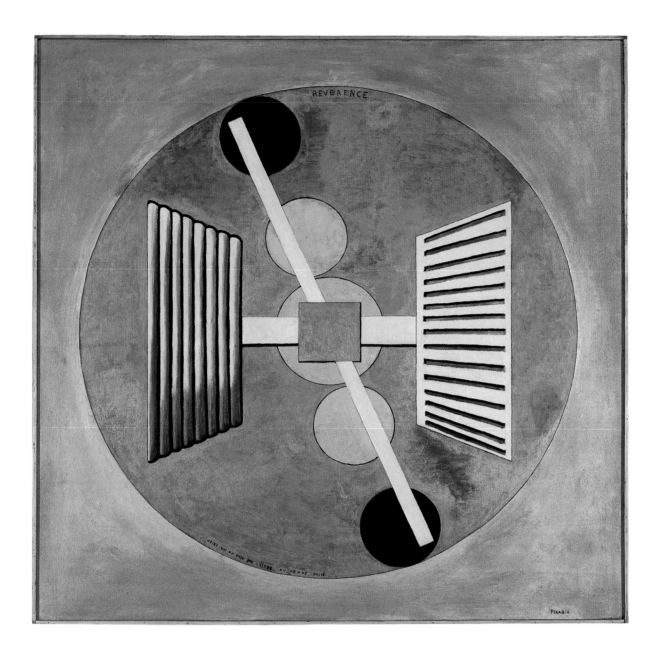

FRANCIS PICABIA Illustrations from the journal *291*, no. 5–6, deluxe edition, Paul Haviland, Agnes Ernst Meyer, Alfred Stieglitz, and Marius de Zayas editors and publishers, July–August 1915, reproductions of ink drawings on vellum paper, 43.9 × 28.9 (17 5/16 × 11 3/8). Francis M. Naumann Fine Art, New York

278 *Ici, c'est ici Stieglitz/foi et amour*
(Here, This Is Stieglitz/Faith and Love): cover

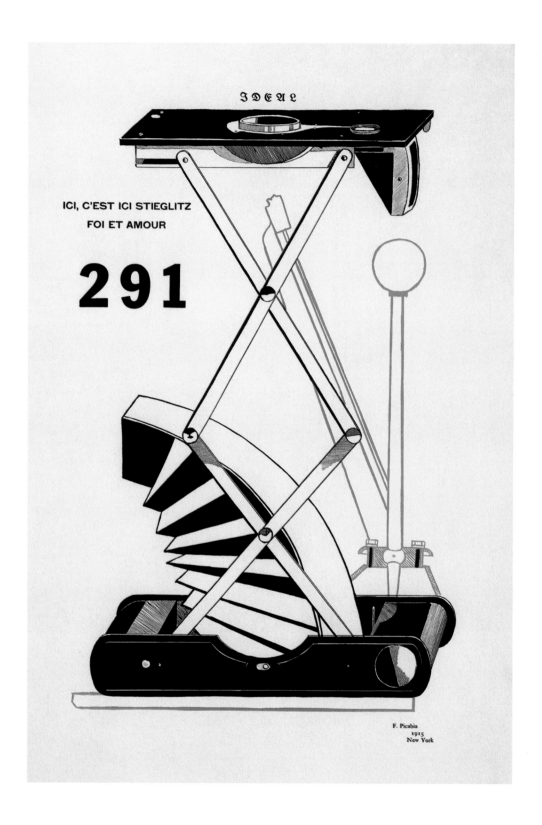

279 *Le Saint des saints / C'est de moi qu'il s'agit dans ce portrait*
(The Saint of Saints / This Is a Portrait About Me)

280 *De Zayas! De Zayas!*

281 *Portrait d'une jeune fille américaine dans l'état de nudité*
(Portrait of a Young American Girl in a State of Nudity)

282 *Voilà Haviland* (Here's Haviland)

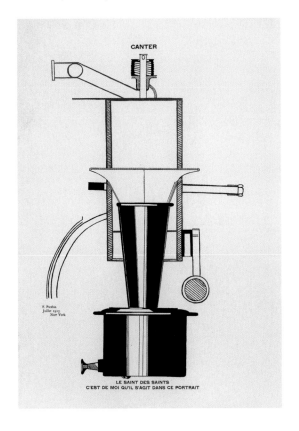

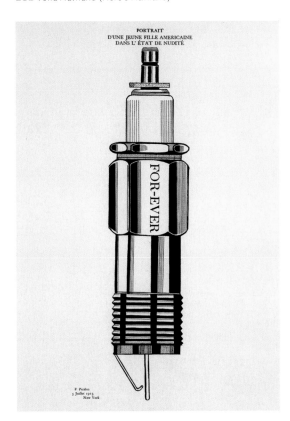

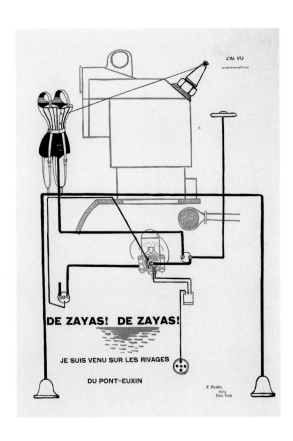

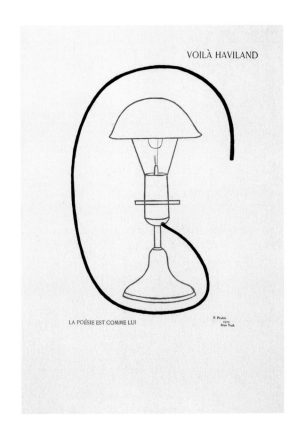

283 **FRANCIS PICABIA** *Âne* (Donkey), cover of the journal *391*, no. 5, Francis Picabia editor and publisher, June 1917, 37 × 26.8 (14 9/16 × 10 9/16). Research Library, The Getty Research Institute, Los Angeles

284 **FRANCIS PICABIA** *Américaine* (American Woman), cover of the journal *391*, no. 6, Francis Picabia editor and publisher, July 1917, 37.2 × 26.7 (14 5/8 × 10 1/2). Research Library, The Getty Research Institute, Los Angeles

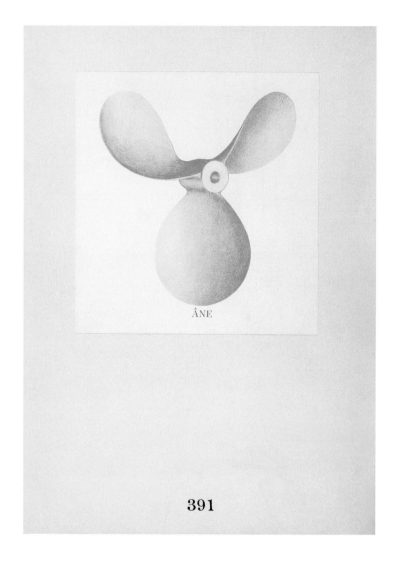

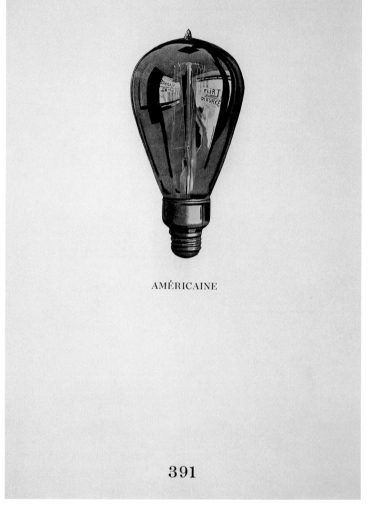

285 FRANCIS PICABIA *Intervention d'une femme au moyen
d'une machine* (Intervention of a Woman by Means of a Machine), 1915,
gouache and pencil on paper, 75.9 × 50.8 (29 ⅞ × 20). Collection of
David Ilya Brandt and Daria Brandt

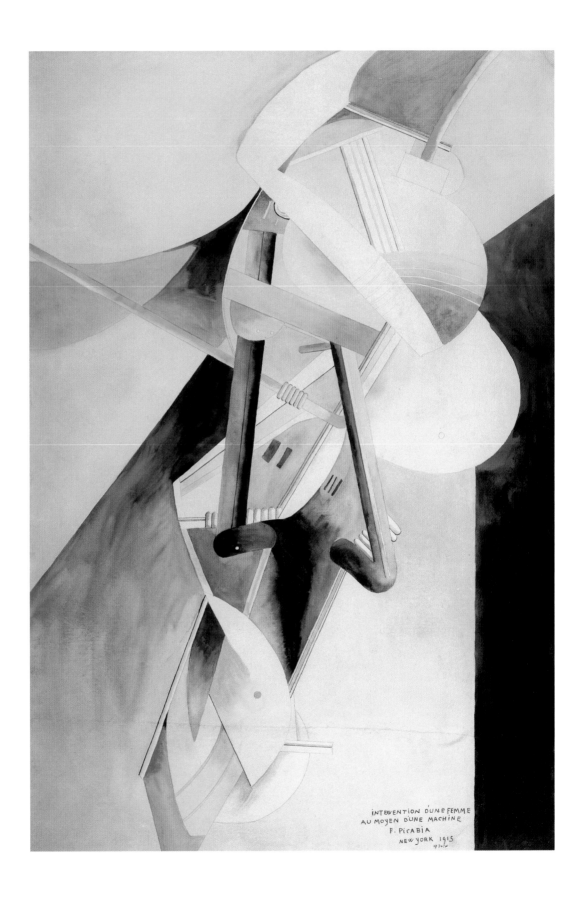

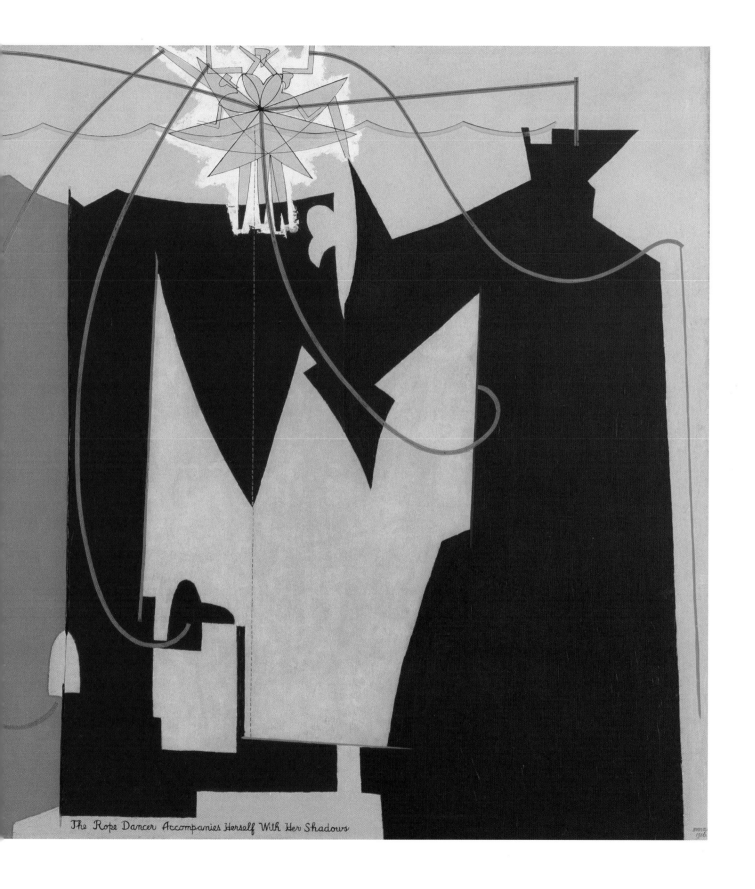

The Rope Dancer Accompanies Herself With Her Shadows

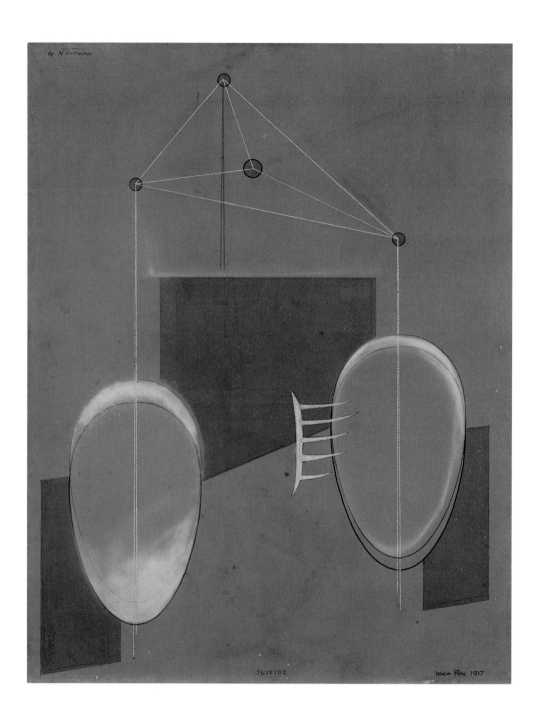

288 MAN RAY *Admiration of the Orchestrelle for the Cinematograph*, 1919, airbrushed ink and gouache, ink, and pencil on gray paper, 66 × 54.6 (26 × 21 ½). The Museum of Modern Art. New York, Gift of A. Conger Goodyear

289 MAN RAY *Seguidilla*, 1919, airbrushed gouache, watercolor, ink, and colored pencil on board, 55.9 × 70.6 (22 × 27 ¹³⁄₁₆). Hirshhorn Museum and Sculpture Garden, Smithsonian Institution, Joseph H. Hirshhorn Purchase Fund and Museum Purchase, 1987

290 MAN RAY *La Volière* (Aviary), 1919, airbrushed gouache, pencil, and ink on card, 70 × 55 (27 ⁹⁄₁₆ × 21 ⅝). Scottish National Gallery of Modern Art, Edinburgh

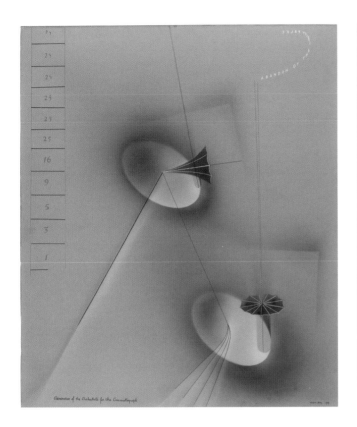

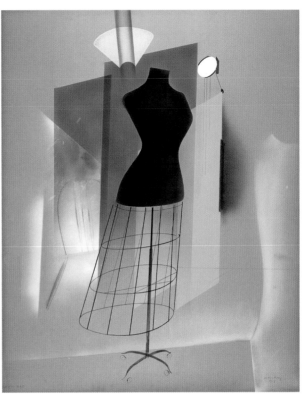

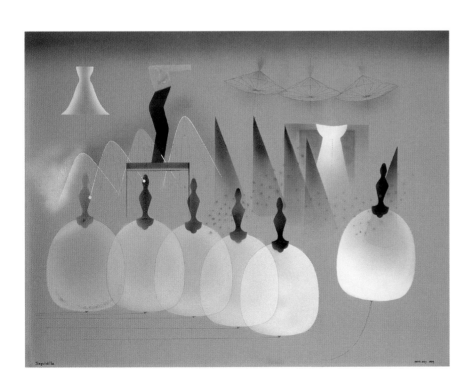

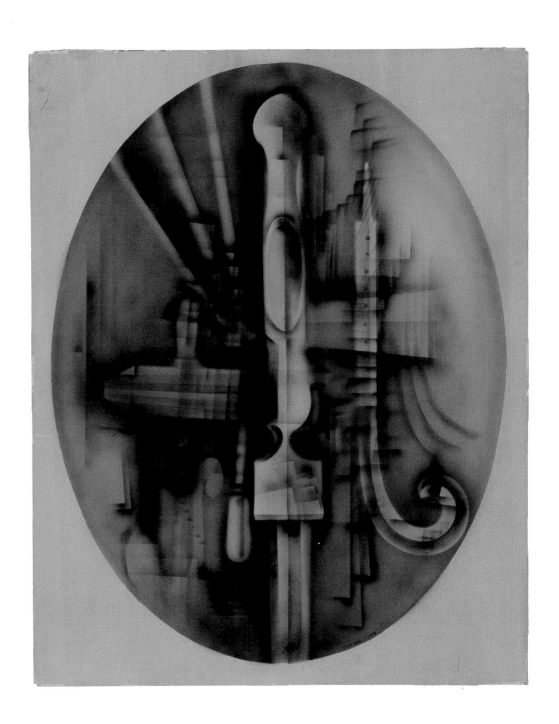

292 MAN RAY *By Itself II*, 1918, wood, with base: 60 × 21 × 19 (23 ⅝ × 8 ¼ × 7 ½). Kunsthaus Zürich

293 MAN RAY *By Itself I*, 1918, wood, iron, and cork, 43 × 18.5 × 19 (16 ¹⁵⁄₁₆ × 7 ⁵⁄₁₆ × 7 ½). Westfälisches Landesmuseum für Kunst und Kulturgeschichte Münster, Germany

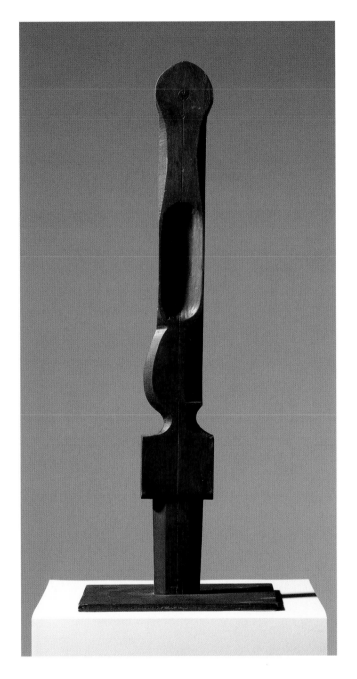

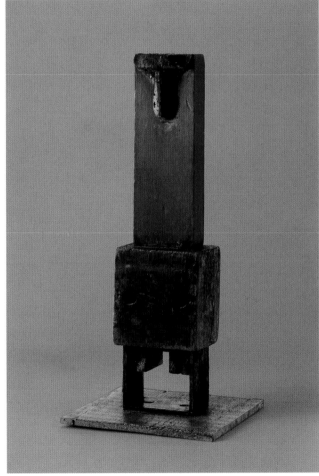

294 **MAN RAY** *Obstruction*, 1961 (replica of 1920 original), 63 wooden coat
hangers, 110 × 120 × 120 (43 ⁵⁄₁₆ × 47 ¼ × 47 ¼). Moderna Museet, Stockholm.
Gift 1966 from the artist

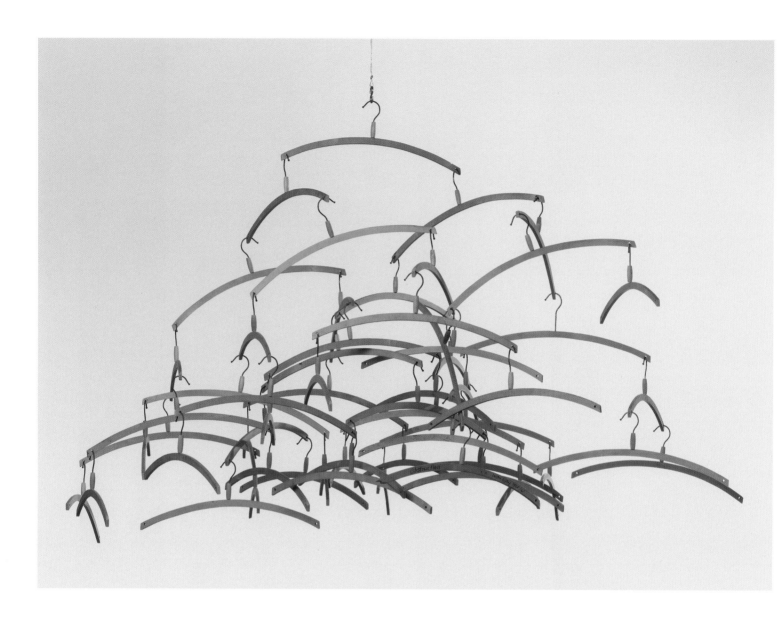

295 **MAN RAY** *Lampshade*, 1954 (artist's later version of his 1921 aluminum replica of his lost 1919 /1920 original, which was a found, broken paper lampshade on a stand), painted aluminum, 152.5 × 63.5 (60 1/16 × 25). Centre Pompidou, Musée national d'art moderne-Centre de création industrielle, Paris. Remittance in lieu of inheritance taxes to the government of France, 1994

296 **MAN RAY** *Boardwalk*, 1917, assemblage of wood, oil, furniture knobs, twine, and fabric on wood panel (shot with three bullet holes by students protesting a 1958 Dada exhibition at a commercial gallery in Paris), 85.5 × 92 × 11.5 (33 11/16 × 36 1/4 × 4 1/2). Staatsgalerie Stuttgart

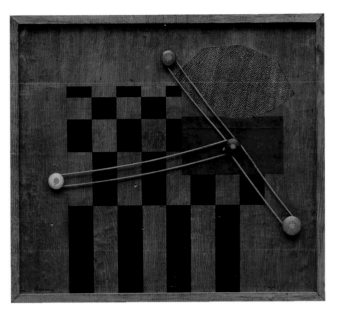

297 **MAN RAY** *Compass*, 1920, gelatin silver print, 11.7 × 8.6 (4 ⅝ × 3 ⅜).
Lent by The Metropolitan Museum of Art, Ford Motor Company Collection,
Gift of Ford Motor Company and John C. Waddell, 1987

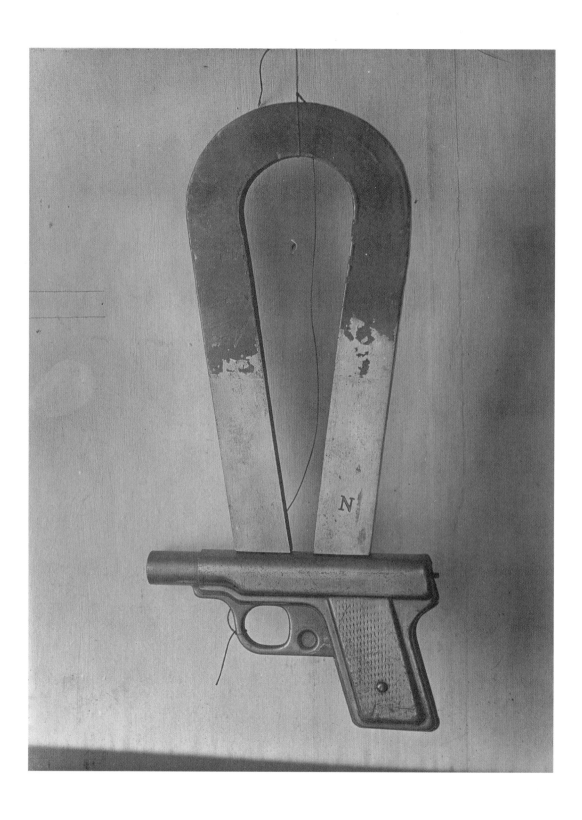

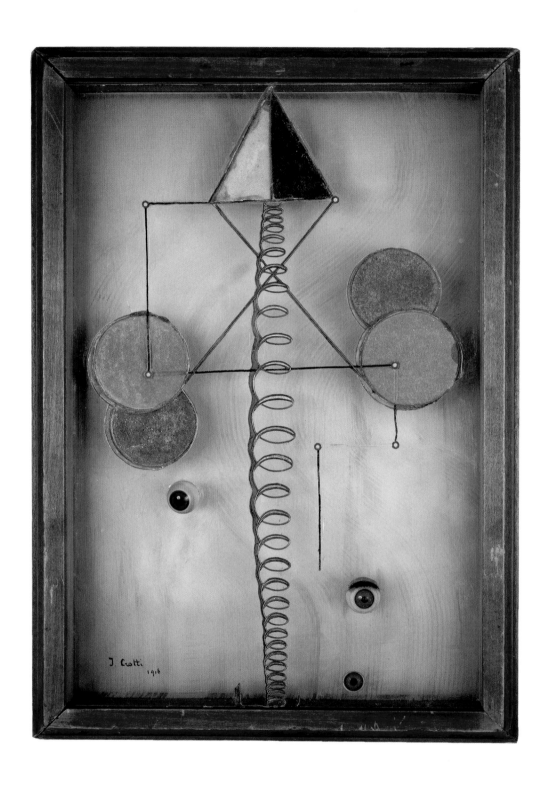

303 JEAN CROTTI Study for *Les Forces mécaniques de l'amour en mouvement* (The Mechanical Forces of Love in Motion), 1916, watercolor and gouache on board, 53.3 × 68.6 (21 × 27). Private collection

304 JEAN CROTTI *Virginité en déplacement* (Virginity in Motion), 1916, oil on canvas, 54 × 65 (21 ¼ × 25 ⁹⁄₁₆). Musée d'Art Moderne de la Ville de Paris

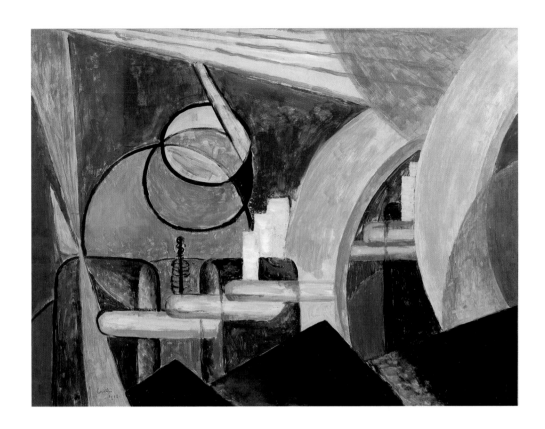

310 MORTON LIVINGSTON SCHAMBERG *Mechanical Abstraction*
(later titled *Painting VIII* by William Agee), 1916, oil on canvas,
76.5 × 51.4 (30 ⅛ × 20 ¼). Philadelphia Museum of Art, The Louise and
Walter Arensberg Collection, 1950

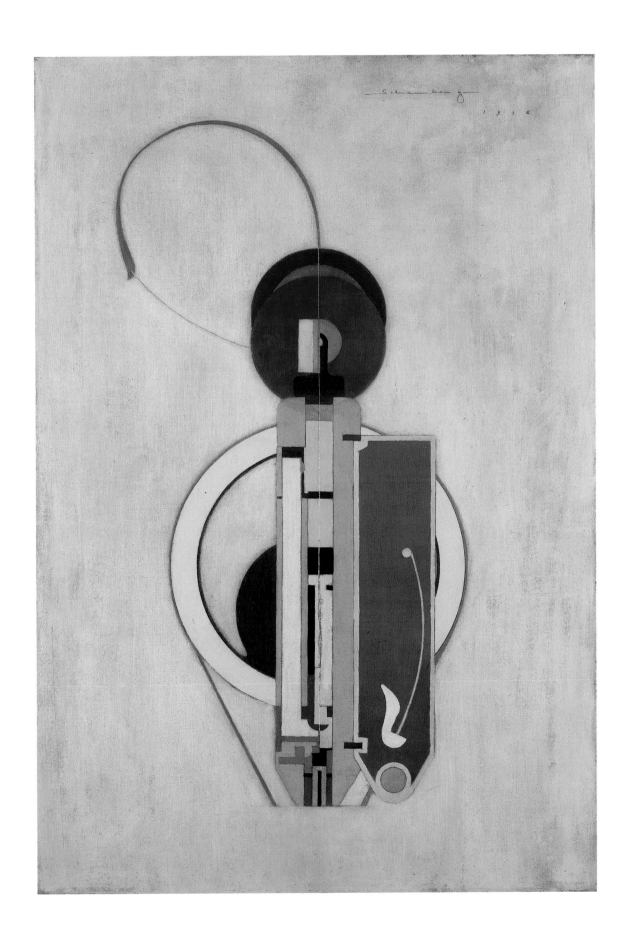

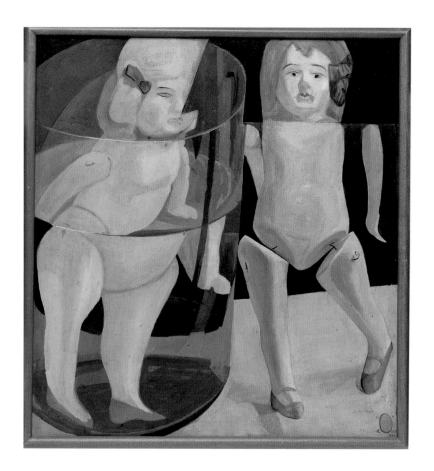

307 JOHN COVERT *Vocalization*, 1919, oil and wooden dowels nailed to board, 60.3 × 67.3 (23 ¾ × 26 ½). Yale University Art Gallery

308 JOHN COVERT *Ex Act*, 1919, oil on plywood and board, 59 × 64.1 (23 ¼ × 25 ¼). The Museum of Modern Art, New York, Katherine S. Dreier Bequest

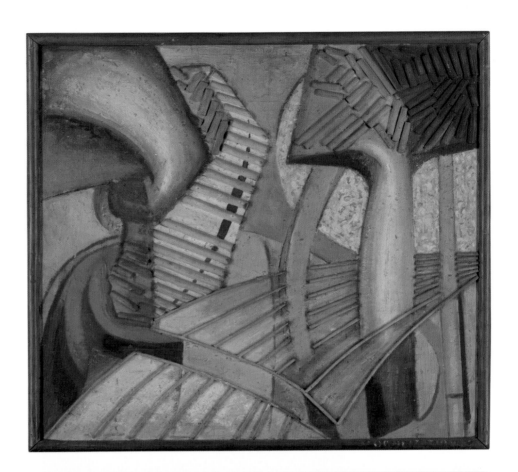

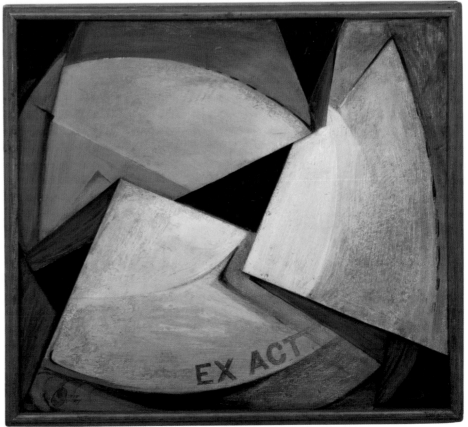

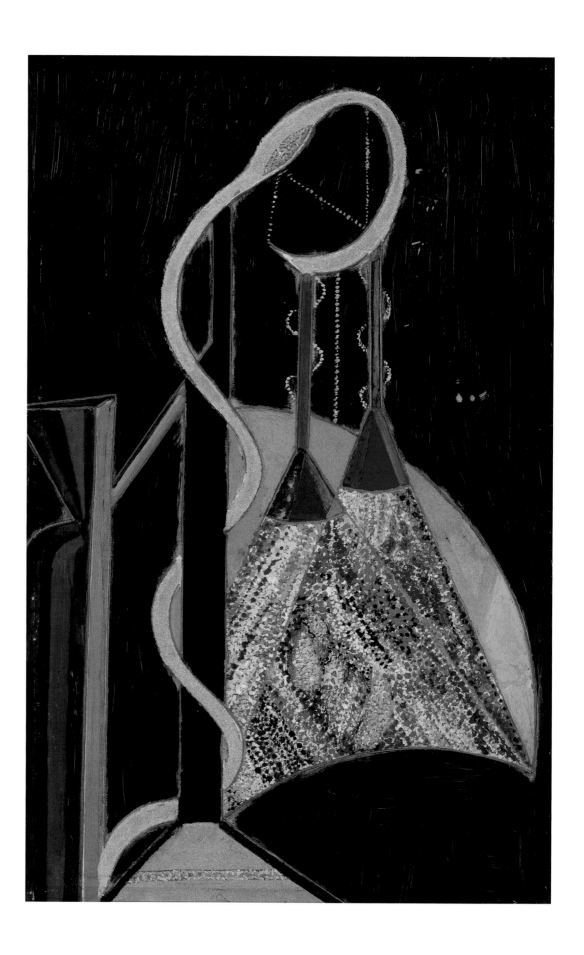

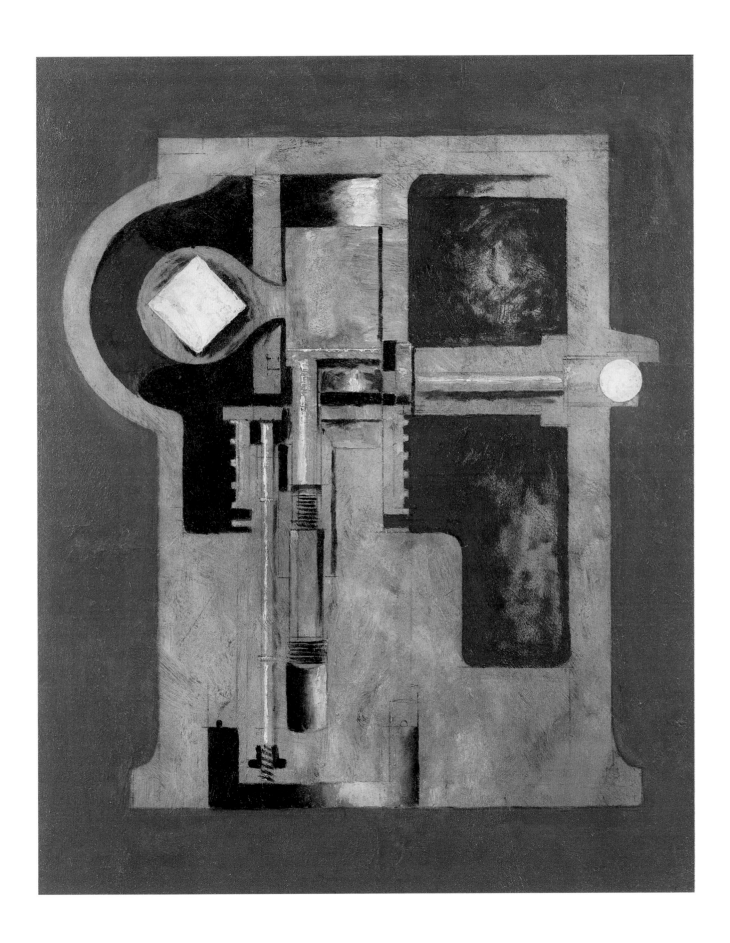

314 CHARLES SHEELER *Portrait of Marcel Duchamp*, photograph of sculpture by Baroness Elsa von Freytag-Loringhoven, c. 1920, platinum silver print, 25.1 × 20 (9 7/8 × 7 7/8). Francis M. Naumann Fine Art, New York

315 BARONESS ELSA VON FREYTAG-LORINGHOVEN *Limbswish*, c. 1917–1918, metal spring, curtain tassel, and wire mounted on wood block, height with base 55.1 (21 11/16); base approx. 35.6 × 19.1 (14 × 7 1/2). Mark Kelman, New York

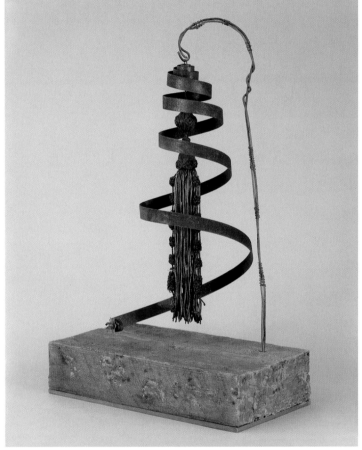

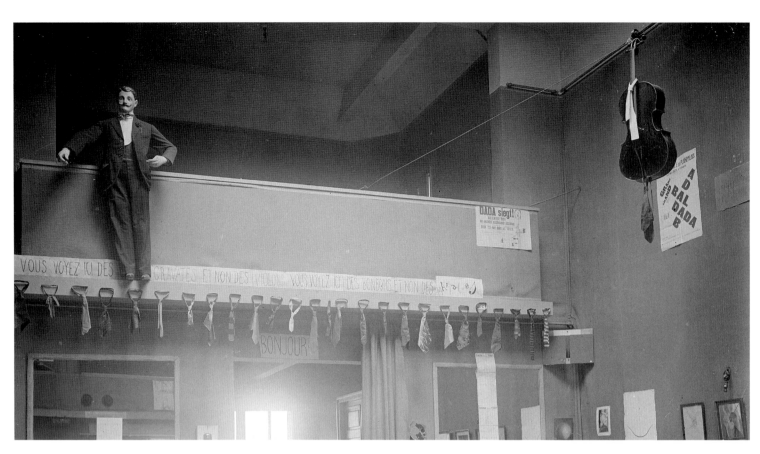

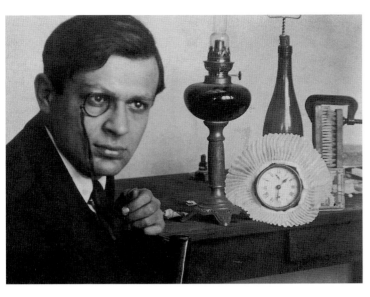

PARIS

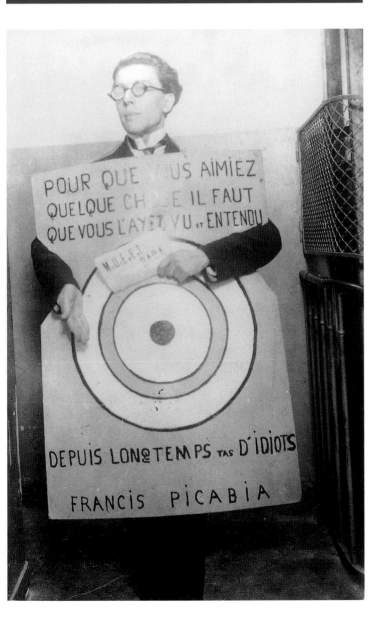

Louis Aragon
Céline Arnauld
Hans Arp
André Breton
Jean Crotti
Paul Dermée
Marcel Duchamp
Suzanne Duchamp
Paul Eluard
Max Ernst
Man Ray
Francis Picabia
Georges Ribemont-Dessaignes
Philippe Soupault
Tristan Tzara

6

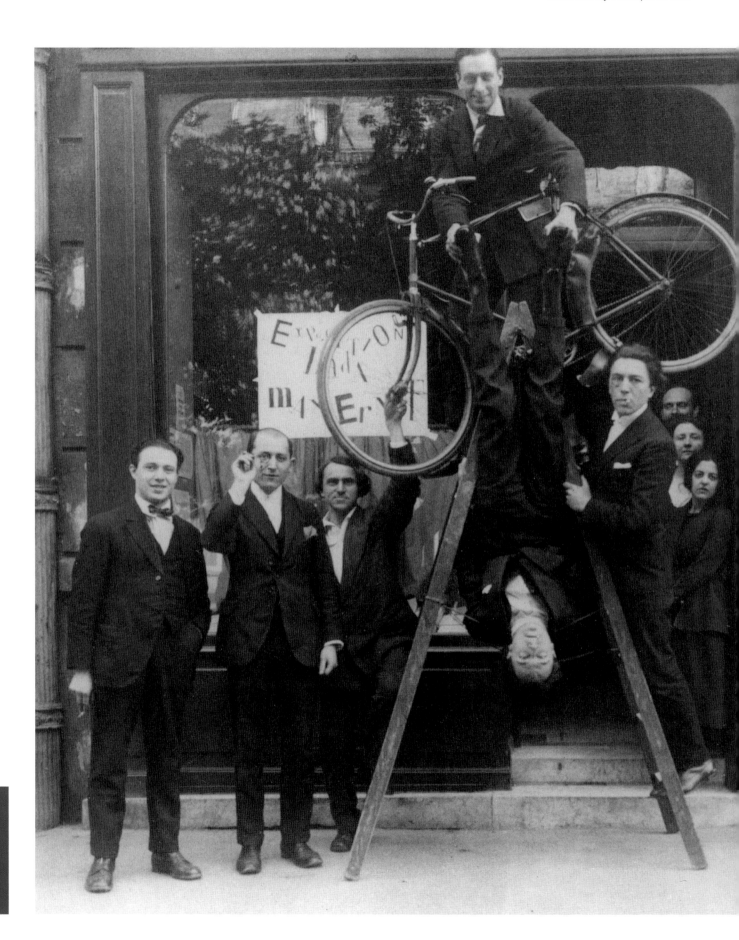

JANINE MILEAF and
MATTHEW S. WITKOVSKY

When Dada came to Paris, in late January 1920, it came fast and furious: six group performances, two art exhibitions, and more than one dozen publications in the space of five months. Each event and work received exceptional public attention, reflected in extensive, frequently outraged commentary in the press. The cumulative effect of this first "Dada season," as it became known, was to mark the movement as a nihilistic collective force leveled at the noblest ideals of advanced society. According to critical consensus, Dada represented youthful provocation, an adolescent destructiveness that (for those favorably inclined) should clear the way for a new intellectual engagement with art and the world at large.[1]

This nutshell understanding, neither wholly inaccurate nor especially satisfying, has frequently eclipsed awareness of the extent of Paris Dada, and its specific character: the ways in which Dada engaged the city's history as a capital of spectacle, revolt, and commodity exchange. Such considerations offer a means to give Dada in Paris an internal, strategic coherence that illuminates both major and minor aspects of the group's history, while avoiding the pitfall of interpreting international Dada in francocentric terms.[2] The famed passage of much of the Parisian membership into the surrealist movement, for example, may be explained as a continuation of locally shared preoccupations rather than a story in which Dada serves merely as preface or foil to its exceptionally long-lived successor.[3]

Paris provided Dada with a specific setting, that of a metropolitan capital recovering from war. This setting shaped the movement, which thus differed from Dada in the smaller, more homogeneous cities of Hannover and Cologne, the neutral wartime refuge of Zurich, or the distant urban environment of New York. Of the principal centers for Dada, only Berlin matched Paris in scale and circumstance. Divided crucially by the war, which left Germany defeated and France victorious but maimed, Dada groups in these two cities nevertheless show remarkable parallels with regard to their strategies and their critical reception. Dadaists reached the broadest possible public in both places, for instance, by coordinating exhibition extravaganzas, publications, and theater performances with a systematic infiltration of the mass media. In these cities, again more than in the smaller or exilic centers, Dada became a lightning rod for debates over national cultural heritage, partly because of resurgent nationalism in the immediate postwar period, but also because of the great ambition of native-born leaders such as Richard Huelsenbeck and André Breton.

Even these parallels, however, keep from view the specific character of Paris Dada. Dada in Paris is best remembered for its love of spectacle, from the Festival Dada in May 1920 to the premiere of *Relâche* (No Performance) by Francis Picabia at the end of 1924. Despite their variety, the Paris group's many performance initiatives demonstrate a consistent, quasi-philosophical interrogation of modern artistic identity, of the status of artists—singly and collectively—in an era of proliferating avant-gardes. They also form an extended meditation on art's relation to the public, or put more broadly its place in society. Those reflections gained a new dimension when André Breton and Louis Aragon proposed, in April 1921, to take the "show" outdoors, onto the streets of Paris, in a guided tour of the nondescript church of Saint Julien le Pauvre.

The spectacles of Paris Dada, but also many of the individual paintings and literary works, exhibit a profound violence: physical hurt, damage to language, a wounding of pride or moral spirit. This violence, which may seem uncharacteristic of French sensibility, is often explained as nihilism or anti-aesthetic provocation. The attacks are more pointed than that, however, for they are caustic rather than annihilating. When Georges Ribemont-Dessaignes promises, in an address "Au Public" (To the Public), to "rip out your spoiled teeth, your pummeled ears, your tongue full of sores"; when Hans Arp makes a sculpture, *La Planche à oeufs* (The Eggboard) **[349]**, in imitation of eggs hurled at a person's head, or Marcel Duchamp has fabricated a readymade with the title *La Bagarre d'Austerlitz* (The Brawl at Austerlitz) **[323]**, these creative acts carry specific historical weight in relation to the recent war. The vitriolic humor of these works bespeaks an engagement with contemporary society that is profoundly ethical in its motivation, though often not expressly political in content. Dadaists addressed themselves, moreover, directly to the public, inviting or inciting audience members to express their own unspent aggressions in a radical form of participatory theater.

One of the greatest areas for ethical concern in Paris, epicenter of consumer desire in modern times, is the complicity of art—ideally an expression of liberating, critical insight—in a regime of salable products. The threat of success and fashionability looms over the Paris group, somewhat analogous to the bitter discussions about political complacency held in Berlin Dada circles. Political dissent and commercial success are understood across the Dada network to be mutually antagonistic properties, yet it is in the French context that thinking about capitalism and avant-garde aesthetics finds its fullest elaboration. This has much to do with the experience of Picabia, Duchamp, and Man Ray in New York, notably Duchamp's felicitous idea of the readymade. But if the impetus to a transformative visual aesthetic stems from the land of skyscrapers and assembly lines, reflection on the consequent role of art and artists develops in Paris, the consumerist city par excellence. These issues were particularly complicated and stimulating precisely because Dada embraced manufacture, markets, and the mass media, rather than shunning or seeking to transcend these seismic cultural phenomena.

Debates over the character of radical art and poetry, and over the value of provocation or outright violence, caused internal rifts from the very outset. In Paris more publicly than elsewhere, Dada formed a shifting coalition of alliances rather than a unified front of attack. Granted, Dada was a highly individualistic movement. Yet few of its affiliates argued over the terms of solidarity with the assiduity of the Paris membership. Assembly-style meetings in cafés; plans for tribunals and congresses; and polls, questionnaires, or feuding editorials printed in *Littérature*, the group's core journal, as well as in the popular cultural daily *Comoedia* all contributed to a demanding atmosphere of constant aesthetic and ethical judgments.

For Breton and Aragon in particular, such judgments were intended to legitimate Dada by defining its historical purpose, mostly with respect to standards set by earlier French literary rebels: Charles Baudelaire, Arthur Rimbaud, the Comte de Lautréamont, and others. These chosen precursors became the foundational pantheon for surrealism at its inception in 1924. Such continuity in lineage, coupled with the loud rejection of Dada by the founders of surrealism, has made Dada seem merely an "interlude" in the formation of the surrealist movement.[4] If one looks at structure rather than chosen precursors, however, then surrealism betrays a tremendous continuity with Dada: in both cases, a judgmental, factious climate in which possibilities for collective action are tested insistently against expressions of individual dissent. As with Dada internationally, the social formation of the avant-garde was subjected by Paris Dada to radical critique, and surrealism emerged fortified by that process, intellectually and creatively.

SPECTACLE

Dada began formally in Paris, as it had in Zurich, with live performance. On 23 January 1920, almost exactly four years after the inaugural soirée at the Cabaret Voltaire, the

editors of the journal *Littérature*, Louis Aragon, André Breton, and Philippe Soupault, organized what was to be the first in a series of Friday gatherings for the public. In a rented room sandwiched between two cinema parlors and their competing orchestras, the organizers recited their own poetry along with verse by representatives of the pre-war and contemporary vanguard. These readings were interspersed with onstage presentations of artwork similarly chosen to represent a span of production from the pre-war generation to the current one. For musical interludes, the *Littérature* crowd turned here, as they would in subsequent events, to the clique of modern French composers known as the Groupe des Six, who took Erik Satie as their father figure.

Following the precedents of Zurich and Berlin—where Dada cabaret evenings had begun in January 1918—performances in Paris Dada served as much to identify the movement to itself as to define it publicly. Tristan Tzara, who made his Paris début at the "First *Littérature* Friday," galvanized activity in the French capital with ideas gained from his Zurich days. The polyvalent artists Francis Picabia and Georges Ribemont-Dessaignes, who were not close to the editors of *Littérature* previously, began publishing in its pages during the heady period of January–February 1920, when the newfound group held four events in as many weeks. In January as well, René Hilsum, a high school classmate of Breton, opened a bookstore called Au Sans Pareil; he soon found himself publishing dadaist books and hosting exhibitions by Picabia and Ribemont-Dessaignes. Minor participants such as Paul Dermée and his companion Céline Arnauld were impelled by the performances to radicalize their language, testing a bolder voice in manifestos and journal projects associated with the Dada juggernaut. For Paul Eluard, a little-known talent in early 1920, these manifold activities spurred the formation of an original poetic sensibility; established figures such as Satie or the writer André Gide, meanwhile, gained from their momentary association with Dada a rejuvenated notoriety (welcome or not).

Breton and Aragon yearned to proclaim a revolution in French poetry, and in doing so to emerge from the shadow of the "cubist" circle of writers formed during the final pre-war years, and still generally considered the most modern domestic talent.[5] Unlike Tzara or the Berlin dadaists, the French did not look for renewal in African chants or primordial sounds, and indeed the general absence of primitivism in Paris Dada (with the exception of jazz and blackface, manifestations linked to industrial rather than non-Western civilization) sets it apart from Germanic centers of the movement. Instead, the new coalition in Paris sought to radicalize creativity by opening it up to the mundane, the anonymous, to the spontaneous or the collectively produced. "Anything can take the place of a poem," claimed Aragon in 1923, recalling the aims of the group's inaugural event.[6] Thus the eclectic mix at this Friday soirée of new verse, art reviews, and most provocatively Tzara's reading of a parliamentary address clipped from the newspaper—his voice drowned out by clanging bells—all were to be considered truly modern poetry.

Tzara himself was keenly interested in the mix of literary genres, a deflationary collision of "high" with "low" that he had emphasized in recent issues of his journal *Dada*. He also understood the value to a performance of frustrating one's audience. In April 1919, Tzara and Walter Serner had mounted the largest Dada spectacle to date in Zurich, before a crowd of perhaps one thousand people. Serner had read there a rude and caustic manifesto, addressing his words to a tailor's dummy while seated on a chair onstage, his back to the public. Tzara's contribution to the "First *Littérature* Friday" matched this approach; his decision to read, with cacophonous accompaniment, the words of reactionary French politician Léon Daudet seems a calculated attack on national values. At the same time, it should be noted that Tzara's performance and media strategies yielded results in Paris that had been rare in Switzerland. In place of a community of exiles, Tzara now joined forces with individuals well connected to the native cultural establishment, who were also eager to develop a creative practice of protest and liberation shaped in the public sphere.

The newly formed Paris group advanced its performance interests through painting as well. Two works by Francis Picabia, *Le Double Monde* (The Double World) **[371]**, 1919, and *Riz au nez* (Laugh in Your Face), 1920, were carried onstage by Breton at the "First *Littérature* Friday," and together with the reading by Tzara they gave the event its central, tumultuous character. The first work, *Double World*, followed Marcel Duchamp's altered Mona Lisa **[316]** from which Picabia retained not the image but the inscription: L.H.O.O.Q., or "She's got a hot ass." Centered vertically on a canvas nearly four-and-a-half feet tall, the ribald phrase could be read and sounded out easily by the audience; saucy idioms, one of the most socially devalued forms of speech, were now also to be invested with poetic value.

Double World extends the iconoclastic program to a specifically pictorial domain, for the painting includes further words that pertain to crating artwork: *haut* (top), *bas* (bottom, painted at the top and facing the other direction),

fragile and *à domicile* (deliver to the home address). Picabia switches here the modernist attention to framing for a more strictly conceptual reflection on packaging, that is on the institutional value of artworks as precious objects to be transported for exhibition and sale. The references in this painting are alternately obscure—Duchamp's own ready-made had not yet been seen in public—and offensive in their manifest vulgarity. Picabia's other painting, likewise presented by Breton, effected an even more aggressive lesson in art appreciation. This composition consisted of several marks and inscriptions in chalk on slate, the largest of which read "RIZ AU NEZ," a pun meaning either "rice on your nose" or "laugh in your face." The work undoubtedly reminded viewers of a puerile joke scrawled by some naughty pupil on the schoolroom blackboard. After reading a gloss on Picabia's painting written years earlier by Guillaume Apollinaire, Breton took out a sponge and simply erased the slate, as if to say: class over.

The first Dada performance in Paris thus sketched the revitalization of poetic value through a confrontation with the public marked by effrontery as well as professorial posturing. Despite uneven results, this initial undertaking had a catalytic effect on the participants and on *le tout Paris*. A multitude of newspaper reviews registered the scandal, making

Dada an overnight sensation. In advance of their next event, just two weeks later, the group disseminated to overeager editorial offices the misinformation that Charlie Chaplin would join them onstage. The lure of Chaplin, beloved of many avant-gardists for his populist characters and his comedic inventiveness, astutely suggested media stardom as a model for Dada spectacle. Indeed, in Paris even more than elsewhere, Dada overwhelmed the press for a time and gained a mass following of sorts: a mixture of students, cultural elites, and adventure-seeking citizens prepared and willing to take part in increasingly raucous events.

Comoedia, a daily arts tabloid weighted toward theater and cinema, soon became a central forum for debates over Dada and its effect on French audiences. Charges of enemy subversion, lunacy and charlatanism appeared here just as in German newspapers, pretexts to isolate what seemed to many a traitorous insurgency against bedrock national values. "[The Dada movement] was born in Switzerland of *German* parents, however neutral," warned the essayist Rachilde (Marguerite Valette), shortly after a Dada performance evening **[fig. 6 1]** in late March held to commemorate the pathbreaking French farce *Ubu roi* (King Ubu), 1895, by Alfred Jarry. "What moves this crazy machinery is a wish to *disturb* French art...." Yet what sickened Rachilde

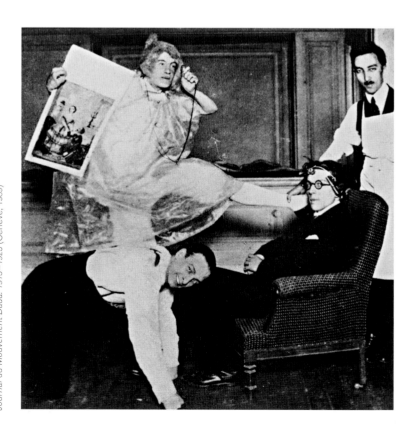

6.1 Paul Eluard, Philippe Soupault, André Breton, and Théodore Fraenkel onstage at the Maison de l'Oeuvre in "You'll Forget Me" by Breton and Soupault, Paris, 28 March 1920. From Marc Dachy, *Journal du Mouvement Dada: 1915–1923* (Genève, 1989)

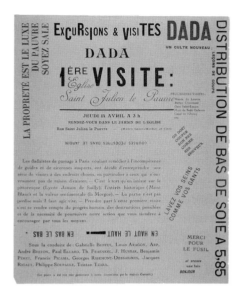

6.2 Tristan Tzara, prospectus for the mock guided tour *Excursions et visites Dada: 1ère visite, Eglise Saint Julien le Pauvre* (Dada Outings and Visits: First Visit, Church of Saint Julian the Poor), André Breton and Tristan Tzara et al., editors, April 1921, letterpress. National Gallery of Art, Library, Gift of Thomas G. Klarner

most was the combative delight shown by Dada's audiences, and in her consternation she not only failed to segregate public from performers, but actually classed them together within a militarized cultural environment: "We're troops.... An order arrives from anywhere, a telephone call or a leaflet... and we march."[7]

If Dada represented an unorthodox military campaign, then, those who followed it were soldiering unthinkingly under renegade command—a curious image that reveals as well as any Dada statement the recent war's lasting effect on cultural discourse. In an editorial for *Comoedia* entitled "Le bourgeois enragé" (The Crazed Bourgeois), critic Jules Bertaut likewise mused with horror on the abasement of a social class that fostered the spectacle of its own rejection. "What is extraordinary, unforeseen, comical and 'monnstrous' as Flaubert would have said, is that... the artists sulk *and the middle classes rush to applaud!*"[8]

These and other commentaries show observers of the time grappling with the phenomenon of a succès de scandale that exhibited unprecedented hostility yet found an equally unprecedented welcome. Members of the Dada group reflected on the same phenomenon just as quickly. Indeed, direct interrogations into Dada's meaning and the motivations of its audience soon became staples of the public performances, giving Paris Dada an insistently self-reflexive, almost philosophical character. "You don't understand what we're doing, do you," wrote Picabia for one February event, in a text printed as well in *Bulletin Dada*. "Well, dear FRIENDS, we understand it still less. How nice, see, you're right." With equal directness, Tzara challenged audiences to join

him in decrying their own ridiculousness: "Look at me! I'm an idiot, I'm a joker, I'm a fake.... I'm like all of you! But ask yourselves, before you look at me," he continued, ending the pretense of solidarity, "if the eyes in your stomach aren't tumors.... You see with your bellybutton—why do you hide from it the ridiculous spectacle we're offering?"[9]

Spectators at the events of February–March could take such statements home with them as well, in issues of *Dada* and *391* whose size, vibrancy, and newsprint paper mimicked the look of tabloids like *Comoedia*. Tzara actually prepared the sixth and seventh issues of *Dada*, titled *Bulletin Dada* and *Dadaphone*, for sale at Dada performances [362, 363]. Just as the Berlin faction of George Grosz and the Heartfield brothers had done one year previously with the single-issue *Jedermann sein eigner Fussball* (Everyone His Own Soccerball) [86], Tzara took his journal out of the realm of the "little magazine," increasing its size and print run and shifting distribution to the street, as it were—changes that effected a radical incursion into the mainstream media domain. Picabia, who also temporarily adopted the tabloid format for his journal *391*, revisited the scandal he had unleashed in January with *Double World*. In issue twelve of the magazine (March 1920), also passed around during at least one Dada event, he reproduced (minus the goatee) Duchamp's "original" version of L.H.O.O.Q., giving it the additional, taxonomic title *Tableau Dada* (Dada Picture) [317]. In this atmosphere of constant, heuristic reflection, everything became the pretext for a definition of Dada. Picabia underscored the point by printing a *Manifeste Dada* on the same page, designing the layout in such a way that Duchamp's art and his own writing seemingly formed a united front of attack.

In his editorial on the "craze" for Dada, Bertaut condemned this movement for upsetting the "moral equilibrium" of French society. For all its outrageous, adolescent blasphemies, however, Dada in Paris itself regularly struck a judgmental, even moralistic tone. The second "Grande Saison Dada," which lasted from April to June 1921, took moral concerns as a guiding focus. Through a series of town hall meetings, the group decided jointly upon various activities, including "excursions," "congresses," "plebiscites," and "indictments and verdicts" [fig. 6.2]. All of these ideas, as Aragon recalled in 1923, took inspiration from the grandeur and menace of the French Revolution, an image of singularly violent authority, as will be discussed below.[10] The "Trial of Maurice Barrès," for example, distilled the divisiveness of Dada theater as a courtroom debate. At issue

was the moral integrity of the writer Barrès, an erstwhile libertarian who had changed his colors during World War I to become a staunch nationalist. Breton, who scripted this "trial" and published its proceedings in *Littérature*, met with stiff opposition from within the Dada ranks. Picabia publicly declared he was "breaking with Dada," while Tzara, instead of defending one or another point of view, used his testimony to attack the entire enterprise. "I have no confidence in justice, even if this justice is made by Dada," he declared, calling the accused and his prosecutors alike "a bunch of bastards...greater or lesser bastards is of no importance."[11]

The "Outings and Excursions," despite the light-hearted title, were conceived as morally guided intrusions into "hackneyed" spaces, such as churches or museums.[12] The dadaists meant to occupy, for the length of a "guided tour," overlooked or overused city sites, architectonic equivalents of the *lieux communs* or "commonplaces" they seized upon in language. "We imagined guiding our public to places," Breton explained at the time, "where we could hold their attention better than in a theater, because the very fact of going there entails a certain good will on their part."[13] Only one such visit took place, to the decrepit Gothic church of Saint Julien le Pauvre, abutting a rubble field near Notre Dame cathedral [**fig. 6.3**]. Despite its ephemerality, this experiment at translating confrontation from the stages of

rented entertainment halls into the "free" space of the street did entail a revolutionary incursion, a model of confrontational urban performance that would be revisited with intensity by neo-Dada movements in the 1950s and 1960s. Soon afterward, the editors of *Littérature* announced a "mural supplement" to the journal, for which they solicited collaborators at work on Paris walls: "The anonymous individual who writes NO on loan posters. The unknown person who signs Edith Cavell on bathroom inscriptions. The artist who draws additions on toothpaste ads...."[14] Through various means, the dadaists aimed to bring their public spectacle out into the city itself.

The event of this second season that received greatest attention in the press was not the Barrès trial or the outdoor trip to Saint Julien le Pauvre, but rather the extravagantly planned Salon Dada, which Michel Sanouillet has called "one of the moments when Dada came closest to perfection."[15] This exhibition stands as one of the grand ventures of international Dada, and as with so many other ambitious collective projects, its organizers used it to anthologize the movement's achievements. Posters from earlier exhibitions, notably the Geneva Grand Dada Ball organized by Serner and the *Dada-Vorfrühling* (Dada Early Spring) show mounted in Cologne were affixed to the wall like trophies above the artworks [**see 57, 222**]. Just as in the landmark Erste

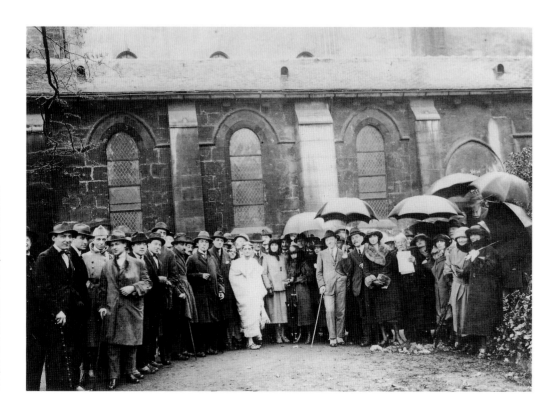

6.3 Dada "outing" to the church of Saint Julien le Pauvre, Paris, 14 April 1921. Collection Timothy Baum, New York

354

Internationale Dada-Messe (First International Dada Fair) of 1920 in Berlin, art came at visitors from all sides, including the ceiling; intruders from above at the Salon included an open umbrella, smoking pipes, a cello, and a long row of neckties [see p. 346]. Also like Berlin, the walls were plastered with slogans, not politically combative as at the German event, but belligerent with respect to the sacred separation of art from commerce: "Has Dada ever spoken to you?" or (above the main entrance) "Dada is the world's biggest hoax."[16] Dada announced itself here, with perverse advertising riffs, as a set of sham consumer goods.

An enormous poster [fig. 6.4] advertised the Salon Dada as international, and indeed its principal organizer, Tzara, secured key works for the show or its accompanying catalogue from Zurich, Cologne, Rome, and New York, as well as by most Dada affiliates in Paris. Max Ernst, whose solo exhibition had just ended at Au Sans Pareil bookstore, mailed from Cologne one of the most impressive entries: *la bicyclette graminée* (The Gramineous Bicycle) [230], c. 1921. Amoeboid forms from a natural-science illustration (perhaps of a gramineous, or grassy, plant) have been isolated through gouache additions to suggest a ritual sex dance of cancerous machine parts. Cellular globules, shown in cross-section, rear and stretch thanks to gear mechanisms that resemble the workings of bicycle wheels. This mix of

mechanical and biological imagery doubles the work's method of creation from mechanically generated illustrations plus hand drawing. With its conflation of machine- and handmade art, and its use of science for blatantly irrational ends, *The Gramineous Bicycle* forms a piece with the mechanomorphic paintings by several members of the Paris group.

Duchamp, who cabled from New York his refusal to participate, nevertheless had a work in the catalogue: *La Mariée* (The Bride), 1912 [fig. 6.5], reproduced also in a review of the show by *Comoedia* on 7 June. This early painting, which helped Duchamp to prepare his elaborate apparatus of masturbatory desire, *La Mariée mise à nu par ses célibataires, même* (The Bride Stripped Bare by Her Bachelors, Even) [or The Large Glass] [248] forms a point of origin for the mechano-sexual orientation of Dada painters in New York and Paris, and it fits too with Ernst's libidinized science imagery. Man Ray followed suit here, sending to the Paris Salon new prints of two photographs, *L'Homme* (Man) and *La Femme* (Woman) [298, 299], that suggested sexual allure and coitus through mechanical means: the clasping of clothespins, the bulbous swell of a metal washbasin, the interlocking blades and frothing rotations of an eggbeater.

The public filled the exhibition space by the hundreds on 10 June 1921 for what would turn out to be the final spectacle of Dada's heyday in Paris. Music, dance, poetry, theater,

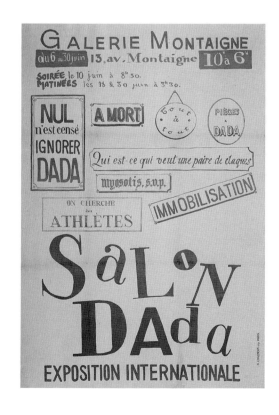

6.4 Tristan Tzara, poster for *Salon Dada, Exposition Internationale,* 1921, lithograph, Collection Merrill C. Berman

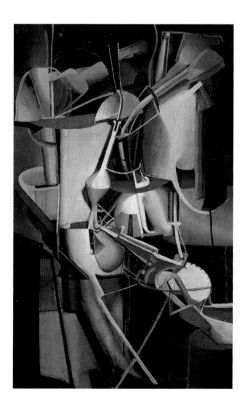

6.5 Marcel Duchamp, *La Mariée* (The Bride), 1912, oil on canvas. Philadelphia Museum of Art, The Louise and Walter Arensberg Collection

and energetic pranks enlivened the visual art on display. The program began with a singer "reading" the exhibition catalogue, a number no doubt conceived by Tzara that recalls his own newspaper recitation at the "First *Littérature* Friday." Then, in a move perhaps inspired by the "excursions" and *Littérature*'s appeal to graffiti writers citywide, the dadaists brought onstage an itinerant porcelain repairer, one Mr. Jolibois, to sing tunes he normally broadcast while plying his trade on the Paris streets.[17] Philippe Soupault returned the performance to the subject of the exhibition itself, moving through the room in a tuxedo jacket and blackface as he commented on each of the works and artists in turn. This burlesque gave way to a series of increasingly grandiloquent or offensive readings, restoring once more the balance between humor and hostility at the core of Dada spectacle. With each recitation, the public became more and more combative, insulting the stage and perhaps throwing coins and food, as they had grown accustomed to doing over the course of the past two "Dada seasons."

Yet at the start of Tzara's new play *Le coeur à gaz* (The Gas Heart), the designated centerpiece of this evening, crowd response took a new turn—the audience walked out. It is possible, in effect, to push one's public to the point of disaffection. One week later, the dadaists found themselves escorted by police from a concert by Italian futurist Luigi Russolo, held in a room adjacent to their own exhibition, after booing the composer and scattering leaflets for Salon Dada among the spectators. The next day, the proprietor of these spaces shut the exhibition down, declaring to the press his intent to "punish" such unruly "children."[18] Infantilized, evicted, and temporarily abandoned by their audience, the dadaists had succeeded remarkably well in radicalizing the spectacle of avant-garde art.

VIOLENCE

If the many aspects of this radicalized spectacle were to be summed up in a word, it would be aggression. Whether humorous, provocative, or intentionally dull, whether juvenile or pedantic, the performances with which dadaists tested their Parisian audience remained consistently aggressive, and belligerence marked many of their artworks and journals. This hostility, which spectators of Dada gleefully returned, did indeed revive the atmosphere of World War I, as commentators like Rachilde and Jules Bertaut observed with dismay in the editorials quoted earlier. Although victorious, France suffered mightily in the conflict, with about six million men killed or wounded, while large swaths of the country's northern regions were laid waste by four years of trench fighting. France had been invaded and ravaged, almost to the outskirts of the capital city, and although a majority seemed anxious to restore a sense of serenity, Dada's perverse popularity suggests that many welcomed the chance to ventilate unspent, caustic rage.

Topical attacks on current events, although by no means absent, were muted in Paris, where (unlike in Zurich or the German city centers) Dada emerged after peace and political stability had been reestablished. But the dadaists' disgust at nationalist sentiment and its attendant hypocrisies was equally strong there and just as clearly linked to the horrific disasters of 1914–18. For some members of the group, the only conscionable response to that debacle had to be a show of violent moral authority. As Aragon explained in discussing the "Great Dada Season" of 1921, the editors of *Littérature* were motivated by "the comparison of our intellectual climate with that of the French Revolution. The issue was to prepare and suddenly decree the Terror. Everything happening suggested that the Revolution was coming and we were at its head. We decided in addition not to wait for 1793: the Terror right away, in '89."[19]

Conjuring the bloodiest civil conflict in French history, Aragon appears to further the image of Dada as pure destruction, a chaotic wave crashing over the postwar "return to order" favored by many artists and the public.[20] Yet his analogy is subtler than that. Dadaist violence, in its subversiveness, courted discipline and chaos at once, and it was deployed—with tremendous self-awareness—against its own makers as well as their declared enemies. The painters of Paris Dada, for example, replayed the state rhetoric of statistical tallies and targeted destruction as pictorial motifs: numbers and targets.[21] In works by Picabia, Jean Crotti, Suzanne Duchamp, or Ribemont-Dessaignes, geometrical forms and numerical equations replace or imprison the human figure. These motifs bespeak death, but also abstraction, order, a unified visual field—the damage of a well-aimed shot but also its precision. Furthermore, on many occasions, the dadaists made themselves into targets for each other or the public, assuming willingly the impossible position of pariahs who aspire to lead an international mobilization.

Ribemont-Dessaignes set a standard for premeditated aggression with his play *L'Empereur de chine* (The Emperor of China), written in 1916 while its author held a lugubrious desk job, informing families that their loved ones had died on the battlefield. *The Emperor of China*, published by Au Sans Pareil in 1921, concerns a brutal takeover of the Chinese throne by

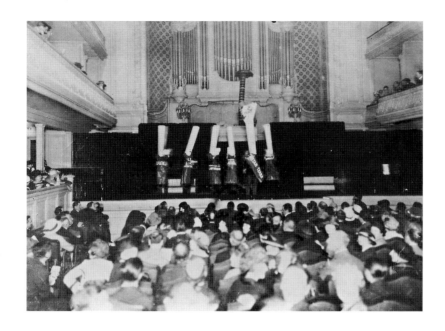

Onane, the emperor's daughter, and her ultimate murder by a loyal servant named Verdict. This sparely written, allegorical drama recounts sickening acts of cruelty—incest, disemboweling, eye-gouging, slaughter—in a language permeated, incongruously, by questions of accounting. When Onane first thinks of slaying her drunken father, she terms his imagined decapitation "disturbing the balance." The emperor awakens and seizes her, threatening her with rape: "It's not because you're my daughter that I won't sleep with you. Geometric progression. Conception squared."[22] Such (literally) calculated violence both poeticizes and desublimates human brutality, as in the concluding scene, where Verdict gazes equanimically upon his mistress' quivering, freshly severed head: "Soon, at the end of a long, vertical thread / You will hold still. And the blood dripping from your neck, a severed tie, sole memory of the weight left behind / Will cap with one final clot / The living flame / Lighted to the sign of your axe."[23]

When Dada "broke out," Ribemont-Dessaignes proved among its most militant performers, his onstage antics forming a complement, like the actions in *The Emperor of China*, to his apparently innocent paintings of alphanumeric abstractions **[357, 358]**. Ribemont-Dessaignes' excoriating address "To the Public," mentioned earlier, participates in the grand ideal of a restorative violence likened by Aragon to the Terror. The audience is a festering body, declares Ribemont-Dessaignes, its teeth and bones gone rotten, its tongue plagued with sores. It needs to be "disinfected with vitriol" and "scrubbed down with passion"—but first, "we're warning you: We are the assassins of all your little newborns...."[24]

Such insults provoked a tremendous public response in Paris, where to a greater degree than elsewhere, pointed aggression from the stage generated (or degenerated into) pandemonium in the hall. The ambitious Festival Dada of May 1920 **[fig. 6.6]** ended in a brawl, with the audience hurling eggs, meat, vegetables, and coins at the players, who themselves led a massacre. In his sketch *Le célèbre illusionniste* (The Famous Magician), Soupault unleashed five balloons from a suitcase, stabbing one labeled "Jean Cocteau" with a kitchen knife. Spectators followed suit, destroying balloons marked with the names of former Prime Minister Georges Clemenceau and military leader Marshal Philippe Pétain, among others.[25] Aggression, then, could engender both solidarity with the dadaists (joining in the act of stabbing balloons) and opposition (pelting them with food)—a mirror reaction to the dadaists' own use of violence simultaneously to breach the social contract and to forge new bonds of community.

At its most riotous, dadaist violence effaced the distinctions between performers and public, not through an invitation to grand communion but, quite the contrary, via spectacular shows of discord among the group's own membership. The 1923 *Coeur à barbe* (Bearded Heart) soirée, the last grand performance of Paris Dada, exemplifies this notorious willingness to fight in public. Organized by Tzara, and sabotaged by Breton and Aragon, the riot-cum-spectacle was described in an eyewitness account by sometime dadaist Theo van Doesburg, who tracked a conflation of audience and performers as the mayhem progressed:

The Dadaists in the audience [led by Breton and Aragon] advanced on the stage Dadaists.... Gentlemen left their elegant companions and, throwing off their jackets, jumped on the Dadaists in the audience. "Assassins!" cried an old man, nervously putting away his spectacles for safekeeping. Other men seated in the boxes inserted their monocles, in order to get a better view....[26]

This particular brawl came late in the movement's Paris tenure, when many had long since declared Dada finished, so it may seem to express nothing more than personal animosities. If we return to 1920, however, we find just this combative merger of victim and aggressor, audience and performer, modeled in another act from the Festival Dada. The manifesto, written by Picabia and published in his journal *Cannibale*, takes the form of a barbed dialogue between an Orator and a Spectator:

ORATOR: That artist or this bourgeois is but a gigantic unconscious who takes his timidity for honesty! Your kindness and admiration, good sir, are more despicable than the syphilis or gonorrhea you transmit to your neighbor, calling it your nature or your love.

SPECTATOR: I cannot continue to compromise myself with such an individual as yourself, and I invite all my fellow spectators to leave the theater together with me, we can't keep company with this character.[27]

6.7 Alfred Jarry, woodcut illustration for *King Ubu*, reproduced in Charpentier/Fasquelle edition of *Ubu Roi*, 1922. Bibliothèque Nationale de France, Paris

From questions of hypocrisy and acceptance, the debate moves onto the plane of sexual identity and then to a discussion of Dada's ultimate value for society: "DADA is speaking to you," intones the Speaker, "it can be neither victory nor defeat, it lives in space not in time." Yet it is the spectator who gets the final word—*misérable*—uttered as he kills the figure of Dada incarnate with a revolver. The program [360] announces that Breton read Picabia's manifesto along with one "Henri Hourly." No mention of such a person occurs elsewhere in the Dada annals; either Hourly was a pseudonym or, more suggestively, perhaps Breton read both parts, thereby intensifying the confusion of Dada and its audience onstage. A related photograph, likely dated to this event, shows Breton wearing a sandwich board with a target painted on it, as he tenders a sheet of Mouvement Dada letterhead [see p. 347].[28] Picabia produced this witty placard as well, which carried the following inscription: "In order for you to like something, you need to have seen and heard it for a long time bunch of idiots Francis Picabia." Echoing Jarry's usurping Ubu [fig. 6.7], who wears a target on his belly, Breton heaps condescension upon his audience even as he invites them to fire upon his person.[29] Dadaist violence, indeed, "can be neither victory nor defeat," for it is at once sovereign and, as scholars have noted, singularly masochistic.[30]

Like the plays and stage appearances, individual works produced within Paris Dada emanate a violent humor, ranging from vulgar or sacrilegious language to images of weapons and wounds (see *Tristan Tzara* [333]), or references to taboos great and small: suicide, cannibalism, masturbation, vomiting. In the original, lost version of Man Ray's *Cadeau* (Gift) [331], the brass tacks doubtless shone against the black metal iron, their sharp points glistening like a row of bayonets or the threatening snarl of the "vagina dentata." With similarly erotic and military overtones, Hans Arp's 1922 construction *The Eggboard* [349], condenses Dada spectacle into a contentious abstraction. Biomorphic shapes, painted a uniform blue and surmounted by ovoid elements, stand in orderly rows disturbed, however, by dripping patches of orange, brown, green, and yellow. Speaking in the 1940s, Arp described his choice of motif in relation to a vicious Dada idea for "an outdoor and parlor game for the upper crust, in which the players are smeared with egg yolk from head to foot by the time they leave the arena...."[31]

In this fantasy, well-heeled spectators would internalize their experience of Dada and replicate it among

themselves, engaging in a silly conflict that highlights the futility of official campaigns of aggression. Arp recalled the idea as naïve, claiming "the bourgeoisie...has less imagination than a worm." This rueful comment does not do justice, however, to Dada's seditious appeal. Precisely its most recalcitrant opponents, shaking with rage, were driven time and again to test their own Dada voice. Thus, the critic Asté d'Esparbès, after pronouncing the Festival Dada an unendurable mess, and swearing his desire that this be the last article ever written about the group, confides that upon leaving, "I called the conductor a subversive water fountain, the passengers frenetic vaseline, the Madeleine a public burden, the Boulevard des Italiens a peremptory chess game with vegetal balconies...."[32]

The brutal collision of phallic and ovoid shapes in The Eggboard also humorously suggests a primitive sex act. Jane Hancock has interpreted this piece as equating a masturbatory, unproductive eroticism with soldiers in a suicidal lineup, sacrificed to the brutality of war.[33] For Hancock, the battle lines are clear; in this and other geometric abstractions of the 1920s, she contends, Arp articulates a desire to infect unthinking reason with irrational, insightful disturbance. One might clarify, however, that The Eggboard brings orderliness and disturbance into eternal cohabitation. The combination of mock military discipline and egg-tossing insurgency is characteristic of Dada inventiveness, which structures violence even as it rankles tranquility. During their

Zurich days, Arp and Sophie Taeuber developed an abstract vocabulary that alternated between apparently haphazard shapes and the constricting order of the grid [see 20–24]. The Eggboard sustains a similar dialectic, particularly when one considers that the rows of blue figures might also signify catapults to launch the eggs atop them at other potential victims. Covered in splatters of paint and unbroken yolks, The Eggboard is both a surface and an object, a target and a tool of aggression.

Picabia likewise concentrated on ordered violence and aggressive sexuality, but in another register. His earlier mechanomorphic paintings inserted the machine as a mean-spirited surrogate for the feminine. Now, in the years of Paris Dada, he elaborated on this thematics of malevolent womanhood to establish an interplay between eroticism, shooting, and targets. In Jeune fille (Young Girl) [375], and La Sainte Vierge II (The Virgin Saint II) [367], both 1920, the female figure is pictured as a gunshot and its effects. Young Girl, a drawing with a circular cutout around which the title is written, reads as a vulgar pun. Both bullet trace and girl are portrayed abstractly as a "tight hole." This abusive representation receives an anticlerical cast in The Virgin Saint, where the Madonna figures as a splatter of blood that crudely evokes defloration. The Virgin Stain, as one might call it, carries a further pun, for vierge (virgin) sounds very close to verge (prick). In any reading, the exemplar of lofty maternity has been defiled, made material, through projectile ink.

Around 1922, Picabia signaled a new relation to these subjects and to Dada itself, revising his lexicon of erotic aggressions via recourse to classical figuration, on the one hand, and geometric abstraction on the other. Two paintings exhibited at the Salon d'automne in September 1922 announced this shift, duly noted in the New York Times as "Geometrism" in contrast to "Cubism and Dadaism."[34] The resulting works do not so much reverse Picabia's violent inclinations, however, as offer a newly schematized expression of them. La Nuit espagnole (Spanish Night) [fig. 6.8] and La Feuille de vigne (Fig Leaf), both 1922, use classically stylized nudes to satirize the dominant postwar aesthetic. By appropriating the poses and technique of Jean-Auguste-Dominique Ingres in cartoon form, Picabia thumbed his nose at a major figure of French cultural tradition, one tied very closely to the nationalist "return to order."[35]

Picabia did so more precisely by violating the figure of the classicized nude. In Spanish Night, a male flamenco dancer, silhouetted in black against a white background, reaches across a stark divide to enchant his apparently prudish—

6.8 Francis Picabia, *La Nuit espagnole* (Spanish Night), 1922, oil on canvas. Museum Ludwig, Cologne

though naked—female partner, presented in reverse silhouette in a pose quoted from Ingres' 1856 painting *La Source* (The Spring). The Ingresque female seems the ostensible spectatorial prize, bedecked with luridly colored red and pink targets over her erogenous zones. Potshots riddle both figures, however, suggesting once again a combination of violence and pleasure that spares no one. In a related painting from 1923, *Dresseur d'animaux* (The Animal Tamer) **[380]**, the title figure seems precisely designed for a sadomasochistic ball, though he himself is curiously emasculated. Once again, dadaist insurrection is presented in a mock orderly fashion; Picabia uses a caricatural imitation of studies in classical proportion to show his imperturbable eunuch as both master and slave to a motley gathering of dogs, whose attitude toward training ranges from attentive to urinary.

Picabia explored this thematic as well in *Optophone* **[378]**, c. 1922, exhibited at the Galerie Dalmau in Barcelona and again in Paris at the Salon des indépendants in 1923. Here, a shift in scale causes the target's rigid geometry to engulf the female figure, partly covered as well by a swath of saffron-colored pigment. The nude, rendered in delicate contour lines, conjures the odalisque also beloved of Ingres, imprisoned here within a highly structured field of concentric circles. A closely related work, *Chariot* **[377]**, c. 1922–23, similarly employs a coercive linear pattern to contain a fragile figure. In each painting, there is a sense that the body is fighting a losing war with its surrounding geometry. The

nude in *Optophone*, her sex squarely positioned at the bull's-eye, becomes the target of desire on the part of spectators such as those seen at the Dalmau opening—one with a cigar conveniently jutting into the white space near the painting **[fig. 6.9]**. Yet Picabia's title enables an alternative reading, for the optophone was a machine designed to convert light into sound and vice-versa.[36] The concentric circles may thus be read as radiating signals, while the nude becomes an energy-emitting source rather than the focus of desiring looks—once again complicating the distinction between origin and object of aggression.

Marcel Duchamp's contemporary experiments in rotation pursue a less literal motif of moving spirals that convey a hypnotic sense of penetration. Duchamp's *Rotative Demisphère (Optiques de précision)* (Rotary Demisphere [Precision Optics]) **[326]**, 1924, and the related *Disks Bearing Spirals* **[325]**, 1923, or the film *Anémic Cinéma*, 1926 **[see p. 415]**, result from an investigation of optics and erotics, where a spiral form set in motion alternately projects into the space of the viewer and recedes. These pulsating, breastlike forms make vision seem palpable and manifestly eroticize the act of seeing. The endlessly rotating forms threaten viewers with extinction through repetition; the death drive beats beneath the libidinal pulse.[37] Man Ray's *Indestructible Object* **[332]**, on the other hand, consolidates the look of danger through an alternate rhythm. The pendulum of a metronome, carrying the photograph of a

6.9 Opening of Francis Picabia's exhibition at Galerie Dalmau, Barcelona, 18 November 1922. Comité Picabia, Paris

disembodied eye, swings back and forth, menacing and taunting the viewer with its persistence.[38] Once again, the victim here is also the aggressor, as Man Ray authorized each viewer to construct and obliterate a similar effigy: "Cut out the eye from a photograph of one who has been loved but is seen no more. Attach the eye to the pendulum of a metronome and regulate the weight to suit the tempo desired. Keep going to the limit of endurance. With a hammer well-aimed, try to destroy the whole at a single blow."[39] Man Ray completed this piece only in the 1930s, when he attached to the metronome the image of an eye from his lost love, the photographer and model Lee Miller. The conflation of subject and object in this mechanical assemblage harkens back, however, to Dada's proclivity for shifting damaging desires incessantly between audience and actor.

PRODUCTS

If Man Ray's assemblage *Indestructible Object* epitomizes Paris Dada's violent reversals, its material components signal in exemplary fashion the dadaist engagement with sundry commodities. Of all the Dada cities, it was Paris that most emphatically made Dada into a recognizable brand name. With crowds of thousands and a steady stream of press chatter, the movement became *en vogue* in Paris more than anywhere else; it did so, not coincidentally, in a city historically attuned to the nuances and pitfalls of fashionability. The record of Paris Dada is filled with commentary on artistic creation as a product line, on the salability of scandal, and on the possibilities—however futile—of art entering the commodity stream yet halting its flow. Between New York and Paris, indeed, dadaists brought to the fore a key, even definitional, area of discourse for avant-garde art, namely its relation to commodity fetishism. By engaging consumer society in the themes, materials, and procedures of their art, instead of attempting to transcend it, evade it, or observe it with detachment, the dadaists confronted the challenge inherent in innovative bourgeois culture: to sell without selling out.

The nineteenth-century legacy of commercial passages and *grands magasins* marks Paris as a city of glittering wares and trade spaces—the Paris memorialized by Louis Aragon in *Paysan de Paris* (Paris Peasant), 1926, and later by Walter Benjamin in his *Passagenwerk* (Arcades Project), left unfinished in 1940. Along with advanced technology, the French capital also excelled in the production of recuperated goods from castoffs and rubbish, which were traded among the lower classes in venues like the flea market of St. Ouen.[40] Breton moved toward the flea market in his surrealist phase,

disrupting the commercial ecology there by declaring the true "find" to be an object of negligible exchange value, in the art market or everyday life. That practice had its roots, however, in the Dada era; it took off from Duchamp's "readymade," a concept born between Paris and New York, and from the uniquely Parisian notion (in the "excursion" of 1921 and related ideas) to interrogate the city itself as a commodity spectacle. Manufactured products, meanwhile, became works of art not just through the operation of the readymade, but also in the dysfunctional machines painted or assembled by Picabia, Jean Crotti, Man Ray, Ribemont-Dessaignes, and Suzanne Duchamp. These painted works disassemble, as it were, the American glorification of the machine that Picabia, Duchamp, and Crotti encountered in New York, and which soon found its echo in modern art under the rubric of the "machine aesthetic."[41] In France, that more affirmative view, with its vocabulary of straight lines and standardized production, is epitomized in purism, which has been pitted along with the "return to order" against the nihilism of Dada. However, overlap between the seemingly polar groups occurred in journals like Theo van Doesburg's *De Stijl*. Such heterogeneous collaborations evidence more fluid and ambivalent relations to the machine across the spectrum of avant-gardes.[42]

The readymades and machinic compositions of Paris Dada came accompanied by an ironic commercial rhetoric elaborated largely by Tzara, Picabia, and Duchamp. In 1922, for example, Duchamp proposed to Tzara a scheme for incorporating Dada internationally. Cast in ordinary metal and in gold, platinum, and silver editions, the word could be purchased for as little as one dollar and worn as "bracelet, badge, cuff links or tie pin....The act of buying this insignia," Duchamp explained, "would consecrate the buyer as Dada... the insignia would protect against certain maladies, ...something like those Little Pink Pills which cure everything...a universal panacea, a fetish in a sense...."[43] This rank capitalist gesture— to sell the "protection" of name-brand scandal to anyone willing to part with a dollar—exemplifies a desublimatory, mock-democratic impulse in Dada tied precisely to petty commerce. It echoes Tzara's disavowal, in response to a letter from Duchamp requesting his imprimatur for the journal *New York Dada*: "You ask for authorization to name your periodical Dada. But Dada belongs to everybody...Like the idea of God or the toothbrush (an excellent invention by the way)."[44] Dada was marketed, as that comparison implies, to be an article of faith and an item of light manufacture—a belief system for sale at the local store.

The conspiratorial agreement between Tzara and Duchamp to make membership in Dada purchasable by one and all signaled a distinctly commercial avenue for their art, while reserving curative and transformative powers for its name.[45] Where Dada's German adherents adopted epithets like "dadamax," "Dadasoph," or "Oberdada," the group in Paris treated the word as a brand or class of manufacture. Picabia generated categories of antiart production, for example, labeling his own and others' works "Dada Picture" and "Dada Drawing" **[317, 318]**. Tzara, meanwhile, suggested with his Paris publications an alternative market environment in which Dada ruled the burgeoning media and advertising world: *Bulletin Dada*, *Dadaphone*, *Dadaglobe*.

Unlike conventional brands, the Dada label stood for no stable or reliable line of merchandise. In this lay its subversion of the marketplace, which rewards brand identity just as the mechanisms of cultural capital reward style in art. Unreliable manufacture thus offered a calculated affront to both aesthetic conventions and accepted commercial practice. Precisely by bringing art, hyperbolically, into the marketplace —by packaging it as a common product—dadaists could demolish the barrier pretentiously erected to safeguard art as a "higher value" and also sabotage regular business operations.

The simultaneous infiltration of institutionalized art and institutions of commerce proceeded unequally, however, for art made an easier target. Particularly vulnerable were recent avant-garde movements, like expressionism, cubism, and futurism, that had begun in rebellion only to become quickly accepted, established. In his "Manifeste Dada 1918," **[see fig. 9, p. 12]**, which galvanized the future Paris Dada group, Tzara decried the accommodation of art to a buying public and the avant-garde's descent into academicism:

> We have enough cubist and futurist academies: laboratories of formal ideas. Is the aim of art to make money and cajole the nice nice bourgeois? Rhymes ring with the assonance of the currencies and the inflexion slips along the line of the belly in profile. All groups of artists have arrived at this trust company after riding their steeds on various comets. While the door remains open to the possibility of wallowing in cushions and good things to eat.[46]

Tzara entreats his listeners to oppose the degradation of art into revenue for a plush lifestyle, yet after skirting this moral high ground he deliberately abandons it once more to flirt with the equation of art and commerce: "Dada is the signboard of abstraction: advertising and business are also elements of poetry."[47] The question taken up by Dada was not

how to avoid industrial capitalism altogether, seeking refuge in Worpswede or Tahiti, or founding latter-day artisans' guilds in England and Austria; it was, precisely, how to enter the capitalist world to critical effect—to make poetry from business without making a business of poetry, or making poetry that was merely good for business. "Therefore, Madam, be on your guard," added Tzara in his letter regarding *New York Dada*, "and realize that a truly dada product is a different thing than a label."[48] Just what that "different thing" could be forms the crux of Dada's art production.

Duchamp conceived the readymade en route between the crowded storefronts of Paris and Rouen and the new economy of skyscrapers that he discovered in New York. Some of his earliest examples involved objects purchased in France. When he departed for America in the summer of 1915, Duchamp left sitting in his studio the items he would later remake and designate as "readymades," *Roue de bicyclette* (Bicycle Wheel) and *Porte-bouteilles* (Bottlerack) **[253, 254]**. He had earlier "rectified" a calendar landscape, purchased at an art supply store in Rouen, with a dot each of red and green pigment (standard colors of the French apothecary) and called it *Pharmacy*. In New York, he bought a snow shovel and inscribed it with the prognostic phrase *In Advance of the Broken Arm* **[255]**; then he wrote his sister Suzanne, still living in Paris, and asked her to help him do the same with *Bottlerack* by choosing her own phrase and similarly inscribing it upon the object. To aid her, Duchamp explained his notion by reference to the American influence: "Here in N.Y., I have bought various objects in the same taste and I treat them as 'readymades.' You know enough English to understand the meaning of 'ready-made' that I give these objects..."[49] His selection of goods, each typical of its country—a stand for drying wine bottles and a bicycle wheel in the land of oenophiles and cycling enthusiasts; a snow shovel in a city famed for its work ethic and its blizzards— suggests that the notion of the readymade took shape in the negotiation between two highly developed consumer societies, places where cultural identity could be consummately encapsulated in purchaseable goods.

Art historian Molly Nesbit has shown how Duchamp's inclination toward industrial products derived from his typically French childhood education.[50] Trained in drafting as part of a standardized curriculum that inculcated in students a love of industrial manufacture, Duchamp acquired early the skills that guided his readymade choices and his plan for *The Large Glass* **[248]**.[51] When he sought to undermine reigning conventions of art, Duchamp turned not to handicraft or

rubbish but to common industrial or consumer goods: comb, typewriter, snow shovel, urinal. Having established his preference for mechanical drawing over painterly effect, Duchamp then moved into production, commissioning new works to be manufactured by others in the same spirit. While still in New York, he ordered a miniature window from a carpenter and dubbed it *Fresh Widow* **[273]**, a punning title that refers to the double windows common in Parisian apartments as well as the newly minted widows of World War I. Like all core Dada works, this object mixes the mechanical and the handmade—but it does so at the level of ideas rather than appearance. *Fresh Widow* looks like a floor sample for a perverse line of windows built to admit no light. If he had wanted to profit from his flagrantly unproductive product, Duchamp might have applied for a patent. Instead, Duchamp took the multiply ironic step of hand-painting a copyright notice on the piece in the name of his alter ego, Rrose Sélavy. This designation (assuming it were valid) protects not ideas intended for mass manufacture but the unique intellectual property of individuals, such as poems, art images, or music.

The Brawl at Austerlitz **[323]**, 1921, another miniature window commissioned with the French context in mind, was in fact made in Paris. The title punningly conflates the name of the Parisian train station, Gare d'Austerlitz, with the Napoleonic battle commemorated by that station—once again joining industrialization to a history of war. During the Third Republic, Parisian train stations became favorite subjects of Edouard Manet and the impressionists. Shown as sites of passage obscured by billowing steam, these train station paintings figured modernity as a challenge to existing habits of vision, yet they remained firmly within the camp of salable, and in Duchamp's parlance, *retinal*, art—an art rejected by both Duchamp and Tzara. In Duchamp's oeuvre, the canvas is replaced repeatedly by panes of glass, as in this work where (again in echo of *Fresh Widow*) vision is frustrated by white streaks. These smudges imitate a glazier's markings, their placement in the middle of each pane a deliberate affront to taste and vision. Neither good art, if by that one means a window onto reality, nor finished work (the white streaks ought to be removed at the end of the job), *The Brawl at Austerlitz* manages to undermine faith in art and labor alike, as well as in the marketplace for either form of production.

Returning to the apothecary on a different trip to Paris, Duchamp produced another pharmaceutical readymade, asking a druggist to empty and reseal an ampoule labeled "physiological serum." Back in New York, he presented the resulting 50 cc *Air de Paris* (50 cc of Paris Air), **[324]**, to Walter Arensberg as a souvenir. In this exchange, a purchase was drained of its usefulness, in resistance to what Tzara called the "monetary system"; if it had any curative power this would, once again, be in the realm of Dada. Likewise, Duchamp made his wedding gift to Suzanne Duchamp and Jean Crotti in the form of directions for a readymade, to be fabricated by leaving a geometry book outside where the winds would tear apart its pages.

One might suppose that, as gifts, these works left the commercial economy for an alternative circuit of exchange. Yet Man Ray's *Gift*, mentioned earlier, which follows a similar logic of gift giving, makes plain the difficulty of escaping the world of trade. Months after his arrival in Paris, Man Ray made his solo debut at Philippe Soupault's newly acquired bookstore, Librairie Six. During the opening, Man Ray slipped out to a hardware store, where he purchased the items for this final, impromptu contribution to his exhibition. Gluing the upended tacks to the iron's smooth surface, Man Ray proffered a "gift" that seems more like a weapon, conjuring the image of a bloodied and scorched recipient. In the logic of French anthropologist Marcel Mauss' *Essai sur le don* (The Gift), 1925, this work dramatizes the indebtedness established by gift exchange, arguing for the intractability of commercial culture.[52] Even in a tribal context, Mauss argued, the presentation of material goods binds individuals willingly or not to a larger circuit of trade and community. Man Ray's thorny object thus makes palpable the risks associated with accepting such an offering, even if given in the spirit of friendship.

As part of his gambit to move from manufacture into production, Duchamp also undertook on occasion to play the role of salesman.[53] In *Tzanck Check* **[322]** 1919, Duchamp boldly reduced art to monetary value when he drew by hand a check for his dentist Daniel Tzanck. Written in English and made out in dollars on an American bank, even though the transaction took place in Paris, the check promised its payee an exorbitant fee of $115 for dental care. Realizing the inflation of his own signature, Duchamp eventually bought back his faux check from the dentist for more than its stated worth. Tzanck, an avid collector who regularly traded his services for art, thereby achieved what many barkeeps hope for when they accept paintings in exchange for libations—the artist's signature, the brand name incarnate, gains in value over time, rewarding the tolerant creditor with good returns.[54] Similarly, Duchamp proposed in 1924 a gambling scheme to generate "guaranteed" winnings at the roulette tables in Monte Carlo, financed by a bond offering

that traded explicitly on his value as authorial investment capital, *Obligation Monte Carlo* (Monte Carlo Bond) **[320]**. "If anyone is in the business of buying art curiosities as an investment," noted Jane Heap in *The Little Review*, "here is a chance to invest in a perfect masterpiece. Marcel's signature alone is worth much more than the 500 francs asked for the share."[55]

While Duchamp interrogated the intricacies of trade relations, Picabia and others took apart the aesthetic of industrial manufacture in paint, reconfiguring sexuality and the human body as emanations of mechanical production. In 1919, Picabia exhibited four mechanomorphic paintings in Paris at the Salon d'automne. *L'Enfant Carburateur* (The Child Carburetor) **[276]** followed Duchamp's iconography of the bride and her bachelor apparatus, suggesting that this relative of his *Fille née sans mère* (Girl Born Without a Mother), 1917–1919, is likewise a dysfunctional machine. The significance of this work and others, rendered with house paint on raw plywood, escaped the organizers; obliged to include a former Salon member, they relegated Picabia's submissions to the stairwell. Picabia responded by wondering aloud, in the *Journal du Peuple*, whether the Salon "exists only to support the dealers" and nationalist or academic painters, and suggesting pointedly that the organization's recent move to the Grand-Palais may have prompted a deliberate retreat from truly modern art.[56] Picabia pressed similar institutional attacks throughout the Paris years. "Dada accuses you of liking everything through snobbery, once it costs a lot," he wrote in a manifesto delivered during the 1920 season, taking aim at a complicit audience with arguments ironically comparable to those used by the movement's fiercest opponents.[57] One recalls as well his painting *Double World* **[371]** from the very first Paris Dada event, which included in the composition crating indications and the designation "ship to the home address." As Picabia recognized, salability, fashionability, popularity had become pivotal terms of discussion here, markers of an institutional authority that threatened to crush Dada by marginalization and assimilation in equal measure.

Ribemont-Dessaignes, Crotti, and Suzanne Duchamp, all familiar with Picabia's machine idiom from its inception in New York, expanded on it in Paris even before Picabia's return in 1919. Ribemont-Dessaignes, a close ally of Picabia who became managing editor of *391* in 1919–20, proposed his own maleficent machine in *Silence* **[359]**, c. 1915. A menacing composite of gears and bellows, springs and screws, this painting suggests the destructive force of industrial production run amok. Crotti's *La Mariée dévissée* (The Bride Unscrewed) **[351]**, 1921, the result of another dangerous

mechanical operation, appears to have been formed by the explosion of a timepiece or other implement. Stenciled letters and numbers scattered throughout the composition shift in scale to produce the effect of movement in space. In opposition to Duchamp's bridal figure, this painting suggests a personal narrative, almost certainly alluding to Crotti's consort Suzanne. She in turn produced her own anxiety-laden, yet amorous machine coupling in *Un et une menacés* (He and She Threatened) **[355]**, 1916. Here, an actual plumb bob dangles from a painted series of pulleys and a gear. This multimedia mechanism intersects with the image of a tilting crane, a less than subtle phallic reference. These machinic compositions evince the Dada desire to destabilize distinctions between art and industry, whether in paint or typography, prose or poetry. At the biggest showing ever of their work, however, in April 1921, Crotti and Suzanne unexpectedly announced their departure from Dada to form "TABU," a two-person movement that infused abstract paintings with spiritual and symbolic intentions.[58] Yet even with this decision, they remained within the dadaist fold, for such declarative splits are in fact germane to the structure of the Paris group.

ALLIANCES

"All society is but an ensemble of intertwined solidarities."
—André Breton, Robert Desnos, Benjamin Péret,
Comme il fait beau! (What Nice Weather!), 1923[59]

Dada sounded a battle cry against bourgeois culture; we have seen how its contingent in Paris treated institutions of art, public audiences, and the marketplace as enemy forces to be infiltrated through means "as violent as possible." As in the war that formed their generational consciousness, dadaists, too, sought allies for their various campaigns. This search had little to do with the utopian internationalism of later 1920s avant-gardes, however, for the dadaists came together precisely to test the mechanisms of communal behavior. Personal relations, no matter how tempestuous, did not guarantee the movement its uniqueness, later memoirs notwithstanding. What set Dada apart was its systematic reflection on the mechanisms whereby individual judgments are incorporated within a collective framework. For this reason it is more apt to speak of alliances, pacts, or unions within the movement than friendships or hatreds. The Paris group is paradigmatic in this regard. Their public quarrels and equally visible affirmations of solidarity, most often explained as expressions of character or "mere"

polemics, in fact traduce a reflection on community structure fundamental to Dada internationally.

Fractures in Paris Dada became public during the Barrès trial of May 1921, when Tzara and Picabia clashed with Breton [**figs. 6.10, 6.11**]. Mutual recriminations followed in print throughout that spring and again during much of 1922, appearing almost weekly at times, so that Paris Dada became a group of exemplary fragility. That instability would later be contrasted to the centralization and longevity of surrealism, the movement founded by several former dadaists—Breton, Eluard, Soupault, Aragon, and others—in 1924. Yet Dada's interrogation of community arguably prepared the structure of surrealism, a highly self-reflexive artistic formation that likewise kept unfettered individualism (e.g., explorations of the human psyche) in tension with insistently collective activity. The latter-day tendency to view Dada as the "anarchic" antithesis of surrealism, or as a transitory antecedent, obscures this structural continuity.[60] Likewise, fights over the paternity of key ideas, such as automatism, chance, or the very term "surrealism," make it difficult to appreciate to what degree those concepts are the common province of both groups. Such arguments have their origin in bitter recollections by surrealists, particularly Breton, who became eager to reject their dadaist past—an expression of the residual animosity that always arises when alliances go sour.

The atmosphere created by Dada tended not toward harmony but intensity—a word employed repeatedly by Tzara during his Zurich days.[61] Writing in 1923, Louis Aragon

6.10 The Maurice Barrès trial, Salle des Sociétés Savantes, Paris, 13 May 1921. Collection Timothy Baum, New York

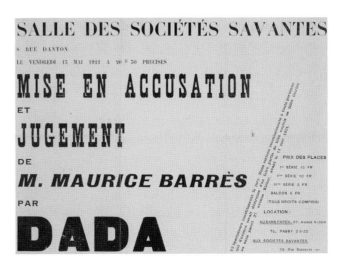

6.11 Poster for the mock trial of Maurice Barrès, 1921, letterpress. National Gallery of Art, Library, Gift of Thomas G. Klarner

tellingly recalled the aftermath of Paris Dada's inaugural spectacle, the "First *Littérature* Friday," in similar terms:

> Leaving the edginess of our début, we were overcome by disgust at all this stupidity we had just stirred up for the first time.... André Breton, Théodore Fraenkel, Paul Eluard and I walked back in a very bad mood, and we argued over boots lying on the sidewalk.... Suddenly my patience gave out and I told Eluard two or three of those violent truths for which the person who says them can't be forgiven. It was like a strong electric discharge, there on the Boulevard Sébastopol. One could say that the Dada movement truly began then, with its fights, its arguments and that heavy atmosphere...all the shame which marked that singular period and which fails to explain its sparks and its darkness.
>
> Still, there was a sort of bond of affection between us.... We spent almost the entire next day together, and there was no more talk of last night's dissensions.[62]

The structure of a Dada soirée pitted the performers against one another as well as the audience; one thinks again of Tzara reading from the newspaper while Breton and Aragon drown out his recitation with clanging bells. That fractious intensity was what Dada affiliates probed in their public events, and the energy released by it illuminated their artworks and publications. Certain guiding ideas came from Tzara and his experiences in Zurich, but the editors of *Littérature* developed novel mechanisms of critical insight. The team of Breton, Aragon, and Soupault launched their first interrogation of community values already in November 1919 with the survey, "Pourquoi écrivez-vous?" (Why Do You Write?). This disarmingly simple query permitted a brilliant exposé of the stagnating literary scene in Paris, thanks to the complicity of the more than eighty respondents whose answers appeared in three subsequent issues, days before the rush of Dada's first "Season." Authors who strove for sincerity sounded merely inane: "For the pleasure of expressing my thoughts freely" (Louis Vauxcelles); "To try to express all that can be divine in the human condition" (Jean Bertheroy). Academician Jean Giraudoux made patent the high-handedness and xenophobia soon to characterize the most virulent attacks on Dada: "I write in French, as I am neither Swiss nor Jewish and because I have all the requisite [honors and] degrees...." The best answers in this cleverly humiliating context were brief, subversive, and playful: "Because" (Blaise Cendrars); "To write better!" (Max Jacob); "To kill time" (Knut Hamsun).[63]

Newspapers and magazines made regular use of surveys (as they continue to do today) to garner celebrity quotes for their pages, or to harmonize public opinion on a controversial subject. (One chilling example of the latter is "Should the Dadaists Be Shot?," published in the *Revue de l'époque* at the height of Dada's controversial entry in April 1920, which elicited an overwhelmingly affirmative reader response.)[64] The editors of *Littérature* aimed to do neither. Instead, they used surveys combatively, to delineate areas of dissension among their respondents and, in a maneuver typical throughout Dada, within their own membership as well. The March 1921 issue of the journal, for example, opened with a ranking (from −25 to +20) of nearly two hundred cultural and political figures, from Ludwig van Beethoven to Marcel Proust, John Stuart Mill (−17.45) to Charlie Chaplin (+16.09). Next to the cumulative average for each person thus evaluated appeared the score allotted by each of the jurors: Aragon, Breton, Eluard, Ribemont-Dessaignes, Tzara and others. Furthermore, their names all figured on the list of those ranked. Readers were thereby invited to perform their own evaluations, to gauge the relative popularity within Paris Dada of its own members, and to assess where the group agreed and where its adherents parted company.[65] Just over one year later, in April 1922, *Littérature* revisited this structure in a less competitive register with the survey "Some Preferences," which listed answers to a questionnaire on personal choices—favorite city park, favorite color, favorite body part—submitted once again to the journal's contributors. "We defend [little] our predilection for certain things around us. It's in this area as well that we find ourselves the most foreign from one another," opined Breton in his prefatory remarks.[66]

Group activities were designed, then, not to promote easy solidarity but to make participants uncomfortable. Everyone had to score everyone else while "defending" choices that, as Breton put it, only enhanced a sense of mutual estrangement. Even the survey "Why do you write?" which implicitly united young rebels against literary stuffed shirts like Giraudoux, nevertheless refrained from delineating camps of opposition. Each respondent was thus left to find his or her own allies.

Similarly, the 1921 Dada Season took shape during a meeting filled with contentious exchanges, the record of which appeared in *Littérature* in December 1920 under the title "Court Report" (Procès-Verbal).[67] There followed "a series of meetings and discussions" in public spaces during early 1921, deliberate echoes, as has already been noted, of councils

held during the French Revolution.[68] These elaborate preparations mirror the format of the Season itself, particularly the Barrès trial. Breton pursued this mock courtroom format subsequently. In the first days of 1922, an announcement appeared in *Comoedia* for his most ambitious venture to date, the Congrès international pour la détermination des directives et la défense de l'esprit moderne (International Congress to Determine the Aims and the Defense of the Modern Spirit), known commonly as the Congress of Paris. Breton assembled for the purpose a deliberately eclectic coalition of fellow organizers to guide deliberations on contemporary artistic innovation, its future, and its manifold differences from reactionary adherence to the past.[69] Representatives from several countries were to debate the nature of "the modern spirit," then, in an exchange that as Breton envisaged it would yield clarity but by no means consensus. Indeed, as throughout his Dada career,[70] Breton stressed here that disunity served as his governing principle:

> The [seven] members of the organizing committee…
> profess ideas too divergent to be suspected of agreeing among themselves so as to restrict the modern
> spirit in favor of a chosen few; their *dissensions are public*. The misunderstanding among them attests to the
> impartiality at the heart of this Congress. It nevertheless permits the endurance of a *minimum of agreement*
> so as not to paralyze this venture.[71]

A feud that erupted between Breton and Tzara, which played itself out on the pages of *Comoedia* and other newspapers in February–March 1922, demolished plans for the Congress; typically, the verdict came in the form of a published "resolution," following a quorum to which people had also been summoned by newspaper announcement.[72] This verbal skirmish spurred Breton, who had already indicated impatience with Dada, to write a series of essays denouncing the movement as empty and finished.[73] Yet the self-reflexive, definitionally factious grouping Breton proposed for his Congress project retained hallmarks of a Dada venture. The Congress would have forced, most notably, an investigation into the basis for an avant-garde alliance, as indeed the language of the initial press release implies: "agreeing among themselves" (*s'entendre*) and "misunderstanding" (*malentendu*) both relate to *Entente*, the French name for Allied opposition to Germany in World War I. Entente was the goal of this project: a provisional accord marked by the "minimum of agreement" necessary to further mobilization.

Dada's mercurial community, which tested itself under varying circumstances in most of the movement's city centers, produced many expressions of maximal collectivity as well. In Paris, following the musketeer spirit of "one for all, all for one," we have the solo exhibitions of Picabia and Ribemont-Dessaignes (April–June 1920), Max Ernst (May–June 1921), and Man Ray (December 1921). These last two shows in particular were organized and broadcast to the press as collective manifestations. A review of the Ernst exhibition in *Comoedia*, appeared under the rubric: "The 'Dada Season' Is On." It came illustrated with a photograph taken in front of the exhibition space at Au Sans Pareil showing René Hilsum, the owner, alongside an *assemblage vivant* that featured Soupault with a bicycle, itself perched on top of a ladder, with Breton as counterweight **[see p. 348]**.[74] Ernst, denied a travel visa, appears here in name alone, on a poster for the show. This substitution of an object or representation for a person inadvertently furthers a common Dada practice of placing surrogates in group photographs **[fig. 6.10]** as a means to deflate the unifying myth of "being there" usually projected by pictures of social bonding.

The Man Ray exhibition at Soupault's Librairie Six provides another fine study of the Dada collective in action. "We read in all the magazines and newspapers that Dada is long dead," opens the press release, sent to the dailies on 1 December. "The haste with which people are burying this character proves conclusively and amusingly how annoying and burdensome Dada was.… The interrogations, subtleties, and bawling of this *enfant terrible* bothered all the upstanding, conscientious artists." The corporate Dada body, pictured here grotesquely as a child buried alive under bad press, produced this show in its key aspects. The accompanying catalogue consisted of an anonymous preface followed by "some definitive remarks," semi-nonsensical quotations from the group's many members that read like jibes spoken at a festive roast. Balloons had been hung across the exhibition space to further the party atmosphere—again not quite comfortable, as they hid the paintings themselves from view until they were popped with a loud bang by the Dada cohort.[75]

There are variants of a group portrait, finally, taken by Man Ray in November 1921, just before his exhibition opening **[fig. 6.12]**. Dada's allies of the moment, which include both Soupault and his wife Mick Verneuil, the bookstore's original owner, sit or stand for the camera with mock seriousness. Everyone seems pleasant enough, although they hold a variety of mysterious objects to no apparent purpose. At the far left, meanwhile, we see once again a surrogate

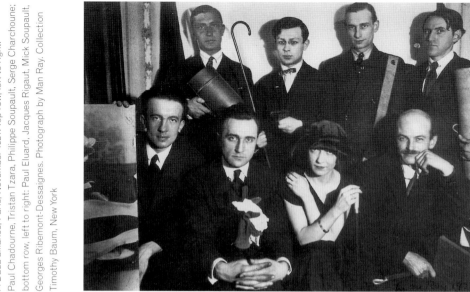

6.12 A Dada alliance, Paris, November 1921. Top row, left to right: Paul Chadourne, Tristan Tzara, Philippe Soupault, Serge Charchoune; bottom row, left to right: Paul Eluard, Jacques Rigaut, Mick Soupault, Georges Ribemont-Dessaignes. Photograph by Man Ray. Collection Timothy Baum, New York

object. In place of the photographer, Eluard holds up one of his recent paintings, drawing our eyes to the signature, place and date: graffiti to proclaim, "Man Ray was here." For a second version Man Ray pasted a self-portrait photograph over the painting, continuing his wry play upon identification (of oneself, with a group) through the typically dadaist form of collage.

Man Ray's photograph, in both its versions, continues in diminutive form the mural-size production L'Oeil cacodylate (The Cacodylic Eye) **[365]**, presided over by Francis Picabia for most of 1921. Begun during a spell of opthalmic illness in March, this monumental canvas was filled in by visitors to his sickbed, then shown audaciously that November at the Salon d'automne; finally, Picabia brought the painting out at a New Year's Eve party to invite further additions. He prepared the theme by painting in a large, cartoonish eye, an imitation plaque with the title at the top, and most provocatively his own "tag" along the lower left border surmounted by a small head shot of himself, smiling impishly. Further tightly cut pictures of faces—Gabrielle Buffet, Jean Cocteau, a highly sexualized photograph by Man Ray of a young woman smoking a cigarette **[300]**—endow this canvas with the jarring, half-mechanical and half-handmade look characteristic of Dada journals, particularly those by Tzara or Picabia's own 391. Duchamp, who understood intimately the subversion of art and language prepared by such a framework, pasted on two photos of his shaven head, adding under these shocking little images a pun that coupled Picabia's name to that of his own transgendered alter ego, Rrose Sélavy.

Tzara likewise grasped the fundamental solipsism of the exercise. His inscription, "Je me trouve très Tristan Tzara," at one level exposes the emptiness of readymade language by making an idiomatic phrase into a tautology: "I find myself very [myself]." In another reading, the line "makes sense" through a pun on Tzara's pseudonymous name that involves juggling multiple languages: triste an Tara means (in French, German, and Romanian, respectively) "sad for my country." Obviously, it is hard to be homesick and trilingual at once.

Cacodylic Eye marks a summa in the trajectory of Paris Dada; it distills the themes discussed throughout this essay. Spectacular, aggressive, radical in its challenge to audiences as well as to conventions of art and commodity value, the work also produces community in a singularly contestatory manner. "I am nothing," wrote Picabia in Comoedia at the time of his Salon d'automne showing. "I am Francis Picabia; Francis Picabia who has signed the Cacodylic Eye, in the company of many other people...."[76] These multiple signatories belonged to various camps, from core Dada adherents to fellow travelers, from worshipful protégés (Pierre de Massot), to benevolent onlookers (dancer Isadora Duncan, opera singer Marthe Chenal), to outspoken critics such as Jean Metzinger, or other painters who had no connection to the movement (François Hugo, H. Jourdan-Morhange). Among the latter names are undoubtedly some forgeries, a characteristic ruse. Yet these contributors, impersonated or not, whether amused or skeptical, have all been memorialized as momentary allies of Dada. Their cacophonous accord, which seems distant from Breton's idea for the Congress of

Paris, nevertheless operates along comparable lines: a "minimum agreement" that permits an accumulation of individual opinions to produce a forceful, visually and conceptually coherent whole.

Picabia's invitational work possesses a self-irony, a lightness of touch, as Breton's planned Congress did not, and this is the great difference between their two similarly ambitious projects. That divide in sensibility separates Tzara as well from the *Littérature* team, despite their shared, abiding desire for a revolutionary renewal of poetic creativity. Tzara's manner confounded the French. "In disputes, he would always abandon positions he had won or lost to move to the current object of debate," Aragon reported with bemusement.[77] Tzara's many publications and spectacles aimed too at memorializing fleeting alliances, of the sort pulled together through *Cacodylic Eye*. The lineup of differently colored ties nailed to a parapet wall at the Dada Salon of 1921, which Tzara took the lead in organizing, gives one figure for this motley community. Tzara's other great collective project in Paris, the unrealized anthology *Dadaglobe*, suggests the worldwide reach of his ideal avant-garde media concern. One may guess at the intended results from Tzara's earlier anthology, the double issue *Dada* 4–5 (May 1919) **[see 53, 54]**, which combines submissions from disparate movements and diverse countries to create, as Tzara wished, "an atmosphere of windstorm, dizziness, . . . the look of a great demonstration of new art in an outdoor circus."[78]

The circus, a public meeting-ground peopled by assorted performers engaged in loosely related enterprises, gives another figure for the Dada community as imagined by Tzara. Breton seems to have wished for a tighter, more interdependent ensemble. Differences on this point underlie the occasionally vicious disputes of 1922, which have too often been taken erroneously either as a clash in personalities or as the sign of an irreducible opposition between dadaist nihilism and the more constructive surrealist formation to come. Surrealism did indeed emerge as the new, reigning avant-garde constellation in late 1924. Interviewed soon after, Tzara reflected with bitterness on the difference between these two groups: "One notes that at the time of dadaism, no one wanted to be Dada. Now we have surrealism, and everyone is looking to be part of it, so much so that one needs to get a degree and, lacking surrealist diplomas, we are threatened by fists."[79] This partisan hyperbole nevertheless serves to emphasize that the question of group dynamics subtended both movements.

Max Ernst's monumental 1922 canvas *Au rendez-vous des amis* (At the Rendezvous of Friends) **[345]** stands as a "hinge work," to use the French expression, a depiction of the nascent surrealist community in terms largely consistent with the structure of a Dada collective. Its cast of characters, often presented by scholars as emphatically surrealist, in fact includes many who took part in Ernst's first Paris exhibition and other key events of the 1920–21 Dada seasons: Breton, Aragon, Benjamin Péret, Eluard, Théodore Fraenkel, Soupault, Arp, Ernst himself, and Johannes Baargeld, his closest collaborator in Cologne Dada. Tzara is indeed absent, just as key dadaists went missing at many important moments (Picabia and Breton declined to show at the Salon Dada, for example). But to focus narrowly on personalities misses the point, for Dada and surrealism alike strove, if anything, to deflate the cult of authorial egos. Such aims are manifest in the automaton appearance of these assembled "geniuses," their stiff poses and awkward gestures taken from manuals on psychiatric illness or communication among deaf-mutes.[80]

Far more important than the question of who is in or out of this painting is the sense it gives of how those present interact. The collaged appearance of this assembly, its facture from oil paint notwithstanding, suggests once again a crowd of jostling individuals who have arrived at an entente characterized by minimal agreement. Misunderstanding, indeed communication breakdown, seems the overriding theme at this get-together. Desnos and Baargeld, standing at the right, look as though they want to move in synch, as does the threesome of Péret, Jean Paulhan, and Fyodor Dostoevsky (in a cameo role, with Ernst as a ventriloquist's dummy on his knee) seated front and center. Managing somewhat to coordinate their awkward hand gestures, members of this improbable chorus line nevertheless step clumsily over one another's feet, to the tune played on a nonexistent piano by René Crevel. (Crevel's invisible keyboard rhymes visually with the boards of a miniature stage at left, where a cast of doll-sized people evidently collaborates far more fluidly than the painting's principal subjects.) Breton, ennobled by a red mantle, appears in vain to be calling a meeting to order. Further potential participants stand in line (including an unnumbered Ribemont-Dessaignes, another key dadaist), forming a processional left of center that disappears toward the horizon; from this undifferentiated mass, Ernst suggests, has spread forth a group of highly individuated allies who form a nearly dysfunctional ensemble.

The blatant display of hermeticism in *At the Rendezvous of Friends* seems ripe for an explanation that would "crack its code." Coding may be understood here, however, as an end in itself, a further means to interrogate the formation of community. Coded messages are designed to be opaque to outsiders but transparent for whomever possesses the key to unlock them; thus deciphered, they imply total communicability, a flow of information that is fully meaningful (if closely guarded). The "coded" references in *Rendezvous*, by contrast, hold no key to meaning, and the many hand signals in particular have to date eluded dogged scholarly efforts at cryptanalysis.[81] Elizabeth Legge has compellingly suggested that this "sign language without signification" matches the views of the *Littérature* group, which evinced extreme skepticism regarding the ability of words to hold or convey true meaning (Legge might have said the same of Tzara and Picabia).[82] Dadaists in Paris and elsewhere seized on stock phrases—clichés, slogans, puns—as glaring examples of the conventionality that permeates both ordinary language and most attempts at expressive writing. Eluard's journal *Proverbe* [374] suggests this focus in its very title; Aragon, meanwhile, published in Picabia's *Cannibale* a poem-manifesto called "Suicide," consisting simply of the letters of the alphabet printed in order.[83] Codes, which depend explicitly on convention for their comprehensibility and carry military resonance besides, fit well within this constellation of linguistic targets.

If the coded gestures in this painting hold no decipherable message, they do pay homage to a real-life "secret language": the trance utterances elicited at spiritist séances conducted in Breton's apartment beginning late September 1922, which Ernst attended as well. Breton reflected on these séances *in medias res* with his essay "Entrée des médiums" (The Mediums Enter), *Littérature*, November 1922, where he first stressed the term "surrealism" and defined it as "psychic automatism" connected with the dream state. These gatherings are thus rightly understood as the true beginning of the surrealist movement, which would be codified only two years later with the founding of the Bureau de recherches surréalistes and the publication of Breton's "Manifeste du surréalisme."[84]

These séances bear a striking, though not surprising, structural similarity to the collective activities undertaken in Paris Dada. "No doubt about it, here we are again: Crevel, Desnos and Péret on one side, Eluard, Ernst, Morise, Picabia, and myself on the other. We'll soon see how our positions differ," begins Breton, and right away we have the division

into groups, the interrogatory structure so familiar from earlier events.[85] Crevel, Desnos, and Péret played here the role of "sleepers," or those who entered a hypnotic state, while the others took turns questioning them. The exchanges were turbulent and—in another reminder of Dada—grew increasingly violent; Breton asked for an end to the séances in February or March 1923 because, as he recalled much later, Crevel had tried to instigate a group suicide, while Desnos had threatened Eluard with a knife.[86] Indeed, from the very first, participants exhibited a mix of unease and fascination that recalls strikingly the characterization by Aragon of the "First *Littérature* Friday," Dada's début event in Paris. "After each séance we are so bewildered and shattered that we promise ourselves never to start again," wrote Breton's wife Simone to her cousin barely two weeks into the experience, "and the next day, all we want is to find ourselves again in that catastrophic atmosphere where we all hold hands with the same anguish."[87]

Breton, Picabia, and other guiding participants in these spiritist séances had no interest in connecting with the dead, as Marguerite Bonnet observes, but in promoting a new "discursive capacity" among themselves. This discourse, marked by disjunctive, alogical snatches of speech, amounted to a "verbal collage" for which Ernst's works of 1920–22 provided a fitting analogue.[88] Breton sensibly dedicated the first literary production to emerge from the séances to Ernst. *Comme il fait beau!* (What Nice Weather!) appeared in *Littérature* in February–March 1923, just as the séances themselves were coming to an end. This collectively generated poem, the record of yet another tumultuous and short-lived group experience, may be seen to repeat the progression of Dada's first Season, which culminated in the May 1920 issue of *Littérature* with its "Twenty-Three Manifestos of the Dada Movement," or even of the meteoric passage marked by the Cabaret Voltaire and its eponymous journal in 1916 [see 7]. In each case, a coalition formed, possessed of magnetic appeal but also tantalizing fragility, and tested itself in the extreme before splitting apart to yield further creative paths. The difference is that where Dada coalesced on public stages, the surrealists sealed their pact in private rooms. From allies to initiates—but that is the subject of another story.

The authors wish to thank Mark Levitch for his steady hand in the preparation of this essay, and Thalia for her miraculous good nature.

1 Thus Jacques-Emile Blanche, among the most favorably inclined critics, commented one month into this stormy "season": "It is high time, really, to make a clean sweep, before rebuilding anything solid and pure" (*Comoedia*, February 26, 1920, 2).

2 The predominant attention (at least c. 1930–1980) to Dada as a Francophone phenomenon, despite its origins and tremendous spread in Germanic countries, reflects the number and influence of early memoirs: Louis Aragon, "Projet d'histoire littéraire contemporaine," in *Littérature* new series, no. 4 (September 1922), 3–6; André Breton, *Les Pas perdus* (Paris, 1924); Philippe Soupault, *Histoire d'un blanc* (Paris, 1927); Georges Hugnet, "L'Esprit Dada dans la peinture" in *Cahiers d'Art*, 1932–36, vol. 7, no. 1–2; no. 6–7; nos. 8–10 [1932]; vol. 9, nos. 1–4 [1934]; vol. 11, nos. 8–10 [1936]; and Georges Ribemont-Dessaignes, "Histoire de Dada," in *La Nouvelle revue française* 213 (June 1931), 867–879 and 214 (July 1931), 39–52, among others. In his groundbreaking anthology, *The Dada Painters and Poets: An Anthology* (Cambridge, Mass., 1951), Robert Motherwell reinforced the bias in these firsthand accounts, as later scholars have commented, by weighting the selection of texts two-thirds to one-third in favor of the New York–Paris axis.

3 Richard Sheppard, among others, makes this point in the introduction to *New Studies in Dada. Essays and Documents*, ed. Richard Sheppard (Driffield, England, 1981), 8–9.

4 Marguerite Bonnet calls 1920–1922 "l'intermède Dada," in André Breton, *Oeuvres complètes*, ed. Marguerite Bonnet, vol. 1 (Paris, 1988), 1280. Robert Short shares this view in his "Zurich Dada as Read by André Breton in Paris," in *Paris Dada: The Barbarians Storm the Gates*, ed. Elmer Peterson (New York, 2001), 95–131.

5 Cubism, for years the lightning rod for debates over modern culture in France, had been transferred as a term from art to poetry through commentary on writers such as Max Jacob and Guillaume Apollinaire, who kept company with the actual cubist painters. The "cubist generation" of poets included Pierre Reverdy and Pierre Albert-Birot, both of whom published periodicals of importance for Dada in Zurich and Paris; Paul Dermée and Ivan Goll count among the minor literary talents formed by Apollinaire, who held a fleeting place in Paris Dada.

On "cubist poetry" generally, see *The Cubist Poets in Paris: An Anthology*, ed. L. C. Breunig (Lincoln, Neb., 1995).

6 Louis Aragon, *Projet d'histoire littéraire contemporaine*, ed. Marc Dachy (Paris, 1994), 65.

7 Rachilde, "Le sourire silencieux," *Comoedia*, April 16, 1920, 1. Rachilde later supported the dadaists at the mock trial of Maurice Barrès in May 1921. See André Breton, "Les Enfers Artificiels," *Oeuvres complètes*, ed. Marguerite Bonnet, vol. 1 (Paris, 1988), 629–630; trans. by Matthew S. Witkovsky as "Artificial Hells. Inauguration of the '1921 Dada Season,'" *October* 105 (Summer, 2003), 143.

8 Jules Bertaut, "Le bourgeois enragé," *Comoedia*, April 16, 1920, 1.

9 Tristan Tzara, "Tristan Tzara," *Oeuvres complètes*, vol. 1, ed. Henri Béhar (Paris, 1975), 373. Tzara's text first appeared in an early, self-reflexive compilation, "Vingt-trois manifestes du mouvement dada," *Littérature* 13 (May 1920).

10 Aragon, *Projet*, 103–104.

11 Picabia, "M. Picabia se sépare des dadas," *Comoedia*, May 11, 1921, 2; reprinted in Francis Picabia, *Écrits*, vol. 2, ed. Olivier Revault d'Allonnes (Paris, 1978), 14–15; trans. by Matthew S. Witkovsky as "Mr. Picabia Breaks with the Dadas," *October* 105 (Summer 2003), 145–146. Tzara's transcribed testimony appeared in *Littérature* 20 (August 1921) and is reprinted in Tzara, *Oeuvres complètes*, vol. 1, 574. See also Marguerite Bonnet, *L'Affaire Barrès* (Paris, 1987), 38.

12 Aragon, *Projet*, 104.

13 Breton, "Artificial Hells," 140.

14 *Littérature* (May 1921), 24.

15 Michel Sanouillet, *Dada à Paris* (vol. 1) (Paris, 1965), 278.

16 Cited in Asté d'Esparbès, "Le Vernissage de l'Exposition Dada," *Comoedia* June 7, 1921, 2; a detailed description of the Salon Dada, including slogans, is found in Sanouillet, *Dada à Paris*, 275–285.

17 Sanouillet, *Dada à Paris*, 281, reprints an eyewitness account offered in *Le Petit Havre* (June 14, 1921); he also indicates that Mr. Jolibois had been asked to participate in the Saint Julien le Pauvre outing.

18 Sanouillet, *Dada à Paris*, 284.

19 "La Grande Saison Dada 1921," in Aragon, *Projet*, 103.

20 For more on the "return to order," or the general reiteration of classicist harmony and nationalist values in postwar France, which effectively repressed the trauma of the recent conflict, see Kenneth Silver, "Purism: Straightening Up After the Great War," *Artforum* 15, no. 7 (March 1977), 56–63, and Romy Golan, *Modernity and Nostalgia: Art and Politics in France Between the Wars*

(New Haven, 1995).

21 These exact motifs were tellingly revisited by Jasper Johns, following the next world war. On his related painting *Flag*, 1954–55, in the context of postwar America, see Fred Orton, "A Different Kind of Beginning," *Figuring Jasper Johns* (Cambridge, Mass. 1994), 89–146.

22 Georges Ribemont-Dessaignes, *Théâtre: L'empereur de Chine, Le serin muet, Le bourreau du Pérou* (Paris, 1966), 36–37.

23 Ribemont-Dessaignes, *Théâtre: L'empereur de Chine*, 124–125.

24 Georges Ribemont-Dessaignes, "Au Public," *Dada: Manifestes, poèmes, articles, projets, theatre, cinema, chroniques (1915–1929)*, ed. Jean-Pierre Bégot (Paris, 1994), 11–12. The threat to kill newborns was especially inflammatory given France's postwar preoccupation with "depopulation"—regarded across the political spectrum as a paramount national security issue—and the fervent neonatalist campaign launched to combat it, which led to the most oppressive law in Europe against propaganda for abortion and contraception (1920), among other measures. See Mary Louise Roberts, *Civilization Without Sexes: Reconstructing Gender in Postwar France, 1917–1927* (Chicago, 1994), 89–119. Thanks to Mark Levitch for pointing out this connection.

25 See Sanouillet, *Dada à Paris*, 174–178.

26 Cited from Evert van Straaten, " 'Tzara was almost beaten to death!' Theo van Doesburg an eyewitness of the Soirée du coeur à barbe," *Jong Holland* 3:4 (November 1987), 62.

27 Francis Picabia, "Festival—Manifeste—Presbyte," *Cannibale* 2 (May 25, 1920), 17–18; repr. in Francis Picabia, *Écrits 1912–1920*, vol. 1, ed. Olivier Revault d'Allonnes (Paris, 1975), 232–233.

28 Germaine Everling places this image at the Maison de l'Oeuvre event in March 1920, but the chronology in Isabelle Monod-Fontaine and Agnès de la Beaumelle, *André Breton. La beauté convulsive* (Paris, 1991) sites it at the Salle Gaveau Festival Dada. George Baker has argued that the latter is correct given its relation to the violence staged in this text. See George Baker, "Long Live Daddy," *October* 105 (Summer 2003), 63.

29 For more on the motif of the target in Jarry, see Elizabeth K. Menon, "The Excrement of Power: Alfred Jarry, Ubu Roi, and Dada," in Peterson, ed., *Barbarians Storm the Gates*, 33–66.

30 Sanouillet, *Dada à Paris*, 174–175.

31 Jean Arp, "The Navel Bottle," (1948), in *Arp on Arp: Poems, Essays, Memories*, trans. Joachim Neugroschel (New York, 1972), 239; quoted in Jane H. Hancock,

"Jean Arp's *The Eggboard* Interpreted: The Artist as a Poet in the 1920s," *Art Bulletin* 65: 1 (March 1983), 124.

32 Asté d'Esparbès, *Comoedia*, May 27, 1920, 3.

33 Hancock, "Jean Arp's *The Eggboard*," 135.

34 *New York Times*, December 12, 1922, cited in *Francis Picabia: Galerie Dalmau, 1922* [exh. cat., Musée national d'art moderne, Centre Georges Pompidou] (Paris, 1996), 90.

35 Arnauld Pierre advances this thesis in "Dada Stands Its Ground: Francis Picabia versus the Return to Order," in Peterson, ed., *Barbarians Storm the Gates*, 132–156.

36 See Marcella Lista, "Raoul Hausmann's Optophone: 'Universal Language' and the Intermedia," in *The Dada Seminars*, ed. Leah Dickerman with Matthew S. Witkovsky (Washington, 2005), 83–101. On the connections between *Optophone* and Duchamp's sound experiments, see Agnès de la Beaumelle, "Picabia kaléidoscope, 1922," in *Galerie Dalmau, 1922*, 14–16.

37 Rosalind Krauss develops this argument in "The Im/pulse to See," in Hal Foster, ed., *Vision and Visuality* (Seattle, 1988), 67.

38 For more on the operations of desire in this work, see Janine Mileaf, "Between You and Me: Man Ray's *Object to Be Destroyed*," *Art Journal* 63:1 (Spring 2004), 4–23.

39 "Object of Destruction," *This Quarter* V:1, special surrealist number (September 1932), 55.

40 On the Paris flea markets and their relation to avant-garde art, see Janine Mileaf, "From *Fountain* to Fetish: Duchamp, Man Ray, Breton and Objects, 1917–1936," ch. 3, Ph.D. diss. (Philadelphia: University of Pennsylvania, 1999).

41 See Dickran Tashjian, *Skyscraper Primitives: Dada and the American Avant-Garde, 1910–1925* (Middletown, Conn., 1975).

42 Hal Foster argues that the ubiquitous figures of interwar man-machines, from the constructivist engineer to the dysfunctional dada automaton to the surrealist dismembered mannequin, evoke the death drive with "the insistent call of the inhuman." See Hal Foster, "Prosthetic Gods," *Modernism/Modernity* 4:2 (1997), 30.

43 September 1922, Quoted in Todd Allen, "Here Nothing, Always Nothing: A New York Dada Index, Etc." in Francis M. Naumann, *Making Mischief: Dada Invades New York* [exh. cat., Whitney Museum of American Art] (New York, 1996), 163, and repr. in *Affectionately, Marcel: The Selected Correspondence of Marcel Duchamp*, ed. Francis M. Naumann and Hector Obalk,

trans. Jill Taylor (New York and Amsterdam, 2000), 124–126.

44 *New York Dada*, April 1921, 2; repr. in facsimile in Francis M. Naumann, *New York Dada 1915–23* (New York, 1994), 204.

45 Duchamp's financial scheme contrasted sharply with a related proposal from Breton, who in 1935 lamented false surrealisms and looked for a similar sort of official marker: "...it would be desirable for us to establish a very precise line of demarcation between what is Surrealist in its essence and what seeks to pass itself off as such for publicity or for other reasons. The ideal, obviously, would be for every authentic surrealist object to have some distinctive outer sign so that it would be immediately recognizable; Man Ray thought it should be a sort of hallmark or seal." André Breton, "Surrealist Situation of the Object," in *Manifestoes of Surrealism* (1935; Ann Arbor, 1969), 257.

46 Tzara, "Dada Manifesto 1918," in Motherwell, *Dada Painters and Poets*, 77.

47 Tzara, "Dada Manifesto 1918," in Motherwell, *Dada Painters and Poets*, 78.

48 *New York Dada*, 2; repr. in facsimile in Naumann, *New York Dada 1915–23*, 204.

49 Marcel to Suzanne Duchamp, January 15 [1916], New York; repr. in Naumann and Obalk, eds., *Affectionately, Marcel*, 43–44, from an original in the Jean Crotti Papers, Archives of American Art, roll 2394, frames 180–181.

50 Molly Nesbit, "Ready-Made Originals: The Duchamp Model," *October* 37 (Summer 1986), 61–62, and elaborated in "The Language of Industry," in *The Definitively Unfinished Marcel Duchamp*, ed. Thierry de Duve (Cambridge, Mass., 1991), 352–384. In the later article, Nesbit argues that the legacy of this curriculum was the eclipse of the body by the line, and by extension, the play between the projection of the feminine by Rrose Sélavy and the masculinized vocabulary of industry.

51 Nesbit, "The Language of Industry," 353.

52 Marcel Mauss, *The Gift: Form and Reason in Archaic Societies*, trans. W. D. Halla (New York, 1990).

53 This role was not always undertaken in a Dada spirit. Duchamp helped his friends sell their art on several occasions, notably in 1926 when he became part owner of a large group of sculptures by Constantin Brancusi left in the estate of John Quinn, preventing the works from becoming dispersed in the marketplace. See *Constantin Brancusi 1876–1957* [exh. cat., Philadelphia Museum of Art] (Philadelphia, 1995), 60. In a more ironic vein, Duchamp attempted to peddle a series of "opti-

cal disks" at the Concours Lépine, an annual inventors' fair, in 1935. On the Concours Lépine, see Henri-Pierre Roché, "MARCELDUCHAMPS-OPTICALDISKS," *Phases* 1 (January 1954), and "Souvenirs de Marcel Duchamp" in Robert Lebel, *Marcel Duchamp* (Paris, 1959), 79, quoted in Rosalind Krauss, *The Optical Unconscious* (Cambridge, Mass., 1993), 97–98.

54 For more on Tzanck, see Peter Read, "The *Tzanck Check* and Related Works by Marcel Duchamp," in Rudolf E. Kuenzli and Francis M. Naumann, eds. *Marcel Duchamp: Artist of the Century* (Cambridge, Mass., 1989), 95–105.

55 J[ane] H[eap], "Comment," in *The Little Review* 10:2 (Autumn–Winter 1924–25), 18–19. Quoted in Schwarz, *The Complete Works of Marcel Duchamp*, rev. ed. (New York, 2000), 703.

56 Picabia, letter to Frantz Jourdain, *Journal du Peuple* (2 November 1919), 2; repr. in Picabia, *Écrits*, vol. 1, 181.

57 Francis Picabia, "Manifeste Cannibale Dada," *Dadaphone* (*Dada* 7) (March 1920) [3]; repr. in Picabia, *Écrits*, vol. 1, 213.

58 See William Camfield and Jean-Hubert Martin, eds. TABU DADA: *Jean Crotti and Suzanne Duchamp 1915–1922* [exh. cat., Kunsthalle Bern] (Bern, 1983).

59 André Breton, Robert Desnos, Benjamin Péret, "Comme Il Fait Beau!" *Littérature* 9 (February 1–March 1, 1923), 6–13, reprinted in André Breton, *Oeuvres complètes*, vol. 1, ed. Marguerite Bonnet, Philippe Bernier, Etienne-Alain Hubert and José Pierre (Paris, 1988), 439–448.

60 For classic expressions of these twin tendencies, see Maurice Nadeau, *Histoire du surréalisme* (Paris, 1944); Robert Short, "The Politics of Surrealism, 1920–1936," *Journal of Contemporary History* 1:2 (1966), 3–25; William S. Rubin, *Dada, Surrealism and Their Heritage* [exh. cat., Museum of Modern Art], New York, 1968, especially 11–16.

61 On "intensity," see Jeffrey T. Schnapp, "Bad Dada (Evola)," *The Dada Seminars*, 31–55.

62 Aragon, *Projet*, 75.

63 "Pourquoi écrivez-vous?" *Littérature* 10 (December 1919), 21–26; *Littérature* 11 (January 1920), 20–26; *Littérature* 12 (February 1920), 19–26.

64 Cited in Elmer Peterson, "Dada in Paris," in *Dada and the Press*, ed. Harriet Watts (New Haven, 2004), 233, 252.

65 *Littérature* 18 (March 1921), 1–7.

66 *Littérature*, new series, no. 2 (April 1, 1922), 1–4; cited in Breton, *Oeuvres complètes*, 436. The respondents here included Aragon, Jacques Baron, Breton, Eluard, Théodore Fraenkel, Max Morise, Benjamin Péret, Ribemont-Dessaignes, Jacques Rigaut,

Soupault, and Roger Vitrac. Although this collectivity (with the exception of Ribemont-Dessaignes) is generally taken as the literary core of Paris surrealism, it should be noted that everyone but Baron and Morise had played some role in the events of 1920–21.

67 Aragon, *Projet*, 101.

68 Aragon, *Projet*, 103.

69 The initial committee numbered seven people: Breton, composer Georges Auric; painters Fernand Léger, Robert Delaunay, and Amédée Ozenfant; and writers Jean Paulhan and Roger Vitrac.

70 For example, in "For Dada" (August 1920), Breton argued: "They [people] even go so far as to claim that, in the guise of extolling individuality, Dada constitutes a real danger to it, without stopping to notice that we are bound together especially by our differences." André Breton, *The Lost Steps*, trans. Mark Polizotti (Lincoln, Neb., 1996), 56.

71 Breton, [Appel du 3 Janvier 1922], *Oeuvres complètes*, 435. The appeal originally appeared on January 3, 1922 in *Comoedia* and *L'Ère nouvelle*. It also appeared in *Aventure* (January 1922) and *La Nouvelle revue française* (February 1922); cf. *Oeuvres complètes*, note 1, 1281.

72 This resolution is printed in Breton, *Oeuvres complètes*, 1282–1283. For fuller documentation on the exchange, see Tzara, *Oeuvres complètes*, 586–592; Sanouillet, 319–347. Arnauld Pierre discusses the Breton/Tzara dispute, among others, in his "The 'Confrontation of Modern Values': A Moral History of Dada in Paris," in *The Dada Seminars*, 241–267. Elmer Peterson reprints certain period articles in *Dada and the Press*, 278–286.

73 See in particular "Après Dada" (March 1922); "Lâchez tout" (April 1922); "Clairement" (September 1922), in Breton, *Oeuvres complètes*, 259–266. Breton continued to meditate on Dada's "rise and fall" through the end of that year. Republished in 1924 in his collection *Les Pas perdus* (*The Lost Steps*, trans. Mark Polizotti, 1996), these texts suggest in their cumulative length just how important the Dada movement had been for Breton.

74 Asté d'Esparbès, "Un Vernissage mouvementé," *Comoedia*, May 7, 1921, 2.

75 See Matthew Josephson, *Life Among the Surrealists*, quoted in Merry Foresta, *Perpetual Motif: The Art of Man Ray* [exh. cat., National Museum of American Art] (Washington, D.C., 1988), 103.

76 Francis Picabia, "L'Oeil Cacodylate," *Comoedia*, November 23, 1921, 2; trans. in George Baker, "The Artwork Caught by the Tail," *October* 97 (summer 2001), 82. Baker provides an exhaustive physical and theoretical account of this work.

77 Aragon, *Projet*, 59.

78 Tzara to Paul Dermée, June 1918, Tristan Tzara writings and ephemera, Research Library, the Getty Research Institute, Los Angeles; trans. in full in Matthew S. Witkovsky, "Pen Pals," in *The Dada Seminars*, 270–293.

79 *Les Nouvelles littéraires* (October 25, 1924), 5; cited in Tzara, *Oeuvres complètes*, 698.

80 Ludger Durenthal, et al. *Max Ernst. Das Rendezvous der Freunde* [exh. cat., Museum Ludwig] (Cologne, 1991). For a diligent, English-language survey of the literature on this magnum opus, see William A. Camfield, *Max Ernst: Dada and the Dawn of Surrealism* [exh. cat., Menil Collection] (Munich and Houston, 1993), 128–131.

81 Camfield, *Max Ernst*, 129 and note 33, 347–348.

82 Elizabeth M. Legge, *Max Ernst: The Psychoanalytic Sources* (Ann Arbor, Mich., 1989), 167–169.

83 Louis Aragon, "Suicide," *Cannibale* no. 1 (April 25, 1920).

84 In the "Manifesto," Breton places these séances at the beginning of the "chemin suivi" that leads to surrealism, see *Oeuvres complètes*, 323. He mentions there his essay "Entrée des Médiums," which appeared first in *Littérature* in November 1922 and was republished in 1924 in *The Lost Steps*.

85 André Breton, "The Mediums Enter," in *Lost Steps*, 89.

86 André Breton, *Conversations: The Autobiography of Surrealism*, trans. Mark Polizzotti (New York, 1993), 70.

87 Camfield, *Max Ernst: Dada and the Dawn of Surrealism*, 126. Original citation in Breton, *Oeuvres complètes*, 1303.

88 Bonnet, ed., in Breton, *Oeuvres complètes*, 1301 and 1418. Bonnet, following Breton, omits to mention Tzara as another kindred spirit. Early commentators on Dada nevertheless noted a similar tactic in Tzara's poetry. "He takes visible pleasure in bringing together words that, when coupled, lose their meaning," wrote Georges Casella admiringly in a review of Tzara's play *Mr. Antipyrine* (*Comoedia*, March 29, 1920, 2). It was in Paris as well that Tzara explained how anyone might make an authentic poem by tossing words cut out of the newspaper into a hat, then retrieving and pasting them down in random order ("Manifeste sur l'amour amer et l'amour faible" ["Manifesto on Weak Love and Bitter Love"]), read December 9, 1920, during the opening to Picabia's exhibition at Jacques Povolozky. Tzara, *Oeuvres complètes*, 382.

PARIS

PLATES

316 MARCEL DUCHAMP *L.H.O.O.Q.*, 1919, rectified readymade: pencil on reproduction of Leonardo da Vinci's *Mona Lisa*, 19.7 × 12.4 (7 ¾ × 4 ⅞). Private collection

317 FRANCIS PICABIA after **MARCEL DUCHAMP** *Tableau Dada par Marcel Duchamp: LHOOQ* (Dada Picture by Marcel Duchamp: LHOOQ), illustration on the cover of the journal *391*, no. 12, Francis Picabia editor and publisher, March 1920, 55.6 × 38.1 (21 ⅞ × 15). Research Library, The Getty Research Institute, Los Angeles

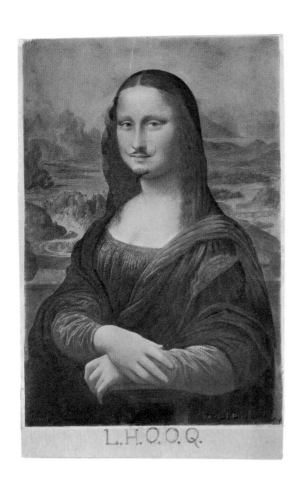

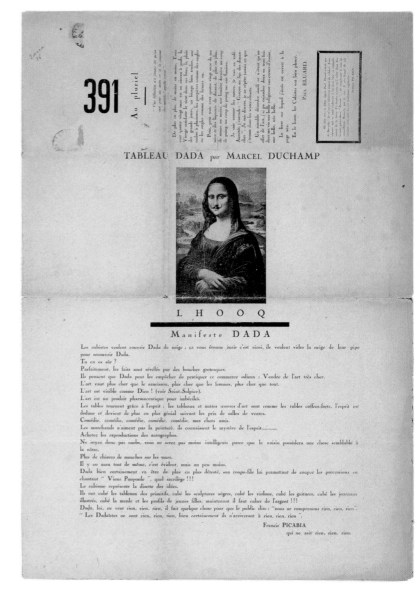

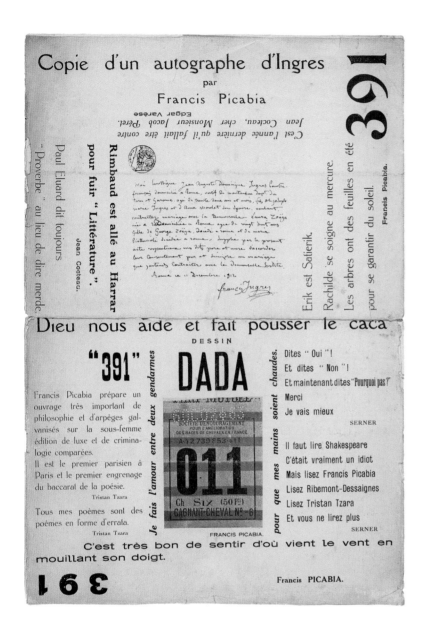

320 MARCEL DUCHAMP *Obligation Monte Carlo* (Monte Carlo Bond), 1924, photomontage on letterpress print, 31.5 × 19.5 (12 ⅜ × 7 ¹¹⁄₁₆). Private collection

321 MAN RAY *Marcel Duchamp as Rrose Sélavy*, c. 1920–1921, photograph retouched by Duchamp, gelatin silver print, 21.6 × 17.3 (8 ½ × 6 ¹³⁄₁₆). Philadelphia Museum of Art, The Samuel S. White 3d and Vera White Collection, 1957

322 MARCEL DUCHAMP *Tzanck Check*, 1919, ink and rubber stamps on paper, 21 × 38.2 (8 ¼ × 15 ¹⁄₁₆). The Israel Museum, Jerusalem, The Vera and Arturo Schwarz Collection of Dada and Surrealist Art at The Israel Museum

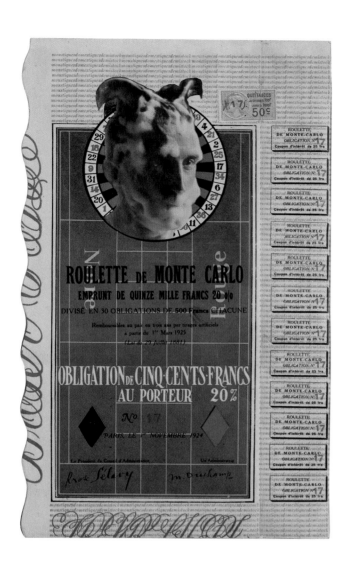

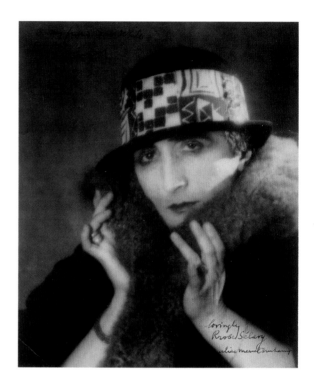

323 MARCEL DUCHAMP *La Bagarre d'Austerlitz* (The Brawl at Austerlitz), 1921, front and back of miniature window, painted wood and glass with wooden base, 67.8 × 33 × 20.2 (26 ¾ × 13 × 7 ¹⁵⁄₁₆). Staatsgalerie Stuttgart

324 MARCEL DUCHAMP *50 cc Air de Paris* (50 cc of Paris Air), 1949 (artist's replacement for broken 1919 original), readymade: opened and resealed glass ampoule, height 15.2 (6). Philadelphia Museum of Art, Louise and Walter Arensberg Collection, 1950

325 MARCEL DUCHAMP *Disks Bearing Spirals*, 1923, ink, white paint, and pencil on seven white paper disks, mounted on paper disk attached to board, 108.2 × 108.2 (42 ⅝ × 42 ⅝). Seattle Art Museum, Eugene Fuller Memorial Collection

326 MARCEL DUCHAMP *Rotative Demisphère (Optiques de précision)* (Rotary Demisphere [Precision Optics]), 1924, motorized optical device: painted wood demisphere fitted on velvet disk, copper collar with plexiglass dome, motor, pulley, and metal stand, 148.6 × 64.2 × 60.9 (58 ½ × 25 ¼ × 24). The Museum of Modern Art, New York. Gift of Mrs. William Sisler and Edward James Fund

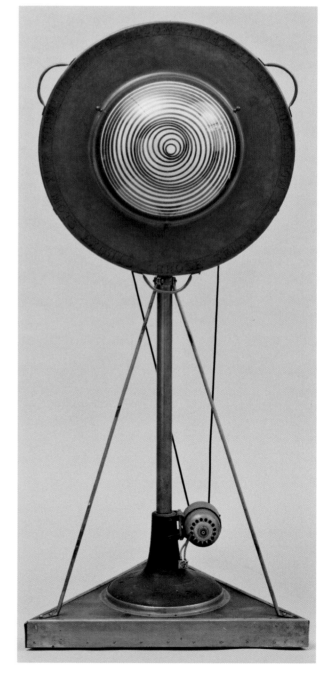

MARCEL DUCHAMP Four of nine *Disks Inscribed with Puns*, 1926; for use in the film *Anémic Cinéma*, produced by Duchamp with Man Ray and Marc Allegret, 1925–1926; each disk: white letters pasted on cardboard, painted black, mounted on phonograph record, diameter: 30 (11 ¹³⁄₁₆). Collection Carroll Janis, New York

327 *On demande des moustiques domestiques (demi-stock) pour la cure d'azote sur la Cote d'Azur* (Domestic mosquitoes [half-stock] requested for a nitrogen cure on the Cote d'Azur.)

328 *Bains de gros thé pour grains de beauté sans trop de Bengué.* (Tea bath for removing beauty spots with a minimum of Bengué.)

329 *Avez vous déjà mis la moëlle de l'épée dans le poêle de l'aimée?* (Have you ever put the marrow of the sword in the oven of your beloved?)

330 *L'Aspirant habite Javel et moi j'avais l'habite en spirale.* (The aspirant inhabits Javel and I had a spiral-shaped penis.)

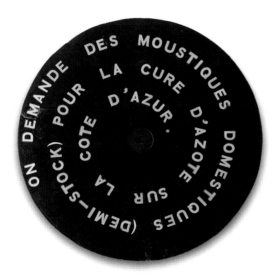

331 MAN RAY *Cadeau* (Gift), c. 1958 (replica of lost 1921 original), painted flat iron with row of tacks, heads glued to bottom, 15.3 × 9 × 11.4 (6 ⅛ × 3 ⅝ × 4 ⁹⁄₁₆). The Museum of Modern Art, New York. James Thrall Soby Fund

332 MAN RAY *Indestructible Object*, 1964 (replica of destroyed original of 1923–1932 titled *Object to Be Destroyed*), metronome with cutout photograph of eye on pendulum, 22.5 × 11 × 11.6 (8 ⅞ × 4 ⅜ × 4 ⅝). The Museum of Modern Art, New York. James Thrall Soby Fund

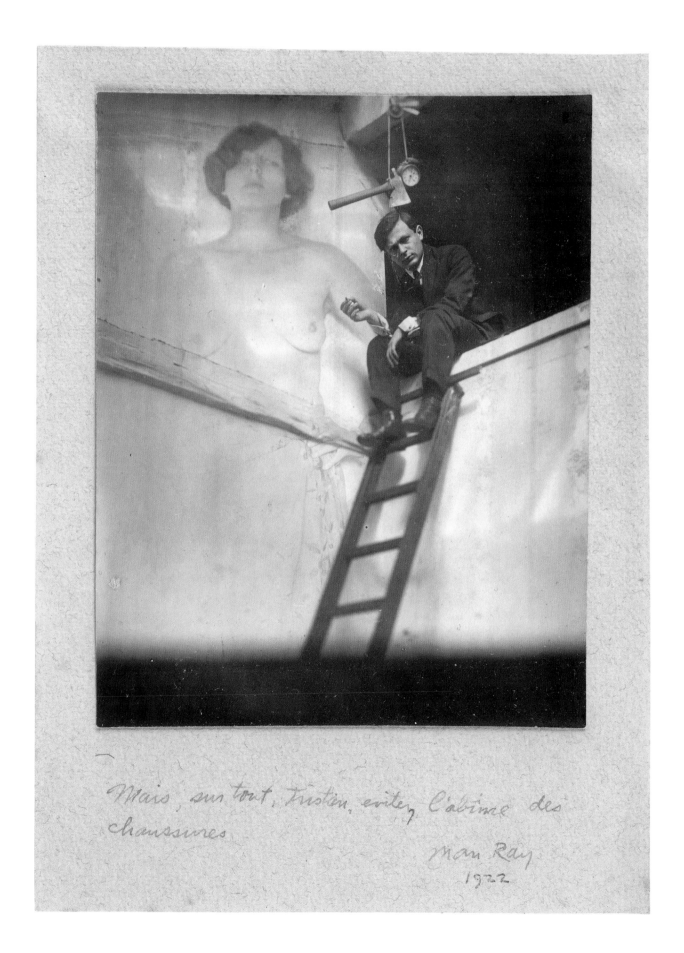

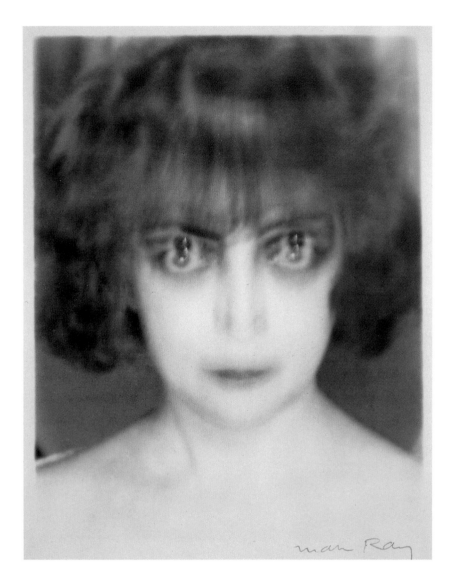

337 **MAN RAY** *Rayograph*, 1922, photogram: gelatin silver print,
23.9 × 29.9 (9 ⅜ × 11 ¾). The Museum of Modern Art, New York.
Gift of James Thrall Soby

340 **MAX ERNST** *Microgramme Arp 1 : 25,000,* illustration in the journal *Littérature,* series 1, no. 19, Louis Aragon, André Breton, and Philippe Soupault editors, Au Sans Pareil, May 1921, 22.5 × 14.1 (8 ⅞ × 5 ⁹⁄₁₆). Research Library, The Getty Research Institute, Los Angeles

341 **MAX ERNST** *Pietà ou la révolution la nuit* (Pietà or Revolution by Night), 1923, oil on canvas, 116.2 × 89.9 (45 ¾ × 35 ⅜). Tate. Purchased 1981

342 **MAX ERNST** Untitled (*Dada*), c.1922–1923, oil on canvas, 43 × 31.5 (16 ¹⁵⁄₁₆ × 12 ⅜). Museo Thyssen-Bornemisza, Madrid

343 MAX ERNST *La Chute d'un ange* (Fall of an Angel), 1922–1923, gouache, oil, and pencil on paper on board, 44 × 34 (17 5/16 × 13 3/8). Private collection

344 MAX ERNST *Deux Enfants sont menacés par un rossignol* (Two Children Are Threatened by a Nightingale), 1924, oil on wood with painted wooden elements in artist's frame, 69.8 × 57.1 × 11.4 (27 1/2 × 22 1/2 × 4 1/2). The Museum of Modern Art, New York. Purchase

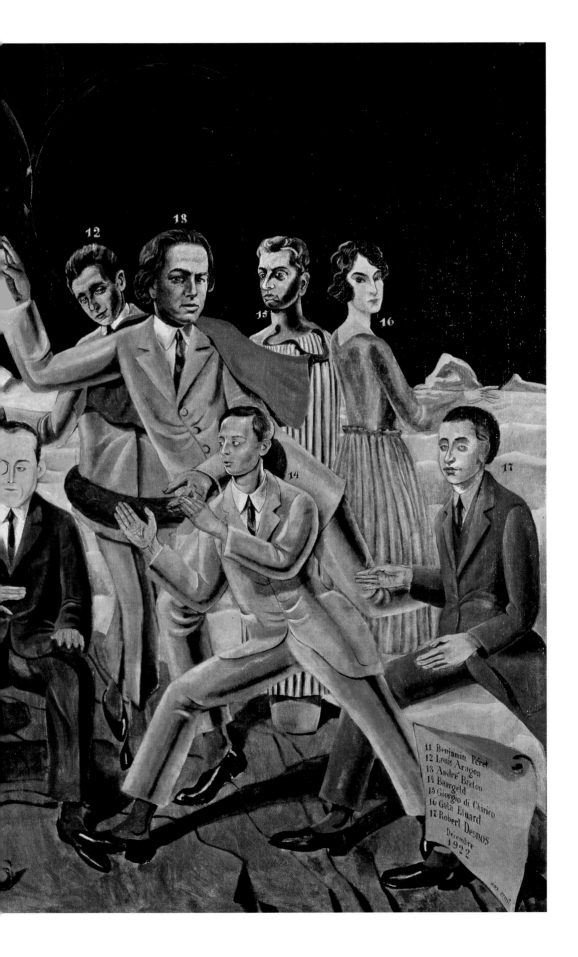

11 Benjamin Péret
12 Louis Aragon
13 André Breton
14 Baargeld
15 Giorgio di Chirico
16 Gala Eluard
17 Robert Desnos
Décembre
1922

346 HANS ARP *Horloge* (Clock Face), 1924, painted wood relief, 65.3 × 56.8 × 5 (25 11/16 × 22 3/8 × 1 15/16). Centre Pompidou, Musée national d'art moderne-Centre de création industrielle, Paris. Gift of M. Claude Gubler, 2004

347 Unknown artist, *Arp with Navel-Monocle*, 1926, gelatin silver print, 17.8 × 16.8 (7 × 6 2/3). Galerie Berinson, Berlin / UBU Gallery, New York

348 HANS ARP *Plastron et fourchette* (Shirt Front and Fork), 1922, painted wood relief, 58.4 × 70 × 6.1 (23 × 27 1/2 × 2 3/8). National Gallery of Art, Washington, Ailsa Mellon Bruce Fund

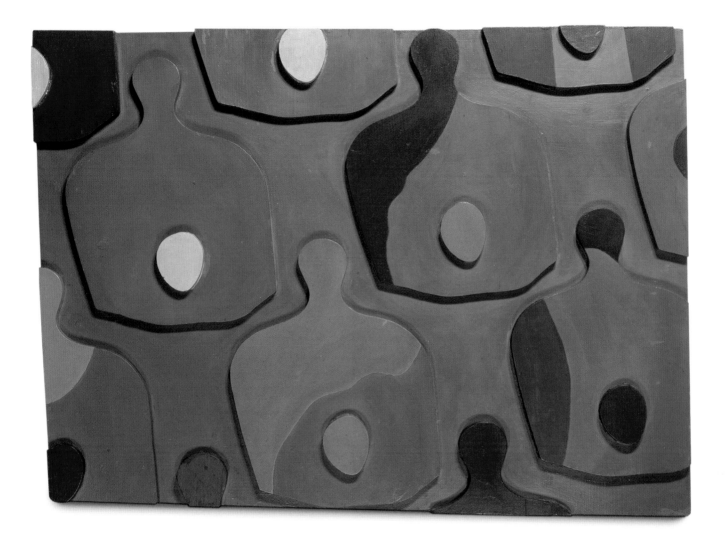

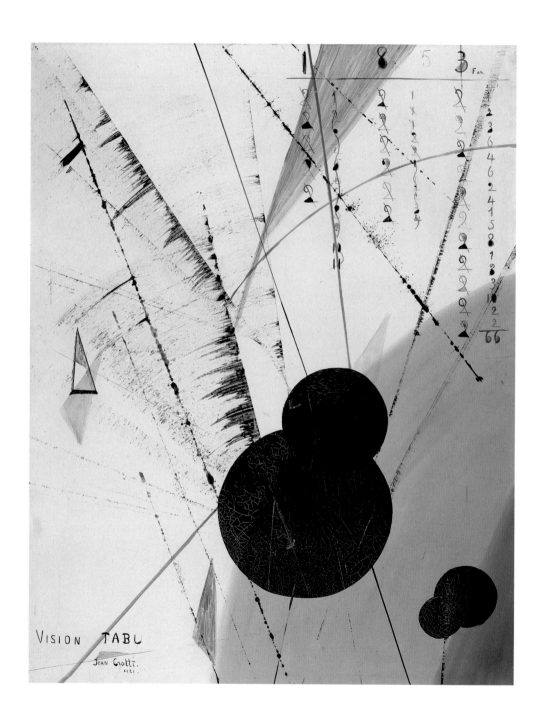

351 JEAN CROTTI *La Mariée dévissée* (The Bride Unscrewed), 1921, oil on canvas, 81 × 65 (31 ⅛ × 25 ⁹⁄₁₆). Musée d'art Moderne de la Ville de Paris

352 JEAN CROTTI *Portrait d'Edison* (Portrait of Edison), 1920, gouache, watercolor, and pencil on paper, 48.9 × 64.5 (19 ¼ × 25 ⅜). Tate. Purchased 1978

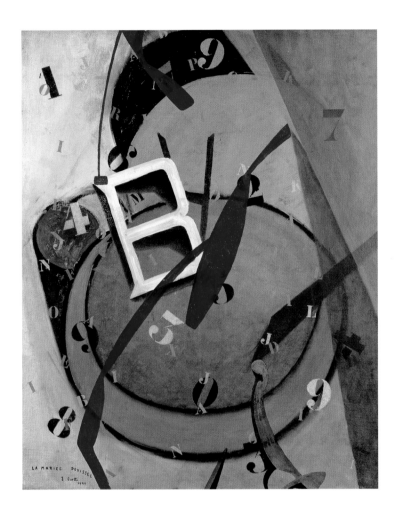

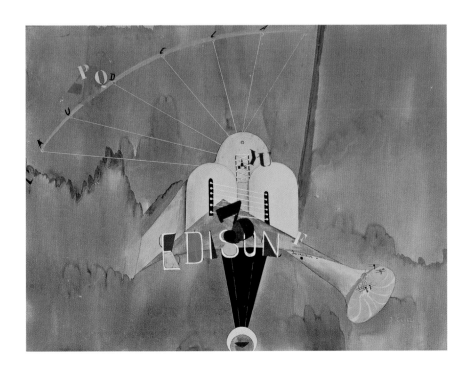

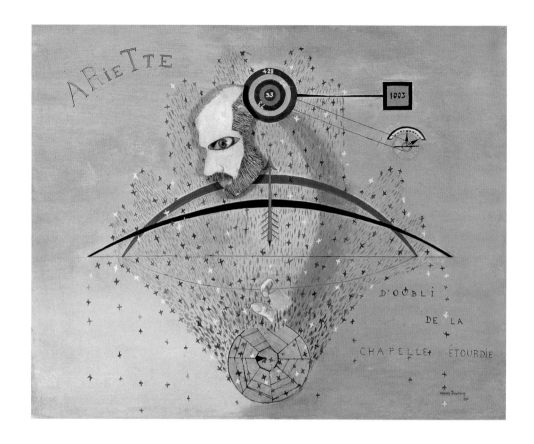

354 SUZANNE DUCHAMP *Solitude entonnoir* (Funnel of Solitude), 1921, oil and collage on canvas, 102.5 × 84 (40 ⅜ × 33 ⅟₁₆). Private collection

355 SUZANNE DUCHAMP *Un et une menacés* (He and She Threatened), 1916, watercolor, clock gear, metal rings, plumb bob, and string on paper, 70 × 54.5 (27 ⁹⁄₁₆ × 21 ⅟₁₆). Private collection, courtesy Galerie 1900–2000

356 SUZANNE DUCHAMP *Multiplication brisée et rétablie* (Broken and Restored Multiplication), 1918–1919, oil and collage of silver paper on canvas, 61 × 50 (24 × 19 ⁱ¹⁄₁₆). The Art Institute of Chicago, Gift of Mary P. Hines in memory of her mother, France W. Pick; through prior acquisitions of Mr. and Mrs. Martin A. Ryerson, H. J. Willing, and Charles H. and Mary F. S. Worcester

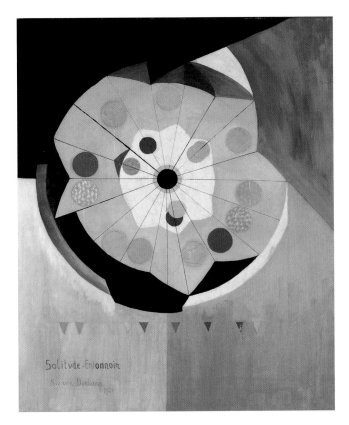

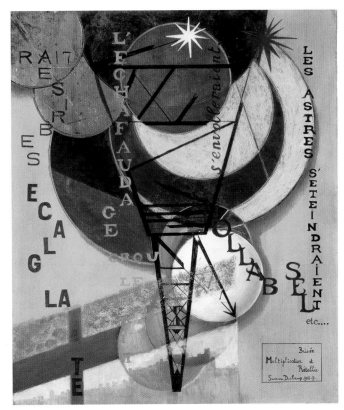

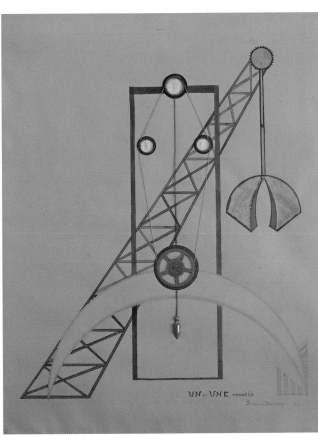

360 FRANCIS PICABIA and **TRISTAN TZARA** Prospectus for *Festival Dada*, Au Sans Pareil, 1920, offset lithograph, 37 × 27 (14 9/16 × 10 5/8). Elaine Lustig Cohen Dada Collection, The New York Public Library, Astor, Lenox and Tilden Foundations

361 IL'IA MIKHAILOVICH ZDANEVICH Cover of the journal *Le Coeur à barbe* (The Bearded Heart), no. 1, Tristan Tzara editor, Au Sans Pareil, April 1922, letterpress, 22.6 × 14 (8 7/8 × 5 1/2). Collection Merrill C. Berman

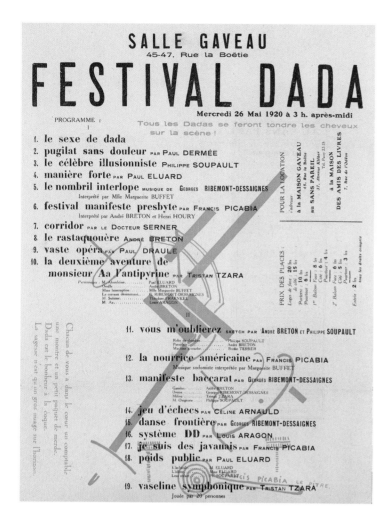

362 Unknown artist, cover of the journal *Dada*, no. 6: *Bulletin Dada,* Tristan Tzara editor, February 1920, letterpress, 37.6 × 27.7 (14 ¹³/₁₆ × 10 ⅞). National Gallery of Art, Library, Gift of Thomas G. Klarner

363 FRANCIS PICABIA Illustration on the cover of the journal *Dada*, no. 7: *Dadaphone*, Tristan Tzara editor, Au Sans Pareil, March 1920, 27 × 18.7 (10 ⅝ × 7 ⅜), letterpress reproduction of ink drawing. National Gallery of Art, Library, Gift of Thomas G. Klarner

364 FRANCIS PICABIA *Mouvement Dada*, 1919, ink on paper, 51.1 × 36.2 (20 ⅛ × 14 ¼). The Museum of Modern Art, New York. Purchase

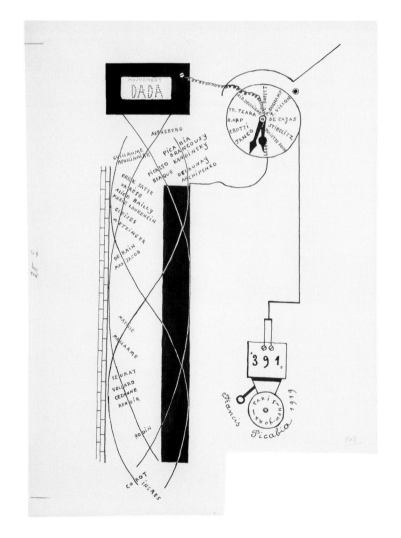

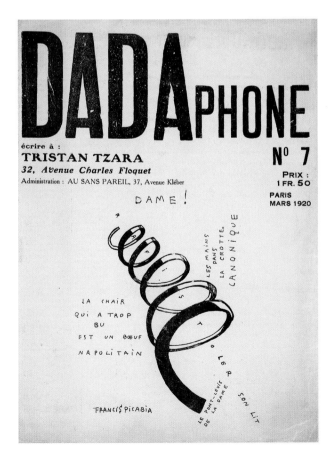

365 FRANCIS PICABIA *L'Œil cacodylate* (The Cacodylic Eye), 1921,
oil with photomontage and collage on canvas, 148.6 × 117.4 (58 ½ × 46 ¼).
Centre Pompidou, Musée national d'art moderne-Centre de création
industrielle, Paris. Purchase, 1967

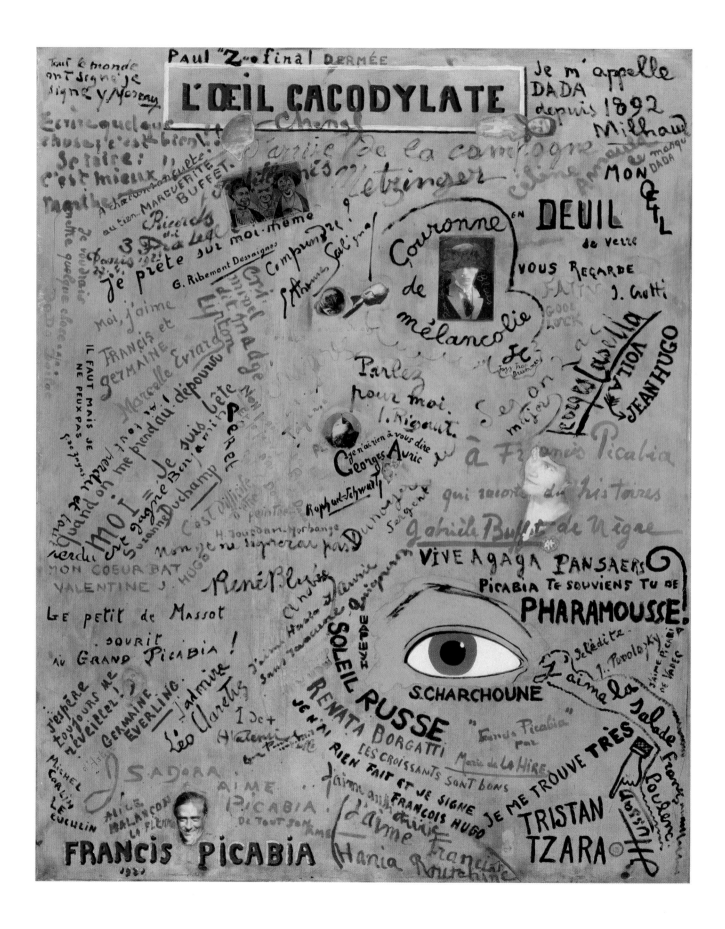

366 FRANCIS PICABIA *Francis Picabia par Francis Picabia* (Francis Picabia by Francis Picabia) or *Autoportrait* (Self-Portrait), c. 1920–1922, ink and watercolor on paper, 32.4 × 27.8 (12 ¾ × 10 ¹⁵⁄₁₆). Musée d'art Moderne de la Ville de Paris

367 FRANCIS PICABIA *La Sainte Vierge II* (The Virgin Saint II / The Blessed Virgin II), 1920, pencil and ink on paper, 32 × 23 (12 ⅝ × 9 ¹⁄₁₆). Bibliothèque Littéraire Jacques Doucet, Paris

368 FRANCIS PICABIA *Machine tournez vite* (Machine Turn Quickly), 1916/1918, ink and watercolor with gold paint on paper mounted on canvas, 49.6 × 32.7 (19 ½ × 12 ⅛). National Gallery of Art, Washington, Patrons' Permanent Fund

369 FRANCIS PICABIA *La Veuve joyeuse* (The Merry Widow), 1921, oil and photomontage and collage elements on canvas, 92 × 73 (36 ¼ × 28 ¾). Private collection

370 FRANCIS PICABIA *M'Amenez-y* (Take Me There), 1919–1920, oil on board, 129.2 × 89.8 (50 ⅞ × 35 ⅜). The Museum of Modern Art, New York. Helena Rubinstein Fund

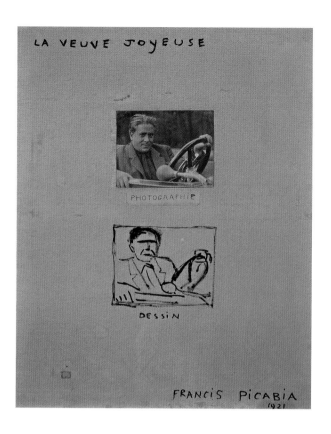

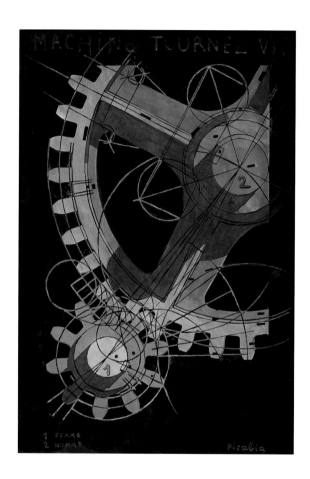

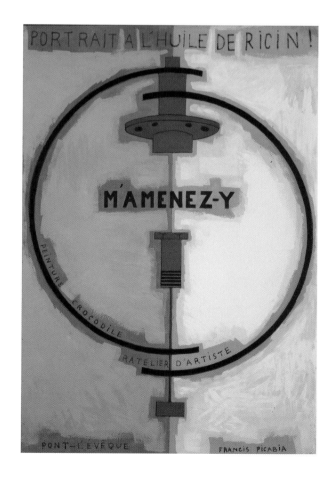

371 FRANCIS PICABIA *Le Double Monde* (The Double World), 1919, enamel paint and oil on board, 132 × 85 (52 × 33 ½). Musée national d'art moderne, Centre Georges Pompidou

372 FRANCIS PICABIA *Prenez garde à la peinture* (Watch Out for the Painting/Wet Paint), c. 1916–1919, oil, enamel, and metallic paint on canvas, 91 × 73 (35 ¹³/₁₆ × 28 ¾). Moderna Museet, Stockholm

373 FRANCIS PICABIA *Danse de Saint Guy* (Dance of Saint Guy), 1919–1920, refabricated and retitled *Tabac-Rat* (Rat Tobacco) by the artist, 1946–1949, twine, board, and ink in open, gilt wood frame, 104.4 × 84.7 (41 ⅛ × 33 ⅜). Centre Pompidou, Musée national d'art moderne-Centre de création industrielle, Paris. Purchase, 1996

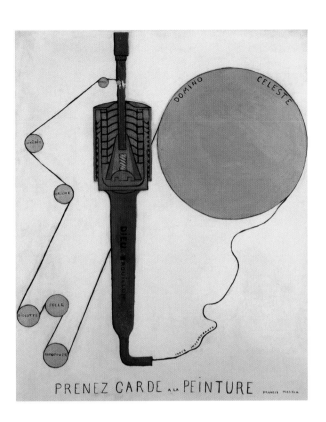

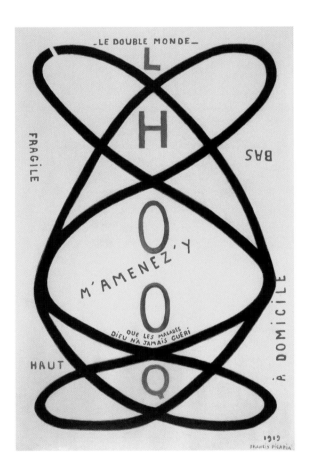

374 FRANCIS PICABIA *La Jeune fille* and *Machine de bons mots*, illustrations on the cover of *Proverbe* (Proverb), no. 4, Paul Eluard editor, April 1920, 27.6 × 21.4 (10 ⅞ × 8 ⁷⁄₁₆). Centre Pompidou, Musée national d'art moderne-Centre de création industrielle/Bibliothèque Kandinsky, Centre de Documentation et de recherche, Paris

375 FRANCIS PICABIA *Jeune fille* (Young Girl), 1920, ink on paper with circle cut out, 28 × 22.3 (11 × 8 ¾). Bibliothèque Paul Destribats, Paris

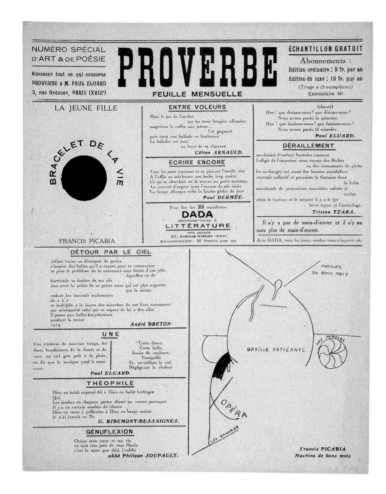

376 FRANCIS PICABIA *Tableau rastadada* (Rastadada Picture), 1920, photomontage and collage with ink on paper, 19 × 17 (7 ½ × 6 ¹¹⁄₁₆). Bibliothèque Paul Destribats, Paris

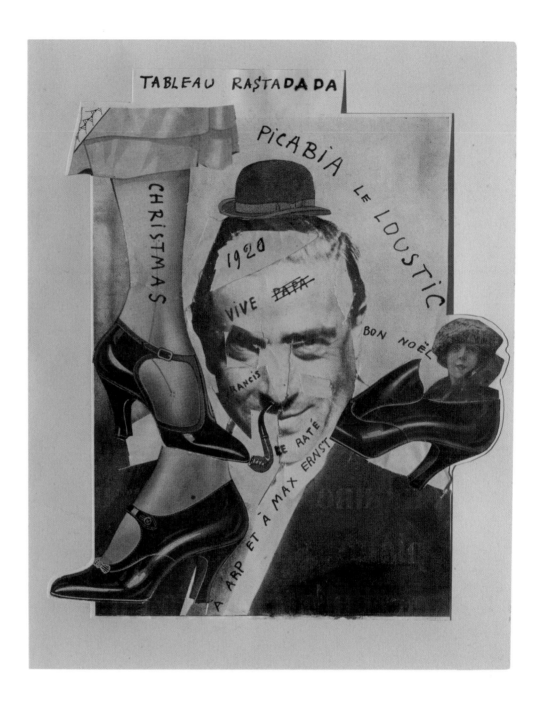

377 FRANCIS PICABIA *Chariot*, c. 1922–1923, watercolor, ink, and pencil on paper, 60 × 71 (23 ⅝ × 27 ¹⁵⁄₁₆). Clodagh and Leslie Waddington, London

378 FRANCIS PICABIA *Optophone*, c. 1922, ink and watercolor on board, 72 × 60 (28 ⅜ × 23 ⅝). Private collection

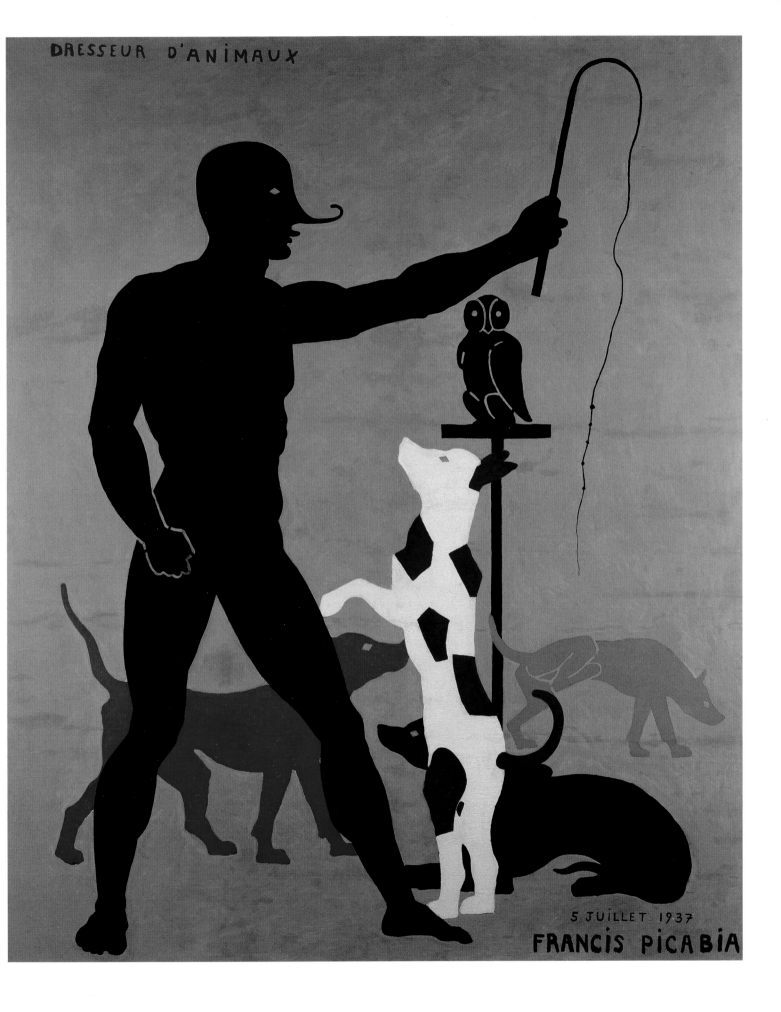

DRESSEUR D'ANIMAUX

5 JUILLET 1937

FRANCIS PICABIA

DADA FILMS

EMMANUELLE DE L'ECOTAIS and MARK LEVITCH

Dada film projects occupy a central but quixotic place in the Dada movement. Several prominent Dada artists worked extensively with film in the 1920s, including Hans Richter, Viking Eggeling, Man Ray, Francis Picabia, and Marcel Duchamp, and their wildly experimental works were often woven into landmark Dada performances. Yet the films' heterogeneity makes them difficult to classify under any single rubric. Some are abstract, some figurative, some a skillful combination; a few even have a quasi-narrative structure. Musical accompaniment was integral to some of the films while others were silent. Many date from Dada's heyday, but several were made after 1924, by which time many Dada artists had started to move in new directions, including, notably, toward surrealism. But for all their differences, the films' simultaneous engagement with, and critique of, the newest and most popular mechanical mass medium fits perfectly with the dadaists' consuming interest in all modern media, including advertising, propaganda, the illustrated press, and newsreels. People across Europe and America were flocking to studio films in unprecedented numbers in the 1920s, when commercial cinema became a global cultural force that continues to this day. Dada artists, however, were unsatisfied with film's easy ability to reproduce reality and the uncritical escapism that often resulted when this was combined with conventional narrative. Instead, as they did with photography, Dada artists drew attention to the film medium's usually concealed materiality and processes and investigated its particular formal and expressive possibilities. Finally, familiar Dada strategies of incorporating chance, disrupting narrative, and investigating abstraction as a means of universal language locate these efforts in the Dada universe.

Film ist Rhythmus (Film Is Rhythm)
c. 1921, later retitled *Rhythmus 21*

3 minutes
black and white
silent

Rhythmus 23
(Rhythm 23), 1923–1925

2 minutes
black and white
silent

Hans Richter

Hans Richter and Viking Eggeling were among the first creators of abstract film in cinematic history. The films marked the culmination of the two painters' joint investigation into pictorial issues undertaken in Switzerland and Germany from 1918 to 1921—namely, how to include the abstract forms that they had developed in their quest for a universal visual language into compositions analogous to music that incorporated movement and time. After studying Chinese scrolls and after their own experiments with painting on scrolls, the artists turned to film to introduce a kinetic element.

For his *Rhythmus* films, Richter shot paper rectangles and squares of different sizes and colors one image at a time. The shapes, which appear shaded as blacks, grays, and whites, move dynamically. They appear and disappear, swell and shrink, change speeds, and overlap to create a sense of depth. *Rhythmus 23*, which Richter had originally hoped to hand color, is similar to *Rhythmus 21* but largely forsakes spatial illusion to investigate the interplay between lines and planes. Though produced in Berlin, both Richter's and Eggeling's

films were first conceived in Zurich and emerged directly from the experimental interest in abstraction found within Zurich Dada— as seen in its visual arts, poetry, and dance. Dada ally Theo van Doesburg, the founder of *De Stijl*, early championed Richter's and Eggeling's cinematic works. *Rhythmus 21* was screened at the Coeur à barbe soirée (Bearded Heart soirée) in Paris on 6 July 1923 with Man Ray's *Retour à la raison*.

Viking Eggeling
with
Erna Niemeyer

Hans Richter

Max Endrejat
cinematographer

Hans Richter

Reimar Kuntze
cinematographer

Symphonie diagonale
(Diagonal Symphony), 1923–1924

5 minutes
black and white
silent

Filmstudie
(Film Study), 1926

3 minutes 30 seconds
black and white
silent
original musical score by
H. H. Stuckenschmidt

Vormittagsspuk
(Ghosts Before Breakfast), 1927–1928

8 minutes
black and white
silent
original musical score by
Paul Hindemith

Like Richter's Rhythmus works, Eggeling's abstract film, *Symphonie diagonale*, uses geometric shapes and musical analogy (symphony rather than rhythm) to suggest the universal potential of an abstract visual language. The artists' films, however, have a different sensibility. Eggeling practiced "cinematic drawing," exactly reproducing the delicate shapes he had rendered on a horizontal scroll; his film is thus more pictorial and less cinematographic than Richter's Rhythmus films, which are populated with simplified shapes. The playfulness apparent in *Symphonie diagonale* belies the complex and rigorous philosophy that structured Eggeling's approach to life and art—one based on a scientific analysis of the elements of form and how they react under different conditions that he dubbed "polarity" and "analogy." The film was first screened publicly in Berlin on 3 May 1925 shortly before Eggeling's untimely death.

Filmstudie, produced in Berlin, marks Richter's departure from wholly animated films that used strictly abstract vocabulary. Instead, Filmstudie features, as Richter later noted, the "incorporation of natural elements in a poetic relation with abstract forms." In one segment, for instance, a series of floating circles transforms into similarly situated and proportioned eyeballs, which then give way to superimposed images of a woman's face. Interrelating abstract images and their recognizable counterparts, Filmstudie operates through association and analogy rather than narrative. Richter later described it as "a dream with rhythm as the lifeline."

In Vormittagsspuk, Richter forsakes abstraction and instead constructs an absurdist narrative in which quotidian objects—hats, coffee cups, ties, among others—rebel against their routine existence and take on lives of their own. With flying bowler hats provoking farcical chase scenes, Vormittagsspuk is undeniably humorous. Yet the film's unsettling, if temporary, subversion of person-object relationships, the instability the film attributes to bourgeois cultural markers, and its dynamic New Vision camerawork, which features angled shots, distortions, and extreme close-ups, makes it also a potent critique of traditional values. Vormittagsspuk premiered at the International Music Festival in Baden-Baden in 1928.

Man Ray

Retour à la raison
(Return to Reason), 1923

2 minutes
black and white
silent

Retour à la raison premiered at the dadaists'
notorious Coeur à barbe soirée in Paris on
6 July 1923, a day and a half after Tristan Tzara
showed Man Ray, who had never made a film
and was not working on one at the time, that
Man Ray's name figured in the gala's program
as the producer of a Dada film. Confronted
with Tzara's fait accompli, Man Ray adapted
the technique of the Rayograph —camera-
less still pictures made by placing objects
directly in contact with photosensitive paper—
to movie film. He sprinkled short sections
of film with salt and pepper, added pins and
thumbtacks to other sections, and exposed
the film briefly to light. After developing, he
spliced the resulting footage with sporadic,
unrelated shots that he had on hand, includ-
ing a field of daisies, a nude torso, and an
egg crate dangling on a string. Deviating
from all cinematic conventions, the provoca-
tive short film, which also broke twice at
the screening, incited a riot. *Retour à la raison*
highlights the incorporation of chance and
the focus on materiality in Dada films. It was
also seen as a direct challenge to the descrip-
tive films being churned out by big studios.

Man Ray

Fernand Léger
director

Dudley Murphy
Man Ray
cinematographers

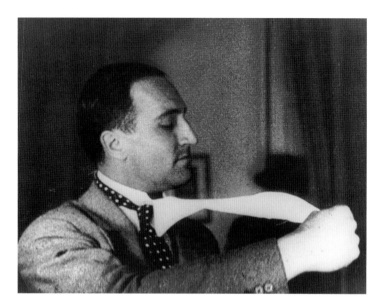

Emak Bakia
1926

15 minutes
black and white
silent

Le Ballet mécanique
(Mechanical Ballet), 1924

10 minutes
black and white
silent

Financed generously by American patrons Arthur and Rose Wheeler, Man Ray's *Emak Bakia* is a fully realized cinematic endeavor that Man Ray described as a "cinepoem." The film seemingly randomly alternates luminous abstract optical effects (derived from distorting mirrors, a rotating turntable, and crystals) and narrative passages (including a car crash, simulated by Man Ray's throwing the camera in the air and more carefully planned shots, like the legs of a dancer doing the Charleston). Yet *Emak Bakia*'s systematic visual disconnects, its continual frustration of coherent narrative, its use of eyes as a recurring motif, and its focus on the process of filmmaking (including shots of Man Ray filming) all draw attention to the conditions of vision and representation in film. *Emak Bakia*, which is Basque for "Leave me alone," is named after the Wheelers' villa in Biarritz, where part of the film was shot. Set to the jazz accompaniment of Django Reinhardt, *Emak Bakia* premiered in Paris in November 1926 and in New York in spring 1927.

Le Ballet mécanique is composed of incessant, rapidly cut images. Many of the fleeting images are avowedly industrial, like pumping pistons and gears, but they also include mundane objects, like swinging Christmas ornaments, saucepan covers, and hats, as well as abstractions of light and line, dancing mannequin legs, numbers, geometric shapes, and people involved in repetitive tasks. The film employs novel techniques, such as extreme close-ups and kaleidoscopic lenses, and it powerfully juxtaposes images, speeds, and rhythms to produce a sort of cinematic equivalent of Léger's pictorial emphasis on contrasting forms. Cinematographer Dudley Murphy shot most of the footage. Man Ray was involved in the early stages of planning and shooting (perhaps explaining the images of Kiki of Montparnasse, a famous Parisian model who was Man Ray's companion). The poet Ezra Pound and Stravinsky protégé George Antheil also contributed to the film, though Antheil's daring musical accompaniment was not completed until after the movie's 1924 premiere in Vienna and, being longer than the film, is usually performed separately.

René Clair
director

Francis Picabia
screenplay

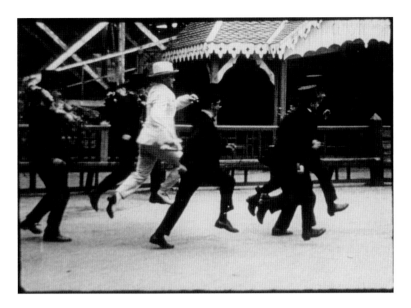

Entr'acte
(Intermission), 1924

18 minutes
black and white
silent
original musical score by
Erik Satie

Considered the Dada film par excellence,
Entr'acte was named for the space and time it
occupied: the intermission of *Relâche*, a
ballet designed by Picabia and Satie in con-
junction with the Swedish Ballet Company.
While projecting a film in the middle of a bal-
let is itself a Dada gesture, *Entr'acte*'s system-
atic subversion of a unifying narrative structure
marks it as a classic Dada critique of a domi-
nant media paradigm. Mixing humor, absurd-
ity, and violence, the film relates the story of a
man shot to death whose funeral turns into
a wild chase after the hearse breaks away from
the mourners and careens through the coun-
tryside. In both structure and technique the
film alludes to but undermines cinematic
conventions, subjecting a "readable" situa-
tion to bizarre and outrageous alterations
(like a graceful ballet dancer gradually shown
to have a beard or the final awakening of
the corpse at the end of the chase). *Entr'acte*
features Marcel Duchamp, Man Ray, and
Swedish Ballet star Jean Börlin. It premiered
4 December 1924 at the Théâtre des Champs
Elysées, Paris.

Rrose Sélavy
(Marcel Duchamp)
with
Man Ray
Marc Allégret

Anémic Cinéma
1926

7 minutes
black and white
silent

Anémic Cinéma emerged from Duchamp's earlier
kinetic and optical experiments, like *Rotary
Demisphere (Precision Optics)*, 1924 **[see 326]**. In
Anémic Cinéma, nine cardboard disks inscribed
with puns **[327–330]** rotate on the screen
alternately with ten rotating disks bearing spi-
rals (based on Duchamp's *Disks Bearing Spirals*
[325] of 1923). The alternating disks under-
line different processes of seeing and appre-
hending verbal and optical images: the disks
with puns have to be read, which emphasizes
the disks' flat surface, while the disks with spi-
rals, thanks to optical illusion, are perceived
as hypnotic, three-dimensional forms. The film
also has a strong, if ambiguously gendered,
sexual subtext; the rotating disks with spirals
appear to pulse in and out, a sexual allusion
reinforced by the frequent sexual alliterations
of the disks with puns. Duchamp's penchant
for the conceptual can be seen in the film's
anagrammatic title; in its use and juxtaposition
of puns and optical illusions, both of which
can be read in two valid but incompatible ways;
and in its copyright, which bears the autograph
of Rrose Sélavy, Duchamp's feminine alter-ego,
as well as his/her thumb print.

RELATED EVENTS

ZURICH

BERLIN

HANNOVER

COLOGNE

NEW YORK

PARIS

CHRONOLOGY

MATTHEW S. WITKOVSKY

This chronology follows the trajectory of Dada from 1911 until 1926, in Zurich, Berlin, Hannover, Cologne, New York, and Paris. Events within each city appear within color-coded horizontal bands. Small arrowheads, following the same color code, link pictures to specific cities. A seventh timeline traces Dada's development outside these six city centers, as well as artistic, social, and political occurrences of direct relevance to the movement. Quotations are taken almost entirely from period sources. The chronology is not exhaustive, but instead recounts key events in narrative form and aims to suggest Dada's rhetorical tenor and conceptual preoccupations.

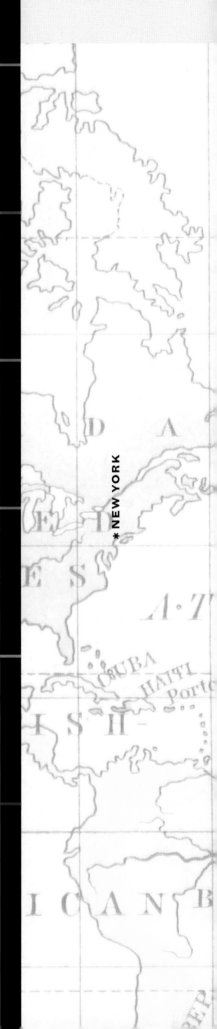

1911

December Vasily Kandinsky's *Über das Geistige in der Kunst* (Concerning the Spiritual in Art) appears, a foundational text on the value of abstract painting taken up by the members of Zurich Dada.

NEW YORK

1912

April–May Herwarth Walden holds his inaugural exhibition (12 April–31 May) of the Italian futurist group. The first internationally known showmen of the avant-garde, futurists perform and exhibit throughout Europe in 1912–14; thanks to Walden, they are seen especially widely in Germany.

1913

January Telephone lines link New York and Berlin. March Russian poet Aleksei Kruchenykh writes "Dyr bul shchyl," the first za'um or "transrational" poem: clusters of letters that move between abstract sound and suggestions of comprehensibility. Kruchenykh and his Russian futurist colleagues also pioneer experiments in visual

April Walter Serner moves from Vienna to Germany to get a Ph.D. in the law. He begins publishing in *Die Aktion*, a journal for art and criticism put out by the anti-authoritarian political activist Franz Pfemfert. The circle of pre-war contributors to *Die Aktion* includes Hugo Ball, Richard Huelsenbeck, Franz Jung, and Hans Richter.

September Johannes Baader, a practicing architect in Berlin, has in the last several years become devoted to esoteric, mystical ideas (such as plans for a "World Temple," 1906)— ideas that have influenced Raoul Hausmann, who befriended Baader in 1905. In a steadily increasing climate of political hostility and outright conflict, Baader declares 26 September

an annual day to "sow world peace" and proposes a cosmogony in which he is the guarantor of that peace.
Fall Hannah Höch and Georg Gross begin studies at a school attached to the Museum of Applied Arts in Berlin-Charlottenburg.

April The Austrian psychoanalyst Otto Gross has joined the circle around Pfemfert's *Die Aktion*. His article "Zur Überwindung der kulturellen Krise" (Overcoming the Cultural Crisis), which appears in the journal this month, rejects Sigmund Freud's view that psychic conflicts are based in "natural" family structures and blames instead

Else Plötz, painter, divorcée, and extravagant personality, moves to New York, having passed through the city on her arrival from Germany in 1910. She is thirty-nine years old. In November she marries a dashing but financially ruined German aristocrat and thereby acquires her most enduring name: Baroness Elsa von Freytag-Loringhoven.

Marcel Duchamp, Jean Crotti, and Francis Picabia attend dinner lectures organized by the Artistes de Passy, a self-consciously modernist group that includes poet and art critic Guillaume Apollinaire. Duchamp, Picabia, and Georges Ribemont-Dessaignes first met in 1911 in the company

* PARIS *COLOGNE *ZURICH *HANNOVER *BERLIN

BRITISH ISLES HOLLAND GERMANY RUSSIA
NEWFOUNDLAND FRANCE PORTUGAL SPAIN
ATLANTIC ALGERIA FRENCH SAHARA EGYPT
HINTERLAND GUINEA SOUDAN KAMERUN
Guiana Guiana Guiana
OCEAN FRENCH CONGO CONGO ANGOLA
GERMAN SOUTH-WEST AFRICA EAST AFRICA MADAGASCAR

poetry, although unlike the dadaists, they prefer the immediacy of hand-written texts to print media. **August** Negotiations in London to end the second Balkan War fail conspicuously to address the participants' demands. The constituencies of southeastern Europe are caught in a theater of interlocking alliances among the major powers—Russia, Austria-Hungary, Germany, France, and Britain —the exigencies of which eventually trigger World War I. **November** Guillaume Apollinaire publishes four relief sculptures and paper con-structions by Pablo Picasso in his first issue as editor of *Les soirées de Paris*; all but six of the magazine's forty regular readers cancel their subscriptions in protest. Picasso, Georges Braque, and Juan Gris begin in earnest to make collages and assemblages in fall 1912. Although rarely reproduced and almost never exhibited, these works quickly become known to futurists and dadaists, who take them as a major source of inspiration. **December** "[W]ithin a year the Feminist Movement has become of interest to everyone" (Alice Hubbard, *Harper's Weekly*, 13 December). Coined in the 1880s by French women's rights advocate Hubertine Auclert, the term "feminism" comes into vogue now in the United States, bringing fresh aggressiveness to the struggle for women's equality.

the patriarchal, bourgeois state for its repressed citizens: "The psy-chology of the unconscious is the philosophy of revolution." His books and essays greatly influence the future Dada group. **Fall** In Munich Huelsenbeck, now studying phi-losophy and literature, meets the aspiring poet and theater director Ball and the chanteuse Emmy Hennings, a performer at the Simplizissimus cabaret.

The futurist group: Palazzaeschi, Papini, Marinetti, Carrà, Boccioni, 1913. Photograph by Mario Nunes Vais. Giovanni Lista, Paris.

February–March Francis and Gabrielle Buffet-Picabia arrive in New York, in advance of the Armory Show that will make Picabia, Marcel Duchamp, and several other young European artists overnight celebrities in America. The exhibition opens on 17 February, with nearly seventeen hundred works on display; it draws some ninety thousand visitors in New York before closing 15 March. Duchamp's *Nu descendant un escalier* (Nude Descending a Staircase) provokes a *succès de scandale*. Picabia, meanwhile, is courted by the press as one of the only European "art rebels" physi-cally present in the city. On 4 March, Theodore Roosevelt skips the inauguration of President Woodrow Wilson to visit the Armory Show. **March–April** Picabia holds an exhibition (17 March– 5 April) at 291, the gallery run by photographer and modern art crusader Alfred Stieglitz. Around this time, he sees machinelike com-positions by Stieglitz' associate Marius de Zayas, an inspiration for his own development of "machine pictures" in the years to come. Picabia returns to Paris soon after his show closes.

of the "Puteaux cubists," the institu-tional locus of French cubism.

Duchamp selects—without yet calling it as such—his first ready-made, *Roue de bicyclette* (Bicycle Wheel), and begins preliminary stud-ies for *The Bride Stripped Bare by Her Bachelors, Even (The Large Glass)*. **November** Thanks to Picabia's connections, Duchamp receives a part-time position at the Sainte-Geneviève library in Paris, a job he will keep until he leaves wartime France in 1915.

February Charlie Chaplin makes his screen début in the Mack Sennett film *Making a Living*, with Keystone pictures. **February–March** In Moscow, Vasily Kamensky and David Burliuk publish two books, *Nagoy sredi odetykh* (Naked among the Clad) and *Tango s korovami: zeleznobetonniye poemi* (Tango with Cows: Ferro-Concrete Poems), that deploy letterpress type irreverently across pages of brightly colored wallpaper. **June** 28 June: Archduke Franz Ferdinand, heir to the Austrian throne, and his wife, the Duchess of Hohenberg, are assassinated in the Bosnian capital, Sarajevo. **July–August** Outbreak of war. On 28 July Austria-Hungary declares war on Serbia— by telephone!—in response to the assassination of the archduke. Fulfilling the terms of an accord with Austria-Hungary, Germany does the same for Russia on 1 August, and France two days later. In nearly every case, superannuated rulers are swayed by deliberate misinformation from their advisers. The United States declares its neutrality on 4 August. Britain enters the conflict this same day, when the Germans overrun Belgium en route to their French opponents; the resulting Western Front soon stretches from the Belgian coast to the Swiss-French border. Russia invades East Prussia, establishing the Eastern Front, on 17–19 August. By December war is being waged as far away as the Falkland Islands, off the coast of Argentina.

June Marcel Iancu (soon Janco) and his brother Jules leave their hometown of Bucharest for Zurich, where Jules arrives 26 June. Marcel possibly comes later, for he does not register with the police (a procedure required of all foreigners, for domestic changes of address as well as border crossings) until 14 December. **August** Outbreak of war. Hugo Ball volunteers enthusiastically on 6 August in Munich but is refused by the army for health reasons. Undaunted, he heads for the Western Front. One month later, he signals his mounting horror in "Zwischen Dieuze und Lunéville" (Between Dieuze and Lunéville), a dispatch to his hometown newspaper. Emmy Hennings responds to the call to arms by forging passports to help others avoid it, an enterprise that lands her temporarily in prison.

The Romanians Tristan Tzara (Samuel Rosenstock), the Janco brothers, and Arthur Segal all reach Switzerland before their country enters the war in August 1916. Tzara at least has to negotiate after that with the Romanian military attaché in Paris, corresponding in November 1916, March 1917, and again in January 1918 before he is discharged from service. Segal is branded a draft dodger and loses his citizenship.

Hans Richter is inducted on 15 September, then sent as an artillerist to the Eastern Front. He is partly paralyzed at Vilnius in early 1915; one of his brothers is severely wounded and another killed. Placed in the reserves

August Outbreak of war. Baader, who gives an impression of intermittent mental clarity, is deemed unfit for service. He renounces his architectural profession, calling it "bourgeois-technological building," and devotes himself to spiritual construction projects. Huelsenbeck volunteers on 3 August but soon develops neuralgia, a nervous affliction, and is released in late October without having seen direct combat. During his subsequent medical studies, he will serve as an assistant field doctor in 1917 and 1919. Hausmann somehow avoids conscription; he nevertheless considers volunteering in 1916, enticed by the prospect of testing his character on the battlefield.

When her current art school closes its doors, Höch briefly joins the Red Cross, then enrolls (again alongside Gross) in a new school where students make war posters and pictures for hospitals. Called to the front in spring 1915 and January 1917, Gross ends both times in a hospital, first with a fever that leads to a painful sinus operation, next with a temporary psychosis. Confined to an asylum, Gross submits to a "lunacy test" only to avoid further active duty. As a mark of his profound disgust, in 1916 he anglicizes his name as George Grosz.

Helmut Herzfelde, an apprentice book designer, suffers through a year or so of guard duty in Berlin before he simulates mental illness. Reassigned,

August Outbreak of war. Kurt Schwitters, enrolled at the Dresden Art Academy until August 1915, is called up quite late. He serves just over two months (12 March–19 June 1917) in an infantry regiment before being declared unfit for active service, perhaps through simulated stupidity and/or bribery, and reassigned as a draftsman in a Hannover ironworks. "Everything fermented terribly in the war," Schwitters recalls in 1930. "I couldn't use what I had brought from the Academy, what was new and useful was still growing, and an imbecilic struggle raged around me over things I don't care about."

May Hans Arp and Max Ernst meet at a Werkbund show in Cologne. **August** Outbreak of war. Alfred E. F. Gruenwald, later Johannes Baargeld, volunteers 2 August and joins the Rhineland Mounted (Cuirassier) Regiment in Cologne. He eventually (February 1917) becomes a lieutenant with the German army's airborne division. Ernst enlists, together with his brother Carl, an entering medical student; the two are assigned to a local field artillery regiment. In January 1915 Ernst is sent to the front in northern France, then transferred in 1917 to Danzig, on the Eastern Front. Like Baargeld, Ernst finds himself promoted to lieutenant before the war's end.

March *The Little Review*, founded by pianist and literary critic Margaret Anderson, begins publication in Chicago. When the painter Jane Heap becomes coeditor in 1916, the magazine turns its attention toward art as well. *The Little Review* offices relocate to New York in 1917, and from 1920 the journal regularly features work by Baroness Elsa, Picabia, Man Ray, and Duchamp. **August** Outbreak of war. As a result of United States neutrality, New York, like Zurich, attracts key members of international Dada; Duchamp, the Picabias, and Jean and Yvonne Chastel Crotti all arrive in 1915. The discussions and activities of the American-born dadaists, meanwhile, reflect awareness of the newly militarized world—whether in comments on that world or a frenzied withdrawal from it.

Two of the group have close contact with the war at its outset. Elsa's husband Leopold, good in bed but bad with finances, departs New York with a boatload of fellow volunteers for Germany, taking his wife's savings with him. The ship is intercepted en route, and he becomes a French prisoner of war for four miserable years. Carted to another internment camp in Switzerland at the war's end, he puts a bullet in his head in April 1919. The Baroness remains in New York, where she begins to wear military accoutrements in public.

John Covert, first cousin to Walter Arensberg, returns to his hometown

Ribemont-Dessaignes and Picabia form a close friendship that will prove key to the dynamic of Paris Dada. During this time, however, Ribemont-Dessaignes suffers an intellectual crisis and abandons painting temporarily. **May** Conjoining procedures of chance and science, Duchamp establishes a "standard measure" for certain forms in the *Large Glass*: three one-meter lengths of sewing thread dropped onto a canvas on the ground, then fixed exactly as they have fallen. **August** Outbreak of war. In 1909 Duchamp was declared medically unfit (as he will be again in January 1915). His brothers Raymond and Gaston (Jacques Villon), however, are both pressed into service. Gaston survives the war, but Raymond dies in October 1918 of typhoid. Their sister Suzanne, meanwhile, soon begins work as a nurse's aide in Paris, a job she will keep after the war's end.

Picabia's wife, Gabrielle Buffet, secures him a job as a general's chauffeur at a Parisian barracks. He accompanies the general when the government retreats temporarily to Bordeaux. She herself joins the Red Cross. In November Picabia's father, who holds a position in the Cuban embassy, finds work for his son with a military supply mission to Cuba. Picabia abandons the mission when he arrives in New York in June 1915 but fulfills the mission, including a stop in Panama, in the fall.

5 August: French parliament ratifies a state of siege, thereby activating military laws that reinstate or tighten censorship of the press, songs, theater, books, and even private speech. Similar clampdowns are announced in all the warring countries. Restrictions ease in France only in October 1919, while in Germany they remain vigorously enforced through the Dada years and after. **September** Trenches become the operative battlefield layout. Along hundreds of miles, men live in narrow ditches, augmented on the parapet (enemy) side by sandbags several feet high and rows of barbed wire. Enormous rats breed by the millions in "no-man's land," the few dozen yards that separate opposing armies, scouring empty food tins and feasting off the eyes and livers of tens of thousands of human carcasses. Heavy rains dissolve the trenches to mud, in which frogs and snails proliferate and soldiers' feet turn gangrenous. The layered stench of rotting flesh, weeks-old sweat, latrines, cordite, poison gas, creosol disinfectant, cigarettes, and food being cooked in the middle of it all reduce new arrivals to nausea.

> They were in one of many mouths
> of Hell
> Not seen of seers in visions; only felt
> As teeth of traps; when bones and the
> dead are smelt
> Under the mud where long ago
> they fell
> Mixed with the sour sharp odour of
> the shell

in March 1916, Richter leaves Germany that September. Walter Serner, an Austrian subject, abandons Germany already in 1915, perhaps after an incident the previous December in which he abused his title as doctor (of law!) to forge an attestation of heart trouble for future Dada affiliate Franz Jung. The Bavarian-born Christian Schad also arranges for a fake attestation to avoid conscription in Munich. Otto van Rees, a Dutch citizen, is not so lucky; he serves several months at the front before he is hospitalized and then discharged in March 1915, perhaps partly for making a collage that seems evidence of mental imbalance.

Although his mother has lived in Weggis, Switzerland, since 1906, Hans Arp holds a German passport and is also in Cologne when the war breaks out. He moves to Paris for almost a year to avoid conscription, then relocates to Zurich after being interrogated by French police. In Zurich, he may have feigned mental illness to the German authorities. Sophie Taeuber, a Swiss citizen, remains in Zurich, where she teaches textile design at the university beginning in 1916. **November** In Berlin, Ball begins the diary that he will keep, in entries filled with prescient insight and self-awareness, throughout his involvement with Zurich Dada. Ball publishes the papers only weeks before his death in 1927, as *Flucht aus der Zeit* (Flight Out of Time).

he spends the remainder of the war delivering—or rebelliously trashing—mail in the city. He, too, fashions an English name for himself in 1916: John Heartfield. His brother Wieland, who has modified the family name slightly as well, volunteers for medical duties at the war's outbreak, but soon opposes the conflict. Sent into combat again in early 1917, Herzfelde tries to desert, then endures a year of largely frontline service before beginning a five-week hunger strike on New Year's Day 1918, as a result of which he is shipped to a Berlin hospital and eventually discharged.

The wartime career of painter Otto Dix is entirely different. After volunteering on 22 August, Dix is trained as a machine-gunner, and mobilized in September 1915. He fights until the very end of the war, notably in the months-long Somme campaign of 1916, and regularly learns new uses for his equipment (antiaircraft defense, indirect fire); from late 1917, he applies for a position in a flying division. By far the most active of the dadaists in combat, Dix also depicts the devastation of the war with prolonged intensity, from 1916 until well into the 1930s.

Rudolf Schlichter, whose south German Catholic family detests the Prussians almost as much as the Allied forces, avoids military service until 1916. He is sent to the Western Front, but returns in 1917 to Karlsruhe, near his hometown,

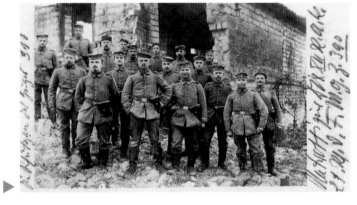

Otto Dix, second from left, front, with his squad in Champagne, 13 March 1916, photographic postcard. From Linda McGreevy, *Bitter Witness* (New York, 2001)

of Pittsburgh after studying painting in Munich and Paris for most of the previous six years. In "The Real Smell of War: A Personal Narrative," published in the New York magazine *Trend* that November, Covert recounts traumatizing scenes of mob patriotism in Paris and carnage at the front. **Fall** Walter and Louise Arensberg move to New York. Their apartment will become a principal salon for the dadaist group.

Ribemont-Dessaignes is mobilized in 1915, landing a job in the Service de renseignements aux familles (Family Information Service)—a lugubrious position that involves telling civilians where their loved ones have been killed or buried. He is discharged by 1917.

Crotti departs nine months into the war for the United States. As a Swiss citizen, he is no doubt exempt from conscription, but he may have felt uncomfortable not to be in uniform with all other able males.

André Breton writes to fellow poet Théodore Fraenkel at the end of August that it is naive to call the war—following public opinion—a conflict of (French) culture versus (German) barbarism. Breton, a medical student, is drafted February 1915. He spends the war years working at hospitals in Nantes, Saint-Dizier, and Paris and serves at the front for several weeks in late 1916.

—Wilfred Owen, "Cramped in That Funnelled Hole" (c. 1916)

October Birth control activist Margaret Sanger is indicted on charges of distributing obscene literature through the mail. She flees America, leaving instructions to distribute one hundred thousand copies of "Family Limitation," her pamphlet on contraceptive techniques.

December Trench fever, a sickness that causes aching, rashes, and fever for days or even weeks, is first reported along the Western Front. The disease is spread by lice that breed in the uncleanable seams of soldiers' uniforms. It will affect all armies for the duration of the war, largely because the cause remains unidentified until 1918.

January–April Lecturer and activist Emma Goldman tours New York State and New England. At the height of her popularity during this time, Goldman delivers over three hundred speeches in 1915 alone. She receives greatest applause for speaking on war (against) and birth control (for). **March** The British launch the first planned bombing raid of the

war. Bomber aircraft, first tested by the Italians in November 1911, are a technological novelty deployed from the start by British and German forces, with haphazard tactical results but to tremendous psychological effect. **April** On 22 April the Germans release chlorine gas at Ypres, the first large-scale use of chemical agents in the war. Gruesome and

March One month after his registration in Zurich (11 February), Walter Serner joins the staff of the "literary war newspaper" *Der Mistral* (The Mistral, or "storm wind"). Proceeding from the insight that the institutions of the bourgeoisie—legal, political, cultural—constitute a "grammar of war," editors Hugo Kersten and Emil Szittya

attack not so much the conflict itself but the language and social structure that legitimate it. Poems by Filippo T. Marinetti and Guillaume Apollinaire that dismantle conventional syntax are published to complement this editorial program. **April** Around this time, Otto van Rees joins his family in Ascona, a center of pacifism and alternative living where they have

after undertaking a hunger strike. His art-school classmate Georg Scholz, already a reservist in July 1914, spends the entire war on the front lines, mostly in Galicia. The experience of omnipresent filth and sickness (Scholz is quarantined with salmonella in 1916 and later hospitalized for war wounds) remains with him in 1920, when he writes

in the pro-dadaist journal *Der Gegner* (The Opponent) that Germans judge world cultures by a failsafe measure: "the toilet. . . . Thus, the military doctors seemed like priests of German culture, because their chief duty, other than declaring troops 'fit,' consisted in watching over the placement of latrines."

February Ball, who moved from Munich to Berlin the previous October, speaks (12 February) at a memorial service he and Huelsenbeck have organized to honor writers killed in the war—among them Ball's close friend Hans Leybold, who committed suicide after being wounded at the front in late 1914. Ball writes to his sister, Maria Hildebrand-Ball

(13 April), that Leybold "would have greatly applauded me" for his statements, qualified in the *Berliner Börsen-Courier* (n.d.) newspaper as expressions of "derision, hate, doubt, urgency." **March** Hennings joins Ball in Berlin. On the 26th, Ball and Huelsenbeck put together a "politische Soirée" in the Austria Café, where Ball delivers a prescient

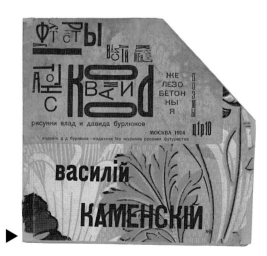

Interior, Arensberg apartment, New York, c. 1918. Photograph by Charles Sheeler, Philadelphia Museum of Art, The Louise and Walter Arensberg Collection, 1950

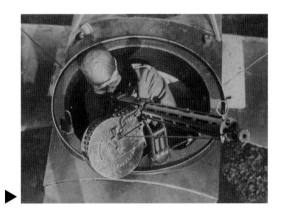

Cockpit machine gun, 1915. Getty Images

March Stieglitz launches *291*, a forum for De Zayas, Picabia, and Paul Haviland, each of whom sees in machine forms a source of aesthetic renewal. "No. 0" of *The Ridgefield Gazook* appears this month as well, edited by Man Ray. "Published unnecessarily whenever the spirit moves us," as the cover states, the magazine never makes it to issue number one.

June Duchamp leaves for New York, taking with him a study in glass, *9 moules mâlic* (Nine Malic Moulds), and plans for the *Large Glass* proper. The ship leaves from Bordeaux in southwest France, not Le Havre as is customary—that city is dangerously near the front lines—and keeps its lights off until well out on the ocean

June Picabia arrives in New York on a French government mission. Once landed, Picabia abandons the duties of god and country for the pleasures of Walter Arensberg's salon and the editorial team of *291*.

Later this month, Duchamp is "processed" at Ellis Island with the rest of the "aliens" before entering the city in good health, with fifty

as a measure of protection against submarine attack.

Vasily Kamensky, cover of *Tango with Cows: Ferro-Concrete Poems*, 1914. Letterpress on wallpaper by Kamensky, The Museum of Modern Art, New York, Gift of the Judith Rothschild Foundation

psychologically devastating, poison gases are also difficult to handle, and for this reason do not greatly further military objectives. "I wish those people who write so glibly about this being a holy war," exclaims one nurse of a different agent, mustard gas, "could see the poor things burnt and blistered all over with great mustard-coloured suppurating blisters, with blind eyes…all sticky and stuck together, always fighting for breath, with voices a mere whisper, saying that their throats are closing and they know they will choke." **May** *New York Times* reports (18 May) that six thousand Armenians have been slaughtered in and around the town of Van. After rounding up the entire Armenian leadership in April, Turks and Kurds in the country proceed over the next three years to massacre between six hundred thousand and two million Armenians through death marches, mass executions, and labor camps. It is the first modern genocide, although that word will be coined only in 1944. **July** The portable *Kleif*, or "small flamethrower," has its initial moment of glory in a surprise German attack on British troops in Flanders, causing nearly eight hundred deaths and indescribable terror. Flamethrowers, battle weapons since Greek times, are modernized by the Germans in 1900 and come to be adopted later by the British and French. They char humans well at one hundred feet and under, but cannot aid long-range advances.

taken refuge from the war. Like Arp, Tzara, Ball, and others after them, the couple frequents the household established in Ascona the preceding fall by Segal and his wife, Ernestine. In September, the Van Reeses move to nearby Zurich. **May–June** Ball and Hennings reach Zurich, desperately poor, on an invitation by Serner to collaborate on *Der Mistral*—which folds after its third issue on 26 April. Ball has used two passports in transit and registered under a false name to avoid inquiries. He moves to Geneva to keep incognito but is found out and incarcerated for a week in August. **July** Marinetti sends Ball his book *Parole in libertà* (Words in Freedom), excerpts from which have appeared in *Der Mistral*. "They are just letters of the alphabet on a page," writes Ball in his diary (9 July). "There is no language any more…it has to be invented all over again." **August** Schad arrives in Zurich. He is introduced by the Polish graphic artist Marcel Słodki to the émigré community, among others Serner, who becomes a mentor and his liaison to the Dada group. **September** Janco takes up architecture studies at the Swiss Federal Institute of Technology (ETH), where he remains for the full four-year curriculum. His architectural training inspires a series of plaster reliefs and assemblages during the Dada period, while his involvement with the Zurich group leads him to introduce subjects such as abstract art in presentations at the ETH.

speech on "Die revolutionäre Idee Russlands" (Russia's Revolutionary Idea). "This war is a cabinet war, a government war," he writes his sister Maria (13 March). "The enormous brutality with which all humanity, education and culture are being oppressed…will be avenged." **April** In a different sphere of the nascent Dada community, Hausmann and Höch first meet, probably at an event hosted by the "cultural emperor" Herwarth Walden. Walden's *Der Sturm* (The Storm), first a gallery and magazine (1910), then a publishing house, and from 1916 an art school and bookstore as well, attracts much of the Berlin intelligentsia. **May** The other core of Berlin Dada is formed by Gross, who returns temporarily to civilian life on 11 May, and the Herzfeld(e) brothers. The three first meet at a soirée hosted by expressionist painter and printmaker Ludwig Meidner, whom Hausmann knows. In his newly rented quarters in the outlying Südende district, Gross begins to depict the frenzy of wartime Berlin, from its whores to its profiteering businessmen. Placed last on the bill of an "Expressionistische Soirée" (12 May), Ball and Huelsenbeck deliver a primitivist art that, while certainly indebted to expressionism, is fresh in its public combativeness. Huelsenbeck declaims "negro poems," while Ball recites alogical verse. The reviewer for the *Berliner Börsen-Courier* (14 May) merely

Back: Magda Segal, Arthur Segal, Aditya van Rees, Adya van Rees, Hans Arp. Front: Otto van Rees, François Arp, 1916. Stiftung Hans Arp und Sophie Taeuber-Arp e.V., Rolandseck

dollars to his name. Duchamp is met by Walter Pach, one of the organizers of the Armory Show, and taken to the Arensbergs' home. Duchamp and Man Ray meet that summer near Man Ray's art-colony home in Ridgefield, New Jersey. **September** After an April visit to Crotti's older brother, now a prominent surgeon in Columbus, Ohio, and a summer spent in his company on Shelter Island, Jean and Yvonne Crotti arrive in New York, completing the (as yet officially unnamed) dadaist emigration.

In an interview, with the *New York Tribune* (12 September), Duchamp declares that the war will produce a "severe, direct art," for people are growing hardened, even "callous" about "the death of those nearest and dearest to them." **October** De Zayas opens the Modern Gallery (7 October). This inaugural exhibition occasions further press interviews, including one with the *Tribune* (24 October) held jointly by Duchamp, Picabia, De Zayas, and the newly arrived Crotti. "I have enlisted the machinery of the modern world," Picabia confides, "and introduced it into my studio." Following upon Picabia's militarized language (art through "enlistment"), Duchamp speaks once more of the war directly. He came to New York, he declares, because he found Paris "frightfully lonely," "like a deserted mansion" with the lights out. "In such an atmosphere, especially for one who holds war to be an abomination, it

Autumn Tzara arrives in Zurich.
October Ball and Hennings begin performing in the cabaret act "Maxim," with Ball also writing skits and playing piano for the troupe. "We have snake-men, fire-eaters, tightrope-walkers, everything you could want," Ball writes his friend Käthe Brodnitz on 16 November. The ensemble goes on tour that winter.

Tzara and his high-school classmate Ion Vinea inaugurate the Bucharest journal *Chemarea* (The Call) with a subversively militaristic editorial statement: "Let us march in, with good armor.... Instead of passports, [give us] an arsenal.... Smoke bombs in wastepaper baskets, pencils with blades....[N]ow it's the turn of those young people, sent urgently

to fight, to ask themselves where they are being sent." Tzara relocates to Zurich before the journal appears.

Schad and Serner collaborate on *Sirius*, the former providing woodcuts in an expressionist style, the latter critical essays and reviews of new art and literature. Ivan Goll, a poet and pacifist recently arrived from Strasbourg, and Arp and Van

Rees are among the contributors.
November The Galerie Tanner gives Arp and the Van Reeses an exhibition (15 November–1 December), to which all the artists contribute cubist-inspired arrangements that range from still lifes to abstract collages—Van Rees' bold poster design for the show counts among the latter. Arp and Taeuber first meet here.

shakes his head: "And then came expressionists without rhyme or reason. The audience started to laugh at the earnest youths onstage and at their pompous nonsense."

Baroness Elsa von Freytag-Loringhoven, 7 December 1915. International News Photography

may readily be conceived that existence was heavy and dull."
November Man Ray has his first exhibition, at New York's Daniel Gallery. **December** The press agency International News Photography captures Baroness Elsa posing in various costumes, presumably in her studio quarters at the Lincoln

Arcade Building, where Duchamp and Crotti are also living. By this time, the Baroness has become, through her "shameless" street performances and sexually provocative artworks, a focal point of the Arensberg circle.
Winter 1915–16 Duchamp and Crotti share a studio for a time. Demonstrably influenced by his French colleagues, Crotti creates

abstract assemblages on glass that feature machine elements and take humor and dynamism as themes: *The Clown* and *Les Forces mécaniques de l'amour en mouvement* (The Mechanical Forces of Love in Motion). These two assemblages and his sculptural homage, *Portrait sur mesure de Marcel Duchamp* (Portrait of Marcel Duchamp Made

to Fit) are seen repeatedly in New York and help to cement the community of dadaists there.

RELATED EVENTS

Vselenskaja Vojna (Universal War), by Kruchenykh and Olga Rozanova, appears; it is the first book of abstract collages ever published. **January** Sigmund Freud begins to publish his introductory lectures on psychoanalysis. Freud's ideas, widely discussed already in Germany and America, become fully popularized only during the 1920s. **February** Psychiatrist F. W. Mott writes of "shell shock" in describing mental disturbances among soldiers who may or may not have been physically wounded.

The German assault begins (21 February) on Verdun, a logistically insignificant yet symbolically important fortress in northeast France. Planned expressly to "bleed France to death," the battle drags on until 18 December, claiming nearly half a million French and German lives while yielding no tactical advantage. **March** Albert Einstein publishes the latest, and soon to be most widely read, version of his work on a "general theory of relativity." **July** 1 July: By the end of day one in the "Battle of the Somme," near Amiens,

ZURICH

December Ball's friend Brodnitz visits Zurich from Germany and helps Ball and Hennings to stage an evening of readings on 17 December. She and others suggest that the duo found their own cabaret. Late next month, Ball shares his plan for an "Artists' Pub: à la Simplizissimus [their principal venue in Munich] but more artistic and with clearer purpose."

February "The young artists of Zurich, whatever their orientation, are invited to come along with suggestions and contributions of all kinds," reads a newspaper announcement for the Cabaret Voltaire in February. The ur-site of world Dada opens February 5, operating in rented quarters in the downtown Spiegelgasse street. The already cramped space will frequently be lined with paintings, making it claustrophobically intimate. Directly across the river is the school "for dance, tone, word, and form" run by Rudolf von Laban, whose students perform at the Cabaret and become romantically involved with its organizers. Ball, Arp, Tzara, Taeuber, Janco, and Hennings soon coalesce as the original ensemble.

On 12 February, the Cabaret showcases futurist and symbolist poems, and one week later folk songs from France and Russia: an eclectic mix of international avant-gardes and non- or anti-German cultures. Ball's acquaintance, Richard Huelsenbeck, arrives on the 26th from Berlin, reading that night and the next from his store of percussive, primitivist verse.

BERLIN

January Max Ernst participates in a two-person show at the Sturm Gallery (2–31 January). He travels to see the exhibition, perhaps on military leave, and meets Gross and the Herzfeld(e) brothers.

Höch enters (1 January) a long-term position at the Ullstein Press, making embroidery and lace designs for women's journals. Ullstein publishes an increasing number of photographically illustrated magazines, such as *BIZ* (The Berlin Illustrated Times), *Der Querschnitt* (The Cross-Section), and *Uhu* (Owl), which will provide Höch with sources for her photomontages. **March** Hans Richter is the subject of a special issue of *Die Aktion*, with an encomium by critic Theodor Däubler, in the same month that he receives his army discharge. **May** The Herzfeld(e) brothers purchase rights to *Neue Jugend* (New Youth), a publishing entity and journal once owned by a high-school classmate. The first number of the "new *Neue Jugend*" appears in July. **June** Richter has a one-person show in Munich, at Hans Goltz's Galerie Neue Kunst, with

HANNOVER

COLOGNE

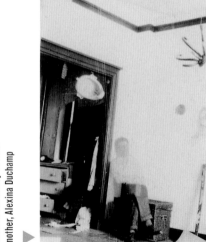

Marcel Duchamp's studio, 33 West 67th Street, New York, 1917–1918. Photograph by Henri-Pierre Roché. Philadelphia Museum of Art, Marcel Duchamp Archive, Gift of Jacqueline, Paul and Peter Matisse in memory of their mother, Alexina Duchamp

NEW YORK

January Man Ray moves to Manhattan and begins work on *The Rope Dancer Accompanies Herself with Her Shadows*. This piece, remarkably analogous to Hans Arp's "chance" collages of the same year, involves imitating cut-paper shapes in paint.

Picabia exhibits at the Modern Gallery (5–26 January). The so-called machine paintings are presented here in number for the first time, an event that generates quantities of negative verbiage in the press. On 15 January Duchamp writes to his sister Suzanne in Paris, asking her to create a "readymade at a distance." After explaining the presence of a bicycle wheel and a bottle rack in his now vacant Paris apartment, he asks Suzanne to sign the latter with an inscription he will provide in a subsequent letter (now lost). **April** Duchamp discusses his idea of "readymade" publicly for the first time, in an interview for the *Evening World* (4 April) that coincides with two group shows in which he is represented: at the Bourgeois Galleries (3–29 April) and the Montross

PARIS

At some point during his military assignment, Ribemont-Dessaignes writes *L'Empereur de chine* (The Emperor of China), considered the first Dada play. **February** Breton meets Jacques Vaché, a soldier being treated for a leg wound, during his medical rounds at the hospital in Nantes. Vaché is a poet and wag who, in Breton's eyes, incarnates an ideal of cynical, even nihilistic humor (his term is "umor," without the h) and irreverence toward established values in society and the arts. After Vaché's death in January 1919, Breton transfers his hero worship almost immediately to Tristan Tzara. **Fall** Suzanne Duchamp makes *Un et une menacés* (He and She Threatened). The assemblage painting, which includes a plumb bob, a gear mechanism for a clock, and other mechanical elements, reflects an awareness of recent art developments in New York that she has presumably gained by seeing the work of Crotti, recently resettled in Paris.

twenty thousand British soldiers have died, and forty thousand more have been injured or captured. The battle, which concludes in November, gains the Allies six miles, against a cost of 1.2 million German, French, and British casualties.

A marathon exchange of grenades at the battle of Pozières Heights (26–27 July) lasts over twelve hours. The

grenade, introduced in the fifteenth century, becomes a weapon of choice in battles that involve racing down trenches and blowing their occupants to bits. Perhaps one hundred million grenades—hand- and rifle-powered, sometimes fabricated from jam tins, occasionally filled with poison gas—are detonated in 1914–18. **August** 27 August: Italy declares

war on Germany. **September** The British forces test a landship, better known by its code name "tank," at the battle of Delville Wood, to no particular effect. At up to twelve tons, slow-moving (two mph) and fatally incapable of bridging wide trenches, the first tanks often end up by "getting ditched." This motorized armor, however, will win the war, for it alone

can withstand the fire of machine guns. Improved versions of the tank, themselves fitted with multiple machine-gun turrets, are deployed in 1918 by the hundreds on the Allied side. **November** Hiram Maxim, inventor of the machine gun (1885), dies on 24 November. Machine guns have only now come into general use, with the Germans leading the way

March Performances continue apace in the Cabaret Voltaire. On the 14th, Arp reads from *Ubu roi* (1896), the outrageous farce by Alfred Jarry that begins with the prototypically dadaist shout: "Merdre!" On the 30th, Tzara, Huelsenbeck, and Janco recite Tzara's first "simultaneous poem" (verses read by more than one person at once) called "L'Amiral cherche

une maison à louer" (The Admiral Is Looking for a House to Rent). **April** In his diary entry for 18 April, Ball first mentions the word "dada" in connection with discussions about a new journal. Ball probably came up with this word as well, sometime in late March. His record of the conversation suggests that the directors of the Cabaret Voltaire grasped the force of

this word to suggest discomfiting subjects, and more broadly to destabilize ingrained expectations of meaning and order: "*Dada* is 'yes, yes' in Rumanian, 'rocking horse' and 'hobbyhorse' in French. For Germans it is a sign of foolish naïveté, joy in procreation, and preoccupation with the baby cariage." **May** 30 May: Simultaneous poems, a "bruitiste" (noise-music) concert,

and dances "on themes from the Sudan" with masks by Janco make tonight's bill at the Cabaret. The dancers likely are students of the choreographer Laban, who in addition to his compositional work has begun exploring a means to transcribe the "primeval, universal" language of dance into an abstract "alphabet" of written symbols—a

seventy works. "Complexity at the price of standing still is a result of bourgeois cowardice," Richter writes in a preface to the accompanying catalogue. That September, he decamps to Zurich and immediately joins the Dada circle there. **October** Baader writes an audacious appeal to the Kaiser to end the war immediately. He also

declares himself "lord in the realm of the mind," and thus exempt from involvement in this conflict. **Winter** Herzfelde and Grosz, as he now writes his name, assemble the *Erste George Grosz-Mappe* (First George Grosz Portfolio), published in spring 1917, nine lithographs of urban anomie drawn in what Grosz calls in 1925 a

"knife-hard style" taken from "folkloristic drawings in the urinals."

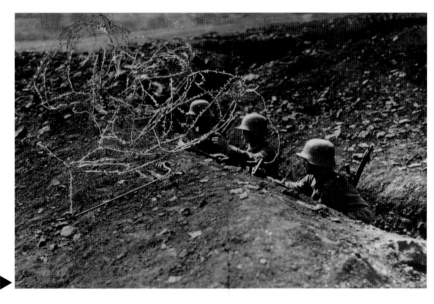

German trench defenses, c. 1916.
Getty Images

Gallery (4–22 April). In all, twelve works are on view, including two explicitly titled "readymade" (*Traveller's Folding Item* and an unidentified object). The *Evening World* article is appropriately sensationalist. "Big, Shiny Shovel Is the Most Beautiful Thing He Has Ever Seen," Crotti is quoted in reference to Duchamp's *In Advance of the Broken Arm*, which

hangs from the ceiling in their shared studio. **June** or **July** Picabia leaves New York once more for Barcelona. **Fall** Crotti and Chastel return to Paris.

Man Ray starts work on ten collages collectively called *Revolving Doors*. These works continue his interest in an abstraction that is not transcendent, but rooted in quotidian

objects and modern experiences: *Long Distance*, *Decanter*, and *Concrete Mixer* are some of the titles. Man Ray is also attuned to the disarmingly radical effect of recasting ordinary things in abstract terms. He writes of *Decanter* in 1919: "It acquires courage from its sudden change of function: built to reject, it becomes an instrument of acceptance."

November The writer Henri-Pierre Roché meets Duchamp and joins the Arensberg circle.

De Zayas writes Tristan Tzara (16 November), from whom he has recently received ten copies of what is likely *La première Aventure céléste de Mr. Antipyrine* (The First Celestial Adventure of Mr. Antipyrine), which contains a version of the very first

ZURICH
BERLIN
HANNOVER
COLOGNE
NEW YORK
PARIS

(one hundred thousand already in 1914). More than any other technology, these new automatic weapons are responsible for the years-long stalemate. At 70 to 150 pounds, they weigh far too much to help an advance charge, but they rip through oncoming human flesh with terrifying efficiency.

project with some connection to the dadaists' researches into abstraction.

Cabaret Voltaire, the group's first publication, appears at the end of the month. Ball announces in an editorial the forthcoming release of the journal *Dada*—the first time this word appears in print. **June** Ball, trussed like an upright lobster inside his "cubist costume"—clawlike hand coverings,

a hat of white and blue, a cylinder of blue cardboard surmounted by a red-and-gold mantle—reads his first "poems without words" (23 June). "Gadji beri bimba/glandridi lauli lonni cadori/gadjama bim beri glassala...." he intones and records in detail that night how, in the effort to avoid disgrace with this tremulous experiment, his voice took on the

"ancient cadence of priestly lamentation." Shortly thereafter, Ball experiences a spiritual epiphany. He closes the Cabaret Voltaire, and after the next event takes his distance from Dada and Zurich. **July** Bastille Day (14 July) is marked by the first, carnivalesque Soirée Dada, held elsewhere now that the Cabaret is defunct. Music, dancing, manifestos, costumes,

paintings, simultaneous poems are part of the festivities. That month, Tzara launches "Collection Dada" with his violently rhapsodic book, *La première Aventure céléste de Mr. Antipyrine* (The First Celestial Adventure of Mr. Antipyrine): "a naughty boy died somewhere/and we let the brains continue/the mouse runs diagonally across heaven/the mustard

Marcel Janco, spread from the illustrated book *La première Aventure céléste de Mr Antipyrine* (The First Celestial Adventure of Mr. Antipyrine) by Tristan Tzara, 1916, linoleum cut. The Museum of Modern Art, New York. Purchase

dadaist manifesto. Duchamp recalled in the 1960s that he first learned of the Dada phenomenon through this book.

Djuna Barnes, later Baroness Elsa's helpmate, gives the first published account of her costuming in the *New York Morning Telegraph Sunday Magazine* (26 November): "...[O]ne sees the Baroness leap

lightly from one of those new white taxis with seventy black and purple anklets clanking about her secular feet, a foreign postage stamp— cancelled—perched upon her cheek; a wig of purple and gold... an ancient human notebook on which has been written all the follies of a past generation."

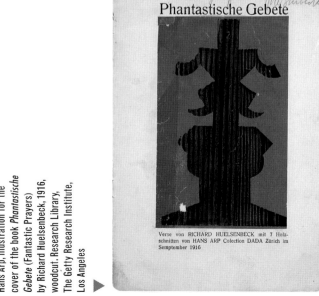

Hans Arp, illustration for the cover of the book *Phantastische Gebete* (Fantastic Prayers) by Richard Huelsenbeck, 1916, woodcut. Research Library, The Getty Research Institute, Los Angeles

runs from a nearly squashed brain/ we have become lamplighters."
This book contains the first printed explanation of Dada: "Dada is our intensity.... it's shit after all but from now on we mean to shit in assorted colors and bedeck the artistic zoo with the flags of every consulate...."
July–November Away from Zurich, Ball and Hennings attempt to

organize a tour in which he would repeat his sound poems in costume. They decide that Hennings will solicit interest by distributing leaflets, into which Ball inserts a series of press reviews: "It looks pretty, and people might think we're world-famous." Yet the reviews are not exactly favorable. One commentator (*Volksrecht*, Zurich, n.d.) lumps Ball's ideas with cubism

and futurism as "the spawn of aimless fantasy and perverse sexuality," while others describe Hennings as "four years old and ravaged" (*Die Aktion*, Berlin, n.d.), possessed of an "expressive, if not pretty" voice and a face destroyed by morphine (*Nieuwe Amsterdamer*, n.d.). **September** Hans Richter arrives from Germany now or soon afterward. **September**

and **October** Two further "Collection Dada" volumes appear, both by Huelsenbeck: *Phantastische Gebete* (Fantastic Prayers), with woodcuts by Janco, in September, and *Schalaben schalomai schalamezonai*, with drawings by Arp, in October. The poems mix vulgar provocation with abstract evocations of non-Western language: "the priest closeth his trou-ouserfly

Picabia on a small wooden hobby-horse, ("dada" in French), 1920. Giovanni Lista, Paris

1917

February Uprisings in Russia (24–27 February) lead to the collapse of the czarist regime.

On 26 February, the Victor Talking Machine Company in New York releases two songs by the Original Dixieland Jass Band. Neither original nor African American, the group nevertheless brings jazz music to a national audience. **April** The United States declares war on Germany. **May–June** The French labor movement clogs Paris with a cumulative total of perhaps one hundred thousand striking workers. These disruptions coincide with a mutinous wave of protest along the French front lines. **November** 7 November: The Bolshevik (Majority) party takes power in Moscow, in

rataplan rataplan his trou-ouserfly and/his hair juts ou-out of his ears/chupuravanta burroo pupaganda burroo…" ("Plane"). **November** Schad moves to Geneva. **December** Ball returns to Zurich and is temporarily reconciled with Tzara and the other dadaists.

Tzara abandons *Mpala garoo*, a poetry collection originally planned as the first volume of the "Collection Dada" series. At the Zurich library, Tzara has been reading African and Oceanian poetry, extending Huelsenbeck's primitivist example to real anthropological research. He begins to print these source poems and his own commentary on African art in avant-garde journals in 1917.

January–February The first *Exposition Dada* (Arp, Richter, Janco, and others) opens at the Galerie Corray (12 January–28 February). **March–April** On 29 March, opening day of the renamed Galerie Dada (still located in Hans Corray's spaces), Tzara writes to Giuseppe Raimondi, director of the Roman journal *Avanscoperta* (Reconnaissance).

Tzara indicates his interest in Italian avant-gardists (Enrico Prampolini, Giorgio Morandi) and asks for reproductions: "The pieces must be abstract and have real value." Art and poetry by Prampolini, Raimondi, and others appear scattered throughout the first four issues of *Dada*, along with notices of Italian journals such as the futurist *Noi*.

January Paul Westheim, an art critic for the newspaper *Frankfurter Zeitung*, founds a monthly journal that will become a pillar of Weimar culture in Berlin: *Das Kunstblatt* (The Art Paper, 1917–33). Cautiously socialist, Westheim keeps a safe distance from Dada. Nevertheless, he counts Grosz and critic Carl Einstein among his friends, and positive reviews of Dix, Schlichter, and Ernst appear here as well.

This month or next, Huelsenbeck, who returned to Germany the previous winter from Zurich to study medicine, moves to Berlin. He soon meets again with Hausmann and Franz Jung, and shares news of the Cabaret Voltaire and its aftermath. **March** *Neue Jugend* publisher becomes Malik, an

Kurt Schwitters meets Christof Spengemann, a Hannover critic friendly with Herwarth Walden. The two become lifelong friends.

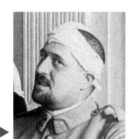

Guillaume Apollinaire wounded, 1916. Courtesy Enrique Mallon

January Arthur Cravan and Leon Trotsky arrive on the same ship in New York City. Cravan, a poet and pugilist who has gone six rounds against heavyweight champion Jack Johnson in Barcelona the previous spring, will gain still greater notoriety as an associate of New York Dada, by undressing himself while addressing the public in April. Perhaps pushed from a boat in Mexico in 1918, his body was never positively identified. Trotsky, always fully clothed for his speeches, will rejoin his rivalrous colleague Vladimir Lenin in Moscow later in the year—the two might have compared notes on Dada, for Lenin had his own stories to tell from Zurich. Lenin subsequently appoints Trotsky Commissar for

March Ribemont-Dessaignes publishes a short polemic, "Civilisation," in Picabia's journal *391*: "It is henceforth confirmed that the purest way to attest to one's love for a neighbor is really to eat him.... To possess by heart or by stomach? The latter is surer. And in the event of an order to the contrary, there's always vomiting."

In the inaugural issue of Pierre Reverdy's journal *Nord-Sud* (North-South) Paul Dermée argues that the time is ripe for "organization, classification, science, i.e., a *classical* age"—hallmarks of the "return to order" later exemplified by Dermée's journal *L'esprit nouveau*, which progresses as the complement to Dada in postwar Paris. Dermée and his

what is known as the October Revolution. The new government sues for peace, signing an independent armistice with Germany. Over 3.5 million Russians have died in the war.

The Dutch periodical *De Stijl* publishes its inaugural issue (dated October).

In Tiflis, Georgia, Kruchenykh, Zdanevich, and others found the group "41°," named for the city's latitude on the globe. Zdanevich publishes a cycle of typographically innovative scripts such as *Ostrav paskhi* (Easter Island, 1919) and *Ianko krul' albanskai* (Yanko, King of the Albanians, 1918). The latter play features a compound character, "two thieves born from a she-goose," who only shouts the letters of the alphabet.

The inaugural Galerie Dada exhibition (17 March–7 April) shows a selection of artists from Herwarth Walden's Sturm Gallery in Berlin. Paintings by Vasily Kandinsky, Paul Klee, and Gabriele Münter provide the backdrop for a lecture series and dance performances, including "abstract dances" by Taeuber set to the equally abstract "Gesang der Flugfische und Seepferdchen" (Song of the Flying Fish and Seahorses) by Ball (29 March). **April** A second Sturm Gallery exhibition opens directly after the first (9–30 April), with more recitals that extend the omnivorous enthusiasm for fresh ideas. A soirée on 14 April features poetry by Kandinsky, Apollinaire, Blaise Cendrars, and Sturm affiliates.

(The Trieste native Alberto Spaini apparently performs the recitation of works by Marinetti ascribed on the program to Ball, giving the dadaists an impression of Marinetti's own style of declamation.) The highlight of the evening is a suite of dance and theater performances with masks by Janco. The next soirée, on 28 April, includes music by Arnold Schoenberg and a tribute to the Catholic reformer and philosemite Léon Bloy. **May** The third Galerie Dada exhibition (2–29 May) mixes work by artists the dadaists admire —Giorgio de Chirico, Paul Klee, Elie Nadelman—with contributions by the group itself. Emphasis is put on graphics, tapestry, children's drawings, and relief sculpture, forms

operation run by Wieland Herzfelde, John Heartfield (as he is now called), and George Grosz with the express purpose of supporting radical leftist art and literature. The name Malik (from the Hebrew *melech*: king or leader) comes from a novel by expressionist Else Lasker-Schüler, who has supported this venture and the artists involved in it from the first. **June** The censors have ordered the journal *Neue Jugend* to cease printing for the duration of the war. Two final issues appear, one in May and one this month, in a format that brazenly defies the ban: an American-style tabloid nearly two feet tall by one-and-a-half feet, folded. For the June issue, the title is printed in bright red and green, and a large photograph of New York's Flatiron Building appears on the front page. (The United States has just declared war on Germany.)

August Huelsenbeck, in correspondence with Tristan Tzara, tells him about the activities of Herzfelde, Hausmann, Grosz, and others, positioning himself as a Berlin-Zurich liaison. **Fall** A second portfolio of twenty lithographs, the *Kleine Groszmappe* (Small Grosz Portfolio), appears, published by Malik. The cover design matches the contents in its purposeful jumble of drunken letters, recycled advertising images, and conflicting styles of typeface. ("Metropolis vivisected *sans gêne* Das Kunstblatt, December 1917).

Foreign Affairs. After Lenin's death, things get progressively worse for Trotsky, who is eventually exiled and stripped of his citizenship. He, too, meets an unhappy end in Mexico; Stalinist agents there plant an ax in his skull in 1940. **January** From Barcelona, Picabia issues the first number of *391*, the longest-lived of the Dada periodicals. Subsequent numbers are printed in New York, Zurich, and Paris. "You'll receive a magazine, *391*, which is the double of your *291*," Picabia crows to Stieglitz. The Picabias bring copies of the first four issues to New York in April.

April–May Margaret Anderson responds to a climate of increasing intolerance in the United States— the Society for the Suppression of Vice, for example, has been raiding meeting places for homosexuals— with an article in *The Little Review* that consists of a blank page and the caption: "We will probably be suppressed for this." **April** 9 April: The Society of Independent Artists (the Independents) is readying its inaugural exhibition. The society membership counts a number of players from New York Dada: Katherine Dreier, Walter Arensberg, and Stieglitz on the advisory board; Duchamp as head of the exhibition committee; John Covert as secretary. At a private viewing, a porcelain urinal signed "R. Mutt" and titled *Fountain* draws heated criticism. "You mean to say," expostulates painter George Bellows, "if a man sent in horse manure

companion Céline Arnauld nevertheless become fringe actors in Paris Dada. They have ties particularly to Tristan Tzara, from whom Apollinaire, an editor at *Nord-Sud*, solicits a work for the very next issue of the journal. **June** Apollinaire's farce *Mamelles de Tirésias* (Breasts of Tiresias) has a controversial premiere (24 June). The play, which introduces the term surrealism, contains innovations— particularly its dissociation of language from setting or plot— that prove formative for Paris Dada and its echoes around Europe. Yet its patriotic message seems entirely heartfelt: the French should make more babies, to counter the German menace. **October** Louis Aragon meets Breton at Adrienne Monnier's bookstore, La Maison des amis des livres. The two medical students continue their military service together at the Val de Grâce hospital in Paris. **November** Picabia passes through Paris just long enough to make the acquaintance of an elegant young Belgian woman named Germaine Everling. The two leave together for Switzerland, where Picabia's wife and children are staying. Everling becomes a long-term addition to his private life.

Apollinaire delivers a lecture on "L'esprit nouveau et les poètes," in which he explains what he means by "new spirit": French "good sense" and "a horror of chaos" or "disorder." The lecture appears in print in December 1918, soon after Apollinaire's death.

ZURICH

of creation not usually championed as high art. Reaching back as well as out, Tzara and Ball organize on 12 May an evening of "Alte und neue Kunst" (Old and New Art) in which they present stories of the European Renaissance, poetry from east-central Africa, and some contemporary writing, all as support for their interest in abstraction and liberating the creative spirit.

In late May, Ball and Tzara quarrel once again, and Ball breaks definitively with Dada. **July** The first issue of *Dada* appears, edited by Tzara. **November–December** The Kunstsalon Wolfsberg becomes a new, though hesitant, venue for Zurich Dada with an exhibition (14 November–10 December) that includes work by Arp and Segal.

December Among the artworks reproduced in the second issue of *Dada* is a *Tableau en papier* (Paper Painting) by Arp, known today as one of his *Collagen nach dem Gesetz des Zufalls geordnet* (Collages Arranged According to the Laws of Chance). Arp and Taeuber have been exploring the conjunction of geometric abstraction, which

looks mechanically produced, with an equally depersonalizing but antimechanical cultivation of randomness.

BERLIN

Putting his spiritual-critical insight to entrepreneurial ends, Baader makes plans with Hausmann to found a Christus-GmbH, or "Christ Company."

Through Count Harry Kessler, an aristocratic patron of the avant-garde, Grosz and Heartfield obtain jobs at the army's propaganda film service, which soon (18 December) becomes the premier German film

company UFA. Heartfield will keep this employment until early 1919. **October** Baader presents himself in nationwide parliamentary elections (9 October) as a candidate from Saarbrücken.

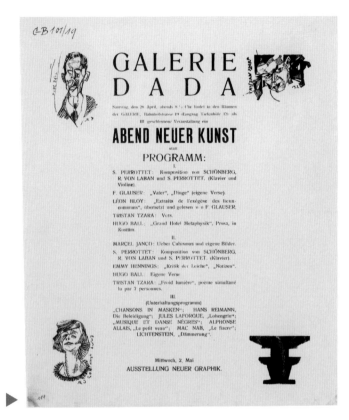

First Dada Evening, Galerie Dada, Zurich, 1917. Kunsthaus Zürich

HANNOVER

COLOGNE

NEW YORK

glued to a canvas that we would have to accept it?" *Fountain* is withdrawn; Duchamp, Arensberg, and Stieglitz resign in protest; and the rest, as they say, is history.

In the absence of *Fountain*, reviewers single out a different item of bathroom art, Beatrice Wood's *A Little Water in Some Soap*, which features a scalloped bar of soap nailed

to the drawing of a nude woman in the tub, in such a way as to accentuate her private parts. This comically vulgar redo of Sandro Botticelli's "Venus on the Half-Shell," a foretaste of the "mistreated masterpieces" by Albrecht Dürer, Paul Cézanne, and others with which dadaists will later regale the European public, marks "the keynote of the childish whim,

the unbridled extravagance, the undisciplined impudence and immature ignorance and even derangement" to which the Independents' Exhibition "gave free fling" (*Philadelphia Public Ledger*, 10 April).

In the face of general consternation, Duchamp and Picabia invite Arthur Cravan to lecture on "The Independent Artists in France and

America" (19 April), knowing well that Cravan is not the type to provide reassurance. Exhibition guards forcibly remove him after he curses foully and begins to strip; Arensberg later bails him out of jail. "What a wonderful lecture!" Duchamp recalls that evening. **May** The army initiates selective conscription, eventually calling up nearly three million

PARIS

men. None of the Arensberg circle is pressed into service. It is unclear how Man Ray and Morton Schamberg manage this. Covert is already working for the Committee on Public Information, a government propaganda organization. Arensberg and Joseph Stella, born in the 1870s, are above the age limit (as is Stieglitz). Duchamp, interviewed by the French

authorities, finds himself appointed to a government mission — made into "a miserable bureaucrat," as he reports in a letter to Ettie and Florine Stettheimer (8 October). **May** *The Blind Man*, a journal first issued on opening day of the Independents' exhibition, publishes a second number, devoted to "The Richard Mutt Case." Articles appear in defense of *Fountain*,

and Stieglitz photographs the piece on display in Gallery 291. The editorial team, led by Duchamp and Wood, also holds a riotous costumed ball (25 May) "at Ultra Bohemian, Pre-Historic, Post Alcoholic" Webster Hall. Duchamp climbs a flagpole, Wood dances "continuous syncopations" in a brocaded gown, and the general merriment lasts well into the night.

This month as well, Wood, Duchamp, and Henri-Pierre Roché put out *Rongwrong*, named following a printer's error in transcribing the original title: *WrongWrong*. **September** Picabia and his wife Gabrielle Buffet leave New York, she to rejoin their children in Switzerland, he for Barcelona, where he will prepare his first book

1918

New Year's Day The all-black Fifteenth Infantry Regiment, led by machine-gunner and symphony conductor James Reese Europe, joins the Forty-Second "Rainbow" Division of the United States Army in France. The soldiers are barred, both going and returning, from parades on New York's Fifth Avenue, being told "black is not one of the colors of the rainbow." Hindered by the proscriptions of segregation, the regiment, now numbered the Three-Sixty-Ninth, is reassigned to the French army, where it earns widespread respect. A brass band (the "Harlem Hellfighters") that Europe is asked to form entertains crowds of thousands, igniting a fresh craze for jazz and ragtime. Europe is gassed in June, and while recovering writes "On Patrol in No Man's Land," one of his most popular postwar hits. **April** *Calligrammes* by Guillaume Apollinaire, written in 1913 and throughout the war, is published. These "shaped" poems, in which words and lines are formed into drawings, spur the dadaist revolt against conventional, rectilinear

February Guillaume Apollinaire writes to Tzara to decline his request for submissions to the third issue of *Dada*, citing concern over his image during a time of—literally—entrenched nationalism: "I think it might compromise me. . .to collaborate on a revue that, however good its spirit, has German collaborators, however friendly toward the Allies."

Francis Picabia moves to Lausanne to be treated for depression, and perhaps alcoholism. **June** In a long and detailed letter to Paul Dermée, his first solid contact within the future Paris Dada circle, Tzara sets forth his concept for issues 3 and 4-5 of the journal *Dada* (24 June). Tzara describes the vagaries of postal inspectors, censors, importation officers, and booksellers prejudiced against ideas from abroad, as well as the need to manage publication budgets and supervise printing with care; "business," Tzara asserts, "is also an element of poetry, like pain or farce." **July** 23 July: Tzara reads "Manifeste Dada 1918" to spectacular effect at a one-person soirée in the Meise Hall. Although the evening

January "Ladies and Gentlemen! This evening is intended as a show of support for Dada, a new international 'art movement' founded in Zurich two years ago....We were for the war, and today Dada is still for the war. Things have to collide: the situation so far is nowhere nearly gruesome enough." Thus Hulsenbeck introduced Dada to Berlin, with his "Erste Dada-Rede in Deutschland" (First Dada Speech in Germany), during a soirée at Isaac Neumann's Graphic Cabinet (22 January). Four days later, the *Vossische Zeitung* newspaper prints the first public mention of a "Club Dada" in a review mockingly titled: "O Burrubuh hibi o burrubuh hihi o hojohojolodomodoho." **April** or **May** Now and over the summer, Hausmann composes a series of visually striking, phonetic poems, such as "grrrün" (grrreen), "bbbb," and four *Plakatgedichte* (poster poems). The latter are "couplets" formed by letters, punctuation marks, and symbols that Hausmann asks a professional printer to choose at random from his tray. Hausmann

June Schwitters goes to Berlin, where he has work in an exhibition at Walden's Sturm Gallery (he signs the guestbook on the 28th). This début showing features *Abstraktionen*, several nearly abstract canvases that directly precede the invention of Merz. Schwitters finds in the Sturm circle a receptive audience for his multimedia experiments in poetry, painting, and performances. **November** Within weeks of the armistice and the Kaiser's abdication, Schwitters resigns from his draftsman's job to devote himself to art.

November An Allied occupying force remains in German lands west of the Rhine River. The Versailles Treaty, signed in 1919, places Cologne under British military control for a period of five years. **Late** Baargeld joins the left-wing Independent Social Democrats and becomes a party functionary. He will remain active in party politics through 1920.

of poetry, *Cinquante-deux miroirs* (Fifty-Two Mirrors). **December** Crotti and Chastel return briefly to New York, even as they finalize their divorce (29 December).

Man Ray begins to make aerographs, a form of spray-painting. **February–July** Four years after abandoning painting, Duchamp creates *Tu m'* to satisfy a request from Katherine Dreier. This "tombstone" composition, Duchamp's last work in oils, inventories those previous works by the artist created by operations of chance or selection, and it is itself a readymade of sorts: tracings of the projected outlines cast by these various pieces when placed in raking light. An advertising painter is hired to create the pointing finger and signs it, prominently, while other elements are painted in by Yvonne Chastel, now Duchamp's companion. **June** "Love-Chemical Relationship" (inspired by *The Large Glass*) appears in *The Little Review*, the first of nearly two dozen poems by Baroness Elsa printed in the magazine through 1925. "Kiss me....upon the gleaming hill..."; "Slippery it must be—I will glide...A-H-H-H..." and "Gay god—scarlet balloon" are among the verses that challenge both censors and sexual conformists with their mystical ecstasy. **August**

letterpress printing. **October–November** Sailors in the port city of Kiel refuse to report for duty on 30 October. The mutiny culminates in a widespread, working-class uprising that topples the Kaiser and swings the country briefly toward radical left-wing governance. To counter this "November Revolution," a national network of Freikorps is established

that eventually numbers four hundred thousand armed veterans. This volunteer paramilitary organization intervenes brutally on behalf of rightist army leaders and politicians well into the 1920s. **November** Apollinaire dies of the flu (9 November), his demise accelerated by a head wound sustained at the front in 1916. Dadaists mourn him in Paris

and Zurich, and he is subsequently celebrated by visually oriented poets around Europe. "His season ought to have been the joy of victory, our victory, that of the new, essential laborers of obscurity and the verb. He knew the motor of the stars, the exact dosage of tumult and discretion." (Tristan Tzara, *Sic*, January–February 1919).

On the eleventh hour of the eleventh day in the eleventh month, with chilling, mathematical precision, the world war comes to an end. Statistics are soon tallied: 8.5 million soldiers dead and 21 million more wounded; 195 trillion dollars spent by the belligerent nations. The European map is changing radically, as Russian, Austro-Hungarian, Ottoman,

is conceived to promote a new book by Tzara and Arp, the manifesto becomes its centerpiece and proves tremendously influential in the further popularization of Dada internationally. Tzara speaks here of a need for spontaneity, abstraction, openness to chance, and a healthy disgust toward logic and ruling order; the form of his text is of a piece with its

content. "Tranquility sadness diarrhea is also a feeling war business poetic element infernal economic mind screw it all national hymn an ad for brothels...," he writes by way of synopsis in his "Chronique zurichoise" the next year. **August** Tzara and Picabia first correspond, during a stay by the latter at the Swiss spa town Bex-les-Bains.

September An adaptation of the commedia dell'arte play *Il re cervo* (König Hirsch / King Stag) by eighteenth-century Venetian satirist Carlo Gozzi opens the Swiss Marionette Theater in Zurich (11 September). Sophie Taeuber (whose sister works for Carl Jung) makes the sets and marionettes for this production, which for the first time unites Dada

publicly with psychoanalysis. Characters such as the Freudian Analyst, Dr. Oedipus Complex, and the Ur-Libido fairy fight over a king and his beloved in a realm named after the hospital where Jung has his clinic. "Kill me, kill me," cries the wicked minister Tartaglia at the end. "I haven't analyzed myself and I can't stand it any more!"

reads the results aloud, possibly at the Café Austria on 6 June. **April–July** The sixteen-page *Club Dada* appears. Letterpress explosions, scattered like shrapnel across the cover pages, advertise the Club's publications and activities, and scream empty slogans: "Watch your health!" "What do we want? What can we do?"

Club Dada is available at the first great Berlin Dada event, a soirée in the Berliner Sezession building (12 April). Grosz now joins Huelsenbeck and Hausmann, enlivening their talks by singing, dancing jazz "syncopations," and bouncing soccer balls off the heads of the assembled. Success spurs the group to further actions. Grosz mounts several "Futuristisches

Cabaret" evenings with primitivist "Apachentänze" (Apache Dances). Hausmann and Baader begin feeding bombastic news items to the daily *Berliner Zeitung am Mittag*. The two also plan a "simultaneous novel," along lines developed the following year by André Breton and Philippe Soupault, and read texts in the street. In the midst of this volcanic activity,

Huelsenbeck unexpectedly takes leave of the Club, returning only late in the year. **June** Kurt Schwitters has his first show in Berlin, at Walden's Sturm Gallery, which will become his principal exhibition space during the Dada years. Either now or at one of his next two Sturm exhibitions, in January or June of the following year, he meets Hausmann,

Finding wartime America almost as stifling as wartime France, Duchamp relocates to Buenos Aires, where he will stay nine months in a state of self-imposed withdrawal. **October** Morton Schamberg dies of the "Spanish flu," one of twenty-five to fifty million victims of this epidemic worldwide.

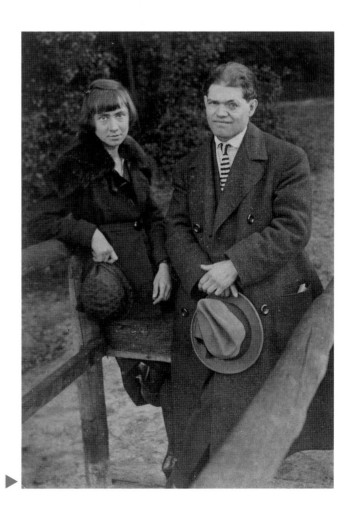

Hannah Höch and Raoul Hausmann in Schlachtensee, 1918. Berlinische Galerie, Landesmuseum für Moderne Kunst, Photographie und Architektur

RELATED EVENTS

ZURICH

BERLIN

HANNOVER

COLOGNE

NEW YORK

PARIS

and Prussian empires give way to new state formations. From Russia in particular comes a fresh political model, and branches of the Communist Party are founded in the West within months of the war's end; most European nations have an official Communist Party by 1921. In the defeated nations, domestic government temporarily collapses. Across

much of central-eastern Europe, captainless and impoverished soldiers band together to terrorize civilian populations, and turn later (the Freikorps) to abetting political extremists.

Arp, Janco, and Richter have tried to improve a second-rate exhibition of modern painting at Kunstsalon Wolfsberg, to which Picabia was invited to send paintings as well. In the end, the gallery owner rejects Picabia's works—but not before Tzara and the others see and admire them, cementing Picabia's standing in the group. "The Salon's director

is an abominable and pretentious insect, whose impotence and lack of talent have been etched in the shape of vermin on his feeble intellectual capacity," Tzara assures the fuming painter by letter (26 September). **November** Serner relocates to Geneva (30 November), but the authorities there refuse him a visa. After weeks of negotiations, Serner

returns (around 1 March) to Zurich. **December** The third issue of *Dada*, which opens with Tzara's "Manifeste Dada 1918," signals a tremendous shift in conception. Jumping from a small, squarish booklet to a brightly colored newsprint the size of an illustrated magazine, this issue mixes assorted typefaces and integrates illustrations into the text block.

The cover summarizes the radicalized posture with a self-aggrandizing phrase by Descartes, set on a diagonal: "I don't even want to know if there have been other men before me."

Höch, and Hans Arp, all of whom become lifelong friends. **July** The 30 July issue of the *Berliner Zeitung am Mittag* contains Baader's *Acht Weltsätze* (Eight World Theorems), a collection of radiant, mystical propositions that begins with the redemptive assertion: "People are angels and live in heaven." Baader has

tailored these theorems to the world's most prestigious awards, the Nobel prizes in chemistry, physics, literature, medicine, and peace. Having "solved" all the problems the Nobel committee seeks to address, Baader cheerily proposes that he receive all five awards that year. **July** or **August** Hausmann and Höch take a trip by the Baltic Sea. During this

vacation, the couple first discusses photomontage, their most influential visual contribution to international Dada, and Höch's principal creative idiom for the rest of her life. Among the many possible sources in popular culture for the technique, one mentioned by Höch seems suggestive: a commemorative military picture she acquires, with the heads of soldiers

pasted in over standard uniforms. **September** With the article "Vom Sticken" (On Embroidery) in the trade magazine *Stickerei- und Spitzen-Rundschau* (Embroidery and Needlework Survey), Höch begins a series of writings on the artistic legitimacy of embroidery and its inherent abstraction. In her job at Ullstein Press, Höch designs many

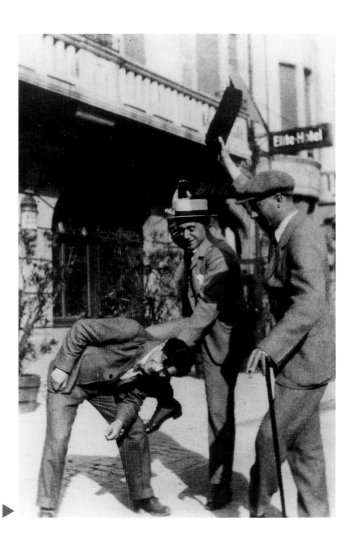

Tristan Tzara, Hans Richter, and Hans Arp in front of the Hotel Elite, Zurich, 1918. Stiftung Hans Arp und Sophie Taeuber-Arp e.V., Rolandseck

patterns for embroidery, cutwork, filet, lace, and other kinds of stitchery. Beginning in 1919, she uses Ullstein's pattern illustrations in turn to make abstract photomontages. **October** Hausmann's book *Material der Malerei, Plastik und Architektur* (Material of Painting, Sculpture, Architecture) appears as the third Club Dada publication, in an edition of just twenty-three copies. The spare design includes four colored woodcuts and a vitalist plea, in prose stripped of punctuation, to make art and architecture vectors of exuberant abstraction. **November** One week after the Kaiser's abdication and the declaration of peace, Baader interrupts a mass in the Berlin Cathedral (17 November). "You don't give a damn about Christ!" he yells, before he is thrown out of church. Baader elaborates in a press statement: "[Because] not just you, but the whole of so-called christianity doesn't give a damn, that's why this awful war happened, that you, my friends, and your spiritual leaders have on your conscience." **December** The Novembergruppe takes shape in Berlin. Adopting its title from the momentous political events of the previous month, this broadly based, utopian art alliance pledges to do away with academies, socialize theaters and liberal occupations, and wed progressive art to the "brotherhood" of working people. Most of those associated with

Scene from *König Hirsch* (King Stag), Zurich, 1918, marionettes by Sophie Taeuber-Arp. Museum Bellerive, Zürich

435

RELATED EVENTS

January–February Berlin, Stuttgart, and Bremen are among the cities engulfed in street battles between supporters of the communist Spartacists' Union and defenders of a right-wing military leadership. Communist leaders Rosa Luxemburg and Karl Liebknecht are murdered by Freikorps agents (15 January) immediately after the pitiless Gustav Noske becomes minister of defense; Luxemburg's putrefied corpse is dredged from a Berlin canal at the end of May. **February** D. W. Griffith, Charlie Chaplin, Douglas Fairbanks, and Mary Pickford found United Artists films to challenge the studios' exploitation of actors. Chaplin, *The Tramp*, proves particularly appealing, and in Europe both public and avant-garde audiences applaud him from Paris to Moscow— sometimes before seeing his films (Chaplin reaches Germany only in October 1921, for example). **March** In Milan, Benito Mussolini founds (23 March) the Fasci di combattimento, the first political organization to adopt the Latin word *fasces*. **April–May** The Bauhaus school

ZURICH

January–February After its début in Basel last November, the inaugural showing of the artists' collective Das neue Leben comes to the Kunsthaus Zürich (12 January–5 February), with Arp, Taeuber, and Picabia among the exhibitors. Picabia has contributed eleven "Compositions," his largest showing in Switzerland in light of the fiasco at Kunstsalon Wolfsberg. The group's manifesto abolishes hierarchies of visual creation and calls on individuals "to realize new ideas in better materials." With these works as his examples, Tzara lectures (16 January) on abstract art. While this show is up, Picabia comes for three weeks to Zurich. He and Tzara meet and collaborate on the eighth issue of *391*, printed here as well, which contains a balance of material from the Zurich and Paris Dada enclaves. One text in particular, which Tzara and Picabia write on a shared page, moving outward from the middle in opposite directions, takes its place alongside the street performance by Raoul Hausmann and Johannes Baader in July 1918, and the novel *Champs magnétiques*

BERLIN

Berlin Dada join the group or work with it during the first postwar years, even though the dadaists collectively charge the Novembergruppe with insufficient radicalism.

January Grosz, Heartfield, and Herzfelde join the Communist Party at or just after its founding. Baader, meanwhile, writes Tzara on 19 January to share news of a "peace offensive" he is launching to coincide with the first elections for the Weimar national assembly to be held that day. His opening salvo takes the form of a telegram to culture minister Hans Sivkovich: "BAADER, not WILSON, makes peace FOR GƎRWany." **February** Funded by Count Kessler, Malik issues *Jedermann sein eigner Fussball* (Everyone His Own Soccer Ball), like *Neue Jugend* a tabloid-sized broadsheet, with a cover that parades a fanfold of leading politicians under a competition announcement: "Who is the prettiest?" Herzfelde spends two weeks in prison (7–20 March) for this publication. **April** Scholz and Schlichter exhibit in Karlsruhe with the newly founded Gruppe Rih (Wind), named for an Arabian stallion in a book by Schlichter's personal hero, adventure novelist Karl May. Directions to the show are chalked on houses around town using the motif of a cubist phallus.

HANNOVER

Early Schwitters begins to produce assemblages, his first Merz works. He asks Raoul Hausmann now or in late 1918 to be admitted into Berlin's Club Dada, a request that Richard Huelsenbeck vetoes soon after, on the grounds that Schwitters is bourgeois. **April** Paul Steegemann opens a publishing house in Hannover. He describes his most famous book series in a later publicity brochure: "The Silbergäule is the (now) popular name of an edition in which... authors of a partly humorous, partly serious outlook are published, apparently unselectively. This lack of selectivity hides a system, however —the great chaos of our mental structure. We shed our skins daily: from Lao-Tze to Dada. And he is a fool who confuses chaos for a dungheap!" **May** Schwitters first writes to Tristan Tzara (24 May), indicating his "great interest" in Dada publications and in sustaining a correspondence.

This month or next, Schwitters makes his largest assemblage to date, *Das Arbeiterbild* (The Worker Picture). The title alludes to the Freikorps massacre of early May,

COLOGNE

February–March Ernst, Baargeld, Heinrich Hoerle, and other transient members of the small proto-Dada faction in Cologne create *Der Ventilator* (The Fan), a pro-Marxist weekly that the British occupation forces ban after its sixth issue. The neologism "Stupidien" first appears here as a coded place name for benighted, contemporary Germany; turning the insult ironically upon themselves, the Cologne dadaists will later identify with "stupid-land" as well. **March** Ernst, his wife Luise Straus, and other young artists disrupt a performance at the municipal theater with catcalls and a parodic rendition of the now discredited national anthem. Guardians of public taste decry "those circles who see what they call art as a playground for experimental psychiatry, especially *psychopathia sexualis*, who swoon over futurism, cubism, dadaism and crazed expressionism...." (*Bücherwelt*, May 1919). **May** The Arbeitsgemeinschaft Kölner Künstler (Cologne Artists' Guild) is founded, with the future dadaists among its membership, partly to take advantage

NEW YORK

August Katherine Dreier sails on her first European trip since before the war. Duchamp meets her in Rotterdam. In addition to visiting family whom she has not seen in years, Dreier uses this and subsequent travels to scout for new art to be shown in New York. With trips to Berlin, Cologne, and Hannover, and expert guidance from Duchamp and Man Ray, Dreier becomes a key, if unwitting, member of the international Dada network—a sort of Margaret Dumont to the dadaists' Brothers Marx. **November** Man Ray has a one-person show at the Daniel Gallery, with work from the last six years. His aerographs are exhibited for the first time, along with all ten panels of *Revolving Doors*.

PARIS

January "I was truly enthusiastic over [the Manifeste Dada 1918]; I no longer knew from whom to expect the courage you show," writes Breton (22 January) in his very first letter to Tzara, whom he sees as a beacon of avant-garde rebellion. **March** Breton, Aragon, and Philippe Soupault put together the first number of *Littérature*. Over the course of twenty issues, the last of which appears in August 1921, this largely literary journal becomes one pillar of Paris Dada and a nucleus of the future surrealist group. Picabia returns from Switzerland, settling in Paris now with Everling. **April** Jean Crotti and Suzanne Duchamp marry in Paris. **July** Duchamp returns to Paris after a month-long sea voyage from Buenos Aires to London. **August** *Pensées sans langage* (Thoughts Without Language) appears, the first volume of poetry by Picabia published in Paris. The short introduction by "Udnie," a fictive creation from Picabia's pre-war years, follows the hermetic references of his "machine paintings": "demagnetizing condensator current[s]," a "void equal to the

for applied arts opens in the east-central German town of Weimar.

6–7 April: A Soviet Republic is proclaimed in Munich. It is soon succeeded by a "dictatorship of the proletariat" with its attendant Bavarian Red Army (16 April). Noske's paramilitaries arrive to quell it in May and massacre over one thousand people in six days.

(Magnetic Fields) by André Breton and Philippe Soupault in May–June 1919, as a pioneering example of automatic writing.

Also this month, Segal has a one-person show at Kunstsalon Wolfsberg (18 January–16 February), with forty-seven works. Segal explains the socialist credo behind his new painting style in a catalogue statement:

Berlin Dada has a short, first exhibition, once more in the print gallery of Isaac Neumann (28–30 April). Although Höch presents abstract pieces, the press labels the show satirical, goaded by Grosz' painting *Deutschland, ein Wintermärchen* (Germany, a Winter Fairy Tale) and a "monstrous" assemblage by Baader (now lost). Indeed, assemblage comes

which overturned the workers' soviet in Munich. **July–August** Schwitters exhibits his Merz assemblages for the first time in two group shows at the Sturm Gallery. In the July issue of *Der Sturm*, Schwitters explains the term, which he began to employ the previous winter. "The word Merz means essentially bringing together all conceivable materials

of a controversial new public subvention for local artists. Ernst draws upon this fund to produce his lithograph portfolio *Fiat Modes, pereat ars* (Let There Be Fashion, Down with Art), advertised in the forthcoming Dada journal *die schammade* as "the first case known to us in which a municipal administration has commissioned a dadaist work of art.

sum of currently unused energies," and so forth. The poem itself is, by contrast, lyrical, at times almost tender: "a caress brings me back to see her/her hands beat like a heart/on the greasy idol with shining eyes…the skin, captured poetry,/smiles like a young man/just introduced/and discreet as a poor display of wares." **November** *Littérature*

On May Day, approximately four hundred soldiers, sailors, and marines raid the office of the *New York Call*, a socialist newspaper, where they beat the editors and vandalize the premises. **June** At Versailles, France, the Allied powers present Germany (28 June) with a final treaty of terms for peace, which couples tremendous reductions in

"Equivalence is juxtaposition and superposition…. Each part is as important as the others. One is there for all, all for one." **March** Swedish painter Viking Eggeling registers (17 March) in Zurich, then moves to outlying towns through August 1919 before returning to Germany. He participates throughout these months in Zurich Dada events.

to the fore here, principally thanks to Jefim Golyscheff, a fleeting but vital member of Berlin Dada, who apparently puts together at least one piece (also lost) from children's toys and densely collaged newspaper clippings.

A soirée on 30 April marks the show's high point, with readings by Huelsenbeck and Hausmann and a simultaneous poem for seven people.

for artistic ends, and in technical terms, a principle of equality for each kind of material." His project has the air of a rescue mission, a means to ennoble the world by transforming its daily matter into Art, yet his delight in listing materials suggests Schwitters also bears a subversive love of trash. **August** "An Anna Blume" (To Anna Blossom),

Cologne marches in step [with Dada]." **August–September** The Ernsts and Baargeld visit Paul Klee in Munich and bring back nearly three dozen works by him for a fall exhibition in Cologne. Through Klee, they learn of Arp's participation in Zurich Dada. Ernst also discovers the work of Giorgio de Chirico, reproduced in the journal *Valori plastici* (Plastic

advertises a bluntly provocative survey among authors both young and established, which consists of a single question: Why do you write?

Four works by Picabia are included in this year's Salon d'automne (1 November–10 December). They are the first examples of his "machine" painting to be seen in Paris—but the organizers hang them under a

assets and territory with the demand for financial compensation to all affected civilians in the victorious countries. American economist John Maynard Keynes and others predict an economic disaster in Germany.

The United States Senate passes the nineteenth constitutional amendment, extending voting rights to women. Shocking protests followed

Tzara, likely the one who had introduced him to Richter, publishes two of Eggeling's lithographs on the theme of "Basse générale de la peinture" (Figured Bass in Painting) in the fourth issue of *Dada* that May. The plan to animate abstract images through a "figured bass," or a succession of visual shapes equivalent to counterpoint in musical harmony,

Golyscheff, a musician by training, performs an "Antisymphonie" with Höch, on pot lids and rattle. **June** *Der Dada* appears, edited by Hausmann and Baader, with the agreement of Tzara, leader of the original *Dada*. Photomontage is not yet part of the typographic gestalt, but multidirectional, competing typefaces have become the norm—

composed by late June, appears in *Der Sturm*. "O thou, beloved of my twenty-seven senses, I love thine! Thou thee thee thine, I thine, thou mine, we?" This grammatically rebellious, ribald love poem catapults Schwitters to notoriety nationwide, and translations into several languages soon follow. **November** With help from Schwitters and Tzara,

Values). Knowledge of Dada and de Chirico fuses in Ernst's works of the next several months, most prominently in *Fiat Modes*. **Fall** Arp is once again in Cologne, visiting his father. He and Ernst begin a close collaboration that generates the core of Cologne Dada. **October–November** Ernst creates his first printing-block and rubbing

stairway. In response, Picabia sets the tone for Paris Dada by creating a public scandal: an open letter to the Salon president and an attack in *391* that, typically, Picabia orchestrates but does not himself write. The virulent charges are signed instead by managing editor Ribemont-Dessaignes, who displays such a talent for handling the furor that he becomes

that chamber's rejection of a previous version in September 1918, among them a nationwide lecture tour by formerly incarcerated suffragists dressed in copies of their prison garb. It will be August 1920 before the amendment is ratified by the requisite three-quarters of states. Germany, meanwhile, extended the vote to women immediately after

inspires Eggeling and Richter to begin their joint experiments in cinema. **April** Serner and Tzara fill the Kaufleuten Hall to capacity for the eighth and final Dada soirée, bringing Zurich Dada into the realm of big-time entertainment. The first pieces, writes one M. Ch. for the daily *Berliner Börsen-Courier* (17 April), meet with "ironic exultation,"

as has a rhetoric of institutional parody. "Take an ad out with Dada!" "Put your money in Dada!" Attached is a thirteen-point pamphlet by Golyscheff and Hausmann, "Was ist der Dadaismus und was will er in Deutschland?" (What Is Dadaism and What Does It Want in Germany?) that rescripts U.S. President Woodrow Wilson's vision for postwar Europe.

Spengemann inaugurates his journal *Der Zweemann* with an issue on international Dada. The magazine includes a manifesto signed by members from Zurich and Berlin, but not Schwitters. His Merz manifesto is reprinted, however, and Schwitters also sends illustrations that month to *Der Zeltweg*, the final periodical issued by Zurich Dada. **Late** Capitalizing on the poem's

drawings. Attracted particularly to science and classroom education, he begins to use diagrams, forms and letters, as well as a teacher's manual that inspires many of his *Übermalungen* (overdrawings). **November** Official entrance of Dada into Cologne. Arp, Ernst, Baargeld, and Heinrich Hoerle secede from the Cologne Artists'

known as the "polemicizer" of Dada. **December–February 1920** In three installments, *Littérature* prints responses to its questionnaire, "Why do you write?" The eighty-three answers give a depressingly complete perspective on the self-inflated, parochial literary scene in Paris. Sincere authors sound inane or sentimental, while established

RELATED EVENTS

the armistice; France does so only in 1944, and Switzerland not until 1971.

The *Illustrated Daily News*, the first tabloid newspaper, begins publication in New York. Its front pages feature splashy photographs and full-page headlines, a format pioneered by the London *Daily Mirror*. The first issues go nowhere, but when the owners start exploiting sex and scandal, the New York *Daily News* becomes a top seller and is soon copied worldwide. **September** Adolf Hitler joins the minuscule German Workers' Party, founded in January of that year in Munich on a vaguely defined platform of rabid nationalism and socialist economic principles. Hermann Goering and Rudolf Hess already are members. **October** Julius Evola, a painter once apprenticed to leading futurist Giacomo Balla, writes Tristan Tzara from Rome to announce, "I belong enthusiastically to your movement, which I have been close to in all my works for some time without knowing it." **November** The United States Department of Justice launches a nationwide raid against suspected revolutionaries; in New York alone, over two hundred people are arrested. Congress calls upon the film industry "to build up and strengthen the spirit of Americanism." **December** From Brussels, Clément Pansaers sends letters to Pierre Albert-Birot and to Tzara, declaring himself to be dadaist in his "poetic and artistic conception"

ZURICH

particularly a simultaneous poem for twenty people conducted by Tzara. Then Serner reads, "in a cutting voice," his manifesto "Letzte Lockerung" (Final Dissolution), and a scandal breaks out such as "old-time Zurichers" have never seen. Serner reads calmly while the public hurls orange peels, coins, and insults; cigarettes and more coins greet Tzara's new Dada proclamation, drowned out within seconds. "Messrs. the dadaists, who were never more unnecessary than presently, should confine their manifestos to their numerous magazines...and not burden the public with them." The review is accurate in most respects—but its author is really Serner himself, winking at the scandal mongering press. **May** With the double issue *Dada 4-5*, also titled *Anthologie Dada*, Tzara undertakes the first of many attempts internationally to synthesize Dada and summarize its impact on the world. His "Chronique Zurich," which opens the issue, is only half-joking in its historical ambition: "shit was born for the first time...." On the facing page, Picabia schematizes the "Mouvement Dada" as a device somewhere between a time bomb and a grandfather clock, on which the names of dadaists from New York, Paris, and Zurich mark the hours until detonation (Picabia's own journal *391* is given as the motor). **September** Serner's acts of journalistic sabotage reach a new level with his review of a fictitious yet

BERLIN

Baader asks Tzara (28 June) to publicize his new work HADO, or "Handbuch des Oberdada" (The Oberdada Handbook). One of the purest dadaist engagements with the press, Baader's project, conceived expressly to counter the Versailles peace and reparations treaty signed the same day, consists of an album of front-page clippings compiled from major German newspapers of all political persuasions. It is not clear whether this unicum is ever completed. **July** Once more on the offensive, Baader enters the National Assembly in Berlin on 16 July with handfuls of a pamphlet called "Die grüne Leiche" (The Green Corpse), which he reads out and then throws down from a balcony upon the heads of the country's elected representatives. **August** An unprecedentedly ambitious publication project is afoot, the "Grand Dada World Atlas" or *Dadaco*, its title another wink at commercial enterprise. The idea, generated by Huelsenbeck with Tzara's input, is to chart the movement in its global reach and its history, with scores of contributions from the various Dada branches. The Munich publisher Kurt Wolff prepares a contract, and announcements appear later in the year for a January publication. Unfortunately, the project eventually falters due to editorial infighting, Wolff's reticence about the contents, and above all the collapse of the German economy. **Late fall** Schlichter moves to

HANNOVER

popularity, Steegemann titles a new anthology of verse by Schwitters *Anna Blume*. The word "dada" is emblazoned on the cover, a prod to the Berlin group, who reject him even more violently on account of this poem's success. In the book, Schwitters explains that his writing and visual art are of a piece: "Merz poetry is abstract. It is analogous to Merz painting in that it uses as given elements ready-made sentences from newspapers, posters, catalogues, conversations, and so forth, with or without alteration." Alfred Sauermann and Fried Hardy-Worms, obscure or possibly pseudonymous writers likely associated with Schwitters (Hardy-Worms advertises *Anna Blume* and *Die Kathedrale*; Sauermann promotes an exhibition of dadaist graphics by "Kurt Square and his circle"), print several pamphlets between late 1919 and mid-1920 that reflect Schwitters' interest in dismantling language. Sauermann's *O Siris: was ist dadaismus? oder der versuch einfaches ei-WEIS darzustellen* (Oh Siris: What is Dadaism? or, the Attempt to Represent Simple Egg-WISE) includes, for example, a statement rent by misspellings and printer's mistakes: "Dada ism is the nAked, unconcealed expression of our time in aLL its hatefulne and beauty, in its entire profligacy and i s Deepest magnanim ity, in its gigantic licentiousness and its fussy constraint."

COLOGNE

Guild to exhibit under the name "Gruppe D" (for "Dada"), issuing *Bulletin D* as their manifesto and catalogue. Alongside their own assemblages and drawings, the group presents two works by an "Unknown Master of the Early 20th Century," an African sculpture, and a wire model lent by the engineering firm of Leyboldt, among others. **November** Tristan Tzara probably writes to Ernst for the first time; Ernst replies in December. The ensuing correspondence, quite frequent through 1922, establishes a conduit between Dada in Paris and Cologne; poems, ideas, journals, and collages are sent back and forth for reproduction and sale. Many joint projects in these years, from Ernst's first solo exhibition (in Paris) to his collaborations with Eluard and Tzara, are realized through the mail, largely to circumvent obstacles to international travel.

NEW YORK

PARIS

figures such as Jean Giraudoux betray a high-handedness and xenophobia that will become characteristic of attacks on Dada in France: "I write in French, as I am neither Swiss nor Jewish and because I have all the requisite [honors and] degrees. ..." The simplest replies— "To write better!" (Max Jacob); "Because" (Blaise Cendrars); "to kill time" (Knut Hamsun, the final respondent)— come off the best. **December** Duchamp pencils a mustache and goatee over a reproduction of the *Mona Lisa*, titling it *L.H.O.O.Q.* Having accomplished this witty, highly scandalous gesture, Duchamp sets sail for New York after Christmas, leaving Paris only weeks before the Dada tempest is unleashed.

and proposing to "centralize" the movement in Belgium. Pansaers believes he has been "resurrected"; he wrote sentimental novels and nationalist literature in Flemish, before the experience of the war caused him to change his political allegiance, his language (to French), his aesthetic convictions, and to embrace the dadaist cause.

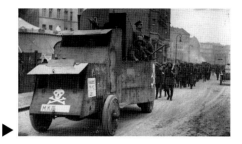

▶

wholly plausible ninth "Dada-Soirée," published in the *Neues Wiener Journal* on 20 September. Among other acts, Serner casts Arp as a "centrifugal hairdresser" who wields giant pins about the head of a barber's doll fitted with a wig of lilac, green, and yellow hair, and Tzara as the inventor of an idea — "probably in the process of being patented" —

for a slotted metal disc that can be rotated to reveal a changing assortment of colored letters, to be used as words in a "kaleido-mobile poem." **October** Serner has left Zurich again for Geneva at the very end of September and moved in with Schad, with whom he may have begun an affair. From early October, he bombards Tzara by mail with examples of

Schad's latest work, a series of small photograms (cameraless photographs) that register the impression of household items, detritus, and packaging labels. Tzara forwards several of the images, which he later dubs Schadographs, to Huelsenbeck in Berlin for the latter's *Dadaco* anthology, and he brings them as well to Paris. **November** *Der Zeltweg*,

named for the home street of Zurich's Mouvement Dada, appears under the editorial direction of Serner, Tzara, and Otto Flake, the latter a writer and Nietzsche scholar friendly with Arp. This is the last Dada publication in Zurich. **December** Late this month, after much negotiation with authorities, Tzara obtains a travel visa and leaves Zurich for Paris.

Berlin, bringing his decadent personality — boot fetishism, pedophilia, blood-filled adventures, sadism — to the acknowledged epicenter of vice and immorality in modern Germany. He is joined by Scholz and other members of Gruppe Rih, which has aligned itself with the Novembergruppe. **November** Critic and political activist Carl Einstein teams

with Grosz to edit the "satirical weekly" *Der blutige Ernst* (Bloody Serious), a successor to the now-banned journal *Die Pleite* (The Strike). The periodical appears, far less than weekly, in six issues until February 1920, when it too is hounded out of existence by censors. Grosz and Heartfield once again adopt a tabloid format and use it to showcase

Grosz' caricatural prints. 30 November: For the first time, the entire cast of Berlin Dada assembles onstage, at a Dada-Matinée in the Tribüne Theater. The next day, Alfred Kerr profiles the membership unsympathetically but in detail for the *Berliner Tageblatt*. Kerr offers exceptional praise for cabaret writer and poet Walter Mehring, an important fellow-traveler

in Dada, calling him "the group's satirical talent." However, Kerr complains that the dadaists lack proper collective organization and "a real artistic ethos"; they need "a genius — not an association." Another reviewer finds instead a powerful collective critique behind the dadaists' bluff: "[T]here is a force in them with which one must reckon;

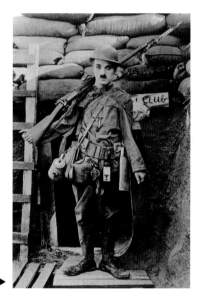

▶

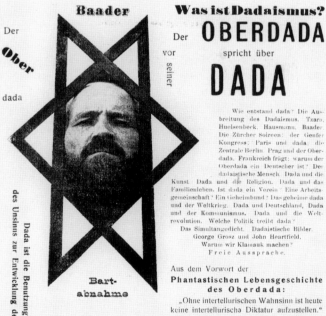

Johannes Baader, *Der Oberdada*, handbill, June 1919. Bauhaus-Archiv Berlin

▶

January The United States Congress declares alcohol consumption unconstitutional as of 17 January.
February Hitler renames the German Workers' Party the National Socialist German Workers' Party (NSDAP). The swastika, an Egyptian symbol with a Sanskrit name, is soon adopted as party identification. Freikorps volunteers wear swastikas on their helmets when they aid a coup attempt in Berlin one month later.
March Miklós Horthy, a former Habsburg admiral, becomes regent of Hungary, bringing a definitive end to the short-lived Soviet Republic proclaimed there in November 1918. Horthy's "White Terrorism" drives out the country's intelligentsia, with the result that artists' communities form

In his last and greatest newspaper hoax, Serner sends a series of articles on an invented "Erster Dada Weltkongress" (First Dada World Congress) to daily newspapers in Prague and Berlin. Sculptor Alexander Archipenko and composer Igor Stravinsky are said to be among the attendees. Serner credits the latter (in the *Berliner Börsen-Courier*, 29 December) with premiering his "symphonic poem" *Le chant du rossignol* (The Nightingale's Song), which is in fact first performed on 2 February 1920 in Paris. The faked reports will continue into February, as Serner describes a duel between himself and Tzara that supposedly unleashes a tremendous commotion and subsequent court proceedings.

Final Dissolution by Serner appears with Paul Steegemann in Hannover.
February Serner has arranged for a series of Dada art exhibitions at the Geneva gallery Salon Néri. The first opens on 1 February with works by Schad and a local painter, Gustave Buchet. Schad shows here *Trépanation indienne* (Indian Trepanning) and other relief sculptures incrusted with treasures from the trash can and the hardware store.

Ball and Hennings are married in Bern on 21 February. **March** Serner organizes a Grand Dada Ball in Geneva, suitably inflated by him in pseudonymous press announcements. His goal is to raise money so he can leave Geneva, for "to stay here," as he has written Tzara (2 February), "is

force and, in fact, 'movement.'" (L.R., "Dada-Tribüne," untitled newspaper clipping, December 1919).
December Grosz and Heartfield provide puppet performances for Mehring's play, "Einfach klassisch! Orestie mit einem glücklichem Ausgang" (Simply classic! *Oresteia* with a Happy Ending), performed at the grand reopening of Schall und Rauch (Sound and Smoke), the cabaret originally founded in 1901 by theater impresario Max Reinhardt.

January Arp travels to Berlin and meets Hausmann and Höch.
January–March Baader, President of All the World, Hausmann the Dadasopher, and the World-Dada Huelsenbeck mount a six-week Dada Tour through eastern Germany and Czechoslovakia. Crowds of perhaps up to two thousand people come armed with noisemakers and prepared to rush the stage. The variable program includes speeches and primitivist verse by Huelsenbeck, with percussive musical accompaniment; verbal exchanges between Hausmann and Baader; and most popular of all, Hausmann's *Dada-Trot* (Sixty-One Step), described with mixed feelings in *Hamburger Nachrichten* (19 February) as "a truly splendid

January Reviews of "Anna Blume" surge in intensity with its appearance in book form. Felix Neumann appends to his trauma-inflected pronouncements on Berlin Dada a complete citation of the poem, which he deplores (the lines "Anna Blume/Thou drippy animal" cause him particular offense). Schwitters responds with a hilarious deconstruction of Neumann's prose in the February issue of *Der Sturm*. Another reviewer, Karl Neurath, prefers parody to lament. Neurath says he will no longer write sentences like "The offerings of today's art market were on view in the Kunsthalle...," but rather: "Halle I love thou I thine? Today's? Sick craze? The offerings! The! Offerings! Were? Where?...

George Grosz, Wieland Herzfelde, and John Heartfield in boxing training, Berlin, c. 1920. John-Heartfield-Archiv, Stiftung Archiv der Akademie der Künste

February The portfolios *Fiat Modes pereat ars* by Ernst and *Die Krüppelmappe* (The Cripple Portfolio) by Heinrich Hoerle are published with subventions from the Cologne municipality. Arp brings texts from Paris for the journal project *die schammade*, an internationally oriented publication in the spirit of *Anthologie Dada* (Zurich) and *Dadaco* (Berlin).

April *die schammade*, the most ambitious project of Cologne Dada, appears in print after months of preparations. Paid for by Baargeld's patrician father, promoted by Hoerle to the press, and compiled largely by Ernst, it is a truly communitarian undertaking. Paris Dada is heavily represented, and elements of Zurich Dada as well, but Ernst snubs the

January Duchamp arrives again in New York, bringing with him *50 cc Air de Paris*, a transatlantic ready-made souvenir that he will offer as a present to his patrons, the Arensbergs.

In "The Art of Madness," Baroness Elsa and Jane Heap argue in *The Little Review* that trauma may be harnessed for radical insights. Of her coauthor, Heap says, "When a person has created a state of consciousness which is madness and adjusts (designs and executes) every form and aspect of her life to fit this state there is no disorder anywhere." At the same time, the Baroness lives, destitute, in the reeking squalor of a meat-packing district tenement.
February Duchamp takes stock of Prohibition's effect on social life

January René Hilsum, a former schoolmate of Breton's, opens (10 January) the bookstore and publishing house Au Sans Pareil. The new firm will issue a book series, *Collection de Littérature*, which becomes the Paris sequel to Tzara's original *Collection Dada*. The bookstore itself hosts a number of key one-person exhibitions in 1920 and 1921.

Months of epistolary anticipation lead, one week later, to a messianic event: Tzara arrives in Paris. He receives a hero's welcome, despite initial surprise at his physically small stature and foreign accent. "Tzara's poems," as Louis Aragon remembers in 1922, "which were no different then than his reviews or manifestos, had the force of a declaration of war."

abroad, principally in Vienna and Berlin. **May** In Florence a group of humorists publishes a journal measuring under 6 x 4 inches with the ironic title L'Enciclopedia. The editors (Fernando Agnoletti, Primo Conti, and others) announce an exhibition juried by Giorgio Vasari that will contain Giotto's Scomposizione di Vergini (Decomposition of the Virgins) and a "dadaist project" by Leonardo da Vinci. They solicit articles of three lines maximum and print as a "first installment" one half-sentence from a novel by the famously prolific risorgimento author Cesare Cantù. **May–June** After visiting Paris during the height of the first saison Dada, Theo van Doesburg tests the pseudonym I. K. Bonset in this month's issue of De Stijl. He writes Tzara from Holland (6 June) that "one of my literary colleagues, I. K. Bonset, intended to found a dadaist journal, but he lacks money, time and people." Three weeks later, Tzara receives a further letter with background information, tailored to Van Doesburg's conception of Tzara himself: "Bonset has refused all 'careers' and positions in society ...he is 'against everything and everyone' and carries the consequences of that attitude." Van Doesburg keeps his alter ego secret, publishing fake portrait photographs as part of the bluff.

Poet Edmund Miller provides an essay to accompany the first exhibition of work by Mieczysław Szczuka that is written partly phonetically, in defiance of conventional orthography.

infinitely idiotic." **April** The second Dada exhibition organized by Serner at Salon Néri opens on 1 April. The main attractions are works by Picabia and Georges Ribemont-Dessaignes, but a letter from Serner to Tzara (31 March) reveals that he also hung copies of 391 and the seventh issue of Dada in the galleries. **July** After a half-year in the French capital, Tzara passes through Switzerland en route to Romania, a trip that depresses him with the thought of cultural myopia in "the Balkan darkness." Zurich does not fare much better. "Seen from this provincial hole, Paris looks fabulous," he writes to Picabia (11 July). "All the films they show here are faked, cut, censored. What a stupid country!... I can't imagine how I spent several years here."

send-up of the most modern exotic-erotic social dances that have befallen us like a plague...."

Deep-seated worries about Dada as an organized contaminating agent can be perceived in the torrent of commentary that accompanies this tour. One writer, Felix Neumann, is led by his fears into a hysteria of mixed metaphors: "Such people, however meaningless when taken singly, are nevertheless dangerous in the systematic nature of their operations. With a thousand weapons of persuasion, they gnaw at the roots of our intellectual strength" (Die Post, 6 January 1920). **February** Responding to Hitler's initiative to establish the NSDAP (Nazi Party), Baader founds the Deutsche Freiheitspartei (German Freedom Party). Huelsenbeck's Phantastische Gebete (Fantastic Prayers) appears in a second edition, published by Malik in Berlin. Originally illustrated with abstract woodcuts by Marcel Janco, the book now contains caricatural drawings by Grosz, shifting the emphasis from moments of acoustic abstraction to strains of vulgar apocalypse: "Great pensive ass for centuries on end....Ha he's travelling there (you can't see it) with the corpse in the corner/Blinking philosophically distorted grimaces behind his lids" ("Meistersinger Death"). **March** Painter Oskar Kokoschka is attacked in Der Gegner as a "Kunstlump" (art rogue) by Grosz and Heartfield, after he laments

That's how I will write, Kurt Schwitters! And you'll understand me!...You lovely, miserable you! You'll feel it, the steepness of my extensions." (Weser-Zeitung, Bremen, 20 January 1920). **April** Schwitters travels to Cologne to visit Max Ernst. The two artists seem to establish a friendship, yet Schwitters' association with the Sturm Gallery earns him ridicule in the pages of die schammade later the same month. **June** Schwitters and Steegemann poster the city of Hannover with the Anna Blume poem, printed in Gothic typeface to match the look of campaign sheets for parliamentary elections that month. Schwitters also takes out newspaper ads, urging voters to "Elect Anna Blume." **June–July** The Berlin Dada Fair includes a work by Rudolf Schlichter entitled Der Tod der Anna Blume (The Death of Anna Blume). Schwitters visits the show. His book Die Kathedrale appears that month with Steegemann in Hannover. Really a small portfolio, the book consists of a series of lithographs made by playing with typesetting materials, such as spacers and printing blocks. Perhaps in response to this latest affront by the Berlin group, Schwitters seals the book with a wrapper that reads: "Careful. Anti-Dada." **November** Schwitters publishes the first two of three letters to Hans Arp, one of his closest friends among the established dadaists, in Die Pille (The Pill), a Hannover weekly. Schwitters fundamentally challenges

key artists of Berlin and Hannover, even though he has met most of them personally.

The dadaists find themselves eliminated from the Cologne spring salon, even though it (like the New York Independents in 1917) is ostensibly jury-free. They organize a Dada-Vorfrühling (Dada Early Spring) exhibition in response, in rooms rented at the Brasserie Winter. Arp and Francis Picabia join the local group. Girls dressed for communion who recite ribald poems; an entrance located just past the men's toilet; and an invitation to visitors to go after one work, with an axe, form part of the lore that accumulates around this controversial manifestation. **May** Shut down temporarily by the police on obscenity charges, Dada Early Spring reopens with a gleeful boast: "Dada Triumphs!" The group itself is breaking up, however, as Baargeld and the Hoerles each decide, for separate reasons, to end their affiliation. **June** Ernst travels to the Dada Fair in Berlin. **November** "FaTaGaGa is the FAbrication de Tableaux GAsométriques Garantis [Fabrication of Guaranteed Gasometric Paintings]," Ernst writes Tzara to announce his new collaborative project with Arp; he includes examples for publication in Paris. Ernst requests, however, that the printer hide all trace of handwork in the photocollages, by rephotographing them, "to guard the secret of FaTaGaGa!"

in a letter to Paris (26 February): "quiet, too quiet." **April** Duchamp, Man Ray, and Dreier open the Société Anonyme, the first museum in America devoted exclusively to contemporary art. The inaugural exhibition (30 April–15 June) includes work by Picabia, Man Ray, Georges Ribemont-Dessaignes, Schamberg, and Duchamp. Duchamp, in charge of the installation, has had the moldings removed and added lace paper edging to all the picture frames. At one point, it is suggested that critics should pay double admission. **May** Gabrielle Buffet-Picabia leaves for France, charged among other things with asking Tzara to write a "monthly public letter" about modern art in Europe for the Société Anonyme. (Tzara must have declined.) **July–August** More riffs on sex and plumbing by Baroness Elsa. "America's comfort:—sanitation—outside machinery—has made America forget [its] own machinery—body!" ("The Modest Woman," The Little Review.) **August** The third Société Anonyme show includes With Hidden Noise, 1916, Duchamp's readymade ball of twine with an unidentified object locked in its interior. "The thing is to guess what it is, in an art sense," reports the reviewer for the Evening World (2 August) "and if you do this correctly you ought to get a prize. You deserve it at all events." **November** Kurt Schwitters has a solo exhibition at the Société Anonyme (1 November–15 December).

The battle goes public on the 23d, when Tzara makes a surprise appearance at the first Littérature matinee, joined by Ribemont-Dessaignes, Eluard, Picabia, Soupault, Breton, and others. The full force of Dada has hit Paris. Tzara reads a poem to the accompaniment of clanging bells and shouts that nearly drown out his voice. Picabia shows a recent painting, inspired by Duchamp's mustachioed Mona Lisa, which simply stuns those who see it: "One [of the paintings],...'really beautiful' as the speaker assured us, was called L.H.O.O.Q. Try to say that out loud. I'm sure you will tie yourself in knots like a crazy person" (Les soirées de Paris, 29 January). The performers contend with cries of "Back to Zurich!"; within days the papers are full of news about the event. **February** Paul Eluard puts out the first issue of Proverbe; Breton writes for 391, and Picabia for Littérature; his book Unique eunuque appears with the recently founded Au Sans Pareil. The Dada group coalesces in print and on stage, with riotous events that convulse all Paris on the 5th, 7th, and 19th of the month. Another publication, Bulletin Dada (the sixth issue of Tzara's Dada), is sold at the door as the program to these manifestations.

"Did you know there was a 'Dada Movement'?" (Éclair, 1 February). "[It] does not, as one might think, have to do with an improvement of the equine race [dada in French

RELATED EVENTS

ZURICH

BERLIN

HANNOVER

COLOGNE

NEW YORK

PARIS

Miller presents a laundry list of things he and Szczuka oppose, from the "petrifying" imitation of established forms to easy eclecticism; "against the identification of aesthetic delight with pleasure; against obscurantism, cunning, gotham, ugh, against, against...." **July** The second issue of *Bleu*, an arts magazine in Mantua, Italy,

includes contributions by Van Doesburg, Johannes Baargeld, and several members of Paris Dada. The artist Aldo Fiozzi contributes his assemblage, *Valori astratti di un individuo Y* (Abstract Values of Person Y), which works telephone wire, porcelain, wood, and metal into an abstract composition augmented by chemical formulae and other symbols.

November Hungarian poet and activist Lajos Kassák rallies support among the Vienna exiles for his journal *MA* (Today). Contributors read poems by Richard Huelsenbeck and Kurt Schwitters at a literary evening this month, and the January 1921 issue of *MA* has a three-page spread on Schwitters, with assemblages and a Hungarian translation

of "An Anna Blume." Throughout 1921, the journal publishes poems and art by Hans Arp, Van Doesburg/Bonset, Viking Eggeling, and Hans Richter; the June issue is devoted largely to George Grosz. Kassák, meanwhile, demonstrates his affiliation through explosive collage compositions that incorporate references to the Berlin *Dadaco* project,

accidental damage to artworks during a recent political uprising. "We are overjoyed," the two men write, "that the bullets are whistling into galleries and palaces...instead of the houses of the poor in the workers' districts." This exchange cements a new, extreme convergence in Berlin Dada between communist politics and aesthetic iconoclasm. **April** The

fifth issue of *Schall und Rauch*, the organ for Max Reinhardt's newly reopened cabaret, reproduces a pair of puppets by Höch in color on the cover. Höch may have performed with the puppets at this time; photographs show her using them during the run of the great Dada show that takes place this summer. **April–May** Grosz has his first one-person show,

at the Galerie Neue Kunst in Munich. **May–June** Otto Burchard, a gallery owner known for his expertise in Chinese bronzes and orientalist fantasies, suddenly champions radical artists, beginning with Schlichter (15 May–15 June). Schlichter's titles speak for themselves: *Die Mordepidemie* (The Murder Epidemic), *Vergewaltigung* (Rape), *Cowboys*

und Mexikaner. **June** Eggeling and Richter have been working since the previous winter at Richter's family estate on an abstract, geometric language of film. Now they send a prospectus to producers and obtain a grant from the film company UFA to experiment on what their pamphlet (since lost) calls a "Universelle Sprache" (Universal Language).

grammar and orthography. The letter degenerates by degrees into a stream of unseparated words, then letters, before breaking off at "dilemadiemadedilemma"; the editor explains that the typesetter had a maniacal fit and threatened to strike before readying more of this writing for print.

Cover of *Letzte Lockerung: Manifest Dada* (Final Dissolution: Dada Manifesto) by Walter Serner, 1920. Research Library, The Getty Research Institute, Los Angeles

means "hobbyhorse"] but rather with a society for the bewilderment of the human race."

A forewarned but still curious public arrives by the hundreds at all three appearances, at times perhaps topping one thousand people. Promised Charlie Chaplin, they are instead greeted by a raucous show of dissatisfaction, encapsulated

in Ribemont-Dessaignes' address "Au public" (To the Public): "Before we disinfect you with vitriol and make you clean and scrub you down with passion.... We will take a great antiseptic bath—And we're warning you—We are the assassins—Of all your little newborns...." **March** "This spectacle is absolute dementia, utter looniness," reports Alfred

Bicard ("Une soirée chez les Dadas," *Oeuvre*, 28 March), the day after attending an evening of new plays performed at the Théâtre de l'oeuvre, in a twenty-fifth-anniversary tribute to Alfred Jarry's *Ubu roi* (King Ubu). Contentions of insanity circulate widely in the press: "lectures by the crazies," say reviewers, who report cries of "To Charenton!"—the Paris

equivalent of Bellevue—from the audience. These charges of dementia come coupled with warnings about the Teutonic threat to Gallic civilization. A lengthy denunciation of Dada from the right-wing paper *L'ordre public*, for example, casts the Salon as another battlefield: "And while people are trafficking—under the French stamp—these insane

for example (1923), or recycle a poster from the Maurice Barrès trial in Paris (1921).

Evola publishes *Arte astratta* (Abstract Art), the first significant treatise on the subject in Italy. The cover, with its overlay of biomorphic, differently colored outlines on a green background, distinctly recalls camouflage—

developed for military purposes by the French army in 1915. In an exchange regarding his book, Evola maintains that abstraction "is the only [means] by which a *proletarization* of art will never be possible, because abstraction is...absolute *egoization*, and transcends radically every basis for community...." (*Griffa!*, 7 November 1920).

June–July Max Ernst is present at a war council on 6 June to plan the greatest project yet conceived by the Berlin dadaists: the Erste Internationale Dada-Messe (First International Dada Fair). The nearly two-hundred-work show, which opens on 30 June, is actually only some-what international, with Francis Picabia, Arp, Ernst, Johannes

Baargeld, and (in name) the Russian constructivist Vladimir Tatlin. Schlichter, Scholz, and Dix, all newcomers, add formidable presence, Dix with his over five-foot-long collage painting *Kriegskrüppel (45% erwerbsfähig!)* (War Cripples [45% Fit for Service]) and Schlichter through the porcine "ceiling sculpture" *Preussischer Erzengel* (Prussian

Archangel). Höch shows many works, including her magnum opus, *Schnitt mit dem Küchenmesser* (Cut with the Kitchen Knife), and a freestanding sculpture (since lost) assembled from textile snippets, feathers, and abstract metal shapes. The catalogue by the Malik team, which appears only in mid-July, stands as an artwork in its own right.

In these months, dadaism attains unparalleled international visibility, with the Festival Dada in Paris, the recent *Dada-Vorfrühling* (Early Spring) exhibition in Cologne, the release of *New York Dada*, and this show in Berlin. The movement seems really to have become a global menace, and reviewers take the threat seriously. "Instead of a Berlin [and a

Christian Schad, poster for exhibition of the work of Gustave Buchet and Christian Schad, Salon Néri, Geneva, February 1920. Musée d'art et d'histoire, Ville de Genève

Raoul Hausmann and Hannah Höch at the First International Dada Fair, Berlin, 1920. Berlinische Galerie, Landesmuseum für Moderne Kunst, Photographie und Architektur

products of foreign inspiration, the schools of Munich, Dresden, Berlin, Leipzig and Vienna are pursuing their tenacious effort at stylistic renovation, and preparing to invade the world market, to the detriment of our artists and our culture!" **April** Picabia exhibits (16–30 April) at Au Sans Pareil. He also publishes (April–May) two issues of *Cannibale*,

a journal that consecrates primitivist violence against civilized conventionality. Picabia opens the first issue with an attack on Mme Rachilde, "woman of letters and good patriot," by insisting on the value of miscegenation: "I am of many nationalities and Dada is like me." Louis Aragon follows this salvo with a devastatingly simple poem, "Suicide," which

consists merely of the letters of the alphabet. **May** May 26: Festival Dada, Salle Gaveau, the most ambitious event to date. The location is a recital hall in the ultra-élite 8th arrondissement normally reserved for symphony concerts. Walking "sandwich-men" advertise the program, which includes *Vaseline symphonique*, a piece for twenty people by Tzara;

"La nourrice américaine" (The American Wet-Nurse), a "sodomist composition" by Picabia; and Ribemont-Dessaignes' "Le Nombril interlope" (The Bellybutton Interloper). The audience gleefully hurls eggs, vegetables, coins, and meat at the performers. In one number, "the famous magician" Philippe Soupault, dressed in blackface,

Mercer 85 HP (Tristan Tzara and Francis Picabia). From *Cannibale* no. 2 (Paris, Au Sans Pareil, 25 May 1920).

Paris and Cologne] 'Main Branch', it would be much more useful to have a Main Sanatorium for the mentally retarded. These kind of people could benefit especially from physical labor, such as street cleaning or coal shoveling." (*Kölnische Volkszeitung*, 22 June 1920). The authorities concur; Baader's house is searched in November, while Herzfelde, Grosz,

Schlichter, and Burchard are taken to court the following June. **July** or **August** Out of the ashes of the aborted *Dadaco* project comes *Dada Almanach*, a panoramic compendium published to coincide with the Dada Fair. Edited by Huelsenbeck, the anthology recycles *Dadaco* contributions primarily from Dada's Swiss and French branches, while partisan

judgments minimize or exclude many involved in the Dada Fair itself. Yet the book's texts and illustrations strive to present Dada in historical scope, through portrait photographs, press reviews, reprints of documentary materials, a lengthy "Chronique zurichoise" by Tzara, and Huelsenbeck's sweeping introduction. **June– August** Katherine Dreier travels

through Germany (28 June–21 August), including Berlin and Cologne. She meets with Ernst and Grosz, and later plans with Ernst a Dada exhibition for New York the following winter, sadly never realized. **September–October** Berlin police confiscate all copies they can find of Grosz' latest print portfolio, *Gott mit uns* (God with Us),

Raoul Hausmann and Richard Huelsenbeck on their Dada tour in Prague, 1920. Berlinische Galerie, Landesmuseum für Moderne Kunst, Photografie und Architektur

releases five balloons from a suitcase, then stabs one marked "Jean Cocteau" with a large kitchen knife. Spectators happily demolish the others, including two inscribed with the names of the former prime minister, Georges Clemenceau, and army commander Marshal Philippe Pétain. **May–June** An exhibition at Au Sans Pareil by Ribemont-Dessaignes

(28 May–10 June) follows by two weeks Picabia's show there. **October** Walter Serner visits Paris, staying perhaps through (or returning in) December. He promises closer collaboration between Paris and Berlin Dada, but leaves Breton a false mailing address.

Dermée, who in 1919 founded the publishing house L'esprit nouveau to

produce his writing, now joins with Amédée Ozenfant and Charles-Edouard Jeanneret to inaugurate a journal of the same name. This new periodical consolidates a "machine age" aesthetic tangentially related to the iconography of Dada in New York and Paris, yet which leads in a diametrically opposed direction: toward harmony, system, standards, the "call

to order." The Paris dadaists all appear among the "associates" listed in *L'esprit nouveau*, even though only minor figures such as Dermée, Arnauld, and Ivan Goll publish in its pages. **December** Picabia has his second one-person exhibition this year, in the bookstore of Jacques Povolozky. At an opening soirée (9 December) attended by a wide

Swiss psychiatrist Hermann "Kleck" Rorschach publishes *Psychodiagnostik*, the book that introduces ink-blot drawings as a diagnostic test. **February** Recently resettled in Prague, the Russian linguist Roman Jakobson publishes "Dada" in the Moscow journal *Vestnik teatra*. Jakobson classifies Dada as a movement born of Einstein's physics, a world linked by radio and telephone, and the experience of moral abandonment during the war. He draws attention to the movement's self-awareness: "Dada honorably perceives the 'limitedness of its existence in time'; it relativizes itself historically, in its own words." For Jakobson, Dada's high profile and alogical creations are strategies to "lay bare the

a mordant representation of army life shown at the Dada Fair this past summer. The army later appropriates the rights to this work, and the plates used to make it are seized and destroyed as a hysterical pre-caution against future reprinting. **October** Huelsenbeck begins commuting between Berlin and Danzig for a year of practical training, having passed his medical examination (28 July). **December** Theo van Doesburg makes a short visit to Berlin and the newly established Weimar Bauhaus (20 December–3 January). Among the many people he meets are Hausmann and the film team of Richter and Eggeling.

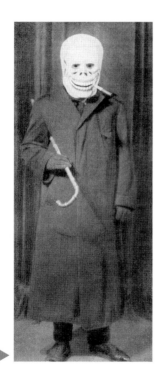

George Grosz dressed as Death, 1919/1920. Deutsche Literaturarchiv, Marbach am Neckar

spectrum of Parisian high society, from a Murat family princess to Pablo Picasso and Erik Satie, plus the usual suspects from the Dada camp, Tzara reads his "Manifeste sur l'amour faible et l'amour amer" (Manifesto on Weak Love and Bitter Love). This address includes the legendary instructions for a dadaist poem— cut up a newspaper article and place the clippings inside a bag. "Take [them] out one by one. Copy conscientiously in the order in which they were removed. The poem will look like you. And voilà, you are an infinitely original writer of charming sensibility, albeit misunderstood by the commoner."

January During the carnival season, Baader organizes a Dada-Ball at the Berlin Zoo (20 January). A printed leaflet announces his invitation to the president and all national and municipal officials, with their wives. "They will have free access if after the ball they give the Oberdada free access to them as well." **April** Hausmann dedicates his 1920 collage "Dada Cino" (Dada Film) to Schwitters, attesting to their deepened friendship.

The leading organizers of the Dada Fair stand trial for slandering and defaming the army. On 20 April, fines and sentences are handed down: 300 marks for Grosz, for his portfolio *God with Us*, and 600 for Herzfelde as its publisher. Burchard

Late 1920–early 1921 Sturm publishers issue a monograph on Kurt Schwitters, illustrated by a baker's dozen of montages that mix doodles, postal address stamps, and labels such as "printed matter" or "author's copy." In his foreword, Schwitters articulates his idea of "a total Merz picture. Poetry quotes, kitsch pictures as part of paintings, using consciously kitschy and consciously bad parts in the artwork, etc." **January** This month's issue of *Der Ararat* contains "Merz," the artist's lengthiest treatment of this subject to date. Schwitters describes Dada here as a movement divided in two. "Kerndadaisten" (Core dadaists), led by Tzara, rally to abstraction, nonsense, and a rigorous openness to

May Ernst mails Tzara works for exhibition, poems for Tzara's latest publication project, *Dadaglobe* (unrealized), and news that he will spend the summer near Imst, in the Tyrolean Alps. "After that I'm thinking of going to Paris as the eldest son of Voltaire and a Vaulter.…Dada-ly yours." **August** Tzara arrives with Maya Chrusecz at Imst, where Arp joins them as well. The group prepares a new issue of the journal *Dada*, called *Dada au grand air* (Dada Outdoors)— a laughing salute by inveterate café-goers to this robust vacation spot. Chrusecz apparently devises the German subtitle, "Der Sängerkrieg im Tirol" (The Singers' War in the Tirol), an image of hyperbolic yodelling that, typically for Dada, turns culture

January "Dada will get you if you don't watch out; it is on the way here." With this headline, reporter Margery Rex provides Dada its first major newspaper coverage in the United States (*New York Evening Journal*, 29 January). Rex quotes extensively from "Manifeste Dada 1918" by Tzara, the acknowledged "father" of Dada. She solicits exegetic statements by others as well. "Dada is irony," says Katherine Dreier. "Dada is nothing," says Duchamp, and adds: "[T]he Dadaists say that everything is nothing; nothing is good, nothing is interesting, nothing is important." "Dada is a state of mind," contributes Man Ray, inadvertently giving decades' worth of scholars a pat refrain. Rex offers her

February Tzara writes Man Ray in New York (3 February), thanking his American counterpart "in the name of all the Dadas" for sending material to be included in the anthology *Dadaglobe*, a publication to consecrate international Dada. Like the *Dadaco* venture in Berlin, this ambitious project never appears. **March** Picabia takes to his bed for a month with a case of ophthalmic shingles. To alleviate his depression, a parade of visitors helps him to create *L'Oeil cacodylate* (The Cacodylic Eye), a large canvas full of signatures and visual additions around the enlarged figure of an eye. In November Picabia audaciously exhibits this collectively generated work at the Salon d'automne. **April** Suzanne

devices" —of form, of politics, of historical systems. **March** The second issue of the Belgrade journal *Zenit* contains an article by editor Ljubomir Micić on "Dada-DadaIZAM." Micić finds the dadaists unnecessarily despise art-making, particularly painting, and merely claim to be liberated from bourgeois constraints— yet he admires their ferocity.

Throughout 1921–22, *Zenit* publishes news on Dada and primary texts, mostly through the offices of poet and typographer Dragan Aleksić, who probably first learned of Dada in October 1920 while studying in Czechoslovakia. **April** Anton Bragaglia opens the *Mostra del Movimento Italiano Dada* (Exhibition of the Italian Dada Movement) at

his Casa d'Arte in Rome, showing works by Evola, Fiozzi, and Gino Cantarelli (5–30 April). Van Doesburg, Tzara, and Louis Aragon attend the opening, along with the best of the Roman nobility. **May–June** Self-described "futurist-dadaist" poetry evenings take place throughout May in most large Polish cities. During these months as well, the

leading avant-garde collective Formiści (Formists) prints writings by Paul Eluard, Georges Ribemont-Dessaignes, and Ivan Goll. **July** A Jersey City match on 2 July between American heavyweight boxer Jack Dempsey and Frenchman Georges Carpentier is announced live, thanks to an epochal partnership between Westinghouse and AT&T. Ringside

ZURICH

I. K. Bonset (Theo van Doesburg), *Je suis contre tout et tous* (I am opposed to everything and everybody), January 1921. From Jo-Anne Birnie Danzker, ed., *Theo van Doesburg: Maler-Architekt* (New York, 2000).

BERLIN

and Schlichter are acquitted. These results are actually lenient, partly because the accused have humbled themselves in their defense. Socialist literary critic Kurt Tucholsky protests that they have abandoned their radicalism: "The trial dilutes blood to lemonade. If Grosz didn't mean it like that—we meant it like that." (*Die Weltbühne*, 1921) **June** Baader

announces his latest brainstorm: a Dadaistische Akademie in Potsdam. 20 June: Hausmann, Höch, Scholz, Schlichter, Grosz, Dix and others sign a letter in *Der Gegner* to protest the Novemberguppe's exclusion of works by Dix and Schlichter from an upcoming exhibition.

HANNOVER

new materials and forms of expression; "Huelsendadaismus" (Husk dadaism), personified by Huelsenbeck, deals in political propaganda and is doomed to a short existence. **April** Schwitters has his first one-man show at the Sturm Gallery, with a key selection of seventy assemblages, drawings, and collages that give the most complete overview

of Merz to date. **May–July** Schwitters recites poetry in Jena, Dresden, Erfurt, Weimar, and Leipzig. In July his writings appear for the first time in Theo van Doesburg's journal *De Stijl*. The two artists meet that summer, together with Arp, and begin planning Dada events in Holland. **September** Schwitters, his wife Helma, Hausmann, and

Hannah Höch undertake an "Anti-Dada-Merz" trip to Prague, appearing there on 6 September. Among Schwitters' recited verses are the self-explanatory "Alphabet read backwards" and "Cigars," a poem made up exclusively of sounds included in the title word. Hausmann reads his sound poem "fmsbw," which gives Schwitters the kernel

for his concrete poem "Die Ursonate" (The Primal Sonata). He also declaims the manifesto "PRÉsentismus," in which he describes a machine capable of converting audio and visual signals interchangeably that he later calls the Optophone. Hausmann's goal is a tactile apprehension of light and sound and an aesthetic awareness of the body's energy

COLOGNE

into mock warfare. Further inclusions arrive from Paris with André Breton, who stops by on honeymoon in early September, and Paul and Gala Eluard, who show up later that month. **October** *Dada au grand air* has been greeted by Baargeld "and my few other friends" with "a shout of joy," Ernst recounts to Tzara on 8 October; he has sent fifty copies to

Arp and will divide the others— along with the bills—among Tzara, Chrusecz, and himself. Beyond that stimulation, Ernst reports, "we are bored with all our might," and concludes: "I want at all cost to get out of Cologne and Germany." **November** The Eluards visit Ernst for a week. Paul Eluard buys two exceptionally important paintings,

Oedipus Rex and *Der Elefant von Celebes* (The Elephant from Celebes), and he and Ernst collaborate on their first joint book, *Répétitions* (published March 1922). The Ernsts and Eluards also travel with Baargeld to Düsseldorf, where Ernst has organized (via Tzara) an exhibition for Man Ray.

NEW YORK

own definition: "Nonsense, with or without meaning…is Dada." **February** Heap and Anderson lose a landmark fight to publish excerpts from James Joyce's *Ulysses* in *The Little Review*. The trial is ostensibly about obscenity but has as its subtext the "deviant" behavior of lesbian publishers whose female contributors, notably the Baroness

Elsa, talk at least as frankly as their male counterparts. **February** Man Ray and Duchamp have undertaken to sell new Dada publications in New York; Duchamp remits the money they have collected by check to Picabia in Paris (8 February). **April** In the context of a second Schwitters exhibition (15 March–12 April) at the Société Anonyme, the organizers hold an April

Fool's Day symposium on the subject "What Is Dadaism?" One disgusted reviewer comments the following day in *American Art News*: "The Dada philosophy is the sickest, most paralyzing and most destructive thing that has ever originated in the brain of man…."

Single issue of the baptismal publication *New York Dada*, edited by Duchamp and Man Ray. The cover

features Duchamp's transgendered, Jewish alter ego, Rose Sélavy, as the trademark image for a highly iconoclastic make of perfume. **June** Man Ray writes to Tristan Tzara (8 June): "Dada cannot live in New York. All New York is dada, and will not tolerate a rival, will not notice dada. It is true that no efforts to make it public have been made…but there is no

PARIS

Duchamp and Jean Crotti put on display nearly the entirety of their Dada oeuvre at the Galerie Montaigne. With this show, however, the couple takes leave of Dada and publicly announces a new, two-person movement: TABU. The name has been chosen by Crotti, who underwent a mysterious, quasi-religious experience while in Vienna in February.

A second "Dada Season," far briefer than the first, begins with an outdoor manifestation, the visit to the Church of Saint Julien le Pauvre. "All that has happened until now under the sign of Dada was just a sideshow," Breton declares to a group huddled in the rain, on a rubble field that abuts this nondescript Gothic church. The weather and the

poor reception discourage further outings, but Breton's idea to bring Dada and its participants fully into public space is daring nonetheless. **May–June** Max Ernst has his first one-person show, a retrospective of work since 1919 at Au Sans Pareil (3 May–3 June). He mails in the artworks, as the British occupying authorities in Cologne refuse him a

visa to enter France. The opening night is packed and full of the expected delirium, equal to the show's motto: "Putting under marine whisky/ is done in khaki & in five anatomies/ Long live sports." **May** On the 13th, Breton, who has temporarily wrested control of the Dada enterprise from Tzara and Picabia, convenes the "Trial of Maurice Barrès," a formerly

commentary for "The Fight of the Century" is sent by telephone line to a radio transmitting station and then broadcast to theater halls in dozens of American cities, as well as via relay to Radio Tour-Eiffel in Paris. **September** In Zakopane, Poland, Stanisław I. Witkiewicz (Witkacy) and others publish the leaflet "Papierek lakmusowy"

subtitled "Pirublagizm" (sic) (Litmus paper, or pure-hoaxism), a partly self-satirizing, partly anti-Dada manifesto signed "Marceli Duchański-Hoax." Such early attention to Marcel Duchamp is exceptional in central Europe. "[A]ttaining Pure Hoaxing is an extremely hard task," write the authors, tongue firmly in cheek, noting how hard it is to "distill"

lies from truth. "But we, the pure hoaxers, adore impossibilities.... WE ARE HOAXING, nous hoaxons, wir hoaxieren, noi hoaxamo, hoaxujemy." **November** Hitler's NSDAP establishes the *Sturmabteilung* (Storm Troopers). Their terrorist street actions against Jews and political opponents keep the NSDAP banned in parts of Germany, and later

throughout the country after Hitler's failed coup attempt in 1923; they also become the party's most effective weapon when allowed to reconstitute in 1925.

Nearly one year after the Communist Party is founded in Italy (21 January), the Fasci di combattimento regroup as the National Fascist Party.

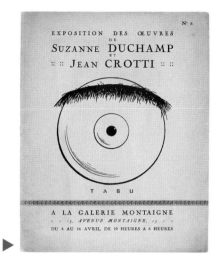

Cover of the exhibition catalogue *Exposition des oeuvres de Suzanne Duchamp et Jean Crotti: Tabu*, 1921. Research Library, The Getty Research Institute, Los Angeles

output: "Thanks to electricity we are capable of transforming our haptic emanations into moving colors, into sounds, into new music."

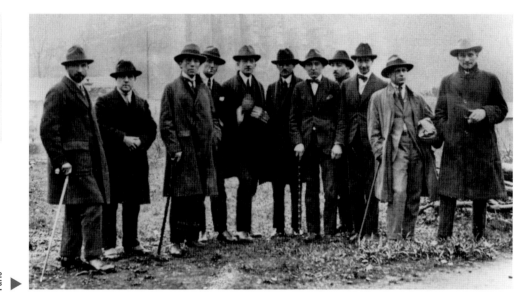

Dada group at Saint Julien le Pauvre, 1921. Left to right: Jean Crotti, Asté D'Esparbès, André Breton, Jacques Rigaud, Paul Eluard, Georges Ribemont-Dessaignes, Benjamin Péret, Théodore Fraenkel, Louis Aragon, Tristan Tzara, Philippe Soupault. Giovanni Lista, Paris

one here to work for it, and no money to be taken in for it, or donated to it. So dada in New York must remain a secret." This judgment downplays the impact of recent events, such as the April Fools' symposium at the Société Anonyme. Man Ray draws a fascinating parallel, however, between Dada and the metropolis, both feeding off a market of labor and publicity.

libertarian author who has become a mouthpiece for ultra-nationalist views. Breton wants a trial to debate whether such changes of posture amount to ethical treason. Tzara participates as a "witness" but challenges Breton, who is playing the part of judge: "I have no confidence in justice, even if this justice is made by Dada" (*Littérature*, August 1921). Picabia, mean-

while, causes a scene by exiting the proceedings, just two days after publishing a solemn declaration of leave-taking from Dada. Feuding and dissension within the group have now been made public. **June** The final event of this "season" takes place, the Salon Dada at the Galerie Montaigne (6–8 June). This exhibition culminates the international "invasion" of

Paris, with contributions from Ernst and Johannes Baargeld, Hans Arp, Walter Mehring, Man Ray, Julius Evola, and others. Breton, Picabia, and Duchamp decline to participate.

The festivities include appearances by an "authentic porcelain repairer," an actual street merchant with a lusty voice named Mr. Jolibois; a mock inspection by the president

of Liberia, actually Soupault in blackface once again; and a performance of Tzara's play, *Le coeur à gaz* (The Gas Heart), actually a flop because the public begins to exit the gallery in droves. To keep up morale, Mr. Jolibois and his Dada assistants sing the "Marseillaise" to close the evening. **July** Man Ray arrives in Paris and is met by Duchamp, himself

RELATED EVENTS

ZURICH

BERLIN

HANNOVER

COLOGNE

NEW YORK

PARIS

dada invite les petits *Paul et Madame Eluard*
au vernissage de l'exposition max ernst
qui aura lieu au sans pareil
37 avenue kléber le 2 mai à 20 h 30

à 22 h le kanguroo
à 22 h 30 haute fréquence
à 23 h distribution des surprises
à partir de 23 h 30 intimités

saison dada

Invitation to the opening of *L'Exposition max ernst* (Max Ernst Exhibition), 1921. Centre Pompidou, Musée national d'art moderne-Centre de création industrielle / Bibliothèque Kandinsky, Centre de Documentation et de recherche, Paris

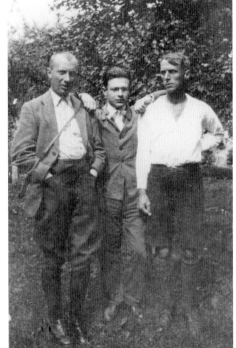

Hans Arp, Tristan Tzara, and Max Ernst outside the Gasthaus Sonne, Tarrenz, Austria, late August–early September 1921. Mark Kelman, New York

Portrait of group at Tarrenz, Austria, 1921, left to right: Tristan Tzara, Maya Chrusecz, Luise Straus-Ernst, André Breton, and Max Ernst. Courtesy Calmels-Cohen

only recently returned from New York. Duchamp brings him to his lodgings, a hotel room that Tzara has just vacated to travel, among other places, to Ernst's vacation town in the Tyrol. **November** Crotti distributes his tract, "TABU Manifesto," at the opening of the Salon d'automne (1 November), where he and Suzanne Duchamp have several paintings on

view. The Arensbergs, erstwhile patrons of New York Dada, seem especially eager for news of the movement now that they have relocated to Los Angeles. Duchamp writes them (15 November) with the promise to send an anthology of writings by Comte de Lautréamont, published at Au Sans Pareil with a preface by Philippe Soupault: "You will find there all the

Dadaïc seeds." **December** Not six months after arriving in Paris, Man Ray has a one-person exhibition (3–30 December) at the Librairie Six bookstore, run by Soupault. He shows his airbrush paintings, the portfolio *Revolving Doors*, and a new work, *Cadeau* (Gift), an assisted readymade consisting of a dangerously dysfunctional clothes-iron. In

Duchamp's inspired installation, bunches of colored balloons obscure the paintings, until the guests take action and burst them. The collectively prepared catalogue features eulogies by Ernst, Aragon, Arp, Eluard, Ribemont-Dessaignes, Soupault, and Tzara. Man Ray has been officially welcomed into the group.

January–December The German mark loses its value approximately two hundred thousand-fold during the year; prices escalate hourly at times. **February** Van Doesburg releases the first of four issues of *Mécano*, referred to by color (bright yellow, deep blue, dark red, and white). Van Doesburg adapts the title from Meccano, the British construction game for children, patented in 1901. "I am planning to put together a superb Bulletin, on the *most vile* paper that exists and *yet still be* very modern," he wrote to *De Stijl* collaborator Antony Kok in February 1921. Conceived expressly as a forum for international Dada, the journal draws primarily upon its creator's contacts in Paris, Hannover, and Berlin. **May** Serge Charchoune (Sergei Sharshun), a Russian émigré who has relocated from Paris to Berlin, encapsulates his peripatetic life in the journal *Perevoz Dada* (Dada Ferry), impishly subtitled "official mouthpiece of the third and a half International."

In Antwerp, Maurice van Essche edits a special issue of the journal *Ça ira* (It's Alright) on the "birth, life, and death" of Dada as a movement, with contributions largely from secondary members of Paris Dada close to Clément Pansaers.

A symposium of the recently founded Union internationaler fortschrittlicher Künstler (Union of International Progressive Artists) takes place in Düsseldorf on 29–31 May,

October 20 October: Sophie Taeuber marries Hans Arp in Tessin.

January Now a licensed physician, Huelsenbeck opens a general medical practice, first in Danzig, then from fall 1923 in Berlin. **April** Grosz's new book *Mit Pinsel und Schere* (With Brush and Scissors), though not entirely composed of photomontages, nevertheless treats this medium more extensively and explicitly than any other book from the international Dada network. In place of his signature, several of the works bear the stamp "George Grosz Constructor." **Summer–late fall** Grosz travels for five months in Russia, where he is greeted by Lenin and Trotsky, among others, and generally treated with great respect. Grosz also meets twice in Moscow with Vladimir Tatlin, the "machine artist" vaunted at the 1920 Dada Fair. He nevertheless returns disappointed, and subsequently leaves the German Communist Party. This in no way diminishes his commitment to proletarian causes. **June** Hausmann and Höch separate. **June** or **July** The published play *Methusalem oder der ewige Bürger* (Methusalem or the Eternal Bourgeois) by Ivan Goll includes costumes by Grosz. Grosz' dehumanized, caricatural renderings of contemporary society find their echo in the ideas of Goll, a poet and playwright from Strasbourg who spent the war in Switzerland, and now shuttles between Paris and Berlin. Grosz' Methusalem is stolid and machine-made, as Goll has imagined him, but more violent, with a coffee grinder

In the new edition of *Anna Blume*, Schwitters prints a "novelette" called *Die Geheimlade* (The Secret Chest) in which he reassigns the acronym KAPD (German Communist Workers' Party) to stand for his latest idea: the German Imperial ANNA BLUME Party. **April** George Grosz exhibits at the Galerie von Garvens in Hannover. **September** At the close of the Weimar Congress, Schwitters sets off with Arp, Tzara, and Van Doesburg on a brief performance tour that closes in Hannover. On the night of 30 September, Hannover Dada enjoys the apex of its international solidarity; the above-mentioned artists, joined by Hausmann and Höch, stage an evening of readings and performances at the Galerie von Garvens, under the title "Dada-Revon" ("Revon" being the topsy-turvy name for Han-NOVER). El Lissitzky attends, upon invitation from Schwitters.

April–September Ernst, Arp, Eluard, and others meet at different points over the summer at last year's Tyrolean vacation spot. Ernst and Eluard prepare *Les malheurs des immortels* (The Misfortunes of the Immortals), a thoroughly collaborative book; the two men choose each other's texts and collages, in person but also through the mail. The book appears on 25 June. After Eluard visits again in July, Ernst leaves his wife and, having failed to obtain a travel visa, takes the train illegally to France. He crosses the border by using his friend's passport, a prescient symbol of the degree to which the two men's identities subsequently become intertwined. Ernst portrays that relation in several paintings and in the murals he makes for the Eluards' house in Eaubonne, which mark his final dadaist phase.

February Duchamp arrives once more in New York, having announced that his alter ego Rrose (now with two R's) will be opening a fabric-dyeing business with one Leon Hartl: "If we are successful, we don't know what we'll do." Luckily, the venture fails within six months. **March** *The Little Review* devotes an issue to Francis Picabia, which also includes a defense of Baroness Elsa: "[She] is the first American Dada.... When she is dada she is the only one living anywhere who dresses dada, loves dada, lives dada." **June** Duchamp is at work on the design for a book of art reviews by critic Henry McBride, underwritten by the Société Anonyme. He confers with McBride by letter on the choice of illustrations (14 June): "Concerning Picabia, I have a number of *391* in which there is a drawing by him which is simply an ink blot... which he calls *La Sainte Vierge* (The Virgin Saint)—Do you think that's too Dada?" **November** Duchamp and Robert Desnos correspond "telepathically," via cablegram, to create a series of punning poems attributed to Rrose Sélavy in the December issue of *Littérature*—yet another instance of art through the mail. "[W]ords have stopped playing. Words are making love," writes Breton in his preface to these verses.

January Pierre de Massot makes Paris Dada the focus of a literary survey that stands as the first historical overview of the group, *From Mallarmé to 391.*

Having turned his attention primarily to photography, Man Ray creates his first photograms, quite likely after Tzara shows him the little experiments by Christian Schad that he has dubbed Schadographs. Man Ray soon baptizes his works in a similar fashion, calling them Rayographs or Rayograms. **January–February** Breton plans a "Congrès pour la détermination des directives buts et la défense de l'esprit moderne" (Congress to Determine the Aims and the Defense of the Modern Spirit), a lofty attempt to organize a unified, avant-garde voice that ultimately fails. Tzara is invited to join the committee but refuses; Breton responds with an article that calls Tzara an attention-grabber "from Zurich." **August** Man Ray has nearly or entirely completed *Champs délicieux* (Delicious Fields), a suite of Rayograms that furthers his preoccupation with abstraction made from ordinary objects and by mechanical means. The published portfolio includes a preface by Tzara entitled "La photographie à l'envers" (Photography Upside Down). **September** Tzara, who has been speaking on Dada in Weimar and Jena, delivers a lecture (25 September) on "Dada in Paris," sponsored by Theo van Doesburg's journal *Mécano*.

RELATED EVENTS

ZURICH

BERLIN

HANNOVER

COLOGNE

NEW YORK

PARIS

attended by over five dozen individuals, including Otto Dix, Raoul Hausmann, Hannah Höch, El Lissitzky, Richter, and Van Doesburg. A vigorous debate on the 30th, in which Richter and Van Doesburg banish subjectivity from art and Hausmann leads a spirited rendition of "Oh Tannenbaum," culminates in secession from the symposium by most

of the above-named. **June–November** In June single issues appear in Zagreb of the journals *Dada-Jok*, edited by Branko ve Poljanski, and *Dada-Jazz*, by Aleksić; Aleksić publishes *Dada-Tank* in September, with his arresting poem "Obilatosti berze creva" (The Abundance of the Intestinal Stock-Market). All three revues show sophisticated under-

standing of Dada typography, and the two by Aleksić have texts by Tzara, Schwitters, and Huelsenbeck as well. Poljanski's *Dada-Jok*, conceived as a broadside against these institutionalized dadaists, features irreverently captioned views of Zagreb monuments, and photo-collages made from medicine and geometry books. It also has the cleverest title: *Dada* means

"yes, yes" in Serbian, while *jok* means "no" in Turkish, the language of Serbia's pre-war oppressor.

A series of Dada performances takes place in bars and movie theaters across Serbia, advertised through posters of an appropriately loud design. The participants play with nationalist values, mixing Serbian with German and Hungarian,

for a brain, boards nailed over his face, and a giant kitchen knife cutting diagonally across his fat belly in place of a patrician's sash. Grosz also has the idea, never realized, to create shieldlike, over-life-size assemblages of machine parts and other objects mounted on wood and canvas, behind which the actors would speak their lines.

Kurt Schwitters, *Memoiren Anna Blumes in Bleie: eine leichtfassliche Methode zur Erlernung des Wahnsinns für jedermann* (Anna Blume's Lead Memoirs: An Easy-to-Use Method by Everyone for Mastering Insanity), 1922. National Gallery of Art, Library, Gift of Thomas G. Klarner

In a letter to Tzara, Duchamp proposes perhaps the grandest scheme yet for incorporating Dada internationally: a secret society of healers whose members own a one-dollar insignia in precious metals with the word "Dada." This amulet could "be worn as a bracelet, badge, cuff links or pin.... The act of buying [it] would consecrate the buyer as Dada....[T]he

insignia would protect against certain maladies...something like those Little Pink Pills which cure everything...a universal panacea, a fetish in a sense...." **October–December** Ernst, now established in the house of Paul and Gala Eluard, paints *Au rendez-vous des amis*, his consecration of the Dada brotherhood—from Arp to Fyodor

Dostoevsky. **November** On 26 November, Eluard, Soupault, and Tzara attend a talk by Iliazd (Il'ia Zdanevich) on Russian Dada, part of the burgeoning manifestation of Dada among Russian expatriates in Paris.

Picabia has a large exhibition in Barcelona, at the Galerie Dalmau (18 November–8 December).

André Breton lectures at the opening, covering Dada painters and poets from Duchamp and Ernst to Aragon, Richard Huelsenbeck and Tzara.

further languages of imperialism; on one occasion, Aleksić strips from formal wear to a boxing outfit, while at another venue reproductions of artwork by Francis Picabia, Hausmann, and others are displayed as settings for theater sketches. **July** Mamie Smith records "That Da Da Strain," soon sung by Ethel Waters and others. "Have you heard it, have you heard it, that new Da Da Strain?/It will shake you, it will make you really go insane...." **September** A Konstruktivistischer Kongress (Constructivist Congress) takes place in the Bauhaus city of Weimar, attended by Arp, Taeuber, Schwitters, Tzara, and Van Doesburg (revealed here as the dadaist Bonset). Tzara addresses the gathering on 23 and 25 September, delivering what many take for an elegy: Dada "drew the world's attention to *death*, to its constant presence among us," and now is destroying itself. Yet the speech has moments of great optimism. Tzara seems to affirm that, like all organic communities, Dada renews itself through decomposition: "[One] characteristic of Dada is the continual separation of our friends." **October– December** The Galerie Van Diemen, Berlin, hosts the *Erste russische Kunstausstellung* (First Russian Art Exhibition) from 15 October–late December, providing western Europeans with their first in-depth look at recent developments in Russian and Soviet art.

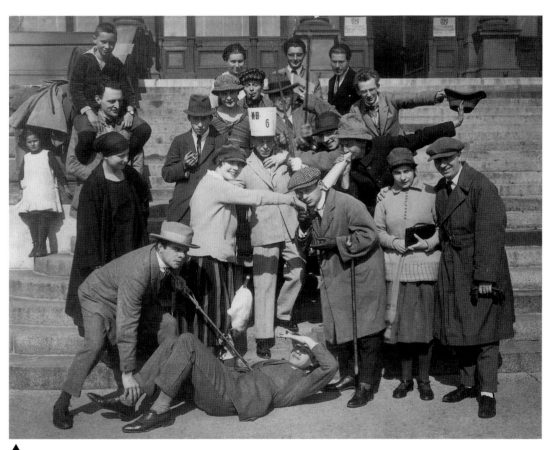

▲

Participants in the Weimar Congress, September 1922. Far left: Max Burchartz (carrying son); back row, from left: Lucia Moholy-Nagy, Alfred Kémény, László Moholy-Nagy; third row, above the poster, El Lissitzky (checked cap); second row: Nelly van Doesburg, Theo van Doesburg (with poster in hat), Tristan Tzara (gloved and monacled), Nini Smit, Hans Arp; in front, Werner Graeff (with stick), Hans Richter (on ground), Bauhaus-Archiv Berlin

1923

RELATED EVENTS

ZURICH

BERLIN

HANNOVER

COLOGNE

NEW YORK

PARIS

July Richter inaugurates the journal *G*, an abbreviation for *Gestaltung* (Formation). The opening issue, coedited by El Lissitzky, contains articles by Van Doesburg and Hausmann; Schwitters, Arp, and Tzara are among the subsequent contributors. Lissitzky later criticizes *G* as intellectually passé and snobbishly produced: "Let us hope that it will improve and

become more like a real American weekly" (letter to J.J.P. Oud, 8 September 1924). **October** 28 October: Mussolini effectively takes power in a spectacular "march to Rome." **November–December** The Czech avant-garde group Devětsil invades the prestigious Rudolfinum cultural house to hold a Bazar moderního umění (Modern Art Bazaar),

late November to mid-December. The title makes oblique reference to the Berlin Dada Fair of 1920, and the exhibition includes collectively selected objects—a lifebelt, a coiffeur's dummy, a set of ball bearings, a mirror—that echo dadaist gestures, albeit with an unguarded admiration for industrial manufacture.

Sophie Taeuber-Arp and Hannah Höch, Rügen, 1923. Stiftung Hans Arp and Sophie Taeuber-Arp e.V., Rolandseck

January The first issue appears of *Merz*, Schwitters' irregularly published and variably sized publication, which moves between magazine, portfolio, and book formats for the nine years of its existence. In this inaugural number, Schwitters recounts his first joint performance in Holland with Nelly and Theo van Doesburg (10 January): "Our

appearance…was like a powerful victory train. Our public…believes it must scream dada, shout dada, whisper dada, sing dada, howl dada, grumble dada.… We are the dadaist private orchestra, and we'll blow you." The Holland Dada tour crosses the country through 14 February, with additional appearances on 12 March and 13 April.

Spring? Schwitters begins work, now or earlier, on the *Merzbau*, a metastatic architectural growth that eventually consumes the family residence. Early on, Höch helps Schwitters design a "bordello with a three-legged lady"; Schwitters and/or Hausmann add a reproduction of the *Mona Lisa* with Hausmann's face pasted over it, and in another cavity

Schwitters places a brassiere filched from Sophie Taeuber. Further "columns" and "grottoes" come to divide this teeming space, among them (as he writes in 1931) a "sadistic murder cavern with the sorely mutilated body of a pitiful young girl tainted with tomatoes and many Christmas gifts"; a Goethe grotto, which supposedly contains the poet's

February "Dada is Dead" appears in the New York journal *The Freeman* (8 February). The author, Vincent O'Sullivan, mentions a vaudeville show in Paris that featured a funeral procession for now-deceased ideas of the previous year. "Among them was our old friend Dada. Which proves two things: 1) that Dada has become known to the general

public; 2) that Dada is really dead." **February** Duchamp leaves New York for Rotterdam. It is his seventh international sea passage since 1915 and the final one for many years to come. **April** Baroness Elsa sails to Germany, never to return to the United States. **August** Covert takes a job as sales agent in New York for the Pennsylvania-based

Vesuvius Crucible Company. He renounces art making, even refusing Dreier's invitation in 1924 to direct the Société Anonyme gallery. It will be twenty years before he returns to steady drawing or painting.

February The Union des artistes russes (Union of Russian Artists), led by Iliazd and Mikhail Larionov, organizes a Bal travesti (transmêntal) (Transvestite [Transmental] Ball) in honor of Russian poetry and its Dada affiliations. Tzara publishes a poem in the catalogue, which is strewn with tiny, nineteenth-century advertising images: a violin, apothecary bottles, a

bicyclist on an 1870s velocipede (the "boneshaker"), and others. **July** *La soirée du coeur à barbe* (The Bearded Heart Soirée), scheduled by Tzara and Iliazd for 6 and 7 July at the Théâtre Michel, aims to effect a return to the great soirées of 1920–21. On the program are films by Charles Sheeler and Paul Strand, Hans Richter, and Man Ray; musical

pieces by Igor Stravinsky, Erik Satie, and others; a variety of poems; and as centerpiece Tzara's play, *Le Coeur à gaz*. An eyewitness report by Van Doesburg (published only in 1987, in the journal *Jong Holland*) reveals that many of the promised efforts may not have taken place, including some film showings, because of the incredible turmoil that evening: "The Dadaists in

the audience [Breton, Aragon, and others opposed to Tzara] advanced on the stage Dadaists.… Gentlemen left their elegant companions and, throwing off their jackets, jumped on the Dadaists in the audience.… The actors began again, but…the Dadaists in the audience made the play impossible to follow. They refused to leave and freely gave

Kurt Schwitters, cover of the journal *Merz*, no. 1: *Holland Dada*, January 1923, letterpress. Elaine Lustig Cohen Dada Collection, The New York Public Library, Astor, Lenox and Tilden Foundations

leg as a relic; and a "ten percent crippled war veteran who has no head but still manages to get along...." **July** The fourth issue of *Merz* concentrates on "banalities." By this is meant a wide range of real or invented aphorisms, for instance, "Philip kissed her and held her warm cheek against his for a moment," an English-language original attributed to Goethe, and "'Now I have to go back into the shit' (front-line soldier on leave, 1917)." **August** Höch, Schwitters, Arp, and Taeuber vacation together on the island of Rügen, in the Baltic Sea. Probably just prior to this trip, Schwitters publishes Arp's portfolio *7 Arpaden* (7 Arpades), a progression of abstract shapes derived from body parts such as the bellybutton, or vanities like a handlebar moustache. **December** Hausmann and Schwitters stage a *Merz-Matinée* in the Tivoli concert building in Hannover. El Lissitzky designs the poster.

Kurt Schwitters, *Rekonstruktionsskizze Merzbau* (Reconstruction sketch of Merzbau), Kurt Schwitters Archiv im Sprengel Museum Hannover

their names and addresses to the police.... At twelve-thirty the most elegant automobiles began arriving at the door of the Théâtre Michel. No passerby would have suspected that this stylish audience had just witnessed an uproar."

January Incapacitated by stroke since March 1923, Vladimir Lenin dies on 21 January. Joseph Stalin, secretary general of the Communist Party since 1922, begins to consolidate his position, although he will not achieve uncontested power until 1929. **October–December** In Bucharest, Ilarie Voronca, Stefan Roll (pseudonym of

February Grosz and Herzfelde stand trial once more (16 February), this time on charges of obscenity connected with the portfolio *Ecce Homo*, portions of which were confiscated in April 1923. The two men and their associate, Julian Gumperz, each pay a fine of 500 marks. **July–August** Dix publishes *Der Krieg* (The War), fifty etchings depicting the

Late 1923 or **early 1924** Schwitters debuts his "Ursonate" in the Potsdam home of publisher Gustav Kiepenheuer. A very short excerpt from this half-hour long poem, which consists of rhythmically uttered letter combinations devoid of conventional meaning, appears in the sixth issue of *Merz* in October 1923, and a further fragment is

May René Clair films *Entr'acte*. In the opening scene, a chess game between Duchamp and Man Ray on the roof of the Théâtre des Champs-Elysées ends abruptly when the contestants and their respective pieces are hosed into oblivion. **July** Tzara collects his major speeches of the past several years, and important vignettes, in the book *Sept manifestes*

Georghi Dini), and Victor Brauner edit *75 HP*, a journal with a jazzy cover and an engine in its title. Brauner and Voronca contribute "Picto-poésie," a collage like drawing composed of industrial vocabulary words (Kodak, elevator, truck) on a multicolored background, as well as two playfully designed manifestos. This publishing project directly precedes the *Prima*

expoziție internationalā Contimporanul (First International Contimporanul Exhibition), November–December, hosted by the leading Romanian art magazine, *Contimporanul*. Organized by Marcel Janco, among others, the wide-ranging show has work by Arp, Schwitters, Arthur Segal, Eggeling, and Richter. **December** The Bauhaus relocates (26 December)

to Dessau, where it will stay from 1925–28. The Bauhaus becomes still better known during this time for its embrace of constructivism in all the arts, gaining visibility as a showcase for international studies.

daily alternation of drudgery and sickening terror in the trenches, on both sides of the Western Front. This massive undertaking appears at the height of tenth-year anniversaries marking the start of the Great War. Dix maintains a disquieting neutrality with regard to the events depicted: "I...had to see how someone next to me suddenly fell and was gone, the

bullet hitting him right in the middle. I had to experience all that very precisely. I wanted to. In other words, I'm not a pacifist at all."

published in *Mécano* 4/5 (January 1924). In 1925 Schwitters takes the remarkable step of recording the poem's scherzo movement and issuing the album as the thirteenth number of *Merz*. The poem continues to emerge in fragments before appearing complete, in a design by constructivist typographer Jan Tschichold, as the final issue of

Merz (1932). **April–July** Together with El Lissitzky, Schwitters prepares a double issue (8/9) of *Merz*, sparer in design and more earnest in tone than previous issues of the journal. Subtitled "Nasci" (Becoming), the folio-sized periodical sets forth a credo of formal experiments based in apparently inherent laws of growth or balance. As if to

emphasize the link between Dada and constructivism internationally, "Nasci" places reproductions of work by Kazimir Malevich, Vladimir Tatlin, Piet Mondrian, and Lissitzky alongside an assemblage by Schwitters, one of Man Ray's Rayograms and a *Collage Arranged According to the Laws of Chance* by Arp.

Lenin's funeral, Red Square, Moscow, 1924, Getty Images

dada (Seven Dada Manifestos). Tzara charts the trajectory of his critical choices, from Apollinaire and African art to Picabia, Huelsenbeck, Arp, and Man Ray's photograms, and his poetic and performative strategies as well, thereby giving a historical shape to the Dada period. A preface written for a later edition of the book illuminates his intentions. "One may consider

[these writings] as a certain Dada coherence [assembled] only to fix... a moment defined by certain personal reactions to a devastating world. The dates in which they first appeared say enough about the agitation, but in spite of that the violent refusal, on which they were founded. They therefore don't pretend to bring solutions to problems that they seem

barely to have formulated." **July–November** Funded by collector Jacques Doucet, Duchamp enlists Man Ray's help to further experiments begun in New York four years ago, as he fabricates a new mechanical device baptized *Rotative Demisphère (Optiques de précision)* (Rotary Demisphere [Precision Optics]). This machine, circumscribed with a pun

signed by Rrose Sélavy, inspires the spiralling abstractions in *Anémic Cinéma* (1926). **October** Breton, Eluard, Soupault, Aragon, and several other writers and artists launch the Bureau de recherches surréalistes (11 October), the founding institution of international surrealism. "One notes that at the time of dadaism, no one wanted to be Dada," asserts

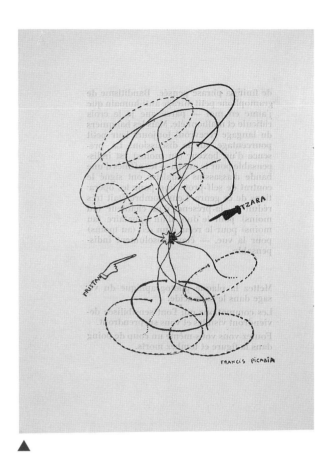

Francis Picabia, illustration in *Sept manifestes dada* (*7 Dada Manifestos*) by Tristan Tzara, 1924. National Gallery of Art, Library, David K. E. Bruce Fund

Marcel Duchamp and Brogna Perlmutter as Adam and Eve in *Cinésketch*, 1924. Man Ray Trust

Tzara in an interview for *Les Nouvelles littéraires* (25 October). "Now we have surrealism, and everyone is looking to be part of it, so much so that one needs to get a degree and, lacking surrealist diplomas, we are threatened by fists.... Dada took off from surrealism as conceived by Guillaume Apollinaire, working to expand principles of spontaneity."

October Picabia issues the nineteenth and final number of *391*. **November** George Grosz exhibits old and recent work in the Galerie Joseph Billet, Paris.

Rrose Sélavy, president, and Marcel Duchamp, administrator, establish a company to issue thirty bonds of five hundred francs each to underwrite Duchamp's plan to beat the odds at Monte Carlo and other casinos on the French Riviera. The bonds will pay twenty percent interest. Chance is linked to money, money to art, and art to eros, which is life itself. Jane Heap promotes the venture in *The Little Review*: " Marcel's signature alone is worth much more than the 500 francs asked for the share." **December** Premiere

of Picabia's humorously titled *Relâche* (No Performance) takes place on 4 December. Cinema and dance interact spectacularly, for example, in a filmed "overture," where Picabia and Satie descend from the heavens to fire a cannon directly at the audience. During intermission, René Clair and Picabia show the equally aptly titled *Entr'acte*, filmed in May. The New

455

RELATED EVENTS

ZURICH

BERLIN

HANNOVER

COLOGNE

NEW YORK

PARIS

Francis Picabia, poster for *Cinésketch* gala, 1924, lithograph with watercolor. Collection Merrill C. Berman

▶

February The NSDAP reforms on 27 February, two years after Hitler's unsuccessful coup attempt. *Mein Kampf* (My Struggle), dictated by Hitler to Hess during a prison sentence, appears in July. **May** Composer and budding theater director Emil F. Burian begins publication in Prague of *Tam Tam*, a journal for avant-garde music and performance,

Grosz, with editorial help from Herzfelde, publishes *Die Kunst ist in Gefahr* (Art Is in Danger), a collection of articles on the place of creative work in contemporary society: "Today's artist, unless he wants to be useless, an antiquated misfit, can only choose between technology and class war propaganda." **May** The Novembergruppe organizes

Year's Eve reprise includes an additional routine that furthers the play between staged and filmed reality. Called *Cinésketch*, this ballet features intertitles as in a silent film, but announced loudly through a megaphone; the lights are also switched on and off with the action in imitation of cinematic scenes. Duchamp and a young woman named Brogna

Perlmutter appear briefly at one point as Adam and Eve, modeled after Lucas Cranach. The narrator cries out as the stage goes dark: "The policeman, who doesn't understand, wants to arrest everybody."

Pierre Naville and Benjamin Péret launch *La Révolution surréaliste*, edited from July 1924 by Breton. Man Ray illustrates this inaugural issue with

a still from his film *Retour à la raison* (Return to Reason) and an image of his (now lost) dadaist object *New York*, 1920. "We must arrive at a new declaration of the rights of man," declares the cover, under a picture of surrealist gatherings that resembles a League of Nations conference.

the title of which means both "tom-tom drum" and "there-there," or in German *da da*. **December** Poet František Halas lectures (10 December) on dadaism in Brno, Czechoslovakia. Halas asserts the importance of attempting abstract art, of celebrating vital instincts from drinking to copulation, and of exposing the absurdity of bourgeois mores. He admires the dadaists for "frightening, humbling, but also teaching" the masses about the real horrors of war, and concludes that dadaism and communism make a fine basis for modern creativity. Halas also stresses one must laugh at oneself and society alike. Indeed, he opens by quoting Tzara: "Look at me well. I'm an idiot, a hoaxer, a smoker. . . . I'm ugly, short, dull. I'm like all of you," and adds, "this is how every lecture should begin."

Der absolute Film, a showing of experimental cinema (3 May) at which Picabia and René Clair's *Entr'acte*, and *Symphonie diagonale* by Eggeling are projected. Eggeling himself is sick with blood poisoning; he dies on 19 May, just thirty-nine years old. "His *Diagonal Symphony* did not of course tackle all the problems of an absolute film. But I believe that . . . he certainly began the task in the most radical, elementary way, and pursued it with the most discipline." (Adolf Behne, *Die Welt am Abend*, 23 May 1925).

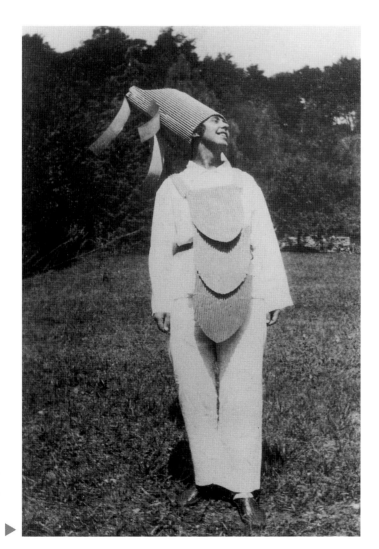

Sophie Taeuber-Arp, Ascona, 1925. Stiftung Hans Arp und Sophie Taeuber-Arp e.V., Rolandseck

March Schwitters goes to Prague to recite poetry at the invitation of Devětsil. His play *Schattenspiel* (Shadow Play) is part of the opening repertoire of Divadlo Dada (The Dada Theater) founded by ex-Devětsilers Jiří Frejka and E. F. Burian in April–May 1927. Meanwhile, the principal Devětsil theater company, Osvobozené divadlo,

November The Société Anonyme opens (19 November) a mammoth, "International Exhibition of Modern Art," with three hundred works from around twenty different countries. Although the emphasis is on very recent art, Duchamp's *Large Glass*, in storage for the last three years, forms a centerpiece of the exhibition. The artist has traveled again to New

RELATED EVENTS

ZURICH

BERLIN

HANNOVER

COLOGNE

NEW YORK

PARIS

stages plays by Georges Ribemont-Dessaignes, André Breton and Philippe Soupault, Guillaume Apollinaire, and Ivan Goll in its repertoire during 1926–29. **November** Devětsil leader Karel Teige publishes "Dada" in the little magazine *Host*. This extended survey article, driven by the thesis that Dada means cynical laughter and delight in contradiction,

later grounds part of a two-volume reflection on art and contemporary society, *Svět, který se směje / Svět, který voní* (The World That Laughs / The Sweet-Smelling World), 1928–30. Overly focused on the movement's nihilistic aspects, Teige nevertheless appreciates Dada as restorative: "Having witnessed the end of art, philosophy, aesthetics, and morals,

the dadaists were not shaken by the emptiness of life: rather, they danced an extravagant foxtrot on the ruins."

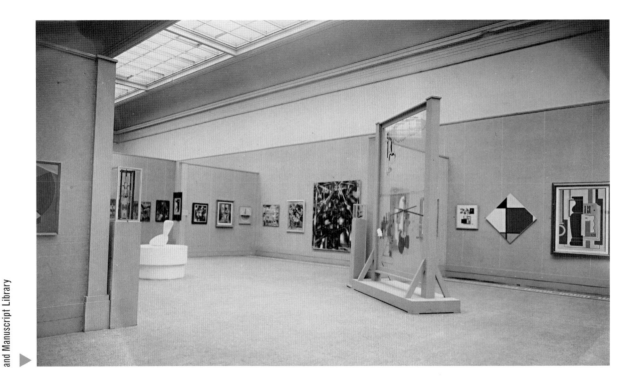

View of the Société Anonyme exhibition, showing Marcel Duchamp's *Large Glass*, 1926. Yale Collection of American Literature, Beinecke Rare Book and Manuscript Library

York, principally to install a large exhibition of work by his close friend Constantin Brancusi that opens two days earlier.

Duchamp has likely carried with him the seven-minute film *Anémic Cinéma*, which has its premiere at the Fifth Avenue Theater sometime after his arrival in late October. The pulsating abstractions and saucy

puns fail to leave an impression on this foreign audience.

REFERENCES

In addition to these sources, I have found the research of William Camfield, Francis Naumann, Walter Vitt, and Eva Züchner particularly helpful. My thanks to Timothy Benson, Andrew Kner, Mark Levitch, Darko Šimičić, Piotr Piotrowski, and Michael Taylor for elucidating details of this chronology, and to Leah Dickerman for her guidance throughout its preparation.

Except as noted below, book and periodical citations have been translated by the author from period editions or reprints. Newspaper reviews were researched primarily in the Tzara archives at the Bibliothèque Jacques Doucet, Paris, with further examples quoted from books and articles by Todd Alden, Hanne Bergius, and Hans Burkhard Schlichting listed here. Original copies of periodicals and ephemera were studied at the Getty Research Institute, Los Angeles (along with the Johannes Baader papers and correspondence between Tristan Tzara and Paul Dermée); Special Collections, the Library of the Museum of Modern Art, New York; and the Spencer Collection, Department of Prints and Drawings, New York Public Library.

Letters and other period testimony are quoted from the following books:

Alden, Todd. "Here Nothing, Always Nothing: A New York Dada Index, etc.," in Francis Naumann and Beth Venn, *Making Mischief: Dada Invades New York.* New York, 1996.

Benson, Timothy, and Éva Forgács, eds. *Between Worlds: A Sourcebook of Central European Avant-Gardes, 1910–1930.* Cambridge, Mass., 2002.

Berg, Hubert F. van den. *The Import of Nothing: How Dada Came, Saw, and Vanished in the Low Countries (1915–1929).* New Haven, 2002.

Bergius, Hanne. *Montage und Metamechanik.* Berlin, 2000.

———. *Das Lachen Dadas.* Berlin, 1988.

Bolliger, Hans, Guido Magnaguagno, and Raimund Meyer. *Dada in Zürich.* Zurich, 1985.

Breton, André. *Oeuvres complètes,* vol. 1, ed. Marguerite Bonnet et al. Paris, 1988.

Caumont, Jacques, and Jennifer Gough-Cooper. "Ephemerides on and about Marcel Duchamp and Rrose Sélavy, 1887–1968," in *Marcel Duchamp Vita/Opera* [exh. cat. Palazzo Grassi, Venice] (Milan, 1993).

Gammel, Irene. *Baroness Elsa: Gender, Dada, and Everyday Modernity. A Cultural Biography.* Cambridge, Mass., 2002.

Hoek, Els, ed. *Theo van Doesburg oeuvre catalogue.* Utrecht, 2000.

Hofacker, Marion von. "Chronology," in Stephen Foster, ed. *Hans Richter: Activism, Modernism, and the Avant-Garde.* Cambridge, Mass., 1998.

Lista, Giovanni. "Dada in Italia," in *Dada, L'arte della negazione.* Rome, 1994.

Picabia, Francis. *Ecrits 1913–1920,* ed. Olivier Revault d'Allonnes. Paris, 1975.

Ribemont-Dessaignes, Georges. *Dada: Manifestes, poèmes, articles, projets, théâtre, cinéma, chroniques 1915–1929,* ed. Jean-Pierre Bégot. Paris, 1994.

Sanouillet, Michel. *Dada à Paris.* Paris, 1993.

Schlichting, Hans Burkhard. "Hugo Ball Chronik," in *Hugo Ball. Leben und Werk.* Berlin, 1986.

Schwitters, Kurt. *Das literarische Werk,* vol. 5, *Manifeste und kritische Prosa,* ed. Friedhelm Lach. Cologne, 1981.

———. *Wir spielen, bis uns der Tod abholt. Briefe aus fünf Jahrzehnten,* ed. Ernst Nündel. Frankfurt and Berlin, 1974.

Serner, Walter. *Das Gesamte Werk,* vol. 2: *Das Hirngeschwür,* ed. Thomas Milch. Munich, 1982.

Sheppard, Richard, ed. *New Studies in Dada. Essays and Documents.* Driffield, 1981.

Spies, Werner, and Götz Adriani. *Max Ernst Collagen.* Cologne, 1988.

Thater-Schulz, Cornelia, ed. and Berlinische Galerie, *Hannah Höch. Eine Lebenscollage.* 2 vols. Berlin, 1989.

Tzara, Tristan. *Oeuvres complètes,* vol. 1, 1912–1924, ed. Henri Béhar. Paris, 1975.

Quotations have been made from the following English-language works and translations:

Huelsenbeck, Richard. *Fantastic Prayers,* in Malcolm Green, trans. and ed. *Blago Bung Blago Bung Bosso Fataka!* London, 1995.

———. ed. *Dada Almanac,* trans. Malcolm Green et al. London, 1995.

Owen, Wilfred. "Cramped in That Funneled Hole," in Tim Cross, ed. *The Lost Voices of World War I.* London, 1988.

Tzara, Tristan. *The First Celestial Adventure of Mr. Antipyrine,* trans. Ruth Wilson, in Mel Gordon, ed. *Dada Performance.* New York, 1987.

Tristan Tzara and Paul Eluard, *Papillons Dada* (Dada Fliers) 1919–1920. Centre Pompidou, Musée national d'art moderne-Centre de création industrielle/ Bibliothèque Kandinsky, Centre de Documentation et de recherche, Paris

Chaque spectateur est un intrigant, s'il cherche à expliquer un mot : (connaître !)

Expliquer : *Amusement des ventres rouges aux moulins de crânes vides.*

— *TRISTAN TZARA*

Un autre : **TAISEZ-VOUS,** le langage n'est pas stenosteno, ni ce qui manque aux chiens !

DADA

Société Anonyme pour l'exploitation du vocabulaire.

Directeur : *TRISTAN TZARA.*

DADA ne signifie **RIEN**

Si l'on trouve futile et l'on ne perd son temps pour un mot qui ne signifie rien....

TRISTAN TZARA.

ARTISTS' BIOGRAPHIES

AMANDA L. HOCKENSMITH and SABINE T. KRIEBEL
with contributions by ISABEL KAUENHOVEN

PARIS

Louis Aragon

born 1897 Paris
died 1982 Paris

Louis Marie Alfred Antoine Aragon was born on 3 October 1897 in Paris as the illegitimate child of Louis Andrieu and Marguerite Toucas-Massillon. In order to cover up his illegitimacy, Aragon's parents pretended that he was the adoptive son of his grandmother Claire Toucas. He was told that his mother Marguerite and her sisters were his older sisters. Aragon developed his interest in literature early in life, writing plays, poems, and stories at a young age. Aragon attended the Lycée Carnot in Paris, receiving his *baccalauréat* in 1915. In 1916 at his mother's insistence, Aragon began his study of medicine at the Faculté de médecine in Paris.

Louis Aragon, 1923.
Man Ray Trust

During his time there, he met Colette Jeramec who would become his first wife in 1917. He also made the acquaintance of André Breton in 1917 at the bookstore of Adrienne Monnier, La maison des amis des livres, which both young men visited frequently.

In 1917 Aragon wrote his first serious text, *Alcide ou De l'esthétique du saugrenu* (Alcide, or of the Aesthetic of the Absurd). When the avant-garde poet and playwright Guillaume Apollinaire read *Alcide*, he asked Aragon to write a critique of the premiere of his piece, *Mamelles de Tirésias* (Breasts of Tiresias). The review appeared in *Sic* in March 1918, and Aragon's first poems were published in the same month: "Charlot sentimental" in *Le film* and "Soifs de l'ouest" (Thirsts Out West) in *Nord-Sud*. On 20 June 1917 Aragon was mobilized and enlisted in the Twenty-second Section of the medical regiment. He was sent to Val de Grâce and trained as a medical orderly. Here he again encountered Breton, also a student of medicine with strong

literary interests, and the two began a friendship that lasted until 1932. In May 1918 Aragon's mother revealed the truth surrounding the circumstances of his birth, prompted by strong pressure from Aragon's father. In June 1918 Aragon was enlisted in the 355th Infantry Regiment as a medical orderly and sent to Hauts-de-Meuse. On 6 August 1918 in an attempt to save injured soldiers, Aragon was buried three times by exploding shells and presumed dead. A few weeks later, on 15 August 1918, he received the Citation d'ordre de l'infanterie divisionnaire for his evacuation of the injured under dangerous conditions. He subsequently received the Croix de guerre. Near Nouvron-Vingré (Aisne) Aragon stumbled upon a dead soldier who had been reading a volume of poetry. This experience left a lasting impression on him, which he would evoke several times in his writings.

On 1 March 1919 the first issue of the journal *Littérature* appeared, coedited by Aragon, Breton, and Philippe Soupault. In November 1919 Aragon resumed his study of medicine. Upon the invitation of the *Littérature* group, Tristan Tzara moved from Zurich to Paris, an event which Aragon retold in an essay "Tristan Tzara arrive à Paris." On 7 February 1920 the dadaists held a soirée in the Club du Faubourg, which Aragon described in "Manifestation du Faubourg." Aragon performed the part of "Monsieur Cricri" in both parts of Tzara's *La première Aventure céléste de Mr Antipyrine* (The First Celestial Adventure of Mr. Antipyrine) in the spring of 1920. In late December 1920 Aragon and Breton sought to join the newly created French Communist Party but were discouraged from doing so by a party functionary.

On 17 February 1921 Aragon's first novel, *Anicet ou le panorama, roman* (Anicet, or the Panorama, a Novel), was published. On 14 April 1921 the "Grande saison Dada" opened, described by Aragon in "La Grande saison Dada 1921." Aragon and Breton organized an exhibit of Max Ernst's works in Paris, which opened on 3 May 1921. On 13 May 1921 at 9:30 the dadaists launched a trial against Maurice Barrès, a prominent symbolist writer, poet, and journalist, whom they blamed for attacking the safety of the spirit. Aragon played the role of the public defender.

After 1924, Aragon became a key member of the surrealist movement. A visit to the Soviet Union in 1930–31 prompted a break with surrealism based on his political convictions.

Aragon became a prominent writer of the communist left. He died on 24 December 1982 in Paris. STK

SOURCES

Aragon, Louis. *Aragon. Chroniques*, ed. Barnard Leuilliot. Paris, 1998.
Aragon, Louis. *Aragon. Oeuvres romanesques complètes*, ed. Daniel Bougnoux. Paris, 1997.

PARIS

Celine Arnauld

See Paul Dermée.

ZURICH
HANNOVER
COLOGNE
PARIS

Hans (Jean) Arp

born 1886 Strasbourg, Alsace
died 1966 Basel, Switzerland

Hans Arp was born in the city of Strasbourg in Alsace, a region between France and Germany that for centuries was contested territory. As the son of a German father and a French Alsatian mother, Arp received German and French given names. Called both Hans Peter Wilhelm and Jean Pierre Guillaume, he grew up speaking French, German, and the Alsatian dialect. Between 1900 and 1908, he studied art at the Strasbourg School of Arts and Crafts, the Weimar Academy of Art, and the Académie Julian in Paris but was dissatisfied with the academic and tedious instruction. After his family moved to Weggis, Switzerland, in 1906, Arp spent several years there writing and drawing in isolation, interrupted only by brief trips to Paris.

In 1910 Arp began to establish contacts with artists he had met in Paris and cofounded the Moderner Bund, an exhibition society for Swiss modern artists. He also traveled widely, establishing connections with artists and writers in Paris, the expressionist Blaue Reiter (Blue Rider) group headed by Vasily Kandinsky in Munich, and Herwarth Walden's Sturm (The Storm) Gallery and magazine in Berlin. As a result of these contacts, several of his drawings were published in the *Blaue Reiter Almanach* in 1912, and he was employed by Walden to organize exhibitions and write reviews in Berlin. These experiences were formative to Arp's artistic development; among the Zurich dadaists, Arp was the most knowledgeable about modern art movements.

460

Arp was in Cologne when Germany declared war on France. He took one of the last trains to Paris to escape the draft and lived there for about a year in the artists' and poets' enclave of Montmartre. After he was arrested by the Paris police and investigated for espionage, he was advised to leave France immediately. On his entry into Switzerland, he was sent to the German consulate in Zurich to be conscripted, a fate he avoided by feigning mental illness.

After arriving in Switzerland, Arp went to Arthur Segal's house in Ascona, where he soon struck up a close working relationship with Otto and Adya van Rees, a Dutch couple who were also taking refuge in Switzerland from the war. With Otto van Rees, Arp designed and painted a mural for a children's school in Ascona. For Arp, these artistic collaborations, which he described as analogous to the workshops of the Middle Ages, were an important way of counteracting the isolating effects of modernity.

His most important collaborator was Sophie Taeuber, whom he met in 1915 and married in 1922. Taeuber influenced Arp to begin working with unconventional materials and techniques; in Arp's words, the two of them "embroidered, wove, painted, and pasted static geometric pictures." For Arp, using new materials meant rejecting tradition, and working in techniques considered "applied" rather than fine art opened up new artistic possibilities. He was also intent on eradicating the traces of human personality from his work. In their "duo-collages," he and Taeuber used a paper cutter instead of scissors to eliminate the trace of the artist's hand. By overcoming the constraints of tradition and individual subjectivity, Arp hoped to "approach the pure radiance of reality."

As he continued to develop his collage works, he abandoned the strict geometrical regularity of his early work with Taeuber and explored the operation of chance and the generation of abstract forms through observations of nature. Sketching with India ink on the shores of the lake at Ascona, Arp made drawings of rocks, broken branches, roots, and grass. By simplifying these forms and transposing them into three dimensions, he created a series of abstract reliefs composed of irregularly shaped, brightly painted pieces of wood. Arp called these reliefs "Earthly Forms," suggesting both their relation to organic life and

Hans Arp, c. 1922. Hannah-Höch-Archiv, Berlinische Galerie, Landesmuseum für Moderne Kunst, Photographie und Architektur

their abstraction. By locating the source of abstraction in nature, which for him was imbued with spiritual meaning, Arp sought to create an art that could act as a cultural restorative for an age brutalized by the unchecked development of rationalized technology, represented for him, as for the other dadaists in Zurich, by the horrific events of World War I.

When the war ended, Arp was able to reestablish the international contacts that had been so important to him prior to 1914. In Cologne he formed a Dada collaborative with Johannes Baargeld and Max Ernst, contributing poetic texts to the collages of Ernst. Later he became affiliated with Dada in Paris, and his work became more figurative. The reliefs from this period parody everyday objects, which are made absurd by the overt simplification of their forms. When Paris fell to the Germans in 1940, Arp and Taeuber were forced to seek refuge in the south of France. Taeuber's accidental death in 1943 devastated Arp, and he never quite recovered. He wrote scores of poems dedicated to her memory and insisted on the continued importance of her work, which he had exhibited alongside his own on many occasions. In 1945 Arp asked Marguerite Hagenbach, a mutual friend of his and Taeuber's, to become his companion; they were married in 1959. Eventually Arp returned to sculpture, and in his later years received numerous exhibitions and prizes. In 1966 he was honored by the installation of his memorial plaque to

Dada (a white marble relief with a gilded navel) on the façade of the former Cabaret Voltaire in Zurich. ALH

SOURCES

Arp, Jean. *Arp on Arp: Poems, Essays, Memories,* ed. Marcel Jean, trans. Joachim Neugroschel. New York, 1972.
Hancock, Jane, and Stephanie Poley. *Hans Arp* [exh. cat., The Minneapolis Institute of Arts], Minneapolis, Minn., 1986.

BERLIN

Johannes Baader

born 1875 Stuttgart, Germany
died 1955 Adldorf, Germany

Johannes Baader was born in Stuttgart, Germany, on 21 June 1875. Between 1892 and 1894, he was apprenticed in stonemasonry while he studied architecture at Stuttgart's Royal School of Building and Construction. In 1903 he became an architect in the Union of Artists for Monumental Tomb Sculpture in Dresden. Baader moved to Berlin in 1905, where he befriended Raoul Hausmann. He produced designs for a zoo for Carl Hagenbeck in 1911–12, but the plans were never realized. Because Baader likely suffered from manic depression, he was declared unfit for military service and was therefore not drafted into World War I. Instead, he dedicated his energies to what he called "spiritual architecture," utopian designs of monumental, metaphysical, and messianic dimensions, and contributed to the journals *Das Blaubuch* (Blue Book), *Die freie Strasse* (Open Road), and *Der Dada* in 1917. Baader's philosophical underpinnings were eclectic. Like many of his generation, he

Johannes Baader, 22 June 1919. Photograph by Hannah Höch. Hannah-Höch-Archiv, Berlinische Galerie, Landesmuseum für Moderne Kunst, Photographie und Architektur

found inspiration in Friedrich Nietzsche's vitalist philosophy and the idea of the *Übermensch*, or superman, who transcends bourgeois morality to live purely by individual values and the will to power. He also drew his intellectual and spiritual sustenance from both eastern and western mysticism.

As self-proclaimed *Oberdada*, or head Dada —a choice of nickname that typified Baader's grandiose, often megalomaniacal authority— Baader's Dada tactics were largely in the form of spectacular manifestos and public performances, often in collaboration with Raoul Hausmann. In the autumn of 1917, for instance, Baader and Hausmann founded a Christus-GmbH, or "Christ Company," to protect war deserters, thus associating conscientious objection with Christian martyrdom. Similarly, on 17 November 1918, Baader staged a performance in the Berlin Cathedral called *Christus ist euch Wurst* (You don't give a damn about Christ), which at once mocked clergy and parishioners as well as political pieties. This assault provoked a public scandal, and Baader was arrested for blasphemy. Hausmann, in turn, wrote a letter to Berlin's minister of culture arguing for Baader's right to free speech. In March of 1919 Baader and Hausmann announced the Dadaist Republic Nikolassee to start on 1 April 1919 under the auspices of the Central Committee of the Dada Movement. On 12 March 1919 Baader and Hausmann staged a "Propaganda Evening" in Café Austria, where they founded the Antinationaler Rat der unbezahlten Arbeiter or ARUDA (Anti-National Committee for Unpaid Workers) and Club der blauen Milchstrasse (Club of the Blue Milky Way). Baader announced the death and the resurrection of Oberdada on 1 April 1919, and as such, participated in the *Erste Berliner Dada-Ausstellung* (First Berlin Dada Exhibition) in the Graphic Cabinet of I. B. Neumann.

Baader was a vocal participant in the discourses of postwar Weimar Germany in a markedly dadaist fashion, putting out his *Buch des Weltfriedens* (Book of World Peace), a reaction to the Treaty of Versailles, on 28 June 1919, which became known as "Handbuch des Oberdada," the Oberdada Handbook. Similarly, on 16 July 1919, Baader threw flyers into the meeting of the Weimar National Assembly printed with the slogan "Dadaists Against Weimar" and three days later proclaimed the socialist politician Philip Scheidemann as *Ehrendada* (Honorary Dada) in a streetcar. On 11 November 1919, exactly a year after the Kaiser abdicated, Baader printed a calling card that announced him to be the President of the Earth and Universe. In that position Baader applied to teach at the Bauhaus with Walter Gropius in 1920 but his application was rejected. Johannes Baader died on 14 January 1955 in Adldorf, Bavaria. STK

SOURCES

Baader, Johannes. *Oberdada: Schriften, Manifeste, Flugblätter, Billets, Werke und Taten*, ed. Hanne Bergius, Norbert Miller, and Karl Riha. Lahn-Giessen, 1977.

Bergius, Hanne. *Montage und Metamechanik. Dada Berlin—Artistik von Polaritäten*. Berlin, 2000.

Richter, Hans. *Dada: Art and Anti-Art*, trans. David Britt. London, 1965 (originally published as *Dada: Kunst und Antikunst*. Cologne, 1964).

Riha, Karl, ed. *Johannes Baader: Das Oberdada*. Hofheim, 1991.

Saurs Allgemeines Künstlerlexikon, trans. David Britt. Munich, 2001.

The Twenties in Berlin: Johannes Baader, George Grosz, Raoul Hausmann, Hannah Höch [exh. cat., Annely Juda Fine Art], London, 1978.

COLOGNE

Johannes Baargeld

born 1892 Stettin, Germany (now Szczecin, Poland)
died 1927 near Chamonix, France

Johannes Theodor Baargeld was the pseudonym adopted by Alfred Emanuel Ferdinand Gruenwald as an ironic, leftist response to the predominantly Catholic and capitalist culture of his hometown, Cologne. (*Bargeld* is the German word for cash.) Born on 9 October 1892 in Stettin, Germany, Baargeld was the eldest son of the prominent Romanian-Jewish insurance director Heinrich Leopold Gruenwald. The future dadaist grew up in Cologne in a wealthy home, exposed to contemporary art and culture, beginning with his parents' collection of modern paintings. After finishing gymnasium in Cologne, Baargeld studied law and economics at Oxford from 1912 to 1913 and continued at the university in Bonn. With the outbreak of war in 1914, Baargeld enlisted and served as a reserve lieutenant in the Rhineland Cuirassier Regiment of Count Gessler from 1914 to 1917 and became a lieutenant with the German army's airborne division in February 1917. In the same year, he started to write lyrical and political texts for Franz Pfemfert's pacifist journal *Die Aktion* (Action). In 1918 Baargeld joined the Independent Socialist Party of Germany (USPD), which was the radical-left wing of the Socialist Party, thus breaking tradition with his conservative bourgeois upbringing. Baargeld was actively involved with the Rhineland Marxists during the immediate postwar period.

Baargeld (also called Zentrodada) cofounded Dada in Cologne along with Max Ernst in the late summer of 1919. In what might be called his pre-dadaist activities, Baargeld financed the publication of a Marxist-oriented periodical, *Der Ventilator* (The Fan), engendered by the postwar British occupation of the Rhineland. Guilefully camouflaged as an entertainment supplement to the daily press, *Der Ventilator* eluded British censors and was delivered to factory gates—often as many as twenty thousand copies. The journal served as a satirical political and artistic forum for members of what would become Cologne

Dada, including Max Ernst and Angelika and Heinrich Hoerle. *Der Ventilator*'s overtly political response to a theater scandal caught the attention of the British, however, and its publication was immediately banned, thus terminating Baargeld's subversive efforts after six issues. After *Der Ventilator*, Baargeld focused his energies on the Dada publications *Bulletin D* and *die schammade*, an ambitious compilation of Dada activities in Cologne, Paris, and Zurich coedited with Ernst. He also organized and participated in the Cologne Dada exhibit in the Winter Brewery in April of 1920. Though Baargeld's initial contributions to Cologne Dada were in the form of political texts and poetry, he developed his visual skills as an autodidact, preferring nontraditional media of collage, photomontage, assemblage, and typography. His dadaist works typically combined provocatively enigmatic text with illustrations or found images.

Baargeld continued his university studies in philosophy and economic theory in Cologne,

Alfred Ferdinand Gruenwald [Johannes Baargeld], 1924, Collection of Lotte Hansen, Krueth. From Walter Vitt, *Bagage de Baargeld* (Starnberg, Germany, 1985)

where he completed his doctorate in July 1923 on the development of privatized life insurance during the war. Baargeld died on 17 or 18 August 1927 at the age of thirty-four. It is presumed that Baargeld, an enthusiastic mountain climber, got lost in the fog and froze to death while scaling the Dôme du goûter en route to Mont Blanc. STK

SOURCES

Vitt, Walter. *Auf der Suche nach der Biografie des Kölner Dadaisten Johannes Theodor Baargeld*. Starnberg, 1977.

Vitt, Walter. *Bagage de Baargeld: Neues über den Zentrodada aus Köln*. Starnberg, 1985.

ZURICH

Hugo Ball

born 1886 Pirmasens, Germany
died 1927 Sant' Abbondio, Switzerland

Born into a strict and highly devout Catholic family, Hugo Rudolf Ball was a sensitive child, who grew up fearing the severity of his mother's faith. As a young man, he was apprenticed to a leather factory, but after suffering a nervous breakdown, was allowed by his family to attend university in Munich and Heidelberg,

where he studied German literature, philosophy, and history, and began a dissertation on Friedrich Nietzsche. Describing his search for philosophical meaning as "my problem, my life, my suffering," Ball devoted himself to intense study, reading widely across various systems of thought, including German moral philosophy, Russian anarchism, modern psychoanalysis, and Indian and early Christian mysticism. It was Ball who provided the Dada movement in Zurich with the philosophical roots of its revolt.

From 1910 to 1913 Ball embarked on a career in the theater, first studying acting with Max Reinhardt and then working as a director and stage manager for various theater companies in Berlin, Plauen, and Munich. His ambition was to develop a theater modeled on the idea of the *Gesamtkunstwerk*—a synthesis of all the arts—that could motivate social transformation and rejuvenation. He also began writing, contributing critical reviews, plays, poems, and articles to the expressionist journals *Die Neue Kunst* (The New Art) and *Die Aktion*, both of which, in style and in content, anticipated the format of later Dada journals. In *Die Aktion*, poems written jointly by Ball and Hans Leybold appeared under the pseudonym Ha Hu Baley. Leybold, a young and rebellious expressionist writer, was one of Ball's best friends and an active influence on his intellectual development. Also important to the formation of Ball's ideas, especially during the Dada period, were Vasily Kandinsky, the abstract painter and leader of the expressionist Blaue Reiter group, and Richard Huelsenbeck, a young doctor and student who would later become central to Dada in Zurich and Berlin, both of whom he met for the first time in Munich in 1912–13.

In 1914 Ball applied for military service three times and was rejected on each occasion for medical reasons. The trauma he experienced when he took a private trip to the front in Belgium prompted him to abandon the theater and move to Berlin, where he began to delve into political philosophy, especially the anarchist writings of Peter Kropotkin and Mikhail Bakunin. He began writing a book on Bakunin that would continue to occupy him for the rest of his life. With Huelsenbeck, Ball staged several antiwar protests in Berlin, the first of which took place in February 1915 and was a memorial to fallen poets, including

Hans Leybold, who had been mortally wounded at the front. Other expressionist evenings hosted by Ball and Huelsenbeck included the kind of aggressive and theatrical readings that would characterize Dada performances.

In mid-1915 Ball and Emmy Hennings, a cabaret singer whom he had met in Munich and whom he would marry in 1920, left Berlin for neutral Zurich. There, in February 1916, after stints with theatrical companies and vaudeville troupes, they opened the Cabaret Voltaire. At the Cabaret, Ball was organizer, promoter, performer, and the primary architect of Dada's philosophical activism. He advocated the intentional destruction and clearing away of the rationalized language of modernity that for him represented all that had led to the "agony and death throes of this age." His poetry was an attempt to "return to the innermost alchemy of the word" in order to discover, or to found, a new language untainted by convention. One of Ball's most innovative poetic forms was the sound poem, a string of noises which, when premiered at the Cabaret in June 1916, he performed with a mesmerizing, almost liturgical intensity. In his diary account of the reading, Ball recorded how his chanting had transported him back into his childhood experience of mass, leaving him physically and emotionally exhausted.

In July 1916 Ball left the Dada circle in Zurich in order to recuperate in the small village of Vira-Magadino in the Swiss countryside. When he returned in January 1917, it was at the request of Huelsenbeck and Tristan Tzara, who wanted him to help organize Galerie Dada, an exhibition space that opened in March 1917. Events at the Galerie included lectures, performances, dances, weekend soirées, and tours of the exhibitions. Although Ball supported the educative goals of the Galerie, he was at odds with Tzara over Tzara's ambition to make Dada into an international movement with a systematic doctrine. He left Zurich in May 1917 and did not again actively participate in Dada activities.

By the end of 1917 Ball was living in Bern, writing for the radical *Die Freie Zeitung* (The Free Newspaper), an independent paper for democratic politics. Ball contributed articles on German and Soviet politics, propaganda, and morality. He also returned to his study of Bakunin and prepared a manuscript of his 1915 *Zur Kritik der deutschen Intelligenz* (Critique of the German Intelligentsia) for publication. The *Critique* was a virulent attack on Prussian militarism and its effect on German culture that Ball had written partly in response to the nationalistic fervor that gripped Germany during World War I.

After 1920, when he and Hennings moved to the small Swiss village of Agnuzzo, Ball became increasingly mystical and removed from political and social life, returning to a devout

Catholicism and plunging into an ambitious study of fifth- and sixth-century Christian saints. He began revising his personal diaries for the years 1910–21, and in 1927 these writings were published as *Die Flucht aus der Zeit* (Flight Out of Time). Containing philosophical writings and acute observations of Dada performances and personalities, it remains one of the seminal documents of the Dada movement in Zurich. ALH

SOURCES

Ball, Hugo. *Flight Out of Time: A Dada Diary*, ed. John Elderfield, trans. Ann Raimes. Berkeley, Calif., 1996 (originally published as *Die Flucht aus der Zeit*. Munich and Leipzig, 1927).

Huelsenbeck, Richard. *The Dada Almanac*. New York, 1966 (originally published as *Dada Almanach*. Berlin, 1920).

Mann, Philip. *Hugo Ball. An Intellectual Biography*. London, 1987.

Teubner, Ernst, ed. *Hugo Ball (1886–1927): Leben und Werke* [exh. cat., Wasgauhalle Pirmasens], Pirmasens, 1986.

PARIS

André Breton

born 1896 Tinchebray, France
died 1966 Paris

Born into a family of modest means, André Robert Breton grew up in the industrial Parisian suburbs, where his father was the assistant manager of a glassworks. He showed an early love for poetry, especially for the romantic writings of Charles Baudelaire and the symbolist poems of Stéphane Mallarmé. After completing his secondary studies, and under pressure from his parents to choose a career, he decided to pursue medicine, enrolling in a year-long premedical program in Paris.

André Breton in military uniform, 1916. Private collection

Breton's friendship with the poet Paul Valéry contributed to the development of his literary ambitions, and his blossoming interest in painting distracted him from his scientific studies. On his second try, he managed to pass the qualifying exam and entered medical school in October 1914, under the shadow of World War I.

Breton received his summons in February 1915. He was assigned to an artillery regiment and sent to Brittany for basic training, after which, on the basis of his medical background, he was posted as a nurse in Nantes, southwest of Paris. In February 1916, at the hospital, he met Jacques Vaché, a wounded soldier whose personal charisma and irreverent attitude toward art, literature, and society made him a fascinating companion and later, a source of surrealism's mythic beginnings. In 1916 Breton requested a transfer to the neuropsychiatric center at Saint-Dizier, where France sent its victims of shell shock and other mental disorders associated with the war. Although Breton considered becoming a psychoanalyst, it was the strange and unexpected poetry he encountered in the soldiers' stories that most affected him. After four weeks at the front, he was reassigned to a military hospital in Paris, where he again came into contact with the literary avant-garde. Through his friendship with the poet Guillaume Apollinaire, Breton met Philippe Soupault. Together with Louis Aragon, also a student at the military hospital, Breton and Soupault founded *Littérature* in 1919. In early 1919 Breton came across *Dada 3*, published by Tristan Tzara, and they began a correspondence based on Breton's admiration for Tzara's radical position announced in his "Manifeste Dada 1918."

Between 1920, when his statement *Pour Dada* (For Dada) was published in *Nouvelle revue française*, and 1922, when his *Après Dada* (After Dada) appeared, Breton participated in and helped organize Dada events in Paris. He was instrumental in bringing Tzara from Zurich, who appeared unexpectedly at a poetry reading held by Breton's journal *Littérature* in January 1920. The first event coordinated by Breton was the Dada outing to Saint Julien le Pauvre in April 1921, where he hoped that the outdoor encounter between the dadaists and their audience would turn the city itself into the site of Dada theatricality. By bringing Dada into the streets, he wanted to avoid an aesthetic position of hermetic noninvolvement; as he stated in "Les enfers artificiels" (Artificial Hells), an account of Dada events prepared in 1921 for the bibliophile Jacques Doucet, the "intrusion of poetic order on moral order in our time was a foregone conclusion." Breton, unlike either Tzara or Francis Picabia, wanted to use Dada strategies to articulate a moral and ethical position that would supersede avant-gardist shock tactics.

When in May 1921 he organized a mock trial of Maurice Barrès, a once radical writer, who with the advent of World War I had become one of France's most outspoken nationalists, it was to address the ethical problem of Barrès' betrayal, but also to confront the larger question of the social responsibility of art. However, the trial proceedings revealed the other dadaists' rejection of Breton's hopes for Dada, Tzara declaring "I have no confidence in justice, even if this justice is made by dada." The trial was a failure, its pretensions to moral superiority roundly scorned.

Apparently, Breton continued to be troubled by this question, and in 1922 attempted to convene the International Congress to Determine the Aims and Defense of the Modern Spirit, or Congress of Paris, which was to meet and examine recent trends in art and literature in order to help "stem the current confusion." Breton invited both Picabia and Tzara to participate, but after Tzara's negative reply, and fearing his disruptive interference, Breton wrote a public statement condemning the "promoter of a 'movement' that comes from Zurich." Breton was humiliated when Tzara's rebuttal accused him of xenophobia, a position then rampant in the right-wing French press.

Shortly after this failure, Breton published *Après Dada*, which definitively ended his association with Dada. He would later become famous as the leader of the surrealist movement in France, publishing his *Manifeste du surréalisme* (Manifesto of Surrealism) in 1924. In 1925 he organized the first exhibition of surrealist painting. Breton joined the Communist Party in 1927 and until 1935 remained committed to Marxism. After Nazi Germany occupied France, Breton waited out the war in New York, returning to Paris in 1946, where he died twenty years later. ALH

SOURCES

Breton, André. *Oeuvres complètes*, ed. Marguerite Bonnet, Philippe Bernier, Etienne-Alain Hubert, and José Pierre, vol. 1. Paris, 1988.
Polizzotti, Mark. *Revolution of the Mind. The Life of André Breton*. New York, 1995.
Witkovsky, Matthew S. "Dada Breton," *October 105* (Summer 2003): 125–136.

NEW YORK

John Covert

born 1882 Pittsburgh, USA
died 1960 Pittsburgh

John Covert was born and raised in Pittsburgh, Pennsylvania, by his father, a pharmacist who owned a drugstore. Reportedly shy and secretive throughout his life, he studied mathematics in high school and would later develop a deep interest in cryptography. Between 1901 and 1907, he studied art with Martin Leisser, a realist painter who had received his training in the 1870s at art academies in Munich and Paris. In 1909 Covert followed the path taken by his

teacher and enrolled at the Academy of Fine Arts in Munich. His traditional academic training in Munich, which emphasized drawing from the figure, provided him with a foundation in painting derived from late-nineteenth-century German models that he continued to draw upon in his later work. He was also introduced to German modern art. Although he lived in Paris between 1912 and 1914, he later claimed not to have encountered French modern art, remarking that he "must have lived in armor."

When World War I broke out in August 1914, Covert sailed back to the United States, but not before experiencing firsthand the French mobilization for war. His article, "The Real Smell of War: A Personal Narrative," published in an American magazine in 1914, reports on the atmosphere in Paris of anti-

John Covert, c. 1920–1923. Collection of Anne M. and Charles S. Arensberg, Louisville, KY

German sentiment as searchlights swept over the city. Since Covert spoke French with a German accent, he once found himself threatened on the street. Upon his return to the United States, he settled in New York, where his cousin, Walter Arensberg, a poet and collector of African and modern art, was at the center of a circle of artists, writers, and intellectuals that included Marcel Duchamp, Francis Picabia, and Man Ray. He was a regular at the evening gatherings at Arensberg's apartment, becoming friends with Duchamp in particular.

Covert took an administrative role in the founding and operating of New York's first avant-garde art organizations: the Society of Independent Artists, founded to sponsor unjuried exhibitions of modern art; and the Société Anonyme, founded by Katherine Dreier to exhibit and collect the work of modern artists. During this period, Covert's artistic work included photographic studies of nudes, romantic and symbolic paintings of nudes, and abstract paintings that have since been regarded as his most important contributions to Dada and to modern art in America. In 1919 he made a group of works combining painting with found materials like string, cork, upholstery tacks, and wooden slats. Although partly influenced by the machine forms and sexual content of works by Duchamp, Covert incorporated his own fascination with mathematics

and cryptography into his painting in the form of disguised imagery and coded language.

During his time in New York from 1914 to 1923, Covert was also involved in various activities not directly related to his painting. As a paid researcher, he assisted Arensberg with a study of associative puns and cryptography in the work of the Italian poet Dante Alighieri. In 1918 he was employed by the Division of Films of the Committee on Public Information, a censorship and propaganda organization established by President Woodrow Wilson for the control of information during World War I. For his contribution, he received a certificate of patriotic service.

In 1921 the Arensbergs moved to Hollywood and Duchamp returned to Paris. Although Covert attempted to court wealthy patrons to support his art, he was unsuccessful. He closed his studio in 1923 and took a job as the New York agent for his cousin's Vetruvius Crucible Company, which manufactured large vessels for heating metals at high temperatures. The daybooks he kept to record his sales and expenditures include small paintings and drawings, and many notes are entered in complicated codes. Those kept during the 1940s also note his sober and inebriated days, evidence of his long battle, begun in the 1930s, with alcoholism. Covert retired from his cousin's company in 1951 and died ten years later of cancer. ALH

SOURCES
Klein, Michael. *John Covert, 1882–1960.* Washington, DC., 1976.
Mazow, Leo G., ed. *John Covert Rediscovered* [exh. cat., Palmer Museum of Art], University Park, Pa., 2003.
Naumann, Francis M. *Making Mischief: Dada Invades New York* [exh. cat., Whitney Museum of American Art], New York, 1996.

NEW YORK
PARIS
Jean Crotti

born 1878 Bulle, Switzerland
died 1958 Paris

Jean Joseph Crotti was born in Bulle, a small village outside of Fribourg in French-speaking Switzerland. He grew up in the countryside until his father moved the family to Fribourg where he started a house-painting business. Crotti was expected to work in this business after his father decided to support only his older brother André's higher education. Despite his father's wishes, Crotti studied at the School for Decorative Arts in Munich in 1896 and in 1900 was apprenticed to a theater set designer. In 1901, possibly financed by André who had become a doctor, Crotti attended the Académie Julian in Paris. Until 1912, when he began working in a cubist style, Crotti's painting showed the influences of primitivism and fauvism.

In 1915, seeking a place to live and work away from the disheartening situation in Paris

caused by World War I, Crotti and his wife Yvonne Chastel traveled to the United States, first visiting Crotti's brother in Ohio and then settling in New York. There, Crotti frequented the evening gatherings of artists and intellectuals at the apartment of Walter and Louise Arensberg, collectors of modern art and the center of New York's avant-garde. He became friends with Francis Picabia and shared a studio throughout fall/winter 1915–16 with Marcel Duchamp, who was then beginning to work on *The Large Glass.* Crotti later described his aesthetic and personal transformation in New York as a moment of dadaist asexual reproduction, triumphantly declaring: "1915 Birth of Jean Crotti 2 by auto-procreation and self-delivery and without umbilical cord."

At the Montross Gallery in 1916, three of Crotti's constructions, made of painted glass, metal, and found objects, were exhibited in a group show with the works of Duchamp, Albert Gleizes, and Jean Metzinger. The show caused considerable controversy among art critics, much of it directed at Crotti's *Portrait sur mesure de Marcel Duchamp* (Portrait of Marcel Duchamp Made to Fit), which though attacked as making fun of the public, was praised for its likeness to its subject. Emphasizing Duchamp's intelligent vision, Crotti's metal and wire construction featured prominent glass eyeballs staring out from beneath a sculpted brow.

By September, Crotti was back in Paris, carrying news and greetings to the Duchamp family from their son in New York. Soon after, Crotti fell in love with Duchamp's sister Suzanne, whom he married in 1919. (In the meantime, Duchamp had begun an affair with Crotti's ex-wife Yvonne.) In January 1920 Crotti and Suzanne, along with Picabia and Georges Ribemont-Dessaignes, submitted their work to the first postwar Salon des indépendants, using this major cultural event to inject Dada into Paris.

While Crotti and Suzanne Duchamp were quietly associated with Dada throughout 1920, their central Dada contribution, an April 1921 joint exhibition at the Galerie Montaigne, was also the first indication of their gradual separation from the group. André Salmon, a poet-critic and antidadaist who wrote the catalogue essay accompanying the exhibition, described his friend Crotti as an artist devoted to tradition and to the restoration of a religious art. The April exhibition also included the first public use of the word TABU, which, inspired by Crotti's mystical experience in Vienna earlier that year, would later become the name for his "new religion." By July, he had formalized his ambivalent break with Dada, calling himself "TABU-DADA or DADA-TABU."

Crotti's first major work of TABU, *Mystère acatène* (Chainless Mystery), was exhibited at the Salon d'automne in November 1921, where he also distributed handbills advertising the

Jean Crotti, 1924, Archives of American Art, Smithsonian Institution

new movement. In his article, "TABU," published by the *Little Review* in the spring of 1922, Crotti stated that "TABU is a philosophical religion.... We wish through forms, through colors, through it matters not what means, to express the mystery, the divinity of the universe, including all mysteries."

Crotti continued to paint into his later years and in the 1950s returned to motifs of overlapping circles and trajectories reminiscent of his TABU works of 1921–22. Still preoccupied with breaking "the thread that binds us to matter," Crotti called these new works "cosmic" painting. He and his older brother André died on the same day in 1958. ALH

SOURCES
Camfield, William, and Jean-Hubert Martin. *TABU DADA: Jean Crotti & Suzanne Duchamp 1915–1922* [exh. cat., Musée national d'art moderne, Centre Georges Pompidou], Paris, 1983.

PARIS
Céline Arnauld

born 1893 Nice, France
died 1952 Paris

Paul Dermée

born 1886 Liège, Belgium
died 1951 Paris

Paul Dermée and his wife Céline Arnauld, both active in the Parisian literary avant-garde as writers, poets, and publishers, were frequent contributors to the dadaist journals *Littérature, 391, Cannibale,* and *Proverbe.* They also produced two short-lived journals of their own: in the spring of 1920, Dermée brought out the journal *Z,* and Arnauld directed the sole issue of her periodical *Projecteur.* Dermée, whose real name was Janssen, was born in Belgium, where he did

Céline Arnauld, c. 1920. Both photos from *Dada* no. 7 (March 1920) Paul Dermée, c. 1920.

his university work in science at the Faculté des mines. In 1910 he left Liège for Paris, where he became active in the literary avantgarde as a poet, writer, playwright, editor, and publisher. Before Dermée's participation in Dada, his most important affiliation among the Parisian avant-garde was Guillaume Apollinaire. In May 1917 Apollinaire wrote an accompanying text to the original production of *Parade* calling for a "new spirit" in the arts in France, which was followed that fall by a lecture on "L'esprit nouveau et les poètes," which called for art to reclaim the classical qualities of the French spirit. Dermée echoed this sentiment in the pages of *Nord-Sud*, taking the decidedly nondadaist point of view that after a period of upheaval, the necessary return to science and classicism should not be perceived as a rejection of avant-garde principles but as a stage in the continual progression of history.

Although Tristan Tzara corresponded with Dermée in 1918, planning to make him the proconsul of Dada in Paris, he might have been persuaded against Dermée by André Breton, who reportedly disliked Dermée's opportunistic avant-gardism. In March 1920 Dermée edited the first and only issue of *Z*, a Dada periodical that included writings by Tzara, Francis Picabia, Breton, Louis Aragon, and Philippe Soupault. Dermée's contribution to *Z* consisted of a manifesto, "Qu'est-ce que Dada!" (What is dada!), and a series of foreign news reports in the form of "Radios" (Transmissions). In addition to insults attacking members of the French literary establishment such as the author André Gide and the art critic Louis Vauxcelles, the Transmissions make mocking reference to Henri Lenormand, a dramatist and dedicated Freudian who had published an article on Dada and psychology in March 1920, in which he argued that the "dada phenomenon" could be explained through recourse to concepts such as infant regression. Dermée's manifesto, signed "Dadaist cartésien" (Cartesian Dadaist), indicates that he understood Dada as a powerful but temporary nihilistic force aimed at creating a tabula rasa in preparation for future developments.

Through his contributions to Dada journals and his participation in events like the trial of Maurice Barrès, Dermée remained a peripheral but active figure in Paris Dada, as did Céline Arnauld, whose journal *Projecteur* appeared for one issue in May 1920 after the collapse of *Z*. Arnauld's prospectus for *Projecteur*, on the front page of the first issue, described the journal as "a lantern for the blind" that "doesn't give two hoots for anything—money, fame, publicity." Contributors Dermée, Picabia, Tzara, Aragon, and Georges Ribemont-Dessaignes provided the typical

Dada fare. Dermée and Arnauld continued to publish books of poetry and plays into the 1930s. After Dermée died in late 1951, Arnauld committed suicide. ALH

SOURCES
Dermée, Paul. *Z1 with Notes*, ed. Elmer Peterson. Colorado Springs, Colo., 1972.
Huelsenbeck, Richard. *The Dada Almanac*. New York, 1966 (originally published as *Dada Almanach*. Berlin, 1920).
Peterson, Elmer, ed. *Paris Dada: The Barbarians Storm the Gates* (vol. VI of *Crisis and the Arts. The History of Dada*, Stephen C. Foster, general editor). New York, 2001.
Sanouillet, Michel. *Dada à Paris*. 2 vols. Paris, 1993.

BERLIN
Otto Dix

born 1891 Gera, Germany
died 1969 Singen, Germany

Otto Dix was born on 2 December 1891 in a working-class family in Untermhaus, a village near Gera, Thuringia. He was the oldest child of Franz Dix, who worked as a molder in a foundry, and his wife Louise, née Amann. From 1905 to 1908 he received training as a decorative painter in Gera. In the fall of 1909 Dix moved to Dresden, where he enrolled in the School of Applied Arts in January 1910. At school Dix concentrated on decorative work, learning to draw ornamental designs and flowers characteristic of the art nouveau aesthetic that dominated at the time. Since Dix received no formal training in easel painting at the practically oriented arts and crafts school, he studied the old masters in the Dresden state collections.

In 1911 at the age of twenty, Dix encountered the ideas of Friedrich Nietzsche, which would influence his art significantly. Nietzsche urged no less than the collapse of the bourgeois moral code, promoting instead a Dionysian affirmation of life and an exaltation of both joy and pain. Nietzsche advocated the cultivation of intense bodily experiences in order to achieve a nontranscendent self-realization, the most powerful of which, according to the philosopher, were music, singing, dancing, sex, birth, hatred, fighting, and war. Dix's enthusiasm for Nietzsche's ideas inspired his only known sculpture, a life-size plaster bust of the thinker. Acquired by Paul Ferdinand Schmidt for the Dresden City Art Collection in 1923, the bust was Dix's first work to be sold and remained in the collection until confiscated by the Nazis in 1937.

Like many of his contemporaries who were intoxicated with Nietzschean ideals, Dix responded to the outbreak of war with excitement, believing that it would purge the country of its staid, Wilhelminian bourgeois plutocracy, and Germany would emerge a stronger, more vital nation. He enrolled voluntarily in 1914 and was assigned to a field artillery regiment in Dresden. Early in 1915

he was moved to the nearby town of Bautzen to train as a heavy machine gunner. In the autumn of 1915 Dix was sent to the Western Front in northern France where he took part in the autumn campaign in Champagne, followed by several battles in the Somme in 1916. In late 1917 Dix was in Russia on the Eastern Front, and by February 1918 he had returned to France for several major battles. When the war ended, Dix was in Silesia training to be a pilot. He was wounded several times, once almost fatally. Dix achieved the rank of vice-sergeant-major and was awarded the Iron Cross (second class), the Friedrich-August medal, and the Saxon Service medal with swords. Significantly, Dix continued to draw and paint in the trenches.

Dix returned to Dresden in 1919 and enrolled at the Dresden Art Academy, thus fulfilling his ambition to be a painter. He was a master pupil with Max Feldbauer and Otto Gussmann. In 1920 Dix met George Grosz, who, along with John Heartfield, invited him to participate in the First International Dada Fair. Dix's contributions to the show were *Kriegskrüppel (45% erwerbsfähig!)* (War Cripples [45% Fit for Service]) and *Der Fleischerladen* (Butcher's Shop), gruesome

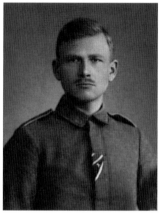

Otto Dix, 1917. From Ulrike Rüdiger, ed., *Otto Dix* (Gera, 1977)

evocations of postwar psychology on the themes of inhumanity, violence, and destitution. Dada sharpened Dix's developing brand of realism, in that it ridiculed falsity and indulged in the low, the caricatural, and the representation of human baseness. Dix's unflinching depictions during the Dada period often combined oil painting and collage, blending the privileged medium of fine-art painting with base everyday materials in a gritty social commentary.

After his involvement with Dada, Dix enjoyed a successful career as a painter, teaching at the Dresden Art Academy from 1927 until 1933, when he was dismissed by the Nazis. He retreated to a country estate near Lake Constance and focused on landscape painting. Otto Dix died on 25 July 1969 in Singen, Germany. STK

SOURCES
Nationalgalerie. *Otto Dix*. Berlin, 1992.
Otto Dix [exh. cat., Tate Gallery], London, 1992.
Schubert, Dietrich. *Otto Dix*. Hamburg, 1980.

Theo van Doesburg

born 1883 Utrecht, The Netherlands
died 1931 Davos, Switzerland

Van Doesburg's given name was Christian Emil Marie Küpper, but from early childhood he called himself Theo van Doesburg after his stepfather, whom his mother married when he was nine years old. As a youth he studied drawing and briefly aspired to becoming an actor. In 1902 he began writing stories and poems, teaching drawing classes, and copying old master paintings in the Rijksmuseum to earn money. He had early success as a caricaturist; in 1910, inspired by the nineteenth-century French cultural satirist Honoré Daumier, he published a portfolio of twenty drawings under the title, "Off with the Masks!"

Van Doesburg had served in 1903 in an infantry regiment stationed in Amsterdam. When World War I broke out, he was called to serve in the town of Tilburg on the Belgian border. Because the Dutch army was mobilized but not fighting in the war, Van Doesburg spent most of his time drawing the peasants, workers, and soldiers in the town, and writing about war and its social implications. His article, "Meditations at the Frontier," was published in 1915. During this period he also delivered his first lectures on modern art, which already show evidence of his later fully theorized belief that art could lead humanity to a higher spiritual realm in which political and economic conflict would be dissolved.

During 1916 and 1917, Van Doesburg formulated a theory of art in which the cooperation between architecture and the arts would create a new universal and transcendental style based on simplified geometric elements. He founded the magazine *De Stijl* as the organ

Theo van Doesburg, 1920. Theo van Doesburg Archive, The Netherlands Institute for Art History, The Hague

for this view, and in 1918, with Piet Mondrian and others, founded an artists' group under the same name. Over the next several years, Van Doesburg worked ambitiously to publicize De Stijl beyond the Netherlands, attempting to transform it into an international movement.

Dada first appeared in *De Stijl* in December 1919, when Van Doesburg made reference to his receipt of Dada materials from Tristan Tzara, and in February he published a quote from Tzara's "Manifeste Dada 1918." Also that month, Van Doesburg went to Paris, where he and Mondrian attended Dada soirées and viewed an exhibition of the works of members of the Paris Dada group, Jean Crotti, Suzanne Duchamp, Francis Picabia, and Georges Ribemont-Dessaignes. Throughout 1920, Van Doesburg contacted Dada groups in Berlin and Paris and received materials from Richard Huelsenbeck and Picabia, which he used as the basis for an article introducing Dada ideas to the Netherlands that appeared in *De Nieuwe Amsterdammer* (The New Amsterdamer) in May 1920.

Van Doesburg understood Dada as a destructive, but healthy clearing away of the old order, referring to dadaists as "destructive constructivists." In mid-1920 he adopted a pseudonym, I. K. Bonset, under which he contributed Dada poems and collages to *De Stijl*, the first of which appeared in May. In 1922 he founded a Dada magazine called *Mécano, an International Periodical for Spiritual Hygiene, Mechanized Aesthetics, and Neo-Dadaism,* in which Van Doesburg appeared as the arts editor and Bonset as the literary editor. Van Doesburg described Bonset as "the whole-hearted Dadaist," employing his alter ego's Dada activities as a strategic weapon against conservative Dutch culture and enemies of De Stijl. Bonset's subversion of culture took place through the development of a new poetics in which typographical arrangement and "phono-gymnastics" attempted to create an elemental language.

In 1923 Van Doesburg embarked with Kurt Schwitters on a Dada tour of Holland. The plans for the tour grew out of successful *Mécano* soirées held in Weimar during the International Congress of Constructivists and Dada, and further evenings in Jena and in Hannover, where Schwitters was the host. The Dada tour in Holland visited about a dozen towns. Intended to introduce Dada to interested members of the Dutch public, it was thus organized in cooperation with local artists' organizations. Van Doesburg's pamphlet "Wat is Dada?" which surveyed and summarized dadaist programmatics from Huelsenbeck to Picabia, was for sale after each performance. The performances themselves began with a lecture by Van Doesburg, "Introduction in Dadasophy," which was followed by Schwitters' declamation of sound poems and short fiction, each reading

being subject to interruption by shouting and barking from the other performers.

After the 1923 Dada campaign, the dadaist impulse quickly faded in the Netherlands, which had never received it enthusiastically. Van Doesburg continued to publish *De Stijl*, and his ideas were widely debated in France after a 1923 exhibition of architectural work by the group, which was accompanied by a manifesto explaining De Stijl's social and spiritual aims. As a result, Van Doesburg received new commissions for architectural interiors and exteriors. In 1931, the year of his death, he brought out a new periodical, *Art concret*, devoted to the search for universal form. He was memorialized in the final issue of *De Stijl*, which appeared in 1932. ALH

SOURCES

Berg, Hubert F. van den. *The Import of Nothing: How Dada Came, Saw, and Vanished in the Low Countries (1915–1929)* (vol. VII of Crisis and the Arts. The History of Dada, Stephen C. Foster, general editor). New York, 2002.

Birnie-Danzker, Jo-Anne, ed. *Theo van Doesburg. Maler-Architekt.* New York, 2000.

Hedrick, Hannah L. *Theo Van Doesburg. Propagandist and Practitioner of the Avant-Garde, 1909–1923.* Ann Arbor, Mich., 1973.

Marcel Duchamp

born 1887 Blainville, France
died 1968 Neuilly, France

Born into a family of artists, Duchamp made his first paintings at age fifteen, and upon the completion of his high school education joined his two older brothers, Jacques Villon and Raymond Duchamp-Villon, in Paris, where in 1904 he enrolled at the Académie Julian. He finished there in 1905 and spent a year in the army working in a print shop in order to avoid the general conscription laws then pending. When he returned to Paris, he found work as an illustrator and cartoonist for popular satirical journals. In 1909 Duchamp began exhibiting paintings that showed the influence of Paul Cézanne and the fauves. At the Sunday gatherings he attended in Puteaux, a Parisian suburb where his brothers had their house and studio, he participated in discussions about philosophy, music, literature, photography, and non-Euclidean geometry. In art, members of what became known as the Puteaux group embraced cubism, which found its most doctrinaire proponents in Albert Gleizes and Jean Metzinger, who in 1912 requested that Duchamp remove his painting, *Nu descendant un escalier* (Nude Descending a Staircase no. 2), from the Salon des indépendants on the grounds that its kineticism was not cubist.

In 1913 *Nude Descending a Staircase no. 2* was exhibited in New York at the Armory Show, where it and the three other canvases Duchamp submitted were sold to American collectors. Between 1913 and 1915, Duchamp adopted a

consciously scientific attitude to art-making, compiling notes for a project that would become *La Mariée mise à nu par ses célibataires, même* (The Bride Stripped Bare by Her Bachelors, Even) [or *The Large Glass*] (1915–1923) and experimenting with methods of measurement and mechanical drawing. Although Duchamp was exempt from military service due to a minor heart defect, the atmosphere in Paris, where he worked as a librarian during the early years of the war, was increasingly hostile and reactionary. As he explained in a letter to his supporter Walter Pach, the art dealer and organizer of the Armory Show, "I do not go to New York, I leave Paris."

When Duchamp arrived in June 1915, Pach arranged for him to stay at the home of Walter and Louise Arensberg, collectors and patrons of modern art, who introduced him to New York's avant-garde. He soon became the center of the circle that gathered at the Arensbergs' apartment in the evenings, where he was often to be found playing chess with Arensberg or Francis Picabia. From 1915 to 1923, with the exception of brief visits to Buenos Aires and Paris, Duchamp made New York his home. His

Marcel Duchamp, 1917. Photograph by Edward Steichen. Philadelphia Museum of Art, The Louise and Walter Arensberg Collection, 1950

activities during his years in the United States directly influenced the conception of artistic practice elaborated as New York Dada. In particular, he provided key theorizations of strategies like the use of mechanical drawing, the deployment of found objects, and the assumption of alternate identities.

Construction of Duchamp's major project, *The Large Glass*, began in New York. The thematization of sexual relationships as mechanical processes that he had begun to investigate as early as 1912 in paintings like *La Mariée* (The Bride), here reached a new and radical synthesis. Painted on glass and including industrially produced wires, *The Large Glass* represents a mechanical diagram of sexual intercourse, the functioning of which was elaborately, though enigmatically, explained by Duchamp in notes related to the project.

Sometime during the fall of 1915 Duchamp developed the idea of the readymade, an industrially produced object that becomes a work of art through the choice or assistance of the artist. His first New York readymade was a snow shovel bought at a hardware store on Columbus Avenue to which he added an inscription: "In Advance of the Broken Arm [after] Marcel Duchamp." The action designating a readymade could also take place at a distance, as demonstrated by Duchamp's January 1916 letter to his sister Suzanne asking her to complete *Porte-bouteilles* (Bottlerack), which he had purchased as a "sculpture already made" and left in his apartment in Paris. *Fountain*, the most notorious example of Duchamp's readymades, was submitted to the first exhibition of the Society of Independent Artists, an organization Duchamp helped to found, under the pseudonym R. Mutt. Despite the stated program of the group to exhibit anything submitted by artists who had paid the fee, *Fountain* was rejected, resulting in a scandal that was only heightened when it was revealed who had authored the work.

Duchamp created his female alter ego Rose Sélavy in the fall of 1920, and for the next twenty years, he signed his work with this pseudonym. As a persona, Rose Sélavy was consistently identified with commercial methods of signifying authorship such as the copyright and the trademark. *Fresh Widow*, the first work copyrighted by Rose Sélavy in 1920, was built by a carpenter for Duchamp and is a reproduction of a set of French doors. By replacing the window panes with black patent leather and titling the work "fresh widow" (a pun on "French window"), Duchamp alluded to the mass casualties of World War I.

On Duchamp's visits to Paris throughout these years, he created works that would become emblematic of Dada's sensibilities, including *L.H.O.O.Q.* and *50 cc Air de Paris* (50 cc of Paris Air). He also contributed to the formation of Dada identity when in 1921, he and Man Ray collaborated on the only issue of *New York Dada*. Including a mock statement of authorization sent by Tristan Tzara from Paris, the issue was the only official Dada publication to appear in the United States.

Between 1923 and 1942, Duchamp lived in Paris, where he continued investigations into optics begun in 1918 with the creation in 1925 of *Rotative Demisphère* (Rotary Demisphere) and in 1935 of the *Rotoreliefs*, both of which experimented with the visual tricks produced by forms in motion. Duchamp designed the Rotoreliefs to be played on an ordinary record player and attempted to sell them at the annual inventors' fair in Paris, a largely unsuccessful venture. He also pursued his passion for chess, participating in tournaments in the United States and Europe and publishing a guide to endgame situations

cowritten with the German chess master Vitaly Halberstadt.

When the Germans occupied Paris in 1942, Duchamp left again for New York, where he renewed contact with the avant-garde and its patrons. Beginning in 1942, he began making notes for the last major project of his life, *Étant donnés*, a three-dimensional tableau in which his lifelong preoccupation with the relationship between viewing and sexuality gained a direct and unambiguous representation. Duchamp died in 1968. ALH

SOURCES

Gibson, Michael. *Duchamp Dada.* Paris, 1991.
Marcel Duchamp [exh. cat., Palazzo Grassi], Milan, 1993.
Naumann, Francis M. *Making Mischief: Dada Invades New York* [exh. cat., Whitney Museum of American Art], New York, 1996.
Naumann, Francis M. *New York Dada 1915–1923.* New York, 1994.
Schwarz, Arturo. *The Complete Works of Marcel Duchamp.* 2 vols. New York, 1997.

PARIS

Suzanne Duchamp

born 1889 Blainville, France
died 1963 Neuilly, France

Suzanne Duchamp, the fourth of the Duchamp children, was nearest in age and temperament to her brother Marcel, and they remained close throughout their adult lives. In 1905 she began studying painting at the Ecole des Beaux-Arts in Rouen, becoming familiar with avant-garde art through a local modern painting organization and her brothers, three of whom were studying art in Paris. She married a local pharmacist in 1911 but was divorced after only two years.

Shortly after World War I broke out, Suzanne went to Paris, where she served as a nurse's aid, continuing in this position even after the end of the war. Marcel was in Paris until he left for New York in 1915, and he and Suzanne saw each other frequently, as can be ascertained by his sketches done in the hospital

Suzanne Duchamp, c. 1924. Photograph by Man Ray. The Museum of Fine Arts, Houston, Gift of William and Virginia Camfield

where she worked. However, no work by Suzanne survives from this period, indicating that she may have stopped painting for about two years, until 1916, when Jean Crotti, a painter and friend of Marcel's, returned to Paris, bearing news of Marcel and of the exciting art being made in New York. Suzanne's pictorial response to Crotti's descriptions was *Un et une menacés* (He and She Threatened), a picture that represents, as do many of Marcel's works at this moment, a machine allegory of the relationship between the sexes. Suzanne's interpretation of this new vocabulary included incorporating into the work actual machine parts such as a clock gear and a plumb bob.

Between 1916 and 1919, Suzanne developed her work further in two key paintings: *Radiation de deux seuls eloignés* (The Radiation of Two Solitary Beings Apart) and *Multiplication brisée et rétablie* (Broken and Restored Multiplication). However, her most productive period of artistic activity began about 1919, when she and Crotti were married. As a wedding present, Marcel sent them instructions for *Readymade malheureux* (Unhappy Readymade), which involved suspending a geometry textbook on the porch and letting the wind and rain gradually tear it apart.

In 1920 Suzanne showed several of her works at the Salon des indépendants, along with Francis Picabia and Crotti. In 1921 she and Crotti, who had maintained a certain distance from Dada events, mounted a two-person show of their work at the Galerie Montaigne. Suzanne's *Ariette d'oubli de la chapelle étourdie* (Arietta of Oblivion in the Thoughtless Chapel), which combines enigmatic painted symbols with a wooden silhouette of Crotti and a glass eye, typifies her particular combination of obscure symbolism and diagrammatic clarity. While the works at this show represented a survey of Suzanne's and Crotti's Dada work, the catalogue to the exhibition also featured a modified title, "TABU Dada," that pointed the way to a new stage in their production.

Crotti took the lead in moving away from Dada and toward a more spiritual investigation of cosmic forms. By 1922 Suzanne had begun making figurative paintings in a naïve style resembling the work of Raoul Dufy or the Douanier Rousseau. Although in later years Crotti received more attention, Suzanne continued to exhibit her work, which appeared in 1956 in a one-woman show in Paris. She died in 1963. ALH

SOURCES

Camfield, William A. "Suzanne Duchamp and Dada in Paris." In *Women in Dada: Essays on Sex, Gender, and Identity*, ed. Naomi Sawelson-Gorse, 82–102. Cambridge, Mass. 1998.

Camfield, William, and Jean-Hubert Martin. TABU DADA: *Jean Crotti & Suzanne Duchamp 1915–1922* [exh. cat., Musée national d'art moderne, Centre Georges Pompidou], Paris, 1983.

Paul Eluard

born 1895 Saint-Denis, France
died 1952 Charenton-le-Pont, France

Born Eugène-Émile-Paul Grindel, Eluard grew up in a lower-middle-class family, the son of a bookkeeper and seamstress. In 1912 he was hospitalized and treated for tuberculosis in a Swiss sanatorium, where he began writing poetry and fell in love with a young Russian woman known as Gala. They were married the following year, and Eluard's first book of poems was published that December. In the spring of 1914, apparently cured, Eluard returned to Paris. When World War I broke out, he was mobilized to an auxiliary unit. However, he spent the war years in and out of hospitals, serving just three months at the front at the beginning of 1917, before being sent back and hospitalized for severe bronchitis.

After the publication in 1918 of his collection *Poèmes pour la paix* (Poems for Peace), Eluard was introduced to Louis Aragon, André Breton, and Philippe Soupault, the editors of the review *Littérature*. Founded by Breton to support "new initiatives in literature and painting," *Littérature* quickly embraced Dada; the second issue, published April 1919, contained Tristan Tzara's Dada poem "Maison Flake," the first of his and other dadaists' many contributions to the review. Eluard's poems were first published there in May 1919, after which he collaborated with the others as an editor. In February 1920, Eluard founded and edited the first issue of *Proverbe*, one of several little magazines circulating as part of the Dada scene in Paris. Filled with short aphoristic and humorous texts by Eluard and other dadaists, *Proverbe* was dedicated to the debasement of language "in a grand fashion."

In 1921 Eluard began an intense artistic collaboration and personal relationship with the Cologne dadaist Max Ernst. Eluard's fascination with Ernst's work, first exhibited in Paris in May 1921, led him to seek Ernst's acquaintance, and in November, he and his wife Gala visited Ernst and his family in Cologne. During this tumultuous weeklong visit, Eluard and Ernst spontaneously collaborated on *Répétitions*, a volume of poetry previously planned by Eluard but which was now reconceived to juxtapose Eluard's poems with eleven of Ernst's collages. It was published the following March, and the Eluards hand-carried several copies to Cologne.

On this return visit, the previously evident sexual attraction between Gala Eluard and Max Ernst became an open affair. Eluard and Ernst began work on a second collaborative book project, *Les Malheurs des immortels* (The Misfortunes of the Immortals). Because Ernst could not obtain a visa from the British government in Cologne to travel to Paris, he and

Paul Eluard, 1922. Photograph by Man Ray. Collection Timothy Baum

Eluard communicated by mail until they could finish their work on vacation together in the Swiss Tyrol in the summer of 1922. In August, Ernst left his wife and illegally traveled to Paris to move into the Eluards' home in Eaubonne, where the affair with Gala became a full-fledged ménage à trois.

Throughout their relationship, Eluard was an important patron of Ernst's work, bringing significant examples of his paintings to Paris and providing him with space to live and work. On his visits to Ernst in Cologne he purchased *Célèbes* and *Oedipus Rex*, and in 1923, Ernst began work on a series of murals decorating the walls, some ceilings, and doorways of Eluard's house. In November, the Eluards held an open house for the *Littérature* group to view the murals.

In March 1924, apparently tormented by Ernst's dominance in their relationship, Eluard disappeared, leaving only a brief note addressed to his father: "I have had enough. I am going on a trip." When he eventually contacted Gala from Southeast Asia, she held an auction of artworks in the Eluard collection to finance her pursuit of him to Saigon. About a month later, Ernst sold some recently completed works and also traveled to Saigon. Eluard and Gala returned together in October. When Ernst came back a few weeks later, he took a separate residence in Paris, and the ménage à trois was over.

Eluard was a central member of the surrealist group from 1924 to 1938, but abandoned it when his political preoccupations took over. He became a member of the Communist Party and in World War II served in the French army and the communist resistance, during which he had constantly to evade the Gestapo. He died in 1952 of a heart condition. ALH

SOURCES

Camfield, William A. *Max Ernst: Dada and the Dawn of Surrealism* [exh. cat., The Menil Collection], Munich and Houston, 1993.

Eluard, Paul. *Oeuvres complètes*, vol. 1, ed. Marcelle Dumas and Lucien Scheler. Paris, 1968.

Pech, Jürgen, ed. *Max Ernst, Paul Eluard, 1921–1924* [exh. cat., Stadt Brühl, Max-Ernst-Kabinett], Brühl, 1982.

Sanouillet, Michel. *Dada à Paris*. 2 vols. Paris, 1993.

Max Ernst

born 1891 Brühl, Germany
died 1976 Paris

Max Ernst was born on 2 April 1891 in Brühl, six miles south of Cologne, to Phillip Joseph Ernst, a teacher at Brühl's Institute for the Deaf and Dumb, and Louise Ernst, née Kopp. The third of nine children and the oldest son to live beyond childhood, Ernst was raised in a well-to-do Catholic household. His father was an amateur painter who encouraged Ernst to paint. In 1910 Ernst enrolled at the University of Bonn, where he focused on courses in history of art, psychology, philosophy, philology, and literature. In the summer and fall of 1912 Ernst was actively engaged with the group of artists around the expressionist painter August Macke and began writing art criticism for the newspaper *Volksmund* in Bonn. A year later, Ernst exhibited his work for the first time with Macke's group Die Rheinischen Expressionisten (The Rhineland Expressionists) in Bonn and at the First German Autumn Salon at Herwarth Walden's Sturm Gallery in Berlin. His early works wrestled with the influence of cubism, futurism, and expressionism. During a visit to the exhibition of the German Association of Craftsmen in Cologne in 1914, Max Ernst met Hans Arp, an encounter that would develop into a meaningful artistic friendship.

Ernst enlisted in the Twenty-third Field Artillery Regiment in Koblenz on 24 August 1914. Serving on the Western Front near Laon and Soissons from July 1915 to March 1916, Ernst suffered minor head and hand injuries. In January 1916 over fifty of Ernst's works were displayed in a two-man exhibition, *Max Ernst: George Muche*, at Sturm Gallery in Berlin. Ernst was granted a military leave of absence and traveled to Berlin in early January 1916, where he met George Grosz and Wieland Herzfelde during his visit. In November 1916 Ernst was transferred to the Eastern Front, where he stayed until mid-May 1917, when he was moved to the Sixteenth Infantry Division in Belgium. Ernst was awarded the Iron Cross, first and second class, for his military service. He continued to publish articles on art during the war, including "On the Origins of Color," in *Der Sturm*, August 1917. On 17 October 1918, a month before the end of the war, Ernst married Luise Amelie Straus, an art historian. Herzfelde was among the guests.

After the war, Ernst elected to pursue art instead of his university education. He established contacts with emerging socialist and avant-garde art groups in 1918 and 1919 and joined the Society of Arts founded by Karl Nierendorf and connected to the group Der Strom (The Current). In the winter of 1919, Ernst collaborated with Johannes Baargeld on *Der Ventilator* (The Fan), a short-lived leftist

Max Ernst in uniform, c. 1914 – 1918. Album of Philipp Ernst, Private collection

journal disguised as an entertainment weekly that became an artistic and political outlet for avant-garde artists during the British occupation of Cologne.

In the summer of 1919, during a visit to Paul Klee's atelier in Munich, Max Ernst met Zurich Dada members Hugo Ball and Emmy Hennings and was exposed to Zurich Dada publications at Goltz's, a gallery and bookstore. Cologne Dada emerged shortly thereafter, its members including Ernst, Baargeld, Hans Arp, Angelika and Heinrich Hoerle, Willy Fick, Anton Räderscheidt, and Franz Seiwert. Ernst and Baargeld organized the exhibition of the "Bulletin D" group in 1919. The show and the accompanying catalogue constituted the first manifestation of Cologne Dada and caught the attention of artist and collector Katherine Dreier, who then brought news of Bulletin D to Paris. In April 1920, outraged at their exclusion from a jury-free museum exhibition, Baargeld and Ernst rented the courtyard of a pub, the Brauhaus Winter, and mounted their own show, the *Dada-Vorfrühling* (Dada Early Spring) exhibition. Ernst's son Ulrich (later called Jimmy) was born shortly thereafter, on 24 June 1920. In October 1920 Ernst and Arp collaborated on their first FaTaGaGa—short for FAbrikation de Tableaux GAsométriques Garantis (Fabrication of Guaranteed Gasometric Paintings).

In May 1921 the "Exposition Dada Max Ernst" opened at Au Sans Pareil, Paris, with a catalogue including a preface by André Breton, but Ernst was unable to get a passport and could not attend. In November 1921 the French poet Paul Eluard traveled to Cologne with his wife Gala to visit the Ernsts. Eluard not only bought Ernst's painting *Célèbes* but also chose eleven of Ernst's collages for his volume of poetry, *Répétitions*, published on 18 March 1922. Ernst and Eluard collaborated on another volume of poetry and collages, *Les Malheurs des immortels* (The Misfortunes of the Immortals), published in July 1922 by Librairie Six, Paris. In August 1922, with the ambition of establishing himself in Paris, Ernst left his wife and child and moved in with Paul and Gala Eluard in Paris, continuing the collaboration

and the ménage à trois begun earlier that year. Ernst subsequently became a major force in the surrealist movement. Max Ernst died on 1 April 1976 in Paris on the eve of his eighty-fifth birthday. STK

SOURCES

Camfield, William A. *Max Ernst: Dada and the Dawn of Surrealism* [exh. cat., The Menil Collection], Munich and Houston, 1993.
Russel, John. *Max Ernst: Life and Work.* New York, 1967.
Spies, Werner. *Max Ernst.* London, 1991.

Elsa von Freytag-Loringhoven

born 1874 Swinemünde, Germany
died 1927 Paris

The Baroness Elsa von Freytag-Loringhoven was born Elsa Hildegard Plötz. Raised by a sensitive, religious mother and an abusive father in a bourgeois home, she ran away at the age of eighteen to live with her aunt in Berlin. She worked as a chorus girl, studied acting and art, and took various lovers. After her second husband abandoned her in Kentucky, she found her way to New York, where in 1913 she married the German aristocrat Baron Leopold von Freytag-Loringhoven. The Baron was on an extended leave of absence from the German military. In 1914 he left the United States to return to Germany, and the ship he sailed on was captured by the French; he spent four

Elsa von Freytag-Loringhoven, c. 1920. University of Maryland Libraries

years in a French prison before he committed suicide. Although now a baroness, Elsa was left penniless.

Baroness Elsa became well-known in Greenwich Village for what she called her "fanciful artistic clothes." Wearing a coal scuttle or wastepaper basket for a hat, she ornamented her dresses with objects and materials she found on the street or stole from Woolworth's, including tin children's toys, gilded vegetables, tea balls, curtain rings, and an electric battery light rigged as a bustle. Destitute and sometimes homeless, she was arrested more than once for trying to bathe in public fountains and was notorious for her lewd sexual assaults, which she perpetrated on the

likes of the American writers William Carlos Williams and Wallace Stevens. Her pleasure posing nude allowed her to earn money as an artist's model at the Art Students League. In 1921 the American poet Hart Crane, responding to the publication *New York Dada*, wrote to a friend about the Baroness: "I like the way the discovery has been made that she has all along been, unconsciously, a Dadaist. I cannot figure out just what Dadaism is.... But if the Baroness is to be a keystone for it—then I think I can possibly know when it is coming and how to avoid it."

Among those claiming Baroness Elsa for Dada was the avant-garde literary and arts magazine *The Little Review*, which in 1920 asserted that "Paris has had Dada for five years, and we have had Elsa von Freytag-Loringhoven for quite two years. But great minds think alike...." Over the course of her stay in New York, Baroness Elsa made several objects that have come to be considered Dada works and was the star of a film Marcel Duchamp made in collaboration with Man Ray called *The Baroness Shaves Her Pubic Hair*.

Elsa had an almost obsessive penchant for Duchamp, of whom she wrote, "Marcel, Marcel, I love you like Hell, Marcel." Her portrait of him, which consisted of a wine glass stuffed full of trinkets and feathers, was photographed by Charles Sheeler, who also took a picture of the sculpture *God*. An assemblage made by attaching a plumbing trap to a block of wood, *God* was long assumed to be a collaborative work by Baroness Elsa and Morton Schamberg. However, given the austere and somber tone of Schamberg's extant works, it is now considered more likely that the idea for the sculpture originated with the Baroness, although she probably had help mounting it to its base. *Limbswish*, another sculpture attributed to the Baroness, was originally a body ornament constructed of a metal spring and a large curtain tassel outfitted to hang from her hip.

In 1923 Baroness Elsa borrowed money to return to Germany. There she lived in abject poverty, selling newspapers on the street and residing in a charity home. While suffering chronic anxiety attacks and thoughts of suicide, she stayed briefly at a mental clinic. She wrote constantly to her American friends, of whom her closest friend and supporter was the novelist Djuna Barnes. In the spring of 1926 Elsa was finally able to obtain a visa to move to Paris. She opened a modeling agency, but it was shut down by French immigration authorities. She died when the gas was left on overnight in her new apartment. ALH

SOURCES

The Art of Elsa von Freytag-Loringhoven [exh. cat., Francis M. Naumann Fine Art, LLC], New York, 2002.

Naumann, Francis M. *Making Mischief: Dada Invades New York*. New York, 1996.

George Grosz

born 1893 Berlin
died 1959 Berlin

George Grosz was born Georg Ehrenfried Gross on 26 July 1893 in Berlin to Karl Gross and Marie Wilhelmine Schulze. When Karl Gross' restaurant failed, the family moved to Stolp, a small provincial town in Pomerania, where he worked as a caretaker and steward of the Freemason's Lodge until his unexpected death in 1900. The widowed Mrs. Gross and the six-year-old Georg moved back to Berlin, trading their rural life in Stolp for the working-class district of Wedding, where Marie Gross earned a living by sewing shirts and renting rooms to lodgers. In 1902 they returned to

George Grosz, 1921. George-Grosz-Archiv, Stiftung Archiv der Akademie der Kunst

Stolp when Mrs. Gross took a job as manager in the officer's casino of the Prince Blücher Hussar's Regiment. As manager, Mrs. Gross lived on premises, which meant that Georg had close contact with German officers during his childhood.

In 1908 the fifteen-year-old Gross was charged with insubordination and expelled from school because of a dispute with a teacher. He began his artistic education shortly thereafter in 1909 at the Dresden Art Academy. Gross' first caricatures appeared in 1910 in *Ulk*, a supplement to the *Berliner Tageblatt*. He graduated with honors from the academy on 30 March 1911.

Gross continued his artistic education between 1912 and 1917 at a school attached to the Museum of Applied Arts in Berlin and studied with the Jugendstil designer Emil Orlik. From August to November 1913, he lived in Paris and took classes at the Atelier Colarossi, developing the skill of rapid sketching from models who changed their pose after five minutes. Such training proved to be invaluable for his art, and from that time forward he carried a small sketchbook in order to draw people and the busy street life of Berlin.

In November 1914 Gross enlisted in the military in Berlin, though he was released six months later for medical reasons. Gross met John Heartfield and Wieland Herzfelde in the

atelier of the expressionist painter Ludwig Meidner in 1915, a meeting that resulted in a long, productive friendship. In 1915 he also published a poem and an illustration in Franz Pfemfert's radical leftist journal *Die Aktion*.

In 1916 Georg Gross changed his name to George Grosz, thus anglicizing and slavicizing the spelling of his German name in an antinationalist protest. On 4 January 1917 Grosz was drafted into renewed military service. Just over a month later, however, he was transferred to a mental hospital in Görden and eventually discharged on 20 May 1917 as unfit for service. Thanks to the interventions of the diplomat and arts patron Count Harry Kessler, Grosz worked with Heartfield at the Military Educational Film Service (later called UFA) producing animated propaganda films.

In 1917 Herzfelde's publishing company Malik Verlag produced the *Erste George Grosz-Mappe* (First George Grosz Portfolio) and the *Kleine Grosz-Mappe* (Small Grosz Portfolio), two collections of socially critical lithographs. Grosz, Herzfelde, and Heartfield joined the German Communist Party at, or just after, the First Party Congress, 30 December 1918–1 January 1919. Grosz also joined the leftist artists' group Novembergruppe in the same year.

In addition to caustic caricatures, Grosz' work during the Dada period included the production of photomontages in collaboration with Heartfield as well as satirical journals, blending aesthetics and politics for a wider public. In 1919, for instance, Grosz cofounded the satirical magazine *Jedermann sein eigner Fussball* (Everyone His Own Soccer Ball) with Herzfelde, which was distributed by the authors on horse-drawn taxis preceded by a brass band. Authorities banned its further appearance. Undeterred, Grosz and Herzfelde began work on *Die Pleite* (Bankruptcy), another satirical paper, which was published until January 1920. Grosz' first one-man show was launched in Munich in April 1920, and a month later, he participated in the International Dada Fair and married Eva Peter. In April 1920 Grosz and Heartfield published an article called "Der Kunstlump" (Art Rogue) in *Der Gegner* (The Opponent), which provoked intense public debates about fine art and revolution. In June 1920, Malik Verlag published Grosz' portfolio of antimilitaristic drawings *Gott mit uns* (God with Us), for which Grosz and Herzfelde were later charged and fined for insulting the German army. This would be the first of three trials in the early 1920s against Grosz on the grounds of public offense.

After Dada, Grosz became increasingly involved in German Communist Party activities, serving in 1924 as the chairman of the Rote Gruppe (Red Group), Germany's Union of Communist Artists, and publishing regularly in the Communist Party satirical weekly *Der Knüppel* (The Cudgel). His enthusiasm for the

Party waned in the mid-1920s. With the advent of the Nazi regime, Grosz settled permanently with his family in the United States, where he taught at the Art Students League in New York and the School of Fine Art at Columbia University among others. George Grosz died on 6 July 1959, shortly after his return to Berlin. STK

SOURCES
Flavell, Mary Kay. *George Grosz*. New Haven, 1988.
Kranzfelder, Ivo. *George Grosz*. Cologne, 1993.
Schneede, Uwe. *George Grosz*. Stuttgart, 1975.
The *Twenties in Berlin: Johannes Baader, George Grosz, Raoul Hausmann, Hannah Höch* [exh. cat., Annely Juda Fine Art], London, 1978.

BERLIN
Raoul Hausmann

born 1886 Vienna, Austria
died 1971 Limoges, France

Raoul Hausmann was born on 12 July 1886, in Vienna, Austria, to Gabriele Hausmann, née Petke, and the Hungarian portrait and history painter Victor Hausmann. In 1900 at the age of fourteen, Hausmann moved with his family to Berlin, where he undertook his first artistic studies under the tutelage of his father. In 1905 Hausmann met Johannes Baader as well as his future wife, the violinist Elfriede Schaeffer. After the birth of their daughter Vera in 1907, Hausmann married Schaeffer in 1908. Between 1908 and 1911 Hausmann enrolled at Arthur Lew-Funcke's Atelier for Painting and Sculpture in Berlin-Charlottenburg, one of the many private art schools in the city, where he studied anatomy and nude drawing. He worked on his first typographical designs as well as glass window designs between 1909 and 1914 and assisted his father with the restoration of murals in the Hamburg city hall in 1914. In 1915 Raoul Hausmann began an extramarital affair with the artist Hannah Höch, forming an artistically productive yet turbulent bond that would last until 1922.

Hausmann's encounters with expressionist painting in 1912, which he saw in Herwarth Walden's avant-garde Sturm Gallery, proved pivotal for his artistic development. He produced his first expressionist lithographs and woodcuts in expressionist painter Ernst Heckel's atelier and published his first polemical texts against the art establishment in Walden's magazine, also named *Der Sturm*. Hausmann remained active in expressionist circles well into 1917, publishing two essays concerned with the relationship between artistic production, human subjectivity, and the spirit in Franz Pfemfert's *Die Aktion*, a journal known for its leftist, anti-militaristic stance.

As an Austrian-born citizen living in Germany, Hausmann was not drafted into military service and thus was spared the shattering war experiences that affected so many of his peers. Yet his initial attitude toward the war was characteristic of the expressionist generation in

Raoul Hausmann, September 1919. Photograph by Hannah Höch. Hannah-Höch-Archiv, Berlinische Galerie, Landesmuseum für Moderne Kunst, Photographie und Architektur

that he believed the devastation on the battlefields held promise of a vital future, destroying calcified Wilhelminian social structures and clearing the way for a new world. In 1916 Hausmann met the two men whose radicalism nourished this idea of a new beginning, namely the psychoanalyst Otto Gross, who considered psychoanalysis to be preparatory work for a revolution, and the anarchist expressionist writer Franz Jung, who was a disciple of Gross and avid reader of Walt Whitman. Inspired by the work of Gross and Jung, as well as the writings of Whitman and Friedrich Nietzsche, Hausmann understood himself to be a pioneer for the birth of the new man. The notion of destruction as an act of creation was the point of departure for Hausmann's Dadasophy, his theoretical contribution to Berlin Dada.

As Dadasoph, and cofounder of Club Dada in Berlin, Hausmann wrote several key Dada texts including the "Dadaist Manifesto" with Richard Huelsenbeck and the sixteen-page Club Dada brochure with Jung and Huelsenbeck. He also edited the journal *Der Dada*. From 1919 onward, Hausmann prepared the big world atlas *Dadaco*, though the project fell through due to editorial difficulties. In addition Hausmann played a central role in organizing Dada events, including the First International Dada Fair with John Heartfield and George Grosz and numerous Dada matinees and soirées in Berlin, often in collaboration with Johannes Baader, and six tours from January to March 1920, traveling together with Baader and Huelsenbeck to Dresden, Hamburg, Leipzig, Teplitz, Schönau, Prague, and Karlsbad.

Hausmann's artistic contributions to Dada were purposefully eclectic, consistently blurring the boundaries between visual art, poetry, music, and dance. His "optophonetic" poems of early 1918 fused lyrical texts with expressive typography, insisting on the role of language as both visual and acoustic.

Boisterous public performances of these poems not only underscored their vocal dimension but also transformed their two-dimensionality into a bodily experience. After August 1918 Hausmann incorporated collage elements into his work, influenced by the photomontages from the front that he saw while on vacation with Hannah Höch. By 1920 Hausmann had manufactured several reliefs and assemblages, only one of which survives, the *Mechanischer Kopf* (Mechanical Head).

After his engagement with Dada, Hausmann focused primarily on photography, producing portraits, nudes, and landscapes. Hausmann left Germany in 1933, emigrating to Ibiza where his photographs reflected a romantic yearning for origins, focusing on ethnographic and architectural motifs of pre-modern life in Ibiza. From 1939 to 1944, Hausmann lived illegally in Peyrat-le-Château, France, with his Jewish wife Hedwig, née Mankiewitz. He published books and essays on Dada after the war, including *Courier Dada*, 1958, and *Am Anfang War Dada* (At the Beginning Was Dada), 1972. Raoul Hausmann died on 1 February 1971 in Limoges, France. STK

SOURCES
Benson, Timothy O. *Raoul Hausmann and Berlin Dada*. Ann Arbor, Mich., 1987.
Berlinische Galerie. *Der Deutsche Spiesser ärgert sich*. Berlin, 1994.
The *Twenties in Berlin: Johannes Baader, George Grosz, Raoul Hausmann, Hannah Höch* [exh. cat., Annely Juda Fine Art], London, 1978.
Zuchner, Eva, et al. *Raoul Hausmann* [exh. cat., IVAM, Centro Julio Gonzáles], Valencià, 1994.

BERLIN
John Heartfield

born 1891 Berlin
died 1968 Berlin, East Germany

John Heartfield was born on 19 June 1891 as Helmut Franz Josef Herzfeld in Berlin-Schmargendorf. He was the first son of the socialist writer Franz Herzfeld, who wrote under the pseudonym Franz Held, and Alice Herzfeld, née Stolzenberg, a textile worker and political activist. In 1895, convicted of blasphemy and fleeing a prison sentence, Franz Herzfeld and family eventually took up residence in an abandoned hut in the woods in Aigen, near Salzburg, Austria. One day in 1899, the four Herzfeld children woke up to find their parents missing. The mayor of Aigen took the children into his foster care, a situation which proved extremely difficult for the young, quick-tempered Helmut.

In 1905, after having finished school, Herzfeld began an apprenticeship in a bookshop in Wiesbaden, Germany. Three years later, in 1908, Herzfeld went to study at the Royal Bavarian School of Applied Arts in Munich, which at the time was Germany's center of art. Herzfeld's role models were influenced by art nouveau commercial design,

including work by Albert Weisgerber, Ludwig Hohlwein, and Koloman Moser, thus nourishing Herzfeld's inclination toward a functional art for a mass audience. In 1912 he worked as packaging designer in a printing company in Mannheim. He also designed his first book jacket, for the selected works of his father. In 1913 Herzfeld moved to Berlin, where he continued his art education at the Arts and Crafts School in Berlin-Charlottenburg, under Ernst Neumann.

In 1914, the same year that Herzfeld won first prize in the Werkbund Exhibit in Cologne for the design of a wall mural, he was conscripted into military service in World War I. Herzfeld served as a guard in Berlin for most of 1915, until he provoked a discharge by simulating mental illness. In his subsequent civil service as a postal carrier in Berlin-Grunewald, Herzfeld tossed the mail into a gully as an act of antiwar sabotage, in the hopes that the inhabitants of this wealthy suburb would get angry at the unsatisfactory conditions on the home front.

In 1916 in the midst of the war, Helmut Herzfeld anglicized his name to "John Heartfield," a protest against the anglophobia that took hold of Germany shortly after the English entered the war on 4 August 1914. "God Punish England!" rang a popular street greeting. (Georg Gross changed his name to George Grosz in the same year.) In July 1916, Wieland Herzfelde and John Heartfield published the journal *Neue Jugend* (New Youth), a vehicle for antiwar and pacifist views. In 1917 Heartfield helped his brother establish the Malik Verlag publishing group and oversaw all typographical projects. During this time, he also worked as a film set designer for the Grünbaum brothers and produced propaganda films and later animated films in collaboration with George Grosz in the Military Educational Film Service (later renamed UFA).

Heartfield, his brother, Grosz, and Erwin Piscator signed up with the fledgling German Communist Party at, or just after, the First Party Congress, 30 December 1918–1 January 1919. In Heartfield's involvement with Berlin Dada, he was known as *Monteurdada*, not only because his preferred artistic medium was photomontage, but also because he took to wearing blue overalls (a *Monteuranzug* in German) in alliance with the industrial laborer. In German, the connection of montage to industrial assembly-line production is linguistically explicit, for *montieren* means "to assemble" while a *Monteur* is a mechanic or engineer.

Heartfield was dismissed from his position at UFA in 1919 because he called for a strike after the murders of Karl Liebknecht and Rosa Luxemburg. He coedited the satirical periodical *Jedermann sein eigner Fussball* (Everyone His Own Soccer Ball), which was banned after the first edition because of its inflammatory content. Together with Herzfelde and Grosz, Heartfield founded the satirical political magazine *Die Pleite* (Bankruptcy), a combination of socially critical reportage and caricature (usually the hand of Grosz). In 1919 Heartfield also befriended Otto Dix. In April 1920 Heartfield and Grosz published an article called "Der Kunstlump" (Art Rogue) in *Der Gegner* (The Opponent), which triggered heated discussions about the roles of fine art and proletarian art. Heartfield helped organize the First International Dada Fair with Grosz and Raoul Hausmann that opened on 1 July 1920, for which Heartfield designed a four-page catalogue.

After his involvement with Berlin Dada, Heartfield designed book jackets, typography, and layouts for left-wing publishers and worked for the German Communist Party as an editor and designer. In 1930 he began to produce political photomontages regularly for the popular procommunist journal *Arbeiter Illustrierte Zeitung* (Workers' Illustrated Journal), generating his anti-Nazi montages in exile in Prague after 1933. When the Nazis invaded Czechoslovakia in 1938, Heartfield fled to England. He joined his brother in the German Democratic Republic in 1951. John Heartfield died on 26 April 1968 in Berlin, East Germany. STK

SOURCES

Evans, David. *John Heartfield, AIZ/VI.* London, 1991.
Pachnicke, Peter, and Klaus Honnef. *John Heartfield.* New York, 1992.

ZURICH

Emmy Hennings

born 1885 Flensburg, Germany
died 1948 Tessin, Switzerland

Emmy Hennings was born to a German-Danish seafaring family in the northern German coastal city of Flensburg. Until she was seventeen, she worked as a maid in various establishments, but aspired to become an actress. She married early and had two children, the first of which died in its first year. In 1906 after her husband deserted her, Hennings left her second child with her mother and began an itinerant life as an entertainer, performing in touring theatricals, operettas, and nightclubs across central and eastern Europe.

By 1913 she had settled in Munich, where she became an intimate of the expressionist poets, playwrights, and novelists who populated Munich's seedy Bohemian quarter and frequented the Café Simplizissimus. Hennings appeared nightly at the café, singing popular cabaret songs and reciting her own poems as well as those written by friends. Between 1911 and 1914 Hennings was arrested multiple times, once for streetwalking (after which she was given a card and registered as a prostitute) and several times for theft. In 1914 she and a friend went to jail for forging

Emmy Hennings in Zurich, 1916/1917. Kunsthaus Zürich

passports for draft evaders. One of Hennings' lovers in Munich was Hugo Ball, whom she had met while singing at the Café Simpl, and whom she would later marry.

In November 1914 Hennings joined Ball in Berlin, where she sang in a variety of restaurants and worked as an artist's model. Because of their opposition to the increasing nationalism of the war effort, Ball and Hennings left Berlin for Zurich in May 1915. They arrived completely destitute and lived on the assistance of Hennings' literary friends until they found work with a vaudeville troupe. In February 1916 they opened the Cabaret Voltaire.

At the Cabaret, Hennings was one of the star attractions, performing as a singer, dancer, and reciter of poetry. Her wide repertoire included popular songs from Denmark, Paris, and Berlin; Chinese ballads; folk songs; her own poems; and poetry written by other dadaists. Hennings' charisma as a performer and her previous cabaret experience contributed to the success of the venture, and her introduction of popular, low forms of entertainment helped set the tone of protest that surrounded the Cabaret's activities.

Hennings began writing in the early 1910s, and her poems dealt with her life outside the safety provided by bourgeois propriety. Addressing such expressionist themes as loneliness,

Self-Portrait [John Heartfield], 1920. John-Heartfield-Archiv, Stiftung Archiv der Akademie der Kunst

ecstasy, captivity, illness, and death, Hennings was able to reflect on her experiences: certain places—prisons, hospitals, cabarets, and the streets—and afflictions—prostitution and drug addiction—recur again and again. Several of her poems, though not strictly dadaist in form or content, were published in Dada magazines and often invoke themes resonant with Dada experiences: "Gefängnis" (Prison), a poem published in the journal *Cabaret Voltaire*, uses the prison as a metaphor for the repressiveness of society protested against by Dada. For Hennings, rebellion against repression took the form of erotic liberty; her promiscuity in Munich was a form of protest, and in 1918, she drafted "Aufruf an die Frauen" (Appeal to Women), an essay that advocated peace through universal human love. However, Ball, in whose journal it was to appear, opposed its publication.

Hennings rarely discussed her early life subsequent to her intense conversion to Catholicism in 1920, preferring instead to emphasize her piety and her devotion to Ball. After he died in 1927, she provided his life with a similar trajectory, consistently portraying his intellectualism as a search for the absolute, which found its rightful home in Catholicism, and slighting his time with Dada as a youthful misadventure. Her memoir, *Ruf und Echo: Mein Leben mit Hugo Ball* (Call and Response: My Life with Hugo Ball), and her editing of collections of Ball's writings and letters have been extremely influential for studies of Ball's philosophical and aesthetic investigations. ALH

SOURCES
Ball-Hennings, Emmy. *Hugo Ball. Sein Leben in Briefen und Gedichten*. Frankfurt am Main, 1991.
Berg, Hubert van den. "The Star of the Cabaret Voltaire: The Other Life of Emmy Hennings." In *Dada Zurich: A Clown's Game from Nothing*, ed. Brigitte Pichon and Karl Riha, New York, 1996, 69–88.
Rugh, Thomas F. "Emmy Hennings and the Emergence of Zürich Dada," *Woman's Art Journal* 2, no.1 (1981): 1–6.

BERLIN
Wieland Herzfelde
born 1896 Weggis, Switzerland
died 1988 Leipzig, East Germany

Wieland Herzfeld was born on 11 April 1896 in Weggis am Vierwaldstätter See, Switzerland. He was the third child of Franz Herzfeld, a socialist who wrote under the pseudonym Franz Held, and Alice Herzfeld, née Stolzenberg, a textile worker and political activist. When Franz Held was convicted of blasphemy in 1895, he fled his prison sentence by leaving Germany and taking up residence first in Switzerland, where Wieland was born, and then in Austria, in Aigen near Salzburg, where the family settled in an abandoned hut in the woods. One day in 1899, the four Herzfeld children woke up to find their parents missing. The mayor of Aigen subsequently took the children into his foster care. When his older brother Helmut (who would

become the artist John Heartfield) went to study in Wiesbaden, the nine-year-old Wieland followed him, a sign of the inseparable bond between the two brothers that would last a lifetime. The publication of Franz Held's *Selected Works* in 1912 was groundbreaking for the young Wieland and inspired his own desire to become a poet. In January 1914 Herzfeld published an essay in *Die Aktion*, Franz Pfemfert's pacifist journal, entitled "Die Ethik der Geisteskranken" (The Ethics of the Mentally Ill). In the same volume, Herzfeld's name was misspelled as "Herzfelde," thus appending an additional "e" to his surname. The expressionist poet Else Lasker-Schüler encouraged Herzfelde to adopt this serendipitous name change for its lyrical impact.

In August 1914 Herzfelde enlisted in the military as a medical orderly and developed a total opposition to the war during the time he

Wieland Herzfelde, 1917. Wieland-Herzfelde-Archiv, Stiftung Archiv der Akademie der Kunst

spent on the Western Front. A dispute with his sergeant provoked sixteen days' arrest, though he was eventually pardoned on the Kaiser's birthday and dismissed from the army. In January 1915 Herzfelde returned to Berlin. During his stay, he met George Grosz at the atelier of the expressionist painter Ludwig Meidner. Herzfelde was recalled into military service in the fall of 1916, however, and transferred to upper Silesia. His attempted desertion in December 1916 ended in capture, and he was transferred to the Western Front soon thereafter in the winter of 1917. In January 1918 Herzfelde decided to protest the war through a hunger strike and managed to weaken himself to the extent that he was sent to recuperate in Berlin, where he collapsed and spent three months in a hospital.

Herzfelde continued to publish journals during the war, namely the politically oriented art and literature magazine *Neue Jugend* (New Youth) from July 1916 to March 1917, which asserted the interplay of critical text and satirical image. Heartfield produced all of the illustrations for the journal. In 1917 Herzfelde founded the left-wing revolutionary publishing

house Malik Verlag, named after a protagonist in an Else Lasker-Schüler poem. Herzfelde joined the fledgling German Communist Party along with Heartfield, Grosz, and the dramatist Erwin Piscator at, or just after, the First Party Congress, 30 December 1918–1 January 1919. In 1919 Malik Verlag published a series of satirical journals, including *Jedermann sein eigner Fussball* (Everyone His Own Soccer Ball), which was immediately banned; *Die Pleite* (Bankruptcy); and *Der Gegner* (The Opponent). On 7 March 1919 Herzfelde was arrested by the right-wing Freikorps on the grounds of the communist sympathies expressed in both *Jedermann* and *Die Pleite*. He was held in prison without trial until 20 March, when Count Harry Kessler intervened on his behalf and had him released. Herzfelde immediately published an account of his arrest and mistreatment in a pamphlet called *Schutzhaft* (Preventive Custody). Herzfelde's position as a writer and publisher of the radical left made him dangerous to the right wing.

Malik Verlag published Dada pamphlets and the catalogue for the First International Dada Fair in 1920, in addition to Grosz' portfolio of anti-militaristic drawings *Gott mit uns* (God with Us). Both Herzfelde and Grosz were charged and found guilty for insulting the German army; Herzfelde was fined 600 Reichsmark (because he was said to have profited from the portfolio) and Grosz was fined 300 Reichsmark.

After Dada, Malik Verlag became one of the prominent presses of the communist left in the Weimar Republic, publishing translations of such authors as Upton Sinclair and John Dos Passos, among others. With the advent of the Third Reich, Herzfelde fled to Prague and then to the United States. He returned to East Germany in 1949, where he took a professorship in Leipzig and continued to write and publish. Wieland Herzfelde died on 23 November 1988. STK

SOURCES
Faure, Ulrich. *Im Knotenpunkt des Weltverkehrs: Herzfelde, Heartfield, Grosz und der Malik Verlag, 1916–1947*. Berlin, 1992.
Herzfelde, Wieland. *Immergrün. Merkwürdige Erlebnisse und Erfahrungen eines fröhlichen Waisenknaben*. Berlin, 1949.

BERLIN
Hannah Höch
born 1889 Gotha, Germany
died 1978 Berlin

Hannah Höch was born on 1 November 1889 in Gotha, Germany, as Anna Therese Johanne Höch. The eldest of five children, Höch grew up in a comfortable, small town bourgeois environment. Her father Friedrich Höch worked as a supervisor at an insurance company and her mother Rosa Höch, née Sachs, was an amateur painter. When she was fifteen, her parents took her out of the Girls' High

moved to The Hague to live with the Dutch writer Til Brugman, with whom she had a nine-year lesbian relationship. During the National Socialist regime, Höch was forbidden to exhibit. She lived in inner emigration in Berlin-Heiligensee, on the outskirts of Berlin, where she continued to work until her death on 31 May 1978. STK

SOURCES

Boswell, Peter, et al. *The Photomontages of Hannah Höch* [exh. cat., Walker Art Center], Minneapolis, 1996.

Dech, Jula, et al., eds. *Da Da Zwischen Reden zu Hannah Höch*. Berlin, 1991.

Lavin, Maud. *Cut with the Kitchen Knife: The Weimar Photographs of Hannah Höch*. New Haven, Conn., 1993.

Pawlow, Kamen. *Hannah Höch* [exh. cat., Museen der Stadt Gotha], Gotha, 1993.

Thater-Schulz, Cornelia, ed. *Hannah Höch. Eine Lebenscollage*. 2 vols. Berlin, 1989.

The Twenties in Berlin: Johannes Baader, George Grosz, Raoul Hausmann, Hannah Höch [exh. cat., Annely Juda Fine Art], London, 1978.

School to care for her newborn sister, Marianne. Höch was not able to continue her education until six years later, when she enrolled in the School of Applied Arts in Berlin-Charlottenburg. She studied glass design with Harold Bengen from 1912 until the onset of World War I in 1914, when the school closed. According to Höch, the war's eruption shattered her comfortable world view and produced in her a newfound political consciousness. Höch returned to Gotha and worked for the Red Cross.

In January 1915 Höch returned to Berlin to continue her studies. This time, she enrolled in a graphic arts class taught by the Jugendstil artist Emil Orlik at the School of the Royal Museum of Applied Arts (later known as the State Museum of Applied Arts). In the same year, Höch met the Austrian-born artist Raoul Hausmann with whom she had an intense, difficult romantic relationship until 1922. She also developed a close friendship with Hannover dadaist Kurt Schwitters—indeed, it was Schwitters who added the final "h" to Hannah so that like Anna, it would become a mirror image. Höch later contributed two grottoes to Schwitters' *Merzbau*, one in 1922 and the other in 1925.

For ten years, between 1916 and 1926, Höch worked three days a week at the Ullstein Verlag, Berlin's major publisher of magazines and newspapers. Employed in the handicrafts department, Höch designed knitting, crocheting, and embroidering patterns for magazines and booklets. In the summer of 1918, while Höch and Hausmann were on vacation at the Ostsee, they claimed to have discovered the principle of photomontage in the form of the cut-and-paste images that soldiers on the front sent to their families. This find would significantly affect Höch's artistic production, for photomontage became the preferred medium for her shrewd social and political critiques of the 1920s. In addition to mass-media photographs, Höch incorporated lace

and handiwork patterns into her montages, thus combining traditional language of women's crafts with that of modern mass culture.

Indeed, one of Höch's primary preoccupations was the representation of the "new woman" of the Weimar Republic, whose social role and personal identity were in a complex process of redefinition in the postwar period. Women enjoyed new freedoms, including the right to vote in 1918 and an increased presence in the working world, albeit in low-paid positions. The subsequent increase in disposable income made women a prime audience for the mass press, which became a venue for expression of desires and anxieties associated with women's rapidly transforming identities. Juxtaposing photographs and text to both endorse and critique existing mass-media representations, Höch parodied elements of bourgeois living and morals and also probed the new, unstable definitions of femininity that were so widespread in postwar media culture.

Höch was the only woman involved with Berlin Dada, and she participated in minor and major events alike. Her engagements ranged from playing a tin lid in Jefim Golyscheff's anti-symphony in an April 1919 Dada soirée to exhibiting in the *Erste Berliner Dada-Ausstellung* (First Berlin Dada Exhibition), along with Raoul Hausmann, George Grosz, Johannes Baader, Walter Mehring, Jefim Golyscheff, Fritz Stuckenberg, and Erika Deetjen. In the First International Dada Fair of 1920 in Otto Burchard's art gallery, the largest of all the Dada exhibitions, Höch presented her socially critical photomontages as well as her handcrafted Dada dolls, in turn showcasing the plurality of artistic tactics she mobilized for her Dada art. In the same year as the Dada Fair, Höch joined the leftist Novembergruppe, participating in annual exhibitions from 1920 to 1923, as well as in 1925, 1926, 1930, and 1931.

After Berlin Dada, Höch developed contacts with De Stijl in Holland. In the fall of 1926 she

COLOGNE

Angelika Hoerle

born 1899 Cologne, Germany
died 1923 Cologne

Heinrich Hoerle

born 1895 Cologne, Germany
died 1936 Cologne

The apartment of Angelika Hoerle (née Fick) and her husband Heinrich Hoerle became a gathering place between 1919 and 1922 for Cologne Dada members Max Ernst, Franz Seiwert, and Willy Fick, Angelika's older brother. The Hoerle *Dadaheim*, or Dadahome, offered Cologne Dada a base from which the artists planned publications and exhibitions. Heinrich Hoerle's *Die Krüppelmappe* (The Cripple Portfolio), Max Ernst's lithographs, *Fiat Modes*, and the Dada journal *die schammade* were produced there. The Hoerles also contributed to Johannes Baader's pre-dadaist magazine *Der Ventilator* (The Fan) as well as to *Bulletin D*, the first journal of Cologne Dada. The Hoerles' decidedly leftist political

convictions brought them to distance themselves from Cologne Dada in 1920 and to form the more activist "Stupidien" along with the artists Seiwert, Fick, Anton Räderscheidt, and Marta Hegemann. When Angelika Hoerle contracted tuberculosis in 1922, all such collaborations came to a halt. Fear of infection kept her former colleagues from visiting. Her husband abandoned her for the same reason.

Angelika Fick was born in 1899, the youngest of four children. Her father, Richard Fick, was a cabinet maker and an active trade unionist in Cologne. Her mother, Anna Fick, née Kraft, was the daughter of a prominent railroad official who cultivated in her children respect for music and the arts. Fick attended local art exhibitions from an early age, and the 1912 *International Sonderbund* exhibition impressed her so that she wished to become an artist. When her brother Willy started lessons at the School of Applied Arts in Cologne in 1912, she assisted with his projects. Although apprenticed in millinery during the war, Angelika Fick kept refining her artistic skills on her own. She was cut off from her family when she married Heinrich Hoerle, because her father considered him to be an unworthy penniless bohemian. The Hoerles eloped in the summer of 1919, and it was Angelika's brother Willy who provided financial assistance to the couple. Upon their return to Cologne, the Hoerles moved into the apartment that became an atelier, publishing house, and meeting place.

Angelika Hoerle frequently acted as *Dadaheim* hostess, a familiar gender role that often occluded her significant artistic contributions in the eyes of her male contemporaries. She issued her critiques of postwar German society in the form of starkly elegant, disturbing drawings. Angelika Hoerle refused to return to

her parents' home while battling tuberculosis. It was her devoted brother Willy who cared for her and eventually wrapped his deathly ill sister in a blanket and carried her home. She died 9 September 1923, a month before her twenty-fourth birthday.

Heinrich Hoerle was born in Cologne on 1 September 1895. He attended the School of Arts and Crafts sporadically in 1912 and contributed to Franz Pfemfert's pacifist journal *Die Aktion* in the early war years. He was posted to the front as a telephone operator in 1917 until the end of the war. The horrifying mutilations he observed at the front reappeared in his art, culminating in the twelve lithographs of the *Cripple Portfolio* exhibited in January 1920, which unflinchingly depict the bodily and psychological devastation of war veterans.

Heinrich Hoerle battled with tuberculosis as a child and witnessed his father's death from the disease in 1920. His fear of the illness brought him to abandon his wife and move in with his mother and his sister Marie, who, ironically enough, died of tuberculosis in the same year as Angelika. In 1925 Heinrich Hoerle's tuberculosis returned, and he died of the disease on 3 July 1936 at the age of forty-one. Before his death, Hoerle enjoyed a successful artistic career, exhibiting his works nationally and internationally as a key member of the Cologne Progressives and editor of their avant-garde journal *a bis z*. STK

SOURCES

Angelika Littlefield, ed., *The Dada Period in Cologne: Selections from the Fick-Eggert Collection* [exh. cat., Art Gallery of Ontario], Toronto, 1988.
Hoerle, Heinrich. *Hoerle und Sein Kreis* [exh. cat., Kunstverein zu Frechen], Frechen, 1971.
Stokes, Charlotte. "Rage and Liberation: Cologne Dada." In Charlotte Stokes and Stephen C. Foster, eds. *Dada: Cologne/Hanover* (vol. III of *Crisis and the Arts. The History of Dada*, Stephen C. Foster, general editor). New York, 1997.
Vitt, Walter. *Heinrich Hoerle und Franz Seiwert*. Cologne, 1975.

Heinrich Hoerle as a field artillery telephone operator, c. 1917, photograph lost. From *The Dada Period in Cologne* (Toronto, 1988)

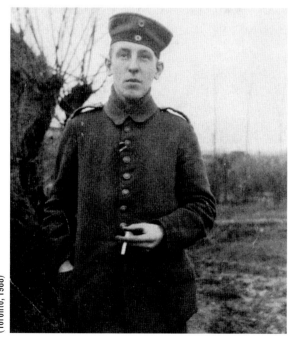

Richard Huelsenbeck

born 1892 Frankenau, Germany
died 1974 Minusio, Switzerland

Huelsenbeck grew up in Dortmund, Westphalia, where his father was a chemist. He aspired to become a writer and was greatly influenced by the poetry and prose of the German romantic poet Heinrich Heine, whose irony and mocking satire of society he wanted to emulate. At the age of nineteen, he went to Munich, where he pursued medicine for a year before beginning his study of German literature and art history.

In Munich Huelsenbeck met Hugo Ball, who would become a decisive influence on his intellectual development. He began to frequent the cafés in the bohemian district of Munich where artists and writers associated with expressionism gathered and through Ball began to publish some of his writings. When Huelsenbeck went to study philosophy at the Sorbonne for the winter semester of 1912–13, he contributed as a "Paris correspondent" to *Revolution*, an "excessively modern and polemical" periodical begun by Ball and his friend Hans Leybold. Ball's critique of Germany and its bourgeois social system reinforced Huelsenbeck's own beliefs and inspired him toward more radical means of expression.

Huelsenbeck followed Ball to Berlin in 1914, where he continued to study German literature and began to publish poems, essays, and book reviews in *Die Aktion*, an art and literature journal associated with radical politics, published by Franz Pfemfert. Huelsenbeck volunteered for military service in August 1914 just after the war began. He served several months in a field artillery unit but did not see the front and was released from service because of neuralgia, a condition characterized by intense nerve pain. Huelsenbeck and Ball became increasingly opposed to the war and to the intensity of German nationalist sentiment. In the spring of 1915, they organized several gatherings to protest the war effort and to commemorate fallen poets. However, the audience who arrived expecting a solemn memorial was shocked when Huelsenbeck began reciting "Negro" poems. Huelsenbeck's aggressive literature recitals at these "expressionist evenings" were deliberately intended to provoke his listeners, and it was this insolent attitude that most characterized his contribution to Zurich Dada's Cabaret Voltaire events.

Huelsenbeck went to Zurich at Ball's request, arriving at the Cabaret Voltaire in mid to late February of 1916. Ball recorded his arrival in his diary and wrote: "He pleads for stronger rhythm (Negro rhythm). He would prefer to drum literature into the ground." When Huelsenbeck performed, he adopted an arrogant and offensive posture, brandishing

his cane at the audience and reciting his poems, according to Marcel Janco, "as if they were insults." His poetry attacked the church, the fatherland, and the canon of German literature (Friedrich von Schiller and Johann Wolfgang von Goethe), and was accompanied by big drums, roars, whistles, and laughter. Huelsenbeck's use of a military drum alluded to the proximity of the war, demanding an immediate and uninhibited bodily response from the audience.

After Ball left Zurich in July 1916, Huelsenbeck developed stomach complaints and constantly talked about returning to Germany. His father's ill health precipitated his return in December 1916; by early 1917 he was in Berlin, where he introduced Dada ideas from Zurich and subsequently became the organizer, promoter, and historian of Dada. In January 1918 he delivered the "Dada-Rede in Deutschland" (First Dada Speech in Germany), and in April read a Dada manifesto. By the end of 1920, Huelsenbeck had already begun to chronicle the history of Dada. After the First International Dada Fair closed, he edited and published *Dada Almanach,* the first Dada anthology. *En avant Dada,* also published in 1920 and subtitled "The History of Dadaism," indicates the extent to which Huelsenbeck considered the movement to be at an end.

Throughout his Dada years, Huelsenbeck had been continually advancing his study of medicine and began to practice in 1920. He also enthusiastically pursued a career in journalism, becoming a permanent correspondent for several Berlin newspapers and a popular author of travel diaries compiled during his stints around the world as a ship's surgeon. Beginning in 1933, Huelsenbeck was repeatedly investigated by the Nazi authorities. Forbidden to write and in constant fear of imminent arrest, he finally obtained passage for himself to the United States in 1936. By 1939 he was practicing medicine and psychiatry in Long Island, New York, under the name Charles R. Hulbeck. His *Memoirs of a Dada Drummer,* written in 1969, offers lively reminiscences of his Dada experiences. ALH

SOURCES

Blago Bung Blago Bung Bosso Fataka! First Texts of German Dada by Hugo Ball, Richard Huelsenbeck, Walter Serner, trans. Malcolm Green. London, 1995.
Füllner, Karin. "Richard Huelsenbeck: 'Bang! Bang! Bangbangbang' The Dada Drummer in Zurich."

In Brigitte Pichon and Karl Riha, eds. *Dada Zurich: A Clown's Game from Nothing* (vol. II of Crisis and the Arts. The History of Dada, Stephen C. Foster, general editor). New York, 1996.
Huelsenbeck, Richard. *Memoirs of a Dada Drummer,* ed. H.J. Kleinschmidt, trans. Joachim Neugroschel (1969). Berkeley, 1991. (Originally published as *Mit Witz, Licht, und Grütze: Auf den Spuren des Dadaismus.* Wiesbaden, 1957.)

ZURICH

Marcel Janco

born 1895 Bucharest, Romania
died 1984 Tel Aviv, Israel

Born Marcel Hermann Iancu, Janco grew up in a family of upper-middle-class assimilated Jews in Bucharest, Romania. In high school, he studied painting and the graphic arts with Iosif Iser and became acquainted with Tristan Tzara and Ion Vinea, with whom he helped found the literary magazine *Simbolul* (Symbol). Janco directed the art section of the journal, contributed drawings and graphics, and probably also financed its publication. The outbreak of World War I meant that Janco was unable to follow the path taken by many students in Bucharest to complete his education in Paris. Instead, in the summer of 1914, he went to neutral Switzerland, changing his name to Janco for ease of pronunciation, and enrolled at the University of Zurich to study chemistry. In the fall of 1915, he transferred to the architecture program at the Swiss Federal Institute of Technology, where he remained for the next four years. When the war made communication with home impossible, Janco and his brother Georges were cut off from their family's financial support. According to Janco, while looking for work playing at cabarets and nightclubs, he and his brother happened upon the opening night at the Cabaret Voltaire.

As a painter, sculptor, printmaker, and designer, Janco's primary contributions to Zurich Dada consisted of his woodcut designs for posters and journal covers, his masks and costumes for the performances taking place at the Cabaret Voltaire, and his sculptural reliefs. Janco's work in each of these media was highly influenced by primitive art, which the dadaists understood broadly as the art of Oceanic and African peoples, the art of the mentally ill, and the art of children. For Janco as for other Dada artists, the primitive provided a means of escape from the bankruptcy of the western European traditions of painting and sculpture.

The graphic works Janco made to illustrate Dada publications—like his woodcuts illustrating Tzara's poems, or the linocuts for posters announcing Dada events—broke free from traditional graphic layouts and combined abstract forms with asymmetrical typeface in a bold synthesis.

Janco's masks were made of painted cardboard, paper, wire, and cloth, glued together to form oversized "faces" that dominated their

wearers, as the following description by Hugo Ball, in a diary entry of 24 May 1916, demonstrates: "Not only did the mask immediately call for a costume, it also demanded a quite definite, passionate gesture, bordering on madness...what fascinates us all about the masks is that they represent not human characters and passions, but characters and passions that are larger than life. The horror of our time, the paralyzing background of events, is made visible." Janco's masks, as invocatory props to Dada performance, represent the playfulness of Dada, but also its dire circumstances. Behind these masks, the dadaists could attain only a relative freedom.

Janco's experiments in sculpture also partook of this impulse to renew society. He understood his reliefs as breaking free of

convention and laying the groundwork for a new kind of aesthetic experience that would enter into the viewer, "shaking his psyche." Probably influenced by Hans Arp, whose wooden reliefs introduced the genre to the dadaist circle, Janco began making his reliefs at the end of 1916 and exhibited them in 1917 at the Galerie Dada. They were carved out of plaster or assembled out of wood; many were composed of brightly colored planes, but there were also examples of unpainted white reliefs. While the relief form has traditionally been understood as combining the characteristics of painting and sculpture, in his lecture on abstract art and architecture delivered in 1918, Janco explained that the play of surface planes in these reliefs derived from his understanding of the structural principles of architecture. In 1919 Janco exhibited a further series of reliefs embedded into the surface of the wall, where they literally became architectural elements.

After 1919 Janco and his brother worked as architects, first for several years in Paris and then in Romania, where they had returned in 1923. In 1922 Janco and Ion Vinea founded the art journal *Contimporanul.* This journal, published weekly and then monthly until 1932, introduced the art and writings of western European dadaists and constructivists to the

avant-garde in Bucharest. Janco also organized exhibitions to bring together work by Romanian and German artists. Through his efforts Romanian audiences were introduced to a broad spectrum of European avant-garde culture. In 1940 Janco emigrated to Israel, where in 1953 he founded the artists' village Ein Hod, dedicated to promoting a greater unity of the arts and society. ALH

SOURCES

Bolliger, Hans, Guido Magnaguano, and Raimund Meyer. *Dada in Zürich* [exh. cat., Kunsthaus Zürich]. Zürich, 1985.

Dachy, Marc. *The Dada Movement, 1915–1923*, trans. Marc Dachy. New York, 1990.

Machedon, Luminita, and Ernie Scoffham. *Romanian Modernism: The Architecture of Bucharest, 1920–1940*. Cambridge, Mass., 1999.

Naumann, Francis M. "Janco/Dada: An Interview with Marcel Janco." *Arts Magazine* 57, no. 3 (1982): 80–86.

Seiwert, Harry. *Marcel Janco, Dadaist-Zeitgenosse-wohltemperierter-morgenländischer Konstruktivist*. Frankfurt am Main, 1993.

HANNOVER
El Lissitzky
born 1890 Pochinok, Russia
died 1941 Moscow

Lissitzky was born into an educated middle-class Jewish family in western Russia. As a youth, he took art lessons from Iurii Pen, who was also Marc Chagall's teacher. In 1909 when Lissitzky was denied entrance to the St. Petersburg Academy because of his religious background, he enrolled at the Technical Institute in Darmstadt, Germany, where he studied architectural engineering. He traveled widely in France, Italy, and Germany during his student years, but was forced to return home at the outbreak of World War I in 1914.

In Moscow he studied for four years at the Riga Polytechnic Institute, receiving a diploma in architectural engineering in 1918. However, his primary artistic activity from mid-1916 took place through his involvement with a national movement to revive Yiddish secular culture in Russia. It gained momentum after the Russian Revolution of 1917 that resulted in the removal of all czarist restrictions on Jews. Lissitzky belonged to the Yiddish publishing house Kultur-Lige, for which he contributed to the design, publication, and circulation of books and other printed materials.

In 1919 Chagall, also a proponent of Jewish national culture, invited Lissitzky to teach architecture and graphics at the Vitebsk School of Art. At Vitebsk, Lissitzky came under the influence of Kasimir Malevich, a painter and radical theorist of abstract art. Lissitzky's style changed dramatically and, following Malevich's example of geometric abstraction, Lissitzky invented Proun, a genre of abstract art that he described as "a way-station between painting and architecture." Abstraction in Vitebsk was also associated with the political restructuring of Russia at

Self-Portrait [El Lissitzky], 1924. Barry Friedman, Ltd.

that moment as it was seen to offer an impetus to radical social change.

Lissitzky left Russia in late 1921 to go to Berlin, where he acted as a cultural ambassador for the *Erste russische Kunstausstellung* (First Russian Art Exhibition) in 1922. Later that same year, he met Kurt Schwitters at the Congress of Progressive Artists in Weimar. Intended to be a conference for constructivists, the congress was disrupted by rowdy dadaists and their performances. Although Lissitzky had criticized Dada as anachronistic, and in a review of Berlin exhibitions had complained that Schwitters was not advancing beyond his artistic beginnings, the two formed a collaboration that would last from 1922 until Lissitzky returned to the Soviet Union in 1925. Lissitzky's influence furthered Schwitters' gradual transition to a more constructivist style of geometric shapes and gridded compositions. Schwitters' dadaist sensibility also influenced Lissitzky to accommodate the irrational and the organic within his predominantly technophilic philosophy. Their collaboration was featured in issue 8–9 of Schwitters' magazine *Merz*, in which they argued that abstract, "elemental" forms be generated not from technology (which was the model favored by the constructivists) but from the resources of nature.

When Lissitzky was diagnosed with tuberculosis and sent to Switzerland to recuperate, he maintained his contact with Schwitters, who sent him advertising work for the Hannover firm Pelikan Ink to provide him with income. Lissitzky also worked with Hans Arp on an anthology of modern art movements called *Isms in Art*, a typographically adventurous picture book about modern art from 1914 to 1924 that included reproductions of artworks by many of those in Dada circles. However, Lissitzky's most important contribution to Dada consists of photographic portraits of himself, Schwitters, and Arp that he made during this period of recuperation. Made by montaging negatives during the development process, these portraits are multilayered representations of the artists and their activities. In these portraits, Lissitzky manipulates the technique of

photographic montage, taking advantage of its opportunities for overlapping and blurring to capture something of the dadaist ambiguity embodied by Arp and Schwitters.

In 1925, unable to renew his Swiss visa, Lissitzky returned to the USSR, where he found a teaching position in interior and furniture design at VKHUTEMAS (The Higher State Artistic and Technical Workshops). Two years after his return, Sophie Küppers, the artistic director of the Kestner Society in Hannover, and Lissitzky's partner for several years, arrived in Moscow and they were married. Lissitzky's work in exhibition design, begun with early projects such as the 1926 *Raum für konstruktive Kunst* (Room for Constructivist Art) in Dresden and the 1928 *Kabinett der Abstrakten* (Abstract Cabinet) in Hannover, flourished under the Soviet regime, which needed artists to design state contributions to international trade fairs and art exhibitions. Lissitzky also contributed photographic and typographic montages to publications such as *SSR na stroike* (USSR in Construction), which advertised the accomplishments of Soviet industry to the world. He died of tuberculosis in 1941. ALH

SOURCES

Dickerman, Leah. "El Lissitzky's Camera Corpus." In Nancy Perloff and Brian Reed, eds., *Situating El Lissitzky: Vitebsk, Berlin, Moscow*. Los Angeles, 2003.

Nisbet, Peter. *El Lissitzky, 1890–1941*. Cambridge, Mass., 1987.

Tupitsyn, Margarita. *El Lissitzky. Beyond the Abstract Cabinet: Photography, Design, Collaboration*. New Haven, 1999.

NEW YORK
PARIS
Man Ray
born 1890 Philadelphia, USA
died 1976 Paris

Born Michael Emmanuel Radnitzky to parents recently emigrated from Russia, Man Ray grew up in Philadelphia, Pennsylvania, until age seven, when his father moved the family to Brooklyn to take a higher-paying job in a garment factory. In 1908, upon graduating from high school, he began painting, first as an amateur in his parents' living room, and then in classes at the National Academy of Design and the Art Students League. At the suggestion of his brother, the family changed its name to Ray in 1912, after which Man Ray signed his work with that name.

In the fall of 1912 Man Ray began taking classes at the Francisco Ferrer Social Center, or Modern School, a meeting place for New York's cultural and political radicals. In order to support himself, he also worked first at an advertising firm and then for the McGraw Book Company designing maps and atlases, a position he held for six years. In 1913 he moved out of his parents' home and to the artists' colony of Ridgefield, New Jersey,

across the Hudson River from Manhattan. There, inspired but overwhelmed by the import of the Armory Show, Man Ray painted primarily in a cubist idiom. In 1915 he published one issue of the *Ridgefield Gazook*, a proto-dadaist and antiwar broadsheet with anarchist references.

In 1915 Walter Arensberg, a wealthy poet and patron of modern art, took Marcel Duchamp out to Ridgefield to meet Man Ray. In December of that year, he moved into Manhattan and became involved in the circle of avant-garde artists, writers, and intellectuals gathered around the Arensbergs. Over the next four years his work ranged over a variety of media, from painting, collage, and found sculpture to airbrush, photography, and film. He produced enigmatic abstractions out of the most common materials, such as the coat hangers used for the 1920 work *Obstruction*, and with the most technically advanced tools, such as the commercial airbrush machine, which he used to make abstract paintings he called "aerographs." In April 1920 Ray had three works shown at the first exhibition of the Société Anonyme, an organization for modern art that he and Duchamp helped Katherine Dreier to establish, and in 1921, he and Duchamp published the only issue of *New York Dada*. Several months after it appeared, Man Ray wrote Tristan Tzara, complaining that "Dada cannot live in New York. All New York is dada and will not tolerate a rival, will not notice dada." He followed Duchamp to Paris shortly thereafter.

Before he even arrived in Paris, some of his works had been shown at the June 1921 Salon Dada at the Galerie Montaigne. About six months after his arrival, he had a one-person show at the Librairie Six bookstore, with a catalogue to which all of Dada's major players in Paris contributed, including Paul Eluard, Louis Aragon, and Tzara. In Paris, Man Ray continued to experiment with photography, which he had begun in New York, documenting his and Duchamp's

works and using the camera to record everyday life and objects from unusual angles. In early 1922, probably after Tzara showed him the cameraless photograms made by Christian Schad, Man Ray began to produce his own photograms, calling them "Rayographs" or "Rayograms."

Man Ray's experiments with photography, which often produced mysterious and disturbing, sexually charged images, brought him into the center of surrealism in Paris in the 1920s. He also became renowned for contributions to the fashion magazines *Harper's Bazaar*, *Vu*, and *Vogue*, for which he photographed during the 1920s and 1930s.

Man Ray continued to live in Paris until 1940, when the war forced him to return to the United States. He lived in Hollywood until 1951, then returned to Paris where he spent the remaining years of his life. ALH

SOURCES

Foresta, Merry A. *Perpetual Motif: The Art of Man Ray* [exh. cat., National Museum of American Art], Washington, DC, 1988.
Naumann, Francis M. *New York Dada 1915–1923.* New York, 1994.
Schwarz, Arturo. *Man Ray. The Rigour of Imagination.* London, 1977.

ZURICH
NEW YORK
PARIS

Francis Picabia

born 1879 Paris
died 1953 Paris

Picabia was born in Paris to a Spanish father and French mother, both of whom came from wealthy, bourgeois families. He grew up in the household of his mother's family and was raised primarily by his father and maternal grandfather after his mother passed away. Picabia was intent on painting, and in 1895 he entered the Ecole des Arts Décoratifs. His early paintings were of Spanish figures and landscapes. By 1902 he had come under the influence of the post-impressionist painters Alfred Sisley and Camille Pissarro and painted in this style until 1909 when his encounter with cubism led him to reevaluate his work. From 1909 to 1912 he experimented with various combinations of cubism, fauvism, and orphism.

In 1913, due to his independent financial means, Picabia was able to accompany his works to the Armory Show in New York, where his abstract paintings and radical aesthetic theories gained him considerable attention. He and his wife, Gabrielle Buffet, stayed there until April, becoming good friends with Alfred Stieglitz, who opened a one-man show of Picabia's works at his gallery, 291. The year between the Picabias' return to Paris and the outbreak of World War I was spent in the company of the lively Parisian avant-garde and was especially productive for Picabia.

When war was declared, Picabia was briefly in uniform, as the French prepared for a possible assault by the Germans on Paris. Through family connections, he was reassigned as chauffeur to a general who participated in the government's temporary retreat to Bordeaux. In early 1915 Picabia faced being assigned to the infantry and again drew on family connections to serve on a military assignment to the Caribbean. When his ship stopped over in New York, he abandoned his mission, becoming a deserter. Although Buffet arrived in the fall of 1915 to escort him to Panama to fulfill his duty, his military status remained unresolved until the autumn of 1917, when Buffet arranged a passport for him to return to France.

For the next several years, Picabia went back and forth across the Atlantic, spending

Francis Picabia, 1922. Photograph by Alfred Stieglitz. National Gallery of Art, Washington

two significant periods of time in New York, first from 1915 to 1916 and again for the greater part of 1917, interrupted by a stay in Barcelona. In New York Picabia developed the mechanomorphic style of abstraction he related directly to his arrival in America, when, as he says, "it flashed on me that the genius of the modern world is machinery." In August 1915 a series of Picabia's mechanical portraits depicting himself and his American friends as technical apparatuses was published in 291. The mechanomorphic paintings exhibited in January 1916 at the Modern Gallery developed a theme that had already appeared in the mechanical portraits: the analogy of human, especially feminine, sexuality with the functioning of a machine.

During his stay in Barcelona in early 1917, Picabia published the first issue of his magazine 391, named in homage to Stieglitz' 291. Over the next seven years, another eighteen issues of 391 appeared, published wherever Picabia lived at the moment, and often in

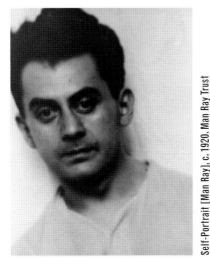

Self-Portrait [Man Ray], c. 1920. Man Ray Trust

collaboration with artists in New York, Zurich, and Paris. Already positioned as an international forum, the magazine gained circulation through friends and like-minded artists who frequently exchanged publications. Beginning with Picabia's sardonic attacks on the artistic and literary establishment of Paris in the first issue, *391* served as a platform not only for his poetry, but also for his acerbic criticism. In its determinedly independent stance, *391* also represented Picabia's free and sometimes dangerous disregard for nationalistic affiliations.

After a stay of three weeks in Zurich in early 1919, during which he collaborated on the publication of *Dada 4-5* with Tristan Tzara and edited the eighth number of *391*, Picabia returned to Paris to become one of Dada's leading protagonists. His mechanomorphic paintings, exhibited at the Salon des indépendants in January 1920, established a visual identity for Dada art in Paris and set a precedent for the public controversy and agitation that would accompany nearly all of Picabia's Dada activities. Even before *L'Oeil cacodylate* (Cacodylic Eye), a collaborative work consisting of the signatures and graffiti of over fifty of Picabia's friends and fellow artists, was exhibited at the 1921 Salon d'automne, rumors had circulated about the explosiveness of Picabia's intended submissions. His virulent pictorial and literary attacks on art, society, and religion made him the target of the press and of Salon committees, with whom he was happy to engage by writing public letters of protest and distributing inflammatory handbills at the doors of the Salon.

During 1921 and 1922, Picabia gradually became disenchanted with the feuds taking place among the Paris dadaists (largely the consequence of disagreements between Tzara and André Breton) and published a series of renunciations of the movement, devoting a special issue of *391* to insulting those who sustained it. Picabia continued to participate sporadically in the Parisian avant-garde, collaborating on projects for film and ballet. In the twenties and thirties, with the exception of one group of abstract works, he painted figurative pictures in many different styles, some of which self-consciously appropriated the art of the past. Throughout this period, Picabia lived primarily in Cannes, settling again in Paris after World War II. Toward the end of his life, he suffered several strokes, declining steadily before he died in 1953. ALH

SOURCES

Borràs, Maria-Lluïsa. *Picabia*. New York, 1985.
Camfield, William A. *Francis Picabia: His Art, Life and Times*. Princeton, N.J., 1979.
Naumann, Francis M. *New York Dada 1915–23*. New York, 1994.
Pagé, Suzanne, et al. *Francis Picabia, singulier idéal* [exh. cat., Musée d'art moderne de la ville de Paris], Paris, 2002.
Sanouillet, Michel. *Dada à Paris*. Nice, 1980.

ZURICH

Adya van Rees

born 1876 Rotterdam, The Netherlands
died 1959 Utrecht, The Netherlands

Otto van Rees

born 1884 Freiburg im Breisgau, Germany
died 1957 Utrecht, The Netherlands

Otto van Rees and his wife Adya, both Dutch painters influenced by the development of cubism, came into contact with Zurich Dada artists in the late summer of 1915.

Born into an academic family, Otto had grown up surrounded by artists, writers, and freethinkers. In 1891 his father, a professor of biology, moved the family to the Dutch countryside where he founded the Colony of International Brotherhood, a cooperative agricultural community based upon Christian-anarchic principles that he developed in correspondence with Leo Tolstoy. In 1904 Otto studied painting with Jan Toorop, a cofounder of the Belgian neoimpressionist painting circle known as "Les XX." Adya, born Adrienne Catherine Dutilh, came from a wealthy family of grain merchants in Rotterdam. She received her

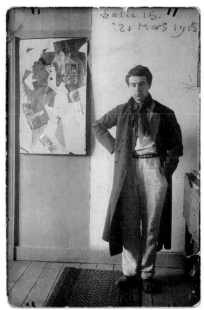

Otto van Rees, 21 March 1915.
Van Rees Stichting, Netherlands

artistic training in a drawing studio known as a fashionable school for upper-class young ladies.

In the fall of 1904 Otto went to Paris on the recommendation of Toorop. Shortly afterward, Adya joined him and the two shared a studio, living together in what they called a "free marriage." They were friends with Pablo Picasso and Georges Braque, whose cubism influenced Otto to move away from his training in a divisionist style toward abstraction. For the next decade, Otto and Adya spent winters in Paris painting and frequenting the soirées and cafés of the Parisian

avant-garde. They spent summers in the country, where their old farmhouse became a gathering place for like-minded artists and writers. Beginning in 1910 at least once a year they visited Ascona, where Otto's mother and older sister were involved in German and Swiss avant-garde circles.

When World War I broke out, Otto was called back home for military duty in Holland, which, though not in the war, had mobilized its forces. He served until 1915, when he was discharged after a stay in the hospital to treat recurrent headaches. Although he had probably experimented with collage techniques in Paris, one of his early collage works, *De Danser*

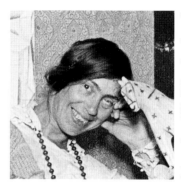

Ayda van Rees, 1915. Stiftung Hans Arp und Sophie Taeuber-Arp e.V., Rolandseck

(The Dancer), dates from this stay in the hospital. After his discharge, he left immediately for Ascona, where Adya and their two daughters had already taken refuge.

In Ascona, a small village outside Zurich, Otto and Adya joined a community of people in Switzerland escaping from the war; they developed an especially close working relationship with Hans Arp. In the summer of 1915 Otto received a commission from Hans Corray, the headmaster of the Pestalozzi School in Zurich where the Van Reeses' eldest daughter was enrolled, to design two murals for the entrance hallway of the school. He executed one mural, and Arp joined him to complete the second one. The result was a pair of large-scale abstract frescoes, meant to be seen in relation to the view of the Alps in the background. In 1919, after the parents of children attending the school objected to their installation, the murals were painted over. The May 1919 issue of *Dada* magazine protested against the destruction of the murals, which were eventually uncovered and restored in 1976.

In November 1915 Otto, Adya, and Arp showed the results of their collaborative work at the Galerie Tanner in Zurich. Comprised of works in the media of collage, needlework, drawing, and painting, the exhibition was cited by Tristan Tzara in his *Chronique zurichoise* (Zurich Chronicle) as the first event of Zurich Dada. Among those works exhibited were an embroidery executed by Adya after a design by Arp, and several collages by Otto, in which abstract

forms were created with tobacco wrappers and pages from Dutch publications. Otto also created the poster for the exhibition, an abstract design of geometric shapes. Most likely the first appearance of dadaist abstraction in Zurich, the exhibition was significant for its display of handicrafts next to paintings and for its presentation of mixed-media works constructed from paper, paint, and fabric.

When Otto and Adya returned to Paris in 1916, Corray purchased all their Swiss works, which were later exhibited at the Cabaret Voltaire and the Galerie Dada. In 1919 on their way to Ascona, the train carrying the Van Reeses and their children crashed into the Orient Express. Their oldest daughter was killed, and Otto was severely wounded. They lived in Holland for the next several years, establishing close connections with Dutch artistic circles. In 1928 they moved to Paris, where they were both briefly associated through Arp with the Cercle et carré (Circle and Square) group to advance abstract art. ALH

with Irène Kuitenbrouwer-Lespaare, secretary-general of the Van Rees Foundation, and Barbara Schoonhoven at the National Gallery of Art

SOURCES

Henkels, Herbert. "Fresko's van Van Rees en Arp in Zuerich." *Museumjournaal* 23, no. 1 (1978): 11–15.

Kuitenbrouwer-Lesparre, Irène. Biography on Otto van Rees. Unpublished MS, 2003.

Otto en Adya van Rees. Leven en Werk tot 1934 [exh. cat., Centraal Museum], Utrecht, 1975.

Schippers, K. *Holland Dada*. Amsterdam, 1974.

Georges Ribemont-Dessaignes

born 1884 Montpellier, France
died 1974 Saint-Jeannet, France

The painter, musician, poet, and playwright Georges Ribemont-Dessaignes was born on 19 June 1884 in Montpellier, France. His father was a professor of obstetrics and an amateur painter. Georges did not attend

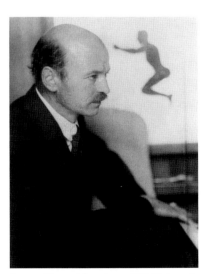

Georges Ribemont-Dessaignes, 1922. Photograph by Man Ray. Collection Timothy Baum

primary school but was taught at home by a priest and a private tutor. Ribemont-Dessaignes studied art at the Ecole des Beaux-Arts and the Académie Julian and his works were exhibited at the Salon d'automne in Paris. His early works were influenced by impressionism and the Nabis. He was involved with the Puteaux group around 1910, which included cubist artists such as Fernand Léger, Jean Metzinger, and Albert Gleizes as well as the future dadaist Marcel Duchamp. After 1913, he seemed to have given up painting, until in 1920, inspired by the work of his friend Francis Picabia, he began to produce mechanomorphic paintings. In 1915 Ribemont-Dessaignes was mobilized for war duty and worked at the Family Information Service in Paris. This period also marked the beginning of his poetic writings.

Ribemont-Dessaignes collaborated with Picabia on the Dada journal *391* in the summer of 1919. In November 1919 Ribemont-Dessaignes and Picabia traveled to Zurich to spend a few weeks visiting Tristan Tzara. At the end of the month, he sent Tzara some requested texts to be included in *Dada 6*— these were quite possibly the poems "O" and "Artichauds" (Artichokes) that were included in *Dada 7*. This was the beginning of his role as official "polémiqueur" (polemicist) of Paris Dada. He also contributed to several other Dada journals, including *Littérature, Mécano,* and *Proverbe.* The year 1920 marked a period of intense Dada activity for Ribemont-Dessaignes. He regularly participated in Dada soirées and events, where his work was performed. For instance, in February 1920, he wrote and performed an iconoclastic poem-manifesto with nine other readers at Grand Palais des Champs Elysées, where the Salon des indépendants was held. André Breton and Philippe Soupault were among the actors who performed Ribemont-Dessaignes' play *Le serin muet* (The Mute Canary) at a Dada soirée on 27 March 1920. His piano piece *Pas de la chicorée frisée* (Dance of the Curly Endive) was performed the same evening, interpreted by Gabrielle Buffet. This piano piece, and another one entitled *Le nombril interlope* (The Bellybutton Interloper) was composed with the help of a roulette wheel. In 1921, plans for an edition of his poems *L'oeil et son oeil* (The Eye and Its Eye), with the assistance of Hans Arp and a drawing by Max Ernst, were in the works, but the volume never materialized.

Georges Ribemont-Dessaignes was actively involved with the surrealist movement from 1924 to 1929 and continued to write poems, essays, and novels. He died on 9 July 1974 in Saint-Jeannet, France. STK

SOURCE

Begot, Jean Pierre. *Georges Ribemont-Dessaignes: DADA, 1915–1929.* Paris, 1994.

Hans Richter

born 1888 Berlin
died 1976 Locarno, Switzerland

Johannes Siegfried Richter was born into a well-to-do Jewish family in Berlin. Although he wanted to be a painter, his father decided he should pursue architecture and thus Richter spent a year as a carpenter's apprentice. Between 1908 and 1911 Richter studied art at the Academy of Art in Berlin, the Academy of Art in Weimar, and for a brief period at the Académie Julian in Paris.

By 1913 Richter had joined the mainstream of the expressionist circles of the avant-garde, meeting artists associated with Herwarth Walden's Sturm Gallery in Berlin, and the radical expressionists who formed the Brücke in Dresden and the Blaue Reiter in Munich. In 1914 he became a part of Die Aktion, an association of expressionist artists and writers gathered around Franz Pfemfert's journal of the same name, who shared socialist and antiwar sympathies. In his graphic work for *Die Aktion,* which consisted of woodcuts, linocuts, and

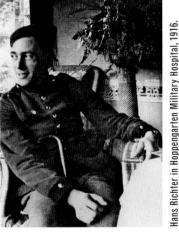

Hans Richter in Hoppengarten Military Hospital, 1916. Collection of Marion von Hofacker

drawings, Richter began to make a decisive break with representational art. Though these works were often portraits of political or literary figures associated with the journal, their emphasis was on the stark impression made by juxtapositions of black and white shapes. The connection established in the context of *Die Aktion* between abstraction and engaged politics would be present throughout Richter's life and work.

When Richter was inducted into the army in September 1914, he and his friends, Ferdinand Hardekopf and Albert Ehrenstein, made a pact to meet again in two years at the Café de la terrasse in Zurich. A few months later, Richter was severely wounded while serving in a light artillery unit in Vilnius, Lithuania. Partially paralyzed, he was sent to recuperate at the Hoppegarten military hospital in Berlin, and in March Richter was officially removed from

active duty. After his marriage in late August, Richter and his wife traveled to Switzerland to consult with physicians about his back injuries. There, on 15 September, he stopped by the Café de la terrasse, where his two friends were waiting. They introduced him to members of the Dada group—Tristan Tzara, Marcel Janco, and Marcel's brother Georges, who were sitting at a nearby table.

From 1917 to 1919 Richter was closely involved with Dada events, exhibitions, and publications, showing his paintings with the dadaists for the first time in January at the Galerie Corray. Throughout 1917 he also produced a series of paintings at a pace of three or four a day that he called "visionary portraits." Depicting Dada friends but so abstract as to elude likeness, Richter deliberately painted these portraits at twilight in a trancelike state, in order to escape from the visible world. According to him, these pictures then "took shape before the inner rather than the outer eye," transcending the particularity of the visible in order to attain a universal image. A series of woodcuts called "Dada heads" also made during this period continued Richter's graphic exploration of abstract portraiture.

In the early spring of 1918 Tristan Tzara introduced Richter to Viking Eggeling, a Swedish painter who had developed a systematic theory of abstract art. Richter, who had been experimenting in his Dada heads with opposing black and white, positive and negative, found in Eggeling a friend and fellow theorist of abstraction. In 1920 they coauthored "Universelle Sprache" (Universal Language), a text defining abstract art as a language based on the polar relationships of elementary forms derived from the laws of human perception. For Richter, the central tenet of this text was that such an abstract language would be "beyond all national language frontiers." He imagined in abstraction a new kind of communication that would be free from the kinds of nationalistic alliances that led to World War I.

Richter and Eggeling also produced an entirely new kind of artwork—the abstract film. Developed out of their theorizations of a universal language of forms, *Rhythmus 21* and *Rhythmus 23* introduced the element of time into the abstract work of art. Now classics of the cinema, the films show geometric shapes moving and interacting in space and set to a musical score. Richter's 1927 film, *Vormittagsspuk* (Ghosts Before Breakfast), which he developed from Dada ideas, shows everyday objects in rebellion against their owners: derby hats, potent symbols of bourgeois propriety and stability, take on lives of their own, parodying their inept masters.

In 1923 Richter began publishing G, a magazine that drew together the work of artists, architects, and writers associated with Dada, De Stijl, and international constructivism. His

films were censored as early as 1927 when the object rebellion of *Ghosts Before Breakfast* was understood as subversive of the social order. As a Jew, a modern artist, and a member of the political opposition, Richter was forced to leave Germany. He eventually emigrated to the United States, where he taught at the Film Institute of City College in New York. In 1962 he retired and returned to Switzerland. ALH

SOURCES

Foster, Stephen, ed. *Hans Richter: Activism, Modernism, and the Avant-Garde.* Cambridge, Mass., 1998.

Gray, Cleve, ed. *Hans Richter by Hans Richter.* New York, 1971.

Richter, Hans. *Dada: Art and Anti-Art*, trans. David Britt. London, 1965 (originally published as *Dada: Kunst und Antikunst.* Cologne, 1964).

Richter, Hans. *Hans Richter.* New York, 1965.

ZURICH

Christian Schad

born 1894 Miesbach, Germany
died 1982 Stuttgart, Germany

Born in Bavaria into a liberal and wealthy family, Christian Schad began studying music and art as a child, and at age eighteen decided to become a painter. He took the Munich Academy summer course in landscape painting and a course in the fall of 1913 on life drawing from

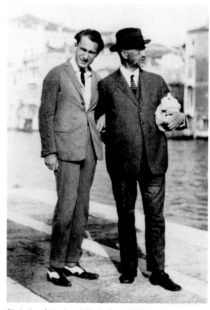

Christian Schad and his father, 1923.
Christian Schad Stiftung, Aschaffenburg

the nude. His parents supported his artistic aspirations by providing him with a studio in the bohemian Schwabing district of Munich, where he developed a painting style influenced by expressionism.

In 1914 his stay at an artists' colony in Holland was interrupted by the outbreak of World War I. Schad took the last train back to Munich, but was determined not to fight in the war. When he was called up for the infantry in July, he avoided serving by having a doctor friend diagnose a fictitious heart problem. He left

immediately for neutral Zurich, arriving there in early August of 1915.

In Zurich he became friends with members of the Dada circle, Hans Arp, Hugo Ball, Emmy Hennings, and Leonhard Frank. However, his most important friendship was with Walter Serner, and the two of them kept their distance from Dada activities. Together they launched the periodical *Sirius*, to which Schad frequently contributed drawings and woodcuts, and which published a portfolio of ten of his woodcuts in 1915. *Sirius* was philosophically opposed to Dada, a position it made explicit when Serner published a criticism of Ball and Richard Huelsenbeck as juvenile rebels. It took the view that, despite the degeneracy of the time, humanity and the history of its intellectual pursuits should be respected.

In the early spring of 1916 Schad began traveling frequently to Geneva and moved there permanently in November. Encouraged by Serner, who had joined him in 1919 and was sharing his apartment, Schad made his most important contribution to Dada and to the history of modern art. By layering scraps of paper or fabric and found objects onto sheets of light-sensitive photographic paper, Schad produced photographs that were entirely abstract and which he referred to as "immaterial collages." Now generally called photograms, these abstract pictures were hailed by Serner as the "collapse of pure technique in art." The introduction of chance effects produced by the uneven penetration of light through the various materials and the use of found objects culled from the streets and cafés of the modern city align Schad's work with similar Dada experiments carried out by Hans Arp and Kurt Schwitters.

Closely related to the photograms are a set of reliefs Schad made during the same period in Geneva. Composed of brightly painted irregularly shaped pieces of wood with small objects attached to their surfaces, these works recall the photograms in shape and in effect. Schad described these works, which he painted with commercial Ripolin enamel and which used the materials—curtain rings, chains, string, and nails—that had previously appeared as shadowy figures in the photograms, as pitting the banal realities of life against the tradition of art. Although surely inspired by Arp's similar relief forms, Schad's reliefs incorporate industrially manufactured metal parts that impart to the reliefs a machinelike quality.

Although Serner attempted to import Dada to Geneva, planning a First Dadaist World Congress, several exhibitions, and a Grand Dada Ball for which Schad designed the decorations and poster, these events never achieved the popularity or success that the Cabaret Voltaire had enjoyed in Zurich. When Schad left Geneva in March 1920, he forwarded his photograms to Tristan Tzara in Paris. Tzara

reproduced several of them in the Paris publication *Dada* under the title "Schadographs." He later sent them to Alfred Barr, curator at the Museum of Modern Art in New York, for Barr's seminal show, *Fantastic Art, Dada, and Surrealism* in 1936.

When Schad returned to Germany after five years in Switzerland, he was dismayed by the economic and social conditions of postwar life. In his reminiscences, he states that "dada had had its day." In the summer of 1920 he went to Italy and began to paint in a realist, pictorial style that would later be characterized as Neue Sachlichkeit (New Objectivity). Living in Berlin from 1927 to 1943, Schad had much success as a painter. Two of his paintings were displayed in the *Grosse Deutsche Kunstausstellung* (Great German Art Exhibition) in 1937, an exhibition of work approved by the Nazis. After his family fortune was lost during World War II, Schad made a living doing portrait commissions and copies of old master paintings. ALH

SOURCES

Bezzola, Tobia, ed. *Christian Schad 1894–1982* [exh. cat., Kuntshaus Zürich], Zurich, 1997.
Bolliger, Hans, Guido Magnaguano, and Raimund Meyer. *Dada in Zürich* [exh. cat., Kunsthaus Zürich], Zürich, 1985.
Lloyd, Jill, and Michael Peppiatt, eds. *Christian Schad and the Neue Sachlichkeit* [exh. cat., Neue Galerie], New York, 2003.
Richter, Günter A. *Christian Schad*. Rottach-Egern, 2004.

Morton Livingston Schamberg

born 1881 Philadelphia, USA
died 1918 Philadelphia

Born into a middle-class German-Jewish family in Philadelphia, Pennsylvania, Morton Livingston Schamberg attended the University of Pennsylvania School of Fine Arts, graduating in 1903 with a degree in architecture. From 1903 to 1906 he studied painting with William Merritt Chase at the Pennsylvania Academy of Fine Arts. Class trips to Holland, England, and Spain, organized and led by Chase, acquainted Schamberg with past art. Over the next several years, Schamberg would return to Europe repeatedly, living and working in Paris from 1906 to 1907 and traveling with his friend and former classmate Charles Sheeler in France and Italy in 1908 and 1909. When he returned to Philadelphia, he and Sheeler rented a studio together. After several years of work, neither earning enough to make a living, they decided in 1913 to take up photography and produced studio portraits for income.

Also in 1913, Schamberg received his first recognition as a painter when he and Sheeler were asked to contribute paintings to the Armory Show in New York. Although Schamberg had been working in a fauve style, after the Armory Show his efforts became

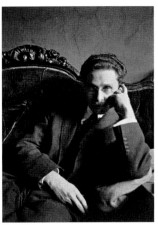

Morton Livingston Schamberg, 1915–1916. Photograph by Charles Sheeler. Courtesy, Museum of Fine Arts, Boston

increasingly abstract and were characterized by linear and planar forms suggestive of architectural elements and fragments of landscape.

In 1916, perhaps in response to the January exhibition of Francis Picabia's "machine paintings" at the Modern Gallery, Schamberg's style changed abruptly. His canvases now featured discrete machine forms brightly painted with a technical precision revealing his earlier training as a draftsman. Several of these paintings were exhibited in a group show with Marcel Duchamp and others in April 1916 at the Bourgeois Gallery in New York. Later, one of these, entitled *Mechanical Abstraction*, acquired a place in the sitting room of the New York collectors and patrons of the avant-garde, Walter and Louise Arensberg.

Described by a reviewer in May 1916 as a "wedding of architect's plans, machinist's drawings and a strange sort of Egyptian relief," Schamberg's machine paintings have elicited numerous attempts to identify their specific source material. Although parts of sewing machines and parts of a machine used for book binding have been identified in the works, and Schamberg's renderings convey both precision and accuracy, the paintings do not illustrate functional machines. They present machinelike forms which, abstracted from their function, become iconic and neutral symbols of modernity.

Schamberg was an occasional visitor to the Arensbergs' New York apartment, the gathering place of French and American avant-garde artists and writers, and the mechano-morphic imagery of his most significant paintings situates him within the dadaist sphere. However, despite being called a "doughty follower of Picabia" after the April 1916 show, Schamberg's ideas about art differed greatly from those espoused by the dadaists. He believed that all art, of no matter what historical era or culture, is constructed according to the same principles, and he viewed his own work as continuing the tradition of classical representation begun in the High Renaissance. His dedication to modern art also motivated him to attempt to educate his hometown Philadelphia audience; in May 1916 he organized

the first important exhibition of modern painting and sculpture in Philadelphia, stationing himself in the galleries to answer questions from curious or skeptical visitors.

Unfortunately, Schamberg's early death in 1918 as a result of the influenza epidemic in Philadelphia cut short his career as a painter and proponent of modern art in America. ALH

SOURCES

Naumann, Francis M. *New York Dada, 1915–1923*. New York, 1994.
Powell, Earl A., III. "Morton Schamberg: The Machine as Icon." *Arts Magazine* 51 (May 1977): 122–124.
Wolf, Ben. *Morton Livingston Schamberg*. Philadelphia, 1963.

Rudolf Schlichter

born 1890 Calw, Germany
died 1955 Munich, Germany

Rudolf Schlichter was born into a family of six children. The son of a gardener and a seamstress, he attended Catholic school as a youth and served as an apprentice in an enamel factory. He first studied art for two years at the Art School in Stuttgart, and then from 1911 to 1916 was a pupil of the well-known impressionist painters Hans Thoma and Wilhelm Trübner at the School of Fine Arts in Karlsruhe. After being drafted into the German army in 1916, Schlichter was released from service one year later as the result of a hunger strike at the French front.

After returning to Karlsruhe in the winter of 1918–19, Schlichter and six former fellow students, including Georg Scholz, founded an artist's group with the programmatic name Rih, an Arabic word meaning "wind." As an organization proclaiming total artistic freedom and opposition to bourgeois art, they sought to establish a foothold for avant-garde art in their provincial town and to make contacts with avant-garde organizations in other cities, which they did by participating in large group exhibitions in Berlin, Frankfurt, and Darmstadt.

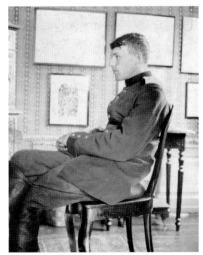

Rudolf Schlichter, 1916–1917. Deutsches Literaturarchiv

Schlichter at this point in his career was exhibiting futurist and abstract compositions. When he moved to Berlin in the fall of 1919, Rih lost one of its most active members, and the organization was dissolved in 1920.

In Berlin, Schlichter joined the Communist Party and became involved in the November-gruppe, a radical society advocating the active participation of artists in social and public life, through which he met George Grosz, John Heartfield, and their Dada circle. Schlichter's decisive new political engagement led him to create satirical drawings and illustrations for leftist magazines such as *Arbeiter Illustrierte Zeitung* (Workers' Illustrated Journal), *Rote Fahne* (Red Flag), *Der Knüppel* (The Cudgel), and *Der Gegner* (The Opponent), and for books, some of which were published by Wieland Herzfelde's Malik publishing company. The dadaists, most likely Heartfield, influenced Schlichter to begin making collages and dadaist sculpture in addition to traditional oil paintings.

A few weeks before the opening of the First International Dada Fair in 1920, Schlichter had his first solo exhibition at the Otto Burchard Gallery in Berlin, showing forty-two dadaist and futurist works that represented scenes of the American wild west and of the metropolitan nightlife and underworld. Carl Einstein wrote a critique of the exhibition already characterizing Schlichter as a verist, a painter whose realism is distinguished by a sharp moral critique of society.

Schlichter's collage *Phänomen-werke* (Phenomenon-Works), a brothel scene which ironically reflects on the alienation and separation of the sexes, was shown at both his solo exhibition and at the Dada Fair. The bodies of the figures are partially composed of machine parts, transforming them into automatons of love. His watercolor, *Dada Dachatelier* (Dada-Rooftop Studio), shows soulless and machine-like figures gathered on a rooftop. The presence of an easel, a model on a pedestal, and a drafting square suggest an artist's studio and the classical aesthetic tradition. Yet the bodies, some with missing limbs or prosthetic parts, and the gas mask disturb the apparent harmony of the scene by recalling the recent experience of the war. For the Dada Fair, Heartfield and Schlichter created the *Preussicher Erzengel* (Prussian Archangel), a stuffed dummy with the head of a pig dressed in the gray uniform of the Prussian military. The artists were subsequently sued for mocking and insulting the German army.

In 1921, when the jury for the *Grosse Berliner Kunstausstellung* (Great Berlin Art Exhibition) denied admission to one of Schlichter's paintings, a group of protesters, among them several dadaists, wrote an open letter to the November-gruppe denouncing it for having become depoliticized and commercial. Subsequently, Schlichter, Grosz, and Heartfield founded the

Rote Gruppe (Red Group) in 1924. A year later, Schlichter participated in the *Neue Sachlichkeit* (New Objectivity) exhibition in Mannheim. During this time, his style had become more sober and objective, and like Christian Schad, he created important portraits of his time.

In 1929 Schlichter married the Swiss courtesan Elfriede Koehler, who was known as Speedy. Under Speedy's influence, Schlichter underwent a deep mental and artistic change. He abandoned his communist commitments, converted to Catholicism, and his style became even less satirical; he now featured Speedy as his primary subject. Beginning in 1933, a series of defamation campaigns and trials by the Nazi government led to the removal of seventeen of Schlichter's works from public museums. Schlichter was banned from his profession. He died in 1955 of stomach cancer. IK

SOURCES

Adriani, Götz, et al. *Rudolf Schlichter. Gemälde-Aquarelle-Zeichnungen* [exh. cat., Kunsthalle Tübingen], Munich, 1997.

Horn, Gabriele, ed. *Rudolf Schlichter* [exh. cat., Staatliche Kunsthalle Berlin], Berlin, 1984.

Metken, Günter. *Rudolf Schlichter—Blinde Mächte: eine Allegorie der Zerstörung*. Frankfurt, 1990.

Schlichter, Rudolf. *Tönerne Füsse*. Berlin, 1992 (first edition: 1933).

BERLIN
Georg Scholz

born 1890 Wolfenbüttel, Germany
died 1945 Waldkirch, Germany

Orphaned as a young boy, Georg Scholz grew up in the house of the well-to-do physicist Julius Ester and was provided with a respectable education. From 1908 to 1914, he studied painting with the impressionist painter Wilhelm Trübner at the School of Fine Arts in Karlsruhe.

Scholz served in the German infantry from 1915 to 1918, noting the cruelties and social injustices of the war in sketches recorded in his diary. After the war Scholz established himself as a freelance artist in Grötzingen near Karlsruhe. First experimenting with expressionist, futurist, and abstract forms, he eventually developed his own style of social-critical, satirical realism aimed particularly at war profiteers.

With Rudolf Schlichter and other artists, Scholz founded Rih (wind), which held its first group exhibition in Karlsruhe. As a local branch of the Novembergruppe, a radical artists' group founded in 1918 to promote the integration of art and society, Rih members also exhibited in Berlin. Although he never moved to Berlin, it was through his contact with the Novembergruppe that Scholz met George Grosz, John Heartfield, and their Dada circle. Scholz became a member of the Communist Party and created satirical political drawings for leftist journals and illustrated books.

Georg Scholz, c. 1921. Private collection, Waldkirch

In 1920 he published an extract of his war diary in Wieland Herzfelde's journal *Der Gegner* (The Opponent).

Although Scholz had not previously participated in any Dada activities, he was invited by Heartfield and Grosz to exhibit his satirical and polemic painting, *Bauernbild Industriebauern* (Farmer Picture), at the International Dada Fair in Berlin in 1920. This painting, which unusually for Scholz includes some collaged elements, portrays a large family of landowners, and denounces their obedience to the Prussian emperor, their mindlessness, and their self-satisfaction. Scholz drew upon his personal experiences after the war to create this picture; when begging for food for his family and himself during the postwar years of famine, Scholz was rudely refused by farmers who told him to look on the compost heap. After the picture's exhibition at the Dada Fair, Scholz was interrogated by parliament but apparently never charged. The other work Scholz exhibited at the Dada Fair, which depicted a severed soldier's head on a tray, is now lost.

In 1923 Scholz began teaching art at the School of Fine Arts in Karlsruhe, becoming a full professor two years later. His style became more sharply realistic and less satirical, his subjects landscapes, portraits, and still lifes. Several works were exhibited at the *Neue Sachlichkeit* (New Objectivity) exhibition in Mannheim. In 1933 he lost his position at the academy and was defamed by the Nazis. In 1937 his works were removed from public museums in Karlsruhe and Mannheim. Having converted to Catholicism, he began creating wall decorations for churches. Shortly before his death in 1945, Scholz was appointed mayor of the little town of Waldkirch by French allies. IK

SOURCES

Badischer Kunstverein, ed. *Georg Scholz—Ein Beitrag zur Diskussion realistischer Kunst*. Karlsruhe, 1975.

Georg Scholz 1890–1945. Ed., city of Waldkirch, Waldkirch 1990.

Holsten, Siegmar. *Georg Scholz—Gemälde, Ziechnungen, Druckgraphik* [exh. cat., Staatliche Kunsthalle Karlsruhe], Karlsruhe, 1990.

Kurt Schwitters

born 1887 Hannover, Germany
died 1948 Kendal, England

Kurt Hermann Eduard Karl Julius Schwitters was born into a well-off family of shopkeepers in the provincial bourgeois city of Hannover. He began studying art at the School of Applied Arts in Hannover in 1908, and from 1909 to 1914 attended the Dresden Art Academy, where he studied traditional oil painting techniques and produced numerous landscapes, portraits, and still lifes. Although Schwitters would become known for his innovative experiments with new media like collage, assemblage, and installation art, he continued to paint traditional pictures throughout his life, often to earn money.

When war broke out, Schwitters returned to Hannover. Drafted, he was then declared unfit for active duty in 1917 when, according to his account, he pretended to be stupid and then bribed an army doctor. He was assigned to perform auxiliary military service, first as a clerical office worker, and then as a mechanical draftsman at an ironworks outside Hannover. He continued to work on his painting and began to write poetry, both of which, though influenced by cubism and expressionism, were also indebted to the German romantic tradition. In 1918, through the Kestner Society, an organization founded in Hannover in 1916 to promote the exhibition and discussion of modern art, Schwitters made contact with Herwarth Walden, whose Sturm Gallery and magazine in Berlin were devoted to promoting expressionism. Schwitters showed two abstract paintings at a group show at Sturm Gallery in June 1918.

Over the winter of 1918–19, Schwitters began making abstract assemblages and collages from materials he found or accumulated in his daily life—ration cards, string, paper doilies, newspaper fragments, streetcar tickets, and other bits of discarded refuse. Schwitters named his new pictures "Merz," after a fragment of the phrase "Kommerz-und Privatbank"

that appeared in one of his first assemblages, and adopted the term to describe all of his artistic activities. Although influenced to make collages by Hans Arp, Schwitters' works far surpass Arp's in the sheer variety of stuff incorporated, borrowing the language and strategies of commercial culture in order to reevaluate the relationship between art and everyday life.

In July 1919 Schwitters first exhibited the Merz pictures at Sturm Gallery and published a programmatic statement on Merz painting in *Der Sturm* magazine. His affiliation with Sturm and the active adoption of his own brand name kept Schwitters from being accepted into the inner circle of Berlin dadaists, though he became good friends with Raoul Hausmann and Hannah Höch. He tirelessly promoted Merz, popularizing his poem, "An Anna Blume," by pasting it up in the streets of Hannover as a poster, and then publishing it in *Der Sturm* and as a separate edition. Anna Blume became a renowned figure. Schwitters included her character in other short stories and poems, and capitalized on her popularity to advertise Merz as the recognizable brand name of Hannover Dada.

In 1923 Schwitters launched *Merz* magazine. The first issue was devoted to the De Stijl-Dada tour that Schwitters organized with the Dutch artist Theo van Doesburg, and subsequent issues featured contributions from Höch, Arp, and Tristan Tzara. In addition to being a medium for the exchange of ideas between dadaists, *Merz* also functioned as a juncture between Dada and international constructivism, as in the 1924 collaboration between Schwitters and El Lissitzky on *Merz* 8–9, "Nasci." Schwitters also used the magazine to further promote his poetry, which had developed after 1921 from parodies of expressionist sentimental lyrics like "An Anna Blume" to abstract sound poetry. In 1932 he published his most famous sound poem, the "Ursonate," as a twenty-nine page special issue of *Merz.* Remarkably, he also recorded his performance of the "Ursonate," which gains much of its appeal from his inimitable delivery.

One of Schwitters' goals with Merz was the achievement of a *Gesamtkunstwerk*, a total work of art, that would encompass painting, poetry, sculpture, theater, and architecture. Around 1923, he began work on the construction of what would become his *Merzbau*, an installation in his home in Hannover (formerly the nineteenth-century home of his parents) that gradually took over his studio and encroached onto the other rooms of the house. Constructed of a series of grottoes that Schwitters filled with borrowed and stolen objects from friends and family and then covered over with further construction, the *Merzbau* became a lifelong project of accumulation and memorialization.

In 1937, after his works were confiscated from German museums and shown in *Entartete*

Kunst, the "Degenerate Art" exhibition, Schwitters emigrated to Norway, where he began a new *Merzbau* project. He remained in Norway until 1940 when the German invasion forced him to flee to England. After a seventeen-month internment on the Isle of Man, he moved to the English countryside, where he continued to make collages and assemblages. In 1943 Allied bombs hit Schwitters' house in Hannover, destroying the *Merzbau.* Shortly before he died, he began work on a new Merz construction in a barn near his home in England supported by a grant from the Museum of Modern Art in New York. ALH

SOURCES

Dickerman, Leah. "Merz and Memory." In *The Dada Seminars*, ed. Leah Dickerman with Matthew S. Witkovsky, 103–125. Washington, DC, 2005.
Elderfield, John. *Kurt Schwitters.* London, 1985.
Orchard, Karin, and Isabel Schulz, eds. *Kurt Schwitters, Catalogue raisonné, vol. 1, 1905–1922.* Hannover, 2000.

Arthur Segal

born 1875 Jassy, Romania
died 1944 London

Arthur Aron Segal grew up in the provincial city of Botosani, Romania, the son of middle-class Jews. Although his parents intended him to enter his father's banking business, Segal was determined to pursue painting and in 1892 went to Berlin to study at the State Institute for Fine Art. Between 1895 and 1906 Segal traveled to Paris, where he studied briefly at the Académie Julian, and to Munich, Dachau, and locations in Italy and Switzerland.

Arthur Segal, 1920. From Pavel Liska, ed., *Arthur Segal, 1875–1944* (Berlin, 1987)

Segal had been exhibiting with the Artistic Youth Society in Romania since 1905; however, his first major showing in Berlin was at the 1910 spring exhibition of the New Sezession, a group of young expressionist painters of which Segal was a founding member. He continued to exhibit regularly with this group for the next two years, during which time he also made connections with the Blaue Reiter in Munich. Between 1911 and 1913, he published woodcuts and linocuts in Herwarth Walden's

Kurt Schwitters, c. 1920. Kurt Schwitters Archiv im Sprengel Museum Hannover

expressionist magazine *Der Sturm*, the most influential journal of modern art and culture in Berlin.

At the outbreak of World War I in 1914, Segal went to Switzerland, where he settled in Ascona, a small village near Zurich with a reputation as a refuge for artists, intellectuals, pacifists, vegetarians, idealists, and political refugees. The house that Segal occupied with his wife and two children became a gathering place for artists, including those associated with Dada in Zurich. As a Romanian citizen, Segal had not been in danger of being drafted, but when Romania entered the war in 1916 he officially became a draft dodger and lost his citizenship.

After arriving in Ascona, Segal briefly abandoned painting, which he realized with despair could not prevent or ameliorate the barbarity of the war, and devoted himself instead to the study of religion and philosophy. Having lost faith in the value of art, Segal attempted to formulate an ethical principle based on the equal valuation of all persons and things that would counter what he felt was the great abuse of power exercised in the war.

In 1915 when he began to paint again, he developed this concept of ethical equality into an artistic principle of "equivalence." By subdividing the canvas into regular geometrical units and fragmenting objects into faceted colored planes, creating nearly abstract compositions, Segal attempted to give equal emphasis to each element of the painting. He also began to extend the colors and rhythms of the painting beyond the canvas and onto the frame, thus symbolically uniting the worlds within and beyond the canvas.

Segal frequently exhibited his paintings with the dadaists, first at the Cabaret Voltaire and later at the Kunstsalon Wolfsberg. His woodcuts were published in the Dada magazines *Cabaret Voltaire*, *Dada 3*, and *Der Zeltweg*. In the catalogue preface to his one-man exhibition at the Kunstsalon Wolfsberg in January–February 1919, Segal explained the compositional principle of equivalence as an attempt to abolish hierarchies so that dominant and subordinate forces would no longer exist. Abstraction thus provided Segal with a means of theorizing a world without authoritative force, one in which people and things would stand in free relation to one another.

Throughout his stay in Ascona, Segal gave private painting lessons to amateur artists. At the end of the war, when he left Switzerland and returned to Berlin, he opened a painting school that remained in business from 1920 to 1930. Although teaching became his primary occupation, Segal continued to paint, exhibit his work, write articles, and lecture about art. He also became a member of the November-gruppe, an artists' society with socialist tendencies formed just after the November

Revolution in Germany to promote the integration of art and society. In the mid-1920s his studio was again a gathering place for artists, art historians, critics, and architects. In 1933 with the rise of fascism in Germany, Segal fled Berlin, going first to Mallorca and then to London in 1936, where he reopened his painting school. ALH

SOURCES

Bolliger, Hans, Guido Magnaguano, and Raimund Meyer. *Dada in Zürich* [exh. cat., Kunsthaus Zürich], Zürich, 1985.
Dietze, Horst. "Arthur Segal: Picture Lending." *Art Libraries Journal* 15, no. 2 (1990): 10–14.
Herzogenrath, Wulf, and Pavel Liska, eds. *Arthur Segal, 1875–1944*. Berlin, 1987.
Richter, Horst. "Der Maler der Gleichwertigkeitsbilder." *Die Welkunst* 57, no. 19 (1987): 2631–2633.

ZURICH
PARIS
Walter Serner

born 1889 Carlsbad, Bohemia (now Karlovy Vary, Czech Republic)
died 1942 unknown

Born Walter Eduard Seligmann, Serner changed his name in 1909, when as a young law student in Vienna he converted from Judaism to Catholicism. While living in Vienna from 1909 to 1912, he contributed a column reviewing Viennese art and theater events to his father's newspaper in Karlsbad. He also became friends with the architect Adolf Loos and the expressionist painter Oskar Kokoschka and was the organizer of Kokoschka's second one-man exhibition in 1911. In 1912 Serner moved to Berlin, where he continued to study law, passing the exam in 1913. Between 1912 and 1914, he wrote art criticism for Franz Pfemfert's *Die Aktion*, a pacifist journal for art and literature.

In 1915 Serner fled to Zurich, possibly to avoid being conscripted, but perhaps because he was in danger of being arrested after providing Franz Jung, a writer for *Die Aktion*, with a forged doctor's certificate of ill health. In Zurich, he became good friends with the artist Christian Schad and began to publish *Sirius*, a journal representing a broad range of avant-garde art and literature. Serner's point of view, for which *Sirius* served as the platform, was deeply pessimistic but also relatively conservative. Unlike the dadaists, he continued to believe that rational understanding produced the best kind of criticism; in an article published in *Sirius* in March 1916, he was sharply critical of Hugo Ball and Richard Huelsenbeck for their "unforgivable blasphemy against the intellect." Basing his article not on Dada performances at the Cabaret, but on a manifesto that Ball and Huelsenbeck had handed out at their Memorial for Fallen Poets in Berlin in 1915, Serner accused them of amusing "monkey-tricks" that offered no real alternative to what they wanted to destroy.

Why Serner changed his mind about Dada, becoming the author of one of the first and most important manifestos of the movement, remains unclear. Though his earlier writings had been skeptical at moments, they do not approximate the tone of the manifesto, "Letzte Lockerung" (Final Dissolution). Drafted in 1918, read by Serner at the eighth Dada soirée in April 1919, and published in the *Anthologie Dada* in May, this manifesto, Serner's most significant contribution to Zurich Dada, expresses a profound nihilism that Hans Richter would later characterize as the "definitive watchword of all that Dada meant philosophically." In it, Serner annihilated the ground of aesthetic judgment and creation, dismantling convention with irony and obscenity.

Even while participating in Dada events in Zurich, Serner was traveling back and forth between Zurich and Geneva, where he moved in September 1919. His attempts to organize Dada events there, such as the First Dadaist World Congress in late 1919 and the Grand Dada Ball in 1920, were financial failures. In October 1920 Serner arrived in Paris, where he

Walter Serner in Geneva, 1919. Photograph by Christian Schad. Christian Schad Stiftung, Aschaffenburg

met André Breton for the first time and reconvened with Tristan Tzara. However, his campaign of misinformation, which involved placing an ad in a Berlin paper describing himself as the world leader of Dada, was not welcomed by Tzara, who was eager to establish his own priority as the leader of Dada.

Serner spent the years between 1921 and 1939 traveling around Europe on a Czechoslovakian passport, writing and publishing criminal detective stories and novels exploring the underworld of lawlessness, drugs, and prostitution. A central figure in these stories was the *rastaquouère*, or confidence-man. The *rasta* also appears in "Letzte Lockerung," as emblematic of Dada's rebelliousness and antisocial tendencies. Serner himself adopted this persona and was often suspected of embodying the reprehensible traits of the characters he described in his novels.

Beginning in the early 1930s, the Regional Youth Office in Munich began petitioning to add Serner's writings to the government's list

of Trashy and Obscene Literature, and in 1933 the German Coordinating Office for the Control of Obscene Pictures, Writings, and Advertisements ordered four of his short story collections to be confiscated. In 1938 Serner married Dorothea Herz, and the couple settled in Prague. For the first time in almost twenty years, Serner established a permanent residence; he and his wife were both listed in Prague's Jewish registry. Although they were issued references for emigration permits, the Serners were deported in 1942 first to Theresienstadt and then further east, where they likely died in a concentration camp. ALH

SOURCES

Lloyd, Jill, and Michael Peppiatt, eds. *Christian Schad and the Neue Sachlichkeit* [exh. cat., Neue Galerie], New York, 2003.

Wiesner, Herbert, and Ernest Wichner. *Dr. Walter Serner: 1889–1942: Ausstellungsbuch.* Berlin, 1989.

PARIS

Philippe Soupault

born 1897 Chaville, France
died 1990 Paris

Child of a well-off bourgeois family, Philippe Soupault grew up in Paris, where he received a classical education. He was on vacation in London during the summer of 1914 when a telegram from his mother called him back to France with the news that war had broken out. Having been to Germany, where he spent an enjoyable summer, he was skeptical of the war, and also of the jingoism that flourished around it. At age eighteen he was called up to fight, but became the victim of an experimental typhoid vaccine administered by the army that almost killed him. He spent the war recovering in a hospital in Paris, where he first encountered the writings of Comte de Lautréamont and discovered his own desire to become a poet.

Through Guillaume Apollinaire, to whom he had sent some of his poems, Soupault was introduced to the Parisian literary and artistic avant-garde. He accompanied Apollinaire to cafés where poets and writers gathered and to the studios of André Derain, Georges Braque, and Pablo Picasso. In 1917 at one of Apollinaire's café gatherings, he met André Breton. In March 1919 Breton and Soupault launched *Littérature*, an avant-garde journal whose title was meant as an ironic comment on literary pretension. The first few issues included works by Comte de Lautréamont, a lost poem by Arthur Rimbaud bought from the poet's brother-in-law, and *Lettres de guerre* (War Letters) by Jacques Vaché, a poet and friend of Breton's who had recently died. In the autumn of 1919 they published three chapters of *Les champs magnétiques* (The Magnetic Fields), a text feverishly produced by Breton and Soupault according to their newly devised rules of automatic writing. Breton had hit on this process intuitively, but together, Breton and Soupault

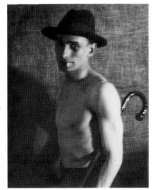

Philippe Soupault, 1921. Photograph by Man Ray, Collection Timothy Baum

refined and theorized it through their readings of Sigmund Freud and the French psychiatrist Pierre Janet.

When Tristan Tzara arrived in the spring of 1920 and Dada events began to take place in Paris, Soupault became one of the participants, known briefly as "Philippe Dada." At the Théâtre de l'oeuvre in March 1920, Soupault appeared onstage in the play *S'il vous plaît* (If you please), a short drama cowritten with Breton in the manner of *Les Champs magnétiques.* At the Salle Gaveau theater, Soupault took part in a spoof of a music hall number, *Le célèbre illusioniste* (The Famous Magician), appearing in blackface wearing a white robe and carrying a kitchen knife he used to puncture red balloons labeled with the names of Dada's targets among the government administration and the Parisian avant-garde. He was also an actor in Tzara's *Vaseline symphonique.* During the performance, he was hit in the face by a steak thrown by an audience member.

Soupault later wrote of his desire during this period to "convert poetry into action." He staged one-person interventions into the lives of ordinary people in Paris: he stopped passersby on the street to ask them if they knew where Philippe Soupault lived, tried to buy oranges from the concierge and sausage from the florist, and offered to exchange drinks with other customers at a bar. He considered these to be his "lived poems." At the Salon Dada in 1921, he exhibited three of his artworks, which consisted of an empty frame filled with red balloons, an eighteenth-century mirror entitled *Portrait d'un imbécile* (Portrait of an Idiot), and a lump of bitumen.

Although Soupault initially refused to renounce Dada when Breton asked for his support for the Congress of Paris in 1922, by 1923 he had also retreated from the movement, becoming active with the surrealists. When Germany gained control of Paris during World War II, Soupault was imprisoned by the Nazis. After his release, he returned to Paris, where he continued to publish and grant interviews well into his eighties. ALH

SOURCES

Aspley, Keith. *The Life and Works of Surrealist Philippe Soupault (1897–1990).* Lewiston, N.Y., 2001.

Polizzotti, Mark. *Revolution of the Mind. The Life of André Breton.* New York, 1995.

Joseph Stella

born 1877 Muro Lucano, Italy
died 1946 New York

Born Giuseppe Michele Stella in a small village outside of Naples, Stella was nineteen years old when he arrived in the United States in 1896. His elder brother Antonio had already established himself as a prominent physician in New York's Italian community, and it was assumed that Stella would also study medicine. After only a year in medical school, Stella began taking classes at the Art Students League. From 1898 to 1901 he attended the New York School of Art, where he acquired his first serious artistic training under William Merritt Chase.

Between 1905 and 1909, Stella built a career as an illustrator for social reform journals and magazines, contributing illustrations for articles on immigrants at Ellis Island, the aftermath of a mine explosion in West Virginia, and conditions for immigrant workers in Pittsburgh's steel mills. Stella would later describe Pittsburgh as "a real revelation...ever pulsating, throbbing with the innumerable explosions of its steel mills." He depicted the mills and the immigrant workers, many of whom were Italian, in a series of naturalist portraits and landscape sketches. It was only after almost two years in Paris, where he saw the work of the Italian futurists and the French cubists and fauves, that Stella would take the American industrial landscape as a subject for his first modern works of art.

Upon his return to America in 1913, Stella began working almost immediately on his first futurist composition. The finished painting, *Battle of Lights, Coney Island, Mardi Gras,* described by one critic as "the last word in modernism" and by another as "a picture...an inhabitant of Mars might make after a visit to New York," launched Stella's career as the first American futurist. His paintings of factories, smokestacks, and bridges became central to artistic and cultural debates about industrialization and its effects on human civilization. He became an active participant in the gatherings of artists and intellectuals hosted at the apartment of Walter and Louise Arensberg, and in late 1915 or early 1916, he met Marcel Duchamp.

Three Heads (Joseph Stella and Marcel Duchamp), 1920. Photograph by Man Ray, Yale University Art Gallery, Gift, Estate of Katherine S. Dreier, 1953

Duchamp's works on glass, along with those of Jean Crotti, probably influenced Stella to experiment with painting on glass; in April 1916 he exhibited two glass paintings at the Montross Gallery. Of these, *Prestidigitator* (a specialist in sleight-of-hand) shows the influence of Duchamp's interest in depicting enigmatic apparatuses and machines.

Although Stella did not fully identify himself with the Dada movement, throughout the late teens and early twenties he maintained friendships and working relationships with the Arensbergs and Duchamp. He served on the board of the Society of Independent Artists, and with Duchamp and Man Ray was on the exhibition committee of Katherine Dreier's Société Anonyme. In November 1920, the Société Anonyme exhibited the collages of the German dadaist Kurt Schwitters, and for the next several years, Stella experimented with the collage medium, producing small compositions from the fragments of paper refuse that the city constantly generated. He often treated these scraps as found objects, simply pasting each dirty and discolored piece of paper onto a support. Although the collages were never exhibited, in 1922 *The Little Review* reproduced two of them in a special issue devoted to Stella.

Although he had become an American citizen in 1923, Stella lived in Italy and Paris from 1926 to 1934, painting a series of Madonnas and Italian landscapes. When the political and economic situation in Europe worsened, he returned to New York and attempted to reestablish his connections with the city's artistic community. Although he was able to show paintings in several exhibitions in the 1930s and early 1940s, his work from this period met with critical incomprehension and even hostility. In 1946, just eight months before Stella died, the Whitney Museum of American Art opened an exhibition of the historical pioneers of American abstraction, which included Stella's famous cubofuturist interpretations of New York. His painting of the Brooklyn Bridge (1919–20) has since become an icon of American modernism. ALH

SOURCES
Haskell, Barbara. *Joseph Stella* [exh. cat., Whitney Museum of American Art], New York, 1994.
Naumann, Francis M. *New York Dada, 1915–1923*. New York, 1994.
Naumann, Francis M. *Making Mischief: Dada Invades New York*. New York, 1996.

ZURICH

Sophie Taeuber

born 1889 Davos, Switzerland
died 1943 Zurich

Sophie Henriette Gertrud Taeuber was born to a German father and Swiss mother and later became one of the only Swiss participants in Zurich Dada activities. Beginning in 1906, she studied decorative painting, drawing, and design at the School of Applied Arts of Saint Gallen. She went to Munich in the fall of 1910, where she studied in the textile workshop of an experimental studio directed by Wilhelm von Debschitz. After a year at the School of Applied Arts in Hamburg, she returned again to Debschitz' studio until she moved to Zurich, where her sister had an apartment.

In the fall of 1915 Taeuber met Hans Arp, an Alsatian artist and poet who would later

Sophie Taeuber with her puppets, Zurich, 1918. Stiftung Hans Arp und Sophie Taeuber-Arp, e.V., Rolandseck

become her husband. She and Arp embarked on an experiment with abstract forms. Taeuber's previous work with abstract geometric compositions in her designs for textiles formed the foundation of their collaborative duo-collages, which were composed of cut paper arranged in strict horizontal and vertical patterns. Taeuber also produced weavings from her own and Arp's designs and was in this respect one of the first artists in Zurich Dada to demonstrate the contribution of the applied arts to the development of abstract art. Throughout her years of involvement with Dada, Taeuber was also a professor of textile design and techniques at the School of Applied Arts in Zurich.

Since 1916 Taeuber had been studying dance with Rudolf von Laban, a Swiss modern dancer and choreographer who advocated a radical form of expressive movement. In April of that year, Taeuber and Mary Wigman, a student of Laban's who would go on to become a prominent modern dancer, began performing at the Cabaret Voltaire dressed in costumes designed by other members of the Dada circle. Because the Zurich School of Applied Arts disapproved of their professors taking part in Dada activities, she danced under a pseudonym.

In 1918 Taeuber received a commission to design the stage sets and marionettes for a production of Carlo Gozzi's play *Il re cervo* (König Hirsch / King Stag), adapted by Werner Wolff and René Morax. It was the first performance of its kind to integrate Dada and psychoanalysis. The animating conflict of the play was the 1913 controversy between Sigmund Freud and Carl Jung over the character of the libido. Taeuber commented ironically on this antagonism by creating marionettes whose inherent freedom from the constraints of human anatomy and motion allowed them to manifest interior, or psychic, states in their physical forms. Between 1920 and 1926 Taeuber traveled extensively, taking vacations with Hans Arp that were often spent in the company of other dadaists like Max Ernst, Paul Eluard, and Tristan Tzara, or Kurt Schwitters and Hannah Höch. After settling in Strasbourg, Taeuber received a commission to decorate an entertainment complex in the center of town called the Aubette. She, Arp, and Theo van Doesburg shared the project. Arp and Taeuber moved to Paris in 1928, where they lived until 1940, when World War II forced them to flee to southern France. Tragically, Taeuber died of accidental gas poisoning in 1943 while she and Arp were in Zurich attempting to obtain passage to the United States. ALH

SOURCES
Krupp, Walburga, and Christoph Vögele. *Variations. Sophie Taeuber-Arp. Arbeiten auf Papier* [exh. cat., Kunstmuseum Solothurn], Heidelberg, 2002.
Kuthy, Sandor. *Sophie Taeuber-Hans (Jean) Arp*. Bern, 1988.
Redberg, Margina. *Farbe und Form: Sophie Taeuber-Arp im Dialog mit Hans Arp*. Bad Homburg, 2002.
Sophie Taeuber-Arp [exh. cat., Musée d'art moderne de la Ville de Paris], Paris, 1989.

ZURICH
PARIS

Tristan Tzara

born 1896 Moinesti, Romania
died 1963 Paris

Poet and tirelessly energetic propagandist for Dada, Tristan Tzara, whose given name was Samuel Rosenstock, was born into a well-off Jewish family in Romania. He attended a French private school in Bucharest as a youth and while in high school met Ion Vinea and Marcel Janco, both of whom shared his interest in French poetry. Together they founded the literary magazine *Simbolul*, in which Tzara, under the pseudonym S. Samyro, published a selection of poems written in Romanian and influenced by French symbolism.

In 1915 seemingly as the result of a family scandal, Tzara's parents sent him to Zurich, where he enrolled at a university to study philosophy. His first poem signed with the name Tristan Tzara (ţara being the Romanian for land) appeared in October of that year. Romania did not enter the war until 1916, but it is not clear when Tzara might have been first drafted for service. In the fall of 1916 he received papers granting him a deferral of military service, and in 1917 he was relieved from military duty.

Shortly after his arrival in Zurich, Tzara reunited with Janco and Janco's brother Georges, with whom, according to Hugo Ball's diary, he attended the opening night of the Cabaret Voltaire. Over the course of the year in 1916, Tzara's activities at the Cabaret of reciting his poems and those of others led to

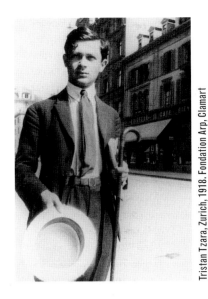

Tristan Tzara, Zurich, 1918. Fondation Arp, Clamart

a more active role in coordinating and planning Dada events. He also, probably through the influence of Richard Huelsenbeck, became interested in African poetry. He incorporated into his poetry scraps of sound, bits of newspaper fragments, and phrases resembling African dialects. Beginning in November 1916, Tzara collected and translated African and Oceanic poems from anthropology magazines in the Zurich library. The *soirées nègres* at the Cabaret Voltaire led to Tzara's lifelong collecting of African and Oceanic art.

On 23 July 1918, in Zurich's Meise Hall, Tzara recited his "Manifeste Dada 1918." Also published in *Dada 3*, this radical dadaist declaration reached André Breton in Paris, thus beginning the connection that would bring Tzara and Dada to Paris a year later. It was through Tzara's efforts that Dada in Zurich reached a broad international audience, and he has often been described as embodying the migratory quality of Dada.

Tzara arrived in Paris and burst upon the avant-garde literary scene in 1920 at a poetry reading organized by *Littérature*. He brought to Dada in Paris a skill in managing events and audiences, which transformed literary gatherings into public performances that generated enormous publicity. He remained the editor of *Dada*, which appeared in France until 1922. As the cohesiveness of the Dada movement in Paris was disintegrating, Tzara published *Le coeur à barbe* (The Bearded Heart), a journal reacting against Breton and Francis Picabia.

From 1930 to 1935, Tzara contributed to the definition of surrealist activities and ideology. He was also an active communist sympathizer and was a member of the Resistance during the German occupation of Paris. Tzara remained a spokesman for Dada, and in 1950 delivered a series of nine radio addresses to his Parisian audience discussing the topic of "the avant-garde revues in the origin of the new poetry." In 1962 Tzara traveled for the first time to Africa. He died in Paris the next year. ALH

SOURCES

Erlhoff, Michael. "'Dit le bonbon': Tristan Tzara in Zurich." In *Dada in Zurich: A Clown's Game from Nothing*, ed. Brigitte Pichon and Karl Riha, New York, 1996.

Ilk, Michael. *Brancusi, Tzara, und die Rumänische Avantgarde*. Rotterdam, 1997.

Peterson, Elmer. *Tristan Tzara: Dada and Surrational Theorist*. New Brunswick, 1971.

Schrott, Raoul. *Dada 15/25*. Innsbruck, 1992.

NEW YORK
Beatrice Wood

born 1893 San Francisco, USA
died 1998 Ojai, California, USA

Beatrice Wood was born into a wealthy upper-middle-class family in California. Her father was a real estate broker and her mother a socially ambitious woman who intended her daughter to enter New York society. To that end, Wood was educated at private girls' schools in the United States and France. In 1912 when she was nineteen, Wood returned to Paris to study painting at the Académie Julian, but quickly became passionate about the theater, studying acting and dance with members of the Comédie-Française. When World War I broke out, her parents brought her back to New York, where she began acting with the French National Repertory Theater.

Eager to rebel against her mother's control, Wood took as her lover Henri-Pierre Roché, a member of the French diplomatic service, writer, and collector of modern art. In the fall of 1916 in a friend's hospital room she met Marcel Duchamp, to whom she declared that anyone could make modern art. When he challenged her to try, she produced a drawing called *Marriage of a Friend* that delighted Duchamp so much that he had it published in an issue of the small avant-garde magazine *Rogue*. He also gave her a key to his studio so that she had a place to draw and paint, activities her mother forbade. She, Duchamp, and Roché soon became fast friends, spending much of their time at Walter and Louise Arensberg's apartment in the company of New York's avant-garde artists and writers. Wood recalls her introduction to modern art at the Arensbergs' house as shocking,

describing the pictures as "the most hideous collection of paintings I had ever seen." In her drawings and watercolors from this period, Wood represented her interactions with these friends and the scenes of their gatherings.

In 1917 at Duchamp's instigation, she submitted two paintings to the exhibition of the Society of Independent Artists. Her work, *A Little Water in Some Soap*, a painting of a nude in a bathtub with a real piece of shell-shaped soap nailed over its private parts, caused both laughter and anger among visitors and critics of the exhibition. After Duchamp's *Fountain* was excluded from the exhibition, Wood, Duchamp, and Roché dedicated the second issue of their magazine *The Blindman* to the ensuing scandal. Wood wrote a short text arguing that R. Mutt, by choosing the urinal, had given the object a "new thought." In the spirit of the joke, she also contributed a stuffy "letter from a mother" objecting to the work and arguing that art should uplift and purify the soul. Wood's drawing of a stick figure thumbing its nose at the world was adopted for the poster announcing the Blindman's Ball, an event held to celebrate the exhibition and the publication of the magazine.

In 1918 Wood left for Montreal with a two-year theater contract. When she returned, the Arensbergs were making preparations to leave for Hollywood; the group surrounding them gradually dissipated. Wood stayed in New York until 1928, when she too went to California. Over the course of sixty years, she gained international recognition for her ceramic work. She continued to work in her studio past her one hundredth birthday. When she died in 1998, she was 105 years old. ALH

SOURCES

Clark, Garth. *Gilded Vessel: The Lustrous Art and Life of Beatrice Wood*. Madison, Wis., 2001.

Franklin, Paul B. "Beatrice Wood, Her Dada…and Her Mama." In Naomi Sawelson-Gorse, ed. *Women in Dada: Essays on Sex, Gender, and Identity*, 104–138. Cambridge, Mass., 1998.

Wood, Beatrice. *I Shock Myself: The Autobiography of Beatrice Wood*. San Francisco, 1985.

Beatrice Wood, c. 1917. Francis M. Naumann Fine Art, New York

SELECTED BIBLIOGRAPHY
AURÉLIE VERDIER

The bibliography is arranged in sections:
General Sources; Dada Cities; Individual Artists,
divided into primary and secondary sources;
and Selected Dada Periodicals.

General Sources

Ades, Dawn. *Dada and Surrealism*. London, 1974.

————. *Dada and Surrealism Reviewed* [exh. cat.,
Arts Council of Great Britain] (London, 1978).

————. *Photomontage*. London, 1976.

Aiken, Edward A. "Reflections on Dada and
the Cinema," *Post Script: Essays in Films and the
Humanities* 3, no. 2 (Winter 1984): 5–19.

Arnaud, Noël. "Les métamorphoses historiques
de Dada," *Critique* 134 (July 1958): 579–604.

Backes-Haase, Alfons. *Kunst und Wirklichkeit:
Zur Typologie des Dada-Manifests*. Frankfurt am
Main, 1992.

Baker, George. "The Artwork Caught by the
Tail," *October* 97 (Summer 2001): 51–90.

————. "Entr'acte," *October* 105 (Summer
2003): 159–165.

Barr, Alfred H., Jr., ed. *Fantastic Art, Dada,
Surrealism* [exh. cat., Museum of Modern Art]
New York, 1936.

Béhar, Henri, and Michel Carassou. *Dada,
histoire d'une subversion*. Paris, 1990.

Benjamin, Walter. "The Work of Art in the Age
of Mechanical Reproduction." In *Illuminations*,
trans. Harry Zohn, 217–251 (New York, 1968).

Benson, Timothy O., and Éva Forgács, eds.
*Between Worlds: A Sourcebook of Central European
Avant-Gardes, 1910–1930*. Cambridge,
Mass., 2002.

Berg, Hubert van den. *Avantgarde und Anarchis-
mus: Dada in Zürich und Berlin*. Heidelberg, 1999.

————. "Dadaist Subjectivity and the Politics
of Indifference: On Some Contrasts and
Correspondences between Dada in Zürich
and Berlin." In *Subjectivity*, ed. Willem
van Reijen and Willem G. Weststeijn, 29–57.
Amsterdam and Atlanta, 2000.

————, ed. *Doesburg/Schwitters. Holland ist
Dada: Ein Feldzug*. Hamburg, 1992.

————. *The Import of Nothing: How Dada Came,
Saw, and Vanished in the Low Countries (1915–
1929)*. New York, 2002.

Bigsby, Christopher William Edgar. *Dada and
Surrealism*. London, 1972.

Bohn, Willard. *The Dada Market: An Anthology
of Poetry*. Carbondale, Ill., 1993.

Buffet-Picabia, Gabrielle. *Rencontre avec Picabia,
Apollinaire, Cravan, Duchamp, Arp, Calder*.
Paris, 1977.

Buschkühle, Carl-Peter. *Dada. Kunst in der
Revolte: Eine existenzphilosophische Analyse des
Dadaismus*. Essen, 1985.

Caradec, François. "Dada avec/sans parangon."
In *Art et Publicité 1890–1990* [exh. cat., Musée
national d'art moderne, Centre Georges
Pompidou] (Paris, 1990), 216–227.

Carrouges, Michel, and Jean Clair. *Les machines
célibataires* [exh. cat., Musée des arts décoratifs]
(Paris, 1976).

Chang, Fang-Wei, ed. *Dada Conquers: The History,
the Myth, and the Legacy*. Taipei, 1988.

Coutts-Smith, Kenneth. *Dada*. London, 1970.

Dachy, Marc. *The Dada Movement, 1915–1923*.
New York, 1990.

Dada. Austellung zum 50 jährigen Jubiläum
[exh. cat., Kunsthaus Zürich] (Zurich, 1966).

Dada [exh. cat., Moderna Museet]
(Stockholm, 1966).

"Dada," special issue, *Les cahiers du Musée
national d'art moderne* 88 (Summer 2004), ed.
Jean-Pierre Criqui.

"Dada," special issue, *October* 105 (Summer
2003), ed. Leah Dickerman.

Dada/Constructivism [exh. cat., Annely Juda
Fine Art] (London, 1984).

Dada y Constructivismo [exh. cat., Centro de Arte
Reina Sophia] (Madrid, 1989).

Dickerman, Leah. "Dada Gambits," *October*
105 (Summer 2003): 4–12.

————. "Dada's Solipsism," *Documents* 19
(Fall 2000): 16–19.

Dickerman, Leah, with Matthew S. Witkovsky,
eds. *The Dada Seminars*. Washington, DC, 2005.

Elderfield, John. "On the Dada-Constructivist
Axis," *Dada/Surrealism* 13 (1984): 5–16.

Elger, Dietmar. *Dadaism*. Cologne, 2004.

Elsaesser, Thomas. "Dada/Cinema," *Dada/
Surrealism* 15 (1986): 13–27.

Erickson, John D. *Dada: Performance, Poetry, and
Art*. Boston, 1984.

Fischer, Hartwig, ed. *Schwitters-Arp* [exh. cat.,
Kunstmuseum Basel] (Ostfildern-Ruit, 2004).

Foster, Stephen C., ed. *Dada: The Coordinates of
Cultural Politics*. New York, 1996.

————, ed. *Dada/Dimensions*. Ann Arbor,
Mich., 1985.

————, ed. "Event" Arts and Art Events. Ann
Arbor, Mich., 1988.

————, ed. *The World According to Dada*. Taipei
and Iowa City, 1988.

Foster, Stephen C., and Rudolf E. Kuenzli,
eds. *Dada Spectrum: The Dialectics of Revolt*.
Madison, Wi., 1979.

Foster, Stephen C., Rudolf E. Kuenzli,
and Richard Sheppard. *Dada Artifacts* [exh. cat.,
University of Iowa Museum of Art] (Iowa
City, 1978).

Foster, Stephen C., and Estera Milman,
eds. *The Avant-Garde and the Text*. Providence,
R.I., 1987.

Fraser, James, and Steven Heller. *The Malik
Verlag. 1916–1947: Berlin, Prague,
New York* [exh. cat., Goethe House]
(New York, 1984).

Freeman, Judi, and John C. Welchman. *The
Dada and Surrealist Word-Image*. Cambridge,
Mass., 1989.

Gale, Matthew. *Dada and Surrealism*.
London, 1997.

Gibson, Michael. *Duchamp Dada*. Paris, 1991.

Giroud, Michel, ed. *Dada Zurich-Paris. 1916–
1922*. Paris, 1981.

Gordon, Mel, ed. *Dada Performance*.
New York, 1987.

Greenberg, Allan C. *Artists and the Revolution: Dada and the Bauhaus, 1917–1925.* Ann Arbor, Mich., 1979.

Grossman, Manuel L. *Dada: Paradox, Mystification, and Ambiguity in European Literature.* New York, 1971.

Haas, Patrick de. *Cinéma intégral: De la peinture au cinéma dans les années vingt.* Paris, 1986.

Haenlein, Carl-Albrecht, ed. *Dada, Photographie und Photocollage* [exh. cat., Kestner-Gesellschaft] (Hannover, 1979).

Hedges, Inez. *Languages of Revolt: Dada and Surrealist Literature and Film.* Durham, N.C., 1985.

Hering, Karl Heinz, and Ewald Rathke, eds. *Dada: Dokumente einer Bewegung* [exh. cat., Kunsthalle und Kunstverein für die Rheinlande und Westfalen] (Dusseldorf, 1958).

Hippen, Reinhard. *Erklügelte Nervenkultur: Kabarett der Neopathetiker und Dadaisten.* Zurich, 1991.

Hopkins, David. *Marcel Duchamp and Max Ernst: The Bride Shared.* Oxford, 1998.

———. "Men before the Mirror: Duchamp, Man Ray, and Masculinity," *Art History* 21, no. 3 (September 1998): 303–323.

Hugnet, Georges. *L'aventure Dada (1916–1922)* [exh. cat., Galerie de l'Institut] (Paris, 1957).

———. *Dictionnaire du dadaïsme, 1916–1922.* Paris, 1976.

Janecek, Gerald, and Toshiharu Omuka, eds. *The Eastern Dada Orbit: Russia, Georgia, Ukraine, Central Europe and Japan.* New York, 1998.

Kuenzli, Rudolf E., ed. *Dada and Surrealist Film.* Cambridge, Mass., 1996.

La Fuente, Véronique de. *Dada à Barcelone, 1914–1918.* Ceret, 2001.

Last, Rex William. *German Dadaist Literature: Kurt Schwitters, Hugo Ball, Hans Arp.* New York, 1973.

Leavens, Ileana. *From "291" to Zurich: The Birth of Dada.* Ann Arbor, Mich., 1983.

Lehner, Dieter. *Individualanarchismus und Dadaismus: Stirnerrezeception und Dichterexitenz.* Frankfurt am Main and New York, 1988.

Lemoine, Serge. *Dada.* Paris, 1986.

Lippard, Lucy R., ed. *Dadas on Art.* Englewood Cliffs, N.J., 1971.

Lista, Giovanni et al. *Dada, l'arte della negazione* [exh. cat., Palazzo delle Esposizioni] (Rome, 1994).

Matthews, J. H. *Theatre in Dada and Surrealism.* New York, 1974.

Maurer, Evan. "Dada and Surrealism." In *Primitivism in Twentieth-Century Art: Affinity of the Tribal and the Modern.* Vol. 2 [exh. cat., Museum of Modern Art] (New York, 1984), 535–593.

Melzer, Annabelle. *Latest Rage in the Big Drum: Dada and Surrealist Performance.* Ann Arbor, Mich., 1980.

Merte, Angela, Karl Riha, and Jörgen Schäfer, eds. *Dada total: Manifeste, Aktionen, Texte, Bilder.* Stuttgart, 1994.

Meyer, Raimund et al. *Dada Global* [exh. cat., Kunsthaus Zürich] (Zurich, 1994).

Meyer, Reinhart et al. *Dada in Zürich und Berlin: 1916–1920.* Kronberg, 1973.

Morteo, Gian Renzo, and Ippolito Simonis, eds. *Teatro Dada.* Turin, 1988.

Motherwell, Robert, ed. *The Dada Painters and Poets: An Anthology.* New York, 1951.

Naumann, Francis M. "Dada Did It," *Art in America* 82 (June 1994): 66–69.

Neff, Terry Ann R., ed. *In the Mind's Eye: Dada and Surrealism.* Chicago, 1984.

Pegrum, Mark A. *Challenging Modernity: Dada between Modern and Postmodern.* New York, 2000.

Roters, Eberhard, and Hanne Bergius, eds. *Dada in Europa. Werke und Dokumente* [exh. cat., Städtische Galerie im Städelschen Kunstinstitut] (Frankfurt am Main, 1977).

Rothschild, Deborah, Ellen Lupton, and Darra Goldstein. *Graphic Design in the Mechanical Age: Selections from the Merrill C. Berman Collection.* New Haven and London, 1998.

Rubin, William S. *Dada, Surrealism, and Their Heritage* [exh. cat., Museum of Modern Art] (New York, 1968).

———. *Dada and Surrealist Art.* New York, 1968.

Rumold, Rainer. "The Dadaist Text: Politics, Aesthetics, and Alternative Cultures," *Visible Language* 21, nos. 3–4 (Summer–Autumn 1987): 413–451.

Sanouillet, Michel. *Dada 1915–1923.* London and New York, 1969.

———. "Le dossier de Dadaglobe," *Cahiers Dada-surréalisme* (October 1966): 111–143.

Sawelson-Gorse, Naomi, ed. *Women in Dada: Essays on Sex, Gender, and Identity.* Cambridge, Mass., 1998.

Sayag, Alain, and Claire Blanchon. *Cinéma dadaïste et surréaliste* [exh. cat., Musée national d'art moderne, Centre Georges Pompidou] (Paris, 1976).

Schaschke, Bettina. *Dadaistische Verwandlungskunst: Zum Verhältnis von Kritik und Selbstbehauptung in Dada Berlin und Köln.* Berlin, 2004.

Schippers, K. *Holland Dada.* Amsterdam, 1974.

Schnapp, Jeffrey T. "Bad Dada (Evola)." In *The Dada Seminars,* ed. Leah Dickerman with Matthew S. Witkovsky, 31–55. Washington, DC, 2005.

Schwarz, Arturo et al. *Almanacco Dada: Antologia letteraria-artistica, cronologia, repertorio delle riviste.* Milan, 1976.

———. *Dada in Italia, 1916–1966* [exh. cat., Galleria Schwarz] (Milan, 1966).

Sers, Philippe. "L'ordre de l'image: Sur Eggeling, Richter, et le cinéma dadaïste," *La part-de-l'oeil* 9 (1993): 167–193.

Sheppard, Richard. *Modernism–Dada–Postmodernism.* Evanston, 2000.

Sheppard, Richard, ed. *Dada: Studies of a Movement.* Chalfont St. Giles, 1980.

———, ed. *New Studies in Dada: Essays and Documents.* Driffield, 1981.

———, ed. *Zürich-Dadaco-Dadaglobe: The Correspondence between Richard Huelsenbeck, Tristan Tzara, and Kurt Wolff (1916–1924).* Driffield, 1982.

Sloterdijk, Peter. *Critique of Cynical Reason.* Trans. Michael Eldred. Minneapolis, 1987.

Herbert, Robert L., Eleanor S. Apter, and Elise K. Kenney, eds. *The Société Anonyme and The Dreier Bequest at Yale University: A Catalogue Raisonné*. New Haven, Conn., 1984.

————. *Irrational Modernism: A Neurasthenic History of New York Dada*. Cambridge, Mass. 2003.

————. "New York Dada: Beyond the Readymade." In *The Dada Seminars*, ed. Leah Dickerman with Matthew S. Witkovsky, 151–171. Washington, DC, 2005.

————. "'Women' in Dada: Elsa, Rrose, and Charlie." In *Women in Dada: Essays on Sex, Gender, and Identity*, ed. Naomi Sawelson-Gorse, 142–172. Cambridge, Mass., 1998.

Kuenzli, Rudolf E., ed. *New York Dada*. New York, 1986.

Mattis, Olivia. "Varese and Dada." In *Music and Modern Art*, ed. James Leggio, 129–161. New York, 2002.

Naumann, Francis M. "The Big Show: The First Exhibition of the Society of Independent Artists," parts 1 and 2, *Artforum* 17, no. 6 (February 1979): 34–39; no. 8 (April 1979): 49–53.

————. *Making Mischief: Dada Invades New York* [exh. cat., Whitney Museum of American Art] (New York, 1996).

————. *New York Dada 1915–1923*. New York, 1994.

————. "The New York Dada Movement: Better Late Than Never," *Arts* 54 (February 1980): 143–149.

Ring, Nancy J. "New York Dada and the Crisis of Masculinity: Man Ray, Francis Picabia, and Marcel Duchamp in the United States, 1913–1921." Ph.D. diss., Northwestern University, 1991.

Schwarz, Arturo. *New York Dada: Duchamp, Man Ray, Picabia* [exh. cat., Städtische Galerie im Lenbachhaus] (Munich, 1973).

Seckel, Hélène. "Dada à New York." In *Paris-New York* [exh. cat., Musée national d'art moderne, Centre Georges Pompidou] (Paris, 1977), 342–367.

Tashjian, Dickran. "New York Dada and Primitivism." In *Dada Spectrum: The Dialectics of Revolt*, ed. Stephen C. Foster and Rudolf E. Kuenzli, 115–144. Madison, Wi., 1979.

————. *Skyscraper Primitives: Dada and the American Avant-Garde, 1910–1925*. Middletown, Conn., 1975.

Watson, Steven. *Strange Bedfellows: The First American Avant-Garde*. New York, 1991.

Zabel, Barbara. "The Machine as Metaphor, Model, and Microcosm: Technology in American Art 1915–30," *Arts Magazine* 57 (December 1982): 100–105.

Zayas, Marius de. *How, When, and Why Modern Art Came to New York*. Ed. Francis M. Naumann. Cambridge, Mass., 1996.

PARIS

Béhar, Henri, ed. *Chassé-croisé Tzara-Breton*. Paris, 1997.

————. *Étude sur le théâtre Dada et surréaliste*. Paris, 1967.

Benedikt, Michael, and George Wellwarth. *Modern French Theatre: The Avant-Garde, Dada, and Surrealism: An Anthology of Plays*. New York, 1964.

Blake, Jody. "Ragging the War." In *Le Tumulte Noir: Modernist Art and Popular Entertainment in Jazz-Age Paris, 1900–1930*. University Park, Penn., 1999, 59–82.

Bonnet, Marguerite. *L'Affaire Barrès*. Paris, 1987.

Carassou, Michel. *Jacques Vaché et le groupe de Nantes*. Paris, 1986.

Carroll, Noël. "Entr'acte, Paris and Dada" (1977), reprinted in Carroll, *Interpreting the Moving Image*. Cambridge, Mass., 1998, 26–33.

Caws, Mary Ann. *The Poetry of Dada and Surrealism: Aragon, Breton, Tzara, Eluard, and Desnos*. Princeton, N.J., 1970.

Debray, Cécile. "'L'affaire Dada': Le 25 février 1920 à la Closerie des Lilas," *Les cahiers du Musée national d'art moderne* 88 (Summer 2004): 100–109.

Gide, André. "Dada," *Nouvelle revue française* 2, no. 79 (1 April 1920): 447–481.

Gleizes, Albert. "L'affaire Dada," *Action* 3 (April 1920): 26–32.

Hulten, Pontus. *The Surrealists Look at Art: Eluard, Aragon, Soupault, Breton, Tzara*. Venice, Cal., 1990.

Massot, Pierre de. *De Mallarmé à 391*. Saint Raphael, 1922.

Peterson, Elmer, ed. *Paris Dada: The Barbarians Storm the Gates*. New York, 2001.

Pierre, Arnauld. "In the 'Confrontation of Modern Values': A Moral History of Dada in Paris." In *The Dada Seminars*, ed. Leah Dickerman with Matthew S. Witkovsky, 241–267. Washington, DC, 2005.

Poupard-Lieussou, Yves, and Michel Sanouillet. *Documents Dada*. Paris, 1974.

Read, Peter. "Apollinaire et Dada: Les limites de l'aventure," *Essays in French Literature* 17 (1980): 70–80.

Samaltanos, Katia. *Apollinaire, Catalyst for Primitivism, Picabia, and Duchamp*. Ann Arbor, Mich., 1984.

Sanouillet, Michel. *Dada à Paris*. 2 vols. Paris, 1993.

————, and Dominique Baudouin. *Dada: réimpression intégrale et dossier critique de la revue publiée de 1917 à 1922 par Tristan Tzara*. 2 vols. Nice, 1983.

Schwarz, Arturo. "Paris 1918–1922. Breton-Tzara: Divergences et convergences," *Mélusine* 17 (1997): 69–82.

Short, Robert. "Paris Dada and Surrealism." In *Dada: Studies of a Movement*, ed. Richard Sheppard, 75–98. Chalfont St. Giles, 1980.

Silver, Kenneth. *Esprit de Corps: The Art of the Parisian Avant-Garde and the First World War, 1914–1925*. Princeton, N.J., 1989.

Sorrell, Marin, ed. "Jacques Vaché's Letters from the Front (1916–1918): A Translation of Lettres de Guerre with Introduction and Notes," *Journal of European Studies* (March–June 1979): 99–120.

White, Mimi. "Two French Dada Films: Entr'Acte and Emak Bakia," *Dada/Surrealism* 13 (1984): 5–19.

Individual Artists

*Artists' writings and interviews precede
secondary references.*

Louis Aragon

Aragon, Louis. *Aragon. Chroniques.* Ed. Barnard
Leuilliot. Paris, 1998.

————. *Aragon. Oeuvres romanesques complètes.*
Ed. Daniel Bougnoux. Paris, 1997.

————. *Projet d'histoire littéraire contemporaine.*
Ed. Marc Dachy. Paris, 1994.

· · ·

Daix, Pierre. *Aragon. Une vie à changer.*
Paris, 1975.

Germain, André. *De Proust à Dada.* Paris, 1924.

Céline Arnauld

*Anthologie Céline Arnauld: Morceaux choisis de 1919
à 1935.* Brussels, 1936.

Hans (Jean) Arp

Arp, Jean. *Arp on Arp: Poems, Essays, Memories.*
Ed. Marcel Jean. Trans. Joachim
Neugroschel. New York, 1969.

————. *Gesammelte Gedichte.* Vol. 1, ed.
Marguerite Arp-Hagenbach and Peter Schifferli.
Wiesbaden, 1963.

————. *On My Way: Poetry and Essays,
1912–1947.* New York, 1948.

————. *Unsern täglichen Traum. Erinnerungen,
Dichtungen und Betrachtungen aus den Jahren
1914–1954.* Zurich, 1955.

Arp, Jean, with El Lissitzky. *Die Kunstismen/Les
ismes de l'art/The Isms of Art, 1914–1924.*
Erlenbach-Zürich, 1925.

· · ·

Andreotti, Margherita. *The Early Sculpture of
Jean Arp.* Ann Arbor, Mich., 1989.

Bolliger, Hans, Guido Magnaguagno, and
Christian Witzig. *Hans Arp zum 100. Geburstag
(1886–1986): ein Lese- und Bilderbuch* [exh. cat.,
Stiftung Hans Arp und Sophie Taeuber-Arp
e.V., Bahnhof Rolandseck] (Zurich, 1986).

Borràs, Maria Lluïsa, ed. *Jean Arp, l'invention
de la forme* [exh. cat., Palais des Beaux Arts,
Brussels] (Anvers and Brussels, 2004).

Fauchereau, Serge. *Hans Arp.* Paris, 1988.

Fer, Briony. "The Laws of Chance." In *On
Abstract Art,* 55–76. New Haven, Conn., 1997.

Grieve, Alastair. "Arp in Zurich." In *Dada
Spectrum: The Dialectics of Revolt,* ed. Stephen C.
Foster and Rudolf E. Kuenzli, 175–205.
Madison, Wi., 1979.

Hancock, Jane, and Stefanie Poley. *Arp, 1886–
1966* [exh. cat., Minneapolis Institute of Arts]
(Minneapolis, 1987).

Last, Rex William. *Hans Arp, the Poet of Dadaism.*
London, 1969.

Rathke, Christian. *Hans/Jean Arp: Korrespondenz
der Formen* [exh. cat., Stiftung Schleswig-
Holsteinische Landesmuseen, Schloss Gottorf,
Schleswig] (Schleswig, 1999).

Rau, Bernd. *Jean Arp. The Reliefs: Catalogue of
Complete Works.* New York, 1981.

Read, Herbert. *The Art of Jean Arp.* New
York, 1968.

Soby, James Thrall, ed. *Arp* [exh. cat., Museum
of Modern Art] (New York, 1958).

Watts, Harriet. *Hans Arp und Sophie Taeuber-Arp.
Die Elemente der Bilder und Bücher* [exh. cat.,
Herzog August Bibliotek] (Wolfenbüttel, 1989).

Johannes Baader

Baader, Johannes. *Oberdada: Schriften, Manifeste,
Flugblätter, Billets, Werke und Taten,* ed. Hanne
Bergius, Norbert Miller, and Karl Riha. Lahn-
Giessen, 1977.

· · ·

Riha, Karl, ed. *Das Oberdada: Johannes Baader,*
Hofheim, 1991.

Sudhalter, Adrian V. "Johannes Baader and the
Demise of Wilhelmine Culture: Architecture,
Dada, and Social Critique, 1875–1920." Ph.D.
diss., Institute of Fine Arts, New York Univer-
sity, 2005.

White, Michael. "Johannes Baader's 'Plasto-
Dio-Dada-Drama': The Mysticism of the Mass
Media," *Modernism/Modernity* 8, no. 4 (Novem-
ber 2001): 583–602.

Johannes Baargeld

Vitt, Walter. *Auf der Suche nach der Biographie des
Kölner Dadaisten Johannes Theodor Baargeld.*
Starnberg, 1977.

————. *Bagage de Baargeld: Neues über den Zen-
trodada aus Köln.* Starnberg, 1985.

Hugo Ball

Ball, Hugo. *Flight Out of Time: A Dada Diary.* Ed.
John Elderfield. Trans. Ann Raimes. Berkeley,
1996, 1974 (originally published as *Die Flucht
aus der Zeit.* Munich and Leipzig, 1927).

————. *Gesamelte Gedichte.* Ed. A. Schütt-
Hennings. Zurich, 1963.

————. *Tenderenda the Fantast.* In *Ball and
Hammer: Hugo Ball's Tenderenda the Fantast,*
ed. Jeffrey Schnapp, trans. Jonathan Hammer.
New Haven, Conn., 2002 (originally published
as *Tenderenda der Phantast.* Zurich, 1967).

Ball, Hugo, and Emmy Hennings. *Damals in
Zürich: Briefe aus den Jahren 1915–1917.*
Zurich, 1978.

· · ·

Egger, Eugen. *Hugo Ball. Ein Weg aus dem Chaos.*
Olten, 1951.

Hennings, Emmy. *Ruf und Echo: Mein Leben mit
Hugo Ball.* Einsiedeln, 1953.

Mann, Philip. *Hugo Ball: An Intellectual Biography.*
London, 1987.

Riha, Karl. "I Was Born a Great Enthusiast:
On Hugo Ball." In *Dada Zurich: A Clown's Game
from Nothing,* ed. Brigitte Pichon and Karl
Riha, 60–68. New York, 1996.

Steinbrenner, Manfred. "Flucht aus der Zeit?"
*Anarchismus, Kulturkritik und christliche Mystik.
Hugo Balls "Konversionen."* Frankfurt am Main
and New York, 1985.

Steinke, Gerhardt Edward. *The Life and Work of
Hugo Ball, Founder of Dadaism.* The Hague and
Paris, 1967.

Teubner, Ernst, ed. *Hugo Ball (1886–1986): Leben
und Werke* [exh. cat., Wasgauhalle Pirmasens]
(Berlin, 1986).

Toman, Jindřich. "Hugo Ball und der Dadais-
mus in Zürich: Eine Analyse des literarischen
Lebens der Avantgarde." Master's thesis,
Albert-Ludwigs-Universität, 1972.

Wenzel White, Erdmute. *The Magic Bishop: Hugo Ball, Dada Poet*. Columbia, S.C., 1998.

André Breton

Breton, André. "Artificial Hells: Inauguration of the '1921 Dada Season,'" trans. Matthew S. Witkovsky, *October* 105 (Summer 2003): 137–144.

————. *Conversations: The Autobiography of Surrealism*. Trans. Mark Polizzotti. New York, 1993.

————. *Entretiens 1913–1952*. Paris, 1952.

————. *The Lost Steps*. Trans. Mark Polizzotti. Lincoln, Neb., 1996.

————. *Oeuvres complètes*. Vol. 1, ed. Marguerite Bonnet, Philippe Bernier, Etienne-Alain Hubert, and José Pierre. Paris, 1988.

. . .

Balakian, Anna. *André Breton: Magus of Surrealism*. New York, 1971.

Balakian, Anna, and Rudolf E. Kuenzli, eds. *André Breton Today*. New York, 1989.

Bonnet, Marguerite. *André Breton: Naissance de l'aventure surréaliste*. Paris, 1975.

Matthews, J. H. *André Breton: Sketch for an Early Portrait*. Amsterdam and Philadelphia, 1986.

Monod-Fontaine, Isabelle, and Agnès de la Beaumelle. *André Breton. La beauté convulsive* [exh. cat., Musée national d'art moderne, Centre Georges Pompidou] (Paris, 1991).

Polizzotti, Mark. *Revolution of the Mind: The Life of André Breton*. New York, 1995.

Sheringham, Michael. *André Breton: A Bibliography*. London, 1972.

Vielwahr, André. *Sous le signe des contradictions: André Breton de 1913 à 1924*. Paris, 1980.

Witkovsky, Matthew S. "Dada Breton," *October* 105 (Summer 2003): 125–136.

John Covert

Klein, Michael. *John Covert, 1882–1960*. Washington, DC, 1976.

Mazow, Leo G., ed. *John Covert Rediscovered*. [exh. cat., Palmer Museum of Art] (University Park, Penn., 2003).

Jean Crotti

Crotti, Jean. *Courants d'air sur le chemin de ma vie. Poèmes et dessins, 1916–1921*. Paris, 1941.

. . .

Camfield, William, and Jean-Hubert Martin. TABU DADA: *Jean Crotti et Suzanne Duchamp 1915–1922* [exh. cat., Kunsthalle Bern] (Bern, 1983).

Ross, Lauren. "Jean Crotti." In *Making Mischief: Dada Invades New York* [exh. cat., Whitney Museum of American Art] (New York, 1996), 197.

Paul Dermeé

Paul Dermée. *Z1 with Notes*. Ed. Elmer Peterson. Colorado Springs, 1972.

Otto Dix

Biro, Matthew. "Allegorical Modernism: Carl Einstein on Otto Dix," *Art Criticism* 15, no. 1 (2000): 46–70.

————. "Walter Benjamin, Otto Dix, and the Question of Statigraphy," *Res* 40 (Autumn 2001): 153–176.

Herzogenrath, Wulf, and Johann-Karl Schmidt, eds. *Otto Dix* [exh. cat., Galerie der Stadt] (Stuttgart, 1991).

März, Roland. "Das Gemälde 'Mondweib' von Otto Dix aus dem Jahr 1919. Eine Neuerwerbung der Nationalgalerie," *Forschungen und Berichte* 25 (1985): 71–81.

————. "Otto Dix: Die Skatspieler: Eine Neuerwerbung fur die Nationalgalerie," *Jahrbuch Preussischer Kulturbesitz* 32 (1993): 351–391.

McGreevy, Linda F. *Bitter Witness: Otto Dix and the Great War*. New York, 2001.

Otto Dix [exh. cat., Tate Gallery] (London, 1992).

Theo van Doesburg

Doesburg, Theo van. *Das andere Gesicht: Gedichte, Prosa, Manifeste, Roman, 1913 bis 1928*. Ed. Hansjürgen Bulkowski. Munich, 1983.

. . .

Beckett, Jane. "Dada, van Doesburg and De Stijl," *Journal of European Studies* 9, parts 1 and 2 (1979): 1–25.

Berg, Hubert van den. "Theo van Doesburg, De Stijl, and Dada." In *The Import of Nothing: How Dada Came, Saw, and Vanished in the Low Countries (1915–1929)*, 111–149. New York, 2002.

Birnie-Danzker, Jo-Anne, ed. *Theo van Doesburg. Maler-Architekt*. New York, 2000.

Eliason, Craig. "Manifestoes by Mail: Postcards from the Theo van Doesburg Correspondence." In *Visual Resources: An International Journal of Documentation* (2001), 449–458.

Hedrick, Hannah L. *Theo Van Doesburg. Propagandist and Practitioner of the Avant-Garde, 1909–1923*. Ann Arbor, Mich., 1973.

Hoek, Els, ed. *Theo van Doesburg, oeuvre catalogue*. Utrecht and Oterlo, 2000.

Marcel Duchamp

Cabanne, Pierre. *Dialogues with Marcel Duchamp*. Trans. Ron Padgett. New York, 1971.

Duchamp, Marcel. *Affectionately, Marcel: The Selected Correspondence of Marcel Duchamp*. Ed. Francis M. Naumann and Hector Obalk. Trans. Jill Taylor. Ghent and Amsterdam, 2000.

————. *Duchamp du signe*. Ed. Michel Sanouillet and Elmer Peterson. Paris, 1994.

————. *Notes*. Ed. and trans. Paul Matisse. Boston, 1983.

————. *Salt Seller: The Writings of Marcel Duchamp*. Ed. Michel Sanouillet and Elmer Peterson. New York, 1973.

. . .

Camfield, William. *Marcel Duchamp: Fountain*. [exh. cat., The Menil Collection] (Houston, 1989).

Caumont, Jacques, and Jennifer Gough-Cooper. "Ephemerides on and about Marcel Duchamp and Rrose Sélavy, 1887–1968." In *Marcel Duchamp Vita/Opera* [exh. cat., Palazzo Grassi, Venice] (Milan, 1993).

Clair, Jean, ed. *Marcel Duchamp: Catalogue raisonné* [exh. cat., Musée national d'art moderne, Centre Georges Pompidou] (Paris, 1977).

————. *Marcel Duchamp ou Le grand fictif: Essai de mythanalyse du Grand Verre*. Paris, 1976.

———. Sur Marcel Duchamp et la fin de l'art. Paris, 2000.

D'Harnoncourt, Anne, and Kynaston McShine, eds. Marcel Duchamp [exh. cat., Museum of Modern Art] (New York, 1973).

Duve, Thierry de, ed. The Definitively Unfinished Marcel Duchamp. Cambridge, Mass., 1991.

———. Pictorial Nominalism: On Marcel Duchamp's Passage from Painting to the Readymade. Trans. Dana Polan. Minneapolis, 1991.

Hamilton, Richard. The Almost Complete Works of Marcel Duchamp [exh. cat., Tate Gallery] (London, 1966).

Hopps, Walter, Ulfe Linde, and Arturo Schwarz. Marcel Duchamp Ready Made, Etc. 1913–1964. Milan and Paris, 1964.

Hulten, Pontus, ed. Marcel Duchamp, Work and Life. Cambridge, Mass., 1993.

Jones, Amelia. Postmodernism and the En-Gendering of Marcel Duchamp. Cambridge, Mass., 1994.

Joselit, David. Infinite Regress: Marcel Duchamp, 1910–1941. Cambridge, Mass., 1998.

Judovitz, Dalia. "Anemic Vision in Duchamp: Cinema as Readymade," Dada/Surrealism 15 (1986): 46–57.

———. Unpacking Duchamp: Art in Transit. Berkeley, 1995.

Krauss, Rosalind. "Notes on the Index, Part 1." In The Originality of the Avant-Garde and Other Modernist Myths, 196–209. Cambridge, Mass. and London, 1985.

———. The Optical Unconscious. Chap. 3, 95–146. Cambridge, Mass., and London, 1993.

Kuenzli, Rudolf E., and Francis M. Naumann, eds. Marcel Duchamp: Artist of the Century. Cambridge, Mass., 1989.

Lebel, Robert. Marcel Duchamp. Trans. George Heard. New York, 1959.

Mileaf, Janine. "L'art sec," Les cahiers du Musée national d'art moderne 88 (Summer 2004): 42–47.

Molesworth, Helen. "Rrose Sélavy Goes Shopping." In The Dada Seminars, ed. Leah Dickerman with Matthew S. Witkovsky, 173–189. Washington, DC, 2005.

———. "Work Avoidance: The Everyday Life of Marcel Duchamp's Readymades," Art Journal 57, no. 4 (Winter 1998): 50–61.

Naumann, Francis M. Marcel Duchamp: The Art of Making Art in the Age of Mechanical Reproduction. Ghent and New York, 1999.

Nesbit, Molly. "His Common Sense," Artforum 33 (October 1994): 92–126.

———. "The Rat's Ass," October 56 (Spring 1991): 6–20.

———. "Ready-Made Originals: The Duchamp Model," October 37 (Summer 1986): 53–64.

Schwarz, Arturo. The Complete Works of Marcel Duchamp. 2 vols. New York, 1997.

Semin, Didier. "Duchamp et Dada: Le négatif préféré à la négation, " Les cahiers du Musée national d'art moderne 88 (Summer 2004): 34–41.

Tomkins, Calvin. Duchamp: A Biography. New York, 1996.

Suzanne Duchamp
Duchamp, Suzanne. "La valeur intrinsèque," La pomme de pin 1 (25 February 1922): 3.

. . .

Baier, Lesley. "Suzanne Duchamp." In The Société Anonyme and the Dreier Bequest at Yale University: A Catalogue Raisonné, ed. Robert L. Herbert, Eleanor S. Apter, and Elise K. Kenney, 246–248. New Haven, Conn., 1984.

———. "Suzanne Duchamp and Dada in Paris." In Women in Dada: Essays on Sex, Gender, and Identity, ed. Naomi Sawelson-Gorse, 82–102. Cambridge, Mass., 1998.

Schwarz, Arturo. "Suzanne Duchamp." In L'altra meta dell'avanguardia 1910–1940: Pittrici et scultrici nei movimenti delle avanguardie storiche, ed. Lea Virgine, 175–177. Milan, 1980.

Viking Eggeling
Georgen, Jeanpaul. "Viking Eggeling's Kinorphism: Zurich Dada and the Film." In Zurich Dada: A Clown's Game from Nothing, ed. Brigitte Pichon and Karl Riha, 168–175. New York, 1996.

O'Konor, Louise. Viking Eggeling 1880–1925, Artist and Filmmaker. Life and Work. Trans. Catherine C. Sundstrom and Anne Bibby. Stockholm, 1971.

Paul Eluard
Eluard, Paul. Oeuvres complètes. Vol. 1, ed. Marcelle Dumas and Lucien Scheler. Paris, 1968.

. . .

Gill, Brian. "Eluard's Dadaist Poetry," Essays in French Literature 18 (November 1981): 65–71.

Max Ernst
Ernst, Max. Beyond Painting. New York, 1948.

———. Écritures. Paris, 1970.

. . .

Aragon, Louis. "Max Ernst, peintre des illusions." In Les collages, 23–29. Paris, 1965.

Camfield, William A. Max Ernst: Dada and the Dawn of Surrealism [exh. cat., The Menil Collection] (Munich and Houston, 1993).

Derenthal, Ludger et al. Max Ernst: Das Rendezvous der Freunde [exh. cat., Museum Ludwig] (Cologne, 1991).

———. "Max Ernst: Trois tableaux d'amitié," Les cahiers du Musée national d'art moderne 31 (Spring 1990): 73–110.

———. "Mitteilungen über Flugzeuge, Engel und den Weltkrieg Zu den Photocollagen der Dadazeit von Max Ernst." In Die Deutsche der Moderne, ed. Klaus Herding, 41–60. Hamburg, 1994.

Foster, Hal. "Armor fou," October 56 (Spring 1991): 65–97.

———. "A Bashed Ego: Max Ernst in Cologne." In The Dada Seminars, ed. Leah Dickerman with Matthew S. Witkovsky, 127–149. Washington, DC, 2005.

———. "Blinded Insights: On the Modernist Reception of the Art of the Mentally Ill," October 97 (Summer 2001): 3–30.

———. "Convulsive Identity," October 57 (Summer 1991): 19–54.

Gee, Malcolm. Max Ernst: "Pietà or Revolution by Night." London, 1986.

Krauss, Rosalind. "The Master's Bedroom," Representations 28 (Fall 1989): 55–76.

———. The Optical Unconscious. Chap. 2, 32–93. Cambridge, Mass., and London, 1993.

Legge, Elizabeth M. Max Ernst: The Psychoanalytic Sources. Ann Arbor, Mich., 1989.

————. "Only Half Saying It: Max Ernst and Emblems," *Word and Image* 16, no. 3 (July–September 2000): 239–269.

Maurer, Karin von. "Images of Dream and Desire: The Prints and Collage Novels of Max Ernst." In *Max Ernst: Beyond Surrealism: A Retrospective of the Artist's Books and Prints*, ed. Robert Rainwater [exh. cat., New York Public Library] (New York, 1986), 37–93.

Max Ernst: Retrospektive 1979 [exh. cat., Haus der Kunst] (Munich, 1979).

Pech, Jürgen, ed. *Max Ernst, Paul Eluard, 1921–1924.* [exh. cat., Stadt Brühl, Max-Ernst-Kabinett] (Brühl, 1982).

Russel, John. *Max Ernst: Life and Work.* New York, 1967.

Spies, Werner. *Max Ernst: Collagen. Inventar und Widerspruch.* Cologne, 1974.

————. *Max Ernst: Collages. The Invention of the Surrealist Universe.* Trans. John William Gabriel. New York, 1991.

————, ed. *Max Ernst: A Retrospective* [exh. cat., Tate Gallery] (Munich, 1991).

Spies, Werner, and Helmut R. Leppien. *Max Ernst. Oeuvre-Katalog. Das graphische Werk.* Houston and Cologne, 1975.

Spies, Werner, Sigrid Metken, and Günter Metken. *Max Ernst Oeuvre-Katalog.* Vol. 1, 1906–1925. 6 vols. Houston and Cologne, 1975.

Spies, Werner, and Sabine Rewald, eds. *Max Ernst: A Retrospective* [exh. cat., Metropolitan Museum of Art] (New York and New Haven, Conn., 2005).

Spies, Werner et al. *Max Ernst: Die Retrospektive* [exh. cat., Neue Nationalgalerie Berlin] (Berlin and Cologne, 1999).

Stokes, Charlotte. "Collage as Jokework: Freud's Theories of Wit as the Foundation for the Collages of Max Ernst," *Leonardo* 15, no. 3 (1982): 199–204.

————. "The Equivocal Ernst: Some Sources and Interpretations of Max Ernst's *Two Children Are Threatened by a Nightingale*," *Arts Magazine* 57, no. 5 (January 1983): 100–110.

————. "The Scientific Methods of Max Ernst: His Use of Scientific Subjects from *La Nature*," *Art Bulletin* 62, no. 3 (September 1980): 453–465.

————. "The Statue's Toe: The Nineteenth-Century Academic Nude as Eros in the Work of Max Ernst," *Pantheon* 67 (1989): 166–172.

Waldberg, Patrick. *Max Ernst.* Paris, 1958.

Elsa von Freytag-Loringhoven
Freytag-Loringhoven, Elsa von. *Baroness Elsa.* Ed. Paul I. Hjartarson and Douglas O. Spettigue. Ottawa, 1992.

. . .

The Art of Baroness Elsa von Freytag-Loringhoven [exh. cat., Francis M. Naumann Fine Art] (New York, 2002).

Gammel, Irene. *Baroness Elsa. Gender, Dada, and Everyday Modernity: A Cultural Biography.* Cambridge, Mass., 2002.

Naumann Francis M. "Baroness Elsa von Freytag-Loringhoven." In *New York Dada 1915–1923*, 168–175. New York, 1994.

Reiss, Robert. "'My Baroness': Elsa von Freytag-Loringhoven." In *New York Dada*, ed. Rudolf E. Kuenzli, 81–101. New York, 1986.

Rodker, John. "Dada and Elsa von Freytag-Loringhoven," *The Little Review* 7 (July–August 1920).

George Grosz
Grosz, George. *Briefe, 1913–1939.* Ed. Herbert Knust. Reinbek, 1979.

————. *Ein kleines Ja ein großes Nein.* Hamburg, 1955. (*George Grosz: An Autobiography.* Trans. Nora Hodges. New York, 1983).

Grosz, George, and Wieland Herzfelde. *Die Kunst ist in Gefahr: Drei Aufsätze.* Königstein, 1981.

. . .

Baur, John I. H. *George Grosz* [exh. cat., Whitney Museum of American Art] (New York, 1954).

Flavell, Mary Kay. *George Grosz.* New Haven, Conn., 1988.

Irwin Lewis, Beth. *George Grosz: Art and Politics in the Weimar Period.* Princeton, N.J., 1991.

Kranzfelder, Ivo. *George Grosz.* Cologne, 1993.

Maurer, Karin von. *George Grosz, 1893–1959, Dedication to Oscar Panizza, 1917–1918* [exh. cat., Staatsgalerie Stuttgart] (Stuttgart, 1999).

McCloskey, Barbara. *George Grosz and the Communist Party: Art and Radicalism in Crisis.* Princeton, N.J., 1997.

Neugebauer, Rosamunde. *George Grosz: Macht und Ohnmacht satirischer Kunst.* Berlin, 1993.

Pérez, Carlos et al. *George Grosz: Obra gráfica. Los años de Berlin* [exh. cat., IVAM, Centre Julio Gonzalez] (Valencia, 1992).

Schneede, Uwe M., ed. *George Grosz: His Life and Work.* Trans. Susanne Flatauer. New York, 1979.

Schuster, Peter Klaus, ed. *George Grosz. Berlin–New York* [exh. cat., Neue Nationalgalerie] (Berlin, 1994).

Whitford, Frank. *The Berlin of George Grosz: Drawings, Watercolours, and Prints, 1912–1930* [exh. cat., Royal Academy of Arts] (London, 1997).

Raoul Hausmann
Hausmann, Raoul. *Am Anfang war Dada.* Ed. Karl Riha and Günter Kämpf. Giessen, 1992.

————. *Considérations objectives sur le rôle du dadaïsme* preceded by *Matériau de la peinture, sculpture, architecture.* Trans. Marc Dachy. Paris, 1994.

————. *Courrier Dada.* Paris, 1958.

————. "Économie de prothèses," *Les cahiers du Musée national d'art moderne* 68 (Summer 1999): 81

————. *Hurra ! Hurra ! Hurra !* Berlin, 1920.

————. *Je ne suis pas un photographe.* Ed. Michel Giroud. Paris, 1975.

————. *Scharfrichter der bürgerlichen Seele: Raoul Hausmann in Berlin 1900–1933: unveröffentlichte Briefe, Texte, Dokumente aus den Künstler-Archiven der Berlinischen Galerie.* Ed. Eva Züchner. Stuttgart, 1998.

. . .

Altman, R., and Jean-François Bory, eds. "Raoul Hausmann et Dada à Berlin. Dossier critique," *Apeiros* 6 (1974).

Bartsch, Kurt, and Adelheid Koch, eds. *Raoul Hausmann*. Graz, 1996.

Benson, Timothy O. *Raoul Hausmann and Berlin Dada*. Ann Arbor, Mich., 1987.

Cachin-Nora, Françoise et al. *Raoul Hausmann, autour de L'Esprit de notre temps: Assemblages, collages, photomontages* [exh. cat., Musée national d'art moderne] (Paris, 1974).

Donguy, Jacques. "L'Optophone de Raoul Hausmann," *Art Press* 255 (March 2000): 56–60.

Fabre, Guilhem. "Un coup de gueule jamais n'abolira le hasard: Raoul Hausmann et la poésie phonétique," *Les cahiers du Musée national d'art moderne* 88 (Summer 2004): 80–85.

Lista, Marcella. "Raoul Hausmann's Optophone." In *The Dada Seminars*, ed. Leah Dickerman with Matthew S. Witkovsky, 83–101. Washington, DC, 2005.

Züchner, Eva et al. *Raoul Hausmann* [exh. cat., Musée d'art moderne Saint-Etienne] (Paris, 1994).

John Heartfield
Heartfield, John. *Der Schnitt entlang der Zeit: Selbstzeugnisse, Errinerungen, Interpretationen: Eine Dokumentation*. Ed. Roland März. Dresden, 1981.

· · ·

Herzfelde, Wieland. *John Heartfield: Leben und Werk*. Dresden, 1988.

März, Roland. *Heartfield Montiert 1930–1938*. Leipzig, 1993.

Pachnicke, Peter and Klaus Honnef, eds. *John Heartfield*. New York, 1992.

Siepmann, Eckhard. *Montage, John Heartfield: Vom Club Dada zur Arbeiter-Illustrierten Zeitung. Dokumente, Analysen, Berichte*. Berlin, 1977.

Emmy Hennings
Ball-Hennings, Emmy. *Betrunken taumeln all Litfasssäulen: Frühe Texte und autobiographische Schriften, 1913–1922*. Ed. Bernhard Merkelbach. Hannover, 1990.

———. *Hugo Ball. Sein Leben in Briefen und Gedichten*. Frankfurt am Main, 1929, 1991.

Hennings, Emmy. *Gefängnis*. Berlin, 1919.

· · ·

Berg, Hubert van den. "The Star of the Cabaret Voltaire: The Other Life of Emmy Hennings." In *Dada Zurich: A Clown's Game from Nothing*, ed. Brigitte Pichon and Karl Riha, 69–88. New York, 1996.

Reetz, Bärbel. *Emmy Ball-Hennings: Leben im Vielleicht: eine Biographie*. Frankfurt am Main, 2001.

Rugh, Thomas F. "Emmy Hennings and Zurich Dada," *Dada/Surrealism* 10–11 (1982): 5–28.

Wieland Herzfelde
Herzfelde, Wieland. "Introduction to the First International Dada Fair," trans. and intro. Brigid Doherty, *October* 105 (Summer 2003): 93–104.

———. *Unterwegs: Blätter aus fünfzig Jahren*. Berlin, 1961.

———. *Zur Sache: Geschrieben und gesprochen zwischen 18 und 80*. Berlin, 1976.

Hannah Höch
Höch, Hannah. "Erinnerungen an Dada." In *Hannah Höch 1889–1978. Ihr Werk, Ihr Leben, Ihre Freunde*, ed. Elizabeth Moortgat et al. [exh. cat., Berlinische Galerie] (Berlin, 1989), 201–213.

———. "Hannah Höch und die Berliner Dadaisten: Ein Gespräch mit der Malerin," *Der Monat* 134 (November 1959): 60–68.

———. "Die Revue: Eine des Reisen mit Kurt Schwitters." In *Dada: Dokumente einer Bewegung* [exh. cat., Kunsthalle and Kunstverein für die Rheinlande und Westfalen] (Dusseldorf, 1958), unpaginated.

Thater-Schulz, Cornelia, ed. *Hannah Höch. Eine Lebenscollage*. 2 vols. Berlin, 1989.

· · ·

Boswell, Peter, et al. *The Photomontages of Hannah Höch* [exh. cat., Walker Art Center] (Minneapolis, 1996).

Burmeister, Ralf. "Das statiche und das dynamische Bild. Hannah Höch un der Film," *Museum Journal Berlin* 14, no. 3 (July 2000): 10–13.

Dech, Jula, and Ellen Maurer, eds. *Da-Da Zwischen Reden zu Hannah Höch*. Berlin, 1991.

Lavin, Maud. *Cut with the Kitchen Knife: The Weimar Photographs of Hannah Höch*. New Haven, Conn., 1993.

Makholm, Kristin Jean. "Film, Portraiture, and Primitivism in the Photomontages of Hannah Höch." Ph.D. diss., University of Minnesota, 1999.

Ollman, Leah. "The Lives of Hannah Höch," *Art in America* 86, no. 4 (April 1998): 100–105.

Pagé, Suzanne, et al. *Hannah Höch* [exh. cat., Musée d'art moderne de la ville de Paris] (Paris, 1976).

Pawlow, Kamen, ed. *Hannah Höch* [exh. cat., Museen der Stadt Gotha] (Gotha, 1993).

Rempel, Lora. "The Anti-Body in Photomontage: Hannah Höch's Woman without Wholeness," *Genders* 19 (1994): 108–119.

Stanislawski, Ryszard, and Dieter Honisch. *Hannah Höch* [exh. cat., Muzeum Sztuki] (Lodz, 1977).

Angelika Hoerle
Heinrich Hoerle
Artinger, Kai. "Angelika Hoerle." In *Etwas Wasser in der Seife: Porträts dadaistischer Künstlerinnen und Schriftstellerinnen*, ed. Britta Jürgs, 49–66. Grambin, 1999.

Backes, Dirk, ed. *Heinrich Hoerle, Leben und Werk 1895–1936* [exh. cat., Kölnischer Kunstverein] (Cologne, 1981).

Hoerle und Sein Kreis [exh. cat., Kunstverein zu Frechen] (Frechen, 1971).

Vitt, Walter. *Heinrich Hoerle und Franz Wilhelm Seiwert: Die Progressiven*. Cologne, 1975.

Richard Huelsenbeck
Huelsenbeck, Richard. *The Dada Almanac*. Presented and translated by Malcolm Green. London, 1993 (originally published as *Dada Almanach: Im Auftrag des Zentralamts der Deutschen Dada-Bewegung*. Berlin, 1920).

———, ed. *Dada: Eine literarische Dokumentation*. Reinbek bei Hamburg, 1964.

———. *Dada siegt! Eine Bilanz des Dadaismus*. Berlin, 1920.

———. *En Avant Dada: A History of Dadism*. In *The Dada Painters and Poets: An Anthology*, ed. Robert Motherwell, trans. Ralph Manheim, 23–47. Cambridge, Mass., 1989 (originally published as *En avant Dada: Eine Geschichte des Dadaismus*. Hannover, 1920).

———. *Fantastic Prayers*. Reprinted in *Blago Bung Blago Bung Bosso Fataka! First Texts of German Dada*, trans. Malcolm Green, 53–86. London, 1995 (originally published as *Phantastische Gebete*. Zurich, 1916).

———. *Memoirs of a Dada Drummer*. Ed. H. J. Kleinschmidt. Trans. Joachim Neugroschel. New York, 1974 (originally published as *Mit Witz, Licht, und Grütze: Auf den Spuren des Dadaismus*. Wiesbaden, 1957).

———. *Schalaben Schalabai Schalamezomai*. Zurich, 1916.

Kapfer, Herbert, and Lisbeth Exner, eds. *Weltdada Huelsenbeck. Eine Biografie in Briefen und Bildern*. Innsbruck, 1996.

. . .

Feidel-Mertz, Hildegard, ed. *Der Junge Huelsenbeck: Entwicklungsjahre eines Dadaisten*. Giessen, 1992.

Füllner, Karin. *Richard Huelsenbeck: Texte und Aktionen eines Dadaisten*. Heidelberg, 1983.

Sheppard, Richard, ed. *Richard Huelsenbeck*. Hamburg, 1982.

Marcel Janco
Ilk, Michael, ed. *Marcel Janco, Das Graphische Werk: Catalogue Raisonné*. Berlin, 2001.

Marcel Janco [exh. cat., Galerie Denise René] (Paris, 1963).

Marcel Janco, Dada documents et témoignages, 1916–1958 [exh. cat., Tel Aviv Museum] (Tel Aviv, 1959).

Mendelson, Marcel L. *Marcel Janco*. Tel Aviv, 1962.

Naumann, Francis M., "Janco/Dada: An Interview with Marcel Janco," *Arts Magazine*, 57, no. 3 (1982): 80–86.

Seiwert, Harry. *Marcel Janco, Dadaist, Zeitgenosse, wohltemperierter morgenländischer Konstruktivist*. Frankfurt am Main, 1993.

Seuphor, Michel. *Marcel Janco*. Amriswil, 1963.

El Lissitzky
Dickerman, Leah. "El Lissitzky's Camera Corpus." In *Situating El Lissitzky: Vitebsk, Berlin, Moscow*, ed. Nancy Perloff and Brian Reed, 153–176. Los Angeles, 2003.

Nisbet, Peter. *El Lissitzky, 1890–1941*. Cambridge, Mass., 1987.

Tupitsyn, Margarita. *El Lissitzky. Beyond the Abstract Cabinet: Photography, Design, Collaboration*. New Haven, Conn., 1999.

Man Ray
Man Ray. *Self Portrait*. Boston, 1963.

. . .

Binder, Walter, et al. *Man Ray. Photographien, Filme, frühe Objekte* [exh. cat., Kunsthaus Zürich] (Zurich, 1988).

Bouhours, Jean-Michel, and Patrick de Haas. *Man Ray, directeur du mauvais movies* [exh. cat., Musée national d'art moderne, Centre Georges Pompidou] (Paris, 1997).

Foresta, Merry, et al. *Perpetual Motif: The Art of Man Ray* [exh. cat., National Museum of American Art, Smithsonian Institution] (Washington, DC, 1988).

Janus, ed. *Man Ray. The Photographic Image*. Woodbury, 1980.

Kicken, Rudolf, et al. *Man Ray, 1890–1976: Photographien* [exh. cat., Kunsthaus Wien] (Munich, 1996).

Krauss, Rosalind. "The Object Caught by the Heel." In *Making Mischief: Dada Invades New York*, ed. Francis M. Naumann, 248–251. New York, 1996.

L'Ecotais, Emmanuelle de, and Alain Sayag, eds. *Man Ray: Photography and Its Double* [exh. cat., Musée national d'art moderne, Centre Georges Pompidou] (London, 1998).

Martin, Jean-Hubert, ed. *Man Ray: Objets de mon affection*. Paris, 1983.

Mileaf, Janine. "Between You and Me: Man Ray's Object to Be Destroyed," *Art Journal* 63, no. 1 (Spring 2004): 4–23.

Naumann, Francis M. *Conversion to Modernism: The Early Works of Man Ray* [exh. cat., Montclair Art Museum] (New Brunswick, N.J., 2003).

———. *Man Ray in America. Paintings, Drawings, Sculpture, and Photographs* [exh. cat., Francis M. Naumann Fine Art] (New York, 2001).

———. *Man Ray: The New York Years, 1913–1921* [exh. cat., Zabriskie Gallery] (New York, 1988).

Penrose, Roland. *Man Ray. Inventor/Painter/ Poet*. New York and Boston, 1974.

Pincus-Witten, Robert. "Man Ray: The Homonymic Pun and American Vernacular," *Artforum* 13 (April 1975): 54–59.

Schwarz, Arturo. *Man Ray. The Rigour of Imagination*. London, 1977.

Francis Picabia
Picabia, Francis. *Caravansérail 1924*. Ed. Luc-Henri Mercier. Paris, 1978.

———. *Écrits*. 2 vols. Ed. Olivier Revault d'Allones. Paris, 1975–1978.

———. "Mr. Picabia Breaks with the Dadas," *October* 105 (Summer 2003): 145–146.

. . .

Baker, George. "Long Live Daddy," *October* 105 (Summer 2003): 37–72.

Beaumelle, Agnès de la et al. *Francis Picabia, Galerie Dalmau, 1922* [exh. cat., Musée national d'art moderne, Centre Georges Pompidou] (Paris, 1996).

Bohn, Willard. "Picabia's 'Mechanical Expression' and the Demise of the Object," *Art Bulletin* 67 (December 1985): 673–677.

Bois, Yve-Alain. *Francis Picabia*. Paris, 1975.

———. "From Dada to Pétain," *October* 30 (Fall 1984): 121–127.

Borràs, Maria-Lluïsa. *Picabia*. New York, 1985.

Boulbès, Carole. *Picabia, le saint masqué*. Paris, 1998.

Camfield, William A. *Francis Picabia* [exh. cat., Solomon R. Guggenheim Museum] (New York, 1970).

———. *Francis Picabia: His Art, Life, and Times*. Princeton, N.J., 1979.

———. "The Machine Style of Francis Picabia," *Art Bulletin* 48 (1966): 309–322.

Camfield, William A., et al. *Francis Picabia, Máquinas y Españolas* [exh. cat. IVAM, Centre Julio González] (Valencia, 1995).

Everling-Picabia, Germaine. *L'anneau de Saturne*. Paris, 1970.

Homer, William I. "Picabia's *Jeune fille américaine dans l'état de nudité* and Her Friends," *Art Bulletin* 58 (March 1975): 110–115.

Hopkins, David. "Questioning Dada's Potency: Picabia's *La Sainte Vierge* and the Dialogue with Duchamp," *Art History* 15, no. 3 (September 1992): 317–333.

Jones, Caroline A. "The Sex of the Machine: Mechanomorphic Art, New Women, and Francis Picabia's Neurasthenic Cure." In *Picturing Science, Producing Art*, ed. Caroline A. Jones and Peter Galison, 145–180. New York, 1998.

La Hire, Marie de. *Francis Picabia*. Paris, 1920.

Le Bot, Marc. *Francis Picabia et la crise des valeurs figuratives, 1900–1925*. Paris, 1968.

Legge, Elizabeth. "Thirteen Ways of Looking at a Virgin: Francis Picabia's *La Sainte Vierge*," *Word and Image* 12, no. 2 (April–June 1996): 218–242.

Martin, Jean-Hubert, and Hélène Seckel. *Francis Picabia* [exh. cat., Musée national d'art moderne] (Paris, 1976).

Massot, Pierre de. *Picabia*. Paris, 1966.

Ottinger, Didier. "*Dresseur d'animaux*, 1923, de Francis Picabia," *Les cahiers du Musée national d'art moderne* 72 (Summer 2000): 80–91.

Pagé, Suzanne, et al. *Francis Picabia, singulier idéal* [exh. cat., Musée d'art moderne de la ville de Paris] (Paris, 2002).

Pierre, Arnauld. "Dada Stands Its Ground: Francis Picabia versus the Return to Order." In *Paris Dada: The Barbarians Storm the Gates*, ed. Elmer Peterson, 132–156. New York, 2001.

———. *Francis Picabia, ou La peinture sans aura*. Paris, 2002.

———. "Picabia, 'Poète impair': Autour d'un ensemble inédit de dessins-poèmes," *Les cahiers du Musée national d'art moderne* 88 (Summer 2004): 22–33.

Sanouillet, Michel. *Francis Picabia et 391*. Paris, 1966.

True Latimer, Tirza. "Inversion, Subversions, Reversions: Did 'Relâche' Queer the Discourse?" *On-Stage Studies*, 20 (Fall 1997): 65–82.

Adya van Rees
Otto van Rees
Henkels, Herbert. "Fresko's van Van Rees en Arp in Zuerich." *Museumjournaal* 23, no. 1 (1978): 11–15.

Kuitenbrouwer-Lesparre, Irène. "Biography on Otto van Rees." Unpublished ms.

Otto en Adya van Rees. Leven en Werk tot 1934 [exh. cat., Centraal Museum] (Utrecht, 1975).

Georges Ribemont-Dessaignes
Ribemont-Dessaignes. *Dada: Manifestes, poèmes, articles, projets, théâtre, cinéma, chroniques (1915–1929)*. Ed. Jean-Pierre Bégot. Paris, 1994.

———. *Déjà-jadis, ou Du mouvement Dada à l'art abstrait*. Paris, 1958.

———. "History of Dada." In *The Dada Painters and Poets: An Anthology*, ed. Robert Motherwell, 101–120. New York, 1951.

. . .

Jotterand, Franck. *Georges Ribemont-Dessaignes*. Paris, 1996.

Jubert, Roxane. "Dire blanc et noir, en deux mots: Le non in-ouï de Georges Ribemont-Dessaignes," *Les cahiers du Musée national d'art moderne* 88 (Summer 2004): 92–99.

Hans Richter
Richter, Hans. *Begegnungen von Dada bis heute: Briefe, Dokumente, Erinnerungen*. Cologne, 1973.

———. *Dada: Art and Anti-Art*. Trans. David Britt. London, 1965 (originally published as *Dada: Kunst und Antikunst*. Cologne, 1964).

———. "Dada and the Film. " In *Dada: Monograph of a Movement*, ed. Willy Verkauf, 39–45. New York, 1957.

———. *Hans Richter*. Neuchâtel, 1965.

———. *Hans Richter by Hans Richter*. Ed. Cleve Gray. New York, 1971.

Sheppard, Richard. "Thirty-three Letters, Telegrams and Cards from Hans Richter to Tristan Tzara and Otto Flake (1917–1926)." In *New Studies in Dada: Essays and Documents*. Driffield, 1981.

. . .

Cousseau, Henri-Claude. *Dessins et portraits Dada* [exh. cat., Musée de l'abbaye Sainte Croix] (Les Sables d'Olonnes, 1978).

Foster, Stephen, ed. *Hans Richter: Activism, Modernism, and the Avant-Garde*. Cambridge, Mass., 1998.

Oeuvres Dada de Hans Richter [exh. cat., Galerie Denise René] (Paris, 1975).

Sers, Philippe. *Sur Dada*. Nîmes, 1997.

Turvey, Malcolm. "Dada Between Heaven and Hell: Abstraction and Universal Language in the Rhythm Films of Hans Richter," *October* 105 (Summer 2003): 13–36.

Christian Schad
Schad, Christian. "Zurich/Geneva: Dada." In *The Era of German Expressionism*, ed. Paul Raabe, trans. J. M. Ritchie, 161–166. Woodstock, N.Y., 1974.

. . .

Lloyd, Jill, and Michael Peppiatt, eds. *Christian Schad and the Neue Sachlichkeit* [exh. cat., Neue Galerie] (New York, 2003).

Misselbeck, Reinhold. *Christian Schad* [exh. cat., Museum Ludwig] (Cologne, 1996).

Richter, Günter A. *Christian Schad*. Rottach-Egern, 2004.

———, ed. *Christian Schad: Texte, Materialien, Dokumente*. Rottach-Egern, 2004.

Schad/Dada [exh. cat., Galleria Schwarz] (Milano, 1970).

Schadographien 1918–1975 [exh. cat., Von der Heydt-Museum] (Wuppertal, 1975).

Schad, Nikolaus, and Anna Auer, eds. *Schadographien. Die Kraft des Lichts* [exh. cat., Museum moderner Kunst] (Passau, 1999).

Morton Livingston Schamberg
Agee, William C. "Morton Livingston Schamberg (1881–1918): Color and the Evolution of His Painting," *Arts Magazine* 57 (November 1982): 108–119.

———. "Morton Livingston Schamberg: Notes on the Sources of the Machine Images." In *New York Dada*, ed. Rudolf E. Kuenzli, 66–80. New York, 1986.

Powell, Earl A. III. "Morton Schamberg: The Machine as Icon," *Arts Magazine* 51 (May 1977): 122–124.

Wolf, Ben. *Morton Livingston Schamberg*. Philadelphia, 1963.

Rudolf Schlichter
Schlichter, Rudolf. *Autobiographie*. 3 vols. Ed. Curt Grützmacher. Berlin, 1992–1995.

. . .

Adriani, Götz, et al. *Rudolf Schlichter: Gemälde, Aquarelle, Zeichnungen* [exh. cat., Kunsthalle Tübingen] (Munich, 1997).

Horn, Gabriele, ed. *Rudolf Schlichter* [exh. cat., Staatliche Kunsthalle Berlin] (Berlin, 1984).

Georg Scholz
Georg Scholz, ein Beitrag zur Diskussion realistischer Kunst [exh. cat., Badischer Kunstverein] (Karlsruhe, 1975).

Mück, Hans-Dieter. *Georg Scholz, 1890–1945: Malerei, Zeichnung, Druckgraphik*. Stuttgart, 1991.

Sternfeld, Felicia H. *Georg Scholz (1890–1945): Monographie und Werkverzeichnis*. Frankfurt am Main, 2004.

Kurt Schwitters
Schwitters, Kurt. *Das literarische Werk*. 5 vols. Ed. Friedhelm Lach. Cologne, 1973–1981.

. *Wir spielen, bis uns der Tod abholt. Briefe aus fünf Jahrzehnten*. Ed. Ernst Nündel. Frankfurt, 1974.

. . .

Bailly, Jean-Christophe. *Kurt Schwitters*. Trans. Jean-François Poirier. Paris, 1993.

Bergius, Hanne. "Kurt Schwitters: Aspects of Merz and Dada." In *German Art in the 20th Century: Painting and Sculpture, 1905–1985*, ed. Christos M. Joachimides, Norman Rosenthal, and Wieland Schmied [exh. cat., Royal Academy of Arts] (London, 1985), 445–449.

Burns-Gamard, Elizabeth. *Merzbau: The Cathedral of Erotic Misery*. New York, 2000.

Dickerman, Leah. "Merz and Memory." In *The Dada Seminars*, ed. Leah Dickerman with Matthew S. Witkovsky, 103–125. Washington, DC, 2005.

Dietrich, Dorothea. *The Collages of Kurt Schwitters: Tradition and Innovation*. New York, 1993.

. "The Fragment Reframed: Kurt Schwitters' Merz-column," *Assemblage* 14 (April 1991): 82–92.

. "Love as Commodity: Kurt Schwitters' Collages of Women." In *Women in Dada: Essays on Sex, Gender, and Identity*, ed. Naomi Sawelson-Gorse, 206–239. Cambridge, Mass., 1998.

Elderfield, John. *Kurt Schwitters*. London, 1985.

. "Schwitters' Abstract 'Revolution,'" *German Life and Letters* 24, no. 3 (April 1971): 256–261.

Elger, Dietmar. *Der Merzbau: Eine Werkmonographie*. Cologne, 1999.

Ewig, Isabelle. "Kurt Schwitters en Hollande." In *Kurt Schwitters* [exh. cat., Musée national d'art moderne, Centre Georges Pompidou] (Paris, 1994), 174–179.

. "Kurt Schwitters, Meister von i," *Les cahiers du Musée national d'art moderne* 88 (Summer 2004): 70–79.

Lemoine, Serge et al. *Kurt Schwitters* [exh. cat., Musée national d'art moderne, Centre Georges Pompidou] (Paris, 1994).

Meyer-Büser, Susanne, and Karin Orchard. *Aller Anfang ist Merz—von Kurt Schwitters bis Heute* [exh. cat., Sprengel Museum] (Ostfildern-Ruit, 2000).

Museum Tinguely. *Kurt Schwitters: Merz—A Total Vision of the World* [exh. cat., Museum Tinguely, Basel] (Bern and Basel, 2004).

Orchard, Karin, and Isabel Schulz, eds. *Kurt Schwitters. Catalogue raisonné*. 2 vols. Ostfildern-Ruit, 2003.

, eds. *Kurt Schwitters. Catalogue of the Works and Documents in the Sprengel Museum, Hannover*. Hannover, 1998.

Schmalenbach, Werner. *Kurt Schwitters*. New York, 1970.

Shaffer, E. S. "Merzkünstler Art and Word-Art," *Word and Image* 6, no. 1 (January–March 1990): 100–118.

Steinitz, Kate. *Kurt Schwitters: A Portrait from Life*. Berkeley and Los Angeles, 1968.

Webster, Gwendolen. *Kurt Merz Schwitters: A Biographical Study*. Cardiff, 1997.

Arthur Segal
Dietze, Horst. "Arthur Segal: Picture Lending," *Art Libraries Journal* 15, no. 2 (1990): 10–14.

Herzogenrath, Wulf, and Pavel Liška, eds. *Arthur Segal, 1875–1944* [exh. cat., Kölnischer Kunstverein, Cologne] (Berlin, 1987).

Richter, Horst. "Der Maler der Gleichwertigkeitsbilder," *Weltkunst* 57, no. 19 (1987): 2631–2633.

Walter Serner
Puff-Trojan, Andreas. *Wien/Berlin/Dada: Reisen mit Dr. Serner*. Vienna, 1993.

Serner, Walter. *Das Gesamte Werk*. Vol. 2, *Das Hirngeschwür: Dada*, ed. Thomas Milch. Munich, 1982.

. *Letzte Lockerung: Manifest Dada*. Hanover, 1920 (translated and reprinted as "Last Loosening Manifesto" in *Blago Bung Blago Bung Bosso Fataka! First Texts of German Dada*, trans. Malcolm Green, 151–160. London, 1995).

. . .

Peters, Jonas. "Dem Kosmos einen Tritt!" Die Entwicklung des Werks von Walter Serner und die Konzeption seiner dadaistischen Kulturkritik. Frankfurt am Main, 1995.

Schrott, Raoul. *Walter Serner und Dada*. Siegen, 1989.

Walter Serner 1889–1942 [exh. cat., Literaturhaus Berlin] (Berlin, 1989).

Philippe Soupault
Soupault, Philippe. *Mémoires de l'oubli*. 4 vols. Paris, 1981–1987.

. *Poèmes et poésies (1917–1973)*. Paris, 1973.

. . .

Aspley, Keith. *The Life and Works of Surrealist Philippe Soupault (1887–1990): Parallel Lives*. Lewiston, N.Y., 2001.

Fauchereau, Serge. *Philippe Soupault, voyageur magnétique*. Paris, 1989.

Joseph Stella
Haskell, Barbara. *Joseph Stella* [exh. cat., Whitney Museum of American Art] (New York, 1994).

Jaffe, Irma B. *Joseph Stella*. Cambridge, Mass., 1970.

Moser, Joann. "The collages of Joseph Stella: Macchie/macchine naturali," *American Art* 6, no. 3 (Summer 1992): 58–77.

Sophie Taeuber

Barten, Sigrid. "Und alle Puppen tanzen: Die Dada-Marionetten von Sophie Taeuber," *Kunst + Architektur in der Schweiz* 47, no. 4 (1996): 426–430.

Bois, Yve-Alain. "Sophie Taeuber Arp against Greatness." In *Inside the Visible: An Elliptical Traverse of Twentieth-Century Art: In, of, and from the Feminine*, ed. M. Catherine de Zegher, 413–417. Cambridge, Mass., 1996.

Faure, J.-L., and C. Rossignol. *Sophie Taeuber-Arp* [exh. cat., Musée d'art moderne] (Strasbourg, 1977).

Gohr, Siegfried, ed. *Sophie Taeuber-Arp* [exh. cat., Stiftung Hans Arp und Sophie Taeuber-Arp e.V., Bahnhof Rolandseck] (Rolandseck, 1993).

Hubert, Renée Riese. "Collaboration as Utopia: Sophie Taeuber and Hans Arp." In *Magnifying Mirrors: Women, Surrealism, and Partnership*. Lincoln, Neb., 1994.

Kessler, Erica. "La danza di Sophie." In *Automi, marionette e ballerine nel teatro d'avanguardia*, ed. Elisa Vacarino, 61–69 [exh. cat., Museo d'arte moderna e contemporanea di Trento e Rovereto] (Milano, 2000).

Lanchner, Carolyn. *Sophie Taeuber-Arp* [exh. cat., Museum of Modern Art] (New York, 1981).

Lulinska, Agnieszka, et al. *Hans Arp, Sophie Taeuber-Arp: exploracions mútues* [exh. cat., Centre de Cultura "Sa Nostra," Palma de Mallorca] (Palma, 2003).

Mahn, Gabriele. " *Tête DADA* (1920) de Sophie Taeuber: Un manifeste plastique," *Les cahiers du Musée national d'art moderne* 88 (Summer 2004): 60–67.

Mikol, Bruno. "Les marionnettes de Sophie Taeuber." Master's thesis, Université de Paris I, 1987.

Rotzler, Willy. "Sophie Taeuber Arp and the Interrelationship of the Arts," *Journal of Decorative and Propaganda Art* 19 (1993): 84–87.

Schmidt, George, ed. *Sophie Taeuber-Arp*. Basel, 1948.

Sophie Taeuber [exh. cat., Musée d'art moderne de la ville de Paris] (Paris, 1989).

Staber, Margit. *Sophie Taeuber-Arp*. Trans. Eric Schaer. Lausanne, 1970.

Tristan Tzara

Tzara, Tristan. *Dada est tatou, tout est Dada.* With notes, bibliography, and chronology by Henri Béhar. Paris, 1996.

———. "Memoirs of Dadaism." In *Axel's Castle: A Study in the Imaginative Literature of 1870–1930*, ed. Edmund Wilson, 304–312. New York, 1931.

———. *Oeuvres complètes.* Vol. 1, ed. Henri Béhar. Paris, 1975.

———. *Seven Dada Manifestos and Lampisteries.* Trans. Barbara Wright. London, 1992.

. . .

Browning, Gordon Frederick. *Tristan Tzara: The Genesis of the Dada Poem, or From Dada to Aa.* Stuttgart, 1979.

Buot, François. *Tristan Tzara, l'homme qui inventa la révolution Dada.* Paris, 2002.

Haldas, Georges, and René Lacôte. *Tristan Tzara.* Paris, 1952.

Peterson, Elmer. *Tristan Tzara: Dada and Surrational Theorist.* New Brunswick, N.J., 1971.

Tison-Braun, Micheline. *Tristan Tzara, inventeur de l'homme nouveau.* Nizet, 1977.

"Tristan Tzara," special issue, *Europe* 555–556 (July–August 1975).

Beatrice Wood

Wood, Beatrice. *I Shock Myself: The Autobiography of Beatrice Wood.* San Francisco, 1985.

. . .

Clark, Garth. *Gilded Vessel: The Lustrous Art and Life of Beatrice Wood.* Madison, Wi., 2001.

Franklin, Paul B., "Beatrice Wood, Her Dada... and Her Mama." In *Women in Dada: Essays on Sex, Gender, and Identity*, ed. Naomi Sawelson-Gorse, 104–138. Cambridge, Mass., 1998.

Selected
Dada Periodicals

391. (Reprinted Paris, Le Terrain Vague, 1960.)

The Blind Man. (Reprinted Rome, Archivi d'arte del 20 secolo, G. Mazzotta, 1970.)

Der Blutige Ernst. (Reprinted Nendeln, Liechtenstein, Kraus Reprint, 1977.)

Bulletin D. (Reprinted in *Von Dadamax bis zum Grüngürtel: Köln in den 20er Jahren*, ed. Wulf Herzogenrath [exh. cat., Kölnischer Kunstverein] (Cologne, 1975), 37–58.)

Cabaret Voltaire. (Reprinted in *Dada Zürich-Paris, 1916–1922*, ed. Michel Giroud, 16–53. Paris, 1981.)

Cannibale. (Reprinted Rome, Archivi d'arte del 20 secolo, G. Mazzotta, 1970.)

Club Dada. (Reprinted Rome, Archivi d'arte del 20 secolo, G. Mazzotta, 1970.)

Dada. (Reprinted Rome, Archivi d'arte del 20 secolo, G. Mazzotta, 1970.)

Der Dada. (Reprinted Rome, Archivi d'arte del 20 secolo, G. Mazzotta, 1970.)

Dada Almanach. (Reprinted New York, Something Else Press, 1966.)

Dadaco. (Reprinted Rome, Archivi d'arte del 20 secolo, G. Mazzotta, 1970.)

Littérature. (Reprinted Paris, Jean-Michel Place, 1978.)

Mécano. (Reprinted Vaduz, Quarto Press, 1979.)

Merz. (Reprinted Bern, H. Lang, 1975.)

Neue Jugend. (Reprinted Berlin, Rütten & Loening, 1967.)

New York Dada. (Reprinted Rome, Archivi d'arte del 20 secolo, G. Mazzotta, 1970.)

Die Pleite. (Reprinted Nendeln, Liechtenstein, Kraus Reprint, 1977.)

Proverbe. (Reprinted Nice, Centre du 20e siècle, 1978.)

Die Schammade. (Reprinted in *Max Ernst in Köln. Die rheinische Kunstszene bis 1922*, ed. Wulf Herzogenrath [exh. cat., Kölnischer Kunstverein] (Cologne, 1980), 241–274.)

Der Ventilator. (Reprinted in Walter Vitt, *Auf der Suche nach der Biographie des Kölner Dadaisten Johannes Theodor Baargeld*. Starnberg, 1977.)

Z. (Reprinted Nice, Centre du 20e siècle, 1977.)

Der Zeltweg. (Reprinted in *Dada Zürich-Paris, 1916–1922*, ed. Michel Giroud, 57–92. Paris, 1981.)

INDEX

Page numbers in *italic* type refer to illustrations. Page numbers preceded by an asterisk refer to artists' biographies. The plate number or figure number of illustrated works is shown in **boldface** type and enclosed in brackets (e.g., **[81; fig. 2.6]**). Illustrations appearing in the chronology are indexed, but the text of the chronology and biography sections is not indexed.

CREDITS

Plates

ZURICH

1 Collectie Centraal Museum, Utrecht

3 CNAC/MNAM/Dist. Réunion des Musées Nationaux/Art Resource, NY, © 2005 Otto van Reese/Artists Rights Society (ARS), New York/Beeldrecht, Amsterdam

4, 5, 22, 35 Kunstmuseum Basel, photo: Martin Bühler

6 Digital Image © 2005 The Museum of Modern Art, New York, © 2005 Marcel Janco/Artists Rights Society (ARS), New York/ADAGP, Paris

8, 54, 56 © 2005 Board of Trustees, National Gallery of Art, Washington, photo: Lorene Emerson

10 CNAC/MNAM/Dist. Réunion des Musées Nationaux/Art Resource, NY, © 2005 Marcel Janco/Artists Rights Society (ARS), New York/ADAGP, Paris

11, 16 CNAC/MNAM/Dist. Réunion des Musées Nationaux/Art Resource, NY, © 2005 Marcel Janco/Artists Rights Society (ARS), New York/ADAGP, Paris, photo: Philippe Migeat

13 © 2005 Board of Trustees, National Gallery of Art, Washington, photo: Ricardo Blanc

17, 45 CNAC/MNAM/Dist. Réunion des Musées Nationaux/Art Resource, NY, © 2005 Sophie Taeuber/Artists Rights Society (ARS), New York/VG Bild-Kunst, Bonn, photo: Jacqueline Hyde

19, 20, 25, 28 © 2005 Sophie Taeuber/Artists Rights Society (ARS), New York/VG Bild-Kunst, Bonn

21, 23, 33, 34 Digital Image © 2005 The Museum of Modern Art, New York, ©2005 Hans Arp/Artists Rights Society (ARS), New York/VG Bild-Kunst, Bonn

24 © 2005 Bildarchiv Preussischer Kulturbesitz, Berlin, © 2005 Sophie Taeuber/Artists Rights Society (ARS), New York/VG Bild-Kunst, Bonn, © 2005 Hans Arp/Artists Rights Society (ARS), New York/VG Bild-Kunst, Bonn, photo: Jörg P. Anders, Berlin

26 © 2005 Kunsthaus Zürich. All rights reserved, © 2005 Sophie Taeuber/Artists Rights Society (ARS), New York/VG Bild-Kunst, Bonn

29 Photo: Peter Schälchli

30 Photo: M. Bertola

32 CNAC/MNAM/Dist. Réunion des Musées Nationaux/Art Resource, NY, © 2005 Hans Arp/Artists Rights Society (ARS), New York/VG Bild-Kunst, Bonn, photo: Philippe Migeat

36 © 2005 Kunsthaus Zürich. All rights reserved, © 2005 Hans Arp/Artists Rights Society (ARS), New York/VG Bild-Kunst, Bonn

37 © 2005 Board of Trustees, National Gallery of Art, Washington

40 CNAC/MNAM/Dist. Réunion des Musées Nationaux/Art Resource, NY, © 2005 Hans Richter/Artists Rights Society (ARS), New York/VG Bild-Kunst, Bonn

42 © 2005 Kunsthaus Zürich. All rights reserved

44 Digital Image © 2005 The Museum of Modern Art, New York, ©2005 Sophie Taeuber/Artists Rights Society (ARS), New York/VG Bild-Kunst, Bonn

46 © 2005 San Francisco Museum of Modern Art, San Francisco, photo: Ben Blackwell

47 CNAC/MNAM/Dist. Réunion des Musées Nationaux/Art Resource, NY, © 2005 Sophie Taeuber/Artists Rights Society (ARS), New York/VG Bild-Kunst, Bonn

48 CNAC/MNAM/Dist. Réunion des Musées Nationaux/Art Resource, NY, © 2005 Sophie Taeuber/Artists Rights Society (ARS), New York/VG Bild-Kunst, Bonn, photo: Georges Meguerditchian

50 © 2005 Hans Arp/Artists Rights Society (ARS), New York/VG Bild-Kunst, Bonn

51 Photo: Silvia Ros

53 Photo: Martine Beck Coppola

58 © The Israel Museum, Jerusalem

59 © 2005 Kunsthaus Zürich. All rights reserved, © 2005 Christian Schad/Artists Rights Society (ARS), New York/VG Bild-Kunst, Bonn

60 © Museo Thyssen-Bornemisza. Madrid

62, 65 Digital Image © 2005 The Museum of Modern Art, New York, © 2005 Christian Schad/Artists Rights Society (ARS), New York/VG Bild-Kunst, Bonn

64 Photograph © 2005 The Metropolitan Museum of Art

BERLIN

66, 76 © Museo Thyssen-Bornemisza, Madrid

67 © Copyright The British Museum

69, 72 CNAC/MNAM/Dist. Réunion des Musées Nationaux/Art Resource, NY, Art © Estate of George Grosz/Licensed by VAGA, New York, NY

70, 75, 132 Digital Image © 2005 The Museum of Modern Art, New York, Art © Estate of George Grosz/Licensed by VAGA, New York, NY

71 Photography © The Art Institute of Chicago

73, 74 Photograph © 2004 Museum Associates/LACMA

77 Art © Estate of George Grosz/Licensed by VAGA, New York, NY

79 © 2004 Kunsthaus Zürich. All rights reserved, Art © Estate of George Grosz/Licensed by VAGA, New York, NY, © 2005 John Heartfield/Artists Rights Society (ARS), New York/VG Bild-Kunst,

81 © Estate of George Grosz/Licensed by VAGA, New York, NY, © 2005 John Heartfield/Artists Rights Society (ARS), New York/VG Bild-Kunst, Bonn

82, 85 © 2005 Board of Trustees, National Gallery of Art, Washington, photo: Lorene Emerson

88 © 2005 Raoul Hausmann/Artists Rights Society (ARS), New York/ADAGP, Paris

90 © Hamburger Kunsthalle/Bildarchiv Preussischer Kulturbesitz, photo: Elke Walford

94 © Tate, London 2005, © 2005 Raoul Hausmann/Artists Rights Society (ARS), New York/ADAGP, Paris

95 CNAC/MNAM/Dist. Réunion des Musées Nationaux/Art Resource, NY, © 2005 Raoul Hausmann/Artists Rights Society (ARS), New York/ADAGP, Paris

97, 135 © 2005 Bildarchiv Preussischer Kulturbesitz, Berlin, photo: Jörg P. Anders, Berlin

98 CNAC/MNAM/Dist. Réunion des Musées Nationaux/Art Resource, NY, © 2005 Raoul Hausmann/Artists Rights Society (ARS), New York/ADAGP, Paris, photo: Jacqueline Hyde

99, 100 CNAC/MNAM/Dist. Réunion des Musées Nationaux/Art Resource, NY, © 2005 Raoul Hausmann/Artists Rights Society (ARS), New York/ADAGP, Paris, photo: Philippe Migeat

102 © 2005 Kunsthaus Zürich. All rights reserved, © 2005 Raoul Hausmann /Artists Rights Society (ARS), New York/ADAGP, Paris

103, 106 Digital Image © 2005 The Museum of Modern Art, New York

105 CNAC/MNAM/Dist. Réunion des Musées Nationaux/Art Resource, NY, photo: Philippe Migeat

108 © 2005 Bildarchiv Preussischer Kulturbesitz, Berlin, © 2005 Hannah Höch /Artists Rights Society (ARS), New York/VG Bild-Kunst, Bonn, photo: Jörg P. Anders, Berlin

109, 117, 119 © 2005 Hannah Höch/Artists Rights Society (ARS), New York/VG Bild-Kunst, Bonn

112 © Institut für Auslandsbeziehungen e.V., Stuttgart, © 2005 Hannah Höch/Artists Rights Society (ARS), New York/VG Bild-Kunst, Bonn

116 © Israel Museum, Jerusalem, photo: Avshalom Avital

121 Photo: Lee Stalsworth

123 © Nationalgalerie. Staatliche Museen zu Berlin-Preussischer Kulturbesitz

124 Digital Image © 2005 The Museum of Modern Art, New York, © 2005 Otto Dix/Artists Rights Society (ARS), New York/VG Bild-Kunst, Bonn

125 © 2005 Otto Dix/Artists Rights Society (ARS), New York/VG Bild-Kunst, Bonn

295 CNAC/MNAM/Dist. Réunion des Musées Nationaux/Art Resource, NY, © 2005 Man Ray Trust /Artists Rights Society (ARS), New York/ADAGP, Paris, photo: Jacques Faujour

297 Photograph © 2000 The Metropolitan Museum of Art

300 © 2005 Man Ray Trust/ Artists Rights Society (ARS), New York/ADAGP, Paris

301 CNAC/MNAM/Dist. Réunion des Musées Nationaux/Art Resource, NY, © 2005 Man Ray Trust /Artists Rights Society (ARS), New York/ADAGP, Paris

302 © Photothèque des musées de la ville de Paris, photo: Charles Delepelaire

304 © Photothèque des musées de la ville de Paris, photo: Jean-Yves Trocaz

305, 308 Digital Image © 2005 The Museum of Modern Art, New York

306 Photo: Robert E. Mates, Inc., N.J.

309 Photo: Paul Macapia

310, 313 Photo: Graydon Wood

311 Photo: Geoffrey Clements

312 Photograph © 2005 The Metropolitan Museum of Art

PARIS
318, 362, 363 © 2005 Board of Trustees, National Gallery of Art, Washington, photo: Lorene Emerson

319, 365 CNAC/MNAM/Dist. Réunion des Musées Nationaux/ Art Resource, NY, © 2005 Francis Picabia/Artists Rights Society (ARS), New York

321 © 2005 Marcel Duchamp/ Artists Rights Society (ARS), New York, © 2005 Man Ray/Artists Rights Society (ARS), New York, photo: Lynne Rosenthal

322 © The Israel Museum, Jerusalem, photo: Avshalom Avital

325 © Paul Macapia

326 Digital Image © 2005 The Museum of Modern Art, New York, © 2005 Marcel Duchamp/Artists Rights Society (ARS), New York

327–330 Photos: David Allison

331, 332, 337–339 Digital

Image © 2005 The Museum of Modern Art, New York, © 2005 Man Ray /Artists Rights Society (ARS), New York

334 © 2005 Man Ray/Artists Rights Society (ARS), New York, photo: Graydon Wood

335–336 © 2005 Man Ray/ Artists Rights Society (ARS), New York

341 © Tate London 2005, © 2005 Max Ernst /Artists Rights Society (ARS), New York

342 © Museo Thyssen-Bornemisza, Madrid

344 Digital Image © 2005 The Museum of Modern Art, New York, © 2005 Max Ernst /Artists Rights Society (ARS), New York

345 Rheinisches Bildarchiv Köln

346 CNAC/MNAM/Dist. Réunion des Musées Nationaux/Art Resource, NY, © 2005 Hans Arp /Artists Rights Society (ARS), New York

348 © 2005 Board of Trustees, National Gallery of Art, Washington

350 Photo: Graydon Wood

351 © Photothèque des musées de la ville de Paris, photo: Jean-Yves Trocaz

352 © Tate London 2005, © 2005 Jean Crotti/Artists Rights Society (ARS), New York

354 Photo: Becket Logan

356 Photograph © The Art Institute of Chicago, All Rights Reserved.

359 Digital Image © 2005 The Museum of Modern Art, New York

364, 370 © 2005 Francis Picabia/ Artists Rights Society (ARS), New York, Digital Image © 2005 The Museum of Modern Art, New York

366 © Photothèque des musées de la ville de Paris, photo: Remi Briant

367 Photo: Martine Beck Coppola

368 © 2005 Board of Trustees, National Gallery of Art, Washington, photo: Philip A. Charles

371 CNAC/MNAM/Dist. Réunion des Musées Nationaux/Art Resource, NY, © 2005 Francis Picabia /Artists Rights Society

(ARS), New York, photo: Philippe Migeat

373, 380 CNAC/MNAM/Dist. Réunion des Musées Nationaux/ Art Resource, NY, © 2005 Francis Picabia Artists Rights Society (ARS), New York, photo: Jacques Faujour

377 Photo: Prudence Cuming, London

Illustrations

INTRODUCTION
fig. 1 Digital Image © 2003 The Museum of Modern Art, New York

fig. 2 Courtesy Photos of the Great War Digital Archive (www.gwpda.org)

figs. 3, 4 Photos: Lt. J. W. Brooke

fig. 6 © ECPAD France. Photo: Léon Heymann

fig. 9 © 2005 Board of Trustees, National Gallery of Art, Washington, photo: Lorene Emerson

ZURICH
p. 17, bottom right © Kunsthaus Zurich. All rights reserved.

pp. 18-19 © 2005 Artists Rights Society (ARS), New York/VG Bild-Kunst, Bonn. Photo: Ernst Linck

1.3 – 1.5, I.7, I.13, 1.14 © Kunsthaus Zurich. All rights reserved

BERLIN
p. 84, top left Bildarchiv Preussischer Kulturbesitz/Art Resource, NY

p. 85 © 2005 Hannah Höch/ Artists Rights Society (ARS), New York/VG Bild-Kunst, Bonn

2.2 © 2005 Hannah Höch/Artists Rights Society (ARS), New York/ VG Bild-Kunst, Bonn

2.5 © 2005 Artists Rights Society (ARS), New York/VG Bild-Kunst, Bonn

2.11 © 2005 Artists Rights Society (ARS), New York

HANNOVER
p. 154, p. 155 bottom, and p. 156 © 2005 Kurt Schwitters/ Artists Rights Society (ARS), New York/VG Bild-Kunst, Bonn. Photo: Michael Herling/ Aline Gwose

3.1 Courtesy Kurt Schwitters Archive at the Sprengel Museum, Hannover. © 2005 Kurt Schwitters/

Artists Rights Society (ARS), New York/VG Bild-Kunst, Bonn

3.3 © 2005 Kurt Schwitters/ Artists Rights Society (ARS), New York/VG Bild-Kunst, Bonn

3.4 © Museo Thyssen-Bornemisza, Madrid

3.5, 3.6 Digital Image © 2003 The Museum of Modern Art, New York; © 2005 Kurt Schwitters/ Artists Rights Society (ARS), New York/VG Bild-Kunst, Bonn

3.7 © 2005 Board of Trustees, National Gallery of Art, Washington, photo: Lorene Emerson

3.8 © 2005 Kurt Schwitters/ Artists Rights Society (ARS), New York/ VG Bild-Kunst, Bonn. Photo: Wilhelm Redemann, Hannover, Repro: Michael Herling

3.10 © 2005 Kurt Schwitters/ Artists Rights Society (ARS), New York/VG Bild-Kunst, Bonn, photo: Michael Herling/Uwe Vogt

poem p. 160 and p. 178n8: Kurt Schwitters, "An Anna Blume" and "Anna Blossom has wheels" from: Kurt Schwitters, Das literarische Werk, ed. by Friedhelm Lach © 1973 DuMont Literatur und Kunst Verlag, Köln Reprinted by permission.

COLOGNE
p. 215, bottom, p. 216 Photos: Irène Andréani

4.6, 4.9 Fick-Eggert Collection, Gift of Dr. F. Michael Eggert and Mrs. Colette M. Lehodey Eggert in memory of great-uncle Willy Fick and Susie and Frank Eggert, 2002

4.7, 4.8 Fick-Eggert Collection, Gift of Angelika and David Little-field in memory of Angie's great-uncle Willy Fick and her parents Frank and Susie Eggert, 2002

NEW YORK
p. 274 Image donated by Corbis-Bettman

p. 275, bottom Réunion des Musées Nationaux/Art Resource, New York © 2005 Man Ray Trust/ Artists Rights Society (ARS), New York/ADAGP, Paris

5.1 © 2005 Artists Rights Society (ARS), New York. Photo: Joan Broderick, 1986.

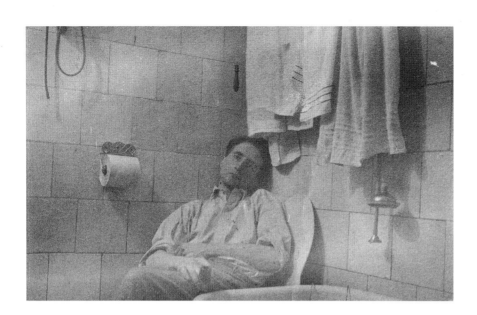